THE SWORD O...

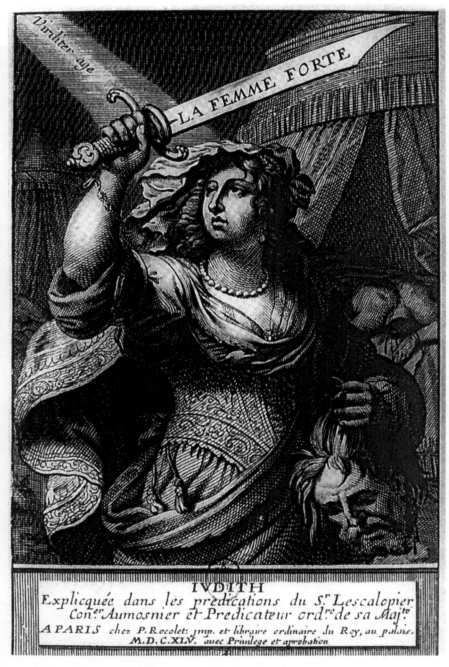

Virilitér age

LA FEMME FORTE

IVDITH

Explicquée dans les prédications du S.ʳ Lescalopier
Con.ᵉʳ Aumosnier et Predicateur ord.ʳᵉ de sa Maj.ᵗᵉ
A PARIS chez P. Rocolet: ꝟꝟ. et libraire ordinaire du Roy, au palais.
M.D.C.XLV. auec Priuilege et aprobation

Abraham Bosse, *Judith Femme Forte*, 1645. Engraving in Lescalopier,
Les predications. Photo credit: Bibliothèque Nationale, Paris.

Kevin R. Brine, Elena Ciletti and
Henrike Lähnemann (eds.)

The Sword of Judith

Judith Studies across the Disciplines

Cambridge

OpenBook
Publishers

2010

OpenBook
Publishers

Open Book Publishers CIC Ltd.,
40 Devonshire Road, Cambridge, CB1 2BL, United Kingdom
http://www.openbookpublishers.com

ISBN Hardback: 978-1-906924-16-4
ISBN Paperback: 978-1-906924-15-7
ISBN Digital (pdf): 978-1-906924-17-1

All paper used by Open Book Publishers is SFI (Sustainable Forestry Initiative), and PEFC (Programme for the Endorsement of Forest Certification Schemes) Certified.

Printed in the United Kingdom and United States by
Lightning Source for Open Book Publishers

Contents

Staging Judith

Visual Arts

Music and Drama

Online Resources

A large collaborative collection of associated digital material is available online, in association with New York Public Library, as part of the Judith Project. This includes: an extensive bibliography of primary and secondary materials, a large iconography collection, and digital copies of many impo: ratant manuscripts held at New York Public Library. These resources, hosted by the Jewish Division of New York Public Library, can be accessed from <http://www.nypl.org/locations/schwarzman/jewish-division> or from the *Sword of Judith* webpage at <http://www.openbookpublishers.com>.

Illustrations

Author biographies

[handwritten note: names bold ?]

Diane **Apostolos-Cappadona** is Adjunct Professor of Religious Art and Cultural History, Georgetown University. Her research, teaching, and publications are centered on the interconnections of art, gender, and religion, and discuss issues such as the human figure, the body, and iconoclasm. She has a particular interest in the iconology of biblical women, including Mary Magdalene, Salome, and Judith. Guest curator for "In Search of Mary *[handwritten note: it ?]* Magdalene: Images and Traditions" (2002), she coordinates the curatorial team for "Salome Unveiled" (2012) for Amsterdam and New York.

Elizabeth **Bailey** is Professor of Art History at Wesleyan College in Georgia. She is currently Chair of the Art Department. She conducts research on medieval and Renaissance tabernacles and rituals in Florence. The importance of the virtue and expression of humility led her to her study of Judith in medieval manuscripts. She is presently co-editing a book of essays.

Janet **Bartholomew** received her M.A. in English from Tennessee State University where she studied protofeminist biblical exegesis in the writings of Early Modern women. She currently teaches at Albion College as a part-time visiting faculty member and is an adjunct professor at Jackson Community College. She has also held faculty positions at Tennessee State University and Nashville State Community College. Her most recent conference papers include "Created for Labor: Rachel Speght's Intertwined Gender Labor System in *A Mouzel for Melastomus*" and "Defending 'Heuah's Sex': Biblical Exegesis in Two Early Modern Protofeminist Tracts."

Paolo **Bernardini** is Professor of Early Modern European History at the School of Law of Insubria University (Como, Italy). The publication of his *Fragments from a Land of Freedom. Essays on Fin de Siècle America* is forthcoming. He co-edited, with Norman Fiering, *The Jews and the Expansion of Europe to West* (2001).

Ruth **von Bernuth** is assistant Professor of early modern German studies at the University of North Carolina at Chapel Hill. Her dissertation focused on ideas of natural folly in medieval and early modern German literature ("Wunder, Spott und Prophetie. Natürliche Narrheit in den Historien von Claus Narren". Tübingen: Niemeyer 2008). She is currently researching the relationship between texts in Old Yiddish and the German literature of the early modern period.

Kevin R. **Brine**, the founder and director of the Judith Project, is an independent scholar and visual artist. He is Member of the Board of Overseers of the Faculty of Arts and Sciences of New York University, and the co-founder, with Clifford Siskin, of The Re-Enlightenment Project at New York University and The New York Public Library. Mr. Brine co-edited, with Garland Cannon, *Object of Enquiry: The Life, Contributions and Influence of Sir William Jones (1746–1797)* (1995). Mr Brine's paintings are published in *Kevin R. Brine: The Porch of the Caryatids: Drawings, Paintings and Sculptures* (2006).

Elena **Ciletti** is Professor of Art History at Hobart and William Smith Colleges in Geneva, New York. Her research interests include Italian patronage and art from the sixteenth through the eighteenth centuries. She has contributed articles on images of Judith to *Refiguring Woman: Perspectives on Gender and the Italian Renaissance* (1991) and *The Artemisia Files* (2005). She is working on a book-length study of the iconography of Judith in Catholic Reformation culture.

Tracey-Anne **Cooper** is Assistant Professor at the Department of History, St. John's University, Queens. Her publications include "Basan and Bata: The Occupational Surnames of Two Pre-Conquest Monks of Canterbury" (2004); "Two Previously Unrecorded Marginal Illustrations in Cotton Tiberius A. iii" (2005); "Tovi the Proud's Irregular Use of the Good Friday Liturgy" (2005); "The Homilies of a Pragmatic Archbishop's Handbook in Context: Cotton Tiberius A. iii" (2006); "Lay Piety, Pastoral Care and the Compiler's Method in Late Anglo-Saxon England" (2006); "Why is St. Margaret's the Only Saint's Life in London BL, Cotton Tiberius A. iii?" (forthcoming) and "Inculcating the Inner Heart of the Laity in Pre-Conquest England" (2008).

Roger J. **Crum** is Professor of Art History at the University of Dayton where he has held the Graul Chair in Arts and Languages. He currently serves as the College of Arts and Sciences Liaison for Global and Intercultural Initiatives. A former member of the Institute for Advanced Study in Princeton, Professor Crum has published on a variety of subjects ranging from the art and politics of Renaissance Florence to Hitler's visit to Florence in 1938. He is the co-editor with John T. Paoletti of *Renaissance Florence: A Social History* (2008) and, with Claudia Lazzaro, of *Donatello Among the Blackshirts: History and Modernity in the Visual Culture of Fascist Italy* (2005).

Robert **Cummings** is Honorary Research Fellow in the University of Glasgow. He has edited *Spenser: The Critical Heritage and Seventeenth-Century Poetry* for the Blackwell Annotated Anthology series. He is the author of critical and bibliographical articles, mainly on sixteenth- and seventeenth-century British poetry (Gavin Douglas, Drummond, Spenser, Jonson, Herbert, Marvell) but also on eighteenth- and nineteenth-century topics. His interests in neo-Latin literature are reflected in publications on Alciati. He is Review Editor of Translation and Literature, and has written on a variety of translation-related topics.

Deborah Levine **Gera** is an Associate Professor of Classics at the Hebrew University of Jerusalem. She is the author of *Xenophon's Cyropaedia* (1993), *Warrior Women* (1997), and *Ancient Greek Ideas on Speech, Language, and Civilization* (2003). At present she is working on a commentary on the Book of Judith for the de Gruyter series, Commentaries on Early Jewish Literature, as well as for the Yad Ben-Zvi Hebrew series, Between the Bible and the Mishna.

Kelley **Harness** is an Associate Professor of Musicology at the University of Minnesota. Her articles on early Florentine opera have appeared in the *Journal of the American Musicological Society* and the *Journal for Seventeenth-Century Music*. She is the author of *Echoes of Women's Voices: Music, Art, and Female Patronage in Early Modern Florence* (2006). She is currently working on a study of sixteenth- and seventeenth-century intermedi.

Henrike **Lähnemann** holds the Chair of German Studies at Newcastle University. Her main areas of research are medieval German literature in the Latin context, manuscript studies and the interface of text and image. In 2006, she published a monograph on medieval German versions of the

Book of Judith ("Hystoria Judith. Deutsche Judithdichtungen vom 11. bis zum 16. Jahrhundert").

Alexandre **Lhâa** is a PhD student at the History Department of the University of Provence and member of the TELEMME research unit, in Aix-en-Provence (France). In June 2008, he attended the International Symposium Ottoman Empire & European Theatre, in Istanbul. His most recent conference papers include "Exotisme et violence sur la scène du Teatro alla Scala" and "Ho introdotto un leggiero cambiamento nell'argomento: Les tragédies antiques adaptées à La Scala (1784–1823)."

Kathleen M. **Llewellyn** is Associate Professor of French and International Studies at Saint Louis University. She has published articles on *L'Heptaméron* of Marguerite de Navarre, the poetry of Madeleine des Roches and Gabrielle de Coignard, conduct literature for widows in early modern France, and the widow in early modern French literature. She is currently working on a book exploring representations of the figure of Judith in French Renaissance literature.

David **Marsh** who studied Comparative Literature at Yale and Harvard, is Professor of Italian at Rutgers University and specializes in the influence of the classical tradition on the Italian Renaissance. His books include *The Quattrocento Dialogue* and *Lucian and the Latins*, and he has edited and translated works by Petrarch, Alberti, Leonardo, Vico, and mathematician Paolo Zellini.

Marc **Mastrangelo** is Associate Professor and Chair of Classical Studies at the Dickinson College. He has written on Socrates, Plato, Sophocles, and the fourth-century Christian poet Prudentius. He is an editor and contributor to *The Unknown Socrates* (2002) and is the author of *The Roman Self in Late Antiquity: Prudentius and the Poetics of the Soul* (2008).

Sarah Blake **McHam** is Professor of Art History at Rutgers University. She has published numerous books and articles on Italian fifteenth- and sixteenth-century sculpture. Her most recent publications are articles dealing with the legacy of Pliny the Elder on such diverse artists as Giambologna, Giovanni Bellini, and Raphaelle Peale, offshoots of her forthcoming book on Pliny's influence on Italian Renaissance art and theory.

Gabrijela **Mecky Zaragoza** received her Ph.D. in German Studies from the University of Toronto in 2005. For her work on Judith, she was awarded both Canada's Governor General's Academic Gold Medal (2005) and the Women in German Dissertation Prize (2006). In 2007–2008, she has held lecturer positions at the University of Massachusetts, Amherst, and at the University of Toronto. She is currently working on a critical edition of little known eighteenth- and nineteenth-century German texts on the conquest of Mexico.

John **Nassichuk** is associate Professor of French Studies at the University of Western Ontario, Canada. His research interests include Renaissance literature, poetics, aesthetics, and Latin erotic literature from the Quattrocento. He recently published "Le couronnement de Judith, représentation littéraire au XVIe siècle d'une héroïne deutérocanonique" (2008) and conducted a graduate seminar in the department of French on Judith in the medieval French canon. Author of many chapters in books and scholarly articles, in 2005 Professor Nassichuk co-authored, with Perrine Galand-Hallyn, *L'Amour conjugal dans la poésie latine de la Renaissance* (2005).

Jann **Pasler**, Professor of Music at University of California, San Diego, has recently published *Writing through Music: Essays on Music, Culture, and Politics* (~~Oxford University Press,~~ 2008) and *Composing the Citizen: Music as Public Utility in Third Republic France* (~~University of California Press,~~ 2009). Currently she is working on another book, *Music, Race, and Colonialism in Fin-de siècle France*. Her article, "The Utility of Musical Instruments in the Racial and Colonial Agendas of Late Nineteenth-Century France," *Journal of the Royal Musical Association* ~~(Spring~~ 2004), won the Colin Slim award from the American Musicological Society for the best article in 2005 by a senior scholar.

Barbara **Schmitz's** main research interest is on Jewish texts from the Hellenistic-Roman times. She wrote her PhD thesis on the function of prayer and speech in the Book of Judith and is currently working on a commentary on the Book of Judith for the series *Herders Theologischer Kommentar zum Alten Testament*. Her most recent book is on the Book of Kings. She is full professor of Old Testament Studies at the Universität Dortmund.

Michael **Terry** is curator of the Dorot Jewish Division of The New York Public Library and the organizer of a number of exhibitions, including

The Hebrew Renaissance – chiefly about the "rediscovery" of Jewish literature in sixteenth- to seventeenth-century Europe – at the Newberry Library in Chicago and Jewes in America – chiefly about seventeenth- to eighteenth-century notions regarding Jews and destiny – at The New York Public Library. His Reader's Guide to Judaism received the National Jewish Book Award.

Susan **Weingarten** is an archaeologist and historian in the research team of the Sir Isaac Wolfson Chair for Jewish Studies, Tel Aviv University, Israel. After publishing "The Saint's Saints: Hagiography and Geography in Jerome," she decided to move from ascetic Christianity to Jewish food. She has just finished a book on haroset, the Jewish Passover food and is working on her major project, "Food in the Talmud." The Judith project has led her to a new interest in medieval European Hanukkah food.

Introductions

1. The Judith Project

Kevin R. Brine

The Book of Judith is the story of a Jewish heroine living during the period of the Second Temple when the Jewish community had returned from the Babylonian captivity and reestablished temple worship in Jerusalem. In this story, a fictional Near East sovereign threatens the religious hegemony of the Jewish people. The story is famous for Judith's pursuit and beheading of the King's general, Holofernes. Judith's success against all odds epitomizes the charter myth of Judaism itself – cultural survival through the commitment to the preservation of the Mosaic Law, with the help of God.[1]

Judith is remembered in the Jewish tradition on the festival of Hanukkah. Roman Catholics chant verse from the Book of Judith in liturgy on Mary's name day in the daily office.[2] Judith is a celebrated figure in European visual arts, drama, and music. The powerful appeal of the Judith story has inspired scribes, composers, playwrights, poets, painters, and sculptors for over two millennia. The famous scene of the beheading of Holofernes with his own sword defines the Judith story. The motif of the sword became a defining attribute of the figure of Judith.[3]

The Sword of Judith is the first multidisciplinary collection of essays on the representation and reception of Judith through the ages. It includes new archival source studies, the translation of unpublished manuscripts, the translation of texts previously unavailable in English, and essays in rel-

1 For Judith as a fictional model for cultural survival in the Hasmonean period, see Steven Weitzman, *Surviving Sacrilege: Cultural Persistence in Jewish Antiquity* (Cambridge, MA: Harvard University Press, 2005), pp. 48–54.

2 The author thanks Marta J. Deyrup for pointing out that verses from the Book of Judith are used in the liturgy sung on the Most Holy Name Day of the Blessed Virgin Mary on September 12. The feast dates to the sixteenth century although the date was changed in the seventeenth century to commemorate the Polish king Ian Sobieski's victory in Vienna over the Turks on September 12, 1683.

3 For the importance of the sword in Judith iconology see Erwin Panofsky, *Studies in Iconology: Humanistic Themes in the Art of the Renaissance* (Boulder, CO: Westview Press, Icon Edition, 1972), pp. 11–13.

✱ 516 BCE – 70 CE
After Nabuchaduezzar II destroyed Solomon's Temple 587 BCE .

atively unexplored areas in Judith Studies, such as Judith in the history of music. It is based on the proceedings of "The Sword of Judith Conference" held at the New York Public Library in the spring of 2008.

Judith Studies emerged as a multidisciplinary field of endeavor in the humanities in the late twentieth century. It was stimulated by the work of feminist art historians, a renewed interest in apocryphal books of the Bible, a new ecumenism in the study of early Judaism and Christianity, and new approaches to early Jewish literature. The (re)discovery of the Italian Baroque artist Artemisia Gentileschi by feminist art historians[4] brought the Judith theme new cultural prominence. For example, the Yvon Lambert Gallery in Paris exhibited a show of contemporary artists in 1978 inspired by Artemisia Gentileschi's *Judith Slaying Holofernes* with works by Cy Twombly, Joseph Kossuth, Daniel Buren, and others. The exhibition catalogue was introduced with an essay by Roland Barthes.[5] Judy Chicago's famous installation *The Dinner Party* (1974–79) created a place setting for Judith at the table of the most important women in history, and Gentileschi's Judith imagery was given fictional treatment in film, drama, and popular novels.

In 2003 Toni Craven's article "The Book of Judith in the Context of Twentieth Century Studies of the Apocryphal/Deuterocanonical Books"[6] reviewed one hundred years of Judith scholarship. By the end of the century, she noted, "Postmodern concerns [in Judith Studies] predominate the period. Scholarship is committed to the past, but it is increasingly gender inclusive, international and eclectic." Beyond traditional biblical studies, commentaries, and translations, Judith Studies now includes art history, social and cultural history, Jewish studies, history of religion, musicology, and literary criticism.

Why Judith? What is the case for Judith Studies? Why has Judith garnered so much multidisciplinary interest? It is beyond the scope of this introduction to attempt to define the relevance of Judith for the study of culture and religion in the humanities. However, we can point out that the

4 See Mary D. Garrard, *Artemisia Gentileschi: The Image of the Female Hero in Italian Baroque Art* (Princeton, NJ: Princeton University Press, 1989); Mieke Bal, *Quoting Caravaggio: Contemporary Art, Preposterous History* (Chicago, IL, and London: University of Chicago Press, 1999); and Mieke Bal, *The Artemisia Files: Artemisia Gentileschi for Feminists and Other Thinking People* (Chicago, IL, and London: University of Chicago Press, 2005).
5 *Word for Word – Artemisia No. 02*. Trilingual edition (English/French/Italian). Texts by Roland Barthes, Eva Menzio, Léa Lublin (Paris: Yvon Lambert, 1979).
6 See Toni Craven, "The Book of Judith in the Context of Twentieth-Century Studies of the Apocryphal/Deuterocanonical Books," *Currents in Biblical Research*, Vol. 1, No. 2 (2003), pp. 187–229.

story has had an uncanny ability to perpetually remain "load bearing," that is, to carry significant cultural, political, and theological meaning in different times and contexts. Parsing the meaning the narrative has captured is the work of Judith Studies. As Roland Barthes wrote for the Yvon Lambert Gallery exhibition, "as a strong narrative this story has exploded, over the centuries, into every possible form of narration: poems (in English, in German, in Croatian), in ballads, oratorios (Vivaldi's *Juditha triumphans* is by now well known), and, of course, figurative paintings."[7]

The Sword of Judith maps the terrain of Judith Studies across disciplines in two sections: Writing Judith: Jewish Textual Traditions and Christian Textual Traditions and Staging Judith: The Visual Arts and Music and Drama. The essays were conceived and developed over the course of a year-long collaboration among scholars called the Judith Project, facilitated by the New York Public Library's Digital Experience Group. ARTstor, the digital image library, has assembled a digital collection of Judith images, some of which are published here, accessible through ARTstor portals at most university, college, government, and private research libraries. Jstor, the digital archive, compiled and made available journal articles on Judith for the benefit of scholars working in the project.

The Sword of Judith is published by Open Book Publishers. Under the direction of the Dorot Jewish Division of the New York Public Library a comprehensive bibliography of Judith Studies has been compiled, the first of its kind, which can be accessed from the publisher's website. In addition, all of the papers published here can be read for free or downloaded in a digital format for a nominal price as an alternative to purchase.

The essays are presented as case studies supplemented by illustrations and new translations. Texts addressed in this book are written in ancient Greek (*Ioudith*); Hebrew (the *Megillat Yehudit*); Anglo-Saxon (*Judith*); medieval French (*Mistère du Viel Testament*); German (Luther Bible, popular folk songs, nineteenth-century dramatic literature); Latin (*Speculum Virginum*); Yiddish (*Dos Bikhli fun der vrumi Shoshana* [Susanna and Judith in Yiddish]); English (Hudson's translation of Du Bartas's epic, *La Judit*); Italian (nineteenth-century newspaper articles, musical librettos), and other texts and languages.

A work of this ambition, conducted cooperatively by many scholars and institutions, in a number of languages, would not have been possible even a few years ago. And the results are being made available to readers, quickly,

7 Yvon Lambert, 1979, p. 9.

cheaply, and with opportunities for them to engage, discuss, correct, and carry the work forward. The Judith Project, which is ongoing, is therefore tangible proof of the success of new approaches to producing, validating, and disseminating knowledge. It is a practical vindication of the Re:Enlightenment Project (www.reenlightenment.org) of New York University and the New York Public Library, which will be formally launched in April 2010 and of which I am proud to be among the founders.

The editors want to point out both the ambitions of the book and its limitations. The organization of the book provides a provisional schema for Judith Studies, which is the result of and will require multidisciplinary collaboration. Within this schema, the papers cover new ground and revisit old terrain. *The Sword of Judith* is not a comprehensive guide to Judith Studies, however. By design, the essays are concise and narrowly focused on specific research agendas within discrete disciplines. The case studies selected for the 2008 Judith Project do not begin to exhaust the diverse research interests of Jewish working in the field today. We take this as a positive sign that indicates the need for new projects of this kind.

The Story of Judith and Holofernes

> The value of information does not survive the moment in which it was new. It lives only at that moment; it has to surrender itself to it completely and explain itself to it without losing any time. A story is different. It does not expend itself. It preserves and concentrates its strength and is capable of releasing it even after a long time.
>
> Walter Benjamin, *The Storyteller*[8]

I begin with a discussion of the story of Judith and Holofernes as told in the earliest extant version of the Book of Judith (*Ioudith*) in the Septuagint (LXX), the ancient and celebrated Greek translation of the Hebrew Scriptures. The discussion will anticipate the two introductory sections: "Writing Judith: Jewish Textual Traditions" and "Writing Judith: Christian Textual Traditions."

8 Walter Benjamin, *Illuminations: Essays and Reflections*, with an introduction by Hannah Arendt (New York: Harcourt, Brace & World, 1968; reprint, Schocken, 1969), p. 90. The author thanks Henrike Lähnemann for referencing Benjamin's poetic original German: "Die Information hat ihren Lohn mit dem Augenblick dahin, in dem sie neu war. Sie lebt nur in diesem Augenblick. Sie muß sich gänzlich an ihn ausliefern und ohne Zeit zu verlieren sich ihm erklären. Anders die Erzählung: sie verausgabt sich nicht. Sie bewahrt ihre Kraft gesammelt im Innern und ist nach langer Zeit der Entfaltung fähig." Walter Benjamin, "Der Erzähler. Betrachtungen zum Werk Nikolai Lesskows," in *Gesammelte Schriften*, vol. II, no. 2 (Frankfurt/Main, 1977), pp. 438–65 (p. 445).

Ioudith has just been published in an important new English transla-
tion from the Septuagint by Cameron Boyd-Taylor.[9] Using a passage of
his translation as a starting point, we will follow Judith's state of mind
leading up to and during the beheading of Holofernes and then discuss
the compelling qualities of Judith as a biblical heroine. I will point out
recent scholarship addressing the importance of the Book of Judith in the
history of Jewish religion, women in the ancient world and the history of
the book. The introduction will conclude by framing the subject of the
essays that follow.

The Septuagint (LXX) is so named because, according to legend, prepa-
ration of the Pentateuch was undertaken at the bequest of King Ptolemy II
(285–46 B.C.E.) and required seventy (two) translators.[10] Later other Hebrew
scriptures were added. Modern scholars place the writing of the Book of
Judith in the Hellenistic era, ca. 135–78 B.C.E., in Alexandria or Palestine
and by an unknown author.[11] There is no extant Hebrew text predating the
Septuagint, and scholars still debate whether the Book of Judith was writ-
ten in Hebrew and translated into Greek or composed originally in Greek.

The most celebrated and notorious part of the Judith story involves the
beheading of Holofernes. What does beheading symbolize? For Otto Rank,
"the discovery of prehistoric graves with decapitated heads (sculls) laid by
the side of the body indicated a prehistoric head cult based on the magi-
cal significance of the head as the seat of personal power."[12] In Greek and
Roman times, beheading was considered a privileged mode of execution,
reserved for Roman citizens; crucifixion was inflicted on those who were
to be publicly shamed. Paul was beheaded; Jesus crucified. In the twelfth
century, in his treatise on justifiable tyrannicide, Bishop John of Salisbury
allegorically interpreted the beheading of Holofernes as the sundering of
an unjust king (as head) from the body politic. For Sigmund Freud, behead-

9 *Ioudith*, trans. by Cameron Boyd-Taylor in Albert Pietersma and Benjamin G.
Wright (eds.), *A New English Translation of the Septuagint* (New York and Oxford:
Oxford University Press, 2007), pp. 441–55.

10 See Abraham Wasserstein and David J. Wasserstein, *The Legend of the Septuagint:
From Classical Antiquity to Today* (Cambridge: Cambridge University Press, 2006).

11 For the date, authorship, and place of composition of the Book of Judith see
Carey A. Moore, *The Anchor Bible Judith: A New Translation with Introduction and
Commentary* (Garden City, NY: Doubleday, 1985), pp. 67–71.

12 See Otto Rank, *Art and Artist: Creative Urge and Personality Development* (New
York and London: W. W. Norton & Co., 1989). Rank continues, "In any case, com-
parison with the head-cult, as it still exists today, suggests the conclusion that the
magical significance of the head as the seat of personal power may be regarded as
the beginning of a belief in the soul" (ibid., p. 181).

ing symbolized castration. This was the most popular reading of Judith iconography in the twentieth century.

The author of the Book of Judith makes it amply clear that the beheading of Holofernes was an act of war and uses the celebratory scene of the presentation of the head to establish Judith as a military heroine. Judith brings the head back from the Assyrian camp to the battlements of Bethulia to inspire the Jews to rout the Assyrian aggressors. The head of Holofernes is exhibited as a war trophy. Judith is honored with the captured booty of Holofernes' armor. The same ancient military convention of exhibiting a tyrant's head to establish that the enemy has been vanquished appears in 2 Maccabees, which describes the head of Nicanor exhibited on a tower (LXX 2 Mc 15:35).

The significance of the beheading is also layered in the biblical text with the idea of retribution for sexual violation. From the outset, the text introduces the threat of rape. Judith is aware that she may be raped when alone with Holofernes and prays with a loud voice:

> Now Ioudith fell face down, and she placed ashes upon her head and stripped off the sackcloth that she wore, and just then in Jerousalem the incense for that evening was being carried into the house of the God, and with a loud voice Ioudith cried out to the Lord and said:
> O Lord, God of my father Symeon, to whom you gave a sword in hand for vengeance on aliens, the ones who ravaged the virgin's vulva for defilement and stripped naked the thigh for shame and polluted the vulva for disgrace, for you said "It shall not be thus" and they did; therefore you handed over their rulers for slaughter, and their bed which, deceived, felt ashamed at their deceit, for blood, and you struck down with slaves with lords and lords upon their thrones, and you handed over their wives for pillage and their daughters for captivity and all their spoils for division among the sons loved by you, who also were zealous in zeal for you and detested the defilement of their blood and called upon you as helper. O God, my God, also listen to me, the widow.[13]

The special twist of the Judith narrative is the transformation of the private, potentially intimate bedchamber scene between the Assyrian general and Judith into a beheading:

> And approaching the bedpost that was near Olophernes' head, she took down his scimitar from it, and drawing near to the bed she took hold of the hair of his head and said "Strengthen me, Lord, God of Israel, in this day." And she struck his head twice with her strength and took his head from him. And she rolled his body from the mattress and took the mosquito

13 LXX Jdt 9:1–2. Biblical books are referenced with the short titles following the Chicago style (cf. index under "Bible").

netting from the posts. And she set forth shortly afterward and handed the head of Olophernes over to her favorite slave, and she threw it in her bag of provision.[14]

I offer these extensive quotations from *Ioudith* because they introduce so many of the themes addressed in what follows. Note Judith's social status as a widow; the references to the sword (scimitar), which became forever iconographically linked to the figure of Judith; the allusion to the worship services at the temple in Jerusalem, locating the narrative in the Second Temple period; note her solitary prayer conducted in sackcloth and, the more unusual detail, prayer conducted after stripping off sackcloth; note also the detail of the mosquito netting that she takes from the posts after she beheads Olophernes. (For an explanation of the significance of the mosquito net, see Barbara Schmitz's essay, Chap. 4.)

Judith: Biblical Heroine

The Book of Judith is one of the three books in the Septuagint, and later Bibles, named for a woman: Judith, Esther, and Ruth. There is also one story named for a woman, the Story of Susanna, found in an addition to the Book of Daniel. Of the four women – Esther, Ruth, Susanna, and Judith – Judith is by far the most autonomous, politically engaged, and spiritually accomplished. As a character, Judith is complex. She embodies political shrewdness and military effectiveness, yet she lives a life of simple piety, chastity, and temperance. As a biblical heroine, Judith functions symbolically as a Deborah, the prophetess, leader, and composer of a song, who is described as "a mother of Israel." Judith functions actively like Jael, the heroine who seduces and kills the enemy. She is a public figure – charitable and civically influential.

As a woman, Judith is beautiful, independent, sexually attractive, wealthy, and intelligent. As penitent before her God, she is vulnerable. She has the longest genealogy of any woman in the Bible and, like Miriam the prophetess, the sister of Moses, she composes a biblical song, yet, unlike Deborah, she is not a prophet. Her role in Second Temple society is that of daughter and widow. Judith not only saves her people; her resourcefulness and faith also make her a symbol of her people. Judith is synonymous with Judaism itself, etymologically and symbolically.

14 LXX Jdt 13:6.

[handwritten note: Clay tablets - Meso 3 mill. BC / Papyrus - Ancient Egypt / Concertina-style - 2nd BC China / Print culture - 3-8 CE]

...lith was composed in the Hellenistic era,
...r Palestine by an unknown author. The
...point in the history of print media and
...the scroll to the codex and the invention
...s Karen Van der Toorn writes:[15]

> ...books in Hebrew, Aramaic, or Greek were written in the Hellenistic era. All books written before that time were not books in the modern sense of the term. The Jewish books that began to appear after 300 b.c.e. differ from earlier texts inasmuch as they do seem to resemble the concept of a book as a single work by a single author, aimed at a particular audience. Hellenism created the conditions under which the new phenomenon could occur. Among the many aspects of this new cultural climate, three have a special bearing on the birth of the Jewish book: the emergence of schools, the foundation of libraries, and the growth of a reading public ... [16]

The transformation in book production from scroll to codex played a key role in shaping how Christians would use the Book of Judith allegorically and typologically. As Roger Chartier explains:

> The Codex undeniably facilitates the organization and handling of the text. It permits pagination, the creation of indexes and concordances, and the comparison of one passage with another; better yet, it permits a reader to traverse an entire book by paging through. From this set of advantages followed the adaptation of the new form of the book to the textual needs of Christianity: in particular, comparing the Gospels and mobilizing citations of the Sacred Word for preaching, worship, and prayer.[17]

The inclusion of the Book of Judith in the Septuagint used by early Christians as the Old Testament in the Christian Bibles facilitated the pairings of Judith with Mary and Jesus with Moses, and Isaiah's prophecies to the birth of Jesus. This enshrined Judith within Catholic theology.

The Book of Judith also signals the creation of a new rhetorical genre in the ancient world. Scholars do not agree about how to classify this text. The Book of Judith has been denominated a romance, or even the first Jewish novel, a genre that includes Esther, Daniel, Tobit, and Joseph and Aseneth. The Book of Judith has also been placed within the genre of Hellenistic

15 See Karel Van Der Koon, *Scribal Culture and the Making of the Hebrew Bible* (Cambridge, MA: Harvard University Press, 2007).
16 Ibid., p. 23.
17 See Roger Chartier, *Forms and Meanings: Texts, Performances, and Audiences from Codex to Computer* (Philadelphia, PA: University of Pennsylvania Press, 1995), p. 19.

romance along with Xenophon's *Cyropaedia* and Pseudo-Callisthenes's *Alexander Romance*. Recently, Sarah Johnson has defined the genre more narrowly and places Judith within a group of peers characterized by their didactic intent and use of history and fiction.

Johnson calls the genre "historical fiction":

> Each of these texts – The Letter of Aristeas, 2 Maccabees, Esther, Daniel, Judith, and Tobit – contains a significant element of historical fiction, deliberate manipulation of historical material to communicate a particular didactic point. A common attitude toward historical fact – treating it as raw material to be mined and manipulated for the purpose of creating a credible, persuasive didactic fiction – unites the authors of these texts and sets them distinctively apart from the mainstream of Jewish and Greek historiography alike. They belong neither to the mainstream of historiography nor to the genre of the ancient novel but to a nebulous group of unclassifiable ancient fictions beginning to proliferate in the postclassical Greek world.[18]

The Book of Judith also reflects a new theology that transformed what it meant to be considered a Jew in the Hellenistic era. This is the crucial relevance of the secondary plot of the book: the conversion of Achior. Judith and 2 Maccabees are the earliest references to conversion in Jewish literature. As Shaye Cohen demonstrates, the Book of Judith and 2 Maccabees, both fictional accounts written in the Hellenistic period, reflect the refashioning of the practice of conversion. "It was this Hasmonean redefinition of Judaism that permitted Josephus at the end of the first century C.E. to state that the constitution established by Moses was not only a genus – a nation, a 'birth' – but also 'a choice in the manner of life'."[19] The Book of Judith is thus an important source for understanding an important social and cultural development within Judaism – the addition of belief to birthright in the definition of a Jew during the Hellenistic period. As Cohen sums up his argument:

> Some of the seers of the exilic and postexilic periods (sixth to fourth centuries B.C.E.) forecast a utopian future in which the gentiles would recognize God, worship in his temple, and either serve the Israelites or "attach themselves" to them. But in none of these texts, even in the eschatological visions, is there a sense that non-Israelites somehow become Israelites through acknowledging

18 See Sara Raup Johnson, *Historical Fictions and Hellenistic Jewish Identity: Third Maccabees in Its Cultural Context* (Berkeley and Los Angeles, CA: University of California Press, 2004), p. 50, and Lawrence M. Wills, *The Jewish Novel in the Ancient World* (Ithaca, NY: Cornell University Press, 1990).
19 See Shaye J. D. Cohen, *The Beginnings of Jewishness: Boundaries, Varieties, Uncertainties* (Berkeley, CA: University of California Press, 1999), pp. 133–34.

the god of the Israelites. None of these texts precisely parallels 2 Maccabees' story about Antiochus Epiphanes and Judith's story about Achior.[20]

Written during the Second Temple period, *Ioudith* also exhibits pre-Rabbinic Jewish ritual and ascetic practices in the portrayal of Judith's private religious practice on the roof of her house in Bethulia. Lawrence Wills recently singled out the importance of Judith and Esther for the study of ancient ritual and asceticism, writing, "The literary presentation of Jewish identity [in Judith and Esther] combined ritual and ascetic themes, a three-way convergence that has been overlooked by scholars of literature, ritual studies, and asceticism when these are studied separately."[21] As we noted in the passages from *Ioudith* presented above, Judith places herself in prayer in an attitude of self-abnegation (after stripping off her sackcloth). This is a rare representation in Jewish literature of the practice of asceticism in antiquity.

Judith is committed to a private religious (ascetic) practice conducted on the roof of her home. Jewish motifs – such as the wearing of sackcloth, tithing, ablutions, private prayer, ritual immersion, food laws, lunar festivals, Sabbath observance, the presence of the high priest, and the observance of the sacrificial cult in Jerusalem – are present in this pre-Rabbinic text.[22] Reference to rabbinic ideology and practice – such as the institution of the synagogue, the rabbinate, and the ideology of a life of study of the Torah as described in the tractate of the Mishna, the Pirkei Avos or the Ethics of the Fathers (written hundreds of years later) – do not appear in the book.

Scholars do not agree about when or why the Book of Judith was written. This question, of course, is undoubtedly linked to the question of why the book was not included in the Hebrew Bible, a subject that Deborah Gera addresses in her introduction to Jewish textual traditions. In *Integrating Woman into Second Temple History*,[23] Tal Ilan provides a thorough review of evidence about the composition of the book and suggests, based on largely circumstantial evidence, that the book may have been written to support the legitimacy of the rule of the Hasmonean queen Shelamzion. In the conclusion to Ilan's chapter on Esther, Ruth, and Susanna she presents her view of the reason Judith was written:

20 Ibid., p. 132.
21 See Lawrence M. Wills, "Ascetic Theology before Asceticism? Jewish Narratives and the Decentering of the Self," *Journal of the American Academy of Religion*, vol. 74, no. 4 (December 2006), pp. 902–25 (907).
22 See Hugo Mantel, "Ancient Hasidim," in *Studies of Judaism* (1976), pp. 60–80, summarized in Carey A. Moore 1985, p. 71.
23 See Tal Ilan, *Integrating Women into Second Temple History* (Tübingen: C. B. Mohr (Paul Siebeck), 1999; repr. Peabody, MA: Hendrick Publishers Inc., 2001).

Esther, Judith, and Susanna are contributions to the theoretical debate on the nature of women and their competence as political leaders. The books do not openly promote woman's leadership, and they are not revolutionary in nature. Yet they do question some of the suppositions of their day on the "natural order." Because the Colophon to the Greek Book of Esther mentions the date 78–77 B.C.E., just one year before the coronation of Queen Shelamzion in Jerusalem, it may be suggested that certainly Esther (and with it Purim) was created as propaganda for this queen's reign. Because of formal and ideological similarities between Esther and the books of Judith and Susanna, I have suggested here that all three can be seen as serving that purpose.[24]

In this short tour of contemporary scholars' writing on Hellenism, early Judaism, and the Second Temple period we can see the importance of the Septuagint *Ioudith*. *Ioudith* plays a definitive mediating role for the early Christians linking Jewish Scriptures to Christian theology through pairing Judith and Mary. The book demonstrates an early form of Jewish asceticism. It allows modern scholars to understand how Judaism itself evolved from a religion of birthright to a religion of choice and presents an early example of a conversion to Judaism in the ancient world. It contained an important set of literary innovations that constituted a critical chapter in the creation of the modern book as we know it. It is one of the earliest examples of historical fiction and is a precursor to the modern novel. It is one of the most eloquent rhetorical constructions in antiquity promoting the leadership capabilities of women, and was perhaps composed as propaganda for a Jewish queen. It also remains one of the most important source texts from antiquity about the social conditions of woman in the Second Temple period.

Judith in Christian Tradition

The Book of Judith was not included in the Hebrew Bible, and, before the tenth century, Jewish literature does not refer to Judith after the text was included in the Septuagint. Then the story reappeared in midrash (Jewish tales) and piyyut (prayers). The Book of Judith was preserved by Christian tradition, however. Though apparently lost to the Jews, the Book of Judith exercised a formative influence on the creation of models of Christian piety and asceticism. Several literary milestones from the first five centuries of Christianity illuminate the ways that Judith was appropriated as a model for Christian spirituality. The first reference to the Book of Judith in the

24 Ibid., p. 153.

Roman period was by Clement, the third bishop of Rome. Clement used Judith as a model for Christian love and communal discipline, writing: "The blessed Judith, when her city was besieged, asked of her elders permission to go forth into the camp of the strangers; and, exposing herself to danger, she went out for the love of her people" (Clement of Rome, The First Epistle to the Corinthians: 55). By the fourth century, the Apostolic Constitutions, the early Christian manual of doctrine and practice, idealized Judith as the pious widow "sitting at home, singing and praying and reading and watching and fasting" (Apostolic Constitutions Book iii: VII).

In Christian doctrine Judith is typologically paired with Mary. Jerome famously used the analogy of Judith's cutting off the head of Holofernes as a metaphor for Mary's chastity with the following allusion to the Virgin birth: "the chaste Judith once more cut off the head of Holofernes" (Jerome, Letter 22: 21). The fourth-century Roman Christian poet Prudentius, in his influential Latin poem *Psychomachia*, typologically paired Judith with Mary and used Judith allegorically as a figure of chastity (cf. Mastrangelo, Chap. 8).

The cultural authority of the Book of Judith in the West comes from its inclusion in the Vulgate, the early fifth-century version of the Bible in Latin translated by Jerome, which preserved the canon of the Septuagint and the Latin scriptures of the early Church.

As Elena Ciletti and Henrike Lähnemann explain in their introduction, Jerome played a crucial role in the Christian reception of Judith over and above his Latin translation. His influence was formative in the development of the place of Judith in Marian theology.

However, in the Western Church the religious authority of the Book of Judith was debated from antiquity forward. The Roman Catholic tradition considers the book to be of divine inspiration (deemed deuterocanonical). The Book of Judith was excised from Protestant Bibles after the Reformation; the Puritans took it out of the Bible in 1644. Categorized as apocryphal (originally meaning secret), it was considered by Protestants a story worthy of moral instruction, but not divinely inspired. The theological divide between Catholics and Protestants had a profound impact on the iconographical treatment of Judith. The theme of Judith was secularized in the nineteenth century but the Catholic Church continued to promulgate the story's canonical status in liturgical practice and papal homily.[25] In secular

25 In the Eastern Orthodox Church, the order of the Hebrew Scriptures in the Bible's Old Testament follows the placement in the Septuagint; the Book of Judith remains as a "history" and is placed as part of the penultimate trilogy (Esther, Judith, Tobit), which appear before the books of Maccabees that conclude the Old Testament.

contexts, the story of Judith and Holofernes, refashioned in art, discourse, and polemics, was used with wildly different connotations: misogynistic, erotic, anti-Semitic, patriotic, nationalistic, and feminist.

Writing Judith: Jewish Textual Traditions

This section consists of four papers and an introduction to Judith in Jewish textual traditions by Deborah Levine Gera. Barbara Schmitz's essay, "Holofernes's Canopy in the Septuagint," is a textual analysis of the Septuagint Book of Judith. Schmitz rhetorically and philologically analyzes the Septuagint and convincingly locates the writing within Greek and Roman literary traditions and provides a new cipher to help us understand the representation of Holofernes.

The second paper, "Shorter Medieval Hebrew Tales of Judith," offers a close reading of an important, but neglected, group of medieval Hebrew tales. Deborah Levine Gera analyzes the changes rendered in character, setting, and plot in the tenth-century Hebrew midrash (tales) through which Judith was reintroduced to Hebrew tradition after a thousand-year, unexplained hiatus. When Judith returns in these tales, Judith is a younger, more vulnerable figure.

The third paper, "Food, Sex, and Redemption in *Megillat Yehudit* (the 'Scroll of Judith'),'' is an interpretation and translation of an unpublished Hebrew manuscript that offers the first written evidence of the assimilation of the Judith narrative into the Hanukkah festival. Susan Weingarten suggests that *Megillat Yehudit* was written as Jewish counter-history, presenting Judith as a sexual being; setting honeyed manna against the Christian Eucharist; and creating a heroine-queen who has a redemptive function, like David and Esther.

The fourth paper, "Shalom bar Abraham's Book of Judith in Yiddish," is a comparative textual and philological analysis of an important Yiddish translation of the Book of Judith in the early modern period. Ruth von Bernuth and Michael Terry challenge the assumption that Jewish and Christian interaction was limited during the reformation. They demonstrate that Shalom bar Abraham's *Book of Judith* in Yiddish, printed in Cracow in 1571 from a lost first edition produced in Italy years earlier, was translated from the Huldrych Zwingli Zurich Bible (1529, 1531) and not the Luther Bible, which was the basis for many other translations. This argument has implications for the way we understand both Ashkenazic attitudes to the Renais-

sance and the Reformation and the relationship of Old Yiddish literature to Christian German sources.

Writing Judith: Christian Textual Traditions

This section, introduced by Elena Ciletti and Henrike Lähnemann, contains seven papers that analyze Judith in diverse literary genres: Christian roman poetry, Anglo-Saxon homily and epic, late-medieval French mystery plays, French and English Protestant epic, medieval German poetry and popular song, and Quaker proto-feminist tracts. The introduction "Judith in the Christian Tradition" sets out the broad framework of Christian tradition that lays the foundation for the construction of the figure of Judith.

Marc Mastrangelo, in "Typology and Agency in Prudentius's Treatment of the Judith Story," reads Roman Christian poetry to investigate the social construction of the role of women in the fourth century A.D. He argues that by locating the Christian doctrine of free will in a typological series of female figures (Judith, Mary, and Pudicitia), Prudentius has made female agency the ideal for both males and females and the imitation of female weakness and chastity a source of moral strength for all.

The reception and adaptation of Jerome's Latin Vulgate Judith, used in Roman Catholic liturgy, is the basis for Tracey-Anne Cooper's analysis of Judith in the Anglo-Saxon corpus and John Nassichuk's analysis of the depiction of Judith's prayer in medieval French mystery plays. (The latter are taken as the foundation of the representation of Judith in subsequent French literature.) Cooper, in "Judith in Late Anglo-Saxon England," shows how the Anglo-Saxons imbued Judith with the qualities of both a military hero and a chaste widow, and used her narrative as a tropological message and an allegorical type.

John Nassichuk's essay, "The Prayer of Judith in Two Late-Fifteenth-Century French Mystery Plays," is a rhetorical (metrical and lexical) analysis of Judith's prayer in *Mystères de la procession de Lille* (ca. 1480) and *Mistère du Viel Testament* (first printing 1502). He demonstrates the use each author makes of the biblical model. Nassichuk explores the two different approaches to translation and shows how the text that strays the furthest from the Vulgate "solemnizes the dignity of the heroine." In doing so, Judith "at last acquires a voice and begins to speak."

Kathleen Llewellyn's essay, "The Example of Judith in Early Modern French Literature," examines the figure of Judith in French dramatic works to understand the historical evolution of the depiction of conduct for woman. Llewellyn treats three "Judiths" in three different works: *Mistère du Viel Testament*, *La Judit* by Guillaume de Salluste Du Bartas (1579), and *Imitation de la victoire de Judich* by Gabrielle de Coignard (1594). She reveals the early modern metamorphosis of the ambiguous biblical heroine. Judith is progressively "rehabilitated" over the course of the sixteenth century, thus reflecting changing perceptions of the feminine ideal in early modern France.

The return to the Septuagint, from the Vulgate, in the great Protestant biblical translations with European vernaculars as target languages establishes the conditions for the widely circulated and read Protestant French epic *La Judit* by Du Bartas. This epic was later translated into English and used to endorse both Catholic and Protestant regimes.

Robert Cummings's "The Aestheticization of Tyrannicide: Du Bartas's *La Judit*" shows how the potent ideological content of the poem (the justification of tyrannicide) could be neutralized and manipulated through translation, reprinting, and rededication.

In Protestant German- and English-speaking countries, Judith, no longer linked to Mary, proved to be rhetorically labile. She serves different functions in different contexts: she is "cunning" in German popular poetry, but, as a public figure and orator, provides a role model for women in Christian communities and Quaker rhetoric.

Henrike Lähnemann, in "The Cunning of Judith in Late Medieval German Texts," demonstrates how the image of Judith as a pious and chaste instrument of God's will, which dominated the Vulgate reception in the German Middle Ages, was supplemented by new roles: the heroine and the cunning woman. The late medieval development of illustrated short versions of the Judith story contributed significantly to developing the iconography of Judith as seductress and, finally, femme fatale.

Janet Bartholomew's essay, "The Role of Judith in Margaret Fell's *Womens Speaking Justified*," shows how English proto-feminist Margaret Fell chose Judith as a figure that exemplified the Quaker belief in women's justifiable right to preach. Fell's biblical exegesis established Judith as a virtuous woman who effectively preached in her own right.

Staging Judith: The Visual Arts

The first identifiable Christian images of Judith are found among fifth-century frescos at Nolo, Naples and the eighth-century frescos of Santa Maria Antiqua in Rome. Judith iconography was nurtured in illuminated manuscript traditions such as the Winchester Bible and the illuminated manuscript of the *Speculum Virginum*, or Mirror of Virgins. From the Renaissance on, "Judiths" were a staple of artist workshops and were produced contemporaneously with the development of oil painting on canvas. Donatello, Caravaggio, and both Artemisia and Orazio Gentileschi created works based on the subject of Judith. Donatello's monumental freestanding bronze of Judith initiated an important change in the iconography of Judith. The sculpture *Judith and Holofernes* became a metaphor for Medici rule in Florence. The five papers on the visual arts elaborate these themes.

Elizabeth Bailey proposes that the illuminated manuscript of the *Speculum Virginum*, or Mirror of Virgins, in the British Library (Arundel MS. 44, dated ca. 1140) is the first extant work of art in which the figure of Judith and the personification of Humilitas are visually related in the same composition. Bailey also argues that this new concept derives from the *Psychomachia* and the Bible and combines the two figures as "brides of Christ."

Noting that images of David were produced predominantly for public contexts while representations of Judith were almost exclusively employed in the private domain, Roger J. Crum analyzes the social and ideological content given to these two Old Testament figures in Renaissance Florence. Crum uses the different deployments of representations of Judith versus David to explore the way that the negotiation between public and private realms reflected tensions between Florentine private interests and public responsibilities.

Sarah Blake McHam's essay, "Donatello's *Judith* as the Emblem of God's Chosen People," deals with the different meanings that Donatello's *Judith and Holofernes* acquired when, in 1495, the newly reinstated Florentine Republic appropriated it from the Palazzo Medici, changed the sculpture's inscriptions, and transferred it to the *ringhiera*, or elevated platform that framed the entrance to the city's center of government. Through an examination of treatises and sermons by the Dominican preacher Savonarola, McHam reveals unrecognized ways in which Judith's slaying of Holofernes became not just a model for the virtuous removal of a tyrant, but as an exemplar of Florentines as God's newly chosen people and their divinely appointed mission to purify Italy.

Diane Apostolos-Cappadona traces the development of Donatello's innovations in the "tradition of costuming," which symbolized Judith as warrior, in his monumental bronze *Judith and Holofernes* and in the work of the next several generations of Italian artists: Botticelli, Mantegna, Michelangelo, Vasari, Caravaggio, and Artemisia Gentileschi. She argues that the symbolic meanings and cultural origins of the alterations these painters made to Judith's costume reflect values taken from the Classical tradition of the female agency of Athena, Diana, and the Amazons.

Elena Ciletti addresses less familiar but ideologically resonant ecclesiastical commissions devoted to Judith, including a fresco cycle by Giovanni Guerra and Cesare Nebbia created for Pope Sixtus V (Lateran Palace, Rome, 1588–9) and individual frescoes by Leonello Spada (Basilica della Ghiara, Reggio Emilia, 1615) and Domenichino (San Silvestro al Quirinale, Rome, 1628). Ciletti shows how these works are congruent with a large corpus of polemical writings on Judith written in the sixteenth and seventeenth centuries and argues that they helped convert Judith into a weapon of Catholic orthodoxy.

Staging Judith: Music and Drama

As the following essays demonstrate, Judith scholarship in the twenty-first century will continue to open new areas of exploration. This section contains six essays that examine dramatic musical works and theatrical stage productions of Judith. The earliest work addressed in the essays was composed in 1629, the date of the earliest opera on the subject of Judith. The latest work treated is the production of the 1849 Nestroy travesty of Hebbel's *Judith*.

Kelley Harness uses archival source studies to demonstrate the important influence female patrons had on the art and iconography of Renaissance and early modern Italy. In this study, Harness looks at five musical works dedicated to or commissioned by nuns, noblewomen, and female regents; the works begin with the first Judith opera, Andrea Salvadori's *La Giuditta* (Florence, 1626), which was sung to music composed by Marco da Gagliano. Following a tradition that stretched back to the sacra rappresentazione, which flourished during the sixteenth and seventeenth centuries in Italy, virtually every performance of a Judith play included at least some music. Harness argues that texts to be sung bore a special responsibility to focus and amplify a play's didactic message.

David Marsh's survey of librettos on the Judith theme shows how the emergence of oratorio around 1600 brought out the dramatic potential of

the biblical Book of Judith, making it attractive to a succession of distinguished composers, including the fifteen-year-old Mozart, who made brilliant use of Metastasio's libretto in 1771. Marsh provides a survey and textual analysis of some sixty years of libretti written on the theme between 1675 and 1734 and set to music as late as 1771.

Following Alberto Mario Bandi's insight that Judith was marginalized during the Italian Risorgimento, Paolo Bernardini shows how the changing treatment of Judith in Italy between 1800 and 1900 can be understood in the context of social and cultural changes that led to the Italian Union and the forging of a new "Italian national identity." Judith's model of individualist action, represented well by the genre of oratorio, was at variance with the need for the representation of collectivist action, for which the perfect genre was opera. From being an individual and a strong supporter of individualistic action and female agency, Judith gradually changed and became the representative of the general will and action in operatic tradition.

Alexandre Lhâa approaches Marcello and Peri's *Giuditta* (1860), which was performed at the Teatro alla Scala in March 1860, as a melodrama that echoes and disseminates the Risorgimento's ideology. Using research on the reception of the opera by audiences, he shows how the opera was changed in subsequent stagings because of Judith's disquieting challenge to the gender assumptions of a patriarchal society.

Jann Pasler analyzes dramatic musical composition and its reception in opera and concert halls and salons to uncover political, social, religious and cultural trends (conflicts, tensions, and anxieties) in late-nineteenth-century France. Pasler proposes that the representation of Judith changed after France's defeat by Prussia and the loss of Alsace and Lorraine; instead of an exotic, orientalist femme fatale, Judith became a symbol of individual strength who reignites the French fervor for war. This transformation occurred in the context of important new biblical translation projects, both Catholic and Protestant, which revalued the sanctity and historicity of the text.

Gabrijela Mecky Zaragoza's essay, "Judith and the 'Jew-Eaters' in German *Volkstheater*," addresses a dark and little-known theme in German popular theater: Judith and anti-Semitism. Drawing on the text of the anonymous 1818 drama *Judith und Holofernes* and Nestroy's 1849 parody of Friedrich Hebbel's 1840 tragedy *Judith*, Mecky Zaragoza brings to light a decisive change in the appropriation of the story. The Jewish narrative is connected to the Jewish Question and used to negotiate images of Jews and Jewishness.

Conclusion

In this introduction I have tried to emphasize unique attributes of the Septuagint *Ioudith* – as a Hellenistic book, a new literary genre, and an important source for the recovery of early Jewish religious practice and the status of women in the ancient world. As the earliest extant text, the study of the Book of Judith in the Septuagint is one of the foundations of Judith Studies. There are two other formative factors that set the conditions for the study of Judith. One is the subject of the thousand-year lacuna in the mention of Judith in Jewish writings and the omission of the book from the Hebrew Bible. The second is the uniquely determining influence of biblical canonical traditions, Catholic and Protestant, on the representation and reception of the Judith story. These two prominent topics, and others, are explored in the introductory chapters on Judith in Jewish and Christian textual traditions.

As P. N. Medvedev has written, seeing (perception) is shaped by genres of expression. As the Book of Judith was translated and the story has been retold in new genres, new aspects of Judith and her tale have been made visible. The essays "see" Judith through the lenses of a broad spectrum of genres – epic, allegory, play, opera, novel, tale, prayer, political tract, painting, fresco cycle, sculpture. As Medvedev noted, "Each genre is only able to control certain definite aspects of reality. Each genre possesses definite principles of selection and a definite scope and depth of penetration."[26] Each genre, that is, provides a new way of seeing Judith.

26 See P. N. Medvedev, *The Formal Method in Literary Scholarship: A Critical Introduction to Sociological Poetics*, trans. Albert J. Wehrle (Cambridge, MA: Harvard University Press, 1985), p. 134, quoted in Gary Saul Morson and Caryl Emerson, *Mikhail Bakhtin: Creation of a Prosaics* (Stanford, CA: Stanford University Press, 1990), pp. 275–76.

2. The Jewish Textual Traditions

Deborah Levine Gera

The apocryphal Book of Judith is undoubtedly a Jewish work, written by and intended for Jews, and Judith is portrayed as an ideal Jewish heroine, as her very name, Yehudit, "Jewess," indicates. Nonetheless, her story has had a checkered history among the Jews and Judith seems to have disappeared from Jewish tradition for well over a millennium.

Let us begin with a brief look at the Book of Judith, as it appears in the Septuagint, the oldest of the extant Judith texts. The book opens with the successful campaign waged by Nebuchadnezzar, king of the Assyrians, against Arphaxad, king of the Medes. Nebuchadnezzar then sends his chief of staff, Holofernes, on an ambitious and punitive military campaign directed against those who did not join him in his earlier, successful war. All nations give way before Holofernes until he approaches the Jews, who decide to resist. The Jews of Bethulia must block the Assyrians' path to Jerusalem and its temple. Holofernes, who is unacquainted with the Jews, learns something of their history and religious beliefs from his ally, the Ammonite Achior. Despite Achior's warning that God may well defend His people, Holofernes places a siege on Bethulia. When water supplies run low, the people of the town press their leaders to surrender to the Assyrians and Uzziah, the chief leader, promises to capitulate if there is no relief within five days. It is at this point that the pious, beautiful widow, Judith, steps on stage. Judith, who leads an ascetic and solitary life, summons Uzziah and his fellow leaders to her home and reprimands them for their lack of faith in God. She then takes matters into her own hands. Judith prays, bathes, and removes her widow's weeds. "Dressed to kill," Judith leaves Bethulia for the enemy Assyrian camp, accompanied only by her faithful

maid. The glamorous Judith charms and deceives Holofernes – as well as his trusty eunuch Bagoas – and promises to deliver the Jews to the Assyrians with God's help. In her dealings with Holofernes, Judith is not only beautiful, but sharp-witted. Her exchanges with the enemy commander are ironic and two-edged and her subtle, duplicitous words are one of the chief charms of the apocryphal book.[1] Holofernes invites Judith to a party in order to seduce her, but he drinks a great deal of wine and collapses on his couch. Judith then seizes Holofernes's sword and cuts off the head of the sleeping general. She returns to Bethulia with Holofernes's head in a bag (and his canopy as well). Achior the Ammonite converts to Judaism when he learns of Judith's deed and sees the actual dead man's head. The Jews of Bethulia, following Judith's advice, subsequently take the offensive, attacking the Assyrian army and defeating them. Judith, praised by all, sings a victory song and then goes back to her quiet life at home. She lives until the ripe old age of 105 and is mourned by all of Israel when she dies.

This briefly is the plot of the Greek apocryphal book and Judith, the heroine, is assigned a heady mix of qualities: she is beautiful and wise, a widow and a warrior, deceptive, bold, and pious. There is no reason to think that the Book of Judith is a historical account. It is an inspiring tale, filled with impressive sounding, but problematic, historical and geographical details, as the very opening reference (LXX Jdt 1:1) to "Nebuchadnezzar, king of the Assyrians, who reigned in Nineveh" and the unknown "Arphaxad, king of the Medes," indicates.[2] Nor is there any reason to doubt the Jewish provenance of the work, in which we find many references to Jewish practices. Prayers to God are accompanied by the customary fasting, sackcloth, and ashes. The temple in Jerusalem, with its priests, daily sacrifices, first fruits, and tithes, plays an important role as well. Judith herself is punctilious in her observance and she fasts regularly except on Sabbath and festivals and on the eve of these holidays. She eats only kosher food, even in enemy territory, where she also performs her ritual ablutions under difficult conditions.[3]

1 See Carey A. Moore, *The Anchor Bible Judith* (Garden City, NY: Doubleday, 1985) (Anchor Bible 40), pp. 78–85, for a good discussion of irony in the book.
2 Benedikt Otzen, *Tobit and Judith* (London: Sheffield Academic Press, 2002), pp. 81–93, is an excellent survey of the history and geography (which he calls topography) of the book and the various scholarly attempts to explain the problematic elements. See too Robert Pfeiffer, *History of New Testament Times: With an Introduction to the Apocrypha* (New York: Harper, 1949), pp. 285–97; he suggests that there may be a historical kernel to the tale. Toni Craven, *Artistry and Faith in the Book of Judith* (Chico, CA; Scholars Press, 1983), pp. 71–74, discusses the "playful manipulation" of historical and geographical facts.
3 See e.g., Moore, *Anchor Bible Judith*, p. 86, and Pfeiffer, *History*, p. 302, on the Jewish

Not only is Judith of the Septuagint a most Jewish heroine, but her story is presented along biblical lines. Indeed, the Book of Judith is filled with many allusions to biblical characters, passages, themes, and situations. Thus, Judith's victory song (LXX Jdt 16:1–17) echoes verses from the Song of the Sea (Ex 15:1–21) and the very last verse of the Book of Judith (LXX Jdt 16:25), telling of the peace and quiet which lasted long beyond Judith's lifetime, is a deliberate echo of the formula "And the land was tranquil for forty years" used in the Book of Judges to describe the tenure of successful judges. This conclusion to the book assimilates Judith to the biblical judges.[4] Judith resembles other biblical characters as well, such as David in his encounter with Goliath (1 Sm 17) and Ehud, who assassinates King Eglon of Moab (Jgs 3:12–30). Above all, Judith is reminiscent of a series of biblical women, including, of course, Jael, who slays the general Sisera in her tent (Jgs 4:17–22; 5:24–27), and Esther, who charms a foreign king with her beauty.[5]

The Book of Judith did not survive in Hebrew. While most scholars are certain that Hebrew was the original language of the work, an increasingly vocal minority of researchers suggest that the Septuagint version, which is composed in careful, but patently Hebraized Greek, was in fact the original version of the book.[6] If, as these scholars suggest, the author of the Book of Judith deliberately composed a work in Hebraic-sounding Greek with literal translations of biblical phrases, this raises a series of questions about the identity of the author, his[7] audience, and the place of the work's composition. A Hebrew Judith was probably composed in Palestine, while a Greek one would be more likely to stem from the Jewish community in Alexandria. A Palestinian author would have to be extremely ignorant of his own country to include some of the geographical

elements of the Book of Judith.

4 See Jgs 3:11 and 30; 5:31; 8:28 (on Othniel, Ehud, Deborah, and Gideon).

5 See Otzen, *Tobit and Judith*, pp. 74–79, and the further references there.

6 Jan Joosten, "The Original Language and Historical Milieu of the Book of Judith," in Moshe Bar-Asher and Emanuel Tov (eds.), *Meghillot v–vi: A Festschrift for Devorah Dimant* (Jerusalem and Haifa: Bialik Institute and University of Haifa, 2007), pp. 159–76, is a recent proponent of this thesis; see too Barbara Schmitz in this volume (Chap. 4) and Claudia Rakel, *Judit – Über Schönheit, Macht, und Widerstand im Krieg* (Berlin: de Gruyter, 2003), pp. 33–40, with the further references there.

7 See Jan Willem van Henten, "Judith as Alternative Leader: A Rereading of Judith 7–13," in Athalya Brenner (ed.), *A Feminist Companion to Esther, Judith and Susanna* (Sheffield: Sheffield Academic Press, 1995), pp. 224–52, esp. 245–52, for a helpful discussion of male and female voices in the Book of Judith. On balance, it seems unlikely that the author of Judith was a woman.

blunders found in the book, so that we would assume that the mistakes are deliberate ones, placed there for a reason, while an Egyptian author could have simply gotten things wrong. The two different languages also point to different kinds of audiences and cultural milieus: an author writing in Greek would perhaps be well acquainted with (and influenced by) Greek authors,[8] as well as the Greek Bible, while one writing in Hebrew would refer first and foremost to the Hebrew Bible. These complicated questions are far from resolved.

In her paper, "Holofernes's Canopy in the Septuagint," Barbara Schmitz (Chap. 4) assumes that Greek was the original language of Judith and that the author of the book was well acquainted with classical culture. She examines a small, but telling, detail found in the Book of Judith, the canopy (κωνώπιον) which Judith removes from Holofernes's bed and carries back to Bethulia, by investigating the use of the term *conopeum* in Greek and Latin authors. This use of classical sources proves fruitful in interpreting the text and narrative strategy of Judith.

There is a general scholarly consensus on the date of the Book of Judith and it is thought that the work was composed in the second half of the second century B.C.E. (or slightly later). The setting of the book is allegedly Assyria (and Babylonia) in the seventh and sixth century B.C.E., but there are traces of Persian and Hellenistic elements – such as names, weapons, and institutions – in the work as well.[9] However, most commentators agree that historical events in Hasmonean times form the background against which the Book of Judith was composed. The character of the tyrannical Nebuchadnezzar, who attempts to rival God, seems based on that of Antiochus IV Epiphanes, and Judith's defeat of Holofernes resembles in many ways the encounter between Judah the Maccabee and the Seleucid commander Nicanor in 161 B.C.E. (1 Mc 7:26–50; 2 Mc 15:1–36). Both Judah and Judith are pious figures who manage to overturn the threat to the temple in Jerusalem posed by a cruel and arrogant king, and they behead the chief military commander in the process. The evidence for Hasmonean influence on Judith is generally thought to be too strong to allow the work

8 It is especially likely that the author of the Book of Judith was acquainted with the *Histories* of Herodotus; see Mark Caponigro, "Judith, Holding the Tale of Herodotus," in James C. VanderKam (ed.), *"No One Spoke Ill of Her": Essays on Judith* (Atlanta: Scholars Press, 1992), pp. 47–59, and Barbara Schmitz, "Zwischen Achikar und Demaratos – die Bedeutung Achiors in der Juditerzählung," *Biblische Zeitschrift*, 48 (2004), pp. 19–38.
9 See Pfeiffer, *History*, pp. 292–95, for a detailed discussion.

to be dated earlier than ca. 150 B.C.E.[10] Since Clement of Rome mentions Judith at the very end of the first century C.E. (*Epistle to Corinthians* 1. 55), the book must have been in circulation by then.

Despite its Jewish content and orientation, and its many biblical allusions, there is no evidence that the Book of Judith was ever a candidate for inclusion in the canon of the Hebrew Bible. There are a variety of explanations as to why Judith was not included in the canon, but no one of these hypotheses is definitive.[11] One theory concerns the date of the book. If Judith was written after 150 B.C.E. this may mean that the book was simply composed too late to be included in the canon before it was closed. There is, however, no scholarly consensus as to when the canon of the Hebrew Bible was firmly fixed and we know for instance that the canonicity of Esther was debated well into the third century C.E.[12] Another argument involves the language of the book. If, as some argue, Judith was originally written in Greek in the diaspora of Alexandria by a Hellenized Jew, or if the Hebrew version disappeared at a very early stage, this would explain why the book survived in the Greek canon, but not the Hebrew Bible.[13] A third explanation centers around the alleged violations of *halacha*, Jewish law, found in the book. One problematic instance is Achior's conversion: he, an Ammonite, undergoes circumcision when he converts, but he does not follow the other rabbinical rules of ritual immersion and a sacrifice at the Temple. It is possible, however, that the Book of Judith was composed before these rabbinical rules were regularized and codified.[14] A fourth theory points to the

10 Otzen, *Tobit and Judith*, pp. 78, 81–87, 96, and 132–35 surveys scholarly opinion on the date of Judith and discusses the relationship between the Book of Judith and Hasmonean history and theology.

11 Carey A. Moore, "Why Wasn't the Book of Judith Included in the Hebrew Bible?," in *"No One Spoke Ill of Her,"* pp. 61–71, ends his discussion of the question with the comment "... the simple fact is that we do not know" (p. 66).

12 See Roger T. Beckwith, *The Old Testament Canon of the New Testament Church and Its Background in Early Judaism* (Grand Rapids, MI: W. B. Eerdmans, 1986), p. 275. All the rabbis named in Babylonian Talmud Megillah 7a who deny the canonicity of Esther belong to the third century C.E.

13 See Joosten, "Language and Milieu," pp. 175–76, for the first claim; Sidnie White Crawford, "Esther and Judith: Contrasts in Character," in Sidnie White Crawford and Leonard J. Greenspoon (eds.), *The Book of Esther in Modern Research* (London: T&T Clark, 2003), pp. 60–76, esp. 70–71 for the second. Some scholars, e.g., Beckwith, *Old Testament Canon*, esp. pp. 382–85, argue against the very notion of a separate Greek Jewish canon and point out that the earliest manuscripts of the Apocrypha are all Christian codices. These codices include different books of the Apocrypha, placed in different locations, thus reflecting Christian reading habits.

14 Cf. Dt 23:4 (an express prohibition of Ammonite conversion) and see Moore, *Anchor Bible Judith*, p. 87.

powerful role allotted Judith and suggests that she was simply too feminist and independent to be accepted by the rabbis, who did not appreciate her subversion of patriarchal norms.[15]

Whatever the reason, the Book of Judith was not included in the Hebrew Bible and the book survived in Greek in the Septuagint, in Old Latin versions and the Vulgate, but not, as we have seen, in Hebrew.[16] The work may well have disappeared from the Jewish tradition at an early stage, for there is no trace of Judith's tale in the Dead Sea scrolls (which include well over two hundred copies of various biblical texts, which date from approximately 150 B.C.E. to 68 C.E.).[17] Nor is Judith mentioned in Philo (ca. 20 B.C.E.– 50 C.E.) or in Josephus (ca. 37–100 C.E.). Arguments from silence are tricky: there is, for example, no surviving fragment of the Book of Esther, a work often linked with Judith, from Qumran, and Philo does not mention any of the apocryphal books. Nonetheless Judith's absence from Josephus is worth noting, for when he rewrites the Bible in his *Jewish Antiquities*, he displays considerable interest in beautiful, biblical women and he utilizes both the Septuagint and the Hebrew Bible when fashioning his tales. Josephus's account of Esther, which includes many ironic and erotic elements, bears a particular resemblance to the Book of Judith.[18]

We must turn, then, to early Christian writers for information about the status of the Book of Judith among the Jews. Origen, writing towards the middle of the third century C.E., tells us that the Jews do not use Judith (or Tobit) and adds that the Jews themselves have informed him that these two books are not found in Hebrew, even in the Apocrypha.[19] Here, too, we must be cautious, for five fragments of the Book of Tobit – four in Aramaic

15 Craven, *Artistry and Faith*, pp. 117–18; Crawford, "Esther and Judith," pp. 70 and 73–76.

16 Robert Hanhart, *Iudith* (Göttingen: Vandenhoeck & Ruprecht, 1979), pp. 7–18, reports on the textual tradition of the Septuagint, Old Latin, and Vulgate Judith as well as daughter versions of the Greek in Syriac, Armenian, etc.

17 James C. VanderKam, *An Introduction to Early Judaism* (Grand Rapids, MI: W. B. Eerdmans, 2001), pp. 150–66, is a helpful survey of the Qumran texts and community.

18 See Louis H. Feldman, "Hellenizations in Josephus' Version of Esther," *Transactions of the American Philological Association*, 101 (1970), pp. 143–70 (p. 145).

19 Origen, *Letter to Africanus 19*: Ἑβραῖοι τῷ Τωβίᾳ οὐ χρῶνται, οὐδὲ τῇ Ιουδίθ· οὐδὲ γὰρ ἔχουσιν αὐτὰ κἂν ἐν ἀποκρύφοις ἑβραιστί, ὡς ἀπ᾽ αὐτῶν μαθόντες ἐγνώκαμεν (Nicholas de Lange (ed.), *Origène, La lettre à Africanus sur l'histoire*, Sources Chrétiennes 302 [Paris: Éditions du Cerf, 1983], p. 562). This letter is dated ca. 245 C.E. "Apocrypha" should be understood here as "hidden" or possibly "stored" books, i.e., the more respected of the non-biblical books; see Beckwith, pp. 325–26 n. 30.

and one in Hebrew – have surfaced at Qumran, so clearly Jews were still reading Tobit in the first century B.C.E. Perhaps they were reading Judith then as well, even if there are no fragments of Judith in any language from Qumran. Jerome, who translated the Book of Judith into Latin at about 400 C.E., says that the Jews count Judith among the Apocrypha (*apud Hebraeos liber Iudith inter Apocrypha legitur*), perhaps implying that in his time the Jews still read or had access to the text.[20] Jerome also states that an Aramaic text underlies his translation of Judith, a translation he allegedly finished in the course of a brief night's work by the lamp (*unam lucubratiunculam*).[21] The Vulgate version of Judith differs in many ways from the Septuagint one, and Jerome presents a humble, more self-effacing heroine.[22] We shall see that it is Jerome's chaste and more domesticated Judith who subsequently found her way into several of the medieval Jewish texts.

Jerome and Origen, then, present inconsistent testimony on the status of the Book of Judith among the Jews in the third and fourth centuries C.E., while in the Jewish tradition we hear nothing at all. This Jewish silence continues for many centuries, for Judith is not mentioned in the Mishnah, Talmud, or other rabbinic literature. It is only from about the tenth (or perhaps the eleventh) century C.E. onwards, over a thousand years after the apocryphal book was first composed, that Judith is found once again in

20 Jerome, *Preface to Judith* (Robert Weber [ed.], *Biblia Sacra Iuxta Vulgatam Versionem* [Stuttgart: Deutsche Bibelgesellschaft, 1969]), p. 691. Other manuscripts have "Agiographa," which seems to be a later reading attempting to place Judith in the context of the canonical books. In his preface to the parallel Book of Tobit (p. 676 Weber), Jerome speaks of the Jews separating the work from the biblical canon and transferring it to the Apocrypha (*librum ... Tobiae quem Hebraei de catalogo divinarum Scripturarum secantes, his quae Agiografa memorant manciparunt*).

21 Jerome, *Preface to Judith* (Weber, p. 691). This mention of an Aramaic version further complicates matters. It is clear that Jerome made use of Old Latin versions of the Book of Judith – and these Old Latin texts were translated from the Septuagint – as well as his alleged Aramaic source. In addition, Jerome introduced some passages of his own composition. See Moore, *Anchor Bible Judith*, pp. 94–101; Otzen, *Tobit and Judith*, p. 141 and the further bibliography there.

22 L. E. Tony André, *Les Apocryphes de l'ancien testament* (Florence: O. Paggi, 1903), pp. 164–68, is a useful tabular comparison of the Septuagint and Vulgate versions of Judith. See too Dagmar Börner-Klein, *Gefährdete Braut und schöne Witwe: Hebräische Judit-Geschichten* (Wiesbaden: Marix Verlag, 2007), pp. 3–11. Leslie Abend Callaghan, "Ambiguity and Appropriation: The Story of Judith in Medieval Narrative and Iconographic Traditions," in Francesca Canadé Sautman, Diana Conchado, and Giuseppe Carlo Di Scipio (eds.), *Telling Tales: Medieval Narratives and the Folk Tradition* (New York: St. Martin's Press, 1998), pp. 79–99, esp. 81–85, discusses the ways in which Jerome transforms Judith.

Jewish literature.[23] When Judith does resurface, it is in a variety of contexts and genres, in brief as well as lengthy form. Thus we encounter Judith in several different kinds of Jewish literature: Hebrew tales of the heroine, liturgical poems, commentaries on the Talmud, and passages in Jewish legal codes. These later accounts vary considerably and it is worth noting at the outset that none of the medieval versions tells a story identical to that found in the Septuagint. Indeed the Septuagint version of Judith virtually disappears from Jewish tradition until modern times.[24]

In many of these medieval Jewish sources, Judith becomes linked with the festival of Hanukkah, an eight-day holiday first instituted by Judah Maccabee in 164 B.C.E., to celebrate the rededication of the temple in Jerusalem. We have seen above (pp. 26–27) that Hasmonean happenings influenced the composition of Judith's original tale and in medieval times, perhaps as a result of this, Judith becomes an actual participant in events surrounding the Hasmonean victories. Another reason for the introduction of Judith into Hanukkah tales and customs seems to be the many parallels between Judith and Esther. Esther and Judith, two beautiful and seductive Jewish heroines who save their people from the threats of a foreign ruler, are associated together.[25] At the same time, the holiday of Hanukkah is associated in Jewish eyes with the festival of Purim, for both festivities are late ones. The two holidays are not mentioned in the Torah, but date to the Second Temple period and their laws and customs are regulated by the rabbis. The holidays share a special, parallel prayer, "On the Miracles," as well. Purim has a heroine, Esther, and a scroll telling her story, *Megillat*

23 If the Hanukkah *sheelta* – a homily on Jewish law and ethics – ascribed to Rav Ahai (680–752 C.E.) is authentic (= text 5f; see the appendix below for a detailed list of medieval Hebrew Judith texts), then the earliest extant Hebrew tale telling of Judith dates back to the eighth century. See Samuel Kalman Mirsky, *Sheeltot de Rab Ahai Gaon: Genesis, Part ii* (Jerusalem: Sura Institute, Yeshiva University and Mossad Harav Kook, 1961), pp. 175–76 [in Hebrew] and Meron Bialik Lerner, "Collections of Tales," *Kiryat Sefer*, 61 (1986), pp. 867–72, esp. p. 869 n. 11 [in Hebrew] for its authenticity; Ben Zion Wacholder, "Review of Mirsky, *Sheeltot de Rab Ahai Gaon*," *Jewish Quarterly Review*, 53 (1963), pp. 257–61, esp. p. 258, thinks that this tale is a late gloss. Text 2 can be firmly dated to the eleventh century, as can text 10.

24 There is one notable exception. The biblical commentator and philosopher Ramban (Nachmanides 1194–ca. 1270) was acquainted with an Aramaic version of Judith, translated from the Septuagint, for he quotes from the Peshitta (Syriac) version of Jdt 1:7–11 in his commentary on Dt 21:14. He says that the verses come from the Scroll of Shoshan (or Susann), apparently referring to a scroll containing the "women's books," Susanna, Ruth, Judith, and Esther, which began with Susanna.

25 See above p. 25 and Crawford, "Esther and Judith."

Esther, and apparently this led to the analogous holiday, Hanukkah, being assigned a similarly seductive heroine, whose story is entitled at times, *Megillat Yehudit*, the Scroll of Judith. It is also worth noting in this context the final verse of the Vulgate version of Judith, apparently a late addition to the text, which speaks of an annual celebration: "The day of this victory was accepted by the Hebrews among their holy days, and is observed by the Jews from that time up to the present day." (Vulg. Jdt 16:31).[26] Thus, even though there is no actual basis for linking Judith with Hanukkah,[27] Judith's tale is frequently enmeshed with the story of Hanukkah in medieval times,[28] and we find this connection in several separate strands of Jewish literature.

The Hebrew stories of Judith, often termed the Judith midrashim, are the largest and most varied group of medieval Jewish texts that mention Judith. While some of the stories are attributed to named authors who can be dated, other tales are simply found anonymously, in manuscripts written as late as the sixteenth century. Two of the Judith stories are known only in published form, in books dating to the eighteenth century (texts D and 9) and there are, in all likelihood, a great many other Hebrew versions of Judith's tale which have yet to be published.[29] Many of the texts cannot be dated with any certainty, but we have seen above (p. 29) that at least some of them were already

26 "*dies autem victoriae huius festivitatem ab Hebraeis in numero dierum sanctorum accepit et colitur a Iudaeis ex illo tempore usque in praesentam diem.*" See, e.g., Louis Soubigou, "Judith: traduit et commenté," in Louis Pirot and Albert Clamer (eds.), *La Sainte Bible*, iv (Paris: Letouzey & Ané, 1952), pp. 481–575 (p. 575), and Yehoshua M. Grintz, *Sefer Yehudith: The Book of Judith* (Jerusalem: Bialik Institute, 1957), p. 197 [in Hebrew] on the lateness of the verse.

27 See however Pierre-Maurice Bogaert, "Un emprunt au judaïsme dans la tradition médiévale de l'histoire de Judith en langue d'oïl," *Revue théologique de Louvain*, Vol. 31, No. 3 (2000), pp. 344–64, esp. pp. 345–46 (and the further references there) for the argument that the author of the Septuagint Book of Judith already subtly refers to Hanukkah. In the sixteenth century, the critical Jewish thinker Azariah de' Rossi objected vigorously to the association of Judith with Hanukkah; see Joanna Weinberg, *The Light of the Eyes: Azariah de' Rossi* (New Haven, CT: Yale University Press, 2001), pp. 636–39.

28 Günter Stemberger, "La festa di Hanukkah, Il libro di Giuditta e midrasim connessi," in Giulio Busi (ed.), *We-Zo't Le-Angelo: Raccolta di studi giudaici in memoria di Angelo Vivian* (Bologna: Associazione italiana per lo studio del giudaismo, 1993), pp. 527–45, discusses Hanukkah in rabbinic Judaism and the various medieval tales associated with the holiday. Mira Friedman, "Metamorphoses of Judith," *Jewish Art*, 12–13 (1986–87), pp. 225–46, esp. pp. 225–32, brings various manuscript illuminations and Hanukkah menorahs which point to the connection between Judith and Hanukkah in Jewish art.

29 See, e.g., a Yemenite account of Judith recently published for the first time in Moshe Chaim Leiter, *A Kingdom of Priests: On Chanukah* (Modi'in, [s. n.], 2006), pp. 435–42 [in Hebrew]).

in circulation in the eleventh century. The tales are not readily accessible. They have been published, chiefly in Hebrew, in a variety of books and journals, but there is no one comprehensive collection of the midrashim.[30] Most of the midrashim have not been translated into English at all, while the existing English versions of these stories are scattered in various venues and have not been collected together. French and German readers are better served.[31] Medieval Hebrew tales of Judith have not, it seems, entered the mainstream of Judith scholarship and scholars who have written about them have generally been interested not so much in the stories themselves as in their sources and the likelihood that these tales preserve ancient Hebrew traditions which go back to the original Book of Judith.[32]

The midrashim can be grouped into several categories (with, as we shall see, some overlapping).[33] One group of Hebrew stories is closely related to the Vulgate (texts B1, C, and D) and these accounts are translations of the Vulgate version of Judith into Hebrew, generally in abridged and adapted form. A minority view holds that these medieval Hebrew tales preserve the ancient, original Hebrew version of the Book of Judith. These early Hebrew

30 André Marie Dubarle, *Judith: Formes et sens des diverses traditions: i: Études; ii: Textes* (Rome: Institut Biblique Pontifical, 1966) and Börner-Klein, *Gefährdete Braut* (who relies heavily on Dubarle) are the fullest collections. See too the texts found in Leiter, *A Kingdom of Priests*, pp. 179–88 and pp. 365–442 [in Hebrew]; Abraham Meir Habermann, *Hadashim Gam Jeshanim: Texts Old and New* (Jerusalem: Reuven Mass, 1975), pp. 40–74 [in Hebrew]; D. Samuel Löwinger, *Judith-Susanna: New Versions Edited According to Budapest Manuscripts* (Budapest: F. Gewuercz, 1940), pp. 1–17 [in Hebrew]; Adolph Jellinek, *Bet ha-Midrasch* (2nd ed.), pp. i–vi (Jerusalem: Bamberger and Wahrmann, 1938), passim. See too the appendix below, pp. 37–39.
31 Translations of various midrashim into English can be found in Charles James Ball, "Judith" in Henry Wace (ed.), *The Apocrypha* (London: John Murray, 1888), pp. 241–360 (pp. 252–57) (texts 2a and 3); Moses Gaster, "An Unknown Hebrew Version of the History of Judith," in idem, *Studies and Texts* (New York: KTAV, 1971), vol. i, pp. 86–91; vol. iii, pp. 31–32 (text 1); Moore, *Anchor Bible Judith*, pp. 103–07 (texts 1 and 3); Bernard H. Mehlman and Daniel F. Polish, "Ma'aseh Yehudit: A Chanukkah Midrash," *Journal of Reform Judaism*, 26 (1979), pp. 73–91 (text D). Dubarle, *Judith*, and Börner-Klein, *Gefährdete Braut*, translate the Hebrew texts they collect into French and German, respectively. See the appendix below.
32 Dubarle, *Judith*, passim is the strongest proponent of the view that the medieval Hebrew versions reflect earlier ancient versions. See however Grintz, *Sefer Yehudith*, pp. 196–207; Otzen, *Tobit and Judith*, pp. 138–40 and the further references there for other views.
33 For other groupings of the tales, see Israel Adler, "A Chanukah Midrash in a Hebrew Illuminated Manuscript of the Bibliothèque Nationale," in Charles Berlin (ed.), *Studies in Jewish Bibliography, History, and Literature in Honor of I. Edward Kiev* (New York: KTAV, 1971), pp. i–viii [in Hebrew] (i–ii); Grintz, *Sefer Yehudith*, pp. 197–98, and Börner-Klein, *Gefährdete Braut*, passim.

accounts were then translated into Aramaic, runs the argument, and it is this Aramaic version that Jerome subsequently translates into Latin. However most scholars contend that these midrashim stem from a much later source, most probably a medieval Hebrew translation of the Vulgate Judith. Because of their close resemblance to – and dependence upon – the Vulgate, these stories do not teach us much about medieval Jewish attitudes toward Judith and her story. They do, however, provide important evidence for a renewed Jewish interest in the Book of Judith – and the Apocrypha in general – in medieval times. From the tenth century onwards, a series of medieval Jewish writers translated many of the apocryphal works into Hebrew, often in adapted form, as part of larger (historical) compositions.[34] The Hebrew Vulgate-based Judith versions are linked, at times, to Hanukkah as well. Thus the title page of one such version (text B1) reads "This is the book of Judith daughter of Merari of Hanukkah," even though there is no mention of Hanukkah in the story itself.

A second group of stories (texts 1, 2a, and 9) consists of rather brief, folkloric accounts which concentrate upon Judith's actual deed. These stories make little reference to the events described in the first half of the Book of Judith and make no mention of Hanukkah. Brief though these tales may be, their basic plot, which deviates in certain ways from the Septuagint, is followed in all the non-Vulgate versions.

A third group of Hebrew Judith stories (texts 3, 4, 5, 8, and 12) is directly linked to Hanukkah, and these stories fall into two parts. In the first half, we hear of the assassination of an enemy leader by Hasmoneans, who object to the leader's desire to exercise his right of the first night (*ius primae noctis*) when their sister is about to be married. Judith, who is now identified as a relative of the Hasmoneans, performs her daring deed in the second half of these stories.[35]

A particularly interesting group of midrashim (texts 7a and 7b) are hybrid tales which have a Vulgate-inspired account in the first half of the tale,

34 The author of the *Book of Josippon* (middle tenth century c.e.) apparently was the first medieval Jewish author to translate and adapt various sections of the Apocrypha. He is followed by, among others, Jerahme'el son of Solomon (early twelfth cent. c.e.) and Rabbi Eliezer son of Asher (mid-fourteenth century c.e.). See E. Yassif (ed.), *The Book of Memory: The Chronicles of Jerahme'el* (Tel Aviv: Tel Aviv University, 2001), pp. 38–40 [in Hebrew].

35 Bogaert, "Un emprunt," pp. 353–58, provides interesting indirect evidence for the circulation of such Hanukkah-Judith midrashim in thirteenth-century France, for he demonstrates how the *Chevalerie de Judas Macchabée* of Gautier de Belleperche incorporates elements of the Hebrew stories.

until immediately after Judith arrives on the scene. The second half of these stories resembles the accounts of Judith found in the Hanukkah tales.

Two papers in this section investigate these Judith midrashim. "Shorter Hebrew Medieval Tales of Judith," by Deborah Levine Gera (Chap. 5), examines the new, less independent role assigned to Judith in the non-Vulgate versions and notes how Judith is diminished both within and without her community. Gera also compares and contrasts Judith with the Hasmonean woman described in the Hanukkah midrashim. "Food, Sex, and Redemption in *Megillat Yehudit* (the 'Scroll of Judith')," by Susan Weingarten (Chap. 6), is a careful study of one particular Hanukkah midrash and the important role played by food, especially cheese, in the story. Weingarten sees this text as a Jewish response to the Christian portrayal of Judith as a precursor of the Virgin Mary. Both Weingarten and Gera note the allusive, biblical Hebrew used in these stories and show how particular biblical quotations are used to hint at the parallels between Judith and biblical figures.

Judith was celebrated in Hebrew poetry as well as prose in medieval times, and there are two liturgical poems (or *piyuttim*) for Hanukkah which tell her story. The two poems (texts 10 and 11) were recited in synagogues in various Jewish communities on the first and second Sabbath of Hanukkah respectively. The first poem, *Odecha ki anafta bi* (I give thanks to you although you were angry with me) (Fig. 2.1), was composed by Joseph ben Solomon of Carcassonne, who is dated to the first half of the eleventh century. This elegant and abstruse poem tells an epic tale of the Jews' resistance to the decrees of Antiochus IV and includes accounts of both the Hasmonean bride and Judith. It bears a considerable resemblance to texts 4 and 12 of the Hanukkah midrashim[36] and this is evidence for the circulation of the joint Hasmonean daughter-Judith tales in the eleventh century, even if the surviving manuscripts of these stories are from a later date. The second poem, *Ein Moshia veGoel* (There is no savior and redeemer), is by Menachem ben Machir of Ratisbon, who was active in the second half of the eleventh century. His poem may be based on the earlier one and he devotes only a few lines to Judith, comparing her to Jael.

We have seen that Judith is not found in the Talmud itself, but later commentators on the Talmud do mention her, always in the context of Hanukkah. These commentators do not tell Judith's story for its own sake, but use elements of her tale to explain the commandments and customs of the holiday. Thus the foremost exegete of the Talmud, Rashi (Rabbi Solomon

36 See Grintz, *Sefer Yehudit*, pp. 205, 207–08.

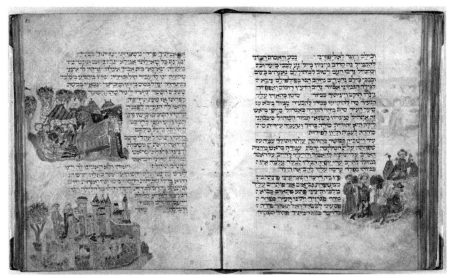

Odecha ki anafta bi, 1434. Hebrew poem on Judith. Hamburg miscellany,
Cod. Heb. 37, fol. 81, Mainz (?). Photo credit: Deborah Levine Gera.

ben Isaac, 1041–1105), when discussing why women, as well as men, are
required to light Hanukkah candles, simply notes that when the Greeks
decreed that Jewish virgin brides were to be bedded first by the ruler, a
woman brought about the miracle. We know that Rashi was acquainted
with the liturgical poem *Odecha ki anafta bi* because he quotes it elsewhere
(in his commentary on Ez 21:18), so it is very likely that he knew of Judith's
deed, but did not choose to mention her by name. Rashi's grandson, the
Rashbam (Rabbi Samuel ben Meir 1085–1174), does mention Judith, and
he is quoted as saying that the chief miracle of Purim came about through
Esther, and that of Hanukkah through Judith.[37] Later commentators bring
further details. Nissim ben Reuben (ca. 1310–75), known as the Ran, refers to
Judith not by name, but as the daughter of Yochanan. In his account, which
he says comes from a midrash, the woman gave the chief enemy cheese to
eat so as to make him drunk, and then cut off his head. This, adds the Ran,
is why it is customary to eat cheese on Hanukkah.[38] In the *Kol Bo* (section
44), a work outlining Jewish laws and customs dating to the thirteenth or
fourteenth century, we find a similar version. In this account, the king of
Greece attempts to seduce Judith, the daughter of the high priest Yochanan,

37 Rashi on Babylonian Talmud Shabbat 23a; Tosafot on Babylonian Talmud
Megillah 4a.
38 Nissim ben Reuben on Alfasi, Shabbat 10a (on Babylonian Talmud Shabbat 23b).

and she feeds him a cheese dish so that he will become thirsty, drink too much, and fall asleep. Such references to Judith's encounter with an enemy whom she fed either cheese or milk are subsequently found in a long line of works which codify *halacha*, Jewish law, and supply the background to the practice of eating cheese dishes on Hanukkah. Indeed, similar remarks are found in Jewish guides and responsa written to this very day.[39]

We arrive, at long last, at the age of print. In the earliest known printed Hebrew version of the Book of Judith, a translation of the Vulgate dating to ca. 1552, the translator, Moses Meldonado, sees fit to apologize for straying from the accounts of Rashi and the Ran. He points out that Jerome's version and those of the Talmudic commentators have something in common – the recollection of God's boundless grace and mercy.[40] And indeed all the various versions of Judith we have looked at – the Septuagint, the Vulgate, the midrashim, prayers, and commentaries – have at least certain elements in common and all will eventually find their way into print in Hebrew and become part of the Jewish textual tradition.

Hebrew was not, of course, the only language used in Jewish texts and from the sixteenth centuries onwards there is a rich tradition of Yiddish accounts of Judith as well, a tradition that has not been sufficiently explored. Old Yiddish is a Jewish dialect of Middle High and Early New High German that is written in Hebrew characters, and its literature is influenced by German sources as well as Hebrew ones. The last paper of this section, "Shalom bar Abraham's Book of Judith in Yiddish," by Michael Terry and Ruth von Bernuth, analyzes the earliest surviving printed Yiddish translation of the Book of Judith of 1571. The authors demonstrate that this publication was not influenced by any Hebrew versions of Judith or by the Luther Bible, and is based entirely on the literal German of the Zurich Bible.

The papers in this section discuss texts written over a period of some 1700 years. Despite her early disappearance from Jewish tradition, Judith proved too vital a figure to vanish entirely. She returned, transformed, in the Middle Ages, and left her mark on Jewish texts, prayers, practices, and ritual art.

39 See the sources in Dubarle, *Judith*, i, pp. 105–07, 109, and the detailed discussion in Leiter, *A Kingdom of Priests*, pp. 362–69. A search of the Bar Ilan Online Jewish Responsa Project (http://www.biu.ac.il/jh/Responsa/) supplies further texts, including a responsum from 1996.
40 See Haberman, *Texts Old and New*, pp. 15–16, 62–74.

Appendix to Chapter 2

A List of Medieval Hebrew Judith Texts

Note: This list is not meant to be exhaustive. The numbering of the texts is based on that of Dubarle, *Judith*.

I. Vulgate-Based Versions

Text B1 – ms. Oxford Bod. Heb. d. 11, Neubauer 2797, fol. 259–65 (ca. 1350). Habermann, *Texts Old and New*, 47–59. Dubarle, *Judith*, i. 20–27; ii. 8–96. Börner-Klein, *Gefährdete Braut*, 19–239.

Text C – Oxford Bod. Opp. 8. 1105. Printed in Venice in 1651. Dubarle, *Judith*, i. 27–33; ii. 8–96. Börner-Klein, *Gefährdete Braut*, 19–239.

Text D – First printed in Smyrna 1731–32 (with a concluding note that it comes from an "old collection"). Jellinek, *Bet ha-Midrasch*, ii. 12–22. Dubarle, *Judith*, i. 33–37. Börner-Klein, *Gefährdete Braut*, 19–239.

Texts E1 and E3 – see below, Texts 7a and 7b.

II. Brief Tales of Judith (Not Related to Hanukkah)

Text 1: "Our Rabbis taught..." Gaster, *Studies and Texts*, iii. 31–32: ms. Manchester, John Rylands library, Cod. Heb. Gaster no. 82 fol. 172r–173r (possibly 10–11 centuries). Dubarle, *Judith*, i. 80–82; ii. 100–03. Börner-Klein, *Gefährdete Braut*, 276–83.

Text 2a: Tale by Nissim ben Jacob (ca. 990–1062). Jellinek, *Bet ha-Midrasch*, i. 130–31: Nissim ben Jacob, *Chibur Yafeh Mehayeshua* (Amsterdam 1746) and Habermann, *Texts Old and New*, 60–61: ms. New York, Jewish Theological Seminary 29652. Dubarle, *Judith*, i. 82–84; ii. 104–109; Börner-Klein, *Gefährdete Braut*, 247–57.

Text 9: The Tale of Judith An expansion of 2a first printed in Livorno in 1845. Dubarle, *Judith*, i. 94–98, ii. 152–63; Börner-Klein, *Gefährdete Braut*, 258–75.

III. Hanukkah-Judith Tales

Text 3: Midrash for Hanukkah
Jellinek, *Bet ha-Midrasch*, i. 132–36: ms. Leipzig, Raths-Bibliothek cod. 12.
Dubarle, *Judith*, i. 84–85; ii. 110–113; Börner-Klein, *Gefährdete Braut*, 338–89.

Text 4: The Tale of Judith: A Midrash for Hanukkah
Löwinger, *Judith-Susanna*, 14–17: ms. Budapest, Bibliotheca Academiae Scientiarum Hungaricae, Kaufman 188, 91–93.
Dubarle, *Judith*, i. 85–86; ii. 113–16.

Text 5: The Tale of Judith / Sheelta for Hanukkah
5a) The Tale of Judith.
Moshe Hershler, "Ma'aseh Yehudit," *Gnuzot* 1 (1984), 175–78: ms. Vatican Heb. 285 (no. 8632), 60r–62r; see Lerner, "Collections of Tales," 868 n. 4.
Dubarle, *Judith*, i. 86– 88; ii. 118–25.

5c) The Tale of Judith.
Michael Higger, *Halachot ve-Haggadot*, ii (New York: Debay Rabannan, 1933), 95–102: ms. New York, Jewish Theological Seminary Enelow 827= Halperin 827 fol. 18–19.
Dubarle, *Judith*, i. 86–88. Börner-Klein, *Gefährdete Braut*, 338–89.

5f) Sheelta Genesis xxvii of Rav Ahai (680–752 c.e.).
Mirsky, *Sheeltot de Rab Ahai*, 182–190: ms. Paris Bibliothèque Nationale: Cde 24, 208 (=Zotenberg 309).
(Not in Dubarle or Börner-Klein).

Text 8: Megillat Yehudit: The Scroll of Judith.
Habermann, *Texts Old and New*, 40–46: ms. Oxford Bod. Heb. e. 10, Neubauer 2746 (1402).
Dubarle, *Judith*, i. 92–94; ii. 138–52.

Text 12: Judith, the daughter of Mattathias.
Adler, "A Chanukah Midrash," ii–vii: ms. Paris, Bibliothèque Nationale 1459.2 (sixteenth century).
Dubarle, *Judith*, i. 100–01; ii. 170–77; Börner-Klein, *Gefährdete Braut*, 326–37.

IV. Vulgate and Hanukkah Versions Combined

Text 7: Megillat Yehudit / Sheelta for Hanukkah
7a) Megillat Yehudit: The Scroll of Judith.
Higger, *Halachot ve-Haggadot*, ii. 103–113: ms. Oxford, Bod. d. 47.15, Neubauer 2669, 38a–39b; see too B. M. Levin, "Sheelta leChanukah," *Sinai*, 3 (1940), 68–72.
Dubarle, *Judith*, i. 37–43, 90–92; ii. 9–55, 127–131. Börner-Klein, *Gefährdete Braut*, 296–325.

7b) Megillat Yehudit.
Löwinger, *Judith-Susanna*, 9–13: ms. Budapest, Bibliotheca Academiae Scientiarum Hungaricae, Kaufman 259, 88–92.
Dubarle, *Judith*, i. 37–43, 90–92; ii. 9–55, 132–36; Börner-Klein, *Gefährdete Braut*, 296–325.

V. Liturgical Poems for Hanukkah

Text 10: *Odekha ki anafta bi* by Joseph ben Solomon (first half of the eleventh century)
Isaac Seligmann Baer, *Seder Avodat Yisrael* (Rödelheim 1868; reprinted Berlin: Schocken, 1937), 629–633.
Dubarle, *Judith*, i. 98–99, ii. 162–67.

Text 11: *Ein Moshea veGoel* by Menachem ben Machir (twelfth century)
Baer, *Seder Avodat Yisrael*, 642–44.
Dubarle, *Judith*, i. 100, ii. 168–69.

3. Judith in the Christian Tradition

Elena Ciletti and Henrike Lähnemann

This essay sets out the broad framework of Christian tradition that unites, explicitly and implicitly, many of the papers in this volume, particularly in chapters 8–21.[1] It begins with the foundations established by the early Roman Church and explores aspects of later heritage in Western Europe. It seems to us that the Christian roots of the Judith mythos have been inadequately acknowledged, with the result that the long trajectory of their influence has been undervalued. We have therefore construed our project as a kind of cultural archaeology, devoted to excavating some key theological currents and undercurrents of the construction of the figure of Judith in Western European thinking. We recognize that many significant branches of this cultural evolution are not addressed, owing to the geographic parameters set by the papers and the delimited nature of our inquiry.[2]

Our schema is generally chronological, extending from the patristic through the early modern periods. Beginning with Jerome, we proceed through the medieval era, mapping first some of the early literary developments and then turning to the parallel visual imagery that later came to virtually dictate the popular perception of Judith. The discussion of the

1 Citations in this introduction are mainly limited to representative references to our specific themes. Full bibliographical details are provided in the referenced papers. For an overview of primary sources, for general literature on the Book of Judith, and for introductory material to specific disciplines and periods, see the extensive bibliographies available on *The Sword of Judith* website, via www.openbookpublishers.com. Biblical books are referenced with the short titles following the Chicago style (cf. index under "Bible").

2 Among the important areas not considered here are the multiple traditions of Eastern Orthodox Christianity, whose Bibles include the Book of Judith because they are based on the Greek Septuagint. Another is Spain, whose participation in the Judithic culture of Roman Catholicism was transmitted to the Americas.

early modern centuries reverses this course: it is anchored primarily in the visual arts, alongside which related literary developments are sketched. From the sixteenth century on, the scenario is enriched by music and drama, which navigated between the textual, the visual and the aural. In tracing our themes, we can invoke only a few of the countless testimonials to the immense interest in Judith across more than a millennium. By the nineteenth century, secular concerns predominated. The features that we address favor the external or public facets of the works in question and their relationships to foundational Christian texts and concepts.

Our material constitutes a segment of the reception history of Judith. For the purposes of this introduction we are privileging the cultural production aspect of this history over that of cultural consumption, an important topic that is addressed in several of the papers themselves. It must be stressed that for a figure as multivalent as Judith, malleability in signification is the norm, with varying and sometimes even opposing constitutive roles played by creators and audiences, especially as popular arts and drama came to transport the topic into ever more widely accessible arenas. We cannot fail to note that the history of the particular forms this process takes is inseparable from the paradoxes inherent in the character presented by the biblical story. Humble and bold, pious and devious, widow and warrior, Judith is ever composed of contradictions barely contained in tense equilibrium.

Any introduction to the Christian tradition must start with the same facts (and problems) stated by Deborah Levine Gera (Chap. 2) for the Jewish tradition. For the Book of Judith, Christian sources and representations precede most Jewish textual evidence we have. Thus the initial papers in this volume deal with patristic and early medieval texts which are antecedent to those considered in all but the first essay of the Jewish section, while the Yiddish examples discussed are dependent on Protestant translations of the Book of Judith.

As Gera points out, Jerome's version of the Book of Judith in the Vulgate proved the most influential single source not only for the Christian textual tradition but also for the visual and musical representations in its wake. For this reason, we will begin with the distillation of his thinking about her book and her importance as stated in his preface, which was appended to the biblical text in manuscript and print for most of its history.

Praefatio Hieronymi in Librum Judith
(Jerome's Preface to the Book of Judith)[3]

Apud Hebraeos liber Judith inter apocrypha legitur: cujus auctoritas ad roboranda illa quae in contentionem veniunt, minus idonea judicatur. Chaldaeo tamen sermone conscriptus, inter historias computatur. Sed quia hunc librum Synodus Nicaena in numero sanctarum Scripturarum legitur computasse, acquievi postulationi vestrae, immo exactioni: et sepositis occupationibus, quibus vehementer arctabar, huic unam lucubratiunculam dedi, magis sensum e sensu, quam ex verbo verbum transferens.

Multorum codicum varietatem vitiosissimam amputavi: sola ea, quae intelligentia integra in verbis Chaldaeis invenire potui, Latinis expressi.

Accipite Judith viduam, castitatis exemplum, et triumphali laude, perpetuis eam praeconiis declarate.

Hanc enim non solum feminis, sed et viris imitabilem dedit, qui castitatis ejus remunerator, virtutem ei talem tribuit, ut invictum omnibus hominibus vinceret, et insuperabilem superaret.

Among the Hebrew speaking Jews, the Book of Judith is counted as belonging to the apocryphal texts; its warrant for affirming disputed texts is deemed less than sufficient. Although it was written in Aramaic, it is taken to be a moral story/among the historical books. But since this book was counted by the Nicene Council as belonging to the sacred texts, I have acquiesced to your appeal (or should I say demand!): and, my other work set aside, from which I was forcibly restrained, I have given a single night's work, translating rather sense by sense than word for word.

I have hacked away at the excessively error-ridden panoply of the many codices; I conveyed in Latin only what I could find expressed coherently in the Chaldean words.

Receive the widow Judith, a paradigm of chastity, and with triumphant laud make her known in perpetual praises.

For not only for women, but also for men, she has been given as a model by the one who rewards her chastity, who has ascribed to her such virtue that she conquered the unconquered among all men, and surmounted the insurmountable.

3 *Patrologia Latina* (PL 29, Col. 37–39). The translation here is Lähnemann's, based on that by Andrew S. Jacobs, University of California Riverside (http://www.ccel. org/p/pearse/morefathers/jerome_preface_judith.htm, accessed 15 December 2009). With regard to the plural form of the unnamed addressees, Jacobs explains that Jerome was likely speaking to the brother bishops, Chromatius and Heliodorus, to whom he had dedicated earlier the adjacent book of Tobit. This is an alternative to the position of Tillemont (and others subsequently), who deduced from its being a book named after a woman that it was intended for Jerome's "beloved fellow-toilers" and companions in Bethlehem, Paula and her daughter Eustochium.

In this document Jerome makes three statements that set the framework for the greater part of the reception history.

Among the Jews, the Book of Judith is considered apocryphal. The Book of Judith is perched rather precariously on the edge of Scripture. The twilight state of its canonicity is expressed by the three conflicting categories in which it has historically been placed: "apocrypha" (non-canonical, apocryphal books), "historiae" (historical accounts but also stories for moral instruction, including fictitious works), and "sanctae scripturae" (canonical books as part of the Holy Scripture).[4] This indeterminacy proved irritating; most of the medieval manuscripts replace the "apocrypha" classification with "hagiographa" ("holy writing," used as a technical term for the third canonical part of the Hebrew Bible) to set the book on the firm ground of canonicity. But Jerome's anecdotal account of his translation process re-enforces the first impression: he says that, as Gera notes (Chap. 2), it was done as a mere "lucubratiuncula" (a night shift set aside for leisurely literary pursuit) and that he employed not the verbatim style, i.e., what befits a canonical book, but a rather more rough and ready mode ("sensus a sensu"). It does not matter that the evidence of Jerome's translation technique belies this claim. What is important is the ambiguous positioning thus achieved for the Book of Judith between the sacrosanct and the fictional, which opened up a freedom of rendering beyond the strictures demanded by canonical texts.

Receive the widow Judith, a paradigm of chastity. In the shorter second part of the preface, Jerome suddenly shifts the focus away from issues of canonicity and translation to the figure of the protagonist herself, the "widow Judith," whose victory raises her to the pinnacle of moral exemplarity. He thereby passes over the greater part of the scriptural narrative, which Judith enters only at mid point, in favor of its culmination, her defeat of the invincible Holofernes. This contraction is in concordance with Jerome's own rendering of the overall story-line in the Vulgate, which is a third shorter than the earlier Septuagint version. The foregrounding in the preface of Judith's climactic feat at the expense of a wider-angled view of the intricacies of the tale and of her multifaceted character would have a long history of repercussions, especially in the visual arts. Jerome's moralizing effects a further condensation: bringing the book in line with hagiography,

4 The status conceded by Jerome to the Book of Judith is taken up in the later notion of "deuterocanonical" texts for those books which had been later accepted than the "protocanonical" books and thus formed part of the Septuagint but not of the Hebrew Bible. This terminology was formalized by the Council of Trent (1545–1563).

Judith is branded as "mulier sancta" (holy woman; Jdt 8:29), one who is defined by a single virtue, chastity, of which she is made a moral example, for men and women alike. He is highlighting here the well-known emphasis on this virtue that differentiates his Book of Judith text itself from that of the Septuagint; it is the Vulgate that stresses the commitment to chastity of Judith's domestic seclusion in Bethulia and her steadfast refusal to remarry. This concentration allows later theological writers to use Judith in similarly reductive ways, as a personification of particular virtues, following their inclinations and the moral fashion of the day.

With triumphant laud make her known in perpetual praise. Judith's story is presented not only as a model but as a source of exultation and exaltation. Jerome's mandates proved to be an incentive for the retelling in different media and genres.

These tropes, which were well developed in patristic scholarship beyond Jerome, became the heart of Judith's symbolic identities in the Christian tradition: as virtue personified, as type of the Church, and, last but not least, as prefiguration of the Virgin Mary. She was thereby inscribed within an immense network of emblematic associations, most of which served to neutralize the negative dimensions of her tactics: dissimulation, the shrewd exploitation of her adversary's sexual presumptions, and violence. In this way Judith's transgression of cultural norms, especially for women, was transmuted into its opposite. Along with her sister heroines of the Old Testament, the chaste widow Judith became a familiar component of typological and allegorical constructions in art and literature in the mid to late Middle Ages, and into the Renaissance as well. In the sixteenth century, this aspect of her identity assumed new cogency with the polemical revival of Marian typology by the Roman Catholic Church in response to the challenges of the Reformation. Jerome himself was a factor here, contested in his double roles as a founder of Mariology and the author of the Vulgate. The historical quarrels about the Book of Judith's canonicity, already ancient in Jerome's time and alluded to in his preface, were reanimated: for Catholics, Jerome's explanation bolstered their ancient, pre-Vulgate practice of including the Apocrypha in the canon, while for most Protestants it justified the contrary position.[5] In the Luther Bible and the King James, the

5 See *The Parallel Apocrypha. Greek text, King James Version, Douay Old Testament, the Holy Bible by Ronald Knox, Today's English Version, New Revised Standard Version, New American Bible, New Jerusalem Bible,* ed. by John R. Kohlenberger (New York: Oxford University Press, 1997) for varied approaches to the Book of Judith's canonicity, including the Eastern Orthodox.

Apocrypha were placed as a separate text group after the Old Testament; in the reformed tradition they were eventually excluded. It was in this period of sectarian division that the salience of Judith reached its apogee, as seen in an unprecedented proliferation of representations.[6] Much the same might be said of Jerome.

Essential to this phenomenon is the creation by Protestants of their own Judith practices, with Luther's recommendation of the Book of Judith as "good tragedy" proving as influential as Jerome's preface. The Luther Bible ironically added to the supremacy of Jerome's redaction since the apocryphal books were added hastily to satisfy the demand for a traditional "full Bible," and an anonymous helper translated the Book of Judith straight from the Vulgate – the only one in the Luther Bible not to go back to a Hebrew or Greek text. Thus the translation history of the marginalized book seems to repeat itself. This also gave authors the liberty to draw on it without restrictions, as seen in Reformation dramas like Joachim Greff's "Tragoedia Judith" (1536), which quotes verbatim from Luther. The flourishing trade in dramatizations of Judith furnished arguments for both sides of the denominational divide across Europe, well into the seventeenth century.

The reception history of the Christian Judith has long been molded by the obvious fact that the virtues she is made to manifest throughout her saga are not limited to chastity and its analogues, humility, temperance and piety. As a type of both Mary and the Church, her core identity as instrument of divine will and savior of her people expanded to encompass victory over the devil and sin itself. She came to be associated with Fortitude and Justice, for instance, and to personify such traits as Wisdom, Magnanimity and Eloquence. As the victorious defender of her people, she was inevitably marshaled in struggles against tyrants and enemies, especially foreign "heathens," and indeed in a wide variety of political and civic arenas, as well as in the discourse of gender manifested in such phenomena as the "Querelle des Femmes." It is clear that her story offered a rich panoply of religious and secular applications. From at least the ninth century, when Hrabanus Maurus dedicated his commentary to her namesake, Queen Judith, they are fused.[7] Our papers chart these dynamics, individually and intermingled, in multiple genres.

6 The unparalleled popularity of Judith during the Reformation is a main theme of Margarita Stocker, *Judith: Sexual Warrior. Women and Power in Western Culture* (New Haven, CT, and London: Yale University Press, 1998); we adopt here her language on p. 46.
7 Judith of Bavaria (ca. 800–843) was, by virtue of her marriage to Louis I (the Pious) of France in 819, Holy Roman Empress and Queen of France.

The cultural visibility of later iconic renderings – among them sculptures of a harnessed heroine, paintings of a naked or tarted-up seductress, dramas of spectacular bloodshed and musical presentations of a love story gone tragically wrong – has influenced the twentieth-century scholarly discussion of the Judith topic. In the scholarship on literature, for instance, it would seem that the expectation of gore and sex had rendered the early traditions that read Judith as *pudicitia* or the Virgin Mary disappointingly tame and therefore of relatively little interest. While there are numerous literary surveys from early modern to modern times, the patristic and medieval traditions mostly form only a brief prequel in theory-informed studies.[8] Also, for a long time there was a tendency in theological research to neglect books that seemed to thwart critical probing, as Judith's does. There is, for example, nothing new that can be learned about the early geography of Israel from analyzing the references in Achior's and Judith's speeches devoted to Israelite history in the Septuagint, and no earlier Hebrew text has emerged. Only recently has it been acknowledged that the openly fictitious character of the book's setting actually furnishes illuminating insights into the contemporary Jewish Hellenistic society, as Schmitz and Gera in this volume demonstrate (Chaps. 4 and 5).

There yet remains a lot to be discovered in terms of how the patristic tradition shaped medieval renderings of the story and how these retellings

8 This begins with Edna Purdie, *The Story of Judith in German and English Literature* (Paris: Librairie Ancienne Honoré Champion, 1927); neither Otto Baltzer, *Judith in der deutschen Literatur* (Stoff- und Motivgeschichte der deutschen Literatur 7) (Berlin: de Gruyter, 1930), nor David Radavich, *A Catalogue of Works Based on the Apocryphal Book of Judith. From the Mediaeval Period to the Present* (Bulletin of Bibliography 44) (Boston Book Co., 1987), pp. 189–92, added substantially to the earlier catalogue. The twentieth century is now charted by Theodore Ziolkowski, "Re-Visions, Fictionalizations, and Postfigurations. The Myth of Judith in the Twentieth Century," *The Modern Languages Review,* 104 (2009), pp. 311–32. Volker Mergenthaler, *Medusa Meets Holofernes. Poetologische, semiologische und intertextuelle Diskursivierung von Enthauptung* (Bern: Peter Lang, 1997) jumps from the Septuagint to early modern times when discussing the discourse of beheading under poetological, semiologic, and intertextual aspects. The same applies to James C. VanderKam (ed.), *Essays on Judith* (Early Judaism and Its Literature 2) (Atlanta, GA: Scholars Press, 1992), and André Lacocque, *Subversives, ou, Un Pentateuque de femmes* (Lectio divina 148), (Paris: Éditions du Cerf, 1992), who continue trends in Judith Studies set by Luis Alonso-Schökel (ed.), *Narrative Structures in the Book of Judith* (Protocol of the colloquy of the Center for Hermeneutical Studies in Hellenistic and Modern Culture. The Graduate Theological Union and the University of California at Berkeley 11) (Berkeley, CA: University of California at Berkeley, 1975), and Toni Craven, *Artistry and Faith in the Book of Judith* (Society of Biblical Literature Dissertation Series 70) (Chico, CA: Scholars Press, 1983).

and their molding of the figure of Judith influenced (early) modern percep-
tions of her and her book. All of our volume's papers that place her within
a wider Christian tradition deal with consequences of Jerome's premises,
both formal and interpretive.[9] As indicated, the Luther Bible and most
other translations derived from it kept to the foreshortened account of the
Vulgate, as did all the Catholic Scriptures. With the notable exception of
the King James Bible, whose Judith came from the Septuagint, it was only
with the Bible revisions of the nineteenth century that the Greek version
was available in new vernacular translations. Outside a scholarly context,
the Book of Judith generally meant, well into modernity, the account of the
Vulgate, and with it the figure of the *mulier sancta* of Jerome's making.[10]

Patristics and Their Medieval Afterlife

The patristic literature informs the medieval presentations of the Book of
Judith twofold.[11] On the one hand it frames the figure of Judith in certain
defined contexts; a significant example is the casting of Judith as *pudicitia* in
the late-fourth-century *Psychomachia* of Prudentius (cf. Mastrangelo, Chap.
8). Together with Jerome's definition of the Judith as *castitas*, this set the
precedent for further personifications. Most prominent is *humilitas*, as in
the earliest (ca. 1140) manuscript of the *Speculum Virginum*, with its unusual
image of "Humilitas vanquishing Superbia," which derives from illustra-
tions of Prudentius (cf. Bailey, Chap. 15). On the other hand, early Christian
practice developed the model of Bible epics as a mode of presenting narra-
tive units from the Old and New Testament. No late antique Judith epic ex-
ists, but the conceptual paradigms established by the likes of Prudentius (cf.
Bailey, Chap. 15) and Juvencus proved a hugely influential literary model.

Bible epics became the prevalent literary mode in which to present the
Vulgate story of Judith in the Middle Ages. This form, not exactly a defined

9 The "Vetus Latina," which was based on the Septuagint (and which Jerome used
to borrow certain phrases for his shorter text), lingered on in some places through
the early Celtic adapters of Latin Bible translations. It may have influenced the
Anglo-Saxon Judith (cf. Cooper, Chap. 9) but otherwise its impact on the Western
Christian tradition is negligible.

10 An important literary reliance upon the Septuagint in the early modern period
is the epic French poem *La Judit* by Du Bartas, published in 1574; see the discussion
by Robert Cummings in this volume (Chap. 12).

11 The following section is partly based on Henrike Lähnemann's, *"Hystoria
Judith": Deutsche Judithdichtungen vom 12. bis zum 16. Jahrhundert* (Scrinium Fribur-
gense 20) (Berlin: de Gruyter, 2006), chapter 1.

genre, stands at the crossing point of theological and literary discourses. Time and again, the attempt was undertaken to transfer biblical material and theological knowledge into the vernacular. We can watch each generation going back to the Scripture and meeting the challenges it presents from a current point of view. This means that there was no tradition formed in its own right in the literary realm but that every text confronted the biblical material afresh.

The Vulgate Bible remained the primary text as such. Its authority was, perhaps paradoxically, strengthened by virtue of its availability to the medieval recipient only in Latin, hence translated, form. Since it retained the prefaces of Jerome, the Vulgate constantly reminded the reader of the process of translation and of the status of the biblical text as not only a testimony of divine inspiration but also of ecclesiastical approval. Jerome became translation personified and the whole chain of transmission was sanctified. Derivation, amplification, and further intermediaries did not weaken the text but added further authorizations to it. For medieval audiences, this was a furthering of the assertion of 1 Thes 2:16; they "received it not as the word of men, but (as it is indeed) the word of God." The translation did not dilute the divine message but rather fortified, justified and praised it.[12]

During the medieval period, in addition to the recurring referencing back to Jerome's version of the Judith story seen in the literary form of the Bible epics, there were also theological commentaries and diverse attempts to make the story-line more coherent by sorting out the confusing chronological order. The first commentary to encompass the full Book of Judith was that of Hrabanus Maurus in the 830s. After that, his only medieval successor was Nicholas of Lyra, who took up the challenge again when he produced a full set of commentaries for his "Postilla litteralis super Biblia" at the beginning of the fourteenth century. This meant that when in the twelfth century the "Glossa ordinaria" was formed, all interlinear glosses and marginal comments were taken from the commentary of Hrabanus. Its dedication to the Empress Judith explains the motivation for the exception to the rule of not writing single commentaries on borderline books like Judith. When he wrote *"Accipite ergo Judith homonymam vestram, castitatis exemplar, et triumphali laude perpetuis eam praeconiis declarate"* (Receive there-

12 This came to be fundamentally challenged in the sixteenth century by Lutheran polemics against "contaminated" biblical translations. For the Protestant Bible translators, the Humanist battle-cry "back to the sources" was even more pertinent for the word of God than for classical learning; only a purified text based on the best manuscripts and edited with scholarly precision in the original language could provide the proper basis for understanding Scripture, not a garbled post-classical Latin translation based on dubious sources, such as Jerome's.

fore Judith, your namesake, a paradigm of chastity, and with triumphant laud make her known in perpetual praises), Hrabanus declared not only the praise of Judith, the model, and Judith, the Empress (who surpasses her), but also of Jerome whose phrasing he borrowed. This cemented the adaptability of Judith as personification, and he then concentrated on an ecclesiological reading of Judith as prefiguration of the Church. Hrabanus was influential as well in what he did not comment upon. Missing are the status of Judith as a widow, for example, and the characterization of her actions as *viriliter* (manly; Jdt 15:11). The decision to appear seductive through self-adornment – precisely the fact that became so crucial in the Renaissance – was explained away by giving only ecclesiastical interpretations of the jewelry.

Via the "Glossa ordinaria," which remained the standard reference work into the (Catholic) seventeenth century, the allegorical explanations of the Book of Judith from the ninth century, marked as *mystice*, were transported right into modern times. They were combined with a wide range of explanatory remarks taken from patristic authors: Ambrose, Athanasius, Augustine, John Chrysostom, Clement of Rome, Eusebius of Caesarea, Junilius, and Origen appear in the compilations of the sixteenth century, together with the historical explanations from Nicholas of Lyra, from the "Antiquitates" of Josephus and, mainly, from Peter Comestor's "Historia Scholastica."

The huge compilation by Comestor is the most prominent instance of another form through which theological learning influenced vernacular retellings and pictorial representations: chronological accounts of world history.[13] The crucial difficulty is, of course, that the Book of Judith is unhistorical. If it is to be integrated in a continuous narrative, it has to be rewritten rather heavily. Peter Comestor located the story in the times of Cambyses by declaring that this Persian ruler (sixth century B.C.E.) was seen by the Israelites as a "new Nebuchadnezzar" since he was as great a threat to their

13 James H. Morey, "Peter Comestor, Biblical Paraphrase, and the Medieval Popular Bible," in *Speculum* 68 (1993), pp. 6–35. There is no critical edition of the Judith-part of the "Historia Scholastica," only the single *Patrologia Latina* edition. For the wide range of other versions of the popular book, one has to consult Maria Sherwood-Smith, "Studies in the Reception of the 'Historia scholastica' of Peter Comestor." The "Schwarzwälder Predigten," the "Weltchronik" of Rudolf von Ems, the "Scolastica" of Jacob van Maerlant, and the "Historiebijbel van 1360" (medium ævum monographs. new series XX) (Oxford: Blackwell for the Society for the Study of Mediaeval Languages and Literature, 2000).

freedom as the latter had been. What does not fit in with this time frame was cut out and replaced with details from secular antique historiography; the rearranged story runs to only a quarter of the length of the Vulgate version. Comestor's Judith is characterized in one sentence only: *"vidua tribus annis, mulier pulchra nimis, sed casta, de tribu Ruben"* (a widow of three years' standing, an exceedingly beautiful but chaste woman, of the tribe of Ruben). Only the adversative *sed* indicates that there might be dramatic potential behind this figure on the margins of history. Comestor's basic storyline was too short to form the only source for medieval literary versions but it provided the means of integrating the Book of Judith in other large compilations which followed, like sets of mystery plays on the Old Testament in France. It also provided the basis for most of the vernacular retellings of the Bible which proved much more influential than straight translations.

To take the example of Germany: the "Historienbibel," a translation of Peter Comestor's compilation, appeared in the fourteenth century, before the full Bible was translated into the vernacular. While other books of the Bible had been translated much earlier, the group undertaking a complete translation only got as far as Judith in the late fourteenth century, in part because of the difficulties posed by the Vulgate's awkward, Hebraizing prose.[14] The Book of Judith itself came fully into play only in the fifteenth century, when multivolume sets of biblical books were made affordable for private owners by the new form of manufactory-style book production, i.e., paper copies with pen-and-wash drawings. Most of the surviving sets of manuscripts of the full German Bible were for affluent owners with limited Latin; their illuminations furnish us with a contemporary understanding of the story (cf. the cover illustration). In the late medieval workshops, vernacular Bibles were produced alongside secular narratives and other stories of popular culture. This inclusion of the vernacular Book of Judith and shorter retellings of the Judith story among the mainstream narratives continued unchanged through early print runs. Meanwhile, all pre-Lutheran vernacular printed Bibles reproduced the same translation of the fourteenth century with a small stock of topical woodcuts that cemented the iconography and made it recognizable.[15] The story of Judith was thus clearly conceived

14 Cf. Fig. 4.1 which illustrates the mistranslation of *conopeum* as "cushion" (German: *küssy*) in one of the prevalent fourteenth-century translations: Henrike Lähnemann, "From Print to Manuscript. The Case of a Manuscript Workshop in Stuttgart around 1475," in *The Book in Germany*, eds. William A. Kelly et al. (Edinburgh: Merchiston Publishing, 2010), pp. 24–40.

15 There are four distinct translations of the Vulgate into German in the course of the fourteenth century; in these, and in these only, are full translations (as dis-

as part of the wider Bible narrative as it was presented in the vernacular, making the heroine a stock figure of popular storytelling.[16]

In German Bible epics, Hrabanus's commentary influenced the two Early Middle High German versions of Judith, the so-called "Older" and "Younger" Judith, both part of the Vorau manuscript of the twelfth century that combined vernacular retellings of Bible stories in a sweep through salvation history from Genesis to the Last Judgment. The Judith of 1254 took in explanations of names from the "Glossa ordinaria" to make the story understandable for a new audience, the Teutonic knights. At the same time, Judith as antetype of Mary increasingly appeared in shorter forms like Marian hymns or verse poetry, as it did in Dante's *Paradiso*. In France, a notable early literary appearance came in the beginning of the fifteenth century, in the brief narration of her story in the *Mystères de la procession de Lille* (cf. Nassichuk, Chap. 10). The vast reservoir of late medieval German verse writing, for example by the Meistersingers of the fourteenth and fifteenth centuries (cf. Lähnemann, Chap. 13), gave a wealth of different, even contradictory assessments of Judith, who started to emerge as a figure in her own right.

By biblical translations of the late fourteenth century, we find similar impulses beginning to stir on behalf of the story's subsidiary characters, chief of whom is Judith's maid. She is a pivotal figure in the plot: she accompanies Judith to Holofernes's camp, guards the entrance to his tent on the fateful night, and bears the provisions and the frightful trophy head. Previously anonymous, she came to acquire a name, Abra, from the Latin references to Judith "et abra sua" (and her maid; Jdt 8:32 etc.) in the Vulgate.[17] This then became her designation in translations up to and including that of the Luther Bible and in early modern drama and literature.

In a third major type of medieval source books, the allegorical collections of the "Biblia Pauperum" and the "Speculum Humanae Salvationis," only two scenes from the Book of Judith made a lasting impact: the bind-

tinct from rhyming paraphrases or retellings in the "Historienbibel") of the Book of Judith extant. They were all copied in the fifteenth century but only one translation made it into print and thus became dominant (Lähnemann, *Hystoria Judith*, p. 75).

16 For example, the *Vier Historien* (four stories), the second oldest vernacular book to be printed (Albrecht Pfister: Bamberg, 1462), is an illustrated compilation of the stories of Joseph, Daniel, Tobit, and Judith.

17 This came via the Hellenistic generic term in the Septuagint for the post of handmaiden, preserved as a loan word in the Vulgate. A name was derived as early as the early twelfth century when the German verse poem "Die Jüngere Judith" calls the servant girl *Ava* – incidentally also the name of the first-known female poet in Germany, Frau Ava, whose biblical poems are preserved in the same manuscript.

ing of Achior as a prefiguration of Christ's flagellation and the beheading of Holofernes as one of the antetypes of Mary's suppression of the devil. The captions of the Judith scenes in the *Hortus Deliciarum* (commissioned 1188–1191 by Herrad of Landsberg) interpret the decapitation as Christ's human nature conquering the devil (cf. Schmitz, Chap. 4).

To sum up: The medieval Judith was the holy woman and chaste widow of the Vulgate version, fashioned as personified virtue by Jerome and the theological authorities, and perceived as a (minor) part of world history as presented by Peter Comestor. While there were some theological qualms about the canonicity of the Book of Judith and therefore about the status of its heroine, the popular perception fed by vernacular retellings and visual representations took the book and the woman simply as part of the Bible. Beyond that, each country had some additional sources of influence and a local literary and iconographic tradition that fashioned different facets of the story and the woman. The contemporary environment was often a factor. A prime early example is that of Anglo-Saxon England, where literary treatments of Judith around the year 1000 derived new urgency from the Viking raids of the time. The conclusion that "Judith needs to be thought of within the context of both the patristic background and the contemporary calamity" (cf. Cooper, Chap. 9) holds true for many subsequent cases.[18]

Visual corollaries of this literary history can be located already in the patristic era, indeed in the shadow of Jerome. The first recorded example of Judith imagery is a (no longer extant) fresco of ca. 404, located in a most prestigious ecclesiastical setting: the new basilica complex erected by Paulinus at Nola, south of Naples.[19] The extensive fresco cycles there were an important contribution to the emerging exegetical praxis of demonstrating the unification of the Old and New Testaments. Their patron was the same Paulinus to whom Jerome wrote his famous letter summarizing the books of the Bible, in which he emphasized the linkages between the Jewish and Christian texts.[20] The former was represented, in the portico at Nola,

18 One important literary example extends beyond the geographical borders of this volume, namely *Judita* (1501) by Marko Marulić, the foundational work of Croatian literature. Its context is generally held to have been the invasions of his homeland by the Ottoman Turks. See the modern English translation: Judith / [*Marko Marulić*], edited and translated from the Croatian by Henry R. Cooper (Boulder, CO and New York: East European Monographs and Columbia University Press, 1991).

19 A recent general source is Jeffrey Spier et al., *Picturing the Bible: The Earliest Christian Art*, exhibition catalogue, Kimbell Art Museum (New Haven, CT, and London: Yale University Press, 2007), pp. 18–20.

20 Letter 53, ca. 394 c.e. Ciletti thanks Catherine Conybeare for her illuminating discussion on Paulinus, Nola, and Jerome (personal conversation). See her book,

by two virtuous pairs: Tobias and Job, Judith and Esther. The nature of
these depictions is not known, except that they had identifying inscriptions.
We are better informed about the didactic intent of Paulinus, whose own
description of his paintings at the site survives: to inspire pilgrims to prayer,
to the renunciation of carnal pleasures, and to the spiritual emulation of his
painted exemplars. It cannot be overstressed that his Judith is not a solo
character or an independent entity. Rather, her significance resides in her
selection for participation in a larger theological scheme, typological and
moral. The pattern thus established would hold in Roman Catholic church
decoration and discourse for well over a thousand years.

From Nola in the fifth century, the art historical record then skips three
hundred years, to the fresco in Santa Maria Antiqua in the Roman Forum of
ca. 705–07.[21] Although only fragments remain, its discernible components
seem to constitute a narrative episode: there is the Assyrian camp with sol-
diers and the tent of Holofernes, the richly dressed Judith, with his head,
and the walls of Bethulia crowded with spectators. As at Nola, she joins a
large assembly of other Old Testament figures; in this case the typological
allegorizing is clearly in the service of Mary/Ecclesia.[22] As seen in our first
two painting examples, the institutional Christian roots of the visual cults
of Judith are identical to those of the textual tradition.

The point is even clearer in the next chronological stage: beginning in at
least the ninth century, it is in Bibles that most Judith representations were
located.[23] A formal or narrative consideration emerged as well. The biblical
illuminations of the Book of Judith were dominated by a single vignette of
the beheading of Holofernes, which often opens the text, set within the con-
veniently tent-shaped *A* for Artaxerxes, the first word. Further scenes were

Paulinus Noster (Oxford: Oxford University Press, 2001). For an English translation
of Jerome's letter, see the Catholic Encyclopedia online (http://www.newadvent.org/
fathers/3001053.htm, accessed 26/12/09).

21 See, for example, Per Nordhagen, *The Frescoes of John VII (A.D. 705–707) in S.
Maria Antiqua in Rome* (Acta ad Archaeologiam et Artium Historiam Pertinentia),
Istitutem Romanum Norvegiae, vol. III (Rome: Bretschneider, 1968), pp. 3–4, 70–71,
88–91. They are located on the north transenna.

22 Eva Tea, *La Basilica di Santa Maria Antiqua* (Milan: Società Editrice "Vita e Pen-
siero," 1937), p. 161, links the frescoes to the allegorical reading of Judith and Esther
as antetypes of Ecclesia by St. Isidoro (560–636).

23 Frances Gray Godwin, "The Judith Illustration of the '*Hortus Deliciarum*'," in
Gazette des beaux-arts, 36 (1949), pp. 25–46. Illuminated Bibles (Septuagint) with
Judith imagery existed in Eastern traditions as well. For an Armenian example of
the fourteenth century, cf. Sirarpie Der Nersessian, *Miniature Painting in the Arme-
nian Kingdom of Cilicia from the Twelfth to the Fourteenth Century*, 2 vols. (Washington,
DC: Dumbarton Oaks, 1993).

rarely added until the fourteenth and fifteenth centuries when richly illu-
minated vernacular Bibles became more common (cf. our cover illustration),
an exception being the Winchester Bible from the twelfth century. A wider
range of episodes occurs in the context of cycles in illustrated treatises such
as the "Speculum Humanae Salvationis," the "Speculum Virginum," the
Hortus Deliciarum, discussed above (cf. Schmitz, Chap. 4, Fig. 4.2). The sub-
sequent emergence of Judith in Gothic sculpture and glass – with the dense
cluster of symbolic associations already noted – is therefore not surpris-
ing. Two prime examples from thirteenth-century France are to be found
at Chartres and in the Sainte-Chapelle in Paris. In the portal of the north
transept of Chartres Cathedral, Judith stands opposite the Queen of Sheba
in an arrangement of Old Testament figures supporting the church. In the
Sainte-Chapelle, the Judith cycle is part of an extensive program of Bible
windows. But a full cycle like this, with episodes from the military his-
tory of the first chapters, is rather the exception to the rule of her imagery
in the Middle Ages, which generally concentrated on the crucial moment of
beheading, variously interpreted and configured. It is clear that already in
this period, the shaping of Judith's story and its attendant moralizing were
determined not only by the context of bibles, Marian churches and other
works in question but also by the audience being addressed, ranging from
nuns to royal courts and other secular groups.

Early Modern Period

The best-known visual representations of Judith are those of the early mod-
ern period, dominated by now legendary conceptions of major figures.[24]
Among the Italians, the list would not fail to contain Donatello, Mantegna,
Giorgione, Michelangelo, Caravaggio, and both Gentileschis, while north
of the Alps, we would find Baldung, Cranach, and Rubens, among others.
Innovations abound, instigated by humanism and transformations in polit-
ical, social and cultural arenas. Even before the impact of the Reformation

24 These individual works of art and the iconographic history they constitute
have generated an immense body of scholarship. Among the more useful over-
views, beyond the lists in the standard iconography compilations, are the article
by Mira Friedman, "The Metamorphoses of Judith," *Jewish Art*, 12–13 (1986–87),
pp. 225–47, which includes Jewish material; chapter 5 of Mary Garrard, *Artemesia
Gentileschi* (Princeton, NJ: Princeton University Press, 1989); and the monograph
by Jaynie Anderson, *Judith* (Paris: Éditions du Regard, 1997). The interdisciplinary
study by Stocker, *Judith: Sexual Warrior* (1998), offers a wide-ranging but uneven
treatment of visual and other materials and themes addressed in this section.

brought new energy to the discourse, artists began the energetic investigations of Judith's inherently paradoxical qualities, which account for the sometimes bewildering range of interpretative positions on display. It is well known that by the late fifteenth century, two of the traits with which she defeated Holofernes, her beauty and her deceit, began to assume new carnality and sensuality.

Although the point is not often stressed, the adventurous new trends coexisted with the medieval associations with Mary. The most authoritative example of iconographic innovation in the service of Marian tradition is Michelangelo's pendentive in the Sistine Chapel ceiling (ca. 1509),[25] but it is not alone. Wherever typological programs continued to flourish, the holy widow of Bethulia could be found among the Old Testament company, both in major Marian shrines such as Siena Cathedral (mosaic pavement panel, 1470s) and more modest sites like Santa Maria della Pace in Rome (fresco by Peruzzi, 1516). The new points of view about depicting Judith were thus added to the already complex base of earlier Christian thinking.

The mix of continuity and change can also be seen in the treatment by early modern artists of the climactic decapitation of Holofernes and its aftermath. The medieval preference for the scene in the tent prevailed and was given even more prominence, among both Protestants and Catholics, while the potential for psychological resonance was expanded by an ever-enlarging repertory of narrative possibilities, from Donatello on. It was, of course, Caravaggio who famously jolted the convention into terrifying new life by portraying the beheading in progress, with Holofernes awakening from his inebriation into screaming consciousness.

Renaissance and Baroque art also took up a few other episodes, sometimes as a sequence of events encompassing the to-and-fro between Bethulia and Holofernes's camp, and even, occasionally, the banquet in his tent (as part of a multi-scene painting by Cranach, for example) or the final battle (sixteenth-century large-scale woodcuts from Germany).[26] The discursive approach lived on most notably in Netherlandish print and tapestry cycles, in the occasional painting series and in printed Bibles and biblical compi-

25 The general Marian cast of the typological scheme of the Sistine Ceiling, articulated by Esther Gordon Dotson in 1979 ("An Augustinian Interpretation of Michelangelo's Sistine Ceiling," *Art Bulletin*, 61, pp. 223–56, 405–29), has recently been updated, with the specific role of Judith clarified, by Kim Butler, "The Immaculate Body in the Sistine Ceiling," *Art History*, 32:2, April 2009, pp. 250–89.
26 For a full list cf. Adelheid Straten, *Das Judith-Thema in Deutschland im 16. Jahrhundert. Studien zur Ikonographie. Materialien und Beiträge* (Munich: Minerva-Fachserie Kunst, 1983).

lations, such as the illustrated "Bibles historiques," as well as in secular interior decorations. An interesting example of the latter, unaccountably ignored in the Judith literature, is the early seventeenth-century painting cycle at the chateau of Ancy-le-Franc in Burgundy, by Nicolas de Hoey.[27]

Most familiar are the iconic depictions, often devoid of narrative setting, of Judith with the sword and the head of Holofernes. They are found in virtually all media, products of every national tradition, not only in painting, sculpture, and prints, but also domestic artifacts, such as needlework, ceramics, and other tableware. There are many other manifestations. Their contexts and expressive contents range across categories: sacred and profane, private and public, erotic and patriotic. Judith with her sword naturally figured Justice, but her symbolic applications extended far beyond this one virtue.

One of the paramount contexts for Renaissance iconography, the revival of classical antiquity and the culture of humanism, yielded predictably rich results for Judith, among them the expansion of figural sources and their formal vocabulary. Much still remains to be probed in this domain (for example, how the costuming of Judith could imbue her with the spirit of antique*virtù*). Garbed in clothing and ornaments suffused with references to Athena and the Amazons rather than in the nondescript cloaks of medieval personifications, the Judiths of Italian artists from Donatello to Artemisia Gentileschi are literally enveloped in the authoritative mantle of classical female heroism (cf. Apostolos-Cappadona, Chap. 18). In this way, the taint of sinful seductive purpose in the sumptuous garments she dons for her expedition to Holofernes's camp, which Jerome characterized in the Vulgate as God's express wish and which was nervously glossed over by the theological authors, was vitiated. The medieval tradition of pairing Judith conceptually with powerful classical women, such as Queen Tomyris, was thus visually updated by early modern artists in both explicit and allusive ways.

Donatello's bronze group of the late 1450s occupies a precocious position in the development of related aspects of humanist influence on Judithic iconography. It established precedents for the encompassing of allegorical abstraction in psychologically nuanced characterization and with it the

27 Ciletti thanks Christine Rolland for informing her about this and other French Judithic sites and for taking her there. An accessible general introduction to the paintings at Ancy (1596–1611), with illustrations, is Magali Bélime-Droguet, "Nicolas de Hoey. De Fontainebleau à Ancy-le-Franc," *Revue de l'art*, 163:1 (2009), pp. 45–54. For the slightly earlier Judith window in the village of Belmesnil in Upper Normandy, see Laurence Riviale, *Le vitrail en Normandie entre Renaissance et Réforme (1517–1596)* (Corpus Vitrearum, France, Études, VII) (Rennes: Presses Universitaires de Rennes, 2007), pp. 365–69.

elaboration of the potential for political appropriation. His sculpture has been much studied in both categories, with the civic dimensions generally paramount, thanks to its original ownership by the Medici, upon whose exile it was co-opted by the Florentine Republic in 1495. The modalities of Judith's republican symbolism were modeled by classical and medieval authors who influenced the Tuscan discourse, as well as contemporary sermons by Savonarola (cf. Blake McHam, Chap. 17). Central to this topic is Judith's long history as a justification for tyrannicide, a topic which would soon explode into violent polemics in the wars of religion, especially after high-profile political assassinations in France, beginning in the 1560s and including the regicides of Henri III and IV (1589, 1610) (cf. Cummings, Chap. 12). In each case, the assassin, whether Protestant or Catholic, was hailed by his proponents as a new Judith.

Florentine civic interests can be seen to resonate not only with Judith's exploits in the Assyrian camp, so graphically explored by Donatello, but also with her redomestication after returning to Bethulia (cf. Crum, Chap. 16). While Judith, together with David, was a potent public figure, the majority of her imagery in Renaissance Florence consisted of sculptures, paintings, and furniture, such as *cassoni* (marriage chests) made for private settings (the interiors of patrician palaces). This is a salutary reminder that the mighty deed in the public realm of war which earned Judith the accolade "manly" was also understood as an emphatically temporary inversion of the "natural" social order. Again we meet the practice of (de)emphasizing segments of Judith's saga in order to create the desired message or meaning for the intended audience. This adaptability to circumstances and to even conflicting purposes is one ramification of the inherent moral ambivalence of the figure of Judith, who could be and was shaped into whatever persona was required.

The civic ramifications of the domestic exemplarity of the widow of Bethulia lead us to somewhat opposing categories of literary production of the early modern era, and they have ramifications in the visual realm: comportment literature, the "Querelle des Femmes" and popular entertainment. Judith was a "star" in all of them but for different reasons. The patristic tradition of celebrating Judith for her temperance, fasting, prudence, prayer, and, above all, chastity continued to be promoted in behavior manuals and sermons, especially in the sections addressed to widows. In this category it was her return to a reclusive life of ascetic piety and her spurning of suitors that were held up for approbation. Judith thus

reinforced gender-based conventions, rooted in the presumed moral defi-
ciencies of the female sex in general, to which she offered a corrective. But
from at least Christine de Pisan's "Le Livre de la Cité des Dames" (early
fifteenth century), her exemplarity was granted a more active role: she
was included among the other women whose heroism and virtue entitled
them to enlistment in the arguments against misogynist detractors in the
"Querelle." Thus from the literary and visual ranks of the "Nine Worthies,"
where she and her old companions Jael and Esther represented Old Testa-
ment heroines, she joined the cast of virile "femmes fortes," whose pop-
ularity rose with the ascension of queens to the thrones of England and
France in the late sixteenth century.[28]

At the same time, Judith's "sisterhood" with biblical figures could
be used to vilify her or at least to emphasize her equivocal morality, on
grounds that are fundamentally sexual. We see this when she was paired,
in literature and the visual arts, with Eve and Delilah. Holofernes thus
joined Adam and Samson, male victims of female cunning. He and Judith
joined the "couples" that proved how men are deceived and enslaved by
women. The development of this trope in German literature can be traced
in the ways that erotic metaphorical language was used already in the fif-
teenth and sixteenth centuries to include Judith among the cunning women
– one result being the emergence in Reformation drama of a new comic side
to the story with a lovesick Holofernes and a camp of boisterous merce-
naries (cf. Lähnemann, Chap. 13). Interest in Holofernes himself and the
vicissitudes of his situation, amorous and otherwise, sometimes gained
him the spotlight, as seen in such dramatic works as Giovanfrancesco Al-
berti's *Oloferne Tragedia* (1594).

It should be noted that neither this introduction nor the papers in this
volume engage directly with the application to literary or artistic produc-
tion of the Freudian correlation of decapitation to castration, which has
dominated much of modern thinking and writing about Judith. The psy-
chosexual issues have been thoroughly aired by cultural historians across
the humanities' disciplines, as well as by psychoanalysts themselves.[29]

28 Cf. Bettina Baumgärtel and Silvia Neysters, *Die Galerie der starken Frauen: Die
Heldin in der franzoschischen und italienischen Kunst des 17. Jahrhunderts* (Munich:
Keinkhardt and Biermann, 1995).

29 Among the signposts in this discourse are the articles in *American Imago* by
Graeme Taylor, "Judith and the Infant Hercules," 41:2 (1984), pp. 101–15, and Lau-
rie Schneider, "Donatello and Caravaggio: The Iconography of Decapitation," 33:1
(1976), pp. 76–91. Cf. also Mary Jacobus, *Reading Women* (New York: Columbia Uni-
versity Press, 1986) and Richard Spear, "Artemisia Gentileschi, Ten Years of Fact

Freud's assertion of the sexuality of Judith, apropos of Hebbel's play (cf. Mecky Zaragoza, Chap. 25) is well known, as is Sacher-Masoch's voluptuous fantasy of identification with Holofernes and its afterlife in the paintings of Klimt and his contemporaries. For the early modern period the kind of psychoanalytic approach that attends to artists' sexual biographies and their unconscious motivations has indelibly marked the recent literature, especially on Caravaggio and Artemisia Gentileschi.[30]

Rather than revisit this well-tended path, we wish instead to stress here the opportunity to enlarge the framing of Judith's cogency offered by less-familiar images, notably those commissioned for Roman Catholic sites (cf. Ciletti, Chap. 19). Such works testify to the enduring relevance of the patristic framework to ecclesiastical sponsors of the visual arts to a degree that had not been understood heretofore. Identical Catholic imperatives can be seen in Judith's treatment in the contemporary theater in Italy, where two of the most cited manifestations are the Jesuit school plays and the court drama of Federico della Valle (ca. 1590s; cf. Marsh, Chap. 21), which was dedicated to the Virgin Mary. One must also note the stained glass windows of Northern European churches, such as those of Upper Normandy and the Netherlands, where the polemical context of the wars of religion applied. The consideration of this material is not antithetical to a psychologically inflected approach, as it helps us situate the varied concerns of both artists and patrons, offering in the process insights into the fertility of the persistent intersection of textual and visual interpretation.

Of course there is no shortage of eroticism in the Book of Judith. It clearly troubled her patristic fashioners and their successors, for whom her Ecclesia/Mary analogies were vital. From Jerome on, the latent sexuality of the chaste widow who calculatedly enticed and exploited the lust of her adversary was suppressed by the Church and recast into its submerged opposite. But the enduring Christian belief in essential female wantonness, the inheritance of Eve, meant that suspicions about Judith's sexual morality

and Fiction," *The Art Bulletin*, 82 (September 2000), pp. 568–79.

30 For both painters, the twin poles of the psychoanalytic axis are the brutality of their treatments of the beheading of Holofernes and the documented episodes of violence in their lives – Caravaggio's criminal record of assaults and even a killing (1606); Gentileschi's sexual violation as detailed in trial proceedings (against Agostino Tassi, 1612). Accessible sources include the documentary appendices in Catherine Puglisi, *Caravaggio* (London and New York: Phaidon, 2000), Mary Garrard, *Artemisia Gentileschi* (1989) and *Orazio and Artemisia Gentileschi*, ed. Keith Christiansen and Judith Mann (New York and New Haven, CT: Metropolitan Museum of Art and Yale University Press, 2001).

could not be obliterated.[31] New opportunities for exploring this issue were offered in the visual arts by the humanist-influenced validation of nude representations, which could signal both "manly" heroism and "womanly" seductiveness, and every intermediate stage in between. Nudity, either partial or total, enhanced Judith's transition from "femme forte" to "femme fatale." It is in the latter guise that she is best known now, with key testimonials provided by sixteenth- and seventeenth-century prints and paintings by an international cast of artists, among them Beham, Cranach, Rubens, and Saraceni.

On the opposite side of this coin is one of the more interesting facets of Judith's reception history, namely that in response to sermons and comportment treatises fostering her exemplarity, some early modern women actively identified with her. There is a wide range of such indications, especially in Italy and France. One is the rise of historiated portraits and even self-portraits, i.e., likenesses of actual women/artists in the guise of Judith, holding the head of Holofernes;[32] literary parallels may be found in such cases as the poetry of Gabrielle de Coignard (cf. Llewellyn, Chap. 11). Another is the commissioning of literary, musical, and visual representations of Judith by women patrons, particularly widows, who aspired to association with her (cf. Harness, Chap. 20). It should be obvious that it is not in her beheading action *per se* that Judith offered a behavioral example for women, but in the strength of character which that action symbolized. A fascinating case of her deployment to support and challenge conventional female social roles simultaneously is that of Angela Merici, who founded the Ursuline nuns as a self-governing and independent community, living together on their own, not enclosed in convents. In the "Regola" which constituted the order in 1535, Merisi charged her followers to guard their virtue and behave bravely, as Judith did when she beheaded Holofernes, and to anticipate a triumphant reception in heaven.[33] A further development can be noted in seventeenth-century England, where the example of

31 These extend back at least as far as the sixth-century Greek chronicle by John Malalas. See Elena Ciletti, "Patriarchal Ideology in the Renaissance Iconography of Judith," in Marilyn Migiel and Juliana Schiesari (eds.), *Refiguring Woman: Perspectives on Gender and the Italian Renassiance* (Ithaca, NY, and London: Cornell University Press, 1991), pp. 35–70, especially pp. 45–46.

32 See, e.g., Caroline Murphy, *Lavinia Fontana: A Painter and Her Patrons in Sixteenth-Century Bologna* (New Haven, CT, and London: Yale University Press, 2003); Flavio Caroli, *Fede Galizia* (Turin: Allemandi, 1989).

33 Querciolo Mazzonis, *Spirituality, Gender and the Self in Renaissance Italy: Angela Merici and the Company of St. Ursula (1474–1540)* (Washington, D.C.: Catholic University Press, 2007), pp. 63–4. The Ursulines were soon forced to accept enclosure.

Judith provided Quaker women with validation for their desire to preach (cf. Bartholomew, Chap. 14). It would seem that the very malleability of Judith was available for women to appropriate, perhaps aided by the dictum of Lodovico Dolce in 1545 that Judith, the model widow, was a personification of the *vita attiva* and the *vita contemplativa* both.[34]

The cultural history of Judith in this period reveals an intersection of diverse voices across many media. The "Querelle des Femmes" was a popular genre that flourished in complex relationship to contemporary comportment literature, which was itself a subset of theological discourse. We have here the convergence and the opposition of differing and hotly contested conceptions of women and their duties. The prominence of ruling queens, female princes, overturned conventional definitions of the female sphere and ideals of feminine agency. Judith provided ammunition for both sides of this debate, on whatever terrain it played out. The Quaker women who used her to defend their right to preach, for instance, battled those who took exactly the opposite position. Factional warfare complicated the matter for queens and their apologists, as indeed for everyone. As William St. Clair observed, it would seem that "the political and ecclesiastical commissioners of Judith presentations were themselves trying to navigate between competing discursive frameworks that they themselves sometimes wanted to preserve and sometimes to jettison."[35] Not surprisingly, the figurative results are marked by dissonance. The corpus of Judith's representations, visual and literary, reveals tensions between irresolvable extremes.

If the interpretive amplification of the Judith and Holofernes story is a feature of early modern culture, its protagonists were not alone among the characters in the saga to undergo this treatment. Judith's maidservant too was affected. One of the most often noted aspects of the iconography is the new range of this figure's characterizations. It has been seen above that by the late Middle Ages she had been granted the name "Abra." From the fifteenth century, her individuality began to be delineated visually, as artists portrayed her in a plethora of forms: young and old, vigorous and decrepit, black and white, fierce and mild, etc. The maidservant consequently garners an increasing share of the beholder's attention. In Artemisia Gentileschi's Judith paintings, for instance, much has been made of the solidarity between the two women, which is formal and psychological, especially when they physically collaborate in the beheading. It is interesting

34 *Dialogo della institution delle donne* (Venice: Ferrari, 1545, and many times thereafter, in Italian and Latin).
35 Communication to the authors, August 31, 2009.

to note that this unbiblical touch was not entirely new but rather an echo of the medieval tradition as seen in, for instance, the *Hortus Deliciarum* (see Fig. 4.2), where Judith bends to the task of beheading Holofernes with the maid's arms around her shoulders. In any case, one finds a similar expansion of the maid's role in literary and dramatic treatments of the late Renaissance and Baroque periods across Europe. She thus seems to share in a contemporary phenomenon affecting Judith as well. In French literature, it was in the sixteenth century that Judith's own voice was heard for the first time (cf. Nassichuk, Chap. 10).

Our volume brings particular attention to the rich Judithic literary tradition in early modern France, both Catholic and Protestant (Llewellyn, Nassichuk, Cummings). We have already noted the importance of the Old Testament Mystère tradition, which provided the roots for the flourishing of Judith dramas in the sixteenth and seventeenth centuries. As our authors show, there was significant intensification of the internal psychology of the heroine, within and beyond the terms set by the Vulgate text; the differing results, along the continuum from conventional piety to transgressive sensuality, bespeak yet again her intrinsic ambiguity (cf. Llewellyn, Chap. 11). The political implications were mined to explosive and shifting effect. The major biblical epic of the period, *La Judit*, begun by Du Bartas ca. 1564 for Queen Jeanne of Navarre, had a long and equivocal afterlife as Huguenot propaganda on both sides of the English Channel (cf. Cummings, Chap. 12). Such developments were not limited to France or to literature.

The ever more exigent voice of Judith was increasingly heard not only speaking but singing. The musical renderings, starting from early Baroque times (cf. Harness, Marsh, Chaps. 20 and 21), operated within the framework sketched above for literary and visual versions of the topic.[36] Patrons of Judith oratorios, operas and intermedi included convents and other religious institutions, as well as secular rulers and civic entities whose interests intersected with those of the Church. The libretti they sponsored were shaped by the religious and political demands of the day, most notably the perceived threat to Christian Europe by the advances of the Ottoman Turks, of whom Holofernes was a symbol by virtue of being Assyrian. As in the other arts, the poets/librettists and composers who wrote Judith musical compositions included figures of the highest significance: Salvadori, Metastasio, Marco da Gagliano, Alessandro Scarlatti, Vivaldi, Mozart.

36 The second-oldest German libretto, for example, is a translation of an Italian Judith libretto by the foremost German poet of his time, Martin Opitz (1635); it presents a direct continuation of the sixteenth-century drama tradition.

The expansion of Judith's visibility onto an ever-wider cultural stage, already begun in the early modern period, intensified in the nineteenth century. By virtue of her inherent applicability to shifting contexts and ideologies, Judith was deployed in the service of such emergent discourses as nationalism, orientalism, and anti-Semitism. These themes, by which her political and cultural relevance was assured, were brought to prominence via opera and drama (cf. Lhâa, Pasler, Bernardini, Mecky Zaragoza, Chaps. 22–25). For the purposes of this essay, it is important to recognize that Judith did not step into the modern era entirely untethered from her traditional Christian (and Jewish) meanings. Indeed, her core identity as a divinely sanctioned savior of her people was essential to her deployment in political causes ranging from the Italian Risorgimento to the resistance of France to Prussia. Moreover, nineteenth-century social and political movements were played out against a backdrop of innovative biblical scholarship and translation that enriched contemporary understanding of the multiplicity of her roots and the ever-shifting history of her status.

The wildly varied reception of the Book of Judith is a reminder that there is no Judith but the writing and staging of Judith. The truism that there are no facts in history or fiction independent of the culturally specific medium in which they are transmitted is vividly illuminated by the Book of Judith and its winding route across the millennia. From the start, her story was both sacred and fictional, a narrative informed by diverse and recurring patterns of salvation history (cf. Gera, Chap. 5, on the parallels to other stories of the Hebrew Bible). These essential factors colored its susceptibility to the addition of new symbolic strata. What is fascinating to see is that the early Christian transformations of the fictitious book shaped its later interpretive resilience long after Christianity had ceased to be the primary framework. It was Judith's contradictory validation by the early Church – as both an historical figure and an abstract "exemplum" – that guaranteed her enduring salience.

On the cusp of the modern era, Judith became a source of contestation by those who regarded her as a holy woman and those who did not, but she was never a figure of indifference. Freud could make the decapitation of Holofernes a symbol of castration because Judith was already the product of many centuries of animated cultural appropriation in which her "coup de grace" had acquired emblematic diversity – as divine act, as triumph of virtue over vice, as fatal blow to carnal lust, as severing of the chains of tyranny, as female act of liberation. In our own time, this variety makes

Judith a natural protagonist for postmodern discourse, including that of contemporary popular culture, as she oscillates between apparently contradictory possibilities. The humble widow enshrined in medieval/Renaissance churches and the lead singer of the current band "Wir sind Helden," who adopted the name of "Judith Holofernes," are worlds apart. But they are linked by the complex strata of meaning accumulated since Jerome shaped the fictitious woman of the Book of Judith into a heroine. It is an astonishing career through Western cultural history.

Writing Judith

Jewish Textual Traditions

I → maybe WIDER GAP HERE?

CAN IMAGE BE IMPROVED?

יוסיפון פרק ה׳ לג

אוב ביט אלין דער קֶוינֶן כורש בוֹיארט אויך דער קֶוינֶן שאון
דער דא ווֹר אין עֶרְוֹאלבטר מֶטש · אוב אויך דער רחם
קֶוינֶן ישטיהו דיא האבן ביידי נֶיבונדן דש עֶינֶר אירֶם לֶעבֶנש
אין דֶן שֶרייבונֶן דיא זיא נֶישטריטֶן האבֶן

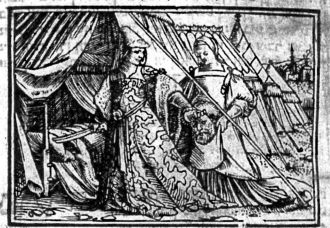

אוב אלֶו ווֹרד דער קֶוינֶן כורש אֵין עֶוטֶן בוֹ זֵינֶם בֿולק אוב
זֵין זֻן לַאבישה דֶער קֶוינֶט אָן זֵיבֶר שטאט · ווֹילך
אוב עֶר נֶינֶן כַמֿבֿישה · אוב עֶר בֶיבֿוֹאבֶן דש נָאבֶן קֶוינֶן רֵיך
שיטֶים אוב דיא קֶוינֶן תֿלֵוֹרה · דיא דֶר שלֹונֶ עֶר מיט דֶעם
שוורט · אוב עֶר בֿרֵאכֿט אוֹם דֶן נָאבֶן נֵאון אירֶש קֶו
קֶוינֶ רֵילֶש · אוב עֶר נֶינֶן כַמֿבֿישה · אוב עֶר בֿיבֿוֹאבֶן
אלֶנֶש לַאנֶד סֶרֶם אוב מֵדֵי · אוֹיך בֿיבֿוֹאבֶן עֶר דיא שטאט
דַמֶשֶׁק · אוב אירֵי הֶרֶן דיא לֶש עֶר דֶר שלֹונֶ מיט דֶעם ש
שוורֶט דַארוֹם דֶש זֵיא הֶן ווֹדֶר שמֶעבֶֿט אָן אים
דַארנַאך נֶֿבֶן עֶר אֵין דֶש לַאנֶד אֶרֵאיבֿיא אוב עֶר שטֵירֶיט מיט
אירֶן אין וֹואוֹבֶֿרֶן אוב מיט אירֶם קֶוינֶן אוב עֶר מַאכֿט אוֹבֿטֶר
טֶעֵנֶן זֵיא אֻונֶדֶר זֵין קֶוינֶ רֵיך אוב עֶר נַאם אירֵי קֶינֶדֶר בֿו
בֿו וֹר פֶֿעבֶֿעֶבֿוֹם · דַארנַאך בֻֿון עֶר נֶעֶן אֶבֿרֵיתֿ אוב

i

Hans Holbein, *Judith*, 1546. Woodcut from *Sefer Yossipon*, Zürich,
Christophe Froschauer. Photo credit: Wiesemann, 2002, Abb. 5 (K 11).

4. Holofernes's Canopy in the Septuagint

Barbara Schmitz

Judith beheads Holofernes – the provocative nature of the story related in the Book of Judith is immediately clear from this somewhat oversimplified summary of the biblical tale. The fact that a man is killed by a woman means that the story was, and sometimes still is, perceived as scandalous. A wide variety of models have been constructed to interpret Judith's shocking deed, including most notably in modern times the influential interpretations by Friedrich Hebbel and Sigmund Freud.[1] Interestingly, however, the question of how we should understand Judith's deed is not only one for the later reception of the story, but in fact forms a theme of the biblical story itself. This paper will analyze the construction of the figure and role[2] of Holofernes, with a special emphasis on the meaning and function of an apparently small detail of the story, the κωνώπιον.

Holofernes appears in the story for the first time in the second chapter (Jdt 2:4) as commander-in-chief of the Assyrian troops. He is instructed by the Assyrian king, Nebuchadnezzar, to conquer the people in the West (Jdt 2:5–13). Judith, who appears later, is introduced and described in detail (Jdt 8:1–8), but Holofernes receives no such treatment and is instead simply characterized through his actions.

1 Friedrich Hebbel, *Judith. Eine Tragödie in fünf Akten* (Stuttgart: 1980 [1839/40]); Sigmund Freud, "Das Tabu der Virginität," in *Ders. Studienausgabe V. Sexualleben* (Frankfurt a.M.: Fischer, 1972), pp. 211–28; see also Sigmund Freud, "Über die weibliche Sexualität," in *Ders. Studienausgabe V. Sexualleben* (Frankfurt a.M.: Fischer, 1972), pp. 273–92.

2 Cf. Barbara Schmitz, "Casting Judith: The Construction of Role Patterns in the Book of Judith," in Hermann Lichtenberger and Ulrike Mittmann-Richert (eds.), *Biblical Figures in Deuterocanonical and Cognate Literature. International Conference of the ISDCL at Tübingen. Yearbook of the International Society for the Study of Deuterocanonical and Cognate Literature 2008* (Berlin: Walter de Gruyter, 2009), pp. 77–94.

Workshop of Ludwig Henfflin, *German Bible*, ca. 1479. Heidelberg
University Library, Cpg 17, fol. 255v. Photo credit: Heidelberger
historische Bestände – digital (http://diglit.ub.uni-heidelberg.de/)

Holofernes is loyal to his king; he follows Nebuchadnezzar's instruc-
tions for conscription and equipping the troops to the letter and simulta-
neously proves his own military expertise (Jdt 2:14–20). The description
of the military preparations focuses solely on Holofernes: he personally
levies the various troops, provides them with a leadership structure, and
ensures the provision of food and equipment. Holofernes the general is
thus characterized as a highly effective man. Even in the depiction of the

military campaign by the Assyrian troops, the action is focused entirely on Holofernes (Jdt 2:22–27; cf. Jdt 7:6–7): He conquers territories, crosses rivers, plunders, steals, and destroys. This description draws in many respects on apocalyptic texts that address the themes of the Day of Judgment and the Day of JHWH (cf. Jer 25:32; Am 1–2; Jl). The horror brought by the Assyrian army is thus personified by the violent, brutal, and ruthless Holofernes, who further demonstrates his power by his destruction of temples and his call for the veneration of Nebuchadnezzar as the only God (Jdt 3:8).

In the first part of the story, Holofernes is therefore portrayed as a successful commander and quintessentially male hero. Yet the later portrayal of Holofernes is quite different and stands in sharp contrast to the characterization at the beginning.[3] The second part of the story (Jdt 8–16) begins with the newly introduced figure of Judith, who remains the focus for the rest of the action (Jdt 8–9). This beautiful, rich widow has heard that the residents of Bethulia, who are on the verge of starvation after being besieged by the Assyrian troops for weeks on end, now want to open the city gates and surrender to Holofernes. This would not only mean the military capitulation of a small city, but would also clear the way for the Assyrians to advance on and conquer Jerusalem, resulting in the submission of Israel to King Nebuchadnezzar, whom the Jews would have to worship as a god (cf. Jdt 3:8; 6:2). Because of the disastrous consequences of a surrender on the part of Bethulia, Judith rebukes the elders of the city who have negotiated a five-day ultimatum with the people. She reflects on the theological implications and consequences of the surrender of the city (Jdt 8) and then announces her intention of carrying out an unspecified act (Jdt 8:32–34). After praying (Jdt 9), Judith prepares for her task, leaves the city, and goes into the Assyrian camp (Jdt 10).

Holofernes does not appear again as an active protagonist until Jdt 10:20. In fact, in the second part of the book (Jdt 8–16), he is only present in Jdt 10:20–12:20; after his assassination (Jdt 13:8) his head and decapitated body are merely used as props.

A key difference between the first and second parts of the story is the construction of space in the latter part: Judith, the woman who leaves the protected space of her house and moves to a place where she is in mortal danger in the camp of the Assyrians, stands in contrast to Holofernes, the man who has now withdrawn into the private, intimate sphere of his

3 The Book of Judith is divided into two parts in the Septuagint (Jdt 1–7; 8–16); this division is crucial for the contrasting portrayal of Holofernes in each part.

interior rooms at the camp. The general, who in the first part stands as the representative of the entire army and is portrayed as a highly successful military operator, is now described in isolation as a private man, whose life and living environment is fundamentally different from that of his soldiers.

The reader only becomes acquainted with Holofernes's living conditions in the camp in the course of the description of the first meeting between Judith and Holofernes, in which Judith succeeds in winning the general's confidence (Jdt 11) and so is able to put her plan into action. Because Judith meets Holofernes this first time not in his tent but in the awning (Jdt 10:22), the first meeting between the two takes the form of each approaching the other: Judith is led into the awning by Holofernes's servants (Jdt 10:20), while Holofernes enters in an almost liturgical procession (Jdt 10:22). Between these two movements is a short, but crucial description of the décor and furnishings of the main tent (Jdt 10:21), which Judith will enter for the first and only time later on for the meal (Jdt 12:16; 13:2) in his tent, the commander, who until now has been portrayed as quintessentially masculine and heroic, is lying on his bed[4] under a purple and gold κωνώπιον. We learn that the κωνώπιον is mounted on four pillars and spans the entire bed, and that it is adorned with emeralds and other precious stones (cf. Jdt 13:9).

The κωνώπιον is a highly interesting detail of the narrative and is mentioned four times in total: once in chapter 10, twice in chapter 13, and once again in chapter 16 (Jdt 10:21; 13:9, 15; 16:19). As already mentioned, when Judith first encounters Holofernes in chapter 10, he is lying on his bed. This bed is draped with a κωνώπιον woven of purple and gold, adorned with emeralds and precious stones (Jdt 10:21). After the murder in chapter 13, Judith pulls the net off of the bed, wraps the severed head in it, and takes it with her to show as a trophy in Bethulia (Jdt 13:15). At the end of the story Judith hands over Holofernes's belongings to the temple in Jerusalem (Jdt 16:19), and the κωνώπιον is explicitly mentioned in this context in chapter 16.[5]

It has often been claimed that the four-fold repetition of the word κωνώπιον is "highly symbolic,"[6] but what exactly is the significance of the

4 Holofernes's bed is an important motif in the story (κλίνη in Jdt 10:21; 13:2, 4, 6, 7; 15:11 and στρωμνή in Jdt 13:9): with the change of the κλίνη to the word στρωμνή in the murder scene in the story when Dina is remanded (Jdt 9:3), but also in the Book of Amos (Am 6:4).

5 Thereby Judith fulfills her promise to Holofernes in Jdt 11:19: by carrying his head in his mosquito net she has indeed led him to Jerusalem and set up a throne for him in the middle of the city.

6 Erich Zenger, "Das Buch Judit," *Jüdische Schriften aus hellenistisch-römischer Zeit* 1

motif and what does it represent? No satisfactory answer has yet been found and the search for the meaning of the κωνώπιον is indeed a difficult task.[7]

The quest begins with the term itself: the Greek word κωνώπιον is derived from the Greek word κώνωψ, meaning "mosquito," so κωνώπιον means "mosquito net."[8] Despite its costly adornments, the κωνώπιον must be a light net since Judith's companion can carry it and its contents unnoticed out of the Assyrian camp. The word κωνώπιον has been translated to Latin as *conopeum*, again meaning "mosquito net." The word *canapeum* has made its way into the European languages via medieval Latin. In French and German, it no longer means a mosquito net, but instead a sofa.[9]

Other written sources shed no new light on the term κωνώπιον. The word κωνώπιον cannot be found anywhere in the Bible, in ancient Middle Eastern texts, or in Greek literature. Likewise, the word κωνώπιον does not occur in archaeological sources. The only mention is found in Herodotus, who reports on stinking fishing nets used to deter mosquitoes in Egypt (Hdt II 95). Clearly, however, there are worlds between stinking fishing nets and Holofernes's costly κωνώπιον, and so this brief note is of no help.

The canopy is first mentioned in Roman times, more specifically during the rule of Augustus. An investigation into Latin literature dating from the first century B.C.E.[10] has produced three pieces of evidence about the *conopeum*.

(JSHRZ I/6), (Gütersloh: G. Mohn, 1981), p. 498.

7 Cf. Art. "Konopeion," in August Pauly, Georg Wissowa, Wilhelm Kroll et al. (eds.), *Paulys Realencyclopädie der classischen Altertumswissenschaft*, vol. 22 (Stuttgart: J.B. Metzler, 1894–1980 [1922]), pp. 1341–42; Rolf Hurschmann, "Konopion," in Hubert Cancik and Helmuth Schneider (eds.), *Der neue Pauly. Enzyklopädie der Antike. Das klassische Altertum und seine Rezeptionsgeschichte*, vol. 6 (Stuttgart: J.B. Metzler, 1996–[1999]), p. 709; Wolfgang Helck, "Moskitonetze," in *Lexikon der Ägyptologie*, vol. 4 (1982), pp. 211–12.

8 Henry George Liddell and Robert Scott, *A Greek-English Lexicon* (Oxford, 1889; reprint: New York and Oxford: Oxford University Press, 2000), p. 460.

9 Cf. Art. "Mücke," in *Paulys Realencyclopädie der klassischen Altertumswissenschaft*, vol. 31 (1933), pp. 450–54; Karl Ernst Georges, *Lateinisch-Deutsches Handwörterbuch* (Darmstadt: Nachdruck, 1918), pp. 1494–787; Christian Hünemörder, "Mücke," in *Der neue Pauly*, vol. 8 (2000), pp. 429–30. The Greek word was taken into Aramaic as *qinuf* and means "net," but also "frame" in the Talmudic sources, cf. Mishnah Sukkah i, 3; Babylonian Talmud Sukkah 10a–b; Babylonian Talmud Sanhedrin 68a; Tosefta Kelim Babva Metzia ii,8. The most interesting variant is *qinufi*, meaning "a curtained couch," which appears in the Aramaic Targum to 2 Sm 16:22 as a translation of the Hebrew *ohel*, a tent; cf. Marcus Jastrow, *Dictionary of Targumim, the Talmud Babli and Yerushalmi, and the Midrashic Literature* ([Repr. der Ausg.] New York: Title Publ., 1943, repr. Peabody, MA: Hendrickson, 2005), p. 1363. For this information, thanks are due to Dr. Susan Weingarten.

10 Cf. also the motif of the Canopy in Juvenal's Satires (Sat. 6, 78–81) originating after 100 C.E.; cf. Ludwig Friedländer, *D. Junii Juvenalis. Saturae XIV* (Leipzig: S.

Horace and Propertius both use the motif in the context of the description of Octavian's victory in 31 B.C.E. against Antony and Cleopatra. In both cases the canopy functions as a symbol of Cleopatra, who is depicted as a *femme fatale.*

1. Horace (epodes 9, 16; 65–8 B.C.E.)[11] describes Cleopatra as an "emancipated woman,"[12] who is counseled by eunuchs. A eunuch connotes a strong contrast to a free Roman citizen, whose ideal is virility and virtue. Cleopatra's reign is understood as a "perversion" of the order of society and is presented as symptomatic of the sharp contrast between the western and the eastern world. The symbol of her reign is a "disgraceful mosquito net" that Horace presents as a "disgusting" symptom of oriental effeminacy.[13]

2. Propertius (50/45–15 B.C.E.) also uses the motif of the canopy in his elegies (elegies 3, 11, 45; 29–15 B.C.E.).[14] He describes a series of powerful women, culminating with Cleopatra. In a horror scenario, he describes how Cleopatra imposes her rule on the Capitol in Rome and spans out her "disgraceful mosquito net" (9, 45). The canopy is presented as the strongest possible contrast to Roman culture and as a luxurious item, which stands for an unthinkable disaster: Cleopatra under her canopy as ruler on the Roman Capitol, the very center of Roman identity.

Hirzel, 1895), pp. 294–95; Edward Courtney, *A Commentary on the Satires of Juvenal* (London: The Athlone Press, 1980), pp. 272–73; Joachim Adamietz, *Juvenal, Satiren (Sammlung Tusculum)* (Munich: Artemis & Winkler, 1993), pp. 358–59.

11 For the following interpretation of the ninth epode of Horace cf. Egil Kraggerud, *Horaz und Actium. Studien zu den politischen Epoden* (Oslo: Universitetsforlaget; Irvington-on-Hudson, NY: Distribution, Columbia University Press, 1984), pp. 66–128; Georg Maurach, *Horaz. Werk und Leben* (Wissenschaftliche Kommentare zu griechischen und lateinischen Schriftstellern) (Heidelberg: Universitätsverlag C. Winter, 2001), pp. 40–43.

12 *emancipatus feminae: Emancipare* is a rare and technical word and is only used here by Horace; cf. David Mankin (ed.), *Horace. Epodes* (Cambridge Greek and Latin Classics) (Cambridge: Cambridge University Press, 1995), p. 166; cf. Robert H. Brophy, "Emancipatus Feminae: A Legal Metaphor in Horace and Plautus," *Transactions and Proceedings of the American Philological Association (TPAPA)*, vol. 105 (1975), pp. 1–11.

13 Daniel H. Garrison, *Horace. Epodes and Odes. A New Annotated Latin Edition*, Oklahoma Series in Classical Culture, vol. 10 (1991), p. 184.

14 Cf. Max Rothstein, *Die Elegien des Sextus Propertius*, vol. 2 (Berlin: Weidmann, 1924), pp. 94–96; Harold E. Butler and Eric A. Barber, *The Elegies of Propertius* (Oxford: Clarendon Press, 1933), pp. 290–91; W. A. Camps (ed.), *Propertius Elegies*, vol. 3 (Cambridge: Cambridge University Press, 1966), p. 108; Burkhard Mojsisch, Hans-Horst Schwarz, and Isabel J. Tautz, *Sextus Propertius. Sämtliche Gedichte* (Stuttgart: Reclam, 1993), pp. 208–09.

Herrad of Hohenbourg, *Hortus Deliciarum*, fol. 60r, 1167–85.
Photo credit: Green II, p. 99.

3. Varro (116–27 B.C.E.), a contemporary of Horace and Propertius, mentions the use of a canopy by a Roman upper class woman who is giving birth; it is therefore presented as despicable, feminine item (Varro, r.r. 2, 10, 8).[15]

Even though these texts from Latin literature are quite different, there is a remarkable similarity in the way they present the canopy: in each case, it is an attribute of women and represents a devotion to luxury and the life style of high society. At the same time it symbolizes women having power over men. In the narrative of Judith, however, the κωνώπιον is an attribute of the man Holofernes, the despotic Lord of the East, who threatens the freedom and religious identity of Western nations and Israel. In the second part of the story, the κωνώπιον serves to make Holofernes appear as a far more effeminate, weakened figure than at the beginning, and opens up an interesting gender perspective in the portrayal of Holofernes in two respects. Firstly, he is a man who surrenders himself to the beautiful Judith; although she says that she is his slave (Jdt 11:5, 16, 17), she in fact makes him her victim. Secondly, as he lies under the κωνώπιον, he is characterized, in very strong terms that are suggestive of cross-gendering, as feminine. Holofernes is portrayed as womanlike and as having deficient masculinity. This is evident even in his reply to Judith's speech: Holofernes replies by quoting a woman when he uses the words of Ruth (Jdt 11:23, cf. Ru 1:6).

Despite these suggestions of femininity in the portrayal of Holofernes, he does continue to figure as a male hero in other respects. He instructs Bagoas to arrange "contact" with Judith without specifying his exact

15 Dieter Flach (ed. and trans.), *Marcus Terentius Varro, Gespräche über die Landwirtschaft*, vol. 2 (Texte zur Forschung 66) (Darmstadt: Wissenschaftliche Buchgesellschaft, 1997).

wishes (ὁμιλέω[16]; Jdt 12:12). His intentions are in fact perfectly clear, since he is worried that he will be a laughingstock if he fails to have "contact" with this beautiful woman. It seems that the ambiguity of his formulation καταγελάσεται (third-person singular) is intentional: this word can be either the feminine form of the verb "she would laugh" or the impersonal form "one would laugh." In accordance with Holofernes's wishes, Bagoas organizes a meal to which Judith is invited. When Judith appears for the meal she has adorned herself, and Holofernes is captivated by her beauty and filled with desire. In order to achieve his goal, he invites Judith to drink, yet ironically this is what brings about his own downfall (Jdt 12:17). While he hopes the alcohol will make Judith obtainable, his own indulgence in alcohol in fact makes him vulnerable to her (Jdt 12:20). In his intoxication, the aggressive conqueror drops completely defenseless onto his bed, which is draped with the κωνώπιον (Jdt 13:2). Judith is now able to kill Holofernes with his own sword (ἀκινάκης[17]; Jdt 13:8).

In the meeting with Judith, Holofernes is in a weak position and loses control of his actions, whereas Judith maintains complete sovereignty of her actions throughout. The fact that the positions of power are exchanged in this way means that the story of Judith, on one level, is a strategic play on established gender roles and the showcasing of an intelligent woman. That Judith's deed is possible at all, however, is due neither to the cunning of Judith nor to the carelessness of Holofernes, but rather finds its explanation on a theological level.[18] Behind the exciting story line, the speeches and prayers in the Judith story contain a deeper level of theological reflection, and the events being recounted receive a theological basis and interpretation. It is clear, for example, that Judith's actions are not guided by emotion, but rather that she interprets her deed as God's action through her hands. By murdering this one person, she aims to save Israel and the whole of the Western world from the threat of the Assyrians (Jdt 13:14, 15; 16:5). After Judith's deed, the decapitated corpse of Holofernes lies in the tent, while

16 The verb ὁμιλέω means "to have dealings with somebody" or "to entertain oneself" (Dn 1:19), but can also be used to mean "sexual contact"; the last meaning occurs in the context of power and rape (cf. Sus. 1:37, 57, 58). Cf. the intertextual network involving ἐπισπάομαι in the context of the sexual activities of Potiphar's wife (Gn 39:12).

17 The word ἀκινάκης describes a small, sharp Persian sword; cf. Herodotus 7,54: Περσικὸν ξίφος τὸν ἀκινάκην καλέουσι; also in Herodotus 3,118.128; 7,67; 8,120; Horace Odes 1,27,5. Cf. the story of David and Goliath, in which Goliath was killed by his own sword (1 Sm 17:51).

18 Cf. Barbara Schmitz, *Gedeutete Geschichte. Die Funktion der Reden und Gebete im Buch Judit* (Herders Biblische Studien (HBS) vol. 40) (Freiburg: Herder, 2004).

his mighty army is unaware of his fate. Judith and her maid manage to escape to Bethulia, taking Holofernes's head and the κωνώπιον as a trophy and evidence of their act. The head of Holofernes is later hung as a symbol of the victory on the city walls of Bethulia (Jdt 14:1, 11).[19]

Yet the story of the κωνώπιον does not end here; it is mentioned again a final time at the end of the story (Jdt 16:19). After looting the Assyrian camp, the people give the most important items they have plundered from Holofernes's tent to Judith, and she donates these items to the temple in Jerusalem (Jdt 16:19). This custom of consecrating property or people to make a holy relic was widespread throughout the ancient world, and was meant to make the spoils of war taboo (for the purposes of destruction or dedication, cf. 1 Sm 5:2; 31:10),[20] since these are connected with an idea of religiosity that is materialistic and contaminated (cf. Jo 6:19; Lv 27:28; Nm 18:14). Interestingly, in addition to a brief reference to the plunder, there is an explicit mention of the κωνώπιον in this context.

Thus, the story ends with Holofernes's κωνώπιον. By handing it over to the temple in Jerusalem, Judith fulfils the pledge she made in her speech to Holofernes, when she promised to bring him to Jerusalem and set up a throne for him in the middle of the city (Jdt 11:19): While Holofernes's torso is left in the Assyrians' camp and his head is displayed on the city wall, his κωνώπιον, together with the rest of the loot, is handed over to the temple in Jerusalem. The handing over of the κωνώπιον marks the climax and the end of the story.

Whereas the first part of the story presents Holofernes in ideal terms as a successful man and brave soldier, the second part of the story in contrast stresses precisely his femininity. The narrative explicitly stages this by contrasting the expectations placed on Holofernes in the first and second parts. The soldiers reserve Judith for Holofernes (Jdt 10:15, 19) and so perpetuate the image of the potent general from the first part of the story. Holofernes discusses with his servant, the eunuch Bagoas, the masculine pressure to perform with Judith (Jdt 12:11, 12). He speculates about a sexual adventure, in which he will seduce the beautiful Judith, or failing this, "take" her by force if necessary. Yet the Holofernes of the second part of the story is not in a position to perform with Judith (Jdt 12:16), but instead succumbs in his anticipation in a wholly unmanly way to a self-inflicted alcoholic delirium. In this way, Holofernes mutates in his meeting with Judith from a brave

19 Cf. 1 Mc 7:47; 2 Mc 15:35; cf. also 1 Sm 31:10.
20 Cf. Art. "Ανάθεμα," in *Der neue Pauly*, vol. 2 (Stuttgart, 1894), p. 2069; Norbert Lohfink, *Neues Bibel Lexikon*, vol. 1 (Zürich, 1991), p. 238.

soldier and a hero confident of success into an excessive drinker, lacking in self-control (Jdt 12:20; 13:2). The indulgent Holofernes at the end of the story stands in sharp contrast to the ideal of the "masculine" warrior who lives in harsh, spartan conditions (cf. e.g. 2 Sm 11:11).

While Judith is a metaphor for the Jewish community and stands for the concept of "community formation,"[21] Holofernes embodies a development in the opposite direction. At the beginning he represents the whole army, Ashur and King Nebuchadnezzar, but at the end all that remains is a dispersing army and its slain commander, whose severed head has become the trophy of his enemies and whose destructive power is now itself completely destroyed. This development is made clear through the recurrent κωνώπιον motif: because of his association with the κωνώπιον, Holofernes appears effeminate, even before he meets Judith, and by using the terminology of cross-gendering he is characterized through the κωνώπιον as feminine. The heroic and virile general is described as a weak man. In contrast to the characterization of Holofernes in the first part of the narrative as an ideal warrior, bold and successful, the second part emphasizes his unmanliness. During the confrontation with Judith, he gives in to alcohol in his thrill of anticipation and thereby becomes powerless and impotent in a very unmanly way. The story reveals that Holofernes, the brave man and hero, is defeated by a woman because he has become a soft and effeminate man.

A reading of the Latin literature which contains the conopeum motif serves to illuminate the meaning and function of the κωνώπιον in the story of Judith. The construction of gender roles in the Book of Judith does not in fact subvert these roles, but rather reinforces them in their patriarchal connotation. Ultimately, therefore, the story of Judith offers a truly patriarchal explanation for the scandalous fact that a woman, however God-fearing she may be, is able to kill a man.

21 Amy-Jill Levine, "Character Construction and Community Formation in the Book of Judith," in Athalya Brenner (ed.), *A Feminist Companion to Esther, Judith and Susanna* (Sheffield: Sheffield Academic Press, 1995), pp. 561–69.

5. Shorter Medieval Hebrew Tales of Judith

Deborah Levine Gera

Judith disappeared from Jewish tradition for well over a thousand years and when she returned, she was, in many instances, quite changed. In this paper, I shall be looking at the portrayal of Judith in a series of medieval Hebrew stories or midrashim, concentrating upon those stories which are not based in their entirety on the Vulgate Judith.[1]

Many details of the plot and the characters in these medieval Hebrew stories are not identical with those found in the Book of Judith. The setting of the story is generally Jerusalem, rather than Bethulia. The enemy king Nebuchadnezzar and his commander Holofernes are often conflated into one figure, the leader whom Judith encounters and kills, and his name and country of origin vary considerably from story to story. Even Judith herself is not always named in these stories and her family background varies. Similarly, an Achior figure, a wise counsellor who advises the enemy commander against attacking the Israelites, is found in virtually all the tales, but his name, position, and profession differ in the different stories.

While the Judith midrashim vary widely in length and detail, they do have many elements in common. In all the tales, Judith's city is besieged and she decides to intervene and meet with the enemy leader.[2] Holofernes attempts to seduce or marry her, arranges a banquet,[3] becomes intoxicated, and is murdered by Judith. She returns to her city with his head and the

1 See above, Introduction pp. 31–34 for a general classification of the different medieval Hebrew stories of Judith. For bibliographical details of the texts surveyed here (texts 1–5 and 7–12), see the list above, pp. 37–39.

2 I use the names Judith, Holofernes, Achior, etc., for the sake of convenience, even if they appear in different form in some of the stories.

3 In the midrashim, the banquet is a large party arranged to celebrate Holofernes's forthcoming victory (which Judith has proclaimed), and not simply an intimate dinner intended for the seduction of Judith, as in the apocryphal book.

Israelites are filled with joy when they learn of Holofernes's death. The enemy discover their leader's body, and are then slaughtered by the Israelites. Their possessions are pillaged.[4] All of these elements are found, of course, in the original Book of Judith and they form the very core of the plot. At the same time, several key features are missing in the medieval stories, which add some new elements of their own.

The omissions and additions of the Hebrew medieval tales are particularly interesting in relation to the figure of Judith herself and it is worth concentrating on her portrayal in these stories, viewing her through a feminist lens.[5] How does Judith fare in the medieval Hebrew stories? For a start, she is sometimes a younger, unmarried woman, rather than a wealthy and independent widow. This makes her a more vulnerable and less experienced figure. In some stories she is called a woman, a girl, and a widow, at one and the same time: perhaps the point is simply that she is a female, a dependent female.[6] In the apocryphal book, Judith is assigned an extraordinarily long genealogy, clearly intended to glorify her and stress her importance. In fact, her husband, Manasses, is said to be of *her* tribe and *her* clan (καὶ ὁ ἀνὴρ αὐτῆς Μανασσης τῆς φυλῆς αὐτῆς καὶ τῆς πατριᾶς αὐτῆς LXX Jdt 8:2) and such an identification of a husband through his wife is unique in the Bible.[7] In the medieval tales, we hear of Judith's family as well, but in these later stories her family is usually enlisted in order to grant her an identity of sorts and lend her status. Indeed, Judith often uses her family connections to explain her defection to the enemy commander. The medieval Judith introduces herself as the daughter and sister of prophets and/

4 For a survey of all these elements in the various tales, see the useful list in André Marie Dubarle, *Judith: Formes et sens des diverses traditions: i: Études; ii: Textes* (Rome: Institut Biblique Pontifical, 1966), at ii, pp. 98–99.

5 Claudia Rakel, *Judit – Über Schönheit, Macht, und Widerstand im Krieg* (Berlin: de Gruyter, 2003), is a recent feminist analysis of the Book of Judith with a rich bibliography. For the changes introduced in these midrashim, see the brief, but illuminating discussion of Leslie Abend Callaghan, "Ambiguity and Appropriation: The Story of Judith in Medieval Narrative and Iconographic Traditions," in *Telling Tales: Medieval Narratives and the Folk Tradition*, ed. Francesca Canadé Sautman, Diana Conchado, and Giuseppe Carlo Di Scipio (New York: St. Martin's Press, 1998), pp. 79–99, esp. 87–90.

6 Widow: texts 3 and 4; young girl: 2a, 8, and 9; woman and young girl: 1, 5a, 5c, 5f; widow, woman, and young girl: 7a and 7b.

7 Compare Ru 1:3. The Vulgate includes a long genealogy for Judith (Vulg. Jdt 8:1), but does not say that her husband is from her tribe and her clan (Vulg. Jdt 8:2). Mention of Judith's ancestors is found in two of the midrashim as well: text 7a lists thirteen ancestors for Judith and text 7b has six forefathers. (This section of these two texts clearly stems from the Vulgate.)

or priests and claims to convey information acquired by her male relatives because of their privileged relationship with God.[8] In the apocryphal book, on the other hand, Judith presents herself to Holofernes as someone who receives messages directly from God (LXX Jdt 11:16–17). It is she, rather than her menfolk, who is said to be privy to divine information.

Since the short medieval stories are considerably briefer than the Book of Judith, it is only to be expected that less space is devoted to a description of the heroine's beauty, piety, and cleverness. It is nonetheless surprising to discover that some medieval midrashim do not mention her beauty at all (texts 3 and 4) and only two make note of her intelligence (texts 1 and 12). These are key features of the apocryphal Judith, noted by the narrator and all those who surround her.[9] Some of the later tales find room for a bit of her irony and deception, two of the apocryphal Judith's quintessential qualities. Such irony is particularly apparent when she expresses her tongue-in-cheek desire to go to bed with Holofernes. Thus in text 1, when the commander attempts to seduce Judith, she replies, "My lord king, I have come here with all my heart solely for this purpose." In many of the tales her reply to the "marriage" proposal is, "I am not worthy to be married to one of your servants, let alone the king."

It is perhaps not surprising that Judith's scolding speech to Uzziah and the city elders disappears (LXX Jdt 8:10–27); nor do we hear of military advice offered by Judith in any of these tales (cf. LXX Jdt 14:1–4). More unexpected is the fact that there is no trace in the midrashim of Judith's long prayer (LXX Jdt 9:1–14) and in some of the stories (texts 3, 4, 5a, 5c, 5f, 7a, and 7b) we do not find any prayer by Judith at all.[10] Courageous and brave though the medieval Judith may be, none of the later stories include the praise and blessings showered upon her by her grateful community. There is no celebratory song and dance in her honor, as found in the Book of Judith (LXX Jdt 15:12–16, 17). Indeed, in all but one of the medieval stories (text 9), Judith does not receive even a single word of praise. While Judith's help is not acknowledged in any way, in one account (text 8), she is nonetheless said to reign over the land and judge Israel after her deed is done.

Many of the medieval tales contain two additional elements that are not found in the Septuagint or the Vulgate versions of Judith and both

8 In many versions (texts 2a, 5a, 5c, 5f, 7b, 8, 9, 10, 12) Judith allegedly comes to Holofernes in order to intercede for her family and save them.

9 See LXX Jdt 8:7, 29; 10:7, 14, 19, 23; 11:20–22, etc.

10 There is a prayer, ישראל שמע ("Hear O Israel"), found in virtually all of the stories, but it is uttered by all of the townspeople, not by Judith.

these additions are related to the fact that Judith is a woman. The first addition revolves around Judith's passage through her city's gates, both on her departure and upon her return. In the apocryphal book it is Judith who scolds and interrogates the leaders of her community, and she goes off freely, on her own initiative, without revealing her plan to anyone (LXX Jdt 8:32–34). In the later midrashim, Judith is challenged within her own community and asked to justify her actions. When she leaves for the enemy camp, she is stopped by the guards at the city gates. These guards interrogate her harshly and accuse her of falling in love with an uncircumcised Gentile or plotting against the city or both: the erotic and the political combine. Often it is only after she takes an oath affirming her innocence that she is allowed to pass through the gates. Even more unexpected is the reception accorded Judith upon her return. After Judith kills Holofernes and returns home with his head, the guards again accuse her of promiscuous or treacherous behavior and refuse to believe that the head she carries actually belongs to the enemy commander. Even in those versions where the city guards accept Judith's explanation of her mission as she leaves the city and approve of her plan, they nonetheless question her harshly when she comes home (texts 8 and 9). Often the wording of their interrogation of Judith when she returns home is identical to the questions they ask when she leaves. "Are you not ashamed in front of God?" אין את מתביישת לפני הקב"ה, they ask (texts 4, 5a, 5f, 7a, 7b). The city guards refuse to believe that a miracle has taken place, asking, "Isn't it enough for you that you have behaved immorally? Do you want to betray the blood of Israel as well?" (text 1; cf. text 3). In some accounts, Judith manages to convince these skeptical watchmen by displaying Holofernes's head, but often that is not enough. In one version (text 8) she is even accused of bringing back a head that she just happened to find rolling about in the street!

Since the guards generally do not believe or trust the victorious Judith when she returns with Holofernes's head, many of the medieval tales introduce a figure based on the apocryphal Achior, the wise counsellor who has warned the enemy leader against attacking. Achior is brought into these stories, sometimes at the very moment of Judith's return,[11] simply so that she can appeal to him to confirm the identity of her victim. The counsellor has so angered the enemy king with his advice against attempting to conquer the Jews that the king hangs him at the city gates. There he waits,

11 Achior appears in different places in the story in the different versions and sometimes is mentioned twice; see Dubarle, *Judith,* ii, pp. 98–99.

literally hanging around, until Judith returns and he can affirm her deed. As brief as these stories may be, Achior needs to be included in order to lend credence and credibility to Judith's deed: in these Hebrew medieval tales, Judith's townspeople trust this foreigner more than they trust her. In the Septuagint, Achior is allotted a different role. When Judith returns from killing Holofernes, she has him summoned and shows him Holofernes's head (LXX Jdt 14:5–8). It is not altogether clear why she does so and the timing is puzzling, for she calls for him immediately after telling the people of Bethulia to hang Holofernes's head on the wall and arm for battle early the next morning. In the Vulgate (Jdt 13:27–31), Achior is also summoned (with no mention of an agent: "*porro Achior vocatus venit*" and Achior being called for came; Vulg. Jdt 13:27) but this takes place, more logically, before Judith suggests that the head be hung on the city wall. The Vulgate Judith shows Holofernes's head to Achior so that he may see and recognize for himself that God does indeed avenge his enemies, just as Achior has stated. Holofernes's head enables Achior to understand and confirm the truth of his claim. In the midrashim, their roles are reversed: Achior confirms the truth of Judith's tale by means of the head and it is she who needs outside witnesses and confirmatory evidence, not Achior.

In the medieval tales, then, it is easier for Judith to enter and depart enemy territory than her own native town. The interrogation she undergoes at the gates of her own city is in striking contrast to the unsuspecting attitude of the enemy guards, who immediately bring Judith to their commander when she first enters the enemy camp. When Judith and her maid leave the enemy territory, the foreign guards are (at her request) specifically ordered by the king not to approach the two women or even utter one word to them. It is interesting to note that already in the Septuagint account of Judith there is a hint of uneasiness when the heroine leaves Bethulia and passes through the city gates. Judith asks Uzziah and the elders to stand at the gates when she and the maid leave, but specifically tells them not to question her, for she will not tell them of her deed until it is done (LXX Jdt 8:33–34). When she arrives at the gates, after dressing up for her mission, Uzziah and his companions are astounded by her beauty. She has them command the young men to open the gates for her and the elders follow her with their eyes until she is out of sight (LXX Jdt 10:6–10). Judith is not challenged in any way in the Septuagint, just stared at and blessed, but there is a stilling of movement here, a slowing down of the plot. In the Vulgate, too, Uzziah and the elders admire

Judith's beauty when she leaves the city gates, but Jerome adds that they nevertheless do not question her and simply let her pass through, *"qui cum vidissent eam stupentes mirati sunt nimis pulchritudinem eius nihil tamen interrogantes eam dimiserunt transire"* (And when they saw her they were astonished and admired her beauty exceedingly. But they asked her no question, and let her pass; Vulg. Jdt 10:7–8). The Vulgate wording seems to imply that it would only be natural to interrogate Judith under the circumstances, as indeed happens with the gatekeepers in the later stories. Jerome also drops the description of the Israelites watching her cross the plain to the enemy camp (LXX Jdt 10:10) and there is no lingering on the male Israelite gaze in the Vulgate.

In this context of Judith tarrying at her city's gates it is worth looking at a manuscript illumination of a special prayer for Hanukkah which includes Judith's story (text 10). The author of the liturgical poem, Joseph ben Solomon, was active in the first half of the eleventh century and his account is clearly based on the medieval midrashim.[12] In a manuscript dated ca. 1434, the Hamburg miscellany (Cod. Heb. 37, fol. 81), we find three illustrations of the section of the poem dedicated to Judith (see above, Fig. 2.1). The first shows Judith and her maid approaching Holofernes who sits outside his tent, the second is the quintessential image of Judith cutting off the sleeping Holofernes's head, but the third illumination is more unusual. It is placed in close proximity to the words of the poem describing Judith's encounter with the guards upon returning to her city, "They saw Holofernes's head but did not believe her," and shows Judith entering the city gates with her maid. A head, possibly that of Achior, peeps over the wall.[13] It is possible that this particular episode was illustrated precisely because Judith is made to wait at the gates in so many of the medieval tales. In an anonymous fifteenth-century German woodcut, we again see Judith and her maid, who is carrying Holofernes's head, at the city gates. The two women are gesticulating, while the two male guards blocking the entrance have their arms folded. The body language of the figures seems to indicate that the women are trying to convince the gatekeepers to allow them to enter.[14]

12 See above, Introduction, p. 34.

13 See Mira Friedman, "Metamorphoses of Judith," *Jewish Art*, 12–13 (1986–87), pp. 225–46 at 225–27 for the illustrations.

14 *Vier Historien des Alten Testaments* (Albrecht Pfister: Bamberg May 1462), fol. 41r in *The Illustrated Bartsch*, vol. 80 (cf. p. 51). The picture is labeled there "Judith leaving the city," but this seems wrong. An earlier illustration of Judith and her maid returning with Holofernes's head to the closed city gates can be found in the twelfth century *Hortus Deliciarum* (Fig. 4.2).

A second innovation found in the medieval midrashim is the excuse Judith offers for rejecting Holofernes's advances: in most of these tales the king almost immediately expresses his desire to marry Judith, minutes after meeting her. It seems that this is a euphemistic way of stating that he would like to have sex with her at once, for Judith invariably agrees to the proposal, but adds that there will be a slight delay. She explains that she is in an impure stage of her menstrual cycle, but will be available to the king that very evening after she undergoes ritual purification at a nearby spring. Consequently she asks the king to order that she and her maid be allowed access to the waters. They are not to be questioned or challenged by the guards at the city springs (and we have seen that they are in fact allowed to move about freely in enemy territory). In the apocryphal Judith, the spring plays a part as well, for Judith allegedly needs to go out in the evenings to commune with God and hear from him if the time to attack the Israelites has come (LXX Jdt 11:17; 12:6–7; Vulg. Jdt 11:14–15; 12:5–7). In the apocryphal book Judith bathes ritually and prays at the spring for three evenings in a row, and this immersion in water is a purification process that is not related to her menstrual cycle. Indeed, the fact that Judith repeats this rite on three successive nights makes it plain that she immerses herself in preparation for prayer; one dipping would have sufficed to end her menstrual impurity. The medieval authors apparently found this purification rite by a woman mystifying or possibly subversive: perhaps this independent, religious woman was too close to God for their taste. At any rate, it is easier for these storytellers to depict an impure, menstruating woman than to envision a holy woman of God, who immerses herself in water in a near-spiritual act of purification, common to men and women alike. All the non-Vulgate-based medieval versions include this detail: in all these stories, Judith's alleged need to perform a purely physical act reserved for impure women is a crucial feature of the plot.

Judith's tale is often linked with the story of Hanukkah and many of the medieval midrashim are related to this festival.[15] Most of the Hanukkah-Judith stories fall into two parts, with another woman, a member of the Hasmonean family who is generally identified as the sister of Judah Maccabee, playing a critical role in the events preceding Judith's own deeds. Some of these Hanukkah tales are carefully crafted and we clearly are meant to compare and contrast the two women.[16] Interestingly, the Hasmonean

15 See above Introduction, pp. 30–31.
16 It is unfortunate that Dubarle, who finds the links between the stories late and artificial (*Judith*, i, pp. 84–85) omits the first half of these Hanukkah midrashim in

heroine, Hannah, as she is sometimes called, is often a stronger character, who seems to have usurped some of Judith's wisdom and courage.

In the Hanukkah stories, a series of decrees are directed against the Israelites, including the *ius primae noctis*, the right of an important enemy minister to sleep with a bride before she has sexual relations with her husband. All proceeds quietly — with the Israelites either obeying this decree or postponing all weddings or the brides remaining miraculously untouched — until it is time for a daughter of the Hasmonean family, Hannah, to marry. Hannah does not wish to cooperate with her family's plan to send her off to the Gentile minister, for she sees herself as an example for other young women and is concerned that if she should compromise, they would all follow suit. At a pre-nuptial party for family and friends, Hannah removes her pretty clothes and jewelry, puts on rags, and serves wine to the partygoers (see texts 4, 5a, 5c 5f, and 12). In another version of the tale (text 3), she messes her hair, tears her clothing, and stands naked in front of the people. Her family and friends, and her brother Judah, in particular, are embarrassed by Hannah's behavior and wish to punish her. Indeed, in one account (text 4) the brothers are prepared to burn their wilful sister at the stake. Hannah contends that it is they, the menfolk of the family, who should be ashamed, because they are willing to have her defiled by an uncircumcised Gentile. She compares her plight to that of the biblical Dina, and urges her brothers to behave as the biblical Simeon and Levi did, i.e., kill the minister.[17] Hannah's brothers plot together and then dress their sister in royal finery. They also erect a series of fragrant canopies leading to the foreign official's house. The minister is pleased by the fuss and honors the Hasmoneans by granting a private audience to Judah and his brothers. Judah cuts off the minister's head, throws it in the Greek camp, chases away the enemy and kills many of them. The assassination of this official then causes Holofernes to arrive on the scene with his army and we next hear of Judith's encounter with Holofernes, in the second half of the Hanukkah midrashim.

While it is clear that the stories of Hannah and Judith were originally two separate tales which were subsequently stitched together, these medieval versions are worth studying in their entirety, for the parallels

his edition of the texts. Dagmar Börner-Klein, *Gefährdete Braut und schöne Witwe: Hebräische Judit-Geschichten* (Wiesbaden: Marix Verlag, 2007) follows in his footsteps. 17 See Gn 34:1–31. Judith alludes to Dina in the Septuagint text (LXX Jdt 9:2–4), but she seems to identify there with the vengeful brother Simeon, rather than the victim, Dina.

and contrasts between Judith and the young Hasmonean woman, as well as those between Judith and Judah, are illuminating. Judith and Hannah are women who are surrounded by male relatives — fathers, brothers, and husbands (either past or future) — but nonetheless find it necessary to act because these men are too passive. Both face impending sexual relations with a Gentile (whom they term an uncircumcised man, עָרֵל), but they manage to avoid these relations. Their actions involve changing their dress — either to rags or to beautiful clothes — for the occasion. Judith gets dressed up, while Hannah first dresses down (or even undresses in some accounts) and then puts on wedding finery. Both women behave in a seemingly shameful and provocative manner: Hannah does so within the circle of her family and friends, while Judith's seductive behavior takes place in enemy territory. Judith takes the initiative in inviting seduction or rape, but Hannah's virtue is at risk because of her family's compliance with the foreign ruler's decrees. Both women are challenged by their townspeople, sometimes in the exact same words. "Are you not ashamed?" they are asked.[18] Hannah responds sharply to the challenge, shaming her family and friends in return, while Judith is defensive and apologetic.

Wine and drunkenness are an important element in Judith's tale, and this may have influenced the unexpected detail of a partially dressed Hannah pouring wine for family and friends at her pre-nuptial party. We do not hear of any wine at the private meeting that the foreign minister arranges for Hannah and her brothers at his house. In text 12, a manuscript of the Hannah-Judith story, we find two illustrations and these seem to point to the exposed Hannah's confrontation of her family and friends as the highlight of the Hasmonean half of the story. The Judith illustration clearly shows the dramatic climax of *that* tale: she stands over a headless Holofernes seated in a chair, and holds a sword in one hand and his crowned head in the other. There is a Hanukkah menorah in the background. The second illustration shows a partially dressed Hannah facing a group of men seated around a table with plates and a cup (Fig. 5.1). We see Hannah from the back and her long hair covers the exposed parts of her body, but that does not detract from her audacity and defiance.[19]

18 Shame is a recurring motif in these stories – see above, pp. 78 and 82. In the Septuagint, Holofernes tells his eunuch Bagoas that he will be shamed if he does not seduce Judith (αἰσχρὸν τῷ προσώπῳ ἡμῶν; LXX Jdt 12:12). In a medieval tale (text 12), Judith pretends to be ashamed when Holofernes wishes to embrace her in front of others and she asks that they be left alone together.

19 See the reproductions in Israel Adler, "A Chanukah Midrash in a Hebrew Illuminated Manuscript of the Bibliothèque Nationale," in Charles Berlin (ed.), *Studies*

Hanukkah-Story, 16th century.
Paris, Bibliothèque nationale 1459.2.

Hannah's harsh words and disreputable appearance cause her brothers to take action. While Hannah accompanies her brothers to the minister's house, it is Judah, sometimes aided by his brothers, who kills the foreigner, cutting off his head with a sword. The parallels with Judith's assassination of Holofernes are plain and in these Hanukkah midrashim Judith resembles Judah, in addition to Hannah.[20] Interestingly, in some accounts (texts

in Jewish Bibliography, History, and Literature in Honor of I. Edward Kiev (New York: KTAV, 1971), pp. i–viii [in Hebrew], at v and vii.
20 D. Samuel Löwinger, *Judith-Susanna: New Versions Edited According to Budapest Manuscripts* (Budapest: F. Gewuercz, 1940) [in Hebrew], p. 6; Börner-Klein, *Gefährdete Braut*, p. 339. Friedman, "Metamorphoses of Judith," pp. 225–27 and 230, furnishes instances of the association of Judith with Judah in Jewish art, in manuscript illuminations and Hanukkah menorahs.

5f and 8) it is Judah (and not Hannah) who has a private audience with the official, just as Judith is left alone with Holofernes in all her tales. This private meeting between Judah and the minister seems influenced by the Judith story, for the historical Judah described in 1 and 2 Maccabees deals with enemy leaders on the battlefield.[21] Disguise and deception feature in both the stories: Judah garbs his sister in royal finery and erects a series of green bowers leading to the minister's house. He organizes a musical procession as well, in order to curry favor with the foreigner and gain entry to his house. Judith simply decorates and presents herself, but both use external devices in order to entrap their victims. The two are enterprising characters who demonstrate a great deal of initiative and the author of text 12 uses a simple literary device to underline this parallel, first asking, "What did Judah do?" in the first half of the story, before outlining the stages of his plan, and then echoing this rhetorical question, "What did Judith do?" in the second part, before telling of her deeds.

Language, the Hebrew language, plays an important part in these medieval tales, for the fact that they are written in Hebrew allows their authors to produce a text replete with biblical echoes and allusions. Some authors do not take advantage of this opportunity and use rather simple language to tell the story of Judith, but others produce rich and allusive texts by means of the biblical quotations and paraphrases they choose to use. A single Hebrew phrase can serve a double function in these tales, both narrating the surface story and pointing subtly to similar biblical scenes and characters that were well known to readers.

A simple instance involves the use of phrases from the Book of Esther. There are obvious parallels between Judith and Esther. Both are beautiful and courageous Jewish women, who manage to charm powerful foreign rulers and save their people. In both their stories we find a crucial encounter involving a near-seduction at a banquet. Our medieval texts often quote phrases from the Book of Esther, telling us that Judith *"won grace and favor in the eyes of"*[22] Holofernes (see Est 2:17 and 5:2; texts 1, 2, 8, 9, 12). In both these texts the phrase is used when the heroine arrives unexpectedly, without any invitation, to see the ruler. In several texts (5a, 5c, 5f, 7b, 8) Holof-

21 Compare too the private audience Yochanan has with Nicanor before killing him, found in another (non-Judith) Hanukkah midrash. See Adolph Jellinek, *Bet ha-Midrasch* (2nd ed.) (Jerusalem: Bamberger and Wahrmann, 1938), i, pp. 137–41.
22 In the following, I italicize actual biblical phrases used in the medieval texts. The translation is that of *TANAKH: A New Translation of the Holy Scriptures* (Philadelphia: Jewish Publication Society, 1985), slightly modified at times.

ernes even echoes Ahasuerus's words at this surprising encounter, saying to Judith: "*And what is your request? Even to half the kingdom, it shall be granted you*" (Est 5:3). These biblical quotations not only assimilate the medieval Judith to the gentler Esther; they also turn Holofernes into a figure closer to the bumbling but sympathetic Ahasuerus.

Other biblical quotations found in the medieval tales point to the heroic, perhaps masculine side of Judith's deed, for she is implicitly compared both to David killing Goliath and to Ehud ben Gera assassinating Eglon, king of Moab, through the use of biblical phrases found in their stories. Thus in text 12 Judith makes herself "*a two-edged dagger*" (Jgs 3:16), just as Ehud does.[23] (Normally, Judith comes unarmed to Holofernes and uses his own sword against him.) Ehud says, "*Your Majesty, I have a secret message for you*" (Jgs 3:19) in order to gain a private audience with the king, and Judith uses the identical words for the identical reason in text 1. Both Ehud and Judith will claim to convey a message from God once they encounter their enemy. In some of the midrashim (e.g., texts 8 and 12) the discovery of Holofernes's body by his servants is based on the account of the discovery of Eglon's corpse in Judges 3:25; both medieval texts quote the phrase from Judges: "*and there their master was lying dead on the floor!*" Other midrashim (e.g., text 2a) make use of the biblical account of the Philistines' reaction to the dead Goliath (1 Sm 17:51) – "*When they saw that their warrior was dead, they ran*" – when telling of the reaction to Holofernes's death. David is also the source for the very act of killing Holofernes in text 2a. Judith, like David, "*stood, grasped the sword ... and cut off his head*" (1 Sm 17:51) and Judith, like David, "*took her life in her hands*" (cf. 1 Sm 19:5). Text 2a, then, contains a cluster of references which assimilate Judith to David in his encounter with Goliath, and this use of multiple references to a single biblical story or character is found in other Judith tales. It seems that these medieval authors deliberately return to the same biblical account several times, subtly underlining the parallels between Judith's deed and biblical themes or figures. These references are plainly intended to be more than a random use of a biblical phrase.

A further biblical figure found in the background of the midrashim is Ruth, especially in her encounters with Boaz. In text 8, Judith asks Holofernes for protection in the very words Ruth uses when Boaz finds her sleeping at his feet: "*Spread your robe over your handmaid*" (Ru 3:9). Judith

23 Ehud hides the dagger under his cloak, while Judith puts it in her sandal; compare LXX Jdt 16:9: "her sandal ravished his eyes" and see too 10:4.

is perhaps as vulnerable and in need of a protector as Ruth,[24] but Holofernes is no Boaz. Perhaps that is why many stories attribute to Judith a variation on another phrase Ruth uses with Boaz. Ruth says to him (2:13): "You are most kind, my lord, to comfort me and to speak gently to your maidservant — though I am not so much as one of your maidservants" (ואנוכי לא אהיה כאחת שפחותיך). Judith, on the other hand, says to Holofernes: "Do as you please [have sex] with me, I am like one of your maidservants" (ואנוכי כאחת שפחותיך).[25] A third reminiscence of Ruth and Boaz is the brief invitation "*Come over here*" (גשי הלום) (Ru 2:14). Boaz invites Ruth to join him in eating bread and vinegar; Holofernes uses the identical phrase when inviting Judith to kiss and touch him (text 12).

The biblical Tamar, who is raped by her brother Amnon, is also alluded to several times in one of our texts (text 8). Holofernes propositions Judith with the very words Amnon uses to Tamar (2 Sm 13:11): "*Come lie with me, sister.*" Amnon has the unfortunate Tamar prepare cakes and feed him by hand, before raping her, and in text 8 we find the same food and feeding by hand described with the identical vocabulary.[26] Judith, however, is no victim, and the cakes she feeds Holofernes are very salty, causing him to drink too much and fall asleep. Here the medieval author seems to be playing with our expectations, comparing Judith's situation to that of Tamar, but underlining the contrast between the two women as well.

It is not surprising to find Judith compared to Esther, Ehud, David, Ruth, or Tamar in these tales. Indeed, students of the apocryphal book of Judith often mention these figures in relation to her. It is unexpected, however, to discover that Judith is compared to Hagar and Delilah as well, by means of biblical citations in the midrashim. When Hagar flees her cruel mistress Sarai, an angel of God asks her, "*Where have you come from, and where are you going?*" (Gn 16:8)[27] and Holofernes addresses the identical question to Judith when she first arrives in his camp (text 2a and 9). Judith, like

24 Rahab is another biblical woman in need of protection, and in one story (text 8) Judith echoes her words as well, begging Holofernes to "*spare the lives of my father and mother, and my brothers,*" just as Rahab pleads with the spies (Jo 2:13).

25 Compare the Septuagint Judith (LXX Jdt 12:13–14) where the eunuch Bagoas invites Judith to a private party with Holofernes and promises her that she will be treated like one of the Assyrian women serving in Nebuchadnezzar's palace. She immediately replies: καὶ τίς εἰμι ἐγὼ ἀντεροῦσα τῷ κυρίῳ μου ὅτι πᾶν ὃ ἔσται ἐν τοῖς ὀφθαλμοῖς αὐτοῦ ἀρεστόν, σπεύσασα ποιήσω ("And who am I to contradict my lord? I shall be quick to do whatever is pleasing in his eyes").

26 לביבות, ואברה מידך; see 2 Sm 13:6, 10, and see Weingarten in this volume, pp. 99 and 104–05.

27 Contrast e.g., Jgs 19:17 and Jon 1:8.

Hagar, is a vulnerable woman traveling on a dangerous journey whose outcome is uncertain. Perhaps we are meant to understand that she also resembles Hagar in the direct supervision and protection afforded her by God. (Indeed, in the Vulgate, an angel watches over Judith [Vulg. Jdt 13:20] — see immediately below). Judith's helplessness and precarious position as a potential victim are emphasized in a second phrase adopted from the Hagar story. Abraham tells Sarai: "Your maid is in your hands. Do with her as you please" עשי לה הטוב בעיניך (Gn 16:6) and it is Sarai's subsequent cruel behavior that causes her to run away. Judith uses a virtually identical expression when expressing her supposed willingness to sleep with Holofernes. "This woman is in the hands of the king and let him do with her as he pleases" (texts 2a and 9).[28] Neither Sarai nor Holofernes manage, in fact, to do as they would have liked with either of the two women, and Hagar and Judith escape their clutches.

A single, tantalizing Hebrew phrase found in only one midrash points to the most surprising parallel of all, that between Judith and Delilah. In nearly all of the medieval tales it is clear that Holofernes does not manage to touch Judith at all. In the Septuagint (LXX Jdt 13:16), Judith makes a point of telling the people of Bethulia that Holofernes did not commit a sin with her, defile, or shame her, while in the Vulgate version (Jdt 13:20) we hear that an angel of God protected her and saved her from sexual contact with Holofernes. Nearly all the medieval stories preserve this tradition of an untouched Judith,[29] but in text 12, Judith (termed here Judith the daughter of Mattathias) is said to hug and kiss the king, once he has cleared the room at her request. She then *"lulled him to sleep on her lap,"* the narrator tells us, using the precise expression for what Delilah does to Samson before calling in the Philistines to cut off his hair and cause him to lose his strength (Jgs 16:19). This implied comparison of Judith with Delilah (and Holofernes with Samson) is unexpected, to say the least. While recent feminist scholarship points to the similarities between Delilah and Judith, two deliberately seductive women who manage to deceive and emasculate powerful warriors, such an approach to Judith is, even today, far from conventional.[30] The provocative parallel also under-

28 For further instances of the expression "to do as one pleases" in a sexual context, see Gn 19:8 and Jgs 19:24 and compare LXX Jdt 12:14.

29 See text 3 where the king falls asleep in Judith's arms (והמלך ישב בחיקה וישן) and contrast text 7b where Judith cradles Holofernes's head in her bosom after she cuts it off (ונטלה הראש ותשימה בחיקה).

30 See, e.g., Betsy Merideth, "Desire and Danger: The Drama of Betrayal in Judges and Judith," in Mieke Bal (ed.), *Anti-Covenant: Counter-Reading Women's Lives in the Hebrew Bible* (Sheffield: Almond Press, 1989), pp. 61–78.

lines the resemblance between their two victims, Holofernes and Samson, and the latter is certainly a positive, if flawed figure. It is hard to conceive that our medieval author meant us to see Holofernes as a tragic victim and his choice of biblical phrasing here leaves us puzzled.

The medieval Hebrew tales of Judith are compelling and undeservedly neglected texts. The translation and publication of a wide sampling of these texts — in their entirety — in English is a scholarly desideratum. The stories are interesting for their additions and omissions in relation to the Septuagint and Vulgate accounts of Judith, and their variations help us read the Greek and Latin apocrypha backwards, so to speak, and approach the older texts in new ways. At the same time, these medieval versions must reflect their authors' own eras and attitudes, which surely underlie the transformation of the figure of Judith into a less powerful and independent figure. Transformed though she may be, the Hebrew medieval Judith is worth exploring.

6. Food, Sex, and Redemption in *Megillat Yehudit* (the "Scroll of Judith")

Susan Weingarten

"You also, son of man, take a written scroll, feed your stomach and fill your belly with what I give you, and it will be as sweet as honey in your mouth." Thus begins the medieval Hebrew manuscript *Megillat Yehudit*, with words taken from Ezekiel (2:8–3:3). Beneath the title, in smaller letters, is the instruction: "to be said on Hanukkah."[1] The story of Judith has been connected by Jews with the festival of Hanukkah since the Middle Ages at least. Rashbam writes that just as the miracle of Purim came about through Esther, so the miracle of Hanukkah came about through Judith,[2] and the authoritative *Shulhan Arukh* (OH 570,2) says "There are those who say we should eat cheese on Hanukkah, because of the miracle over the milk which Judith fed the enemy."[3]

Commenting on Babylonian Talmud, Shabbat 10a, the Ran writes that "the daughter of Yohanan gave the chief enemy cheese to eat to make him drunk and they cut off his head and everyone fled. Because of this there is a custom to eat cheese [on Hanukkah]." [4]

The apocryphal Book of Judith was not accepted into the Jewish biblical canon, and is not mentioned in the Talmudic literature.[5] Indeed, Hanukkah

1 I am grateful to Tova Cohen, Yuval Shahar, Elisheva Baumgarten, and Harvey Hames for discussions of *Megillat Yehudit*. Bibliographic details can be found in the appendix to this chapter on p. 110 below.
2 Rashbam (eleventh century), in commentary on Babylonian Talmud Megillah 4a.
3 Citing the Ran (fourteenth century) and *Sefer ha-Kol Bo* (thirteenth to fourteenth centuries, possibly Provençal).
4 See Gera's contribution in this volume (Chap. 2).
5 Two liturgical poems written around the eleventh century and read on Hanukkah contain some elements of the Judith story. See also Gera (Chap. 2) on the

itself is hardly mentioned, and has no synagogue reading, although a work called *Megillat Antiochus,* based on material about the Hasmoneans, was read in some communities.[6]

However, by the Middle Ages we find not only rabbinical mentions of Judith, but also a number of Jewish versions of the story, in both Hebrew and Yiddish.[7] It is uncertain whether these reflect a Jewish tradition or whether they are Jewish versions of Christian traditions based on the Vulgate. It is clear, however, that the medieval rabbis cited connected the story of Judith to women and to food in particular. In this paper I shall analyze these two connections in one medieval version of the story, *Megillat Yehudit*.

In the apocryphal Book of Judith, Judith takes her own supply of food when she goes to Holofernes: a jar of wine, a cruse of oil, barley groats, fig-cakes, white bread, and, in some versions, cheese.[8] This food is not present in *Megillat Yehudit*, apart from the wine. However, there is other food instead. I shall analyze both its material reality and its literary functions.

Some of the foods in *Megillat Yehudit* are real foods, described in tangible form: pancakes are fried, dough is kneaded and rises, made "glorious" with honey. Celebration of the festival of Hanukkah is real and earthly. However, food in Judaism is also a marker of boundaries between Jews and non-Jews. *Megillat Yehudit* also stresses social boundaries, using food, as we shall see later.

Megillat Yehudit begins, as noted, by quoting the prophet Ezekiel on eating a scroll, a *megillah*. This scroll contains the words of God, which will be "sweet as honey in the mouth." The author is giving divine authority to *Megillat Yehudit* and making its foods very important. *Megillat Yehudit* also ends with honey, in a list of Hanukkah foods which Judith commands should be sent as gifts from one Jew to another.[9] Honey in the Bible is a metaphor for the sweetness of God's Torah (law).[10]

In medieval times, when a Jewish child began to learn Torah, he[11] would

Hanukkah responsum of R.Ahai Ga'on: if this is original, we can push the Jewish Judith back to the eighth century.

6 N. Fried, "A New Hebrew version of *Megillat Antiochus,*" *Sinai* 64 (1969), pp. 97–140 (Hebrew); S. Pershall, "Reading *Megillat Antiochus* on Hanukkah," *HaDoar,* 53 (1974), p. 101 (Hebrew).

7 See papers by Gera (Chap. 5) and Von Bernuth and Terry (Chap. 7).

8 *askoputinen oinou kai kampsaken elaiou kai peran … alphiton kai palathes kai arton katharon.* For the MS variants, see Robert Hanhart (ed.), *Septuaginta,* vol. 8.4: *Iudith* (Göttingen: Vandenhoeck & Ruprecht, 1979), p. 110. The Syriac has *gavta,* cheese.

9 Cf. Est 9:19.

10 E.g., Ps 19:11.

11 Jewish boys received formal Hebrew education; education of girls "lagged far behind": Ephraim Karnafogel, *Jewish Education and Society in the High Middle Ages*

be given a cake made with honey, and the first letters taught would be written on his slate with honey, which he would lick off.[12] He would thus literally eat God's words, and find them sweet as honey in his mouth.[13] Rabbinical works from twelfth- and thirteenth-century Provence and France tell us that the honey cake would have the verse from Ezekiel 3:3 written on it. This verse was also recited by teacher and child. Sometimes this ceremony would take place on Shavuot, the festival of the Giving of the Torah. Marcus has noted the powerful symbolism of the Torah, honey from heaven, paralleled by the God-given manna, sweet as "wafers with honey" (Ex 16:31). God himself calls manna "bread" (Ex 16:32), and it becomes a "test" to see whether the Jews "will follow his Torah or not" (Ex 16:4). This verse is quoted in the introduction to *Megillat Yehudit*: God is also testing his people through food. *Megillat Yehudit* also ends with honey: the circular structure underlines the message.

So far the framing foods of *Megillat Yehudit*. We shall follow the action now with its significant foods. The author has compiled a text thick with biblical allusions. Tracing these allusions to their sources will show that they form a coherent subtext, commenting on the action of the *Megillah*.

After speaking to Holofernes and arranging to come to him in the evening, Judith asks her maid to prepare pancakes, using the vocabulary of the biblical story of the rape of Tamar (2 Sm 13:6), where Amnon asked Tamar to make him pancakes: *telabev levivot*. Both traditional Jewish commentators and modern feminists have picked up this phrase, noting its connection to *lev*, heart – Tamar's *levivot* are not merely pancakes, but food for the heart.[14] In the Song of Songs this word is used even more explicitly: *lebavtini ahoti kallah*, "thou hast ravished my heart, my sister, my spouse" (Sg 4:9). Holofernes earlier used Amnon's words to Judith, "Come lie with me, my sister." But unlike Tamar, who prepared her pancakes in Amnon's sight and thus increased his desire for her, Judith gets her maid to do the work, outside Holofernes's chamber.

The maid makes two pancakes, salts them, and adds pieces of cheese, with the unusual name of *haritzei halav*.[15] This is the only version of the

(Detroit, MI: Wayne State University Press, 1992), pp. 10–11.

12 Ivan Marcus, *Rituals of Childhood: Jewish Acculturation in the Middle Ages* (New Haven, CT, and London: Yale University Press, 1996).

13 See the illustration from the Leipzig Mahzor reproduced by Marcus.

14 Rashi on Sg 4:9; Phyllis Trible, *Texts of Terror: Literary-Feminist Readings of Biblical Narratives* (Philadelphia, PA: Fortress Press, 1984).

15 The *targum* on 1 Sm 17:18 translates *haritzei halav* as *govnin de-halva*, milk cheese.

story of Judith I know which specifies that Judith fed Holofernes with cheese, the Hanukkah food theme noted by the rabbis.[16] The references to *halav*, milk, remind us of Judges 4:19 and 5:25, where Jael, wife of Heber the Kenite, tempted the enemy general, Sisera, made him drowsy with milk, and hammered a tent-peg into his head to kill him. Holofernes is sited "within his tent," also referring to the story of Jael and Sisera, which takes place in a tent; Jael is later called "most blessed of women in tents" (Jgs 5:24). Like Sisera, Holofernes "fell asleep" (Jgs 4:21) before he died.

The reference to *haritzei halav* also alludes to the young David, who took *haritzei halav* to his brothers' captain, just before his encounter with Goliath. Judith is further linked to David's victory over Goliath: when she cuts off Holofernes's head, the words used are the same as when David cuts off Goliath's head (1 Sm 17:51). Similarly she wraps Holofernes's head in her clothes, just as David wraps Goliath's sword (1 Sm 21:10). Thus at the moment of her victory there is a role reversal, when she uses Holofernes's own weapon against him, symbolically castrating the threatened rapist.[17]

The salt in the pancakes is clearly intended to make Holofernes thirsty, so he will drink more wine. Judith pours them into a pot and brings them to Holofernes, who has made a great banquet, the "Feast of Judith." This is a reference to *Megillat Esther*, the biblical Book of Esther. In her conversation with Holofernes, we saw that Judith appeared to accept his demands, but put him off till evening, as Esther put off Ahasuerus. Thus, as in *Megillat Esther*, the dénouement of *Megillat Yehudit* takes place at a banquet. *Megillat Esther* does not say what was eaten at the banquet, but here the food is meaningful. At Esther's banquet, the participants recline on couches, for Haman falls on Esther's couch in supplication. Ahasuerus willfully misunderstands this as an attempt at raping Esther: "Does he mean to rape the queen in my own palace?" he cries, and Haman is taken away to be hanged (Est 7:8). At the Feast of Judith the ever-present danger of rape is underlined by this biblical connection.

Holofernes eats the food Judith's maid has prepared, and gradually gets more and more drunk. At first, quite simply, "his heart is merry," like Boaz when he lies down before Ruth comes (Ru 3:7). More ominously, this expression also alludes to Ahasuerus, whose "heart was merry with wine"

16 H. Simons, "Eating Cheese and *Levivot* on Hanukkah," *Sinai*, vol. 115 (1995), pp. 57–68. Simons's conclusions about *levivot*, however, are based on a mistranslation of the Greek, which refers to barley groats, not wheat flour.

17 Mira Friedman, "The Metamorphoses of Judith," *Jewish Art*, 12/13 (1986–87), pp. 225–46 (230–31), discusses parallels of Judith and David in art.

when he summoned Vashti to his feast to show off her beauty (Est 1:10). Vashti refused, and was deposed, and even, according to the midrash, beheaded (Est 1:10; and see Midrash Esther Rabbah 3:9; 5:2). Here things are reversed: the beheading is reserved for Holofernes, not the queen. Thus, with God's help, the rape does not take place.

We turn now to look at sexual allusions in *Megillat Yehudit*. Unlike Judith in the apocrypha, this Judith is not a widow but a wife. She is painted as a sexual being, to whom sexual approaches are made. We saw how Holofernes says to her, "Come lie with me, my sister," as does Amnon before he rapes Tamar (2 Sm 13:6). Judith's sexuality is further underlined by many references to the book of Esther, where the heroine uses her body to achieve her ends. *Megillat Yehudit* also includes many other intertextual allusions to biblical women, particularly women in situations of dubious sexuality. We could almost claim that it contains a reference to every seduction scene in the Bible. Like the apocryphal book,[18] *Megillat Yehudit* is written on two levels: the story is comprehensible to a reader without knowledge of the biblical texts mentioned, but allusion to these adds extra, tantalizing depth. Some of the allusions come from the Torah, or parts of the Bible read aloud in the synagogue (e.g., the Song of Deborah or *Megillat Ruth*), but others come from parts of the Hebrew Bible never read in synagogue, such as the stories of Delilah and Samson, or Tamar and Amnon. There are many general biblical allusions in *Megillat Yehudit*, but the references to women – particularly seductive women – appear mostly after the appearance of Judith. We shall look at them one by one.

Samson and Delilah (Jgs 15:13). In *Megillat Yehudit*, Holofernes punishes the counsellor who took the Jews' part by having him strung up before the gates of Jerusalem, "with new ropes." This phrase alludes to the new ropes with which the temptress Delilah bound Samson. The scene is being set for sexual temptations (with a hint of outlandish sexual practices). Samson escaped from his new ropes, and the counsellor too will eventually be released.

The concubine on the hill (Jgs 19:2). When Judith wants to leave the besieged city of Jerusalem, the gatekeeper is convinced she has an ulterior motive. His words are taken from one of the most terrible passages of the Bible, the story of the concubine on the hill (Jgs 19). The biblical concubine was gang-raped and then carved into pieces: the gatekeeper seems

18 Eric Gruen, "Novella," in J. W. Rogerson and Judith M. Lieu (eds.), *Oxford Handbook of Biblical Studies* (Oxford: Oxford University Press, 2006), p. 420.

to be warning Judith of the fate awaiting her if she betrays her people. The text of Judges writes that the concubine left her man: *va-tizneh alav pilagsho.* The verb *va-tizneh*, translated here as "left," is clearly related to the root *zonah*, a prostitute, and it is this meaning which appears to be uppermost in *Megillat Yehudit*: the accusation seems to be that Judith wants to prostitute herself to Holofernes. However, she convinces the gate-keeper of her good faith and he lets her pass with a blessing.

Sarah and Pharaoh (Gn 12:14–15). Judith dresses royally, like Esther, (Est 5:1; 2:17), and her beauty is such that when she arrives in Holofernes's camp and his men see her, they praise her to Holofernes, just as Pharaoh's courtiers saw Sarah, Abraham's wife and praised her to Pharaoh. In the biblical story, Sarah was taken to Pharaoh for him to have sex with her. She was eventually rescued by God sending a plague on Pharaoh: the author is alluding to a background of sex and fear, with eventual redemption through divine aid.

Abigail and David (1 Sm 25:32, 25:39, 25:42). The gatekeeper, who at first accuses Judith of wanting to prostitute herself to the enemy, is persuaded by her "good sense," just as David was persuaded by Abigail's. Later, Judith comes to Holofernes's camp with two maids following her, just as Abigail went to agree to David's proposal of marriage, followed by her maids. The author seems to be playing with the reader here, introducing uncertainty about Judith's real intentions: will Judith accede to Holofernes's request?

Rahab and Joshua (Jo 2:13). When Judith comes to Holofernes, she falsely prophesies to him that he will prevail over Israel. To deceive him still further, she uses the words of Rahab the harlot to Joshua in Jericho. Rahab knew that Joshua would destroy her city since he had God's help, and asked him to spare her father, her mother and her brothers and sisters. Judith also asks Holofernes to spare her father, her mother and her brothers. By giving her the words of Rahab, the author is alluding to her sexuality, but also to her virtue in saving Joshua. The reader is left uncertain as to the eventual outcome.

Lot and his daughters (Gn 19:20, 19:30–31). We noted that Judith "finds favor" in Holofernes's eyes, as Esther did in Ahasuerus's eyes (Est 5:2). This expression appears in several places in the Bible, including the story of Lot, who escaped from Sodom with his daughters, while Sodom was destroyed with hail and brimstone. Seeing the destruction, Lot's daughters are convinced it affects the whole world and that there are no men left. Thus they make their father drunk and lie with him, to get themselves

pregnant. Other phrases used in *Megillat Yehudit* here also allude to this story. Both Judith and Lot say "Oh let me escape." Judith's father "left the town and sat on one of the mountains" just as Lot left Zoar and "sat on the mountain." Judith also speaks of her "old father," just as Lot's daughters speak of their "old father" when they intend to make him drunk. *Megillat Yehudit* is referring here to another story of seduction preceded by making the male victim drunk.

Joseph and Potiphar's wife (Gn 39:4–5, 39:11, 41:40). There are also three allusions to Joseph, the victim of a seduction attempt by the wife of Potiphar. *Megillat Yehudit* writes that Holofernes promises Judith, "You shall be in charge of my household and rule over all you desire." Pharaoh also told Joseph, "You shall be in charge of my household." Earlier in the story of Joseph, Potiphar had made Joseph "in charge of his household and all his property." *Megillat Yehudit* has conflated these two references. Pharaoh's act immediately precedes Potiphar's wife's attempt to seduce Joseph, when the biblical text notes that there was no one in the house. When Judith comes to kill Holofernes, *Megillat Yehudit* notes that "there was no one with him in the house."

Joseph was seen as a type of sexual virtue by both Jews and Christians. Bailey notes that in the thirteenth-century *Somme le roi*, Judith and Holofernes are depicted as Chastity and Luxury, with Joseph and Potiphar's wife as their counterparts.[19] But there is also an ambiguity inherent in this reference to Joseph, which introduces an atmosphere of uncertainty: Potiphar's wife was unsuccessful: will Judith's seduction attempt succeed?

Ruth and Boaz (Ru 3:9). Judith asks for Holofernes's protection in the words of Ruth: "spread your skirt over your handmaid." Ruth, who is a figure of virtue in the biblical text, had gone to Boaz to entice him to become her husband by lying down at his feet at night. Virtue and seduction once again go hand in hand.

The Song of Songs (Sg 7:7). In response to Judith's request for protection, Holofernes declares he loves her, using the words of the Song of Songs, "a love with all its rapture." The Song of Songs is the most erotic of all the books of the Bible, with explicitly sexual language and imagery.

Amnon and Tamar (2 Sm 13:11, 13:9). But Holofernes's declaration of "love" is preceded by words which warn of the reality of his lust and intended cruelty: "Come lie with me, my sister," he says, using the words of Amnon to Tamar. When Tamar refused, Amnon raped her. There is also a

19 Cf. Bailey, Chap. 15.

further reference to the story of Amnon and Tamar in *Megillat Yehudit*: in response to Holofernes's desire to lie with her, Judith asks him to clear all the soldiers away from them, just as Amnon clears everyone away from himself and Tamar. Thus the author introduces further tension into the story – if Amnon succeeded in raping Tamar, having cleared away all witnesses, how will Judith escape?

David and Bathsheba (1 Kgs 2:20). The expression Judith uses here, "Do not refuse me," uses the words of Bathsheba to Solomon, her son. The story of Bathsheba and King David (the parents of Solomon) is once again a story of sexual temptation and ambiguous virtue (2 Sm 11).

Dinah and Shechem (Gn 34:19, 34:22). Holofernes agrees to Judith's request "because he desired the daughter of the Jews." This is an allusion to Shechem, who agreed to be circumcised "because he desired the daughter of Jacob."[20] The first part of *Megillat Yehudit* had quoted with horror the suggestion by Shechem after raping Dinah, Jacob's daughter, that his people and the Jews should become one people (Gn 36:16): these words were given to the Greek tyrant who was Holofernes's brother. Here the original version of the phrase "because he desired the daughter of Jacob" was used. The agenda of the author is clear: intermarriage with the surrounding majority is not to be tolerated. Jews must keep to their own truths within their own boundaries.

After the rape, Shechem fell in love with Dinah and wanted to make her his wife, but he was killed by Dinah's brothers, Simeon and Levi. Our author is keeping the readers guessing, tantalizing them with sexually loaded allusions. Will Holofernes succeed in raping or seducing Judith? And if he does, will his fate be like that of Shechem, or like the fate of his own brother who was beheaded by Judah?

Amnon and Tamar (2) (2 Sm 13:11). As we saw, Judith asks her maid to make her food, "so she may eat at her hand." In the story of the rape of Tamar, Amnon had succeeded in being alone with Tamar by pretending to be sick, and asking for Tamar to come and make food for him, so he could eat from her hands. The food Judith's maid makes is the same food as Tamar made, two pancakes, *levivot*. Judith takes the pancakes and brings them to Holofernes in his room, just as Tamar brought her pancakes to the room where Amnon lay. At this point the biblical allusions to the story of Amnon and Tamar cease. Judith is not raped by Holofernes, but outwits him.

20 In the apocryphal Judith this allusion is made explicit: Judith prays to God as the "God of my father Simeon," who helped avenge the rape of Dinah.

Jael and Sisera (Jgs 4:21, 5:27). This outcome is also foreshadowed by references to the story of Jael and Sisera. We noted above that the pieces of cheese, *haritzei halav,* allude to Judges 4:19, where Jael made Sisera sleepy with *halav,* milk, before she killed him. Like Sisera, Holofernes "lay sound asleep" before being killed. The Babylonian Talmud (Horayot 10b) says that Sisera had sex with Jael seven times before he fell asleep, based on the text of Judges 5:27 with the repeated "at her feet he sank down, he fell, he lay; at her feet he sank down and fell; where he sank down, there he fell, done to death." It is unclear to me how far the author of *Megillat Yehudit* was acquainted with the Talmud, but note he uses only the verb "fell" out of all the biblical selection: Holofernes, unlike Sisera, did not succeed in having sex with the woman who killed him.

The Judgment of Solomon (1 Kgs 3:18, 3:28). "No one was in the house with them," says *Megillat Yehudit.* We saw above the original reference to the story of Joseph and Potiphar's wife. But there is also a later intratextual allusion within the Bible itself: the words from Genesis are picked up in Kings, alluding to the two prostitutes in the story of the Judgment of Solomon, who also reported "there was no one else with us in the house." In this story too there is sex, death and a sword – and true judgment at the end: Solomon is said to possess "the wisdom of God ... to do judgment." Judith, too, the allusion implies, is endowed with divine wisdom in the execution of justice.

Tamar and Judah (Gn 38:14, 38:26). Judith and her maid return to Jerusalem *"al petah ha-enayim."* This phrase, (translated by Dubarle: "jusqu'à l'entrée des sources") is an allusion to the biblical story of the other Tamar, daughter-in-law of Judah, son of Jacob, whom he refused to allow to remarry (Gn 38). So Tamar dressed as a prostitute and sat *be-phetah ha-enayim* (variously translated as the "entrance to Enaim"; "at the crossroads" or "in an open place") to seduce him. When she became pregnant, Judah threatened to burn her, but once he understood her motives, he said: "She is more in the right than I am." Judith too appeared to be behaving like a prostitute (and was thus accused by the gatekeeper), but in fact acted only from the right motives.

Thus the author of *Megillat Yehudit* has successfully woven into the text allusions to almost all biblical women associated with seduction, rape or ambiguously virtuous sexuality: Esther, Sarah, Ruth, both Tamars, Dinah, Bathsheba, Jael, Abigail, Delilah, Rahab, two anonymous prostitutes, Lot's daughters and Potiphar's wife. Judith here is not like the Judith of the apocryphal book, of whom it is written "no one thought ill of her." The gate-

keeper did think ill of her, and has to be persuaded of her right motives. Almost all the references to her ambivalent sexuality are contained in biblical references – the author is playing games with his audience.

In the apocryphal book, after killing Holofernes, Judith reverts to her earlier status as secluded widow. Not so in *Megillat Yehudit*. Here she rises to become redeemer, queen, and judge of Israel.

The allusion to the biblical story of the Judgment of Solomon (1 Kgs 3:18) was noted above. Judith, too, this implies, is endowed with divine wisdom in the execution of justice. Having killed Holofernes, she is transformed by her action: the text tells us that the people "shrank from coming near [Judith and her maids]." This is a reference to Moses coming down from Mount Sinai with the Ten Commandments, having spoken with God: all the Israelites "shrank from coming near him" (Ex 34:30). Judith is now endowed with knowledge of God's law. And we leave her putting her wisdom into execution: Judith, we are told, "judged Israel," like Deborah the prophetess (Jgs 4:5).

We have seen Judith associated with King David's family on a number of occasions. The royal House of David has the highest importance in Jewish tradition, for from this house will come the future Messiah. The links with David are repeatedly stressed: when Judith asks God for help, she asks him to remember the "loyalty of David" (2 Chr 6:42). Later she says falsely that Holofernes will sit on the "throne of David." Instead he becomes her victim, and is beheaded like Goliath. Thus, like David, Judith redeems her people from the enemy, with God's help. There are also allusions to women saviors: Esther, Deborah, Miriam,[21] Rahab. Ruth is referred to more than once, ancestor of the House of David and the future Messiah.

Apart from these redeeming women, the redemption of Zion and Jerusalem also figure in *Megillat Yehudit*. Bethulia of the apocryphal Judith becomes Jerusalem, besieged, threatened, but finally redeemed. Holofernes's counsellor quotes Micah 4:8: "Hill of Zion's daughter, the promises to you shall be fulfilled; your former sovereignty shall come again to the daughter of Jerusalem."

Our author takes this prophecy literally. Judith herself is the "daughter of Jerusalem," who eventually rules over the land. *Megillat Yehudit* ends with a prayer from Isaiah: "See the Lord has proclaimed to [the daughter of Zion] your deliverer is coming, see his reward is with him; and

21 Judith returns to Jerusalem with her maids beating timbrels, just as Miriam had led the women with timbrels in the triumph at the Red Sea (Ex 15:20).

they shall be called the Holy People, the redeemed of the Lord" (Is 62:11–12).

Note too that Hanukkah is the feast which celebrates the redemption and rededication of the Jerusalem Temple.

Modern scholars have noted the subversive tendencies of the apocryphal Judith.[22] In the ninth century, Rabanus Maurus, bishop of Mainz, wrote a commentary, where he allegorizes away many of the ambiguities in the apocryphal story.[23] Thus his Judith is Israel, i.e., the Church, and when she abandons her mourning clothes and dresses in her best, he denies the seductive aspects by allegorizing her as clothing herself with Faith, Hope, and Charity. Judith's rejection of Holofernes's food becomes an allegory of the Church's rejection of heathen cult.

Our medieval *Megillat Yehudit* can be read as a Jewish inversion of this Christian Judith, in contrast to this allegorizing Christian tendency. There is no allegory in *Megillat Yehudit*, but a "realistic" account of Jewish victory. Food and victory are real. The seduction and dangers are real – but with God's help, the rape does not take place. Celebration of Hanukkah was real and earthly, as opposed to the Christian symbolic. This Jewish medieval version of Judith's story is used to stress boundaries between Jews and Christians, also in the matter of food.

By beginning *Megillat Yehudit* with Ezekiel's instruction to eat the written scroll, "like honey in the mouth," the author sets up a Jewish-Christian polemic centered on food, especially the honey of the Torah: in Christian terms, the "Old Law," but in Jewish terms the true word of God. *Megillat Yehudit* also ends with food, dough baked with honey. This is reminiscent of manna, heavenly honey-bread, given to the Jews in the wilderness, and used by God as the means by which he tests their faithfulness. Manna is remembered when eating honey cake in the medieval rite of passage conducted when a Jewish child was first taken to learn Torah. From New Testament times, manna was a subject of Christian polemic against Jews. John's Gospel quotes Jesus speaking to the Jews: "I am the bread of life. Your fathers ate the manna in the wilderness and they died … I am the living bread" (Jn 6:48–9). Jesus as bread was a polemical response to manna. And Jesus as bread was eaten by Christians as the Eucharist. John's Gospel begins with the statement that Jesus is the Word made flesh (Jn 1:1f). In beginning and ending his account with the honey of the words of God in

22 Gruen, "Novella," p. 420.
23 [H]Rabanus Maurus, Expositio in librum Iudith (*Patrologia Latina*, 109, 539–592).

the eaten scroll, the author of *Megillat Yehudit* was setting up a polemic with Christian interpretations.

As noted, Rabanus Maurus and other medieval Christian writers and artists[24] were concerned to de-sex Judith, who becomes a neutral figure of humility or chastity, even a prototype of the Virgin Mary. In the apocryphal book, she had been a chaste widow, living in seclusion, and returning to it at the end of the book, never remarrying. This scenario was very acceptable to the many Christians who opposed a widow's remarrying. Thus Jerome writes in his *Preface* to his translation of Judith in the Vulgate: *Accipite Iudith viduam, castitatis exemplum:* take Judith the widow, an example of chastity. Maurus makes Judith's husband Manasseh, who died, an allegorization of Jesus: his Judith becomes *Ecclesia*, the bride of Christ.

In contrast, *Megillat Yehudit*'s Jewish Judith is a woman with definite sexuality. She is not a widow but a wife.[25] I read this as deliberate anti-Christian polemic.[26] Our author is not writing like Jerome and his successors – including the *Speculum Virginum* and Aelfric – for an audience of nuns, or for a Christian empress, like Rabanus Maurus. His Jewish audience were allowed, indeed encouraged, to enjoy food and sex in the right contexts.

Judith's chastity is taken a stage further in Christian writing: Bailey shows Judith representing Israel, i.e., the Church, in the twelfth-century *Speculum Virginum,* and becoming a prototype of the Virgin Mary.[27] In the *Speculum humanae salvationis*, Mary is illustrated fighting the devil, while Judith and Jael are presented as Humility conquering Pride.[28] These presentations support a reading of *Megillat Yehudit* as including a Jewish polemic against Mary.

The cult of the Virgin Mary was strongly developed in medieval Europe.[29] Christians believed that Eve brought about the Fall, whereas Mary brought redemption. Mary was seen as an expansion of Eve, for she was

24 Cf. Bailey, Chap. 15.
25 Holofernes, when he first sees her, asks, "Whose is this young girl?," an allusion to Boaz's words in Ruth 2:5, pointing out her status as sexually available.
26 Note that the action of *Megillat Yehudit* takes place not in Bethulia (or "Virginville," in the happy phrase of Mark Mastrangelo) as in the apocryphal story, but in Jerusalem, at the center of Jewish consciousness.
27 Cf. Bailey, Chap. 15.
28 Marina Warner, *Alone of All Her Sex: The Myth and the Cult of the Virgin Mary* (New York: Random House, 1983), p. 55, describes the *Speculum humanae salvationis* showing "Judith's triumph over Holofernes side by side with an all-conquering Virgin Mary who transfixes Satan with the vexillum thrust deep into his gullet."
29 See Jaroslav Pelikan, *Mary through the Centuries: Her Place in the History of Culture* (New Haven, CT, and London: Yale University Press, 1996).

able to go to battle and defeat the devil. Jews, on the other hand, did not see Eve's sin as sexual. Thus Eve is conspicuous by her absence from the long list of sexually ambiguous women alluded to in *Megillat Yehudit,* whereas Judith, the virtuous wife, not virgin or widow, becomes queen and judges Israel. She is an active ruler in her own right, endowed with divine wisdom, set against the Christian Mary, who may have been "queen of heaven," but is never, to my knowledge, presented as judge.

The royal House of David was very early a subject of Jewish-Christian polemic: Jesus's genealogy at the beginning of Matthew's Gospel includes his descent from the House of David, and he is born in Bethlehem, David's birthplace. Thus the identification of Judith, the victorious Jewish savior, with David, can be seen as part of the Jewish polemic of *Megillat Yehudit,* which presents the true Davidic redeemer against Christian claims.

Megillat Yehudit is no masterpiece. Whether through the fault of author or copyist, it is poorly written with ungrammatical Hebrew and confused phraseology made up of strings of biblical quotations. But it is precisely this sort of work which can perhaps help to shed light on the thoughts and feelings of medieval Jews, a beleaguered minority in triumphantly Christian Europe, striving to preserve their own customs and way of life, and doing it here by reclaiming Judith, the Jewess, as their own.[30]

30 I wrote this paper before reading Leslie Abend Callaghan, "Ambiguity and Appropriation: the Story of Judith in Medieval Narrative and Iconographic Traditions," in Francesca Canadé Sautman, Diana Conchado, and Giuseppe di Scipio (eds.), *Telling Tales: Medieval Narratives and the Folk Tradition* (New York: St. Martin's Press, 1998). Callaghan reads some of the medieval Judith midrashim as expressing a Jewish reappropriation of Judith, although she does not go so far as reading it as anti-Christian polemic.

Appendix to Chapter 6

Megillat Yehudit (the Scroll of Judith)

To be said on *Hanukkah*

Manuscript and editions

The single manuscript of *Megillat Yehudit* is at present in the Bodleian Library in Oxford: A. Neubauer *Catalogue* no. 2746 = Heb. e. 10, fol. 66v–72v. Neubauer's catalogue notes that this document is bound together with *Megillat Antiochus* and other documents, one of which includes four sentences in Provençal. Below the title, *Megillat Yehudit*, is the instruction, written in smaller letters: "to be said on Hanukkah." The manuscript is dated by its colophon to [5]162, i.e. 1402 c.e., and written in Hebrew in a fine regular hand, which Neubauer describes as "Provençal rabbinic." Dubarle, who has edited many of the different versions of the story of Judith, calls it *Megillath Judith de style anthologique* (his no. 8).[31] As he points out, 1402, when the manuscript was copied by Moses Shmeil Dascola, is not necessarily the date of redaction.

The Hebrew text has been published twice in full by A.M. Habermann as "Megillat yehudit le-omrah be-hanukkah," *Mahanayim* 52 (1961), pp. 42–47 and in his *Hadashim gam yeshanim: hiburim shonim mi-tokh kitvei yad be-tziruf mevo'ot ve-he'arot* (Jerusalem, 1975), pp. 40–46. The second part of the manuscript only, with the story of Judith, was published by A.M. Dubarle: *Judith: formes et sens des diverses traditions II: textes* (Rome, 1966), pp. 140–53, with a French translation. There is a microfiche of the whole manuscript in the National Library in Jerusalem.

Translator's note

It is interesting that the act of translating attracts metaphors of the female body. My male Greek teacher used to say of translations that they are like women: if they are beautiful they are unlikely to be faithful, and if they are faithful they are unlikely to be beautiful. I fear this translation is neither:

31 André Marie Dubarle, *Judith: Formes et sens des diverses traditions*, i: *Études* (Rome: Institut Biblique Pontifical, 1966), pp. 92–94. Biblical books are referenced with the short titles following the Chicago style (cf. index under "Bible").

it is certainly not scientific. My excuse is that this is a preliminary transla-
tion, aimed at giving readers who are not familiar with the original Hebrew
some idea of *Megillat Yehudit*. As the writer Shai Agnon said, reading a
Hebrew work in translation is like kissing a bride through her veil. Hebrew
words carry with them a biblical load, all the more so when the work is
written, as here, almost entirely as a string of biblical quotations and allu-
sions. I have noted over three hundred scriptural citations, shown in *italics*,
and I am sure there are more. It would be interesting to analyze them all
and their intertextual effect. I have made a start on the group of references
to women and food in my paper above.

I have used all three published texts of *Megillat Yehudit* as well as the
microfiche for this translation. For the biblical quotations I have made use
of three translations of the Hebrew Bible: the Revised Standard Version;
the New English Bible and the Jewish Publication Society's Tanakh. None
of them is wholly satisfactory in the new context of *Megillat Yehudit*. Note
that changes of person and number of the verb, and other grammatical
infelicities are typical of this document. Many of these are due to the use of
quotations, which the author does not always adapt to the new context. I
am grateful to Deborah Gera for her critical reading of this translation and
her helpful suggestions.

* * * *

You also, son of man, take[32] *a written scroll,*[33] *feed your stomach and fill your belly
with*[34] *what I give you,*[35] *and it will be as sweet as honey in your mouth.*[36] And
bless *the Lord your God who has dealt wondrously with you.*[37] *He has laid the
nations prostrate beneath us*[38] *and those who spoiled us will be our spoil.*[39] *He has
rescued us from our foes and has raised us clear of our enemies.*[40] *Is it not known
in all the world,*[41] *that God has put us to the test, to see whether we follow his law,
or not?*[42] And we have not ceased our service, *but we are weary and have been
allowed to rest.*[43]

32 Ez 4:1.
33 Ez 2:9.
34 Ez 3:3.
35 Ez 3:3.
36 Ez 3:3 (slightly changed).
37 Jl 2:26.
38 Ps 47:4 [3].
39 Jer 30:16.
40 Ps 18:49.
41 Is 12:4.
42 Ex 16:4 (and cf. Dt 13:4).
43 Lam 5:5.

It came to pass, at the beginning of the Kingdom of Jerusalem, that a certain duke burned with desire for Jerusalem and its people, and he went up to Jerusalem, and all his court with him. *Then he besieged it, and built a siege-ramp,*[44] and he did not allow any man to go out or come in. Thus *they were besieged for many days.*[45] *And the famine grew more severe for them and the city was broken up.*[46] Then the duke entered Jerusalem and he prevailed over it and captured it, together with all the fortified cities in Judah. Thus they put their hand under his hand and surrendered. Then *he placed his throne above*[47] the throne of the kings who had been in Jerusalem and *he was triumphant and smote*[48] Israel and *possessed their land.*[49] He took the treasures of the House of God and the treasures of the king,[50] and *imposed a punishment on the land:*[51] *the people of Judah and Benjamin*[52] *could no longer raise up their heads and they were subdued.*[53]

Then he consulted his officers and his[54] nobles and *they behaved wickedly,*[55] saying: "This is the *counsel we counsel:*[56] *the land has been made over to us as our property,*[57] now *let us take their daughters for ourselves*[58] *and they shall take home their lives and nothing more.*[59] *On this condition they will consent*[60] *and we shall become one people."*[61] *Their words pleased*[62] him, and *he deferred not,*[63] for he *desired the daughter of Jacob.*[64]

So he sent and called all the people of Judah and Jerusalem,[65] and they all came to the king. [And the king said to them]: "Listen to me, you stubborn of heart, who are *far from*[66] *salvation.*[67] I am a god and I sit throned like a god.*[68] There is none

44 Ez 4:2 and cf. 2 Kgs 25:1; Jer 52:4.
45 Dt 20:19.
46 Jer 52:6–7.
47 Est 5:1.
48 1 Sm 14:48.
49 Cf. Jer 49:1–2.
50 2 Kgs 24:13 etc.
51 2 Kgs 24:33.
52 Neh 11:4.
53 Jgs 8:28.
54 2 Chr 32:3.
55 Dn 12:10.
56 Is 14:26.
57 Ez 11:16.
58 Gn 34:16 (slightly changed).
59 Jer 21:9 etc.
60 Gn 34:15 (slightly changed).
61 Gn 34:16 (slightly changed).
62 Gn 34:18 (slightly changed).
63 Gn 34:19.
64 Gn 34:19 [RV: had delight in].
65 2 Kgs 23:1–2.
66 Is 46:12.
67 Is 46:13.
68 Ez 28:2.

like me, and there is none able to save you except for me.[69] *I reveal the end from the beginning, what is to be. I say that my purpose shall take effect, I will accomplish all that I please.*[70] *I will give counsel in Zion and my glory to Israel.*[71] *All the king desires as bride-price is*[72] *spoil of dyed cloths, spoil of embroidered cloths,*[73] *a damsel or two for each man.*[74] *Listen to this,*[75] *O daughter of Israel, who loves luxury, and sits*[76] *in her house perfect in beauty,*[77] *and fair to look upon:*[78] if you are destined to marry a man, his friends must bring you [first] to me and I will know you*[79] These two *will not please me:*[80] *a widow, or a divorced woman: these he shall not take, but a virgin of his people.*[81] *Hear this, O House of Jacob,*[82] *behold I have refined you but not with silver, I have tested you,*[83] *and if your ear is not opened,*[84] *know what I shall do to you:*[85] *I shall slay your young men with the sword,*[86] and I will cause your officers and judges to be trodden down. *I will turn my hand upon you,*[87] *and I shall burn all your fortresses.*[88] *Behold, I teach you for your own advantage, in the way you should go.*[89] *Take counsel together and speak."*[90]

He gave them three days' time, *but they did not speak to him either good or evil,*[91] and went away from him *heavy and displeased.*[92] Then the children of Israel *saw they were in trouble:*[93] *they had no power to flee this way or that way,*[94] *and they found no answer.*[95] *Thus they took longer than the time he set them.*[96]

69 Cf. Is 45:21 and 46:9.
70 Is 46:10.
71 Is 46:13.
72 1 Sm 18:25.
73 Jgs 5:30.
74 Jgs 5:30.
75 Is 47:8.
76 Is 47:8.
77 Ps 50:2.
78 Gn 26:7; 2 Sm 11:2; Est 1:11 etc.
79 The editor notes that the text is unclear here, but this is the meaning he proposes, i.e., that the king should spend the first night with a virgin bride.
80 1 Kgs 9:12.
81 Lv 21:14.
82 Is 48:1.
83 Is 48:10.
84 Is 48:8.
85 1 Kgs 20:22.
86 2 Kgs 8:12; Am 4:9.
87 Is 1:25.
88 2 Kgs 8:12.
89 Is 48:17.
90 Is 8:10.
91 Gn 31:24.
92 1 Kgs 20:43.
93 Ex 5:19.
94 Jo 8:20.
95 Jb 32:4.
96 2 Sm 20:5.

So he sent and called them, and he bound them and *put them in the prison-house.*[97] *When he brought them out of prison,*[98] he said to them: "I declared the *former things from the beginning and they went forth from my mouth,*[99] because I *knew that you are obstinate and your brow brass.*[100] *But for the sake of my name I will control my wrath, I will not destroy you. Turn back to me,*[101] *and I will make you high in praise and in name and in honour."*[102]

They all answered at once with *stammering lip and in a different tongue,*[103] saying: "As you say, O lord king, *we are in your hands, to do as you please."*[104] *They stooped, they bowed down together, they could not deliver the burden.*[105] *The beautiful virgins fainted*[106] and said tearfully: "God has found out our *sins and given us as spoil,"*[107] *and they wept sore.*[108]

But the king's command remained firm,[109] and he took them out to his house, and he defiled them by *lying with the women.*[110] Then *the women who had been at ease*[111] said: "*How long will this one be a snare for us?*[112] Would it not be better for us to cease to marry so we should not have to lie with him?" *And they did so.*[113] *Then there ceased in the city*[114] *the voice of mirth and the voice of gladness, the voice of the bridegroom and the voice of the bride.*[115]

This was so for many days: they did not come as in the earlier days, and he was very surprised and *his wrath was kindled.*[116] So he sent and called to the men of the city: "Was this not what I said at first, that you were *stubborn and you turned and did not face me?*[117] By my head! *You are destined for death, for you did not observe*[118] my commandments. It would be better for you if some-one else were to rule you, rather than my men should rule you! You should know therefore, that [the women] *will be their prey."*[119]

97 2 Chr 16:10.
98 Ps 142:8.
99 Is 48:3.
100 Is 48:4.
101 Jl 2:12.
102 Dt 26:19.
103 Is 28:11.
104 Jo 9:25; Jer 26:14.
105 Is 46:2.
106 Am 8:13.
107 Is 42:24.
108 Jgs 21:2 etc.
109 2 Sm 24:4.
110 Zec 14:2.
111 Is 32:11.
112 Ex 10:7.
113 Gen 42:20 etc.
114 Jer 7:34.
115 Jer 7:34.
116 Gn 39:19 etc.
117 Jer 2:27; 32:33.
118 2 Sm 26:16.
119 2 Kgs 21:14.

They replied: "Far *be it from your servants*[120] to cease to do your pleasure. We ceased to *give our daughters in marriage*[121] for we no longer have money to give away our daughters, and because of that *they are debarred from marrying.*"[122]

Then *the worthless man [son of Belial]*[123] answered: "I will try you this time and see *if you are honest.*[124] So go back to your tents and I will command you saying: 'A proclamation shall go forth in Judah and the land of Jerusalem: Every man and woman who do not marry, each of them brings blood on his house, *there is one law for him – he shall be put to death.*'"[125]

Then *there was a second time a veil of tears.*[126] *Trembling, they turned to one another,*[127] *and the counsel* of the women *came to nought.*[128] Thus when the women were married, they would take them to the house of the king and he lay with *crowds of women.*[129] And it came to pass in those days *there was in the city a great upheaval,*[130] and the daughters of Israel *were shut up unto the day of their death, living in widowhood.*[131]

And it came to pass *out of their affliction*[132] they were humbled and returned to God, *with all their heart and with all their soul.*[133] Then *God heard their voice*[134] from his abode, and *he gave them a saviour,*[135] Judah. This man was greater than all men of old, *a mighty hero and man of war.*[136] *He had a beautiful sister,*[137] *of good understanding.*[138] Now her brother decided to give her to a man [in marriage], and he betrothed her, *and all the city was amazed.*[139] When she heard, *she wept and pleaded with him,*[140] not to be given to a man: "lest you should take me and I should fall into the hands of this uncircumcised one, and *I, how shall I suffer my shame? And you will be like one of the scoundrels of*

120 Gn 44:7.
121 Ru 1:13.
122 Ru 1:13.
123 Jgs 19:22 etc.
124 Gn 42:12; 33.
125 Est 4:11.
126 Mal 2:13.
127 Gn 42:28.
128 Is 8:10.
129 Ex 38:8. The meaning of the scriptural word *tzova'ot* is uncertain: "crowds" is the interpretation of the Jewish medieval commentator Rashi.
130 1 Sm 5:9.
131 2 Sm 20:3.
132 Hos 5:15.
133 Dt 6:5.
134 'their voice' is found in the manuscript, but was missed out by Habermann in his edition.
135 2 Kgs 13:5.
136 1 Sm 16:18.
137 2 Sm 13:1.
138 Prv 3:4 etc.
139 Ru 1:19.
140 Est 8:3.

Israel.[141] *Of you the tale-tellers will say:*[142] *'Judah has broken faith, and a shameful deed has been done,*[143] *they took his sister and violated her.'"*[144]

When he heard the words of his sister, *they weighed on him,*[145] *and his wrath was kindled.*[146] *He put on his sword-belt*[147] and went to the king's house. He was sitting on his throne and his officers were on his right and on his left. When he saw him *belted with his sword close to him,*[148] *he derided him,*[149] *saying: "Is it well with you, Judah?*[150] Bring your sister *so we can know her."*[151] But he replied: *"What concern of yours is it whether it is well? Turn behind me.*[152] *Should my sister be treated like a whore?"*[153] Then he drew his sword and *he cut off his head*[154] with all the officers, and he put all the servants of the king to the sword.

Then he went out from there, and *blew the* shofar *[ram's horn],*[155] and the children of Israel assembled as one man. And he said: *"Follow me, for God has given all our enemies into our hands."*[156] So they went out, and they smote man against man, *and they shouted.*[157] Then they [the enemy] *fled*[158] *and the camp was secure,*[159] *and not a man of them remained.*[160] And there was joy in Israel, *for the Lord had made them to rejoice over their enemies,*[161] *and they dwelt in their tents as beforetimes.*[162]

When the great king Aliphorni [Holophernes] heard that his brother was dead because the children of Israel had smitten him, and *taken some of them prisoners,*[163] *his wrath was kindled*[164] and he *burst into wild and bitter sobbing.*[165] He

141　2 Sm 13:13.
142　Nm 21:27.
143　Mal 2:11.
144　2 Sm 13:13; cf. 2 Sm 13:22.
145　Jgs 16:16.
146　Gn 39:19 etc.
147　2 Sm 20:8.
148　2 Sm 20:8.
149　1 Sm 10:27.
150　Cf. 2 Sm 20:9: Is it well with you, my brother?
151　Cf. Gn 19:5.
152　2 Kgs 9:18.
153　Gn 34.31.
154　1 Sm 17:51; 2 Sm 20:22.
155　Jgs 3:27; 2 Sm 20:1, etc.
156　Jgs 3:28.
157　1 Sm 17:52.
158　Jgs 7:21.
159　Jgs 8:11.
160　Nm 26:65.
161　2 Chr 20:27.
162　2 Kgs 13:5.
163　Nm 21:1.
164　Gn 39:19,etc.
165　Gn 27:34.

assembled his camp, a *multitude of people*,[166] *as numerous as the sands of the sea*.[167]

Then the children of Israel *realized they had incurred the wrath of*[168] the king Aliforni, and they feared greatly for their lives. So they built fortresses in all Judah and Jerusalem, and they prepared missiles and many shields and they strengthened the lookouts of their walls and they made towers to put large stones in them. They put a garrison and men of war in each and every town and in Jerusalem, *proclaimed a fast*[169] and prayed to God.

Then Aliforni went up to Jerusalem, he and all his army with him and Israel saw that his camp was very numerous and they feared greatly. Every day he went around the wall with his officers and *his horsemen, his generals and his chariot*.[170] They *sounded great trumpet blasts*[171] *to frighten them into panic*.[172] Thus they did for many days.

Then a man of Israel who was on the wall spoke out, and cried: "*Help, my lord, O king!*[173] Make a treaty with us and we will make you our king. *Silver and gold will not be accounted*,[174] but you should be our support and come to the city and reign over us. And we together *will bow down to your footstool*."[175]

Then [Aliforni] *called loudly to them in the language of Judah*:[176] "O house of Israel, *have you not killed my people?* [177] I seek *the blood of my brother*[178] from you. *If a man were to give all the substance of his house*[179] *it would not save him from me*.[180] I shall destroy the cities of your land and demolish all your *fortresses*[181] *and I shall do it with anger and rage*[182] *and by no means clearing the guilty*.[183] *I shall make you a desolation and the inhabitants an object of hissing and you shall bear the*

166 1 Kgs 3:8.
167 1 Kgs 4:20.
168 1 Chr 19:6.
169 Jon 3:5.
170 1 Kgs 9:22.
171 Jo 6:5.
172 2 Chr 32:18.
173 2 Kgs 6:26.
174 1 Kgs 10:21.
175 Ps 99:4.
176 2 Chr 32:18. The Hebrew for 'in the language of Judah' is *yehudit*. Cf. also 2 Kgs 18:28.
177 Page 62 of the MS ends here. Habermann thought there was clearly a lacuna in the text, which begins again with Holophernes's speech. However, he read *he-atem ami* "Are you not my people?," perhaps thinking the previous verse referred to a speech by Judith because of the mention of *yehudit*. Dubarle reads *ha-mitem ami* "Have you not killed my people?," which is a slightly adapted quotation from Numbers 17:6 [RV 16:41]. This has the advantage of making the whole speech belong to Holophernes, without any lacuna.
178 Gn 4:10.
179 Sg 8:7.
180 2 Chr 32:17.
181 Mi 5:10.
182 Jer 21:5.
183 Nm 14:18.

reproach of my people.[184] I will not return to the house of my kingdom until *I have executed my vile designs.*[185] I shall carry out what I have sworn. I will not stay my sword from blood and *I will wreak vengeance on my foe."*[186]

The man replied *saying: "Let not him who girds on his sword boast like him who puts it off it.*[187] *For I will look to the Lord, I will wait for the God of my salvation."*[188]

On that day Aliforni returned to his tent which he had pitched to sit in. For many days he sat in his tent with his officers and the nobles of the country. Then there came before him, *wondrous in purpose and mighty in deed,*[189] an *honourable man and a counsellor, a cunning artificer and an eloquent orator.*[190] He spoke to the king: "*Let my supplication be accepted before you:*[191] *I would, my lord,*[192] *that we should arise and go*[193] to our home and our land, so we shall not perish sitting in tents and fighting with *the inhabitants of this coastland.*[194] *Do you not know? Have you not heard*[195] what he did to Sihon and Og and the inhabitants of their countries,*[196] all the thirty-one kings? *They defeated them and took possession of their territories:*[197] the Negeb, the Shephelah, the Arabah and all the seacoast.*[198] Every people who will make them tremble will fall by the sword. For behold! God will *take up their cause and rob him who robs them of their livelihood.*[199] My father, see, O see, the shame of your brother, his shameful acts. God has made them *recoil on his own head.*[200] For the Lord their God is the God of gods and Lord of lords,*[201] and the earth is the Lord's and all that is in it.*[202] *Who can contend with what is mightier than he?*[203] God will fight for them. The

184 Mi 6:16.
185 Jer 11:25.
186 Dt 32:43.
187 1 Kgs 20:11.
188 Mi 7:7.
189 Jer 32:19.
190 Is 3:3.
191 Jer 37:20.
192 2 Kgs 5:3.
193 1 Sm 9:9.
194 Is 20:6.
195 Is 40:28.
196 Cf. Dt 31:4.
197 Jo 12:1.
198 Dt 1:7.
199 Prv 22:23. A version of the expression *yariv rivam* [(God) will take up their cause] is also found in the past tense *ravta et rivam* in the Babylonian Talmud Megillah 21b as part of the blessing to be said before the reading of *Megillat Esther* on Purim. At some stage it was transferred to Hanukkah, where it has been said as part of the blessing *Al haNissim* at least since the Mahzor Vitri (ed. A. Goldschmidt, Jerusalem, 2004) in the eleventh century.
200 Jl 4:7 (3:8).
201 Dt 10:17.
202 Ps 24:1.
203 Eccl 6:10.

prophets prophesied to them, saying: *'Hill of Zion's daughter, the promises to you shall be fulfilled; your former sovereignty shall come again to the daughter of Jerusalem.*[204] *If you be mine and will hearken to my voice*[205] each man will go back to his own land.'"[206]

When Aliforni heard the words of this man *he was very wrathful,*[207] and he said: *"You man of blood*[208] *you are telling me a lie.*[209] *You have gone over to*[210] the Jews." The officers were angry with him also, saying: "You have come *to discourage the soldiers.*[211] *Among all the gods of the nations is there one who saved his land from me? And how will he save Jerusalem?"*[212] So they seized him, and swore: "By the life of our lord the king, *he deserves to die!"*[213] The king added: "Because he spoke well of the Jews, *according to this judgement I shall do to him,*[214] *I have decided it.*[215] Go and hang him up *beyond the gates of Jerusalem*[216] *his hands bound and his feet thrust in fetters.*[217] You shall not put him to death, but leave him *to hunger and thirst,*[218] to heat by day and to frost by night.[219] And on that day the inhabitants of Judah and Jerusalem will see my revenge: *my servants shall eat and he will starve, my servants shall drink and he will cry out from sorrow,*[220] *and I will strike him once: I shall not have to strike twice.*[221] Let him come and *deliver him!*[222] *Who will save him from my hands?"*[223]

Then he commanded his servants saying: *"Bind him with new ropes,"*[224] and they strung him up and left him.

He lifted up his eyes to heaven and said: *"Now I am ready to die after I have seen*[225] the revenge of Aliforni and his people." He *stood between heaven and earth*[226] *for three days and three nights and had no bread to eat, nor water to drink.*[227]

204 Mi 4:8.
205 2 Kgs 10:6.
206 Cf. Is 13:14; Jer 15:16.
207 Gn 39:19 etc.
208 2 Sm 16:7.
209 Cf. Jer 40:16; 43:2.
210 Jer 37:13.
211 Jer 38:4.
212 Is 36:20.
213 1 Sm 20:31; 2 Sm 12:5.
214 Ex 21:31.
215 1 Kgs 20:40.
216 Jer 22:19.
217 2 Sm 3:34.
218 Dt 28:48.
219 Jer 36:30.
220 Is 65:13–14.
221 1 Sm 26:8.
222 1 Sm 4:3.
223 Cf. Is 36:20.
224 Jgs 15:13.
225 Gn 46:30.
226 1 Chr 21:16.
227 1 Sm 30:12.

On the third day *a woman of the wives of the sons of the prophets,* whose name was Judith, *cried out*[228] to God, and prayed, and fasted, and beseeched him: "Please, Lord, *who performs kindness to thousands!*[229] *Remember David's loyal service in faithfulness!*"[230] After she had prayed, *the spirit of God suddenly seized her*[231] and she took it to her heart.

Then she said to the gatekeeper of the city: "Open the gates of the city. Perhaps God will be with me and *will deliver us from the hand of our enemies.*"[232] But the gatekeeper said: "*Why are you going so quickly?*[233] *Have you gone over*[234] to the camp of Aliforni? Will you *play the whore with him? Will you betray [us] with your lover?*"[235] Judith replied saying: "*I have mortified myself with fasting*[236] and *poured out my complaint before the Lord.*[237] *Let me go,*[238] for it is time to act for the Lord.*"[239] The gatekeeper saw her *good sense*[240] and said: "Go, and the God of your fathers be with you." And he opened the gate secretly and she went out, herself and her two maids *and he closed the door behind them.*[241]

When the lady went out, herself and her two *maids in attendance,*[242] she *put on royal apparel*[243] and *set a royal diadem on her head*[244] and *dressed her hair.*[245] Her glory increased and her beauty grew, and Judith *won the admiration of all who saw her.*[246] She left and came to the camp of Aliforni, where *they saw her and praised her to*[247] the king. Then she asked, saying: "Where is the king's house?" So they went with her, *a very large army.*[248]

And it came to pass, when she came to the king, she bowed down before him to the ground. When he saw her, *she found favour in his eyes*[249] and he was amazed and asked: "*Whose girl is this?*"[250]

228 2 Kgs 4:1.
229 Ex 20:6; Jer 32:18.
230 This is a combination of 2 Chr 6:42 and Is 55:3.
231 Jgs 14:6.
232 1 Sm 4:3.
233 Gn 27:20.
234 Jer 37:13.
235 Ez 23:5; Jgs 19:2.
236 Ps 35:13.
237 Ps 142:2.
238 Jgs 16:26.
239 Ps 119:126. It is common in rabbinical literature for a quotation of one half of a scriptural verse to refer also to the other, unquoted part.
240 1 Sm 25:32.
241 Gn 19:6.
242 1 Sm 25:42.
243 Est 5:1.
244 Est 2:17.
245 2 Kgs 9:30.
246 Est 2:15.
247 Gn 12:15.
248 2 Chr 24:24.
249 Est 2:17.
250 Ru 2:5.

She answered, saying: "I am one of the daughters of Israel. I am come to you today to go over to you and implore you, *if your handmaid has found favour in your eyes,*[251] *spread your robe over your handmaid.*"[252]

The king said: "Ask me, sister, *what is your wish and what is your request? Even to half my kingdom it shall be fulfilled.*"[253]

[She replied] "My lord the king, your handmaid has an old father, he is a man of God *of the sons of the prophets.*[254] He *arose from within the people and stood on the top of the Mount*[255] *of Olives*[256] and said: '*Hear now*[257] my words, which my God sends to you: "Now on whom do you trust, that you rebel against*[258] the great king Aliforni, my servant? *If you surrender to him you shall escape with your life and live.*"[259] And if you do not listen to my words, at this time tomorrow, my servant Aliforni will come and *sit on the throne of David*[260] and *rule with great dominion.*[261] You will not be saved from his hand and *he will rip up your women with child and dash your children,*'[262] says the Lord." When they heard him they were afraid because of what he said, and they pursued him. So he went and sat on one of the hills *to see what would become of the city,*[263] and he commanded me: 'Go, flee for your life, and go to the great king. Take him all this message and speak for me well before the king, so *I too will escape*[264] because of you." Now I have come. *Hear my supplication!*[265] When you come to the city, *save alive my father and my mother and my brethren,*[266] and *I will be as one of your handmaids.*"[267]

When Aliforni heard the words of the girl, *he rejoiced greatly,*[268] and said: "Do not fear for I will do what you desire and *I will deliver your lives from death.*[269] *You will be in charge of my household*[270] and *reign over all your soul desires*[271] and your father – I *shall make him my body guard for ever.*[272] *Come now,*

251 1 Sm 1:18.
252 Ru 3:9.
253 Est 5:6; 7:2.
254 2 Kgs 4:1.
255 1 Kgs 14:7; Jgs 9:7 and cf. Gn 19:30.
256 Zec 14:4.
257 Jgs 9:7.
258 Is 36:5.
259 Jer 38:2. cf. n. 29.
260 1 Kgs 2:12.
261 Dn 11:3.
262 2 Kgs 8:12, in the reverse order.
263 Jon 4:5.
264 Gn 19:20.
265 Jer 37:20.
266 Jo 2:13.
267 Ru 2:13.
268 1 Kgs 5:21 [5:7].
269 Jo 2:13.
270 Gn 41:40.
271 1 Kgs 12:37.
272 1 Sm 28:2.

lie with me my sister,[273] for it is a great love I have for you, *a love with all its rapture.*"[274]

Judith answered, saying: "By your leave, by your great *splendour,*[275] lest *you pour out [your] fury in blood,*[276] but tonight I shall *cleanse myself from my issue*[277] and *I shall wash my hands in innocence.*[278] *Until evening withhold your hand.*"[279]

Then he said: "As you say, my sister. But *do not hinder me*[280] tonight, *wash and make yourself clean.*"[281]

"*Two things I ask of you,*[282] my lord, I pray you, *do not refuse me,*[283] or let me go away *empty-handed.*[284] Remove *your men's tents,*[285] so that they distance themselves from us *a bowshot's length away,*[286] lest the soldiers should see us embracing,[287] and say what they have seen and we should be demeaned in their eyes. Even if the soldiers see us[288] in the springs and streams, let them not touch us or talk."

And he said: "Good," *for he desired the daughter of*[289] the Jews.[290] *So he made a proclamation aloud*[291] in all the camp and they kept a long distance from them, for *they feared for their lives.*[292]

Then Judith said: "I am thirsty and have been *humbling my soul with fasting.*"[293] So she said to her maid: "*Cook*[294] me *two pancakes so I can eat at your*

273 2 Sm 13:11.
274 Sg 7:6 [7].
275 Ez 28:17.
276 The meaning is somewhat unclear here. The reference to blood seems to be an indirect hint of menstruation, and was taken as such by Habermann. Cf. Ez 14:19.
277 Lv 15:28. The word "from my issue," *mizovi,* is omitted by Habermann, but present in Dubarle and the microfiche of the MS.
278 Ps 26:6.
279 Cf. Eccl 11:6.
280 Gn 25:56.
281 Is 1:16.
282 Prv 30:7.
283 1 Kgs 2:20.
284 Ex 23:15.
285 Nm 16:26.
286 Gn 21:16.
287 The text is unclear here. I have followed the slight re-ordering proposed by Dubarle.
288 Here presumably Judith means herself and her maid, not herself and Holophernes.
289 Gn 34:19.
290 *bat yehudit.*
291 2 Sm 19.5 and many other places.
292 Jo 9:24 and cf. Jo 9:22.
293 Ps 35:13.
294 2 Sm 13:8.

hands."[295] She made her the pancakes and salted them heavily and poured them into the pot with *pieces of cheese.*[296] She took them and *brought them to the room*[297] where Holophernes was.

And Holophernes *made a great banquet,*[298] *the feast of Judith,*[299] *and he ate*[300] the pancakes and the *pieces of cheese.*[301] *He drank too, and his heart was merry.*[302] *He got drunk and he uncovered himself in his tent,*[303] *and he lay down and slept.*[304]

When Judith saw that *he had been drinking himself drunk*[305] and that *he had fallen to the ground*[306] *and there was no-one with him in the house,*[307] she *rose to her feet.*[308] *She spread forth her hands toward heaven and said:*[309] *"O Lord, I beseech, you prosper your handmaid this day.*[310] *Let my own hand save me!"*[311] *Then she took the sword*[312] *and went softly to him, for he was fast asleep.*[313] Then *she held up her right hand and her left hand*[314] and *she smote his head*[315]*, she smote him and killed him*[316] and she *cut off his head*[317] and she put it *wrapped up*[318] in her clothes. Then she went with her maids *beating timbrels*[319] and rejoicing to *the crossroads.*[320] The people of the camp *saw her and they were afraid to come nigh to her.*[321] And they came to the gates of Jerusalem.

They cried to the gatekeeper: Open for *the woman beloved of her friend*[322] and he opened for her and she showed him the head. So he gathered together all the people of the city, and they did not believe it. They said: "Perhaps

295 2 Sm 13:6.
296 1 Sm 17:18.
297 Cf. 2 Sm 13:10.
298 2 Kgs 6:23.
299 Judith is here substituted for Esther in Est 2:18.
300 Ru 3:7.
301 1 Sm 17:18.
302 Ru 3:7.
303 Gn 9:21.
304 Jon 1:5.
305 1 Kgs 16:9.
306 Jgs 3:25.
307 Gn 39:11; 1 Kgs 3:18.
308 2 Kgs 13:21.
309 1 Kgs 8:22.
310 Neh 1:11.
311 Jgs 7:2.
312 Jgs 3:21.
313 Jgs 4:21.
314 Dn 12:7.
315 Jon 7:8.
316 1 Sm 17:49.
317 1 Sm 17:51.
318 1 Sm 21:10.
319 *metofefot.* Cf. Ex 15:20.
320 *petah ha-einayim.* Gn 38:14 (RV: in an open place).
321 Ex 34:30.
322 Hos 3:1.

she found a head thrown onto the road and brought it to us."

Then she said: "*If you will not listen to me and my voice,*[323] *I will take faithful witnesses.*[324] Here, *drawn and cast forth beyond the gates of Jerusalem,*[325] *is a mighty valiant man,*[326] *a counsellor of the king*[327] who ordered him to be hung up by his hands because he spoke well of the Jews to the king. So *they ran and fetched him*[328] and *gave him food and drink, and his spirit came to him again.*[329] Then they showed him the head, and he said: '*Blessed be the name of the Lord,*[330] for he has taken my vengeance on Aliforni. *Know now*[331] that Aliforni *is not alive but dead.*'"[332]

When they heard the words of the herald *they bowed down to God.*[333] Then all the men of war gathered together and *went forth as the sun*[334] girded *with swords,*[335] and *they fell upon them suddenly*[336] and fought them. Then the mighty men of Aliforni saw how it was and went to the tent of Aliforni, but they found the opening closed. Then *they waited until they were ashamed to delay any longer,*[337] and *they cried aloud and there was no answer.*[338] So they opened up and saw their lord fallen down dead on the earth.*[339]

Then *God discomfited them with a great noise*[340] and they fell back and *many were overthrown:*[341] *there remained not so much as one of them.*[342] So let all our enemies perish, O Lord!*[343] They returned that day joyful and glad of heart for all the goodness that the Lord did [344] for us.

Then Judith became *queen over the land*[345] and *judged Israel.*[346] Because

323 2 Kgs 10:6 (this verse is part of the story of cutting off the heads of the seventy sons of the wicked king Ahab).
324 Is 8:2.
325 Jer 22:19.
326 1 Sam 16:18; Ru 2:1 etc.
327 2 Chr 25:16.
328 1 Sm 10:23.
329 1 Sm 30:11–12.
330 Ps 113:2.
331 2 Kgs 10:10.
332 1 Kgs 21:15.
333 Gn 24:26 etc.
334 Jgs 5:31.
335 2 Sm 20:8.
336 Jo 11:7.
337 Jgs 3:25.
338 1 Kgs 18:28–29.
339 Jgs 3:25.
340 1 Sm 7:10.
341 Jgs 9:40.
342 Ex 14:28.
343 Jgs 5:31.
344 1 Kgs 8:66.
345 2 Kgs 11:3.
346 Jgs 4:4.

of this the children of Israel shall make *a very great feast*[347] in their *pots and cauldrons,*[348] with *pieces of cheese,*[349] *gladness and feasting, a good day, of sending portions to one another,*[350] *baked pieces,*[351] food from the frying pan and *dough kneaded until it is leavened*[352] so its glory will grow with honey, *all manner of baked goods,*[353] a wafer, for a memorial to the *man who meddled in a quarrel which was not his*[354] and *the drinking was according to the law: none did compel, for thus the*[355] Queen Judith *had appointed to all the officers of [his] house, that they should do according to every man's pleasure.*[356] *The Jews ordained and took it upon themselves*[357] *to confirm this letter*[358] *to make a day of feasting and joy and a good day.*[359]

And now O Lord, as you were with our fathers, so be you with us, and *bring our souls out of prison.*[360] *Therefore we will look to the Lord, and wait for the God who saves us.*[361] *Behold the Lord will announce to Zion: Behold your Saviour is coming! Behold his reward is with him!*[362] *And they shall be called: The holy people, The redeemed of the Lord.*[363] Amen, Amen, Selah.

The writing of this book was finished by Moses Shmeil[364] Dascola on the 30th day of the month of Sivan, [5]162.[365]

Blessed be the Lord who teaches my hand to bring near from on high all blessing and praise. Amen, Amen, Selah.

347 2 Kgs 6:23.
348 2 Chr 35:13.
349 1 Sm 17:18.
350 Est 9:22.
351 Lv 6:14 [6:21].
352 Hos 7:4.
353 Gn 40:17.
354 Prv 26:27. The reference here is presumably to Aliforni taking up his brother's quarrel with the Jews.
355 Est 1:8.
356 Est 1:8.
357 Est 9:27.
358 Est 9:29.
359 Est 9:22.
360 Ps 142:8 [7].
361 Mic 7:7.
362 Is 62:11.
363 Is 62:12.
364 Habermann has *Shtzeil* here in the text in *Hadashim gam Yeshanim*, but writes *Shmeil* in his comment in his article in *Mahanayim* (p. 43). Examination of the micro-fiche copy of the MS shows either reading is possible, but *Shmeil* seems preferable as a variant of the name *Shmuel* [Samuel].
365 162 = 5162 A.M., i.e. 1402 C.E.

7. Shalom bar Abraham's Book of Judith in Yiddish

Ruth von Bernuth and Michael Terry

The relative inattention to the internal effects of the Reformation on the Jews is no doubt in part due to the dearth of sources available to scholars. This neglect has also been due in part to the assumption that Jewish and Christian interaction was limited. If one begins with the assumption that Jews and Christians were heavily involved with one another throughout the later Middle Ages and early modern period, and if one is ready to read the limited sources available with new questions in mind, it may in fact be possible to say something more about Jewish responses to the Reformation.[1]

The Book of Judith, first printed in Hebrew in Istanbul in 1552, is next found in Hebrew type in a Yiddish translation printed in Cracow in 1571, with an explanatory title page in lieu of a simple title:

> I have published[2] this little book in honor of all women: the story of the pious Susanna, who did not want to lie with the judges but preferred to be put to death. Also, the story of Judith, which is not fully explained in the Hanukkah hymn.[3] Therefore, you pious women, you should definitely buy it. Then I will print the whole Bible in Yiddish,[4] and many other fine things. So says Shalom bar Abraham, may his rock and his redeemer guard him. Printed by the servant of you all, Isaac ben Aaron of Prossnitz, in the year 5331, on the 11th day of the month of Iyyar,[5] in the royal city of Cracow.[6]

1 Dean Phillip Bell in idem and Stephen G. Burnett (eds.), *Jews, Judaism and the Reformation in Sixteenth-century Germany* (Leiden and Boston: Brill, 2006), p. 424.
2 Literally "printed."
3 The Hebrew liturgical poem *Odekha ki anafta,* a *yotser* (hymn) for the first Sabbath of Hanukkah.
4 *In daytshen,* literally "in German." For discussion of the application of this term, see Chava Turniansky's "Yiddish and the Transmission of Knowledge in Early Modern Europe," *Jewish Studies Quarterly* 15:1 (2008), pp. 5–18.
5 Sunday, May 16, 1571.
6 דאש ביבלי האב איך אלי ווייברן צו אירן לאזן דרוקין | איין שמועה פון דער ורומי שושנה די ניט וואלט
בייא דען ריכֿטיר ליגן אונ׳ וואלט זיך אי לאשין טויטן. דאש אנדרי די שמועה פון דער יודית די אים יוצר

7.1. Shalom bar Abraham, *Shmue fun der vrume Shoshane*, 1571. Title page. Cracow.
Photo credit: National Library of Israel.

Shalom bar Abraham appears here in the role of instigator, sponsor, and promoter, with no translator identified nor reference made to the fact of translation. In the one other book with which he is associated, an edition of the Psalms, accompanied by a reprint of Elia Levita's Yiddish translation and a new simplified digest of two classic medieval Hebrew commentaries, Shalom bar Abraham appears again in this capacity. This time it is implicit, in addition, that this is the full extent of his role, that he is not responsible for the digest of commentaries, and the chances are, therefore, that in the case of the Yiddish edition of the Book of Judith, prefaced by the short story of Susanna, he occupies the same position and is not the translator. The image of him that emerges from his edition of the Psalms, printed in Mantua in 1562, is that of a layman, probably of that city, a pillar of the synagogue and a fan of rabbinic learning, made remarkable by the tenacity of his belief in the potential for what may as well be called Jewish educational outreach

פֿון חנוכה ניט בישיידליך שטיט דרום | איר ורומי וייבר וועלט איר מיר רעדליך אוב קויפֿן דא וויל איך
אויך דאש גנצי עשרים וארבע אין דייטשין דרוקין אוני׳ וויל אנדרי היפש דינג | דאש רעט שלום בר אברהם
יצו. גידרוקט דורך הנט אויער אלר דינר יצחק בן הרר אהרן פֿון פרוסטיץ. אין דען יאר דש מן ציֿלט בוינף
טויזנט אוני׳ דריי הונדרט אוני׳ איינן דרייישיג אויֿלף טאג אין דען חודש אייר. אין דער קיניגליכֿן שטאט קראקא

inherent in the publication of suitably attractive and inspirational literature in Yiddish and basic Hebrew. Women readers, knowing only Yiddish, were greatly underserved, except, it was sometimes alleged, with translations of European chivalric romances. Under these circumstances, the opportunity to present the comparably gripping tales of two Jewish women as heroic as any knight could hardly have been more ideal or appealing.

Iconic in the European host culture of the time, nowhere more so than in northern Italy, Judith and Susanna were relatively little known or celebrated within the indigenous Italian Jewish community or among Ashkenazim, including those in the northern Italian communities of German Jewish immigrant origin for whom this slight publication would initially have been intended. The elevated Judith consciousness of their environment aside, both groups, indigenous Italian Jews and Ashkenazim, were likely to be independently familiar with Judith from one Jewish source only – a likelihood evident in Shalom bar Abraham's title page. The high medieval Hanukkah hymn to which he refers, however, had the double disadvantage of presenting the story of Judith with a minimum of detail and in language that systematically sacrifices intelligibility for abstruseness, in the interests of what may have been esteemed as poetry in eleventh-century Catalonia, but which, recited in the synagogue 500 years later, had little prospect of being comprehended. But even if nothing resulted from this annual recitation beyond mere name recognition, still, that was important, for, as a source of unquestioned authority, the liturgical poem conferred authenticity on Judith – making her story, and, by association, that of the still less familiar Susanna, intriguing and legitimate.

If Shalom bar Abraham's evident Italian milieu seems like an odd fit for the Cracow imprint of his version of Judith, as perhaps it should for a book dated 1571, when Poland represented the periphery of Hebrew printing and Italy its center, then it may come as a relief that, on the strength of a small clue on the title page of the Cracow edition, Chone Shmeruk was able to argue persuasively that this book, itself now extant in only one copy, is merely a reprint of a lost true first edition, produced in Italy no later than 1562.[7] Attention to the content of this otherwise unexamined publication

7 Chone Shmeruk, "Defuse Yidish be-Italyah," *Italyah* 3:1–2 (1982), p. 175; "Defuse Polin be-Yidish," in *Kiryat Sefer* 52:2 (1977), p. 389, reprinted in his *Sifrut Yidish be-Polin* (Jerusalem: Magnes, 1982), p. 79; and "Reshitah shel ha-prozah ha-sipurit be-Yidish u-merkazah be-Italyah," in Itiel Milano, Daniel Carpi, and Alexander Rofe (eds.), *Sefer zikaron le-Aryeh Leoneh Karpi: kovets mehkarim le-toldot ha-Yehudim be-Italyah* (Jerusalem: Mosad Shelomoh Meir, 1967), pp. 119–40.

yields additional evidence in support of Shmeruk's hypothesis, amounting to proof. Remarks here, however, are confined to a description of the translation, and, in the first instance, to the identification of its source. Of this, Shmeruk says only that it corresponds, more or less, to the text of the Apocrypha.[8] Which text of the Apocrypha he does not go on to say.

The options are many, and in many languages, but, given the nature of Old Yiddish as a fusion of German and Hebrew components, versions of the Judith story in those languages are the obvious place to start. Even if, in view of the traditionalist orientation of the publisher, preference for a Jewish source were to be postulated, it nevertheless soon becomes clear that the Yiddish translation was produced without recourse to the Hebrew first edition of 1552 or to any of the Hebrew manuscript material for which A. M. Dubarle and others have claimed descent in unbroken line from a supposed Hebrew or Aramaic original.[9] The Yiddish version proves to have minimal Hebrew content, and the sum of what little there is only encourages the impression that the Yiddish translator was entirely unaware of any of the Hebrew versions of Judith. Decisive, however, is the fact that the points at which the Yiddish and the Hebrew versions diverge from the Vulgate do not correspond.

Turning then to the most prominent of possible German sources, the Luther Bible, first published complete with the Apocrypha in 1534, the discrepancies are even wider, the Yiddish translator remaining closer to the Vulgate than the anonymous translator of Judith employed by Martin Luther. This need be no great surprise, since Luther's radicalism and the secret of his success lay in the precedence he accorded to transparency in the target language ahead of fidelity to the source language. What results from this emphasis on functional equivalence over formal equivalence in the case of the Book of Judith is, as elsewhere in the Luther Bible, a paraphrase of the Vulgate, and in no instance does the Yiddish agree with this

8 A supposition of only *approximate* equivalence to the text of the Apocrypha may be attributable to typographical error, the Cracow Yiddish Judith omitting a new chapter number at the start of chapter seven and again at the start of chapter fifteen. Thus, the chapter designated chapter six includes chapters six and seven, but the text gets back on track after that, with the start of chapter eight numbered as such. Similarly, the chapter designated chapter 14 includes chapters 14 and 15, but this time the slip goes unrectified, and chapter 16, the last chapter of the book, is accordingly numbered chapter 15 in the Yiddish. The result, a fifteen-chapter Yiddish Judith, may therefore appear to differ from the sixteen-chapter Judith of Christian Bibles when it does not.

9 André Marie Dubarle, *Judith: Formes et sens des diverses traditions* (Rome: Institut Biblique Pontifical, 1966).

paraphrase against the Vulgate. There is quite a list of earlier German vernacular Bibles through which one might regress in an increasingly improbable quest for a source, were it not that the Luther Bible's immediate precursor presents a version of Judith with which the Yiddish rendition printed in Cracow is in thorough agreement.

Chief responsibility for production of the Zurich Bible belongs to Huldrych Zwingli's right-hand man, Leo Jud. Zwingli's chief objective was to expedite completion of a Protestant Bible by working on the parts that Luther had still to tackle. Starting in 1525, Zwingli convened the clergy of Zurich five times weekly to interpret the Scriptures in a seminar known as the *Prophezei*. Zwingli would lead the discussion, asssisted by Jud and the Hebraist Konrad Pellikan. At the end of each session, Jud would present the conclusions of the group in the form of a draft translation for Zwingli's review. At the same time, Jud worked on his own on a translation of the Apocrypha. Published by Christoph Froschauer in 1529,[10] it was the last of five volumes that collectively succeeded in making available a Protestant version of all the books of the Hebrew Bible and the Apocrypha five years before an equivalent was forthcoming from Luther.[11] Another edition of the Zurich Bible, complete in one volume, appeared in 1530, followed by a first illustrated edition, with woodcuts by Hans Holbein the Younger, in 1531. Subsequent editions corrected numerous typographical errors.

Those books that Luther had translated to date were the first to be studied in the sessions of the *Prophezei*. These were then reprinted, with the language adapted to Swiss German norms and the translation itself lightly revised where Luther's rendition seemed to stray too far from the meaning of the ancient versions, especially the Hebrew Bible. In the judgment of Darlow and Moule, "though the verbal changes are numerous, they seldom involve any material alteration." Still, "the style tends to become harsh and sometimes obscure, partly through striving after literalness."[12] Certainly, Jud's translation of the Apocrypha, unencumbered by the Luther Bible as a point of departure, was free to strive after literalness with abandon, and duly emerged not as paraphrase but metaphrase – a literal translation of the Vulgate, word-for-word.

10 Zurich Bible [Gantze Bibel], vol. 5, titled: *Diss sind die bücher die by den alten vnder Biblische gschrifft nit gezelt sind, ouch by den Ebreern nit gefunden. Nüwlich widerumb durch Leo Jud Vertütschet* (Zurich: Christoph Froschauer, 1529).
11 A sixth volume, containing the New Testament, was published first, in 1524.
12 T. H. Darlow and H. F. Moule, *Historical Catalogue of the Printed Editions of Holy Scripture.* (London: Bible Society, 1911), vol. 2, p. 489.

7.2. *Zurich Bible*, 1536. Woodcuts by Hans Holbein the Younger (1497–1543).
Photo credit: The New York Public Library, Astor, Lenox and Tilden Foundations.

Whether out of deference to its source or to the path of least resistance, the first Yiddish Judith is also a metaphrase, a literal translation of Jud – almost beyond a literal translation. In a highly representative-seeming sample chapter, upwards of 90 percent of the time the Yiddish text reproduces the content of the Swiss German text word-for-word, not by way of exchanging one word for another, but, rather, by using the same German word. To be clear, this statistic elects not to count changes of inflection and spelling, since these remain so unstable in this period as to be liable to alter greatly not just between groups nor even just between individuals but within any given sentence of any given writer, as is certainly the case with the Zurich Bible itself. Even the idea of a 10 percent divergence between versions risks exaggerating the otherness of the Yiddish, since, more often than not, substantive rephrasings can be accounted for by selection of an equivalent word, phrase, or construction perceived as simpler, but one that is just as viable outside a Jewish context as within one.

Much of the Yiddish translator's task here consists in making substitutions for Leo Jud's Helvetisms – the elements of his language that are Swiss German enough to impede comprehension elsewhere. There is nothing Yiddish-specific about this; these regional idiosyncrasies of grammar and vocabulary were similarly unfamiliar to speakers of German anywhere outside Switzerland and its immediate borderlands. Thus, Johann Dietenberger, in the race to cobble together a purportedly fresh German translation of the Bible produced under Catholic auspices so as to offer a sanctioned alternative to the newly appeared Luther Bible, helped himself to Jud's Apocrypha *en bloc*, simply adapting it to High German.[13] Since Shalom bar Abraham's and Dietenberger's divergences from the Zurich Bible do not coincide, it is certain that the Yiddish Judith was translated from a Protestant Bible and not from the derivative version in the so-called Katholische Bibel, however much more likely the latter might have seemed in an Italian Counter-Reformation setting. Dietenberger's version does function as a control, though, offering at least some idea of how much the Yiddish translator is actively translating into Yiddish and how much simply out of Swiss German.

Representative instances of Swiss German forms reworked in the Yiddish, occurring in the sample chapter of Judith in Swiss German and Old Yiddish appended to this chapter, include: i) [Jdt 3:1] *habend* (they had), *ka-*

13 *Biblia, beider Allt vnnd Newen Testamenten, fleissig, treülich vnd Christlich, nach alter, inn Christlicher kirchen gehabter Translation ... Durch D. Johan Dietenberger, new verdeutscht* (Mainz: Peter Jordan, 1534).

mend (they came), and *sprachend* (they said), adapted in the Yiddish to *haben*, *kamen*, and *shprakhn*; and ii) [Jdt 3:2] *dienind, sygind, sturbind,* and *wurdind*, adapted in the Yiddish to *dinen, zayn, shterbn,* and *verdn*. These two kinds of change, applied consistently throughout the Yiddish Judith, reflect both of the most noticeable peculiarities of the language of the Zurich Bible:[14] the use of the plural ending *-end*, in lieu of the ending *-en* used in other German-speaking communities, and the equally distinctive use of the ending *-ind* to form the subjunctive.[15] A certain amount of vocabulary and a number of idioms are also perceived as especially Swiss, and, as such, require the translator's attention. Thus, at Judith 3:2, "better," *weger* in the Zurich Bible, becomes *besser* in Dietenberger's edition and the phonetic equivalent, *beser*, in the Yiddish; coming *down from* the mountains is expressed *hinab ab* in the Zurich Bible but *hinab von* in Dietenberger and the equivalent *hinab fun* in the Yiddish.

While removing features peculiar to Swiss German, the Yiddish translator is simultaneously adding comparably idiosyncratic features characteristic of his target language. These Yiddishisms include a propensity to treat prefixes as separate words and a preference for the prefix *der-* over *er-*. Both tendencies are evident in Judith 3:2, where the Zurich Bible's *erschlagen* (struck down) becomes *der shlagn* in the Yiddish.

The spelling of German remains wildly inconsistent in this period, and even in strictly phonetic Yiddish there is occasional variety, so that *vieh* (German: livestock) is spelled *fikh* in the Yiddish at Judith 2:8 and *vikh* at 3:3, and *fürsten* (princes) is spelled *firstn* in the Yiddish at Judith 3:1 but *virstn* at Judith 3:9 – just as the Zurich Bible fluctuates between *fürsten* and *vürsten* or *folck* and *volck*, though not necessarily on the same schedule as the Yiddish. In some instances, however, a difference in spelling between the Zurich and Yiddish texts indicates a distinct form of a word considered especially, if not exclusively, characteristic of Yiddish. To this category belongs the diphthong *ouch* (also), which in the Yiddish becomes the monophthong *akh* [Jdt 3:9]. When, at Judith 13:10, the Yiddish substitutes a synonym for

14 Thus Hans Rudolf Lavater, "Die Stimme ist Jakobs Stimme, aber die Hände sind Esaus Hände," in *Die Zürcher Bibel von 1531* (Zurich: Theol. Verl., 1983), p. 1369.
15 Dietenberger, likewise, substitutes *haben, kamen,* and *sprachen,* and *dienen, seyen, stürben,* and *würden*. His appropriation of Jud's translation of the Apocrypha follows a precedent established five years earlier in a composite Bible assembled for Anabaptist readers: *Biblia beyder Allt und Newen Testaments Teutsch* (Worms: Peter Schöffer, 1529). Here, too, the language is modified, but more slightly. Indicatives remain as in Zurich, while subjunctives assume the aspect of a compromise: *dienend, seient, stürbent,* and *würdend*.

the Zurich Bible's *bettuch* (bed sheet), it does not appear as the exact pho-
netic equivalent of the German word *leilach*, but, rather, as *laylekh*, as it
usually and uniquely does in Old Yiddish, with the characteristically Yid-
dish substitution of a *schwa* in the last syllable.

In at least a couple of cases, the translator of the Yiddish Judith rejects
what he finds in the Zurich Bible in favor of another kind of Yiddishism: a
Middle High German word that has become old-fashioned or obsolete at
the time of writing – except in Yiddish, where it remains standard. Thus, in
medieval German, *gezelt* was a commoner word for "tent" than was *zelt*. In
the early modern period, the frequencies were reversed in German, and, in
addition, the word *hütte*, originally "hut," was often used in an extended
sense to mean "tent" as well.[16] The Zurich Judith uses *hütte* or *zelt* in four
verses [10:16, 12:4, 13:31 and 16:4] and the Yiddish translator substitutes the
old word *gezelt* on every occasion. Similarly, when Holofernes is "burning
with love" for Judith [Jdt 12:16], love is rendered in the Zurich Bible with
the commonplace *liebe*. The archaic *libshaft*, however, not used by others
since the first quarter of the fifteenth century,[17] remains so exclusively the
word for love among Ashkenazic Jews that the minimalist translator of the
Yiddish Judith feels required to substitute it when he encounters *liebe*.

The biblical style of the Book of Judith will also, at times, elicit a bibli-
cal Yiddish. When the Yiddish Judith translates the Zurich Bible's *Do sang
Judith dises lobgsang* (Then Judith *sang* this song of praise) as *Do zagt Yehudis
das lob-gezang* (Then Judith *says* the song of praise), it is simply reflecting
established Yiddish convention in the rendering of Exodus 15:1. This same
convention is similarly reflected in Jacob ben Isaac Ashkenazi's famous
Pentateuch paraphrase of the early seventeenth century, *Tsenerene*, which
renders the opening words of that verse, "Then Moses and the children of
Israel *sang* this song," as *Denst mol habn kol Yisroel shire gezagt* – "Then all
Israel *said* a song."

Hebraisms in this first Yiddish edition of Judith occur chiefly in the
translator's frequent recourse to biblical or rabbinic Hebrew in attempt-
ing to make sense of the names of people and places – unsurprising given
the challenges presented by the book's odd quasi-biblical milieu. What to
make of Bethulia, as the scene of the drama, is especially perplexing. To
which city of Israel does this unfamiliar name correspond? When Bethulia

16 Erika Timm, *Historische jiddische Semantik: die Bibelübersetzungssprache als Faktor
der Auseinanderentwicklung des jiddischen und des deutschen Wortschatzes* (Tübingen:
Niemeyer, 2005), pp. 298–99.
17 Timm, pp. 392–93.

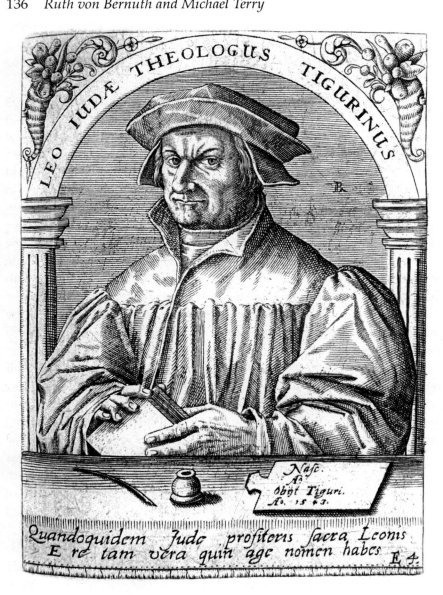

7.3. Jean Jacques Boissard, *Icones virorum illustrium*, 1597–99.
Engraving by Theodor de Bry. Frankfurt am Main. Photo credit: The New York
Public Library, Astor, Lenox and Tilden Foundations.

is finally mentioned at Judith 6:7, the translator plumps for the best-known location beginning with Bet(h): Bethlehem (*Beys Lekhem*). Evidently troubled by too many of Bethlehem's letters unaccounted for in Bethulia, at the next mention [Jdt 6:10] he decides to try Bethel on for size. That cannot have seemed quite convincing either, because later in the same verse he has changed his mind again. Rather than guessing at Bethulia's identity, he now decides that he had better just Hebraize the name. For this purpose, not only *Bet* but also *hul* seem to him plausible enough elements in a conjectural reconstruction of a Hebrew original, but somehow *ia* does not and is replaced. The result is *Beys Kholen* (בית חולן) – but only for a moment. At the next mention [Jdt 7:1], he decides on something less guttural, and this fourth time around he settles on *Beys Hulin* (or *Beys Hulen*, בית הולין), sticking with this invention for the remainder of the book. From the visibility here of the translator's thought process, it is clear that the book was printed from an uncorrected first draft. As a result, his conscientiousness backfires and can only have served to confuse readers horribly.

The Yiddish translator's treatment of other locations can be as inconsistent as his treatment of Bethulia. Thus, Syria is mentioned three times in the Book of Judith and treated by the Yiddish in as many ways. Adopting the Hebrew Bible's equivalent name for the broad geographical entity, the Zurich Bible's *vss allem Syria* [Jdt 2:9] is rendered *fun gants Aram*. By chapter three, however, the translator is opting instead to keep the name Syria as it appears in his Swiss German source, transliterating it first as *Sirye* [Jdt 3:1] and then as *Siriye* [Jdt 3:14].

The third chapter of Judith also finds the Yiddish translator's Bible knowledge failing him. At Judith 3:1, "the princes in Syria and Mesopotamia and Syria Sobal and Libya and Cilicia" send ambassadors to Holofernes. The Zurich Bible lists these countries as "Syria vnd Mesopotamia / vnd Syrie Sobal vnd Libyen vnnd Cilicien." In the Yiddish, they appear as "Sirye, un' Mesepotmie un' Sobel un' Libyen un' Tilkiyen." Syria Sobal is an idiosyncratic form, peculiar to the Vulgate version of Judith, of what the Vulgate calls elsewhere *Syria Soba*, the Septuagint's name for the region known in biblical Hebrew as *Aram Tsovah*.[18] The form *Syria Sobal* is peculiar not just to Judith but to this verse; on its other occurrence, at Judith 3:14, the Vulgate switches spelling from *Sobal* to *Subal*, though Leo Jud harmonizes, spelling the name as *Sobal* on both occasions.[19] Not recognizing *Syria Sobal* as the compound

18 Thus at 2 Sm 10:6 and 10:8 and Ps 60:2 (i.e., Ps 59:2 in LXX and Vulg.).
19 Phonetically representing stress on the first syllable and the unstressed vowel reduced to a *schwa*, the Yiddish shortens the sound of Sobal to *Sobel* at Jdt 3:1,

Aram Tsovah, the Yiddish translator regards the recurrence of the word *Syria* in "the princes in Syria and Mesopotamia and Syria Sobal" if not as confused then at least as liable to be confusing, and he suppresses it. The Yiddish version of Judith 3:1, therefore, reads simply "the princes in Syria and Mesopotamia and Sobal." In Judith 3:14, where Syria is not mentioned again on its own but only as an element of Syria Sobal, the Yiddish translator again takes a stab at making sense of his source material by adding a conjunction and having Holofernes pass through Syria *and* Sobal.

The attention to detail evident in the Yiddish translator's continual struggle to elucidate toponyms is significant, if only for the intellectual engagement that it demonstrates. This is not mindless transcription nor casual storytelling nor the work of a hack, but scrupulous translation, with every element processed by a serious reader, intrigued by the text and intent on comprehending it and communicating its meaning to the best of his ability. This has implications for the "legitimacy" of his Yiddish, too. If he takes so much care over names (and in clarifying or simplifying any other source of possible perplexity that he encounters in the text), it would be unreasonable to suppose him any less careful in making sure to express the unproblematic parts of the book in such a way as to be consistently intelligible to his intended readers.

Having made this claim for the translator's carefulness, it has to be said that his rendition, a few words further along in the same verse, of the place name *Cilicien* as Tilkiyen, is only explicable as an instance of carelessness. In fact, Cilicia is spelled differently in the Yiddish Judith on each of the four occasions that the name occurs: Tilkiye (Zurich: *Cilicia*) at Judith 1:7, Tilkhe (*Cilicie*) at 2:12, Tilkye (*Cilicia*) at 2:15, and Tilkiyen (*Cilicien*) here at 3:1. From the multiplicity of renderings, and especially the experimentation at Judith 2:12 with a guttural version, Tilkhe (טילכי), it is evident that the translator was not at all sure what to make of this place name or even how to pronounce any possible original that lay behind the German form. Part of his problem, however, can no doubt be traced to the blackletter type of the Schwabacher variety in which his source was printed. To confuse the letters C and T cannot have been too hard when they appear as 𝕮 and 𝕿, respectively, especially if their intrinsic difficulty were exacerbated by the translator's perhaps limited exposure to non-Hebrew type.

on the next occasion omitting the vowel altogether and spelling the name at Jdt 3:14 *Sobl*.

If recourse to Hebrew in making sense of proper nouns is a conspicu-
ous feature of the first Yiddish Judith, the use of Hebrew terms rather than
German terms for basic institutions and concepts of Jewish life – the kind of
Hebraism most in evidence in Old Yiddish – is only conspicuous here by its
relative absence. Again, this is understandable, given the translator's word-
for-word method, which means that he will always be confronted with a
Germanic word or construction that he must actively reject as unfamiliar,
unattractive, or otherwise unsatisfactory in Yiddish. The burden of proof
is, as it were, on the prosecution to show that any given turn of phrase in
the Zurich Bible is not viable in Yiddish; otherwise it is only natural that
the principle of inertia should apply. The translator does not start out with
a tabula rasa; that, had he done so, his vocabulary would have been much
more heavily peppered with Hebraisms of this kind is strongly suggested
by the strange turn, discussed later, that the translation takes at the very
end of the book.

Of just twenty or so German terms for which he substitutes a Hebrew
equivalent, four are terms used to designate religious functionaries, which,
had they not been renamed, would have carried a confusingly Christian
connotation for the intended readership. Thus *pfaffen* (clergy) become *rab-
onim* (rabbis) and *priester* (priest) becomes *kohen* (ditto) [Jdt 4:8]. At Judith
4:10, *oberest priester* (high priest) becomes *kohen godol* (ditto) and at 11:8
propheten (prophets) become *neviim* (ditto). Similarly, at 4:8 *altar* (altar)
becomes *mizbe'akh* (ditto), and at 10:9 *das geschähe* becomes *omen* (amen).
These replacements for words that will sound jarringly Christian in a
Jewish context are frequently Hebrew but are not necessarily so. The word
for the corresponding Jewish religious institution may itself be Germanic.
Thus, the Bethulians' all-night vigil of prayer to the God of Israel [Jdt 6:21]
is held, according to the Zurich Bible, in the *kirche* (church), whereas in the
Yiddish edition it takes place in the *shul* (synagogue).

In other cases, Judaism may simply not offer a corresponding institu-
tion. At Judith 10:3, the heroine, transforming herself from ascetic to tempt-
ress, attends to her makeup, hair, clothing, and jewelry and puts sandals
on her feet – *sandalia* in the Vulgate, which Jud renders accurately in the
Zurich Bible with the equivalent term, *sockelen*. Not so the Yiddish, which
substitutes *zoken*, a word used indiscriminately in this time for any kind of
light footwear – socks, soft shoes, or slippers. At Judith 16:11, the sandals
are singled out and referred to once again, for somehow these prove to be
the highlight of her ensemble: "Her sandals ravished his eyes, her beauty

made his soul captive, with a sword she cut off his head." Again, the Vulgate reads *sandalia* and Jud translates *sockelen*, but this time the Yiddish opts for *pantoflen* – specifically slippers. In doing so, however, the Yiddish translator preserves the meaning of *sockelen*, just changing a word that, in a Jewish setting, seems inappropriate. In the German-speaking lands of the late medieval and early modern period, if you were described as wearing sandals, *sockelen*, that typically meant that you were one of two kinds of person: a friar or a bishop. Sandals, *sandalia* or *sockelen*, in each of these cases meant something entirely different. For Franciscans and fellow travelers, it might mean leather straps and a wooden sole. At the other end of the austerity spectrum, "episcopal sandals" were a closed-toe affair, featuring leather soles and textile uppers, possibly embroidered, and perfectly described in a secular context as slippers. In choosing to translate *sandalia* as *sockelen*, Jud has correctly identified the formal equivalent, but, in doing so, he has made of the item that bowls Holofernes over something whose connotations are always ecclesiastical. The *Deutsches Wörterbuch* of Jacob and Wilhelm Grimm[20] locates one work only in the whole of medieval and early modern German literature in which the word *sockelen* is used to designate the footwear of a woman other than a nun, and that is the Zurich Bible's translation of Judith.

Three of the Yiddish Judith's twenty Hebrew expressions refer to the people of Israel – *Yisroel* [Israel; Jdt 16:24], *di Yisroelim* [the Israelites; Jdt 15:4] and *kol Yisroel* [all Israel; Jdt 16:25] – and a fourth term, *Kusim* [Cutheans; Jdt 1:8], is a euphemism for gentiles. In addition, common German expressions indicating all four directions are replaced by the Hebrew terms for north, south, east, and west: *tsofn* [Jdt 16:5], *dorem* [Jdt 2:15], *mizrekh* [Jdt 5:4], and *mayrev* [Jdt 2:5], respectively. No doubt, the word s*eder* (order) gained entry to the vocabulary of Yiddish on the strength of its familiarity in designating the sequence of broad topics within the most accessible of rabbinic texts, the Mishnah, as well, of course, as the order of events in a ritual, as at Passover. Once inside Yiddish, however, it can be used more expansively. Thus, the panic induced by Holofernes's decapitation leads to a mass desertion of Assyrian soldiers, every man for himself, fleeing in disarray, to catastrophic effect. Or, as the Yiddish puts it: *Das volk fun Ashur haten kayn seder ... di Yisroelim aber vilen mit aynem hoyfn un' seder oyber zi* (The people from Assyria were in disorder ... but the Israelites pursued them in orderly formation) [Jdt 15:4].

20 Jacob Grimm and Wilhelm Grimm, *Deutsches Wörterbuch* (Leipzig: S. Hirzel 1854–1960), s.v. *socke* (vol. 16, col. 1390) and *sockel* (vol. 16, col. 1393).

Angesicht (face) is a relatively secular concept, and on one occasion it remains *angesikht* in the Yiddish [Jdt 13:29]; still, Moses's encounter with God as if face-to-face [Ex 33:11] probably leaves some mark on the word, which becomes *ponim* on both other occasions, at Judith 6:14, and, again, at 16:10, where "she anointed her face" is rendered *sy hat jr angsicht gesalbet* in the Zurich Bible and *zi hat ir ponim geshmirt* in the Yiddish. Two further entries on the list of Hebraisms, *khodoshim* (months) and *yontev* (festival) [both Jdt 16:24], have an obvious association with the religious calendar, and another two may be regarded as related to religious values: *Mißfall* (remorse or repentance) becomes *kharote* (ditto) [Jdt 5:19] and *küne* (boldness) becomes the Hebrew homophone *kine* (קנאה, zeal) at Judith 16:12, inflected as if it were a German noun in the accusative: The Persians quaked at her constancy and the Medes *at her boldness* – in the Zurich Bible "*ab jrer küne*" and in the Yiddish "*oyf iren kinen*" (קנאן). Also inflected, as in Modern Yiddish, as if it were German, is the sole Hebrew verb in the book, which occurs, appropriately enough, in reflecting on the moment of action par excellence, for Judith if not for Holofernes, where God "hath delivered him into the hands of a woman and hath slain him" [Jdt 16:7]. That is what the English Vulgate says – but not the Latin. There, the verb is *confudit*, he has *confounded* him, which Leo Jud appropriately renders *geschendt*, he has shamed him. The Yiddish translator's replacement of this verb, however, must not be taken to demonstrate that it lacked currency in Yiddish. To the contrary, at Judith 13:20, where Judith reports back to Bethulia with the oppressor's head in her bag and the good news that, in obtaining it, she has not been violated, the Yiddish translator selects the word *geshent*, she had not been shamed, as the familiar way of putting it in Yiddish, in place of the idiom favored by the Zurich Bible, according to which she had not been stained (*befleckt*). Why, then, should the Yiddish translator have thought to replace *geschendt* here? Maybe the placing of such emphasis on the idea that death at the hand of a woman had humiliated Holofernes seemed if not too macho then at least too abstract to be meaningful. But by dint of changing just a single Hebrew letter, *geschendt* becomes *geshekht*, "shamed" becomes "slaughtered," and the abstract becomes concrete. Once again, the Hebraism is accounted for by association with a basic institution that distinguished day-to-day Jewish life – in this case, of course, the ritual slaughter prescribed for kosher meat. Once again, too, as with the substitution of *kineh* for *küne* at Judith 16:12, the similarity of sounds may have been enough to suggest an idea for a change that might not otherwise have seemed necessary.

In Hebraisms of a third kind, instead of a Hebrew word taking a German form, a German word takes a Hebrew form, albeit not a grammatical form. The word is Germanic, the inflection is Germanic, but the idiom or idea is Hebraic. That this is a prominent feature of many Old Yiddish texts of a more spontaneous nature has been copiously documented by Timm in her *Historische jiddische Semantik,* but even the slightly stilted Yiddish Judith has at least a couple of examples to offer. Holofernes's refusal to negotiate terms with anyone is explained at Judith 3:13: "Nebuchadnezzar the king had commanded him to *destroy* all gods of the earth" – "das er alle Gött in landen *ußrütete,"* that he should *uproot, eradicate* all gods, in the Zurich Bible, but in the Yiddish "daz er *ver-shnayd* ale goter," that he should *cut off* all gods. Horticulturally less radical, "cutting off" is nevertheless the biblical Hebrew equivalent of uprooting, the concept of excision interchangeable with that of extirpation. In the rote learning of the Pentateuch in Hebrew and Yiddish that was the staple of Ashkenazic elementary education, the Hebrew verb *le-hakhrit* would be rendered by the most literal equivalent in the vernacular, imparting to the Yiddish *ver-shnaydn* a sense of destruction not normally associated with the less loaded German verb *verschneiden.*[21] A second example manages to slip in just before the end of the book, at Judith 16:28: "*And she abode in her husband's house* a hundred and five years" – "Sy bleyb in jres manns huß" (she remained in her husband's house) in the Zurich version, but "Un' blayb *zitsn* azo in ir mans hoyz" (she remained *sitting* thus in her husband's house) – again, a change that might seem obscure but for the mediation of biblical Hebrew, in this case the verb *la-shevet,* literally to sit, idiomatically to dwell.[22]

The occurrence of a second example of this implicit kind of Hebraism, such a common feature of Old Yiddish, only at the very end of the book, is, strange to say, not a coincidence. The sixteenth and final chapter of Judith, as presented in the Vulgate and Zurich Bible, comprises two parts: a rhapsodic recapitulation of the story as a hymn of thanksgiving (the Canticle of Judith; Jdt 16:1–21), and a brief epilogue (Jdt 16:22–31), describing the victory celebrations in Jerusalem and Judith's return to a life of seclusion in Bethulia. As in the preceding fifteen chapters, the Yiddish translator continues to offer a word-for-word rendition of his source, but, with the start of the epilogue, everything changes. The modus operandi is suddenly, for the first time, anything but word-for-word. Two hundred and twenty-two words long in the

21 Timm, pp. 234–37, s.v. *farschnajdn.*
22 Timm, pp. 503–04, s.v. *sizer, sizn.*

German, the epilogue is stripped of much of its detail and condensed to just 67 words in the Yiddish. Moreover, what remains does not accurately reproduce even selected parts of the original but paraphrases freely.

Freed from fidelity to the source, the Yiddish itself changes. Hard as it is to gauge much on the basis of a 67-word sample, the language now seems to be more colloquial and to make more use of Hebraisms. While the Yiddish of the Canticle of Judith is 98 percent German (if not necessarily the same German as that of the Zurich Bible) and 2 percent Hebrew, Hebraisms account for 13 percent of the epilogue, a quotient that compares "favorably" with the language of Yehoash,[23] whose Bible translation (New York, 1926–36) offers an appropriate benchmark for purposes of comparison with modern Standard Yiddish.

The celebrations in Jerusalem continue for *three months* – "*dry monat*" in the German, but with *monat* Hebraized to *khodoshim* in the Yiddish, although on its previous occurrences in the book (Judith 2:1 and 8:4) the word had required only transcription, not translation, to function as Yiddish. By this point, however, the proportion of Hebraisms has reached 24 percent of the little text that there is:

[Jdt 16:24–25]

Zurich: Das volck was frölich / wie man denn pfligt / vnnd hat dise fröud deß sigshalb / mit Judith / dry monat gewäret. Nach dem selben ist yederman wider zhuß zogen / vnd ist Judith hochgehalten worden zů Bethulia / noch vil herrlicher im gantzen land Jsraels.

The people celebrated in the customary manner, and this rejoicing over the victory with Judith continued for three months. And after those days every man returned to his house, and Judith was revered in Bethulia, and she was greatly honored throughout the land of Israel.

Cracow: Un' Yisroel varn vraylikh dray khodoshim anander un' makhtn di zelbe tsayt yontev al yar. Un' Yudis var zeyer erlikh unter kol Yisroel.

And Israel celebrated together for three months, and they observed a festival at the same time every year.[24] And Judith was greatly honorable[25] in all Israel.

23 Pen name of Solomon Bloomgarden, an authority, *inter alia*, on Hebraisms in Yiddish, d. 1927. In his translation of the last chapter of Esther (relatively analogous to the last chapter of Judith), Hebraisms account for 11 percent of the words.

24 This detail of an annual observance in celebration of Judith's victory has been freely relocated by the Yiddish from Judith 16:31, the last verse of the book according to the source.

25 *Erlikh*, honorable, perhaps a typographical error in place of *herlikh*, honored, which has the twin merits of corresponding to the Zurich Bible and of making sense.

So much for a change of language, but what purpose could possibly have been served by this complete change of translating strategy, just a paragraph short of the end of the book? No ideological motivation for this abridgment is apparent. True, the most radical aspect of the Book of Judith may not be its endorsement of female leadership or strategic seduction or assassination, all of which has sufficient biblical precedent, but, on the contrary, its endorsement of the protagonist's contemplative and ascetic lifestyle, and especially her celibacy, mentioned with implied approbation here in chapter 16. The highlighting of a young widow's abstention from remarriage may correspond to the Romans' celebration of the ideal of the *univira* or the later Christian institution of the "consecrated widow," but it is without parallel in biblical or rabbinic literature. To the extent, therefore, that the aim of Shalom bar Abraham's little publication may be seen as an attempt to reclaim Susanna and Judith as co-religionist role models, with a view to inspiring at least a modicum of fearless devotion in early modern Jewish women, then Judith's espousal of perseverance in widowhood might have been one element in the book that Shalom bar Abraham, with his revivalist agenda, could have done without. Nevertheless, in spite of all the abridgment, it is one of the lucky details that does survive in the Yiddish, in however truncated a form:

[Jdt 16:26]

Zurich: Dann zur stercke hat sy küscheyt / also / das sy keinen mann mee[26] erkannt jr läben lang / von dem an als jr mann Manasses starb.	And chastity was joined to her virtue, so that she knew no man all the days of her life, after the death of Manasses her husband.
Cracow: Un' nam ayn man ir leblang.	And she married [just] one husband in all her life.

In the absence, therefore, of any possible motive inherent in the content suppressed, there seems nothing for it but to invoke the most mundane of considerations – a sudden shortage of space, constraining the translator, or even the printer, to extemporize a *précis*. The extent to which the substantive content at the end of a manuscript was liable to be compromised by the printer's or sponsor's unwillingness or inability to absorb the additional cost of adding even a single page to the projected length of a book is a topic that must be briefly revisited elsewhere, in connection with Shmeruk's hypothesis about the origins of this booklet, from this perusal of which it may suffice to draw just two conclusions for now.

26 Typographical error, corrected from *mee* to *mer* as early as Froschauer's first octavo edition, Zurich, 1529.

First, regarding the question of how different the Cracow Judith is from the Zurich Judith – aside from script – on a theological plane, it is different in no way whatever. Nowhere does the Yiddish attempt to alter or manipulate the story for ideological reasons – or for the sake of brevity, or for any reason other than clarity. On a linguistic plane, however, the Yiddish introduces a large number of small changes – sufficient definitively to render it a translation, not a transliteration. That is to say that the source has been comprehensively reworked, even if the result ends up sounding very much like the original. Nevertheless, the most telling aspect of the language of the book is the evidence it offers of what minimal modification was required to render a formal German of the academic and professional classes of the 1520s clearly intelligible to Yiddish-speaking women in Italy ca. 1560. A measure of how successfully this was judged to have been accomplished is the decision to print a second edition a decade or so later, this time for readers in Poland. The book's rushed ending makes only more vivid the book's illustration of the wide gap that could be tolerated between how early modern Ashkenazim *would* spontaneously speak, write, and read, and what they *could* evidently handle, with pleasure and without a second thought, if it happened to come their way.

Finally, and obviously, the total dependence of the Yiddish Judith on the Zurich Bible and on no other source lends a certain stature to this obscure and ephemeral publication. It makes it the first Jewish[27] book of the sixteenth century, the century of the Reformation, to be identified as appropriating the fruits of Protestant Bible translation – in this case of Judith, and the pious Susanna,[28] a means to the end of reappropriating two lost Jewish heroines.

27 To the exclusion, that is, of the Luther Bible-based Cracow Yiddish New Testament, 1540.

28 Also taken verbatim from the Zurich Bible, this Yiddish translation of the story of Susanna constituted the first edition of that book in Hebrew script.

Appendix to Chapter 7

A Chapter of Judith in Swiss German and Old Yiddish[29]

[Jdt 3:1]

Then the kings of all the cities and provinces, namely the princes in Syria and Mesopotamia and Syria Sobal and Libya and Cilicia, sent their ambassadors, who came to Holofernes and said:

Also habend aller stetten vnnd landen künig botten geschickt / namlich / die fürsten in Syria vnd Mesopotamia / vnd Syrie Sobal vnd Libyen vnnd Cilicien die kamend zum Holoferne / vnd sprachend:

אונ' | אלזו האבין אלי שטעט אונ' לעבדיר אונ' קויניג באטן גיזענט נעמליך די פירשטן אין שיריא
מעשיפאטמיא אונ' שאביל אונ' ליבין אונ' טילקיאן | די קאמן צום אליפורני אונ' שפראבֿן

Alzo haben ale shtet un' lender un' koynig botn gezent nemlikh di firsten in Sirye, un' Mesepotmie un' Sobel un' Libyen un' Tilkiyen, di kamen tsum Oleforne un' shprakhn:

[Jdt 3:2]

Let thy indignation towards us cease. It is better for us that we should live and serve the great king Nebuchadnezzar, and be subject to thee, than that we should die and be struck down, or suffer even greater misery.

29 In this third chapter of the Book of Judith, chosen arbitrarily to serve as a sample, the Swiss German text is that of the first edition of the Zurich Bible, printed by Christoph Froschauer in 1529. Subsequent editions of the Zurich Bible add or subtract a letter here and there, in line with the unsettled orthography of the time, but make no substantive changes to the text of this chapter, beyond fixing the two typographical errors noted *in situ*. Each verse of the Swiss German is followed by the corresponding passage in Yiddish, according to the text printed in Cracow in 1571. Last comes a romanized version of the Yiddish, employing the YIVO transliteration system, the standard for Modern Yiddish, minimally modified here to reflect the different vocalization practices of Old Yiddish. In Swiss German and Yiddish versions alike, the sometimes erratic original spelling and punctuation, characteristic of early modernity, has been retained. Since Leo Jud's rendition of the Apocrypha in the Zurich Bible represents a word-for-word translation of the Vulgate, and since the Yiddish version first published by Shalom bar Abraham in Italy and reprinted in Cracow is a word-for-word translation from the Zurich Bible, the English version presented here takes for its point of departure the traditional Catholic word-for-word translation of the Vulgate into English, known as Douay-Rheims-Challoner, and adapts it to agree with what Jud makes of the same Latin source.

Laß ab vonn dinem zorn gegen vns: weger ists vns wir dienind läbendig dem grossen künig NebucadNezer / vnnd sygind dir vndetthenig[30] / dann das wir sturbind vnd erschlagen wurdind / vnd grösseren schaden empfiengind.

לאז אוב פֿון דעם צארן גיגן אונז. עש איז אונז בעשיר ווייר דינין לעבינדינג דעם גרושן הערן
קויניג נבוכד נצר | אונ' זיין דיר אונטער טעניג דען דז וויר שטערבן אונ' דער שלאגן ווערדן | אונ'
גרעשירן שאדן אנפֿינגן

Laz ob fun dem tsorn gegn unz. Es iz unz beser vir dinen lebending dem grosn hern koynig Nevukhad Netser, un' zayn dir unter tenig, den daz vir shterbn un' der shlagn verdn, un' gresern shadn anfingn.

[Jdt 3:3]

All our cities *are* [i.e., and] property, all mountains and hills, all fields, great and small *fish* [i.e., livestock], sheep, goats, horses, camels, all our goods, together with our servants – all this is in thy power.

All vnsere stett sind[31] ligende güter / alle berg vnnd bühel / alle välder / groß vnd klein fisch[32] / schaaff / geyß / rossz / kammeel / all vnsere haab / darzů vnser gsind / das sye in dinem gewalt.

אל אונזרי שטעט אונ' גוטר | אלי בערג אונ' ביהילי | אלי ועלדיר גרוש אונ' קלײן | ויך שאף אונ'
רינדר ציגן ראס קעמיל אונ' אל אונזר האב דר צו אונזר גיזינד דז זייא אין דיינם גיוואלט.

Al unzre shtet un' guter, ale berg un' bihele, ale velder gros un' kleyn, vikh shaf un' rinder tsign ros kemel un' al unzer hab dar tsu unzer gezind daz zay in daynem gevalt.

[Jdt 3:4–6]

Let all we have be subject to thy law. Both we and our children are thine. Come to us a peaceable lord, and use our service as it shall please thee.

Es sye dir alles vnderthon. Darzů wöllend wir vnd vnsere kinder din eigen sin / kumm vns ein fridsamer herr / vnnd bruch vnseren dienst nach dinem gefallen.

30 Typographical error, corrected to *vnderthenig* as early as Froschauer's first octavo edition, Zurich, 1529.

31 Apparent typographical error, corrected from *sind* (they are) to *sampt* (together with) in the "Catholic Bible" printed by Peter Jordan in Mainz, 1534, and to *un'* (and) in the Yiddish, but not corrected in the 1536 Zurich Bible (nor in the 1545 edition).

32 Typographical error, corrected from *fisch* (fish) to *vych* (livestock) in Froschauer's first octavo edition, Zurich, 1529, although persisting, like *vndetthenig* [Jdt 3:2], into the monumental first illustrated edition, Zurich, 1531.

עש זייא דיר אליש אונטר טאן. דר צו וועלין וויר און' אונזר קינדר דיין אייגן זיין. זייא אונזר
הער | און' פרויך אונזר דינשט נאך דיינם גיפֿאלין.

Es zay dir ales unter-ton, dar tsu velen vir un' unzer kinder dayn eygn
zayn. Zay unzer her, un' proykh unzer dinst nakh daynem gefalen.

[Jdt 3:7]

Then Holofernes sallied forth, came down from the mountains with the
horsemen and great might, and captured all the walled cities and all the
inhabitants of the land.

Do macht sich Holofernes vf / zoch hinab ab dem gebirg mit dem reysi-
gen züg vnd grosser macht / vnd namm alle veste stett yn / vnd was im
land wonet.

דא מאַכט זיך אליפֿארני אויף און' צוך הינאב פֿון דעם גיבירג מיט דעם רייזיגן היר און' גרושר
מאַכט און' נאם אלי ועסטן שטעט איין | און' וואש אים לנד וואונט.

Do makht zikh Oleforne oyf un' tsokh hinab fun dem gebirg mit dem reyzign
her un' groser makht un' nam ale vestn shtet eyn, un' vas im land vont.

[Jdt 3:8]

And from all the cities he took whatever strong men there were, well-
suited for war, that they should help him.

Vnd nam do vss allen stetten was starcker mannen warend / vnnd zum
krieg touglich / das sy jm hulffind.

און' נאם דא אויש אלין שטעטן | וואש שטאַרקי מאַנין ווארן | און' צום קריג טויגיטן דז זי אים העלפֿן.

Un' nam do oys alen shtetn, vas shtarke manen varen, un' tsum krig toy-
getn daz zi im helfn.

[Jdt 3:9]

And so great a fear lay upon all those provinces, that all the inhabitants of
all the cities, both princes and dignitaries, as well as the people, went out
to meet him at his coming.

Es kam ouch über die selben land ein sölicher grosser schräck / das alle
ynwoner aller stetten / deßglychen die fürsten vnnd was verrümpt was /
mit sampt allem volck / jm / so er kam / hinuß entgegen giengend.

עש קאם אך אויבר די זעלבן לנד איין גרושר שרעקן | אויבר אלי אין וואונר אליר שטעטן דז
גלייכֿן די וירשטן און' הערן מיט אלים ואלק גינגן אים אנטגיגן

Es kam akh oyber di zelbn land eyn groser shrekn, oyber ale in-voner aler
shteten dez glaykhn di virstn un' hern mit alem volk gingn im antgegn.

[Jdt 3:10]

And received him splendidly and solemnly with garlands, lights, with dances, timbrels and pipes.

Vnd jnn herrlich vnnd eerlich empfiengend / mit krentzen / facklen / mit reyen / trummen vnd pfyffen.

אונ' אנטפֿינגן אין רעדליך מיט קרענצליך | אונ' פֿלאקירן מיט רייאן מיט טרומבטן אונ' פֿפֿייפֿין.

Un' antfingn in redlikh mit krentslikh, un' flakern mit rayen mit trumbetn un' pfayfen.

[Jdt 3:11]

And though they did these things, they could not for all that soften his cruel disposition.

Vnd so sy schon sölichs thettend / mochtend sy dennocht sin grusam gemüt nit milteren.

אונ' אוב זי שון זולכֿש טעטן | מאכֿטן זי דינאך זיין גרוויזים ניט לינדר.

Un' ob zi shon zolkhes tetn, makhtn zi denokh zayn groyzem nit linder.

[Jdt 3:12]

But rather he destroyed their cities and cut down their groves.

Sunder er brach jre stett / hüw jre wäld ab.

זונדר ער בראך איר שטעט אונ' איר וואלד אב.

Zunder er brakh ir shtet un' ir vald ab.

[Jdt 3:13]

For Nebuchadnezzar the king had commanded him to destroy all gods of the earth, that he only might be called and esteemed as God by those nations that Holofernes could subjugate with his power.

Dann NebucadNezer hatt jm in empfelch geben / das er alle Gött in landen vßrütete / das er allein für ein Gott genennt vnd gehalten wurde / von denen landen die Holofernes mit sinem gewalt / vnder jn brechte.

דען נבוכד נצר הט אים איין ביפֿעלך גיגעבן | דז ער ור שנייד אלי גאטיר אין אלי לאנדן | דז ער אליין ור איין גֿט גינענט אונ' גיהאלטן ווערד | פֿון דען לאנדן די אליפֿארני מיט זיינם גיוואלט אונטיר אין בראכֿט.

Den Nevukhad Netser hat im eyn befelkh gegebn, daz er ver-shnayd ale goter in ale landn, daz er aleyn ver ayn gõt genent un' gehaltn verd, fun den landn di Oleforne mit zaynem gevalt unter in brakht.

[Jdt 3:14]

And when he had passed through Syria Sobal, and all Apamea, and all Mesopotamia, he came to the Idumeans in the land of Gabaa and Septopoli.

Also zoch er durch Syriam Sobal / vnd durch alles Appamiam / vnd alles Mesopotamiam / kam zun Jdumeern ins land Gabaa vnd Septopoli.

אלזו צוך ער דורך שירייא אונ' שובל אונ' דורך גנץ שפאנייא אונ' קאם צו דען כותים אינש לנד
געבא | אונ' שעפטאפלי.

Alzo tsokh er durkh Siriye un' Sobl un' durkh gants Shpaniye un' kam tsu den Kusim ins land Gebe, un' Septople.

[Jdt 3:15]

He took possession of their cities and stayed there for thirty days, during which he marshaled all the troops of his army.

Nam yn jre stett / vnd bleyb da dryssig tag / in denen er den gantzen huffen siner heermacht zemmen bringen ließ.

אונ' נאם איין אירי שטעט | אונ' בלייב דא דרייסיג טאג | אין דעם ער דען גנצין הויפן זיינר היר
מאלט צו זאמי ברינגן ליז.

Un' nam eyn ire shtet, un' blayb da draysig tag, in dem er den gantsen hoyfn zayner her makht tsu-zame bringn liz.

Christian Textual Tradition

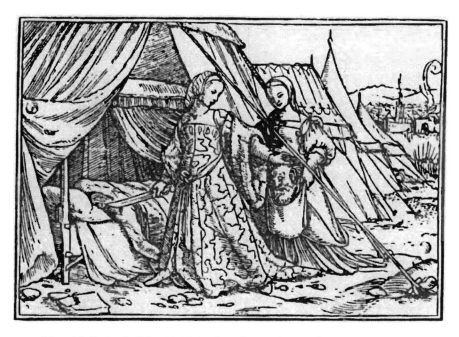

Hans Holbein, *Judith*, 1538. Woodcut from *Biblia Latina*. "Icones," Lyon.
Photo credit: Wiesemann, 2002, Abb. 4 (K 10).

8. Typology and Agency in Prudentius's Treatment of the Judith Story

Marc Mastrangelo

In the late fourth century, the Christian poet Prudentius wrote the *Psychomachia* (The Battle within the Soul), which depicts a series of single combats between personified virtues and vices. Immensely popular in the Middle Ages and Renaissance, the *Psychomachia*'s allegorical battles were depicted in a variety of relief sculptures and paintings throughout churches in Europe.[1] In his poem, Prudentius frequently uses a character or story from the Old Testament that prefigures a character or event from the New Testament, Roman Christian history, and a personified virtue or vice. These typologies form the backbone of Prudentius's poem; so, for instance, the biblical story of Judith who refuses the sexual advances of the Assyrian king, Holofernes, and then kills him in order to save the Israelites is treated at *Psych.* 58–75. In the passage, the personified virtue, *Pudicitia* (Chastity), tells the defeated vice, *Libido* (Lust), that her violent death was predicted by Judith's killing of Holofernes:

Tene, o vexatrix hominum, potuisse resumptis viribus extincti capitis recalescere flatu, Assyrium postquam thalamum cervix Olofernis caesa cupidineo madefactum sanguine lavit	Should you, harasser of human beings, be able to resume your strength and grow warm again with the breath of life that was extinguished in you, after the severed head of Holofernes soaked his Assyrian chamber with his lustful blood, and the unbending Judith,

1 Adolf Katzenellenbogen, *Allegories of the Virtues and Vices in Mediaeval Art* (New York: W. W. Norton, 1964), pp. 7–13.

gemmantemque torum moechi
ducis aspera Iudith
sprevit et incestos conpescuit
ense furores,
famosum mulier referens ex hoste
tropaeum
non trepidante manu, vindex mea
caelitus audax!
At fortasse parum fortis matrona
sub umbra
legis adhuc pugnans, dum
tempora nostra figurat,
vera quibus virtus terrena in
corpora fluxit,
grande per infirmos caput
excisura ministros?
Numquid et intactae post partum
virginis ullum
fas tibi iam superest? Post partum
virginis, ex quo
corporis humani naturam pristina
origo
deservit carnemque novam vis
ardua sevit
atque innupta deum concepit
femina Christum,
mortali de matre hominem sed
cum patre numen.[2]

spurning the lecherous captain's jeweled couch, checked his unclean passion with the sword, and woman as she was, won a famous victory over the foe with no trembling hand, maintaining my cause with a heaven-inspired boldness? But perhaps a woman still fighting under the shade of the law did not have enough strength, though in doing so she prefigured our times, in which the true power of virtue has passed into earthly bodies so that a great head is severed by the hands of feeble agents. Well, since an immaculate virgin has born a child, do you have any claim remaining – since the day when a man's body lost its primeval nature, and power from on high created a new flesh, and an unwedded woman conceived the God Christ, who is man in virtue of his mortal mother but God along with the Father?[3]

Not only do Judith and her story prefigure the victory of the virtue *Pudicitia* over the vice *Libido*, they also prefigure Mary and Christ's immaculate birth.[4] In Prudentius's version of the Judith story, the agency of Judith is emphasized and the typological pairs of Judith/Mary and Judith/*Pudicitia* become directed toward the reader who is encouraged to choose between Judith and Holofernes, chastity and lust.

For Prudentius, the decision and action of Judith is a prototypical act of free will. This extraordinary act by a woman raises the issue of female

2 The text is from the edition of M. Cunningham (ed.), *Aurelii Prudentii Clementis Carmina*, Corpus Christianorum, series latina, vol. 126 (Turnholt-Brepols: Leuven University Press, 1966).

3 Translations with changes are from H. J. Thomson, *Prudentius*, vols. 1–2, Loeb Classical Library (Cambridge, MA: Harvard University Press, 1949).

4 See Marc Mastrangelo, *The Roman Self in Late Antiquity: Prudentius and the Poetics of the Soul* (Baltimore, MD: Johns Hopkins University Press, 2008), pp. 93–96.

agency as it relates to human agency. Recent scholarship has shown that the agency of ancient female figures is delimited according to political and social constraints. Exclusion from political decision making, social segregation, and subordinate legal status all factor into a picture of female agency that has largely been viewed as severely limited. However, some recent work has argued that female roles in religious rituals reveal autonomous actions that contribute directly to the political and social life of the state.[5] Barbara Goff has argued that fifth-century Athenian literature depicts women who obtain fuller agency because these characters take ritual (and social) tasks to an extreme often resulting in the usurpation of masculine power (for example, in Euripides's *Bacchae*, the maenads and Agave[6]). Judith conforms in part to this model as she eliminates a king and preserves her native land.

Taking their cue from Jerome and Ambrose, Prudentius and his contemporary Paulinus of Nola (*Carm.* 26:160–65 and 28:26–7) construct Judith as a universalizable heroic exemplar.[7] However, as this paper argues, the *Psychomachia* uniquely portrays Judith as a typologically constructed, autonomous moral agent who is an example of freely chosen moral action. Her chastity is figured and refigured in the poetic personification of *Pudicitia*, the incarnation of Christ, and the purity of the reader's soul. The last term in this typological series is the reader of the *Psychomachia*, a Roman aristocratic Christian, whose own moral agency is implied by the Judith story. By locating the Christian doctrine of free will in a typological series of female figures (Judith, Mary, and *Pudicitia*), Prudentius has made female agency the ideal for both males and females. The imitation of female weakness and chastity is a source of moral strength for all.

Female agency, then, is tied to general human agency because both flow from an act of moral choice, constructed as a Christian act of free will. The quality and act of chastity are not only signs of a pure soul for Roman females, but also for males.[8] Prudentius simultaneously alludes to both the story of Judith and Matthew 25:7, which develops the metaphor of bridesmaids (all humans!) waiting for the bridegroom (Jesus). The pairing

5 Angeliki Tzanetou, Introduction to Marilyne Parca and Angeliki Tzanetou (eds.), *Finding Persephone: Women's Rituals in the Ancient Mediterranean* (Bloomington, IN: Indiana University Press, 2007).

6 Barbara Goff, *Citizen Bacchae: Women's Ritual Practice in Ancient Greece* (Cambridge: Cambridge University Press, 2004).

7 See also Prudentius's literary descendant, Dracontius, *De laudibus dei*, 3.380ff.

8 Peter Brown, *The Body and Society: Men, Women, and Sexual Renunciation in Early Christianity* (New York: Columbia University Press, 1988), pp. 382–83 and 427.

of texts from Judith and Matthew makes explicit the proposition that female agency exists as a result of a moral choice constructed within the self through the memory of biblical typological exemplars. Hence, female agency becomes identical to human agency (for both males and females).

Christian agency as universal human agency has as its foundation physical, worldly weakness. Spiritual strength for both men and women is constructed from weakness traditionally associated with women. By locating the Christian doctrine of free will in a female figure, Prudentius has bolstered female agency – at least when it comes to salvation and immortality. Early Christian (and thus human) agency often posits worldly weakness and helplessness, a condition that broadly describes the restrictions on ancient female agency; but in the face of a difficult moral choice, inner purity transforms worldly (female) weakness into virtuous action, power, and salvation. The seeds of Prudentius's approach can be seen in the writings of Ambrose and Jerome.

The Reception of Judith: Latin Fathers, Paulinus of Nola, and Prudentius

The Latin Patristic literature has a strong tradition regarding the usage of the Matthew passage and the Judith story. We can connect one branch of the tradition beginning with Ambrose who is cited by both Jerome and Augustine. Ambrose's interpretation of Judith 10 at *De virginibus* 2.4.24 is referred to by Jerome at *Epistula* 22.22 and *Epistula* 58.14, and by Augustine at *De doctrina christiana* 4.129–130 (see also 4.132–33). At *De virginibus* 2.4.24, the bishop of Milan appears to be saying that the desire to preserve one's chastity can become extreme; yet for Ambrose, the Judith story illustrates the most important desire: to preserve one's religion. The same argument is given at *De viduis* 7 that Judith was successful because she acted for the sake of her religion. Ambrose also sees her as an example of chastity, wisdom, sobriety and moderation. Her faith is emphasized at *De officiis ministrorum* 3.13.82–85 in order to conclude that the power of virtue can make even a woman strong in worldly situations, but more importantly, in matters of spiritual salvation as well.[9]

9 At *De officiis*, 3.13.84, Ambrose includes the three basic statuses of Roman women: virgins, widows, and wives. Prudentius, *Psych.* 64 (*mulier*), 66 (*matrona*), 70 and 71 (*virginis*, said of Mary), hits a similar note and adds *meretricis* and *prostibulum* (*Psych.* 49 and 92) as applied to *Libido*. The distinction of purity between *mulier/matrona* and *virgo* is especially important for Jerome.

Jerome refers eight times to texts from either Matthew or Judith in which his exclusive concern is to promote and preserve virginity or chastity (*Epistulae* 22.5; 22.21–22; 22.44; 54.13; 54.16; 79.10; 125.20; and 130.11). In *Epistula* 22, Jerome is concerned with the distinction between wives and virgins. An assumption of all these usages is that virginity makes one ready to receive the bridegroom (i.e., Christ). Two cases have some features in common with Prudentius's treatment elaborated below. At *Epistula* 54.16, Jerome combines Judith 13 with Matthew 25:4 to create a graphic narrative description, which is reminiscent of the Prudentian treatment. *Epistula* 79.10 is a case of typological thinking, as Judith is compared to Anna of the Gospel of Luke (Lk 2:36–38). Jerome's treatment of Judith and surrounding themes appears to have much in common with Prudentius's version – especially, the foregrounding of purity. Regarding 1 Corinthians 7:26 and 7:29, where Paul appeals to married men (and couples) to become celibate, Jerome points out that virginity is a choice originating in human free will and that sexual relations have changed under the new law of Christianity. Thus both men and women can purify their faith through celibacy. This is proven through the positive, typological example of Mary, with which Judith is connected; and through the negative typological example of Eve who represents the old law: *Mors per Evam, vita per Mariam* ("Death through Eve and life through Mary;" *Epistula* 22.21).[10] Relying on a series of typological examples, Jerome shows that the weakness of Judith (and virgins) is actually a great source of strength to overcome worldly and spiritual challenges.[11]

Paulinus of Nola, who wrote both prose and poetry in the late fourth and early fifth centuries, is best known for his poetic cycle, *Natalicia*, which celebrate the life and miracles of Saint Felix of Nola.[12] In the *Natalicia*, he

10 It is worth quoting an extended portion of the passage: *Inveniebatur ergo, ut diximus in viris tantum hoc continentiae bonum et in doloribus iugitur Eva pariebat. Postquam vero virgo concepit in utero et peperit nobis puerum, "cuius principatus in umero eius," Deum fortem, patrem futuri saeculi, soluta maledictio est. Mors per Evam, vita per Mariam. Ideoque et ditius virginitatis donum fluxit in feminas, quia coepit a femina. Statim ut Filius Dei ingressus est super terram, novam familiam instituit, ut, qui ab angelis adorabatur in caelo, haberet angelos in terries. Tunc Olofernae caput Iudith continens amputavit …* Note that *continentiae* is used of men and the old law at the beginning of the passage and *continens* is applied to women and the new law. With Jerome we encounter an unprecedented focus on women as agents of cultural and spiritual change.

11 *nunc, qui infirmus est, fortior est* ("now, one who is weak is stronger;" *Epistula* 22.21). This is said of Lazarus but is applicable to all the exemplars, including Judith, whom Jerome lists.

12 For a full treatment of Paulinus's life and work, see Dennis E. Trout, *Paulinus*

refers to the Judith story twice. The allusion to the story at *Carmen* 26 (402 C.E.) is germane to this discussion. *Carmen* 26:159–165 places Judith within a series of examples of heroic males and females whose "weakness" was more than compensated for by faith:

> A holy faith has endowed women's character with the strength of men, for through such faith the holy woman (Deborah) destroyed the fearsome Sisora, whose temple was pierced with a stake. The wily Judith with her chaste cunning deceived and mocked Holofernes, who had terrorized mighty people far and wide. She remained inviolate in that lewd bed, and then fled from the barbarian's camp victorious after slaughtering their leader.[13]

Paulinus locates Felix at the end of this line of figures (which include David, the Israelites of the Exodus, Joshua, and Rahab), who were able to overcome the weapons of war through their single-minded commitment to God. Again, Judith is one of a series of types, whose victory through faith alone Paulinus wishes to ascribe to Saint Felix so that the village of Nola (and Rome) will be protected from the threat of Barbarian incursions. Just like Jerome, Paulinus employs both men and women in his list of typological exemplars.

Paulinus understands individual agency in terms of faith in an all-powerful god. As he says earlier in the same poem, "Having trust in Christ, consigning everything to the God of powers, regarding God alone as all that is highest – this has always been efficacious in achieving every good" (*Carmen* 26:150–53).[14] Worldly weakness and vulnerability to powerful forces are associated with females in particular. Paulinus makes use of female "weakness" to illustrate the quality of faith, and link it to chastity (*Carmen* 26:132–33; Rahab the harlot who possesses a "chaste fidelity"). The poet relies on a series of typological examples from the Hebrew Bible to project qualities onto Saint Felix. It is striking that female figures, and agency modeled on the subjection of the female, become generalized into a strong notion of Christian agency. In his treatment of Judith, Prudentius employs similar methods as seen in *Carmen* 26, but goes even further by showing how typological series are fundamental to the ideas of free will and the

of Nola: Life, Letters and Poems (Berkeley, CA: University of California Press, 1999).

13 *Femineas quoque personas virtute virili / induit alma fides, mulier qua sancta peremit / terribilem Sisaram transfixum tempora palo; / terrentem magnos late populos Holofernem / arte pudicitiae deceptum callida Iudith / risit, in inpuro quae non polluta cubili / barbara truncato victrix duce castra fugavit.* Translation by P. G. Walsh, *The Poems of St. Paulinus of Nola* (New York: Newman Press, 1975).

14 *semper in omne bonum valuit confidere Christo, / credere cuncta deo virtutum, ponere solum / omnia summa deum ...*

interiority of an individual Roman Christian.

Pudicitia, as she addresses the dying *Libido*, accuses her of corrupting human souls. After the immaculate birth of Christ, there appears to be no role left for lust in human affairs (… *ullum / fas tibi iam superest? Psych.* 70–71). The status of Christ's birth and relationship to humans and the father flows from lustless origins. When *Pudicitia* finishes her speech, she cleans her bloody sword in the Jordan River and places it by a divine spring in a Christian temple (*Psych.* 98–108). Purity remains a resulting condition of the *Psychomachia's* portrayal of virtue. However, aside from the allegorical reference to Christian baptism and purification, these ten lines allegorically refer to the chaste (body) and pure soul, which has become a reality with the incarnation of Christ. Although Prudentius usually does not hesitate to sensationalize his material with graphic descriptions of death and violence, in this adaptation of the Judith passage, he is restrained (*Psych.* 40–108). The only grisly parallel to the biblical passage is the severing of the head of Holofernes. Prudentius excludes the description of Holofernes's headless trunk rolling off his bed and the section in which Judith places the head in a bag of food to bring to the Assyrian leaders. He keeps the focus on the characteristics of the pure soul, which are necessary to preserve one's chastity and therefore make one ready to receive Christ.

In the *Psychomachia* Judith does not hesitate to carry out the deed, whereas in the biblical version she constantly seeks strength from God, without which she does not seem able to accomplish the action (Jdt 13:4 and 7). At Judith 14:1–5, Judith is portrayed as a leader who gives orders and even predicts the outcome of the battle between the Jews and the Assyrians. The biblical Judith gains a personal power and authority after she kills Holofernes, whereas Prudentius characterizes her as a confident leader before and during the slaying of the Assyrian. These differences expose the characteristics emphasized in the typology between Judith and *Pudicitia*, the killer of *Libido*. Prudentius typologically projects this part of Judith's biblical identity on to *Pudicitia* herself who commands, leads, and gains total victory. Regarding the typological connection to *Pudicitia*, Prudentius emphasizes Judith's initiative, and consequently, her agency; but he deemphasizes the Father as prime mover and human passivity, ideas that occupy the foreground of Paulinus's poetry.

For Prudentius, Judith's typological connection with Mary logically leads to the topics of the ontological nature of Christ, his relationship to the Father, and the status of human flesh (*Psych.* 76–86). The theological

positioning is concisely expressed in an apophatic flourish at *Psych*. 82–84:

ille manet quod semper erat, quod non erat esse incipiens; nos quod fuimus iam non sumus, aucti nascendo in melius. mihi contulit et sibi mansit.	He remains what he always was, though begins to be what he was not; but we are no longer what we were, now that we are raised at our birth into a better condition. He has given to me, yet still remained for himself.

Thus the Word, i.e., Christ, always remains what it was, though commencing to be what it was not; and humans were not what they are now. The important, positive meaning that Prudentius gleans from this apophatic (negative and enigmatic) formulation is that human flesh and souls have fundamentally changed due to God taking on human form – while the godhead remains the same. This change in humans is explained not in ordinary thinking and speaking, but in historical terms through the typology of Judith/Mary and, in conceptual terms, through the typology of Judith/*Pudicitia*. The stories of the defeat of *Libido* by *Pudicitia* and the killing of Holofernes by Judith, which together form a complex typological allegory, help define the change in human flesh by portraying the purity acquired from chastity. The quality of the soul, chastity, is a necessary ingredient for the acquisition of purity in both body and soul. Thus, the soul of each Roman Christian can become pure by becoming the re-figuring of chaste Judith, the Israelite woman whose extraordinary actions saved her nation. And finally, female weakness is transformed into spiritual strength for all by typologically relating the stories of Judith, Mary, and the Incarnation. Judith's story, which takes place under the old dispensation of Mosaic law, gains authority only when understood through the stories of the new, Christian, dispensation. For Prudentius, like Paulinus, female weakness becomes integrated into the definition of a salvational Christian agency with the pregnancy of Mary and birth of Christ.

Judith, the *Psychomachia*, and Female Agency

Feminist scholars and anthropologists have no fixed definition of female agency. Their interest has focused more on the methodological and ideological implications concerning agency.[15] However, in the context of Greek women's ritual practices, for instance, it is clear that agency as female autonomy, to whatever degree, grounds the scholarly discussion. The

15 Tzanetou, Introduction, p. 11.

dialectic between agency and subjection or, what Barbara Goff calls "the double bind of agency and subjection," is important as well.[16] In the ancient Greek ritual context, the representation of women oscillates between "female independence and male influence."[17] In the Roman Empire, marriage conferred a new degree of agency on women that was reflected in domestic authority and property ownership, especially amongst widows. By the time of Jerome, the estates of Roman Christian widows were a significant source of revenue for the church – and from the evidence of Jerome's letters, these women also played significant roles in the development of urban ascetic practices.[18] Female agency, then, is conceptually *and* historically specific. The term "agency" functions more meaningfully with historical and conceptual qualifiers; for example, "Roman," "Greek," "Christian," "aristocratic," "ethical," and/or "linguistic."[19]

The meaning of female agency is heavily context-dependent, especially since in representing ancient women, universalizing definitions tend to mask indications of autonomy that might provide important historical perspectives. Elizabeth Clark, following Joan Scott, confirms this idea when she discusses the study of early Christian women, the evidence for whom is primarily textual: "to study the meaning of the rhetoric pertaining to women – in addition to raising up women as agents and victims – enlarges our historical perspective."[20] Thus in my understanding of female agency, I begin from Scott's loose formulation: "… subjects do have agency. They are not unified, autonomous individuals exercising free will, but rather subjects whose agency is created through situations and statuses conferred on them …"[21] Scott effectively guards against projecting twentieth-century notions of the individualist self onto different eras; in the ancient world, for example, a self is conceived as relational to others, to the roles one plays in the family and society, and to the institutions in which one participates.[22]

16 Goff, *Citizen Bacchae*, p. 91 n. 6.

17 Tzanetou, Introduction, p. 12.

18 S. Rebenich, *Jerome* (London: Routledge, 2002), pp. 28–39.

19 E. Clarke, "Engendering the Study of Religion," in S. Jakelic and L. Pearson (eds.), *The Future of the Study of Religion* (Leiden: Brill Press, 2004), p. 222: "Women's agency … has varied considerably with the workings of class, law, social custom, generational differences, and religious hierarchy."

20 Ibid., p. 241.

21 Ibid., p. 236, quotes Joan W. Scott, "The Evidence of Experience," *Critical Inquiry*, 17 (1991), pp. 791–93.

22 Christopher Gill, *Character and Personality in Greek Epic and Tragedy* (Oxford: Oxford University Press, 1996) and *The Structured Self in Hellenistic and Roman Thought* (Oxford: Oxford University Press, 2006) have set the terms of the discussion

If we understand the biblical Judith with Scott's formulation in mind, we see an aristocratic, pious, beautiful, chaste, Israelite widow. By replacing her clothes of widowhood with party dress and suggesting that her chastity is up for renegotiation, Judith further complicates the context of her agency by appearing to be an alluring, pious traitor who, nonetheless, is helpless from the point of view of the powerful commander, Holofernes. Her inverted Odyssean disguise, if you will (Odysseus preferred the disguise of a beggar), puts her in the "normal," subjected role that female agents in these stories played. Yet, just before her entry into the Assyrian camp, when she was back in her Israelite city, Judith is anything but subject to her male colleagues and superiors. The Israelite commander, Ozias, and his soldiers obey each of her commands. From the point of view of the Israelite men, Judith is indeed in charge, the master of her actions, which could result in the salvation of Israel. With regard to the reader, Judith's plan represents a desperate act, the Israelites' last hope. Why else put your faith in a lone widow? And for the character of Judith herself, any successful act that saves her people and comes about through her is an act of God. Her actions are really God's. Thus agency as degrees of autonomy is figured in several ways in the biblical text, according to Judith's variously construed situations and statuses, and according to the perspective of the two main characters and the reader. From the perspectives of male authority, female vulnerability, and an omnipotent God, the biblical text reflects a range of weak and strong agency.

We might add to Scott's formulation of agency that texts construct the female agent as a product of various viewpoints within and exterior to the text. However, given this, it is still possible to understand the biblical and the Prudentian Judith as an "aggrandized" female agent, that is, as an exceptional and "anomalous portrait" of a woman who manipulates her social and political position in a society in which most women were passive and subjected. Many feminist historians argue that the subjection that formed an essential part of women's subjectivity would be ignored if we were to focus on the rhetoric of such exceptional examples as Judith.[23] The task of reconstructing real women's lives, they claim, would be deemphasized. Feminist critics and historians have been involved in a lively de-

regarding the ancient and the modern self.
23 A. Hollywood, "Gender, Agency, and the Divine in Religious Historiography," *Journal of Religion*, 84.4 (2004), p. 247. See also "Agency and Evidence in Feminist Studies of Religion: A Response to Elizabeth Clark," in Jakelic and Pearson, *The Future of the Study of Religion*.

bate concerning this issue, but it is not surprising that Judith is an aggrandized female agent because both in the biblical text and in the *Psychomachia*, Judith furnishes one of the terms in the type/antetype binary of typology. It is a requirement of the method of typology that persons and events from the past stand out in an exceptional way and are associated with other persons or events that come afterward. The point is that through this use of typology both ordinary men and women, whatever the state of their subjection, have access to salvation.

Connections between persons and events of different epochs illustrate how typological thinking in Judith and in the *Psychomachia* helps to define the agency of Judith and *Pudicitia*. Exceptional people and events of the past provide the keys to action for Judith in the biblical text and for *Pudicitia*. For instance, at Judith 9, in her prayer Judith invokes the example of Simeon and Levi, sons of Jacob, who avenged the rape of their sister Dinah (Gn 34): "O Lord God of my father Simeon, to whom thou gavest a sword to take revenge on the strangers who had loosed the girdle of a virgin to defile her, and uncovered her thigh to put her to shame, and polluted her womb to disgrace her" (Jdt 9:2). For *Pudicitia*, Judith herself furnishes the exceptional example that comes to her mind after the killing of *Libido*: "… and woman as she was, [Judith] won a famous victory over the foe with no trembling hand, my bold heavenly avenger!" (*Psych.* 64–65). Similarly, *Pudicitia* is a typological expression of Judith, constructed from the virtue that Judith exemplifies, chastity. Thus, the memory of past exceptional persons and events motivates, supports, and justifies the actions of these characters. The agency expressed by Judith and *Pudicitia* hinges on typological relationships explicit and implicit in the respective texts.

Generalized Agency, Typology, and Free Will in the *Psychomachia*

The autonomy, status, and authority of the *Psychomachia*'s Judith derive from Prudentius's placement of the chaste widow in Christian salvation history. And her establishment as a prominent historical figure is accomplished through her deployment in typologies. The *Psychomachia* is rich with typological associations that define the agency of Judith, Mary, *Pudicitia*, and finally, the Roman Christian reader of the poem. The agency of Prudentius's Judith is realized through understanding her as a typological figure. Associated with the Virgin Mary, and her killing of Holofernes,

she becomes typologically related to the immaculate birth of Jesus. Judith's agency becomes defined in terms of a choice between two autonomous actions: committing adultery or saving her people through chastity (and guile!). Not only does she display her autonomous agency but she also exercises the right choice, thereby cementing her name in Christian universal salvation history, which is told in the *Psychomachia* through a series of types and antetypes from the Hebrew bible, the Gospel, and Roman history.

An examination of the language of *Psych.* 40–109 reveals the role that the trope of typology plays in generalizing female agency as seen in *Pudicitia*, Judith, and Mary. *Pudicitia* is twice referred to as a *victrix* ("victor"; *Psych.* 53, 103), while Judith, who is merely a *mulier* (wife; *Psych.* 63) and a *matrona* (widow; *Psych.* 66), achieves a great victory over Holofernes and the Assyrians. Judith is one of the "feeble agents" or "earthly bodies" through whom virtue defeats powerful vice:

at fortasse parum fortis matrona sub umbra legis adhuc pugnans, dum tempora nostra figurat, vera quibus virtus terrena in corpora fluxit grande per infirmos caput excisura ministros. (*Psych.* 66–69)	But perhaps one might say (wrongly!) that a widow fighting under the shadow of [Mosaic] law was not strong enough, even though she prefigured our times, in which true virtue has passed into earthly bodies, virtue, which through feeble agents, severs the great head.

To understand its full force one must look to *Psych.* 58–63: *tene, o vexatrix hominum, potuisse resumptis / extincti capitis recalescere flatu ... postquam ... Iudith ... incestos conpescuit ense furor* ("Will you [*Libido*], who vex human beings, be able to resume your strength and grow warm again with the breath of life that was extinguished in you after Judith checked [Holofernes's] unclean passion with the sword ...?"). *Pudicitia* indicates that the defeat of *Libido* is temporary, that the typologically prior event of the killing of Holofernes by Judith did not eliminate lust. It is an extraordinary observation because it implies that the battle with lust within each person's soul happens repeatedly (see *Psych.* 893–98). The only way to destroy lust over and over again is for an individual to remember the archetypal story that figures its defeat, for instance, the story of Judith (and *Pudicitia*'s defeat of *Libido*), and finally, to choose to act according to her example. Even a feeble agent gains strength through the acquisition of virtue that purifies the soul.

The rest of this section of the *Psychomachia* forms a reply to the recurring

problem of vice. On the one hand, freewill of the individual appears to be invoked since each person must summon his or her own inner virtues to suppress lust. On the other hand, what allows each person to fight this battle and kill off lust in universal salvation history is the immaculate birth of Christ, which *Pudicitia* explains over the course of twenty-seven lines (*Psych.* 70–97). *Psych.* 66–69 must be understood in this context. The phrase at *Psych.* 66, *sub umbra legis* (under the shadow of [Mosaic] law), points backward to the incompleteness of Mosaic law when an indefatigable lust was operative in the universe, and forward to the new dispensation of Christianity, in which *Libido* will be driven from the soul. This possibility of a future, free of lust, has been prefigured by the action of Judith. The typology has become more specific, pairing Judith's killing of Holofernes – and as a consequence, the saving of the Jewish people – with the birth of Christ by Mary, which saves all Christians. The elimination of lust by Judith typologically indicates Mary, her immaculate conception, and the birth of Christ, a moment in history when individual, freely taken action, resulting in the destruction of vice and evil became available to even "feeble agents." The phrase *infirmos ministros* is typologically tinged, signifying Judith and Mary (as well as Martyrs), females whose worldly weakness is transformed into salvational strength. Through the association of females with weakness *and* salvation, Prudentius, Jerome, and Paulinus of Nola describe a new Christian agency, one that is universalizable to all human beings.

Early Christians such as Prudentius understood the idea of agency to include a degree of autonomy and independence that allows the human agent to choose freely between virtue and vice.[24] What is more, an act of a weak agent can defeat extremely powerful forces, either through earthly victory or through the winning of salvation in "defeat" (David, Judith, Jesus, and the Martyrs, respectively). The exemplary female agent in early Christian writing is often figured as strong though weak, first though last, included though excluded. Judith and Mary are certainly the most unlikely candidates to change the world with their actions, yet they do just that. However, these figures obtain much of their force and authority because of the pivotal roles they play in salvation history. And for Prudentius, salvation history is constructed through a series of typologies that unite the Hebrew past with the Roman Christian recent past, present and future. Adverbial expressions of time indicate these periods: *sub umbra legis* (*Psych.* 66–67), *post partum virginis* (*Psych.* 70, 71), *nostra tempora ... quibus* (*Psych.*

24 Mastrangelo, *The Roman Self in Late Antiquity*, chapter 3.

67–68), *inde* (*Psych.* 76), *post Mariam* (*Psych.* 88), *postquam* (*Psych.* 60). The killing of Holofernes, the incarnation of Christ, and the immortality of Prudentius's Roman Christian reader become constituents of a typology that signify individual salvation through freely chosen action.

Prudentius works out the ultimate meaning of the typology of Judith-*Pudicitia*/Mary/reader at *Psych.* 98–108, which portrays the washing and dedication of *Pudicitia*'s sword. *Pudicitia* is described as a *docta victrix* (a learned victor; *Psych.* 102–103). Her learnedness refers to her knowledge of Christian doctrine. The purity, intrinsic to the story of Mary and the pure birth of Christ, which are figured in the story of Judith and Holofernes, is finally expressed in the treatment of *Pudicitia*'s sword. The sword is cleansed and left in a Christian altar so that it will always remain pure, never to be defiled in any way (*Psych.* 107–108). Paradoxically, a woman's act of ritual cleansing results in a phallic image of purity. Not only should the reader associate the story of Judith with the incarnation of Christ in order to trigger the virtue of chastity in his soul, but the reader should see this traditionally female attribute as a source of strength. Just as *Pudicitia*'s powerful sword shines with "eternal light" (*aeterna luce*; *Psych.* 108), so shall all persons bask in the glow of eternal life provided that he or she knows (*docta*) and commits to the doctrines of the Church.

Female Agency as Religious Sexual Agency

Kathy Gaca has recently argued that early Christianity's prohibition of the worship of goddesses of sexuality, marriage, and child nurture stripped females of their religious agency as goddess worshippers. Gaca remarks that in pre-Christian Greece, women's "religious sexual agency" was "widespread and deeply rooted."[25] From the time of Plato, "women, their sexual bodies, and the female deities in charge of this domain played a pivotal role in this regenerative center of Greek life."[26] For Gaca, the defeat of polytheism by monotheism allows the figure of Christ to appropriate the authority of girls, adolescent girls, and mothers in the sexual and reproductive spheres.[27]

At first glance, this provocative argument appears to contradict the view that early Christian women may have become more independent in the sexual sphere because adultery became equally blameworthy for both males

25 Kathy Gaca, "Early Christian Antipathy to the Greek 'Women Gods,'" in Parca and Tzanetou, *Finding Persephone*, p. 283.
26 Ibid., p. 286.
27 Ibid., p. 283, with 2 Cor 6:14–7:1.

and females (at least in theory) by the fourth century. Given that Gaca's argument focuses on women's actual practices in ancient society, Judith and her story could be understood as a counterexample to her claim that women lost an important aspect of their agency. The use of the Judith story in the *Psychomachia* portrays a kind of female agency that reconfigures a woman's relation to her sexual and reproductive roles. On the one hand, Judith influences history through the pleasurable temptations associated with her body. Her sexual and childbearing potential is subordinated to her capability of saving herself and her people. On the other hand, Judith's agency has been universalized. It is a new kind of agency, grounded on the precepts of post-Nicean Christianity. Both women and men can imitate her historical example when they choose chastity over sexual pleasure in order to behave morally within a marriage or purify the soul for the coming of the bridegroom, Christ.

Thus Gaca may be right that the sexual and reproductive roles of women, so important to the scholarly construction of ancient female agency, are disassociated from women of early Christianity.[28] However, at least for one aggrandized example of female agency, Judith of the *Psychomachia*, the "female" virtue of chastity of paganism is appropriated as central to the universal Christian doctrine of immortality. In practice, most Christian women of this period may have lost an aspect of autonomy and independence that they possessed in their sexual and reproductive lives; but in the ideal and in certain aristocratic circles, women had gained an autonomy consisting in choices that define what it means to be a good Christian. An aristocratic Christian widow of the fourth century could do what she liked with her property if she did not form any more attachments by remarrying and having (more) children. The Jeromes and Ambroses of the fourth century encouraged them not to form these attachments. In other words, these widows should be chaste, and, as a consequence, many gave their wealth to the Church. Jerome and other bishops of the late fourth century appeal to this *mentalité* when raising money for the Church or recasting sexual mores as Christian ones.

28 Clark, "Engendering the Study of Religion," p. 222, cites K. King, "Prophetic Power and Women's Authority: The Case of the Gospel of Mary (Magdalene)," in Beverly Mayne Kienzle and Pamela J. Walker (eds.), *Women Preachers and Prophets through Two Millennia of Christianity* (Berkeley, CA: University of California Press, 1998), pp. 32–33.

Conclusion

To understand constructions of female agency in early Christian or medieval history is in part to see how typology functions. The disassociation of women from the sexual and reproductive sphere, the tolerance for prophecy, and the presence of Christ as the expectant bridegroom help to form a new idea of female (and male) Christian identity. However, a typology that is anchored in an exemplary figure, and also includes the reader, viewer, or parishioner, helps to define in what ways the autonomy and independence of early Christian women and men is to be understood. In Prudentius's *Psychomachia*, Judith's story, as in various martyr stories, shows that the hierarchical relationships given in the world are powerless in the face of internalized Christian virtue. The male Israelite commanders, Holofernes, and *Libido* yield to Judith's authority, which is constructed in large part from her place in a typology. We have seen that this typology includes the most important figures and events in Christian salvation history. Thus Judith herself gains great power from these explicit associations. But if the autonomy of female agency, as seen in Prudentius's Judith, is diminished because it distracts us from how early Christian women lived, it simultaneously undergoes a process of generalization (or appropriation) that results in an ideal Christian agency for both men and women, whose most salient characteristic is a limited version of free will.

9. Judith in Late Anglo-Saxon England

Tracey-Anne Cooper

Judith makes two spectacular appearances in the Old English corpus: she is the brave heroine of a poem which is included in one of the most famous manuscripts of the late Anglo-Saxon period, the Nowell Codex, which also contains the heroic epic, *Beowulf*.[1] Judith is the subject also of a homily

1 The Nowell Codex, named for its mid-sixteenth-century owner Laurence Nowell, who wrote his name on the first page, is now preserved in the British Library as London, British Library, MS. Cotton Vitellius A. xv. In its current state it is a composite of at least two manuscripts, the first part being of the twelfth century and the second part, which contains *Judith*, most commonly dated to the turn of the millennium. Neil Ripley Ker, *Catalogue of Manuscripts Containing Anglo-Saxon* (Oxford: Clarendon Press, 1957), art.216, p. 281, dates the manuscript as *s.* x/xi. Roy Michael Liuzza, *Beowulf: A New Verse Translation* (Peterborough, Canada: Broadview Press, 2000), p. 11, argues for a date of manuscript production in the decade after 1000. The second codex contains five texts: a fragment of the *Life of Saint Christopher*, more complete texts of *Letters of Aristotle* and *Wonders of the East*, *Beowulf*, and *Judith*. The poem *Judith* did not, however, originally follow on from *Beowulf*, because wormholes do not match up and there is great wear on the back of the last folio of *Beowulf*, which indicates that, at one time, it came at the end. The first four texts are inseparable, so *Judith* may have originally come before them or have been part of another manuscript. The latter part of *Beowulf* and *Judith*, however, appear to be the work of the same scribe. Currently, there is much debate about the theme of the "monstrous" tying these works together, following Andy Orchard's book *Pride and Prodigies: Studies in the Monsters of the* Beowulf *Manuscript* (Toronto: University of Toronto Press, 2003). For the date of composition of the poem see n. 4. The most recent edition of the Old English poem is Mark Griffith (ed.), *Judith*. Exeter Medieval Texts and Studies (Exeter: University of Exeter Press, 1997). For a prose translation of the poem see S. A. J. Bradley, *Anglo-Saxon Poetry* (London: J. M. Dent & Sons, 1995). A translation that keeps much of the poetic style of the original (with the occasional loss of precision in the translation) is in Albert S. Cook (ed.), *Judith, An Old English Epic Fragment* (Boston: J. M. Dent & Sons, 1904), pp. 3–27, which can be found at http://www.elfinspell.com/JudithStyle.html. The translations used here are my own and preserve the sense and format of the poem, but not the poetic structure.

by Ælfric, the most prolific and highly-regarded homilist of the age, who rendered her as an appropriate subject for the contemplation of *clænnysse* (chastity) for the benefit of nuns.[2] Thus, even at our first approach to the perception of Judith in late Anglo-Saxon England, we are presented with ambivalence; is she a courageous military heroine to be heralded at the "mead-bench," or is she a pious example of chastity to be meditated upon in the cloister? In actuality, the Anglo-Saxon interpretations of Judith are more complex than even this dichotomy between genres suggests. While the Judith poem is most certainly an heroic epic in the manner of *Beowulf*, particularly in the second half when the Israelite army takes on the Assyrians, Judith's own martial role, though described in gory detail, is actually diminished as she is presented as an allegorical type in a contest between good and evil and she is portrayed very much as the instrument of God. The Judith of Ælfric's homily, on the other hand, is much more the mistress of her own will and actions.

Margarita Stocker referred to Judith as "the Good Bad woman," encapsulating her fundamental ambiguity.[3] It is this very ambiguity that has made her fascinating to many writers throughout the ages. In the process of explicating Judith's shocking act and addressing the ambiguity between her roles as both murdering seductress and virtuous instrument of God, individual authors can transmit their own messages to their audience. The Anglo-Saxons imbued Judith with both the qualities of military hero and chaste widow, and used her narrative both as tropological message and allegorical type. These seeming ambiguities begin to make sense when we understand that these divergent attitudes were produced from an amalgam

2 The base manuscript for Ælfric's homily on Judith is preserved at Cambridge, Corpus Christi College, MS 303, pp. 341–62. This is an early-twelfth-century collection of a selection from both series of Ælfric's *Catholic Homilies* and some other texts. See Ker (1957) art. 57, pp. 99–105. Fragments from the homily are also contained in the badly damaged manuscript London, British Library, MS. Cotton Otho B.x., fols. 29 and 30. The homily's first modern editor, Bruno Assman, "Abt. Ælfric's angelsächsische Homilie über das Buch Judith," *Anglia* 10 (1888), pp. 76–104, suggested a date of 997–1005; whereas Peter Clemoes dated Ælfric's homily on Judith ca. 1002–1005, "The Chronology of Ælfric's Works," in Peter Clemoes (ed.), *The Anglo-Saxons: Studies in Some Aspects of their History and Culture Presented to Bruce Dickins* (London: Bowes, 1959), pp. 212–47. Most recently the homily has been edited, with extensive commentary, by S. D. Lee in an electronic book along with Ælfric's homilies on Esther and Maccabees at http://users.ox.ac.uk/~stuart/kings/main.htm. The Old English text in this chapter is after his edition, but as yet no full translation is available, and the translations here are my own.
3 Margarita Stocker, *Judith: Sexual Warrior. Women and Power in Western Culture* (New Haven, CT: Yale University Press, 1998), p. 24.

of the Anglo-Saxons' past and their present. The patristic scholarship which the Anglo-Saxons inherited had many differing interpretations of Judith; to some she was a tropological model of chastity and faith, while to others she was an allegorical type for the Church, coming to represent all Christians in their struggles. The Judith narrative had also taken on a new urgency and poignancy in the late Anglo-Saxon period, as they confronted their very own "Assyrian" aggressors in the form of renewed Viking assaults beginning in the 990s. Judith, as she was imagined at the turn of the first millennium in Anglo-Saxon England, therefore, needs to be thought of within the context of both the patristic background and the contemporary calamity.

Ælfric's homily was written ca. 1000 and the Nowell Codex was produced at around the same time. There is some contention over the date of the composition of the poems in the Nowell Codex, including *Judith*. David Chamberlain suggests the date 990–1010, a date contemporaneous with the production of the manuscript.[4] The Old English poem and homily were not written to commemorate a woman named Judith in the manner of Rabanus Maurus of Fulda (780–856), a pupil of the great Anglo-Saxon scholar Alcuin, who wrote the first full commentary of the Book of Judith, which he dedicated to Queen Judith, wife of Louis the Pious. We can, therefore, look to the contemporary historical context of the composition of the homily and poem to explain the urgency with which the Anglo-Saxons seem to have embraced the Judith narrative at around the turn of the millennium. When the Viking raids on Britain began again in earnest in the 990s, just three generations after Alfred's victory over them, it must have been a profound shock for a people who had been enjoying what art historians have called a "golden age." Mistakes were made in encounters with the Vikings. King Athelred the Unred (Bad Counsel) may have too rashly paid Viking extortions; meanwhile some earls, like Byrhtnoth, whose heroic defeat is celebrated in the poem *The Battle of Maldon*, may have too hastily engaged them in combat, even letting the raiders assume advantageous positions before entering into the fray. Many noble husbands were slaughtered at Maldon or were away fighting in similar battles, and we have to assume that there were many widows or married women who had to step in to

4 David Chamberlain, "*Judith*: A Fragmentary and Political Poem," in Lewis E. Nicholson and Delores W. Frese (eds.), *Anglo-Saxon Poetry: Essays in Appreciation for John C. McGalliard* (Notre Dame, IN: University of Notre Dame Press, 1975), p. 158. This date is also endorsed by Ian Pringle, "'Judith': The Homily and Poem," *Traditio*, 31 (1975), p. 91. More recently Mark Griffith has proposed a date of ca. 900, Mark Griffith (ed.), *Judith* (Exeter: University of Exeter Press, 1997), p. 47.

provide temporary "good lordship" on behalf of the dead or absent hus-
bands. Good lordship meant many things – fairness, wisdom, constancy,
leadership, but above all protection. These were qualities which lords were
expected to embody at all times and which noble women had to adopt in
difficult times. Thus, Judith is held as a shining example of good lordship
for these tumultuous times, wise not rash, brave not foolhardy, faithful and
pure of heart. If Judith, a weak woman, could prevail against the Assyrians,
so too, contemporaries might extrapolate, could the Anglo-Saxons prevail
against the Vikings.

Judith could be used as a call to all in Anglo-Saxon society to do their
part in the battle against the Vikings. Ælfric wrote a book entitled *On the
Old and New Testament* for his friend Sigeweard in which he includes a brief
synopsis of the tale of Judith.[5] In this book Ælfric refers Sigeweard to an
English version of the *Liber Judith*, which he says has been written "to be
an example to you men, that you defend your country against the attack-
ing army."[6] Ann Astel argues, along with many other scholars, that in this,
Ælfric is referring to his own Old English homily on Judith, which she de-
fines here as a moral lesson which is a "timely call to men such as Sigeweard
to resist the invading army of Danes."[7]

Ælfric, however, was not advocating that women actually pick up the
sword against the Vikings in direct emulation of Judith; indeed Anglo-
Saxon culture valued women as peace-weavers not as warriors, and there
are very few examples of women warriors in chronicles or in literature
compared to the Viking culture.[8] The last part of the extant Ælfrician hom-
ily makes its intended audience apparent; this constitutes a didactic call
to *clænysse,* "chastity," and it is addressed specifically to *myn swustor,* "my
sister," and it is an exhortation to nuns to protect their chastity. Judith is an
admirable exemplar because "she lived in chastity after her husband [died]
on her upper floor" (*Judith* ll. 172–73).[9] There may have been more than
one version of Ælfric's homily on Judith circulating. If the ending (the lines

5 Ælfric, "Letter to Sigeweard," *The Old English Version of the Heptateuch*, ed. S. J.
Crawford, Early English Texts Society, old series 160 (1922), p. 48.
6 "... eow mannum to bysne, þæt ge eowerne eard mid wæpnum bewerian wið on
winnende here." Crawford (1922), p. 48.
7 Ann Astell, "'Holofernes' head': *Tacen* and Teaching in the Old English *Judith*,"
Anglo-Saxon England 18 (1989), pp. 117–133, at 117.
8 The Anglo-Saxon Chronicle, for example, records that in 722, Queen Æthelburg
of Wessex led an army to destroy Taunton, which had formerly belonged to her hus-
band, but this is a solitary incidence in a chronicle that records centuries of Anglo-
Saxon history. See entry for A.D. 722 at http://omacl.org/Anglo accessed on 8/29/08.
9 "hi wunode on clænnysse æfter hire were on hyre upflore."

after l. 356) was changed and addressed to a secular male audience and not a female cloistered one, and the final contemplation was concerned with courage and fortitude, rather than with faith and chastity, then the rest of the homily could stand unchanged and not seem out of keeping with a new audience and new message.

In the beginning of the homily, Ælfric has included a brief "scene-setting" section that is not in the Vulgate. The Vulgate opens by placing the incident within its true historical setting, explaining who the protagonists in the conflict are and how it had come about in terms of chronological history; Ælfric, however, takes a much broader approach in his introduction. His opening is deceptively instructive: he appears to be sorting out any confusion between the two Nebuchadnezzars mentioned in the Bible, although what he is really doing is introducing one of the key messages of the homily – steadfast faith will be rewarded and wavering faith will be punished. The first Nebuchadnezzar, Ælfric says, was able to invade Judaea, destroy the Temple and put the Jewish people to the sword because they had insulted their God through idolatry and devil worship. Ælfric then reports how the Jews were held captive in Babylon until they were released by King Cyrus and returned to Judaea where they rebuilt the Temple. The other Nebuchadnezzar, Ælfric informs his audience, was King Cyrus's son, and he is the one who is relevant to our story; he once more threatened the Jews, through his general, Holofernes. Ælfric does not bother with the minutiae of the chronology found in the Vulgate, but instead, by including the Babylonian captivity, sets the stage for Achior's speech in which he tells of the Jews escaping from the Egyptians across the parted Red Sea and living in the desert by God's munificence. Achior warns:

> … no-one was able to own this people as long as they held their God rightly. But as soon as they bow down away from worshiping Him to the heathen gods, they become ravished and insulted through heathen people. As soon as they with true repentance cried afterwards to their God, he made them mighty and strong to withstand their enemies. Their God truly hates un-righteousness.[10]

Thus, Ælfric, by including the Babylonian captivity, has enhanced the notion from the Vulgate that bad things happen to unfaithful people and

10 "ne mihte nan mann naht þisum folce, swa lange swa hi heoldon heora God on riht. Swa oft swa hi bugon fram his biggengum to þam hæðenum godum, hi wurdon gehergode & to hospe gewordene þurh hæðene leoda. Swa oft swa hi gecyrdon mid soðre dædbote eft to heora Gode, he gedyde hi sona mihtige & strange to wiðstandenne heora feondum. Heora God soþlice hatað unrihtwisnysse!"

good things happen to the righteous, by providing a counterexample to balance the story of God's facilitation of the escape from Egypt. In Ælfric's milieu, with the renewed Viking assaults, he is presenting a poignant argument: that it is the lack of righteousness that has brought the current calamities down on the Anglo-Saxons and that things will not improve until they mend their ways and are once more pleasing to God.

After this altered introduction Ælfric then provides a paraphrase of the Vulgate in the middle (and largest) part of the homily. There are occasional additions for emphasis; for example, in l. 242 he adds *for nanre galnysse*, emphasizing Judith's complete lack of immorality. Ælfric also omits or foreshortens some parts of the Vulgate version; most significantly Judith's speeches have been cropped. This is not unusual, however, in the writing of homilies, where it is important to get on with the narrative and drive home the message. The indignant speech in which Judith challenges the decision by Ozias and the elders to wait five days for God to intervene and, if He does not, then surrender to Holofernes, has been reduced in Ælfric's version to a plea for faith in God; this simplification once again emphasizes Ælfric's main message in the homily – right faith will be rewarded. The prayer Judith offers up to God as she adorns herself before setting off for the Assyrian camp is completely omitted; this may be because in this prayer she reveals her plan to use her beauty to overcome Holofernes, and Ælfric as a good storyteller did not want to give too much away too soon in his tale. The initial conversations between Holofernes and Judith are also reduced in Ælfric's version, but again this may simply be the product of his desire to tell the story well and to get to the main action in Holofernes's tent.

Compared to some older patristic versions and commentary on the *Judith* narrative, Ælfric nevertheless stays somewhat truer to the Vulgate version. Ælfric does not participate in the extreme polarizing of good and evil that we see in Jerome's idea that "chastity beheads lust" or that which was taken up in Prudentius's highly allegorical poem *Psychomachia*; neither does Ælfric's Judith conform to Jerome's notion that she was "a type for the Church which cuts off the head of the devil."[11] Jerome skewed temporality in aligning Judith with Christianity:

> In the Book of Judith – if any one is of opinion that it should be received as canonical – we read of a widow wasted with fasting and wearing the sombre garb of a mourner, whose outward squalor indicated not so much the regret which she felt for her dead husband as the temper in which she looked

11 Jerome, Letter to Salvina, no. 79. http://www.newadvent.org/fathers/3001079. htm accessed on 3/13/08.

forward to the coming of the Bridegroom. I see her hand armed with the sword and stained with blood. I recognize the head of Holofernes which she has carried away from the camp of the enemy. Here a woman vanquishes men, and chastity beheads lust. Quickly changing her garb, she puts on once more, in the hour of victory, her own mean dress finer than all the splendours of the world. (Judith xiii)[12]

Jerome replaces the Jewish cultural practices of Judith's mourning with the notion that she is an archetype for the "bride of Christ" – that is, a nun, waiting in chaste hope and expectation to be united with her "bridegroom" – Christ. Jerome has, however, broken the constraints of temporality, and in the same way that he can reflect himself back into Holofernes's tent, Judith can emanate forward into the Christian milieu, and thus spiritual symbolism can be given free rein. It is interesting, given Ælfric's intended cloistered audience, that he does not make any attempt in the manner of Jerome to make his Judith into a "bride of Christ," but he is content to allow her to remain within her historical context. Indeed, Ælfric leaves a lot of the complexity of Judith's character intact; she is still praised for her *clænnysse* (chastity), but she is by no means the innocent agent of God, who performs his will almost as an automaton.

Ælfric's Judith is an "Eve-like temptress,"[13] who deliberately sets out to seduce and deceive, because "she cast aside her sackcloth and her widow's clothes and adorned herself with gold and with purple garments and with a splendid girdle."[14] Moreover, the explanation she gives in the homily to Holofernes for her presence in his camp is described by Lee as "at best a prevarication, at worst a lie."[15] Unlike the highly allegorical patristic Judith and the Judith of the Anglo-Saxon poem, Ælfric's Judith is present and active; she plans, seizes the opportunity and acts and Ælfric does not try to excuse Judith's actions.

Perhaps because he is writing for the edification of nuns he does not marvel like Ambrose of Milan (339–97) at the inappropriateness of someone of her gender undertaking these actions. Ambrose seems somewhat astounded that a woman could achieve what Judith had achieved:

How great must have been the power of her virtue, that she, a woman, should claim to give counsel on the chiefest matters and not leave it in the hands of

12 Jerome, Letter to Furia, no. 54. http://www.newadvent.org/fathers/3001054.htm accessed on 3/11/08.
13 Lee, VIII, section 3c.
14 "heo awearp hire hæran & hire wudewan reaf, & hi sylfe geglængede mid golde, & mid purpuran, & mid ænlicum gyrlum."
15 Lee, VIII, section 3c.

the leaders of the people! How great, again, the power of her virtue to reckon for certain upon God to help her! How great her grace to find his help![16]

While Ambrose was shocked that Judith, a mere woman, could accomplish such great things, Ælfric is actively trying to encourage the emulation of Judith's spirit, faith, and virtue (though, of course, not the actual act) in the women he is addressing. It is tempting to conclude that perhaps Ælfric, given his own dangerous times, has more sympathy for the idea that desperate times call for desperate measures; as Lee says, "Ælfric, though, clearly full of admiration for her, recognizes her [Judith's] human failings and does not attempt to cover them up."[17] In this way Ælfric perhaps follows some of the patristic authors in seeing Judith as a type for all Christians; for him, however, this is not at all the idealized sinless believer, but a more realistic and sympathetic Christian type, a sinner like the rest of us poor sinful wretches who will inevitably commit infractions but try their best to be righteous.

Ælfric's Judith, though not the idealized type for the Church of the patristics, nevertheless commits only minor infractions, and the theme of *clænnysse* (chastity) is still emphasized throughout, and this makes the homily appropriate for its audience of nuns. Ælfric seems to be saying that if this Jewish woman was able to live in such honorable chastity that she and her people were rewarded by God, then how much easier must it be for his nuns who have had the benefit of Christianity: "You should take an example from this Judith, how cleanly [chastely] she lived before Christ was born."[18] The manuscript preserves at the end of *Judith* the opening few lines of Ælfric's *Life of Malchus*, which, as Lee points out, is thematically similar – Malchus manages to preserve "his chastity despite extreme pressure." The two texts are thus related by the themes of chastity and faith. Ælfric truly believed that calamities occurred to a people when these two principles were corrupted. As in the incident of God punishing the Jews in the Babylonian captivity, which Ælfric added to the beginning of the homily, he believed that God was similarly punishing the Anglo-Saxons for their lack of faith. He was particularly disturbed by the "widespread disregard for moral teaching and practices of Christianity, especially among the monastic orders," to which he attributed the onslaught of the Vikings:[19]

16 P. Schaff and H. Wace (eds.), *St. Ambrose, Nicene and Post-Nicene Fathers of the Christian Church*, second series, vol. 10 (New York: The Christian Literature Company, 1896), p. 81.

17 Lee, VII, section 3c.

18 "Nimað eow bysne be þyssere Judith, hu clænlice heo leofode ær Cristes accennednysse."

19 Lee, VIII, section 3d.

Wel me magon geðencan hu wel
hit ferde mid us
þa ða þis igland wæs wunigende
on sibbe
and munuc-lif wæron mid
wurðscipe gehealdene
and ða woruld-menn wæron
wære wið heora fynd
swa þæt ure word sprang wide
geond þas eorðan.
Hu wæs hit ða siððan ða þa man
towearp munuclif
and godes biggengas to bysmore
hæfde
buton þæt us com to cwealm and
hunger
and siððan hæfðen here us hæfde
to bysmre.

Good it is to me to be able to think
of how easily it went with us
when this island was inhabited in
peace
and monastics were regarded as
worthy
and secular men were watchful of
their enemies,
so that our word sprang widely
throughout this land.
How was it that since then certain
ones have cast down monastics
and God's worshippers have been
brought to shame,
in addition to that, pestilence and
hunger have come upon us,
and since then the heathen army
has shamed us.[20]

Ælfric's homily on Judith, therefore, has a particular sense of urgency which was born out of tumultuous times. It is, in a sense, a call to arms, although it is not directed at military men but at religious women; they are called upon to arm themselves spiritually through diligent chastity and eager faith. The role of the monastic in the fight against the Vikings is as vital as the role of men at arms. In the same way, as we hear in Ælfric's homily, that the Jews were punished by God with the Babylonian exile because of their lack of correct faith, and were rewarded with escape from Egypt and deliverance from the Assyrians by Judith, because they returned to their correct faith, so too are the Anglo-Saxons being punished for lack of correct faith, and, like the Jews, they will be delivered when they return to correct chastity and faith. Ælfric envisions the nuns of Barking assuming the vanguard position in this spiritual battle.

While Ælfric's homily stays fairly close to the Vulgate version and includes little patristic influence, the poem *Judith* has taken many more liberties with the Vulgate text and it displays much more patristic influence. Some changes have been made to suit the poetic format; the Bethulians, for example, are portrayed as a militaristic rather than a religious society, and over half the poem concerns the battle against the Assyrians once Judith has vanquished Holofernes. This would obviously stimulate interest

20 W. W. Skeat, *Ælfric's Lives of Saints: A Supplementary Collection*, EETS, OS 76, 82, 94, 114, 4 vols. (London: N. Trübner & Co., 1881–1900) repr. in 2 vols. (Oxford: Oxford University Press, 1966), XIII, ll. 147–55.

in a martial secular audience, but the concentration on violence also throws into sharper contrast the disparity between Judith's purity and her murder of Holofernes. In many ways *Judith* is a poem of contrasts: between Judith's murderous act and her piety; between the *eadig* (blessed) Judith and *hæðen hund* (heathen dog) Holofernes; between the watchful Bethulians and the drunken Assyrians; between the private sphere of Holofernes's tent and the public sphere of Judith's stirring speech before the battle.

In the Vulgate, Judith tells of her actions upon her return to Bethulia to the Assyrian convert, Achior, but in the poem she just enigmatically shows the head of Holofernes and states simply, *ic him ealdor oðþrong* (I took his life). In the Vulgate, Judith prophesies the outcome of the battle, but in the poem she actually formulates a battle plan which succeeds because of her *gleaw lar* (wise counsel). Yet, in the poem, Judith keeps her participation in hands-on violence to herself; she does not boast in the manner of Beowulf nor does she rashly enter into combat like a male hero; rather, she is much more emphatically God's agent than in Ælfric's homily or in the Vulgate, and she is, therefore, much more in keeping with the Judith of Jerome or Ambrose. Ambrose in his book *Concerning Women* regards Judith's victory over Holofernes as a victory for chastity, her "bridal ornaments" are not beguiling allurements, but in Ambrose's mind are interpreted as "the arms of chastity," and, rather than any bloody beheading, she simply "put forth her hand" and the deed was done. The murderous deed was "not so much the work of her hands, as much more a trophy of her wisdom."[21] In this, Ambrose reflects the attitude adopted early on by the Church Fathers that Judith was a passive agent of God. Clement of Rome (d. 101), for example, in his first epistle to the Corinthians, says of Judith:

> The blessed Judith, when her city was besieged, asked of the elders permission to go forth into the camp of strangers; and, exposing herself to danger, she went out for the love which she bore her country and people then besieged; and the Lord delivered Holofernes into the hands of a woman.[22]

As one might expect, given the genre, Holofernes's death in the Anglo-Saxon poem is more dramatic and bloody than this simple statement by Clement that Holofernes was delivered by God; in the poem, however, the essential element of God's guidance of Judith's actions is still very much present. Judith prays to God immediately before the murder for His sup-

21 Schaff and Wace, pp. 397–98.
22 Alexander Roberts and James Donaldson (eds.), *The Ante-Nicene Fathers*, vol. 1. (Buffalo, NY: Christian Literature Publishing, 1886), p. 20.

port, "*Forgif me, swegles ealdor, sigor ond soðne geleafan*" (Grant me, Heavenly King, triumph and true faith). God answers her prayer immediately, filling her with courage:

Hi ða se hehsta dema	Then the Highest Judge
ædre mid elne onbryde, swa he deð	at once inspired her with courage, as
anra gehwylcne herbuenda	He does with everyone whosoever,
þe hyne him to helpe seceð	dwellers on this earth, who seek for
	his help
mid ræde ond mid rihte geleafan.	with wisdom and right belief.
þa wearð hyre rume on mode	Then her spirit became free from
haligre hyht geniwod;	obstructions to the holy one hope
	was renewed;
genam ða þone hæðenan	she seized then the heathen man
mannan bysmerlice,	firmly by his hair,
ond þone bealofullan	and with her hands dragged him
listum alede,	towards her disdainfully the
	baleful one,
laðne mannan swa heo ðæs	skillfully laid down the loathsome
unlædan eaðost mihte	man, as she the wretch most
wel gewealdan. Sloh ða	easily might control well. The
wundenlocc	curly-haired one
þone feondsceaðan	struck down the fiend-foe
fagum mece heteþonecolne,	with shining sword, the hostile one
þæt he healfne forcearf þone	so that she half cut off then his
sweoran him,	neck,
þæt he on swiman læg drunken	and he lay in a swoon drunk
ond dohlwund.	and wounded.
Næs ða dead þa gyt,	He was not yet dead,
ealles orsawle;	entirely lifeless;
sloh ða eornoste ides ellenrof	she struck again earnestly
oðre siðe þone hæðenan hund,	the courageous virgin on the other
	side of the heathen hound,
þæt him þæt heafod wand forð on	so that his head rolled forth on the
ða flore…	floor…
	[Holofernes's soul goes to hell]
Hæfde ða gefohten foremærne	She gained then by fighting
blæd	renowned fame
Iudith æt guðe, swa hyre god uðe	Judith in battle, as her God
	bestowed
swegles ealdor, þe hyre sigores	Heaven's King, who granted her
onleah.	victory.

While in this secular heroic poem Judith is the expected secular hero, she is not really the Valkyrie-like protagonist that one might expect, but rather she is more of a pious and passive instrument empowered and directed by God. The poet has made much of the single word *bis* in the Vulgate and the fact that Judith had to strike Holofernes twice, and by drawing out the murder in this way Judith appears not so much as a competent warrior-maiden but as someone struggling with a heavier inert body and unfamiliar weaponry as would be appropriate for a woman. Judith's bloody deed is all the more courageous precisely because it is physically difficult and emotionally harrowing for a woman unused to combat.

This murderous moment is also Judith's only contact with Holofernes in the poem (as we have it), and he has already passed out drunk. Any suggestion of inappropriateness in Judith's behavior, dress, and seductiveness is, therefore, avoided. The poem, as it exists, is only a fragment, however, and it opens at a point when Judith is already in Holofernes's camp and he is preparing to feast. There are many varied arguments concerning how much of the poem is lost,[23] but it seems unlikely that it was ever meant to have a long preamble like the Vulgate or Ælfric's homily. Instead, the poem reflects much more closely Prudentius's poem *Psychomachia* in that it is a polarized allegory, stripped of any "unnecessary" narrative detail. Judith's chastity is central to Prudentius's portrayal of her in *Psychomachia*; and like Jerome, he treats her as a type for the Church and an example of chastity and, like St. Ambrose of Milan, he also ruminates on her weakness as a woman. For Prudentius, her womanly weakness was a type for the weakness of humanity in general, which only God through the Incarnation can make powerful.[24]

Assyrium postquam thalamum cervix Olofernis	After the Assyrian Holofernes's neck was chopped in the bedroom;
caesa cupidineo madefactum sanguine lavit,	and the drunk's desire washed out in his blood,
gemmantemque torum moechi ducis aspera Iudith	Sharp Judith scorns the jewels and pillows of the wife-betraying warlord

23 In the London, BL, MS. Cotton Vitellius A.xv manuscript, the extant three hundred and fifty lines of the poem open on a half-line and then fifteen lines later the number "X" appears, this "tenth chapter" (ll. 15–124) is complete, as is the "eleventh chapter" marked XI (ll. 125–135) and the "twelfth chapter" marked XII, of which lines 236–350 remain. See Rosemary Woolf, "The Lost Opening of Judith," *Modern Language Review*, 50 (1995), pp. 168–72.

24 For more on different patristic interpretations of Judith see http://www.voskrese.info/spl/Xjudith.html accessed on 3/13/08.

sprevit et incestos conpescuit ense furores,	and quenches sinful frenzies with a sword.
famosum mulier referens ex hoste tropaeum	The woman is carrying back from the foe, a notorious trophy.
non trepidante manu vindex mea caelitus audax!	Go with unshaking hand, bold heavensent defender!
at fortasse parum fortis matrona sub umbra	Maybe the strong matron's companions up till now were
legis adhuc pugnans, dum tempora nostra figurat,	fighting under the shadow of the Law, still, our times she shapes.
vera quibus virtus terrena in corpora fluxit	In truth, strength flows into earthly bodies; the head of the
grande per infirmos caput excisura ministros.	great is cut off by the weak, powerless servants.[25]

Prudentius thus reflects Jerome's dramatic line, "chastity decapitates lust!" and Judith is equated with the classical virtues: fortitude, temperance, prudence and justice, whereas Holofernes represents the four classical vices: folly, venality, cowardice and lust. Prudentius compresses the Judith narrative into allegory: Judith, typifying virtue, is set against Holofernes's vice, as a polar opposite, in a manner which was to be emulated by the anonymous Anglo-Saxon poet of *Judith*.

In the poem, when Judith gets back to Bethulia, no mention is made of any other characters, such as Ozias and Achior, and so it is unlikely that they had been introduced in the missing opening of the poem. There are thus only two named characters, Judith and Holofernes, who are pitted against each other as allegories of good versus evil, in the manner of Jerome's idea that "chastity beheads lust." Jackson Campbell remarks that "In his poem, only two massive, opposing characters remain, archetypal in their simplicity and in their incompatibility."[26] To highlight the roles played by Judith and Holofernes in the poem, and its conception as a polarized allegory, it is useful to look at how the various characters in the story are referenced.

As well as a consideration of our two protagonists I want to consider also references to God, because the presence of God in the poem, or rather instances when he is invoked by name, dramatically affect the way that Judith is described. The table in the appendix demonstrates that at three key moments when God's presence is emphasized by the poet – at the

25 For translation see http://suburbanbanshee.wordpress.com/2006/12/25/psycho-machia-modesty-vs-lust/ accessed on 3/2/08. Prudentius, *Psychomachia*, 63.
26 Jackson J. Campbell, "Schematic Technique in Judith," *ELH: A Journal of English Literary History*, 38 (1971), pp. 155–72, at 156.

beginning in ll. 1–7a, when Judith's faith is discussed, when Judith prays and then commits the actual murder in ll. 82b–108a, and when the poem explains that Judith's success is attributable to God, in ll. 121a–124b – Judith is depersonalized, and she is referred to, with a single exception, only by the pronoun.[27] This has the effect of removing agency as well as personality from Judith: God is the active named participant in the slaying of Holofernes, and Judith is merely his depersonalized tool. When Judith is summoned to Holofernes's tent she is described as physically beautiful and ornamented, but the poet is not effusive on the point. She is referred to as a "bright virgin" (l. 44, torhtan mægð), though it is unclear whether this refers to the light of beauty or of virtue. She is also referred to as being "ring-adorned" (l. 37, hringum) and "bracelet laden" (l. 36, beagum), but, unlike in Ælfric's homily, she is not explicitly portrayed as being decked out for seduction because the phrases ring-adorned and bracelet-laden are merely stock descriptions of noble women. Just before her murderous deed, the references to Judith change to indicate that she is becoming God's instrument: she is "the Savior's handmaiden" (nergendes þeowen), and "the Creator's maiden" (scyppendes mægð), and, thereafter, throughout the actual deed she is simply referred to by the pronoun.

References to Holofernes also change throughout the poem, becoming progressively more critical the more drunk he becomes. At the beginning of the poem, the poet refers to Holofernes in flattering heroic terms: he is "the bold hero" (l. 9, gumena baldor) and "the gold-giving lord" (l. 22, goldwine gumena). The poet is creating irony here in his heroic references because the auditor of the poem would already know that Holofernes is not what he seems and the wine will eventually reveal his true nature. As he starts to get drunk, the positive heroic references continue, but the poet starts to slip in negative references as well, and he is described as "the evil one" (l. 26, se inwidda).

When Holofernes is extremely drunk he compounds his vice by becoming lustful for Judith, and when he summons her, the references start to alternate between good and bad. By the time Holofernes has passed out, the poet has very few positive things to say about him: he is "the devilish one" (l. 62, se deofulcunda), "the wanton man" (l. 63, galferhð gumena), "the troth-breaker" (l. 71, wærlogan), and "the hateful tyrant" (l. 72, laðne

27 The pronoun is always used for Judith at this point, with two exceptions, where she is referred to as curly-haired, which most likely denotes that she is a Jew because the Israelites at a later point in the poem are referred to collectively as the curly-haired ones (l. 325).

leodhaten). By the time of the actual beheading, Holofernes, like Judith, is most often referred to only by the pronoun, and when he is given a more descriptive reference the heroic epithets have vanished and he is reduced to being only the sinful, heathen enemy. Thus Judith, who is not at this point portrayed as acting under her own agency in any way, is completely justified in her murder. At the actual point of death in ll. 109–11, both Judith and Holofernes are temporarily given back more elaborate references, "the courageous virgin" (l. 109, ides ellenrof) and "heathen hound" (l. 110, hæðenan hund), to underscore at this crux that they are truly polar opposites. Immediately after the beheading Judith is referred to by name, and this can be seen as signifying her return to her own control and the relinquishing of the agency God had assumed during her murder of Holofernes. Hereafter, until the point when Judith is returning to Bethulia, both Judith and Holofernes once more adopt the anonymity of pronouns; at this point in the poem Holofernes is consigned to Hell and God is credited with Judith's triumph. As Judith journeys once more back to her city, the poet's references begin again to bristle with elaborate praise. Judith is "the prudent maid" (l. 125, se snotere mægðe), "heroically brave" (l. 133, ellenþriste). As she gets closer to her city she becomes "dear to her people" (l. 147, leof to leodum) and the poet prefigures her speech and its clever military advice to the Bethulians, by calling her "the shrewd maid" (l. 145, searoðoncol mægð) and "the wise woman" (l. 148, gleawhydig wif).

The poem, therefore, while being written in stirring heroic style, actually owes more of a debt to patristic ideas about Judith than does Ælfric's homily. Whereas Ælfric conceptualized a very human and sympathetic Judith as a tropological message endorsing faith and chastity as a remedy for the island's current calamities, the poet has trimmed down the narrative to present a struggle between two allegorical types – chastity and lust. Therefore, while the poet's medium is reflective of the secular world, with heavy Germanic and militaristic influences, his message and his interpretation of Judith are borrowed from patristic thought. The ambivalence of Judith in the Anglo-Saxon period is, therefore, a product in many ways of our expectations being flouted. In the heroic poem, which in the second half revels in the Israelites' military prowess, Judith is more of a passive agent of God and not a brave warrior herself: she has been reduced to a depersonalized allegory. Likewise in the homily, where one might expect a more passive Judith she is instead much more of an active participant. Her chastity and faith are emphasized, but she has not become, in the manner of patristic

interpretations of Judith, subsumed by her virtues, and she is not subservient to allegory.

The Judith narrative was utilized in this tumultuous period of Anglo-Saxon history, by both poet and homilist, precisely because she embodied ambivalence – she is a good woman who does a bad deed, or rather a deed that would normally be considered a bad thing under any other circumstances. The narrative lends itself to interpretation because her murderous act is so shocking, and it is in the process of explaining her act that individual authors can write their message, whether it be allegorical or tropological. As the Viking invasions turned the world upside down, a heroine was needed who, in similar circumstances, had succeeded against all odds. When others despaired, Judith prevailed. All sections of Anglo-Saxon society had to galvanize to defeat their "Assyrians," the Vikings. The heroic poem used Judith to inspire greater acts of military resistance, while the homily used her to encourage greater acts of spiritual resistance. Judith, an unassuming woman, was called upon by God to assume leadership in a time of crisis, and thus, as Ælfric points out, she was able to fulfill Christ's words in Mark 23:12, which epitomize the beauty of her ambivalence: "In her was fulfilled the Lord's words: Everyone who is exalted shall be humbled and he who is humbled shall be exalted."[28]

Judith in the Winchester Bible

Sometime between ca. 1160 and ca. 1175 in the cathedral scriptorium at Winchester, a Bible was produced, originally in two massive volumes, measuring 583 x 396 mm. The text of the Winchester Bible is complete, the estimated four-year-long labor of a single scribe.[29] Such large Bibles were designed for ceremonial use and display, and "their designers accordingly planned for the decoration on a lavish scale."[30] The illuminations of the Winchester Bible are, however, unfinished. There are "46 complete and fully illuminated initials in gold and colours, most of them historiated. Eighteen further initials are substantially drawn, some of them also gilded. And eight huge holes show where once were yet more illuminations."[31]

28 "On hire wæs gefylled þæs hælendes cwyde: Ælc þe hine ahefð sceal beon geeadmet, & se ðe hine geeadmet sceal beon ahafen."
29 Claire Donovan, *The Winchester Bible* (Toronto, Canada, and Buffalo, NY: University of Toronto Press, 1993), p. 17.
30 Walter Oakshott, *The Artists of the Winchester Bible* (London: Faber & Faber, 1945), p. 1.
31 Donovan (1993), p. 23.

What is of interest to scholars of Judith, however, are the full-page mini-atures, of which four survive. One leaf has been extracted from the Bible and is now preserved in the Pierpont Library as MS 619. Both sides of this extracted leaf are fully colored: the recto "includes the *capitulate* of the first Book of Kings and depicts episodes of the life of Samuel and the anointing of Saul,"[32] and the verso depicts episodes in the life of David, including his defeat and beheading of Goliath. The other two extant miniatures are unfinished; one at fol. 331v stands as the preface to the Book of Judith and the other at fol. 350v faces the opening of the Book of Maccabees. It is very likely that at one time the program of miniature painting was more exten-sive, including at least a "full-page miniature facing the opening of psalms, now cut out, and three pages of canon tables preceding the gospels."[33]

When Walter Oakshott made his extensive study of the Winchester Bible, he identified four different artists at work, and gave each of them names. The designs of all four extant miniatures are thus the work of the Master of the Apocrypha Drawings, and the Morgan Leaf miniatures were colored by the Master of the Morgan Leaf. It is probable that the Judith miniature was also intended to have been colored and simplified by the Master of the Morgan Leaf, though this was never carried out. There is also a space left on the facing folio for a text initial of the Book of Judith, which was never begun.

The Judith miniature has three registers: in the upper register, Achior is shown on the left side telling Holofernes and his warriors about the Israelites and their powerful God, and on the right side Achior is shown being taken from the Assyrian camp and bound to a tree outside Bethulia. The second register shows Holofernes and his men feasting, with Judith presenting a drink to Holofernes. Judith is shown in twelfth-century sec-ular dress, with notably voluminous sleeves and uncovered hair. On the right-hand side of the second register, Judith is shown decapitating Holo-fernes with his own sword (the empty scabbard hangs at his side), while her handmaiden looks on, holding back one side of the canopy. On the left side of the third register Judith, back within the walls of Bethulia, displays Holofernes's head to her countrymen, and points to it with a finger, sug-gesting that she is, at this moment, making the speech in which she rouses the courage of the Israelites to join in the battle that is shown on the right-hand side of this lower register.

32 Donovan (1993), p. 28.
33 Donovan (1993), pp. 23–4.

The episodes of the Judith narrative that the Master of the Apocrypha has chosen to highlight in this twelfth-century English miniature reflect the Vulgate, as one would expect. In addition, it can be argued, however, that they are also the episodes emphasized by the early-eleventh-century homilist, Ælfric. Ælfric's work retained significance even after the Norman Conquest, and the sole complete copy of his homily on Judith survives in a twelfth-century manuscript from Rochester (Cambridge, Corpus Christi College, 303), which, at this time, was part of the same cultural milieu as Winchester.

Appendix to Chapter 9

Ælfric's Homily on Judith

Incipit de iudith quomodo interfecit olofernem

We secgað nu ærest on þisum gewritum þæt twegen cyningas wæron gecweden on Leden Nabochodonosor, swiðe namcuðe begen. An wæs se Chaldeisca þe acwealde Godes folc on Iudea lande for heora geleafleaste, þa þa hi wurðodon wolice hæþengyld & deofolgyld beeodon heora drihtne on teonan. Ða towænde se cyning heora winsuman burh, Hierusalem gehaten, & þæt halige templ.ðe Salomon geworhte mid wundorlicum cræfte.& towearp hi grundlunga, & þæt Godes folc ofsloh, & þa herelafe to his lande adraf to Babiloniam, heora micclan byrig; & hi þær wunedon on his wælhreowan þeowte, gecnæwe heora synna wið þone soþan God. Hundseofontig geara hi wunedon þær on þeowte, oððæt Cyrus cyning hi asænde eft ongean to Iudea lande, þanon þe hi alædde wæron, & het hi eft aræran þæt ænlice templ: swa swa se ælmihtiga God on his mod asænde, þæt he his folce mildsode æfter swa micelre yrmþe.

Here begins the story how Judith killed Holofernes

We say now first in our writing that two kings were called in Latin Nebuchadnezzar, both very well-known. One was the Chaldesian who killed God's people in the land of Judaea because of their lack of belief, when they offered evil idolatry and devil worship, and insulted their Lord. Then the king destroyed the pleasant city, called Jerusalem, and the Holy Temple, which Solomon had built with wonderful skill, and he cast it down to the foundations, and slayed God's people. The remnant he exiled to Babylon, their great city, and there they lived in cruel servitude, acknowledging their sins against the true God. One hundred and seventy years they dwelt in their slavery, until King Cyrus sent them afterwards once more into the land of Judea, to that place from which they had been led, and they vowed afterwards to raise up that unique Temple: just as the Almighty God in his power sent them away, he was merciful to his people after their great misery.

The other Nebuchadnezzar, from Syria, thought that all peoples should bow down to him, but when they refused, he sent his general Holofernes to make them submit. The Jewish people prepared for war in their mountain fortress and Holofernes inquires who they are. Achior speaks up, telling Holofernes about their escape from captivity in Egypt and the parting of the Red Sea. Achior continues…

"Ðæt Godes folc þa eode upp be þam grunde, herigende heora drihten þe hi swa ahredde. & hi wunedon swa on westenum feowertig wintra, þær þær nan man ær eardian ne mihte, & him dæghwamlice com, þurh heora drihtnes sande, mete of heofenum eallum þam mancynne, & þa biteran wyllspringas him wurdon geswette , & eac of heardum stane hi hæfdon yrnende wæter. Hi gewunnon syððan mid sige ðysne eard, & heora God him fylste & feaht for hi; & ne mihte nan mann naht þisum folce, swa lange swa hi heoldon heora God on riht. Swa oft swa hi bugon fram his biggengum to þam hæðenum godum, hi wurdon gehergode & to hospe gewordene þurh hæðene leoda.

Swa oft swa hi gecyrdon mid soðre dædbote eft to heora Gode, he gedyde hi sona mihtige & strange to wiðstandenne heora feondum. Heora God soþlice hata ð unrihtwisnysse!

Nu, for manegum gearum, þa þa misheoldon þone heofonlican God, hi wurdon gehergode, & sume ofslagene, & sume gelædde to fyrlenum landum, on hæftnede wunigende, oððæt hi wendon eft to þam heofonlican Gode þe hi on gelyfað; & hi habbað nu eft heora eard gebogod & þa burh Hierusalem, þær bið heora haligdom.

Ic bidde þe nu, hlaford, þæt þu læte ofaxian gif ðis folc nu hæbbe ænige unrihtwisnysse oððe gylt geworhtne ongean heora God, & hi beoð underþeodde þonne þinum anwealde. Gif hi þonne nabbað nane unrihtwisnesse ne heora Gode abolgen, þonne beo we ealle

"That people of God then went up by the ground and took with them their Lord, who had set them free, and they wandered then in the west for forty years, there where no man had previously been able to live, and daily there came to them, sent by their Lord, food from heaven to all that people, and the bitter well-springs became sweet for them, and from each hard stone they had flowing water. They dwelt afterwards with success in this region and their God helped them, and no one was able to own this people, as long as they held their God rightly. But as soon as they bow down and worship the heathen gods, then they become ravished and insulted through heathen people.

As soon as they with true repentance cried afterwards to their God, he made them mighty and strong to withstand their enemies. Their God truly hates unrighteousness.

Now for many years, when they did not properly hold to the heavenly God, they were ravished, and some died and some he led into the distant land and they lived in captivity, until they went afterwards to the heavenly God in whom they believe and they have now afterwards have boast of their region and the city of Jerusalem, where the holy place is.

I now ask you, lord, that you be informed about whether this people currently have unrighteousness, and they can then be subjected to your will. If, however, they do not have any righteousness and have not angered their God, then are we all to give insult to their

to hospe gedone þurh heora dri-
hten, þe hi bewerað, swa swa his
gewuna is."

God, who protects them just as is
his custom."

Holofernes orders Achior to be bound and left for the Jews to find, who on
doing so fulfill his desire for conversion. Holofernes besieges the city for
twenty days and the Jews grow thirsty. Ozias declares they will wait just
five more days for God's intervention and then they will submit.

Ða wæs on þære byrig, on þam
ylcan timan, an ænlic wimman
on wudewanhade Iudith gehaten,
þæra heahfædera cynnes, swiðe
gelefed mann on þone lyfigendan
God, hlisfull on þeawum, rihtlice
lybbende æfter Moyses æ, Ma-
nases laf. Se wæs hire wer, ac he
wearð ofslagen þurh þære sunnan
hætan on hærfestlicre tide, ute
mid his rifterum þe ripon his corn.
He læfde þære wudewan unlytel
on feo & on oðrum æhtum, æfter
his gebyrdum mycele welan on
manegum begeatum; & hi wun-
ode on clænnysse æfter hire were
on hyre upflore mid hire þine-
num. Heo wæs swiðe wlitig, &
wenlices hiwes, & heo fæste symle
buton on freolsdagum, mid hæran
gescryd to hire lice æfre, on Godes
ege butan unhlisan.

Ðeos Iudith ofaxode hu Ozias
gespræc, & cwæð þæt hit wære
witodlice unræd þæt mann sceol-
de settan swylcne andagan Gode,
þæt he binnan fif dagum þam
folce gehulpe oððe hi woldon ges-
ecan þone Syriscan here & þone
ealdorman to his anwealde: "Ne
gladiað þas word God us to milt-
sunge, ac hi hine gremiað to gram-
licre yrsunge. We sceolon beon
gemyndige his mildheortnesse,
forþan ðe we nyton nænne oðerne
God buton hine ænne. Uton and-

There was in that city, in those
days, a single woman in widow-
hood called Judith, the God's
kind, who was very much beloved
of the loving God, of good repute
among the people, Manasseh's
wife living rightly by Moses' law.
He was her husband but he was
killed due to the sun's heat at
harvest time, while out with his
sickle harvesting corn. He left his
widow not a little in cattle and
other goods, and afterwards his
wife had great prosperity in many
properties; and she lived in chas-
tity after her husband in the upper
chamber with her maidservant.
She was very beautiful and come-
ly and she fasted except for on
feast days, with sackcloth clothing
to her body, with our dishonor in
God's eyes.

This Judith found out how Ozias
spoke, and said that it was truly
foolish that a man should set an
ultimatum to God, that within five
days he should help his people or
they should seek out the Syrian
army and submit to the general's
will: "These words do not gladden
God so that he will have mercy on
us, but they irritate him to wrathful
anger. We must be mindful of the
mild-heartedness, because we do
not know any other God but him
alone. Let us wait for his help at any

bidian mid eadmodnesse his anes frofres. Abraham & Isaac & ure heahfæderas wurdon afandode on heora frecednessum & onearfoðnessum. Hi wæron getrywe þam ælmihtigan Gode, þe hi æfre ahredde. Hine we sceolon biddan, þæt he us geblissige, & of þyssere earfoðnysse us generige."

Æfter þisum wordum, & oðrum gebedum, heo awearp hire hæran & hire wudewan reaf, & hi sylfe geglængede mid golde, & mid purpuran, & mid ænlicum gyrlum, & eode hire syððan, mid anre þinene, ut of þære byrig. & bebead þam folce & þam foresædan Oziam þæt hi na ne hogodon embe hire fær, ac wunodon on gebedum & gebædon for hi; & hi ealle wundrodon hire wlites swiðe.

Heo ða, on ærne mergen, to þam weardum becom, sæde þæt heo wolde gesecan þone ealdormann & hine gewissian to his agenum willan hu he eaðelice mihte þæt manncynn berædan, butan frecednesse his agenes folces, þæt an man ne wurde of his werode amyrred. Hi ða wundrodon hire wlites swiðe, & hire wislicra worda, & mid wurðmynte hi gelæddon to heora ealdormen into his getelde. Sona swa he beseah on hire scinendan nebbwlite, swa wearð he gegripen mid ðære galnesse his unstæððigan heortan; & heo aleat to his fotum, sæde þæt heo wiste to gewissan þinge, þæt þæt Israhela folc swa yfle wæs gehæfd mid scearpum hungre, & swiðlicum þurste, for heora synnum wið þone soðan God, þæt hi moston ealle endemes forwurðan buton hi ðe hraðor to his ræde gebugon.

time with inner peace. Abraham and Isaac and our patriarchs were tested in danger and in hardship. They were true to the Almighty God, who set them free. We must pray to Him, so that he will bless us and liberate us from this hardship."

After these words and other prayers, she cast aside her sackcloth and her widow's clothes and she adorned herself with gold and with purple garments and with a splendid girdle and went afterwards with one maidservant out of that city. And she bid the people and the aforementioned Ozias that they must not concern themselves about her journey, but they should concern themselves with religious services and prayer for her and themselves, and they marveled at her beauty.

She then, in the early morning, came to the guards, and said that she desired to seek out the general and instruct him in how to have his own will, how he might easily take that people by treachery, with no danger to his own men, so that not one man in his own army would be killed. They then marveled at her great beauty, and her wise words, and they led her with honor to the tent of their general. As soon as he beheld her shining countenance, he became gripped with lust in his wanton heart; and she lay at his feet, and said that she knew a special thing, that the Israelites had such a wickedly sharp hunger and greater thirst, on account of their sins against the true God, and that they must all die together immediately unless they bow down to his army.

Heo cwæð eft oðrum worde: "Ic wurðige minne God eac swilce mid þe, & on asettum timan ic sceal me gebiddan gebigedum cneowum to him & æt him ofaxian hwænne þu eaðelicost miht to þam folce becuman, mid ealre þinre fare, tomiddes Hierusalem, be minre wissunge, & þu hæfst hi ealle swa swa hyrdelease sceap. Forþi ic com to þe, þæt ic cydde þe þis."

He gelyfde þa hire wordum & hire wel behet, & his þegenas sædon þæt swylc wimman nære on ealre eorðan swa fægeres wlites, & swa wis on spræce; & se ealdorman hi het gan into his maðmcleofan & þær wunian oðþæt he hyre word sende, & he het his hiredmen hire þenian of his agenum þenungum & his estmetum. Ac heo nolde swaþeah his sanda brucan for his hæðenscipe, ac heo hæfde gebroht on hire þinene fætelse hire fercunge, oðþæt heo hire modes smeagunge mid weorcum gefylde.

Iudith þa abæd æt þam ealdormen þæt heo moste be leafe, on ðam langum nihtum, gan on hyre gebedum to gebiddenne hire drihten ut of þam maðmcleofan on hire cneowgebedum, & he sealde hire leafe þæt heo swa don moste; & heo swa dyde symle on nihtum. Bæd þone ælmihtigan God þæt he hire gewissode his folce toahreddinge on þære frecednysse.

Ða, on þam feorðan dæge, feormode se ealdorman his heahþegnas on his getelde on micelre blisse, & bebead his burðegne þæt he gebringan sceolde into his gebeorscipe þa foresædan Iudith, & he swa dyde. Heo com þa

She said afterwards other words: "I honor my God and likewise you, and at set times I shall make my case known to him in my prayers and be informed by him when you might most easily overcome that people with your army in the midst of Jerusalem, by my instruction, and you will have them all just as sheep to a shepherd. Therefore I have come to you, so that I can acquaint you with this!"

He then believed her words and her good promises, and his thegns said that no woman on earth was ever as fair in countenance or as wise in speech, and the general ordered her to go into his treasure-chamber and wait there until he sent her word, and he ordered his retainers to serve her food from his own table and his delicacies. But she would not however partake of his food because of his heathenness, but she had brought her maid's bag with her own provisions, as far as her spirit's reflection was satisfied with the deed.

Judith then asked the ruler if she could leave, to go out of the treasure-chamber so that she might pray to her Lord on her knees, and he entrusted her to leave to perform what she must, and she did the same every night. She beseeched Almighty God that he through her guide his people to deliverance from their danger.

Then on the fourth day, the general entertained his high-thegns at his table with great joyfulness and he instructed his chamberlain that he must bring into his feast the aforesaid Judith, and this he did. She came there adorned, but

geglenged for nanre galnysse, &
stod him ætforan swiðe fægres hi-
wes, & his mod sona swiðe wearð
ontend on hire gewilnunge to his
galnesse; & het hi beon bliðe on
his gebeorscipe, & heo him behet
þæt heo swa wolde.

Ða wearð Holofernis wundorlice
bliðe ealne þone dæg, & fordrænc-
te hine sylfne mid þam strangum
wine ofer his gewunan, & ealle
his þegnas eac wæron fordræncte;
& hi efston on æfnunge to heora
mane swiðe, & þa burþegnas ge-
brohton þone ealdormann on
anum bedde mid þære Iudith, &
na swiðe ne gymdon syððan heora
hlafordes. Iudith geseah þa, þa þa
he on slæpe wæs, þæt hire wæs
gerymed to hire ræde wel forð; &
het hire þinene healdan þa duru,
& gelæhte his agen swurd & sloh
to his hneccan, & mid twam sleg-
um forsloh him þone swuran, &
bewand þæt bodig mid ðam bed-
dclaðum.

Heo nam ða þæt heafod, & his
hopscytan, & eode hire ut mid
hire þinene swylce on gebedum,
swa swa hyre gewuna wæs, oþþæt
hi buta becomon to þam burh-
geate. Iudith þa clypode & cwæð
to þam weardmannum: "Undoð
þas burhgatu! God sylf is mid us,
se þe mihte gefremode on Israhela
þeode." & hi þa ardlice undydon
þa gatu, & comon endemes mid
leohte hire to, forþan þe hi wen-
don þæt heo ne com na ongean.
Heo astah þa up to anum steapum
beorge, & ætywde þæt heafod
him eallum, cweðende: "Heriað,
ic bidde, mid blisse urne drihten,

not because of wantonness, and
she stood before him with a very
beautiful appearance, and his
heart forthwith quickly became
inflamed in desiring her in accord-
ance with his lust; he commanded
her to be merry at his feast and she
promised that she would do so.

Then Holofernes became won-
derfully merry all that day, and
he made himself drunk with
strong wine beyond his customary
amount, and all his thegns were
also drunk; and the evening closed
in quickly, and the chamberlains
brought then the general into a
certain bedchamber with Judith,
and not all the way and carefully
since it was their lord's. Judith saw
then that he was asleep, and that
the way was open for her plan to
move forward well; and she or-
dered her maid-servant to watch
the door, and grasped his own
sword and struck a blow to his
neck, and with two blows she cut
through his neck, and wrapped
the body with the bedclothes.

She then took the head, and his
counterpane, and she quickly
went out with her maidservant
to pray as was her custom, until
they came outside of the city-gate.
Judith then called out and said to
the watchman: "Undo this city-
gate! God Himself is with us, He
who makes manifest His might in
respect to the Jewish people." And
they quickly undid the gate, and
came in procession with lights to
her, because they thought that she
would never come back again. She
stood up then on a certain high
hill and revealed the head to them
all saying: "Give Praise, I bid you,

se þe ne forlæt on hine gelefende & þa þe hihtað on his micclum truwan, & on me gefylde his mildheortnesse þa þe he behet Israheles hirede; & he ofsloh nu to niht on minum handum his folces feond!"& heo unforht cwæð: "Godes engel soðlice me gescylde wið hine, þæt ic unwemme eft becom to eow; & God self ne geþafode þæt ic gescynd wurde, ac butan besmitennysse he asende me ongean, on his sige blissigende & on eowre alysednesse. Hi sceawodon þa þæt heafod mid swiðlicre wafunge, & Ozias heora ealdor, & hi ealle samod, bletsodon Iudith mid þissere bletsunge: Drihten þe gebletsode on his drihtenlican mihte, se ðe þurh þe gehwyrfde ure fynd to nahte, & se ðe nu todæg þinne naman gemærsode, swa þæt of manna muðum þin mærð ne ateorað."

with bliss to our Lord, he who does not abandon those believing and who rejoice in his great covenant, and in me fulfilled, with His great mercy, that which he promised to the brotherhood of Israel, and he cut down now tonight by my hand his people's enemy!" And she fearlessly said: "God's angel truly shielded me against him, so that I unstained afterwards came to you, and God himself would not permit that I become disreputable, but without blemish he sent me on again, in His glorious triumph and in our liberation."

Ozias blesses Judith. She tells Achior what happened. Judith tells them to put the head on the city walls and the Israelites prepare for battle. The Assyrians find the decapitated Holofernes and lament: "A woman has now shamed us and our king!"

The Israelites win their battle and Ælfric reports that Judith sings "just as it says in the Latin," but he does not repeat it here. Ælfric concludes by exhorting the sisters to chastity.

The *Judith* Poem

tweode
gifena in ðys ginnan grunde. Heo
 ðar ða gearwe funde
mundbyrd æt ðam mæran þeodne,
 þa heo ahte mæste þearfe,
hyldo þæs hehstan deman, þæt he
 hie wið þæs hehstan brogan
[5] gefriðode, frymða waldend.
 Hyre ðæs fæder on roderum
torhtmod tiðe gefremede, þe heo
 ahte trumne geleafan

a to ðam ælmihtigan. Gefrægen ic
 ða Holofernus
winhatan wyrcean georne ond
 eallum wundrum þrymlic
girwan up swæsendo. To ðam het se
 gumena baldor
[10] ealle ða yldestan ðegnas; hie
 ðæt ofstum miclum
ræfndon, rondwiggende, comon to
 ðam rican þeodne
feran, folces ræswan. þæt wæs þy
 feorðan dogore
þæs ðe Iudith hyne, gleaw on
 geðonce,
ides ælfscinu, ærest gesohte.
[15] Hie ða to ðam symle sittan
 eodon,
wlance to wingedrince, ealle his
 weagesiðas,
bealde byrnwiggende. þær wæron
 bollan steape
boren æfter bencum gelome, swylce
 eac bunan ond orcas
fulle fletsittendum; hie þæt fæge
 þegon,
[20] rofe rondwiggende, þeah ðæs
 se rica ne wende,
egesful eorla dryhten. ða wearð
 Holofernus,

she doubted not
His gifts in this wide earth. She
 found there readily
patronage from the excellent Prince
 when she had the most need,
of grace from the highest Judge so
 that she against the highest terror
[5] was protected, the foremost
 King. To her the Father in Heaven,
the Glorious One, advanced this
 favor that she might have a
 steadfast belief
forever in the Almighty. Holofernes,
 as I have heard say,
wrought eagerly an invitation to wine
 and with every magnificent wonder
prepared a banquet. To this the bold
 hero summoned
[10] all his chief thegns; they with
 great speed
did that, the shield-warriors, came
 to the great lord
to set forth, to the people's leader.
 That was the fourth day
since Judith was there, wise in
 judgment
the elf-bright virgin, first sought him.
[15] They then to that feast went to
 sit
the proud to the wine-drinking all
 his companions in trouble
bold corsleted warriors. There were
 deep flagons
carried frequently along the benches, in
 such a manner each beaker and cup
of the sitters in the hall was full; the
 doomed ones who drank it,
[20] the vigorous shield-warriors,
 though their king did not expect it
the awe-inspiring chief lord. The
 Holofernes became,

goldwine gumena, on
 gytesalum,
hloh ond hlydde, hlynede ond
 dynede,
þæt mihten fira bearn feorran
 gehyran
[25] hu se stiðmoda styrmde ond
 gylede,
modig ond medugal, manode
 geneahhe
bencsittende þæt hi gebærdon
 wel.
Swa se inwidda ofer ealne dæg
dryhtguman sine drencte mid wine,
[30] swiðmod sinces brytta, oðþæt
 hie on swiman lagon,
oferdrencte his duguðe ealle, swylce
 hie wæron deaðe geslegene,
agotene goda gehwylces. Swa het se
 gumena aldor
fylgan fletsittendum, oðþæt fira
 bearnum
nealæhte niht seo þystre. Het ða
 niða geblonden
[35] þa eadigan mægð ofstum
 fetigan
to his bedreste beagum gehlæste,
hringum gehrodene. Hie hraðe
 fremedon,
anbyhtscealcas, swa him heora
 ealdor bebead,
byrnwigena brego, bearhtme
 stopon
[40] to ðam gysterne, þær hie
 Iudithðe
fundon ferhðgleawe, ond ða fromlice
lindwiggende lædan ongunnon
þa torhtan mægð to træfe þam hean,
þær se rica hyne reste on symbel
[45] nihtes inne, nergende lað,

Holofernus. þær wæs eallgylden
fleohnet fæger ymbe þæs
 folctogan

the gold-giving lord, became joyful
 at the wine pouring,
he laughed and was loud, he made
 a noise and a din,
so that might hear him at a distance
 from the mirth
[25] How the stout-hearted one
 roared and shouted
spirited and drunk, he exhorted
 frequently
the bench-sitters that they conduct
 themselves well.
As the evil-one over the entire day
his warriors drenched with wine,
[30] the stout-hearted treasure-giver,
 until they all lay in a stupor.
his body of noble retainers had all over-
 drunk as if they were slain by death,
glutted with every good thing. The
 prince of men gave the order
to fill for the sitters in the hall until
 the day faded,
the gloomy night drew near to them.
 The evil corrupt one ordered
[35] the blessed maid be brought
 immediately
to his bedchamber, the bracelet laden,
 the ring-adorned. They quickly
 obeyed,
the retainers, as their lord had
 ordered them,
the armored warriors' ruler,
 marched quickly
[40] to the guest hall, where they
 Judith
found prudent, and promptly then
the shield-warriors began to lead
the bright virgin to the high tent
where the ruler himself always rested
[45] inside each night, hated by the
 Savior,
Holofernes. There was a pure gold
finely-made fly-net around that
 chieftain's

bed ahongen, þæt se bealofulla
mihte wlitan þurh, wigena baldor,
[50] on æghwylcne þe ðær inne com
hæleða bearna, ond on hyne
 nænig
monna cynnes, nymðe se modiga
 hwæne
niðe rofra him þe near hete
rinca to rune gegangan

bed hanging, so that the baleful one
might look through, the leader of men
[50] on everyone who came in there
the children of heroes, and on him
 not any
of mankind, unless the proud
 one
the evil noble summoned him hear
a warrior to come to counsel.

10. The Prayer of Judith in Two Late-Fifteenth-Century French Mystery Plays

John Nassichuk

In the literature of France, Judith is present only rarely before the sixteenth century. Rapid allusions to her well-known exploits in the camp of Holofernes do appear, it is true, with some frequency in the works of poets such as Jean Molinet[1] and Eustache Deschamps.[2] Also, laudatory paragraphs dedicated to Judith figure in the collected biographies of famous women, such as the one by Antoine Dufour (1502),[3] as well as in the writings of Christine de Pizan.[4] Yet although these sundry occurrences attest to the fact that Judith is a known character, they do not make of her the living, speaking personage that she will become in poetry and in theater. Indeed, from its very beginning moments, the sixteenth century introduced a new era in the French-language representation of the ancient, Judaic beauty who charmed and assassinated the Assyrian general. The most telling change in her profile is the fact that in the works of the authors of Mystery plays, epic poets, tragedians, and *paraphrastes*, Judith, once the silent object of invective and encomium, at last acquires a voice and begins to speak.

1 Jean Molinet, *Les faicts et dictz de Jean Molinet*, ed. N. Dupire (Paris: Société des Anciens Textes Français, 1936), p. 391, v. 53; p. 410, v. 10; p. 538, vv. 53–60.
2 Eustache Deschamps, *Œuvres complètes d'Eustache Deschamps* (publiés d'après le manuscrit de la Bibliothèque Nationale par G. Raynaud; Paris: Firmin Didot, 1901), t. II, p. 336; III, pp. 98–99; 113, 183, 303, 389–90.
3 Antoine Dufour, *Les Vies des femmes célèbres* [1504], texte établi, annoté et commenté par G. Jeanneau (Genève: Droz, 1970).
4 See especially the chapter devoted to Judith in the *Livre de la Cité des Dames*, "De Judich, la noble dame veuve," § 176–176b in M. C. Curnow, *The Livre de la cité des dames: a critical edition* (Nashville, TN: Vanderbilt University Ph.D., 1975), t. 1, pp. 438–39.

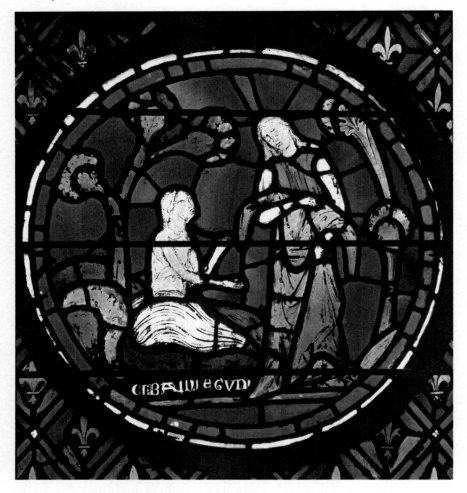

10.1. *Ci baigne Judi*, ca. 1245. Judith-Window D-126. Sainte-Chapelle, Paris. Photo credit: Centre des Monuments Nationaux, Paris.

The present, comparative study shall examine fragments of two Mystery plays from the latter half of the fifteenth century, both of which include the tale of Judith in their massive, and nearly comprehensive, rendering of the Old Testament. These two texts are exceptional amongst pre-sixteenth-century representations of Judith, in that they each offer a sustained, dramatic representation of the heroine. As such, they also constitute an essential foundation of the developments of the Judith theme in epic and dramatic poetry during the ensuing century. The study's particular object is the differing versions of the long prayer uttered by Judith

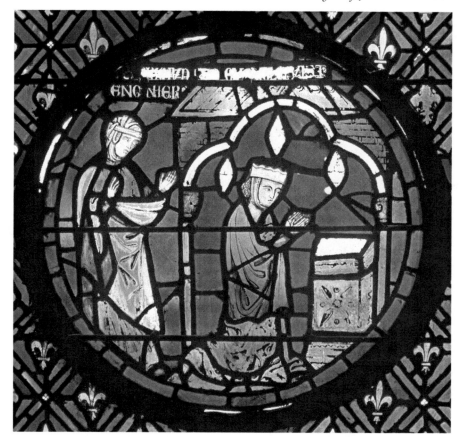

10.2. *Ci prie Judit dieu quele puist enginier*, ca. 1245. Judith-Window D-136.
Sainte-Chapelle, Paris. Photo credit: Centre des Monuments Nationaux, Paris.

in chapter 9 of the biblical narrative. After a brief discussion of references
to the prayer in fifteenth-century poetic texts, the analysis shall treat suc-
cessively of the heroine's oration as it appears in the *Mystères de la proces-
sion de Lille* and the *Mistère du Viel Testament*. Whilst the first of these two
representations produces a French version of the prayer that follows the
Vulgate both in its disposition and its lexical matter, the second, though
generally faithful to the Latin text,[5] strays from it in a measure sufficient

5 See Graham Runnalls's remark to this effect in the introduction to his English
translation of the episode from the *Mistère du Viel Testament. Judith and Holofernes.
A Late-Fifteenth-Century French Mystery Play* (Fairview, NC: Pegasus Press, 2002),
p. 13: "Judith and Holofernes is a dramatization of the Hebrew Book of Judith in the
version found in the Latin Vulgate Bible."

to reflect a particular interpretation of the biblical story. The principal suggestion is not only that the author of the *Mistère du Viel Testament* rewrites the prayer in such a way as to enhance Judith's status as an exemplary figure, but also that this new version subtly likens her voice to that of the prophets and the psalmist.

Judith's Prayer

In fifteenth-century French vernacular poetry outside of the Mystery plays, Judith is hardly the object of much sustained character development. Most references to her are cursory at best, usually mentioning the heroine of Bethulia amongst a host of biblical figures. One exception is to be found in a poem by Eustache Deschamps, which names Judith in a passage emphasizing the importance of prayer. In a ballad on the theme of divine justice, Deschamps compares Judith to Joshua. The poet asserts that these two figures are similar insofar as they both remain rigorously loyal to God's command. Their irreproachable piety exercises a salutary effect upon the people who follow their lead:

Ceste raison se prevue et determine,	This reason is foreseen and affirmed
Tant du nouvel com du viel Testament,	Regarding the Testaments both New and Old,
Par Josué, par Judith la tresdigne,	By Joshua and by most honorable Judith,
Qui prierent Dieu tresdevotement,	Who most devoutly prayed to God,
Leur peuple aussi, pour oster le tourment	As did their people, that He might relieve the torment
Des ennemis et la guerre tresdure	Brought by enemies and by the most bitter war
Qui leur sourdoit; Dieu vit leur sentement,	Which assailed them. God saw their deep piety,
Car a chascun doit rendre sa droiture.[6]	For to each must their due be given.

The poet declares that the prayers of Joshua and Judith brought the Lord to "see" their virtuous sentiment. Implicit here, of course, is the idea that prayer somehow precedes and prepares, or at least anticipates, divine action.[7] Erasmus later highlights this possibility in his 1524 treatise "On

6 *Œuvres complètes d'Eustache Deschamps*, t. II, pp. 98–99, vv. 17–24.

7 Christine de Pizan also invokes this principle. In her version of the narrative, the people ardently pray to God for deliverance from the Assyrian threat. See the *Livre de la cité des Dames*, "De Judich, la noble dame veuve," § 176: "… et estoyent Juyfs

Praying to God." In this remarkable display of biblical erudition, Judith appears amongst a number of Old Testament personages whose prayers were heard and granted. Erasmus follows closely the Vulgate Latin formulation when he declares that Judith defeated the army of Holofernes by means of prayer alone: "Nonne fortissimo virago Judith, Holophernem hostem orando dejecit?"[8] This is the only reference to the Judith story in Erasmus's treatise, although the general theme of the invincibility of prayer even in the face of ruthless, military aggression is a recurring theme.[9] In a sentence that condenses the action of the entire book of Judith, the Dutch humanist has borrowed a Latin expression from chapter four of the Vulgate version, where the priest Heliachim instructs the people of Bethulia to pray fervently, remembering the example of Moses who defeated the mighty (and overconfident) Amalech by the sole force of his prayer.[10] The humanist is not alone, however, in underlining the importance of this reference to the power of Mosaic prayer, for the author of the Judith episode in the *Mistère du Viel Testament* also reproduces the expression from the Vulgate. In the Mystery play, the lines are attributed not to Heliachim, but to Ozias, during a deliberation of Bethulia's notable citizens. At the beginning of the meeting, Ozias sets forth the idea that pious supplication is the best way of fending off enemy aggression:

si comme au point d'estre pris de celluy qui moult les menaçoit dont ilz estoyent a grant douleur; et adés estoyent en oroisons priant Dieu que il voulsist avoir pitié de son puepple et les voulsist deffendre des mains de leurs annemis. Dieu ouy leurs oroisons; et si comme il voulst sauver l'umain lignaige par femme, voulst Dieux yceulx autresi secourir et sauver par femme." Christine thus presents Judith as both God's answer to the prayers of the people and as an intercessor on their behalf: "En celle cité estoit adonc Judich, la noble preudefemme, qui encore jeune femme estoit et moult belle, mais encore trop plus chaste et meilleure estoit. Celle et moult grant pitié du peuple qu'elle veoit en si grant desolacion, si prioit Nostre Seigneur jour et nuit que secourir les voulsist."

8 Erasmus, *Modus orandi Deum*, ed. J. N. Bakhuizen van den Brink, in *Opera Omnia Desiderii Erasmi Roterodami*, vol. V, 1 (Amsterdam and Oxford: North-Holland Publishing Co., 1977), p. 137.

9 For instance, in much the same spirit, Erasmus makes reference to the imprisonment of Peter in Acts 12:5 and notes that the reaction of the Christian contingent was neither one of armed violence, nor of occult practices, but rather, more simply, of fervent prayer. Ibid., p. 132.

10 Jdt 4:13 in *Biblia sacra juxta vulgatam versionem* (Stuttgart: Deutsche Bibelgesellschaft, 1994), p. 693.

Le grand Dieu sera conservant	Our great God will protect us
Nostre cité de Bethulie,	And our city of Bethulia,
Mais que tousjours on se humilie.	Provided we bow before him.
Moÿse, par humilité	Once Moses, through his prayers
Et par vraye fidelité	And his true faith in God,
Amelech, puissant, orgueilleux,	Faced the mighty Amelech,
De sa force presumptûeux,	Who, presumptuous and proud,
Luy confiant en son charroy,	Had trusted in his troops,
En armes et pompeux arroy,	His chariots and his weapons.
Avec l'aide de peu de gens	But, helped by just a few men,
Subjugua luy et tous les siens.	Moses crushed Amelech and his army.
Non ferro armis pugnando	The Bible relates: *Non ferro armis*
Sed precibus sanctis orando	*Pugnando sed precibus sanctis*
Dejecit. Ayons confidence	*Orando dejecit.* Let us be confident
Et priöns en perseverance,	And pray with perseverance,
Et certes nous aurons victoire.	And surely we shall gain victory.[11]

This pious expression of faith articulates what is clearly to be considered the primary moral value of the entire episode. When Judith later confirms this attitude in the face of an oncoming enemy force, she adds that the prayer of the faithful cannot be at all feigned or mechanical. It must be entirely disinterested, proceeding from a sincere heart. One's love for God, says Judith, ought to be perfect.[12] In the heroine's biblical prayer, as also in her prayer from the two fifteenth-century Mystery plays, the condition of such perfect love is adequate "knowledge" of God's uniqueness and of God's power.

Mystères de la procession de Lille

The text of this long Mystery play is preserved in a manuscript dating from the end of the fifteenth century.[13] It contains seventy-two separate episodes, or "mysteries," each one of which relates a biblical tale. Arranged in the general linear order of the Old Testament, these episodes are given a kind of unity by the presence of a prologue whose intermittent speeches constitute

11 *Judith and Holofernes*, op. cit. translated by Graham Runnalls, p. 71. All subsequent English translations from the *Mistère du Viel Testament* shall be taken from this edition.
12 *Mistère du Viel Testament*, pp. 141–42, vv. 894–899: "Seigneurs, certes nous n'arons garde, / Mais que aymions Dieu parfaictement. / Continuons devotement / En oraison, sans fiction, / En faisant exclamaciön, / De noz pechez…".
13 See the introduction to A. Knight's recent edition of the *Mystères de la procession de Lille* (Geneva: Droz, 2001–2004), t. 1, pp. 9–20.

an organizing, narrative authority. The thirty-ninth mystery contains 845 verses and bears the title "Coment Judich tua Holoferne." It offers a well-developed sketch of the Judith episode, following rigorously the order of events as they occur in the Vulgate.

At the beginning of the play, the prologue pronounces 62 verses that recount in full the story of Judith. Characteristically, this same personage acts as narrator throughout the mystery, reappearing at intervals in order to explain the events as they unfold. In his second appearance, after the discovery of Achior, he tells how this Assyrian outcast, upon suffering banishment and exposure at the hands of the men of Holofernes, was accepted with open arms by the priests and the people of Bethulia who promptly invited him to dine with them. According to the Prologue, this moment of charitable conviviality was then immediately followed by a collective prayer:

Et puis le peuple s'en ala,	Then the people made their way
Dedens le temple, où il ora	Into the temple, where they prayed
Toute la nuyt en demandant	All night long, imploring
Aïde à Dieu le tout puissant.[14]	The help of almighty God.

It may well be noticed that this intrusion of the narrator occurs at a point in the story when the prayer motif discreetly manifests itself. Indeed, the prologue's next – third – speech in the Judith mystery also quite nearly coincides with a prayer scene. It comes after the heroine's deliberation amongst the elders of Bethulia and her sustained, imploring address to God. Here the prologue narrates the details of Judith's preparation for departure with Abra, her movement toward the gates of the city where Ozias and the priests awaited her in silence. In general this account remains extremely faithful to that of the Bible, even including the detail of how God augmented the natural beauty of Judith as she fittingly bedecked herself for her exploit in seduction.

The mystery also includes a version of Judith's prayer, in 54 eight-syllable verses. This rewriting of the prayer demonstrates a rigorous fidelity to the general disposition of motifs in the Vulgate text. Even the references to biblical example appear in the same order as in the Latin prayer. In keeping with the biblical model, Judith begins by evoking the heroically vengeful exploits of Simeon after the rape of Dina. She then asks the Lord to contemplate the camp of the Assyrians and to remember what similar arrogance motivated the Egyptian enemy long ago:

14 Ibid., p. 357, vv. 147–150.

Veuillies aidier et secourir	Please, ô Lord, help and rescue
Ta povre vefve a che jour d'hui,	Your poor widow today,
Et donner contraire et anuy	And give the contrary, aye hindrance,
Au siege des Assiriens.	To the Assyrians who besiege us.
Comme tu des Egiptiens	Just as once you confounded
La multitude confondis,	The Egyptians in their multitude,
Quand en la mer tu les perdis,	When you washed them in the sea,
Fay a ceux cy pareillement,	So also do likewise unto those
Qui se fient tant seullement	Who are so trusting only
En leurs lances et leurs espeez	In their lances and their swords,
Et en leurs grandes assembleez	And in their great numbers
De gens, de cars et de chevaulx,	Of people, chariots and horses,
Et ne scavent conbien tu vaulx	Ignoring as they do your great worth
Ne que peut ton saintiesme non.[15]	And the power of your holy Name.

These verses condense the material in verses IX, 6–10 of the Vulgate text. In the same way that the treatment of the Judith episode in the *Mystères de la procession de Lille* reduces the narrative line to a spare, essential résumé of the biblical story, so the prayer, while remaining an important feature overall, is similarly reduced to its essential ingredients. Indeed, the Lille Mystery play tends to organize the material into a methodical, clearly sequenced narrative, with few digressions either lyrical or descriptive. This practice correspondingly pares down the dimensions of the prayer, evacuating luxuriant detail and thus molding a direct, solemn invocation of God.

Despite this scaling-down of the prayer to fit the general economy of detail in the Judith episode of the Lille Mystery plays, it is possible to identify expressions and small passages that appear as direct translations from the Latin of the Vulgate. When Judith pleads for divine mercy on behalf of her people, she beseeches God to uphold his "testament" and to inspire in her the necessary eloquence for the task that awaits her:

Moy, miserable, preng en cure
Et ma petition m'acorde,
Esperant ta misericorde.
De ton testament te souviengne.
La parolle de toy me viengne,
Qui mon conseil puist conforter.
Et ta maison puist demourer
En ta sanctification,
Affin que toute nation

15 Ibid., p. 357, vv. 147–150.

Puist savoir et congnoistre en soy
Qu'il n'est nul autre Dieu que toy.[16]

It is instructive to compare these verses with the Vulgate passage which inspired them, in order to appreciate the unmistakable proximity of the French version to the Latin source. Indeed, the French text borrows in several places the very language of the Vulgate:

> … exaudi me miseram deprecantem et de tua misericordia praesumentem (18) memento Domine testamenti tui et da verbum in ore meo et in corde meo consilium corrobora ut domus tua in tua sanctificatione permaneat (19) et omnes gentes agnoscant quoniam tu es Deus et non est alius praeter te.[17]

Several terms in the French prayer have been borrowed directly from their Latin cognates: "miserable" (miseram), "misericorde" (misericordia), "testament" (testamenti tui), "conseil" (consilium), "sanctification" (in tua sanctificatione). The theme of "knowing God" is also expressed in an identical manner, at the same place in the prayer. The verb "cognoistre," used with the auxiliary "puist" (may, might), corresponds closely, though perhaps not exactly, here to the Latin subjunctive "agnoscant." To the French verb, the poet has added, at once for psychological precision and for the rhyme, the expression "en soy," underlining in this way the intimate, meditative character of such "knowing." Thus a rather close translation of the ending of Judith's prayer in the Latin text punctuates the fervent oration of the heroine as it appears in the mystery play. Strict attention to narrative flow and to essential utterances in the Latin model renders a spare, limpid vernacular poem which tends to emphasize key points in the development of plot and of moral example. Indeed, the *Mystères de la procession de Lille* present a version of the heroine's prayer that follows closely the disposition and even the very language of the Vulgate text in a well-represented version. The result is a sober oration of striking intensity.

The *Mistère du Viel Testament*

The *Mistère du Viel Testament* presents a more detailed, and dramatically complex, version of the Judith story than does the same episode in the *Mystères de la procession de Lille*. Here, there is no prologue character to guarantee the centering presence of an authoritative, narrative voice, whose role is to carefully subsume the dialogue and the speeches by inserting them into

16 Ibid., p. 366, vv. 378–383.
17 Jdt 9:17–19.

a third-person, historical account. Graham Runnalls has well remarked that in their rendering of the Judith story, the author(s) of this Mystery play remain generally faithful to the sequence of events presented in the Vulgate.[18] The specific author of the 2470-verse Judith story, however, hardly restricts his imitation to a close, literal rendering even of the direct speech passages. It may reasonably be said, then, that while this play does indeed present a *translatio* of the biblical story, it is far from offering up a veritable translation of it, in the modern sense of that term.

The essential similarity of the Judith narrative in the *Mistère du Viel Testament* to that of the Vulgate makes possible a comparison of the general ordering of events in the two versions. Easily noticeable, in the light of such a comparison, is the fact that the author of the mystery play organizes things in such a way as to inflate the role of the heroine herself. For this reason, the first words attributed to Judith in the play come at a moment in the story that is slightly anterior to her first appearance in the Book of Judith. Indeed, she pronounces her first lines even before Achior has been rescued by the people of Bethulia. As the elders and priest of the city kneel in prayer, Judith majestically appears, deep in thought, speaking to herself. The first words she utters indicate the line of rigid and courageous piety that she is to maintain until the end. Her position is that the present circumstances require complete submission to the will of God, and confession of sin. This is necessary, she says, in order "to recognize his kindness, / And show him / That we know he created us, / Formed us, / Continues to nourish and sustain us."[19] The means to achieve such a clear demonstration of gratitude and obedience is that of ardent and earnest prayer:

Vers luy oraison fault dresser,	To him must prayers be said
Adresser,	And addressed,
Et ses complaintes renforcer,	And our regrets reiterated,
Que courser	Lest he should
Ne se vueille de noz meffais,	Display anger at our crimes.
Noz pechez a luy confesser	Let us confess to him our sins,
Et penser	And determine
De la maculle hors chasser,	To rid ourselves of our blemishes,
Qu'ambrasser	So in peace
Il nous puisse au lÿen de paix.[20]	He may be able to embrace us.[21]

18 See the introduction to his edition of the *Mystère de Judith et Holofernès* (Geneva: Droz, 1995), p. 22: "*Judith et Holofernès* suit de près le texte biblique non seulement dans ses grandes lignes mais aussi dans de nombreux détails: il ne fait pas de doute que notre mystère est, au sens médiéval, une 'translation' du Livre de Judith."
19 *Judith and Holofernes*, p. 61.

Thus Judith declares the necessity of prayer even before she is petitioned by the elders. Upon her initial appearance in the mystery play, her striking, reasoning figure is juxtaposed with those of the kneeling city authorities. As the men who surround her rest on bended knee to invoke the help of God, Judith constructs the attitude she will maintain, in a versified reflection upon the proper use of prayer and confession. This curious soliloquy, which corresponds directly with no single passage in the Book of Judith, serves rather as a moral illustration of the character herself. At the end of her reflection, she suddenly calls out to her servant, Abra, and declares that the two of them must go to the temple immediately and pray for the well-being of the city.[22] At the end of the dialogue between Judith and Abra, a marginal, didactic note in the text indicates that both women arrive at the temple where they kneel and "make as though they were praying."[23] The stage direction requires that the image of Judith praying impress itself upon the mind of the spectators even before her first appearance in the biblical story line. This early manifestation of the heroine seems to have been orchestrated by the fifteenth-century dramatic author in order to underline the power of her relationship with God through the medium of prayer. In the midst of her supplicating brethren, she stands to the fore as the embodiment – and as the voice – of the divine will meekly carried out by those who pray.

When Judith pronounces her own prayer, she begins by making reference, not to biblical history, but to her intimate relationship with God. The reference to her ancestor Simeon is here reduced to a mere three verses and relegated to the second half of the oration. Instead of invoking this example as a justifying precedent for what she proposes, Judith mentions Simeon's feat as proof of God's overwhelming power:

20 *Mistère du Viel Testament*, vv. 42,501–10.
21 *Judith and Holofernes*, p. 62.
22 *Mistère du Viel Testament*, op. cit., vv. 42,519–24: "Afin que Dieu nous soit propice / Pour confondre noz adversaires, / Oraisons sont tresnecessaires. / Prions bien Dieu pour la cité, / Car el est en necessité, / Ainsi comme je puis entendre."
23 *Mistère du Viel Testament*, op. cit., t. V, p. 261.

Faiz nos ennemis tous retraire	Make all our enemies withdraw
Aux retraitz, que te puissions plaire	And make their retreat, so we can delight you
A tout plaisir, du tout complaire	Delightfully, giving you pleasure
Sans variër,	Eternally,
Nos ennemis contrarier,	And oppose our enemies,
A la louenge de ton nom,	Glorifying your name
Ta puissance magnifier,	Magnifying your power,
Comme a mon pere Symeon,	As once did my father Simeon,
Le quel, pour souverain renon,	Who, to earn sovereign glory,
Fist tous les faulx violateurs	Put all faithless transgressors
Mourir.[24]	To death.[25]

This passage marks a formal transition in the metrical scheme of the prayer. After nine four-verse stanzas composed of three octosyllables followed by one short, four-syllable verse, Judith finishes her oration with a sequence of twenty-one octosyllables. The first, heterometrical part of the prayer, organized in stanzas, is characterized by a reverential, imploring tone which is created in part through the use of recurring imperatives. Such a development does not correspond to any sustained movement in the Latin text, though it does seem close in spirit to the culminating clause of the initial address in the Vulgate version: *"subveni quaeso te Domine Deus meus mihi viduae."*[26] The author dilates the place of the imperative mood in these first stanzas of Judith's prayer, tempering the laudatory narrative of God's justice with a personal declaration of gratitude, devotion, and fidelity on the part of the heroine herself. She also asks God to give to the inhabitants of Bethulia the strength of "recognition," the ability to act in harmony with the divine wisdom. God is the supreme "source of peace," and He is asked to guide this beleaguered people during a time of war:

En foy ton sainct nom glorifie,	In faith your holy name grows glorious,
Ta gloire saincte magnifie,	Your glory, sacred, is magnified,
Manifique essence infinie,	Magnificent infinite essence,
Sourse de paix.	Source of peace.
Pacifie, las, noz torfaiz,	Pacify, I beg you, our evil deeds,
Faiz noz cueurs, qui sont imparfaitz,	Make our hearts, which are imperfect,
D'imperfection tous infaictz,	Infected with imperfections,
Te recognoistre.[27]	Recognize you.[28]

24 *Mistère du Viel Testament,* op. cit., vv. 43,530–40.
25 *Judith and Holofernes,* op. cit., p. 100.
26 *Judith,* IX, 4.

The true, cordial recognition of God is the way of temporal and spiritual salvation for the besieged citizens of Bethulia. It is also the first step, according to Judith, by which God will "magnify" his "holy glory" and thus "glorify" his "holy name." Instead of asking for a providential sign (or rescue) by a certain date, as the city elders are poised to do, Judith prays that God might strengthen the hearts and the faith of her co-citizens. Magnifying the already infinite ("Manifique essence infinie") grandeur of God requires an instrument, as the example of Siméon showed ("Ta puissance magnifier, / Comme a mon pere Simeon").[29]

Only in the second part of this intensely personal oration, written in octosyllables, does Judith make reference to biblical example. Near the end of the prayer, she mentions God's chastening of the Egyptians and asks that the Assyrians receive a similar treatment:

Haultain facteur, voy ta facture!	Highest creator, observe your creation !
Noz peres de pareil pointure	Our fathers likewise were once attacked
Preservas des Egiptiens.	By the Egyptians; you protected them.
Fais ainsi des Assiriens![30]	Do the same for us against the Assyrians[31]

In these emphatic verses, Judith invokes an historical example and beseeches God to reaffirm the divine protection of her people. Despite this sudden return to the concrete matter of the Vulgate prayer, the author is at pains to highlight the fundamental, thematic cohesiveness of this vernacular address to God. "He" accomplishes this through a subtle play of repetition, most notably the double occurrence of the epithet "povre," qualifying the suppliant herself, in the first stanza of the prayer (v. 43,500, "femme povre") and again in the second-last octosyllabic verse (v. 43,544, "ta povre chamberiere"). Here again, this descriptive insistence corresponds to very little in the Latin version, except perhaps the accusative, imperative ex-

27 *Mistère du Viel Testament*, op. cit., vv. 43,507–14.
28 *Judith and Holofernes*, op. cit., p. 99.
29 Here it might be pointed out that Judith's prayer tends to align two elements that some critics such as A. E. Knight have attributed to distinct genres of medieval dramatic invention, distinguishing between "theocentric" and "homocentric" acts. See *Aspects of Genre in Medieval French Drama* (Manchester: Manchester University Press, 1983), p. 24: "Thus the medieval liturgy and mystery plays were theocentric acts by which the participants acknowledged God's presence in the community, while sermons and morality plays were homocentric acts by which the individual was taught the necessity for personal choice in determining his eternal destiny." Judith's position is that the two are inextricably conjoined, since the real Grace of God can only be "recognized" by the truly pious.
30 *Mistère du Viel Testament*, op. cit., vv. 43,534–38.
31 *Judith and Holofernes*, op. cit., p. 100.

pression "*exaudi me miseram deprecantem*" which appears in Judith's final imploration of the Creator.[32]

Judith's prayer in the *Mistère du Viel Testament* is thus strikingly different from the version that appears in the *Mystères de la procession de Lille*. One essential difference lies in the use that each author makes of the biblical model. Whereas the disposition of the prayer in the *Mystères de la procession de Lille* follows closely the Vulgate, the *Mistère du Viel Testament* presents a version which, though clearly inspired by the imperative and lyrical qualities of the Latin text, remains nonetheless quite independent of it. One likely reason for this sort of inventive liberty is the strong portrait of the heroine constructed in the play. Judith appears on the scene even before the rescue of Achior, much earlier than in the biblical text. When she appears, she encounters the elders of Bethulia already in prayer and declares that it is necessary to pray honestly and to confess oneself fully to God. She then proceeds to the temple, accompanied by Abra. Here then, Judith is intimately associated with devotional completeness and honesty, as these are expressed through the praying voice. Such a thematic amplification gives her an authority in the domain of prayer which her original, biblical voice cannot match. This moral authority invested in her is indeed proper to the Mystery play version that culminates in a coronation of the heroine.

Another essential difference between these two fifteenth-century rewritings of Judith's prayer lies in their divergent translations of the Latin verb *agnoscere*. The author of the *Mystères de la procession de Lille* translates it using the verbal construction *cognoistre en soy* and attaches it to the biblical remark which emphatically confirms that there is but one God. In the *Mistère du Viel Testament*, on the other hand, the author has made "recognizing" a spiritual event of which the verbal subject is the plural noun "hearts" (*noz cueurs*). This second, rather inventive reading is not without theological import, as it links Judith's ardent wish, for the spiritual enlightenment of her people, to a way of speaking that is used by the Psalmist,[33] by the prophets,[34] and even by God.[35] It thereby illustrates the significant variance of parallel vernacular, theatrical versions of the Judith episode, both of which have been constructed from a textual model provided by the Vulgate. Of these two imitations of the prayer, the one which strays furthest from the Vulgate model exhibits a decided tendency to solemnize the dignity of the heroine.

32 Jdt 9:17.
33 Ps 50:12.
34 Jer 32:39.
35 Ez 11:19.

In the *Mistère du Viel Testament*, Judith speaks like an exemplary figure whom the author seeks to elevate to a status commensurable with that of saints and prophets. Only continued study of the diverse versions of the Bible available to French authors during the second half of the fifteenth century will tell whether the inventions of the *Mistère du Viel Testament* are themselves the descendants of a particular translation of the biblical text. It seems more likely that the author of this Judith episode has invented a version of the prayer which is very much in keeping with an enhanced, saintly image of the heroine.

11. The Example of Judith in Early Modern French Literature

Kathleen M. Llewellyn

Judith, the biblical heroine who seduced and then beheaded an Assyrian general, clearly seized the imagination of early modern France. Her inclusion in manuals of comportment[1] and her frequent appearance in other forms of literature, as well as her depiction in visual arts, made this widow

1 Christine de Pizan, for example, writes in *Le Livre des trois vertus* (1405): "ce fut dit de la saincte dame Judith, louee de tout son peuple: Tu es la gloire de Jherusalem, tu es la leece d'Israel, tu es l'onneur de nostre peuple, a qui Dieux a donné force d'homme, de laquelle tu as ouvré pour ce que tu as amé chasteté" (it was said of the saintly Judith, praised by all her people: "You are the glory of Jerusalem; you are the joy of Israel. You are the honor of your people. God gave you the strength of a man, with which you have labored because you have loved chastity"). Christine de Pizan, *Le Livre des trois vertus*, ed. Charity Cannon Willard (Paris: Librairie Honoré Champion, 1989), p. 169. Translation from Christine de Pizan, *A Medieval Woman's Mirror of Honor: The Treasury of the City of Ladies*, ed. Madeleine Pelner Cosman, trans. Charity Cannon Willard (Tenafly, NJ: Bard Hall Press; New York: Persea Books, 1989), p. 182. Erasmus includes Judith among his examples for widows in a treatise published in 1529: "egregiam illam viraginem Judith, quae mulier geminum ex invicto viris hofte triumphum reportavit, victoriae, videlicet, & pudicitiae, quarum alteram peperit defperanti patriae, alteram fibi fervavit illibatam. Nam & occidit fortiffimum, & fefellit libidinofiffimum" (Judith, for example, that illustrious female of manly strength who as a woman brought back a triumph over a foe unbeaten by men. Double was the triumph of Judith: a military victory, to be sure, which she produced for her country when it had lost hope, but also a victory for her chastity, which she preserved for herself unimpaired, for she killed a very brave man and made a mockery of a lewd one). Desiderius Erasmus, "Vidua Christiana," *Opera omnia Desiderii Erasmi Roterodami* (Amsterdam: North-Holland Publishing Company, 1969), vol. 5, p. 735. Translation is from Desiderius Erasmus, "On the Christian Widow," *Collected Works of Erasmus*, ed. John W. O'Malley, trans. Jennifer Tolbert Roberts (Toronto: University of Toronto Press, 1988), vol. 66, p. 204.

an important figure in the religious discourse of the era.[2] Yet in certain ways, Judith clearly acts against accepted codes of conduct for women in Renaissance France. Ann Rosalind Jones describes the Renaissance woman as "disempowered."[3] Jones explains: "In the discourses of humanism and bourgeois family theory, the proper woman is an absence: legally, she vanishes under the name and authority of her father and her husband; as daughter and wife, she is enclosed in the private household. She is silent and invisible: she does not speak, and she is not spoken about."[4] Judith, though, is decidedly *present*. Neither silent nor invisible, she is the very conspicuous center of the struggle to save her people, the subject of her own story.[5]

This essay examines the "Judith" texts of three early modern French writers, Jean Molinet, Guillaume de Salluste Du Bartas, and Gabrielle de Coignard, keeping in mind the ambiguity of this biblical heroine, an example who does not seem entirely exemplary. I also explore the similarities and differences among the figures of Judith depicted by these authors, including their departures from the Latin Vulgate,[6] and I consider the ways in which each author represents this powerful and sometimes problematic figure as an ideal to the early modern reader. *Le Mystère de Judith et Holofernés*,[7]

2 Jacques Poirier traces the representation of Judith in French literature in *Judith: Echos d'un mythe biblique dans la littérature française* (Rennes: Presses Universitaires de Rennes, 2004). For a discussion of the "Christianization" of this Jewish heroine, see particularly chapter 2, "Judith la sainte" (pp. 51–77). The iconography of Judith is described at length in Margarita Stocker, *Judith: Sexual Warrior. Women and Power in Western Culture* (New Haven, CT and London: Yale University Press, 1998), and in Elena Ciletti, "Patriarchal Ideology in the Renaissance Iconography of Judith," in Marilyn Migiel and Juliana Sciesari (eds.), *Refiguring Woman: Perspectives on Gender and the Italian Renaissance* (Ithaca, NY and London: Cornell University Press, 1991), pp. 35–70.

3 Ann Rosalind Jones, "Surprising Fame: Renaissance Gender Ideologies and Women's Lyric," in Lorna Hutson (ed.), *Feminism and Renaissance Studies* (Oxford: Oxford University Press, 1999), pp. 317–36 (334), note 1.

4 Ibid., p. 317.

5 Recent scholarship has demonstrated that many early modern women did not obey these strictures of silence. Indeed, Merry E. Weisner asserts that "Sixteenth-century French humanist women were more willing to show their learning in public than their English or Italian counterparts." Merry E. Wiesner, *Women and Gender in Early Modern Europe* (Cambridge: Cambridge University Press, 1993), p. 129.

6 It seems clear that the authors considered in this essay were influenced not only by the Vulgate, but also, at least indirectly, by the tradition dating back to the patristic fathers who held up Judith as a model of piety comportment for widows. See for example Ambrose's "Concerning Widows" (ca. 377) and Jerome's letter to Furia (ca. 394).

7 Jean Molinet, *Le Mystère de Judith et Holofernés*, ed. Graham A. Runnalls (Geneva: Droz, 1995). Unless otherwise noted, English translations are from Jean Molinet,

a theatrical drama, appeared around the year 1500. Although the author of this play is not definitively known, it is widely believed to have been Jean Molinet.[8] Both Du Bartas and Coignard transformed the biblical material into epic verse. *La Judit*[9] of Du Bartas appeared in 1579, and Coignard's *Imitation de la victoire de Judich*[10] was published by her daughters in 1594, after the author's death.

The central theme of Molinet's *Mystère de Judith et Holofernés* is the infinite power of God. Molinet's Judith, like the heroine as she is depicted in the Vulgate, communicates more effectively than any of the other personages in the play the omnipotence of God (and, simultaneously, her faith in him). When she tells the elders of her city Bethulia that she will restore peace, she says she will do so with the Lord's help. Before leaving for the Assyrian camp, Judith prays to God, asking him to give her strength and to guide her. As she approaches the enemy camp and is about to encounter Assyrian soldiers, she pleads again for God's help: "Mon Dieu, ton aide!" (My God, Your help!).[11] Finally, just before assassinating the enemy general, Judith prays to God once again, asking him to give her strength and courage and to guide her in this horrific and heroic deed.

Molinet's Judith prays a great deal, as would any good early modern French widow. Her unshakable faith in God, accompanied by frequent prayer, illustrate Judith's piety, an important characteristic of an ideal early modern French widow. Furthermore, Judith declares that God is her only true spouse, thereby following in this matter, too, the advice commonly given to widows of the era, particularly wealthy widows, not to remarry and instead to devote themselves, and their inheritance, to the Church. The heroine of this *mystère* exemplifies an ideal widow in other ways as well. She is thoroughly virtuous; she has an immaculate reputation. Just as early

Judith and Holofernes: A Late-Fifteenth-Century French Mystery Play, ed. and trans. Graham A. Runnalls (Fairview, NC: Pegasus Press, 2002).

8 For a convincing argument as to why Jean Molinet should be considered the author of this play, see Graham A. Runnalls's introduction to *Le Mystère de Judith et Holofernés*, particularly section 9: "L'auteur: Jean Molinet?" (pp. 59–61).

9 Guillaume de Salluste Du Bartas, *La Judit*, ed. André Baïche (Toulouse: Association des publications de la faculté des lettres et sciences humaines de Toulouse, 1971).

10 Gabrielle de Coignard, *Oeuvres chrétiennes*, ed. Colette H. Winn (Geneva: Droz, 1995). Unless otherwise noted, English translations are from "Gabrielle de Coignard, *Imitation de la victoire de Judich* (1594)," trans. Colette H. Winn and Robert H. McDowell, in Anne R. Larsen and Colette H. Winn (eds.), *Writings by Pre-Revolutionary French Women* (New York and London: Garland Publishing, 2000), pp. 171–211.

11 Molinet, l. 1766. My translation.

modern French widows were expected to withdraw from the greater world and isolate themselves, Judith returns directly to her home after talking to the elders. There is no dialogue in Molinet's play that suggests any socializing on Judith's part. The heroine is noble; even the Assyrian soldiers perceive her nobility and remark upon it. Finally, Molinet assures his audience that Judith is modest: even though she is elegantly dressed for her meeting with Holofernes, one of the Assyrian soldiers observes that her clothes are not *deshonnestes* (indecent).[12]

Molinet's Judith, though, does not entirely conform to the ideal of his day. She must dress attractively in order to tempt and trap Holofernes, and in the stage directions of the *mystère* the author indicates that Judith is to adorn herself sumptuously, as does the biblical Judith, in clothing highly inappropriate for a widow. Furthermore, Molinet's Judith is intentionally captivating in ways other than her alluring attire. In the biblical version of her story, Judith was simply left alone with an already profoundly intoxicated Holofernes. However, the Judith depicted by Molinet invites the general to go to his bed with her, then suggests that he get into bed and assures him that she will follow. She even kisses him onstage!

There are other aspects of Molinet's Judith that deviate from the early modern ideal. Perhaps most importantly, Molinet depicts a Judith who is very strong. She is physically strong, of course; she proves herself capable, at least for one critical moment, of decapitating a grown man, a powerful soldier at that. And Judith's strength far surpasses the physical. She conducts herself as a forcible leader before the Hebrew people and their leaders. Before setting out on her mission, Judith gives a series of orders to the elders, telling them to take their courage from God, to open the gates, and to let her carry out her plan. Finally she commands the elders to pray for the success of her endeavor. When she returns from the Assyrian camp with Holofernes's severed head in a box, Judith gives the order to attack the enemy: "Saillez sur eulx!" (Attack them!)[13] she cries out to the Jewish army. Judith's most potent weapon, however, is her sexuality. She gains admittance into the enemy camp, convinces Holofernes to over-imbibe, and manages to be alone in his tent with the general because she is intentionally seductive. Holofernes's desire to make love to the beautiful widow will enable Judith to assassinate him.

In a final break from the early modern depiction of the ideal woman,

12 Ibid., l. 1914. My translation.
13 Ibid., l. 2381. My translation.

Molinet's Judith is not modest and retiring about her achievement. After decapitating her victim, Judith announces to herself and to the audience that she has accomplished "un chef d'oeuvre de femme" (a woman's master-stroke)[14] with no mention, for the moment, of God's help. Upon her return to Bethulia, Judith announces to the Jews that she has secured a great victory for them, proclaiming that she performed the mighty deed alone, and that she had thereby executed divine justice. This is a departure from the Latin Vulgate, where Judith's first words, upon reentering the city of Bethulia, are: "Laudate Dominum Deum nostrum qui non deseruit sperantes in se" (13:17) (Praise ye the Lord our God, who hath not forsaken them that hope in him [Douay]). Only after Ozias, a Jewish elder, proclaims that God always intervenes on behalf of those he loves, does Molinet's Judith affirm to her people that "A Dieu seul en est deu la gloire" (All the praise must be given to God).[15]

Like Molinet's Judith, the heroine depicted by Du Bartas in *La Judit* is an extraordinarily powerful woman, made to seem even more so in comparison with the Jewish men in this story, men who are almost pitifully weak. When the elders of Bethulia, weakened by a siege on the city, decide to capitulate to Holofernes and his army, Judith's ringing speech about God's infinite power and her promise to take action persuade them not to surrender immediately, instead to allow her the opportunity to carry out her secret plan. Judith accomplishes her goal through great courage and physical strength, of course, but also through the use of thoroughly feminine weapons, weapons of seduction and deceit. She lies, successfully and confidently, to Holofernes and his attendants. She flatters the general, calling him "le plus chery du ciel, le plus fort, le plus sage" (the most beloved by heaven, the strongest, the wisest).[16] Judith's ability to seduce is crucial to this story; Judith is able to gain access to Holofernes, convince him to dismiss his attendants, and subsequently kill him, because she is beautiful and alluring.

As if to emphasize Judith's ability to captivate Holofernes, Du Bartas emphasizes her physical attributes to a far greater degree than the biblical author of Judith's story, who only tells us that "cum audissent viri verba eius considerabant faciem eius et erat in oculis eorum stupor quoniam mirabantur pulchritudinem eius nimis" (10:14) (when the men had heard her words, they beheld her face, and their eyes were amazed, for they wondered exceedingly at her beauty [Douay]). In contrast to this compact

14 Ibid., l. 2230.
15 Ibid., l. 2308.
16 Du Bartas, p. 58, l. 384. All translations of this text are my own.

description of the story's heroine, Du Bartas writes 25 lines in praise of Judith's beauty.[17] Her body is "tout-beau" (altogether beautiful),[18] he tells us, and then proceeds to describe Judith's features, in traditional fashion, starting with the top of her head and progressing downward.[19] She wore her wavy hair in artful disarray. Her forehead was smoother than ice, her eyebrows were arcs of ebony and her eyes were black and as brilliant as stars. Her cheeks seemed to be painted with a blend of lilies and roses. Her lips were vermilion, her teeth a row of pearls. Her neck was ivory and her bosom alabaster. Her hands were flawless and her fingernails like mother-of-pearl. This lengthy description of Judith's beauty serves to objectify her. Rather than an active, acting subject, this detailed portrait transforms the powerful biblical heroine into the object of the reader's imagined gaze, an object of admiration, a *thing* of beauty.

When Holofernes first encounters Judith, she is cast as the object of his lustful gaze: "le pourtrait charmeur de l'estrangere dame / Estant le seul objet du louche oeil de son ame" (the charming portrait of the foreign lady / Being the only object of his soul's ignoble eye).[20] Later, when Holofernes enters his tent and finds Judith there, his actions immobilize and frame Judith so that he can admire her, as if she were but a painting:

Le coronnel arrive et d'un visage humain	The colonel arrives, and with a benevolent air
Luy donne le salut, puis la prent par la main	Greets her and takes her by the hand
Et, l'ayant faite seoir en une belle chaize,	And having seated her in a beautiful chair,
Ses divines beautés il contemple à son aize.	He contemplates her divine beauty at his leisure.[21]

Du Bartas's Judith does *act* upon her physical charms, however. She deliberately enhances her natural beauty by dressing for her encounter with Holofernes as attractively and seductively as possible. For in fact, if Judith's plan is to succeed, she must exercise her seductive powers not only over Holofernes, but over all the Assyrian men whom she would encounter, over any man who might stand in her way as she prepares to execute the enemy of the Jews.

Just as Du Bartas gives his readers a more elaborate portrait of Judith's

17 Ibid., p. 57, ll. 339–63.
18 Ibid., p. 57, l. 339.
19 John Nassichuk examines Du Bartas's portrait of Judith in his essay "The Prayer of Judith in Two Late-Fifteenth-Century French Mystery Plays," (Chap. 10).
20 Ibid., p. 60, ll. 5–6.
21 Ibid., p. 66, ll. 231–34.

beauty than did the biblical author, he also describes her preparations and her clothing in far greater detail, further objectifying the heroine, describing the heroine's actions as she objectifies herself. The reader of the biblical Book of Judith learns only that she bathed and anointed herself with perfume, that she arranged her hair and dressed in her gayest clothes, and put on her earrings, bracelets, rings, and other ornaments. Du Bartas, on the other hand, is not content with the mere mention of perfume. He tells us that the musk with which Judith anointed herself left an aromatic trace behind her long after she had passed. Du Bartas further emphasizes Judith's physical charms by his use of the descriptions of Judith's clothing and jewels as another opportunity to emphasize the beauty of her body. A brilliant ruby rested on her "front de cristal" (crystalline forehead),[22] sapphires and rubies adorned her "col blanc" (white neck),[23] a silver veil covered her hair of gold, and a transparent cape half-covered her "sein blanc et douillet" (soft, white bosom).[24]

Du Bartas appears to have created an independent and invincible heroine, allowed, because of her valiant and sacred motive, to violate the rules of his society: a proper early modern French widow simply did not dress up in her most alluring and costly finery to pay a visit to a man she did not know and then promise to go to bed with him. In fact, no woman of that era would have been admired for her independence and her ability to wield a sword.

However, Du Bartas, in his version of Judith's story, rescues her from excessively heroic behavior, even rehabilitates her according to the standards of early modern French society. He describes Judith as "foible,"[25] or weak, and makes clear that her strength and courage are only a temporary gift from God. Du Bartas seems deeply anxious about Judith's sexuality, and attempts to portray a woman who is at once chaste and seductive. Unlike the biblical heroine, the Judith of Du Bartas is physically caressed by the enemy general, and in fact he holds her in his arms until she convinces him to wait for her in his bed. However, despite this apparent nod to the early modern stereotype of the sexually available widow, Du Bartas goes to great lengths to avoid tainting his heroine's virtuous reputation. He begins his long description of her beauty by reassuring the readers that Judith is chaste, and as soon as he finishes describing the enticing perfume, clothing, and jewels with which Judith adorns herself in preparation for her encounter

22 Ibid., p. 50, l. 49.
23 Ibid., p. 50, l. 53.
24 Ibid., p. 50, l. 54.
25 Ibid., p. 13, l. 7.

with Holofernes, the poet assures his readers that she is modest.

Moreover, Du Bartas makes it clear that Judith finds Holofernes repulsive. The general is drunk and clumsy; every minute that she spends with him seems longer than a year, and she fights to protect her chastity. Judith spends hour after hour with Holofernes, warding off his amorous advances. He finally slips so deeply into a drunken stupor that she not only escapes his ardor, but slays him and flees the Assyrian camp with his head in a sack and her virtue intact.

As Du Bartas depicts her, Judith is far less self-assured than the heroine of Molinet's *mystère*. He reveals to his readers the uncertainty that Judith experiences before she goes to the magistrates: "Judit avec Judit debat" (Judith debates with herself).[26] She speaks respectfully to the high priests, addressing them as "Mes peres" (my fathers),[27] and this Judith not only reveals to the elders more of her plan than Molinet's heroine did, telling them that she intends to go to the enemy camp, she even requests their permission to do so: "Permettés-moy d'aller au camp des infidelles" (Permit me to go to the camp of the infidels).[28]

Despite her seductive behavior, her deceit, her temporary "masle vigueur" (masculine vigor),[29] and finally the bloody assassination she commits, the Judith that Du Bartas depicts is very nearly an ideal woman and widow, according to the standards of early modern French society. Like the biblical heroine, Du Bartas's Judith is beautiful and chaste and has a reputation for prayer and piety. Judith is respectful of masculine authority, and up until the moment when she embarked on her mission to save her people, she never strayed from her mourning rituals, never shed her widow's weeds.

The Judith of Gabrielle de Coignard's *Imitation* is even more chaste than the others we have encountered. This reflects, perhaps, Coignard's own uneasiness with her perilous and ambiguous position as a widow, that is, a sexually initiated woman who is now expected to be chaste. Among all of Judith's virtues, "Sa chasteté sur tout fut hautement louée" (Her chastity was the most highly praised).[30] Before describing Judith's dress, Coignard informs her readers that it covers her to her feet, and she assures us that the only impressions a viewer will have, upon the sight of Judith in this

26 Ibid., p. 46, l. 437.
27 Ibid., p. 47, l. 467.
28 Ibid., p. 48, l. 504.
29 Ibid., p. 13, l. 7.
30 Coignard, l. 630.

attire, is one of holiness and purity. Furthermore, Coignard's Holofernes gets drunk and falls asleep so that her Judith is not required to actively seduce him. Coignard's Judith, like the biblical personage, is never touched by Holofernes. In contrast, as we saw, Molinet's Judith is kissed by Holofernes, and Du Bartas's heroine is caressed and held by the enemy general until she promises to join him in bed, at which point he undresses in front of her. Even so, like an ideal early modern Frenchwoman, Coignard's Judith is concerned about her reputation. Just before beheading Holofernes, she prays to God: "Et sauve mon honneur du danger perilleux" (And preserve my honor from perilous danger).[31] Coignard's Judith is unambiguously virtuous. She is "Remplie de vertus, de toute saincteté" (Filled with virtue and holiness; l. 627), and not only does Coignard inform her readers that Judith is still chaste when she returns from the enemy camp after having executed the general, she also has Ozias assure the Jews of the same thing, speaking to them of Judith's "chaste pensée" (chaste thought).[32]

Coignard's Judith is weaker than the others we have encountered. She is "gresle" (frail),[33] and the author uses a diminutive of the French word for woman when describing her; Judith is nothing but "une femmelette"[34] with a delicate arm. Coignard's Judith is also more humble. Like the biblical heroine, she acknowledges that she cannot do the awesome deed on her own, and asks God to give her the necessary strength. Immediately after slaying Holofernes, Judith praises God; the glory and honor of this deed belong to Him. The first thing that the heroine says to the Jews upon her return to Bethulia is that they must glorify God, for He has delivered them from their enemy.

Judith is also exceedingly polite and respectful in Coignard's *Imitation*. The author calls attention to Judith's courtesy before allowing her to speak: "Entendez comment elle parle aux plus sages" (But hear how she speaks to the most wise),[35] Coignard exhorts us. Her wise words are thoroughly sweet. Although Judith opposes the decision to surrender to the enemy, she calls the high priests her very dear brothers. When she chastises the elders, she includes herself among them, asking: "Helas! Que sommes nous pecheurs audacieux, / De tenter le haut Dieu, le Monarque des Cieux?" (Alas, who are we, impudent sinners, / To tempt the high God, Monarch of

31 Ibid., l. 1284.
32 Ibid., l. 1386.
33 Ibid., l. 843.
34 Ibid., l. 22.
35 Ibid., l. 641.

the Heavens?).[36] Like the heroine of the Vulgate, Judith then warns the high priests that if *we* follow along the path you have chosen *we* will incite God's wrath. Judith's chastity, humility, and respectfulness combine to make her less vigorous and independent than her counterparts in the other early modern versions of her story, closer to the ideal of her day.

Coignard, like Du Bartas, adds a description of Judith's physical beauty to her text. Her description is notably shorter than that of Du Bartas, however, and there are other significant differences between the two portraits of the heroine. Whereas a group of enemy soldiers first relish the sight of Du Bartas's enchanting heroine, it is God himself, le Tout Puissant (the All-Powerful),[37] who sees and admires his own handiwork in Coignard's exquisite Judith. A significant portion of Coignard's portrayal of Judith's beauty is a description not of her body, but of her dress (which, as we observed, covers Judith entirely). Coignard describes the quality of the fabric, the silk and the gold, its "plis ondoyant" (undulating folds),[38] and its hundred colors that bring to mind the sky, the sea, the earth, all of God's creation: "Comme le Tout Puissant fit de rien toutes choses, / … / Le ciel fut esclairé de ses luisans flambeaux" (As the All-Powerful created all out of nothing / … / The heavens were brightened by her radiance).[39] This description of Judith's clothing as a reminder of "the All-Powerful" reduces the sexual aspect of this radiant widow about to seduce a man to his death.[40] It also further objectifies Judith: not only is she a thing of beauty herself, just as is the Judith portrayed by Du Bartas, she is also enveloped by, hidden by, another thing of beauty. Judith's clothing covers her, it closes her off, reminding us of Mikhail Bakhtin's description of the classical (as opposed to medieval) body: it is private, lodged within "palaces, churches, institutions, and private homes."[41] Finally, Judith's beauty, according to Coignard,

36 Ibid., ll. 651–52.
37 Coignard, l. 859.
38 Ibid., l. 844. My translation.
39 Ibid., ll. 849–51.
40 Paula Sommers observes that while lavish clothing is meant to attract attention to the wearer, it can, in fact, protect the body beneath: "The site of gender, the object of social regulation, it is intimately associated with adornment, yet adornment draws attention in its own right and reflects upon itself, while shielding the body of the wearer." Paula Sommers, "Louise Labé: The Mysterious Case of the Body in the Text," in Anne Larsen and Colette H. Winn (eds.), *Renaissance Women Writers: French Texts / American Contexts* (Detroit, MI: Wayne State University Press, 1994), pp. 85–98, here 88.
41 Mikhail Bakhtin, *Rabelais and His World*, trans. Helene Iswolsky (Bloomington: Indiana University Press, 1984), p. 154.

is *divine*,⁴² lifting her above mere mortal women, distancing her from the terrestrial, the corporeal.

Coignard further objectifies Judith by reducing the need for action on her part. Like the biblical Judith, but unlike the heroine as she is depicted by Molinet and Du Bartas, Coignard's Judith has no need to actively seduce Holofernes; he is overcome by her beauty and falls drunkenly asleep without her having to promise to join him in bed. Making Judith less seductive and more dependent upon her physical attractiveness for the success of her plan makes her more objectified than even the Judith of Du Bartas.

Though Coignard's Judith is the most thoroughly objectified of the three heroines we are studying here, she is not consigned to being the object of Holofernes's gaze; she is not reduced to a scopophilic metonym. For Coignard's Judith resists the general's amorous gaze. Instead she returns his gaze, in a scene where Holofernes is framed by his tent, as if *he* were a painting, a scene where he is surrounded by beautiful objects, as if *he* were dressed in finery, a scene where it is *he* who is objectified:

Mais la belle Judith pleine de sang rassis,	But the fair Judith, calm and serene,
Voyant Holofernes dedans sa tente assis,	Seeing Holofernes seated in his tent,
Tissue richement d'or, d'escarlate et soye,	Richly woven of gold, scarlet, and silk,
Couverte des presens que l'Orient envoye.	Filled with gifts from the Orient.⁴³

And though Holofernes continues to admire Judith's beauty, to regard her, that regard is dangerous, deadly: "Il humoit par les yeux cest amoureux venin" (He inhaled through his eyes this amorous poison).⁴⁴

In all of these versions of Judith's story, Holofernes's gaze is obscured when he slips into his drunken stupor, obliterated when he falls into drunken sleep. Now it is Judith's turn to gaze upon this disarmed soldier, this impotent man, this harmless object, and to render it harmless forever. For once Holofernes's gaze is extinguished, Judith is no longer the object of that gaze, she is the acting subject, the savior of her people. All three of these authors refuse to still Judith's righteous arm. And they refuse to silence her. The heroine is endowed with a persuasive and powerful voice. In each of these versions of her story, Judith speaks with authority to the

42 Coignard, l. 871.
43 Ibid., ll. 959–62.
44 Ibid., l. 972.

Jewish elders before leaving Bethulia, with cunning and wisdom in the enemy camp, and in triumph when she returns to her city with Holofernes's severed head.

However, Judith's powerful voice is only temporary, for when she returns to Bethulia, she resumes her role as submissive woman, as ideal widow. In Molinet's *Mystère*, Judith slips back into her community upon her return, identifying once more with the others, becoming once more part of the *nous*: "Suppedité avons totallement / Qui nous faisoit icy gemir et plaìndre" (We have completely and utterly vanquished / Those who sought to crush us underfoot).[45] Judith's submissive dialogue at the end of the play, signaling her rediscovered humility, emphasizes her return to her normal state.

Dont je conclus, pour verité attaindre,	From this I conclude, to speak the truth,
Qu'a resister a mortelles pointures	That, in the struggle against evil aggression,
Droicture aymer, et Dieu et honte craindre,	Righteousness and fearing great God's powers
Faict aux bon cueurs trouver telz avantures.	Will bring believers fortune such as ours.[46]

In the biblical version of her story: "omnes populi gaudebant cum mulieribus et virginibus et iuvenibus in organis et citharis" (15:15) (all the people rejoiced, with the women, and virgins, and young men, playing on instruments and harps [Douay]). Du Bartas, however, limits her celebrating followers to "des dames et pucelles" (women and girls)[47] and insists that they are pure: "sainctes, chastes et belles" (holy, chaste, and beautiful).[48] Judith sings a canticle to the Lord in the Vulgate, but in Coignard's *Imitation* Judith is silent, once again but an object to be observed, a saint perhaps, or a statue:

Et tous les Sacerdos de l'humble peuple Hebrieu,	And all the priests of the humble Hebrew people,
S'estoient ja assemblés à fin de recognoistre	Had already assembled to acknowledge
Les divines faveurs et bien-faits de leur maistre,	The divine favors and good deeds of their Master,
Desirant veoir Judich …	Wishing to see Judith.[49]

45 Molinet, ll. 2401–02.
46 Ibid., ll. 2405–06.
47 Du Bartas, p. 83, l. 331.
48 Ibid., p. 83, l. 332.
49 Coignard, ll. 1540–43.

For, as Catherine Belsey reminds us, "To speak is to possess meaning, to have access to the language which defines, delimits and locates power. To speak is to become a subject. But for women to speak is to threaten the system of differences which gives meaning to patriarchy."[50] In order to serve as a model, in order to represent the feminine ideal, Judith's voice must finally be still.

The choice of such a powerful woman as an example for early modern woman may seem surprising. This, after all, is an era during which women saw their economic, political, social, and sexual power reduced from that which they possessed during the Middle Ages, an era during which their re-valorization as *mère de famille* meant they were limited to that role. However, these renditions of Judith's story ultimately describe the power of God, not of one of his subjects. Judith's very inferiority proves God's strength, his ability to triumph over his enemies by means of the weakest of adversaries. These authors were not in any way obliged to prove or insist upon Judith's innate inferiority as a woman because it was simply assumed, recognized, "known." Judith speaks forcefully, but she is ultimately silenced.

Most importantly, for all her strength, for all the power she wields, Judith does not play a disruptive role in her society. She obeys its rules and laws and upholds its traditions, and in fact Judith is the force that preserves her society, and can therefore be forgiven her momentary strength, her temporary seizure of power. The readers of Judith's story see her becoming progressively weaker and more limited through the accounts of her story written during the early modern period, beginning with Molinet's vigorous and exuberant heroine who is transformed into a more feminine heroine by Du Bartas, then further transfigured by Coignard. This model widow becomes progressively more chaste, more pious, more deferential and dutiful. Finally, Judith is largely objectified by Du Bartas through his physical descriptions of the heroine, and even more so by Coignard as she reduces Judith's actions to a minimum and increases the effect of her appearance to the point where little else is necessary. The authors of these works successively reconstruct the beautiful subject of the Book of Judith into a beautiful object, *La Judit*.

50 Catherine Belsey, *The Subject of Tragedy: Identity & Difference in Renaissance Drama* (London and New York: Methuen, 1985), p. 191.

12. The Aestheticization of Tyrannicide: Du Bartas's *La Judit*

Robert Cummings

The modern editor of Du Bartas's *La Judit*, André Baïche, plausibly dates to 1564 its commissioning by Jeanne d'Albret, mother of Henry of Navarre.[1] It was supposed to celebrate an analogy between the relief of besieged Bethulia by Judith's assassination of Holofernes and the relief of the besieged Orléans, in 1563, by the assassination of the ultra-Catholic François Duke of Guise, by Jean Poltrot de Méré. The preoccupations of the biblical narrative were congruent with those of Du Bartas's French Protestant readers, a minority under siege morally and politically from the insinuations of a corrupt Catholic hegemony. The extent of the Protestant peril was demonstrated by the St. Bartholomew Day's massacre in 1572, the year also when the besieged Protestants of La Rochelle played Catherine de Parthenay's now lost *Judith et Holoferne*.[2] Du Bartas's poem, a vehicle for Protestant anxieties from its first publication in 1574, became, says Margarita Stocker, "the most important single catalyst of Judith's symbolic centrality for Protestantism."[3] But in its definitive 1579 version, little altered from the first, it was dedicated to the Catholic wife of Henry of Navarre.

The Calvinist Simon Goulart's prefatory argument (given in editions of *La Judit* after 1582) identifies the story as a perpetual allegory of the victory

1 André Baïche (ed.), *La Judit [par] G. Salluste Du Bartas* (Toulouse: Faculté des lettres et sciences humaines, 1971), pp. xxi–xxiii. As it appears in 1579, Du Bartas's "Avertissement au Lecteurs" (Baïche, pp. 7–9) asserts that Jeanne d'Albret commissioned the poem fourteen years before.

2 See Giovanna Trisolini, "Adrien D'Amboise: l'Holoferne," in G. Barbieri (ed.), *Lo Scrittore e la Città* (Geneva: Slatkine, 1982), pp. 61–75.

3 Margarita Stocker, *Judith: Sexual Warrior. Women and Power in Western Culture* (New Haven, CT and London: Yale University Press, 1998), p. 56.

of the Church over its enemies.[4] The faithful are tried and God preserves them; but the faithful of any color can lay claim to Judith's part or they can have it wished upon them. In his *Annals* for 1584, Camden gives an account of the plot to secure the English throne for the imprisoned Catholic Mary, Queen of Scots, sister-in-law of the assassinated Guise.[5] "The detestable malice of the Papists" was manifested in books and pamphlets exhorting Queen Elizabeth's subjects "to doe by her as Iudith to her immortal fame dealt with Holofernes."[6] He is thinking of the printer of Gregory Martin's *A Treatise of Schisme* (1578), brought to trial in 1584, who unavailingly denied any treasonous intention when he published the advocacy of Judith as a model for pious ladies "whose godlye and constant wisdome if our Catholike gentlewomen would folowe, they might destroy Holofernes, the master heretike."[7] When Thomas Hudson translated *La Judit* into English in 1584 as *The Historie of Judith*, he dedicated it to the young Protestant King of Scots, James VI, the unsympathetic son of the treacherous Mary.[8] The application should have been sorely tried, but in the event the poem seems untrammeled by the political anxieties it might have provoked. This paper offers reasons why the ideology apparently implicit in the poem should have proved ineffectual.

II

Undoubtedly Du Bartas and his readers understood the Judith story as stressing issues of unjust rule and resistance to it. Alternative emphases were to a great extent closed off so that, for example, the theme of salvation, celebrated in Judith's final hymn (Book of Judith 16), is truncated in Du Bartas's poem (VI.333–60), usurped by a discourse of tyranny. The Septuagint

4 Simon Goulart, *Commentaires et annotations sur la Sepmaine* [sic.] *de la Création du Monde (La Judith. L'Uranie. Le triomphe de la foy, etc.) de G. de Saluste Seigneur du Bartas* (Paris: A. Langelier, 1583, first pub. 1582).
5 William Camden, *Annales: The True and Royall History of the Famous Empresse Elizabeth*, trans. Abraham Darcie from the French of Paul Bellegent, not from the Latin of 1615 (London: George Purslowe et al., 1625), Book 3, pp. 52–74, covers the year 1584. Baïche, *La Judit*, p. cxxxviii, n. 32, notes the earlier *Reveille-Matin des François*, published in French and in Latin with an improbable Edinburgh imprint in 1574, calling for the murder of Mary Queen of Scots.
6 Camden, *Annales*, Book 3, p. 57.
7 Gregory Martin, *A Treatise of Schisme* (London: W. Carter, 1578), sig. Dii[r-v]; see *Oxford Dictionary of National Bibliography*, s.v. Martin.
8 Thomas Hudson, *Thomas Hudson's Historie of Judith*, ed. James Craigie (Edinburgh: William Blackwood & Sons, Scottish Text Society, 3rd ser., 14, 1941).

version of the Book of Judith, on which Du Bartas demonstrably relies, does not know the word *turannos*.[9] *La Judit*, on the other hand, uses the word "tyrant" about three dozen times, and Goulart's notes exaggerate the impression of its frequency.[10] It comes to designate an enemy presuming on the liberties and traditions of the Hebrew people (I.115) and one to whom Judith on that account owes no loyalty: "Holoferne est tyran, non roy de ma province" (VI.116); "This tyrant is no prince of my prouince" (Hudson, VI.116). Because a "tyran" is an enemy of God's people, it signifies an enemy of God (I.299, II.227), such as the modern Turks (VI.207), or Saul of Tarsus before his conversion (VI.196). Goulart's moralizing margins and his *sommaires*, at least from Book IV onwards, reinforce an opposition of holiness and tyranny, especially in Book VI. In this context, and in French, the notion of "tyrant" easily summons the notion of its virtuously avenging opposite "tyrannicide."[11] "Jahel, Ahod, Jehu furent tyrannicides," says Judith as she ponders her mission (VI.120), a line muffled in Hudson's "For then should Ahud, Iahell, and Iehewe, / Be homicids, because they tyrants slewe" (VI.119–20).

Tyrannicide was an unavoidable issue for Du Bartas, because the French religious wars offered occasions for it, and because the prejudices of classically trained intellectuals indulged a moral culture that encouraged its possibility. The *Politics* of Justus Lipsius, who witnessed the horrors of war in France and the Low Countries, entertained murder as one remedy for tyranny. Lipsius observes, from Cicero, that "the Grecians did attribute like honor as they did to their gods, to him who had slaine a tyrant," and from Seneca that "there can no more liberall nor richer sacrifice be offered to Iupiter, then a wicked king."[12] His extensive levying of classical authorities makes the case for tyrant-killing seem part of a general consensus. This consensus reached beyond pagan antiquity. Milton, in a passage in the *Tenure of Kings* that appropriates Lipsius's argument, coolly registers the fact that

9 Baïche, *La Judit*, makes clear Du Bartas's reliance on the Septuagint (pp. clvi–clvii). The Geneva Bible (1561) is free with the word "tyrant" to translate Heb. *'arîyts* or *rôgez*, and also to color NT Greek: where at James 2:6 the King James Version has "Do not rich men oppress you?" (*katadunasteuô*), Geneva has "Doe not the riche oppresse you by tyrannie?"

10 Holofernes is gratuitously designated a tyrant in Goulart's notes on II.405, III.185, IV.415, V.446, VI.55, VI.317.

11 The English word "tyrannicide" is first attested in Hobbes's 1650 *De Corpore Politico*.

12 *Politicorum sive Civilis Doctrinae Libri Sex* (Leiden: Plantijn, 1589), VI.v. I quote from *Sixe Bookes of Politickes or Ciuil Doctrine*, tr. William Jones (London: Field for Ponsonby, 1594), p. 200.

"Among the Jews this custom of tyrant-killing was not unusual," citing what might have been the embarrassing case of Ehud.[13] Baïche argues that, in Du Bartas's poem, Judith's tyrannicide represents a blow on God's behalf and effectively disengages the issue from the humanist obsession with classical anti-tyrannical republicanism.[14] But heresy and tyranny are readily identified in the minds of classically educated bigots.[15]

English or Scottish Calvinists in the mid-sixteenth century, acquainted with exile and at home with a discourse of tyranny and tyrannicide, were often noisy advocates of political assassination. "The holy goost reporteth Ahud to be a saueour of Israel," says John Ponet, and Jael too; John Knox's friend Christopher Goodman argues that since God's laws "reproue and punishe tyrantes, idolaters, papistes and oppressors" political resistance is not resistance to God's ordinance "but Satan, and our synne."[16] Buchanan's partner in his dialogue *De iure Regni* is brought to applaud the honor done to Greek tyrannicides on something like the grounds that rebellion to tyrants is obedience to God.[17] Buchanan's advocacy of tyrannicide was denounced in the Scottish parliament, perhaps at the instigation of his former pupil, King James, and copies were called in by the censors in the very year of Hudson's translation of Du Bartas.[18] Most of the evidence for biblically inspired fanaticism, at least in Protestant England and among the Protestant French, comes from later hostile witnesses. In the wake of the Gunpowder Plot at Westminster in 1605 and Ravaillac's assassination of Henri IV in 1610, the arguments of the Catholic apologists for tyrannicide were misrepresented so as to suggest treasonable excesses. The Jesuit Pierre Coton's *Lettre declaratoire de la doctrine des pères Jesuites* (1610) was travestied as an apology for tyrannicide. The anonymous *Anti-Coton* took

13 John Milton, *The Tenure of Kings and Magistrates* (London: Mathew Simmons, 1649), p. 18.

14 Baïche, *La Judit*, p. xxxviii. On the humanist celebration of Greco-Roman tyrannicides and their assimilation to Hebrew ones see Sarah Blake McHam, "Donatello's *David* and *Judith* as Metaphors of Medici Rule In Florence," *The Art Bulletin*, 83 (Mar. 2001), pp. 32–47.

15 Anne McLaren, "Rethinking Republicanism: *Vindiciae contra tyrannos* in Context," *The Historical Journal*, 49 (2006), pp. 23–52, argues against the secularization of regicidal republicanism.

16 John Ponet, *A Short Treatise of Politique Povver* (Strasbourg: heirs of W. Köpfel, 1556), p. 121, approves tyrannicide and cites Ehud, Jael, Eleazer. Christopher Goodman, *How Superior Powers Oght to be Obeyd* (Geneva: Crispin, 1558), p. 110.

17 George Buchanan, *De iure regni apud Scotos* (Edinburgh: John Ross, 1579), pp. 97–98.

18 Camden, *Annales*, Bk 3, p. 68; on the fate of the *De iure* see I. D. McFarlane, *Buchanan* (London: Duckworth, 1981), pp. 392–415.

on the Spanish Jesuit Mariana as well, whose measured observations on regicide in the *De rege et regis institutione* (1599) had already earned him a rebuke from his order. He is made to commend in colorful terms Jacques Clément, the assassin of the excommunicated Henri III in 1589.[19] The *Anti-Coton* further exaggerates the hyperboles of Pope Sixtus V's *De Henrici Tertii morte sermo* to yield, bizarrely, a parallel between Clément's murder of the king "with the mysteries of the Incarnation, and Resurrection," as well as, more intelligibly, the exploits of Eleazer and Judith.[20] The true author of the sermon may have been Jean Boucher, whose *De justa Henrici Tertii abdicatione* (1589) is the most celebrated defense of the assassination. In any case the radical councils in Paris were circulating Catholic preachers advising the justification of Jacques Clément by invoking Judith's example.[21]

The *Anti-Coton* says that it was a Jesuit novelty to revive positive views of tyrannicide.[22] Coligny, the great Huguenot admiral of France, disparaged Jean Poltrot's motives in assassinating the Duke of Guise.[23] Calvin's own position is unambiguously negative: "a private citizen who lays his hand upon a tyrant is openly condemned by the heavenly Judge," meaning 1 Samuel 24:7; and if "we are vexed for piety's sake by one who is impious," he argues, "it is not for to remedy such evils."[24] We are to obey and suffer. Vermigli's *Commonplaces* concludes a vacillating discussion with the short recommendation that "tyrannie must be abidden."[25] The Elizabethan *Homelie against Rebellion* (1570) reminds congregations that Baruch enjoined the Jews to pray "for the life of Nabuchodonosor king of Babylon, and for

19 *Anti-Coton, or A Refutation of Cottons Letter Declaratorie ... apologizing of the Iesuites Doctrine, touching the Killing of Kings*, trans. George Hakewill (London: T[homas] S[nodham] for Richard Boyle, 1611), p. 6. The *Anti-Coton* is variously attributed to Pierre Du Coignet, to Jean Dubois-Olivier, and to Pierre du Moulin, and the translation tentatively to the anti-Catholic polemicist George Hakewill (1611).
20 *Anti-Coton*, p. 11. Both R. W.'s *Martine Mar–Sixtus* (London: Thomas Orwin, 1591) and A. P.'s *Anti-Sixtus* (London: John Wolfe, 1590) give English versions of Sixtus's sermon.
21 See Bruno Méniel, *Renaissance de l'épopée: la poésie épique en France de 1572 à 1623* (Geneva: Droz, 2004), p. 274.
22 *Anti-Coton*, pp. 1–2.
23 *The Lyfe of ... Colignie Shatilion*, trans. Arthur Golding from the *Vita* of Jean de Serres (London: Vautrollier, 1576), sig. Ciiii[r].
24 John Calvin, *Institutes of the Christian Religion*, ed. John T. McNeill, trans. Ford Lewis Battles, 2 vols. (Philadelphia, PA: Westminster Press, 1960), 1, p. 724 (3.10.6), and *Institutes* 2, p. 1516 (4.20.29).
25 Pietro Martire Vermigli, *Common places of ... Doctor Peter Martyr*, trans. Anthony Marten (London: Henry Denham and Henry Middleton, 1583), p. 329 (4.21).

th life of Balthasar his sonne."[26] King James himself asserts the legal and moral nullity of "the extraordinarie examples of degrading or killing of kings in the Scriptures," a means, he says, "to cloake the peoples rebellion."[27] Some asseverations may be politic. Others like them are only humane. Lipsius, who could rehearse all the arguments for king-killing, but who changed religion as he changed cities, concluded that "civill warre is worse and more miserable then tyrannie."[28] The consequences of commitment to one religious party or another encouraged more than one observer to abandon strictly confessional positions.[29] Montaigne reflected bitterly on his recent experience of atrocities committed under cover of duty and religion and worse than cannibals practice; he commended Epaminondas for scrupling to kill a tyrant.[30] Burton lamented to see "a company of hell-born Jesuits, and fiery-spirited friars, *facem praeferre* to all seditions."[31]

The mix of classical republican liberty and Hebraic righteousness was widely regarded as toxic, and Du Bartas was embarrassed by it. It was always potentially embarrassing. Even Lactantius, "the Christian Cicero," in his grisly account of the bad ends of the persecutors of Christians, makes God's power manifest by having his villains assassinated by their confederates and not by the persecuted, or done away with by disease and not the power of human resistance (*De mortibus persecutorum* 31). Baïche declares that whatever Du Bartas's intentions, *La Judit* is an apology for tyrannicide.[32] The "Avertissement" prevaricates. Du Bartas claims to be no willing advocate of the turbulent and seditious spirits who, "pour servir a leurs passions, temerairement et d'un mouvement privé" (Hudson gives "to serue their temerarious passions and priuate inspirations"), conspire against

26 *Certain Sermons or Homilies (1547) and a Homily against Disobedience and Wilful Rebellion (1570)*, ed. Ronald B. Bond (Toronto: Toronto University Press, 1987), p. 215.
27 James VI, *The Trew Law of Free Monarchies* (London: Waldegrave [i.e., Thomas Creede], 1598), sig. C4ʳ.
28 Lipsius, *Six Bookes of Politickes*, p. 201.
29 See Thierry Wanegffelen, *Ni Rome, ni Genève. Des fidèles entre deux chaires en France au XVIe siècle* (Paris: Champion, 1997).
30 Michel de Montaigne, *The Complete Essays*, trans. M. A. Screech (London: Penguin, 2003), p. 236; Essays 1.31: "Of Cannibals") and p. 904 (3.1: "On the Useful and the Honourable").
31 Robert Burton, *Anatomy of Melancholy* (Oxford: Lichfield and Short, for Henry Cripps, 1621), pp. 525–26 (3.1.3.1).
32 Baïche, *La Judit*, pp. xliii–xliv. Du Bartas commends David's sparing Saul's life (*Trophées* 495–504); Sylvester's marginal commentary on his translation of the passage notes the contrast between David's piety and Bellarmine's supposed approval of the Gunpowder Plot.

the life of even wicked princes. What Ehod, Jael, and Judith did, feigning submission and friendship while plotting murder, merits dreadful punishments. Or it would, he adds in a cautionary note, if they had not been especially chosen by God "pour faire mourir ces tyrans" ("to kill those tyrants" is Hudon's blunter formulation). But pleading ignorance and weak-mindedness, Du Bartas himself refuses any decision on whether or not the principle of tyrant-killing is just, recommending his readers meanwhile to attempt nothing against their divinely appointed superiors "sans une claire et indubitable vocation" ("without a cleare and indubitable vocation"), and never to abuse hospitality, friendship, or kin "pour donner lieu à ses frenetiques opinions et abolir une pretendue tyrannie" ("to giue place to these frenetike oppinions, so to abolish a pretented tyrannie"). Baïche is insistent that the rationality of Du Bartas's Judith in the face of her mission, and her history of moral competence, mark her as chosen in this way.[33] But she has to rely on instincts by their nature beyond scrutiny, and it is far from clear that Du Bartas was interested in them. If Du Bartas had wanted to write an apology for tyrannicide it would not have looked like *La Judit*. And so the poem, despite its necessary concessions to current interest in the issues, is designed to be rid of them.

III

The poem exhibits signs of indifference to the issues that the Judith story supposedly engages with. According to the "Avertissement", Du Bartas's commission specifically required him to "rediger l'histoire de Judit en forme d'un poeme epique" ("to reduce the Historie of Judith in form of a Poem Epique" is Hudson's uncomfortable rendering). This first "juste poeme" in French on a sacred subject was designed to imitate Homer and Virgil "et autres qui nous ont laissé des ouvrages de semblable estofe" ("and others who hath left to vs workes of such like matter"). Unlike Du Bartas's pretended fidelity to the historical truth of an apocryphal text, this declaration of allegiances was not dishonest; but it is strictly nonsensical. Du Bartas had no firm conception of how to go about adapting the Book of Judith to epic norms, nor indeed what epic norms might be. If the poem

33 Baïche (pp. xli–xlii) represents Judith as an instrument of Providence, but also as a rational personality with her own reservations and her own motives. But Méniel, *Renaissance de l'épopée*, p. 456, notes that her courage relies on inspiration from outside (III.428), and sustaining prayer (IV.21–34, IV.433–80, VI. 122–32, VI.140–42).

does not meet expectations, it is not, he says, entirely his own fault. We are apparently to blame Jeanne d'Albret, "celle qui m'a proposé un si sterile sujet" ("who proposed to me so meane a Theame or subiect"). He must mean by this that the theme doesn't of itself generate the sort of material appropriate to epic. This may signify only that Judith is not an exemplary heroine: her achievement is, after all, to lie plausibly and then to murder her host.[34] Or it may signify more broadly that biblical subjects leave no room for invention. The book of Judith is in any case generically indeterminate. Its early modern adaptations are indifferently epic, tragic, or comic. The most frequently printed secondary version of the story in England was Cornelius Schonaeus's Latin comedy.[35] Du Bartas's epic version is haunted by other possibilities.

The machinery of Du Bartas's poem is epic only in a superficial and dubious way. Its most obvious conformity with the narrative economy of epic poetry is beginning *in medias res.* But instead of hastening toward an end in view, which is the point of beginning in the middle, Du Bartas's poem instead recesses Judith's narrative, and forces it into competition with a range of others: Achior's history of the Jews (II.31–388), Charmis's biography of Judith (IV.73–312), Holofernes's account of Nebuchadnezzar's wars (V.249–574). Du Bartas constantly brings into focus what is not immediately relevant to the dynamic of the supposedly principal action. Moreover, Du Bartas's most striking particular debts are to poems whose epic status was, for different reasons, doubtful. His poetic allegiances are with Lucan's *Pharsalia* (as Joseph Scaliger observed) and (as Du Bartas himself acknowledged) with Ariosto's *Orlando Furioso.*[36] The one poem was charged with exhibiting too little invention, the other with exhibiting too much. Whether or not Du Bartas had any kind of moral or ideological design, his method would have got in the way of making it palpable. Sensitive always to the requirements of literary "imitation," he is drawn into dialogue not with the issues that may have been close to Jeanne d'Albret but with the models he turned to to carry the Judith story.

Goulart closes his prefatory argument to *La Judit* with the claim that Du Bartas has written with "l'artifice requis" in a work that has ambitions

34 Gabrielle de Coignard, *Œuvres chrétiennes,* ed. Colette H. Winn (Geneva: Droz, 1995), pp. 99–100, remarks the early modern anxiety about the "femme forte."

35 Cornelius Schonaeus, *Terentius Christianus, sive Comoediae duae. Terentiano stylo conscriptae. Tobaeus. Iuditha* (London: Robinson, 1595). There is a translation into English prose in Bodl. MS Rawlinson 1389, fols 252–379.

36 Joseph Scaliger is quoted in Baïche, p. clxxvi; Du Bartas's 1574 "Avertissment" specifies Ariosto among his models: see Baïche, *La Judit,* p. 89, among the variants.

to permanence, and in describing this "required artifice" he gives the impression, correctly, that Du Bartas has buried his argument, and with it his intentions, in an assemblage of digressions, vivid descriptions, and ornaments.[37] Du Bartas has also buried all questions of his subject's being "sterile," for he is copious. And while sometimes Goulart's commentary is moralizing, the interest he encourages is overwhelmingly in set pieces and rhetorical effects that belong neither to the story of Judith nor to epic poetry. The effect is as when Claude or Rosa gives a historical title to a painting and the eye has to search around to find where the history has been hidden. Baïche quotes J. Vianey's witticism that Du Bartas has applied a sort of "sauce épique" to his biblical material, made up of such ingredients as the Assyrian war council (III.135–84), the siege proper (III.253–358), the military exploits of Holofernes (V.251–574), the banquet in Holofernes's tent (VI.1–54), the final battle when the Israelites descend on the Assyrian camp (VI.263–290).[38] But such passages are less the sauce than the substance of the stew. The rhetorical amplifications are the point of Du Bartas's poem.

For these fashionable amplifications the sources are many, as Baïche's notes indicate. For some of them Lucan supplies a pseudo-epic rationale. The archaeologically elaborate detailing of battle machinery at III.107–14, is apparently derived from Du Bartas's reading of Vitruvius, but it emulates Lucan's account of the siege of Marseilles (Lucan III.388–496).[39] The elaborate description of the starving Bethulians under siege (III.239–320) emulates Lucan's description of the sufferings of Pompey's troops in Spain (Lucan IV.292–315). The satirical description of Holofernes's banquet (VI.1–54) is taken from Lucan's description of the excesses of Cleopatra's dinner table (X.136–71). Ariosto, congenial to the habits of Valois courtly poetry, supplies a precedent for others. When Du Bartas wants to offer an exact (and conspicuously irrelevant) description of Judith's beauty (IV.341–68), it is to Ariosto's famous blazon of Alcina that he turns (*Furioso* VII.11–15) with a little help from his description of Olimpia (XI.71). The description of Judith preparing herself, exceptionally elaborate in the biblical account (Jdt 10:3–5, 7), is touched up with an allusion to Ariosto's Orrigille (*Furioso* XVI.7). And it is to Ariosto that he turns to represent Holofernes

37 Goulart, *Commentaires*, pp. 269–70.
38 Baïche, p. xciv, with notes at clxxvi.
39 Méniel, *Renaissance de l'épopée*, p. 347, from Jean Martin's translation. Dryden's preface to *Annus Mirabilis* gives Lucan's precedent for his own use of naval terminology: *Of Dramatic Poesy and Other Critical Essays*, ed. George Watson, 2 vols. (London: Dent, 1964), 2, p. 96.

in love (V.1–91), or for the image of the drunken Holofernes fumbling with his buttons (VI.52–130), taken from Ruggiero's botched attempts to discard his armor as he tries to rape Angelica (*Furioso* X.114–115), or for Holofernes' fretful anticipation of Judith's arrival, taken from Ruggiero's lying awake for Alcina to visit his bed (VII.23–25). And Du Bartas's recourse to those poets relies on the disintegrative kind of reading for "beauties" typified in Orazio Toscanella's 1574 *Bellezze del Furioso*. Ronsard complains of the tendency to poetic fantastication in his 1572 preface to the *Franciade,* and advertises his anxiety to avoid a poetry beautiful in its details but monstrous in its assembly.[40]

It is telling that the climactic moment, when Judith cuts off Holofernes's head (VI.154–56; Jdt 13:6–10), is reduced to three lines. Du Bartas despatches him with a flurry of punning: "heureuse elle depart avec l'ethnique lame / Le chef d'avec le corps et le corps d'avec l'ame" (reduced in Hudson to "stroke this sleeping Roy / so fell, that from his shoulders flew his powle, / and from his body fled his Ethnique sowle" [VI.154–56]). But all the circumstances of the act are eliminated: the bedpost, the sword on its hanger, the two strokes of the blade, the general tumbled from his bed. It is a moment the averagely careless reader might miss, contrasting markedly with Gabrielle de Coignard's description of the same event, its detail filling close on twenty lines (*Imitation de la victoire,* 1302–20).[41] What even the most inattentive reader would not miss is the mutilation of Holofernes's corpse, first the head spat on, its beard pulled, its eyes poked, its tongue torn out (VI.215–24), and then the trunk, its every part distributed among a mob (VI.310–26). There is no biblical precedent for this. Du Bartas allows a ready-made description taken from Claudian (*In Rufinum* II.400–27) to stand in for a blank that nobody in the history of the story had previously felt impelled to fill. It draws attention from the execution performed by Judith herself and on to Du Bartas's own manneristic engagement with his poetic antecedents.

The description of the dismemberment is a metaphor for Du Bartas's procedure. The interest is not in the fact that Du Bartas has borrowed material, nor where he has borrowed his material from, but rather that he has borrowed transferable details, the sort of things that end up in commonplace books, the sorts of things that don't belong to the matter at hand. The narrative has no more substance than, for example, the vividly ekphrastic

40 *Œuvres complètes,* 2 vols., ed. Gustave Cohen (Paris: Bibliothèque de la Pléiade, 1938), 2, p. 1008.
41 In *Œuvres chrétiennes*; see n. 34.

passages that interrupt it. Judith's embroideries (IV.150–72), which include, among their ornamental eagles and elephants, a strange mix of threats and escapes in divine history (the destruction of Sodom, Susanna's chastity, the chastity of Joseph, the sacrifice of Jephtha), are as real as her own story. The gorgeous tapestries in Holofernes's tent (V.199–288), filled with the dubious glories of Oriental empire (Ninus and Semiramis, the effeminate Sardanapalus, Cyrus), are as real as his own stories. When a literary culture invests as much in imitation as early modern literary culture did, it becomes indifferent to the specific representational character of descriptions, and the poets resort to indefinitely redeployable descriptive templates. They can be brilliant, and Du Bartas was famous for the convincingness of his illusions. But they are not tied to a narrative or moral context. That is why similes are so important to Du Bartas. Some have not worn well, or seem inept. Anne Prescott finds evidence among early English readers of a fascination with Du Bartas's comparisons "often in the very places where the modern reader would wince."[42] Some are complicated and "metaphysical." Some are merely quaint. More striking than any explicatory function is the extraordinariness of the connection between the terms of his similes or the poet's indifference to it. Du Bartas dissimilates correspondences that a little effort might easily have secured. Goulart, who remarks on many of Du Bartas's similes in his margins, is anxious for their rhetorical propriety and their moral point. But few of the similes are in any real sense "proper." They rely on comparisons from experience not too much reflected on, conformable to familiar patterns, sanctioned by ancient or other literary precedents, more often than not transferred from Virgil or Ariosto. They are not particular to the situation Du Bartas or his readers are called on to imagine. And that is in a way the point. They are particular to themselves or their literary sources. Despite Goulart's insistence on aptness, Du Bartas is concerned, rather, with creating little pictures interesting in themselves but which, if they add up at all, add up to a world removed from biblical Judea.

IV

In the dedication to the *Historie of Judith*, Hudson reminded the king that his translation had its origin in his after-dinner observations on the impossibility of matching "the loftie phrase, the graue inditement, the facound

42 Anne Lake Prescott, "The Reception of Du Bartas in England," *Studies in the Renaissance*, 15 (1968), pp. 144–73 (151).

termes of the French Salust" – that is, Du Bartas – "in our rude and im-
pollished english language."[43] Hudson countered with the promise of do-
ing so "succinctly, and sensibly." *The Historie of Judith,* "an agreeable Su-
biect to your highnesse," was the agreed testing ground. Hudson's effort
was apparently corrected by the king ("If I have done well, let the praise
redound to your majesty"), whose version of Du Bartas's *Uranie* came out
in a bilingual edition in the same year and from the same publisher. The
enterprise was part of a competition in a culture so driven by literary emu-
lation that King James could forget that his mother was in danger of losing
her head for playing Judith's part against the tyrant Elizabeth. Du Bartas
played the same game. By 1585, improbably ravished by its "vives et par-
lantes descriptions," he had translated King James's *Lepanto*; the original
and the translation were published together in Edinburgh in 1591.[44] Nei-
ther the author nor his translator could have been much committed ideo-
logically to a poem that celebrated the victory of a Catholic alliance against
the Ottomans. But James published *Lepanto* and its translation with only
enough concern for its political implications to make his preface a miracle
of embarrassed equivocation.[45] Early in the next century Sylvester took up
the challenge in a spirit that suggests he had no interest at all in the poli-
tics of Du Bartas's *La Judit.* Sylvester addressed his version to Queen Anne
and sixteen of her ladies (a predominantly though not exclusively Catholic
clique), and in doing so disparaged Hudson's version, addressed to Queen
Anne's husband, as a betrayal of the poem's heroine.[46] A narrative of tyran-
nicide was metamorphosed into a celebration of the virtues of court ladies.
This was no doubt by way of a joke, but it is remarkable that it was possible
to make such a joke. The poem survives disengaged from any point that its
subject or circumstances might seem to dictate.

43 Hudson, *Historie of Judith*, ed. Craigie, p. 4.
44 *His Maiesties Poeticall Exercises* (Edinburgh: Waldegrave, 1591), sig. M2ʳ.
45 *Poeticall Exercises*, sig. Hʳ.
46 Joshua Sylvester, "Bethulians Rescue," sig. G2ʳ and 78, in *The Parliament of Ver-
tues Royal* (London: Humphrey Lownes, 1614).

13. The Cunning of Judith in Late Medieval German Texts

Henrike Lähnemann

In her song of triumph in the Book of Judith, Judith herself describes her beauty as a form of cunning; all versions are in agreement about this. Judith adorns herself with the express intention of deceiving Holofernes: "εἰς ἀπάτην αὐτοῦ" (for his deceit, LXX Jdt 16:8), "*ad decipiendum illum*" (to deceive him, Vulg. Jdt 16:10), "*jn zu betriegen*" (to deceive him; Luther Bible 1534 Jdt 16:10) etc. While Judith's cunning deeds and words are presented as an unquestionably positive and divinely endorsed device in the Book of Judith, the situation becomes more complex in the reception. As soon as the focus of attention shifts to her as an active heroine, she falls under the proverbial category of *Weiberlist* (cunning women) and is thus subjected to moral judgment.[1]

These shifting contexts for Judith's cunning can be clearly observed in short German texts of the fourteenth to the sixteenth century. Their striking portrayal of her as *"klug"* (clever) and as full of *"list"* (cunning) like other notorious women of history is a decisive stage in the development of the "modern icon," Judith. I will investigate this development by analyzing several anonymous *Meistersinger* stanzas which are representative of the *opinio*

1 *Weiberlisten* as *terminus technicus* denotes a series of women tricking men by specifically feminine strategies ("listen" is the plural form of "die List" = "cunning" and of "die Liste" = "catalogue"). It is used as a proverb in the form *Es ist keine list vber Frawen list* (Luther Bible 1535, Sir 25:18), cf. the article *sub voce* "Weiberlist" in Grimm, *Deutsches Wörterbuch*, vol. 14,1,1 (= Lfg. 28,3, 1914) and the preface by Christopher Irenäus (1565) to a fifteenth-century play about Pope Joan: *Weiberlist, so sagt man, übertrifft alle List* (Women's cunning, as the saying goes, is beyond all cunning), Dietrich Schernberg, *Ein schön Spiel von Frau Jutten*, ed. Manfred Lemmer (Berlin: E. Schmidt, 1971), p. 98, l. 1f.

communis of the fourteenth and fifteenth century, and then concentrate on a broadsheet of the sixteenth century which in its sensational presentation of a text-image version of Judith gives an insight into the popularization of the view of Judith as cunning woman and the way in which this view was disseminated by the media of early modern times.

Example 1: Judith Brings about the Fall of Princes

Stanzas in the form of a *Spruch* make up a large proportion of the exponentially expanding German literary production in the fourteenth and fifteenth century.[2] *Sprüche* that are highly complex metrically and in their rhyme scheme by some of the most highly esteemed poets of the thirteenth century like Walther von der Vogelweide and Frauenlob are used as a means of presenting a wide range of knowledge. In the late fifteenth century, this was formalized in the "schools" of the *Meistersinger*, but even before that there was a clearly defined pool of material from which the subject matter of these texts was drawn: biblical themes, moral advice, and formalized popular knowledge. The form favors enumeration and standardization; for example, when drawing up a list of typological figures Judith proves a versatile example for several of these recurring discourses, being grouped, among others, with types of Mary, cunning women from antiquity, and tyrannicides. A specific angle for commenting on her cunning is the practice of seeing her actions from the perspective of Holofernes, and his fate becomes the core message rather than the salvation of Israel which was stressed in the Marian connection.

In the *Fürstenspiegelstrophen* (verses in the tradition of the *Mirror of Princes*), the story of Judith is used for didactic purposes to highlight the perils of government and the fall of the mighty through pride – and the cunning of women. Two unconnected stanzas in the "Goldene Ton" by Frauenlob from the fifteenth century show this disastrous mixture of female cunning and male pride.[3]

2 *Spruchdichtung* as a technical term refers to a specific form of German poetry, often didactic, composed in specific stanza forms; cf. Nigel Harris, "Didactic poetry," in Will Hasty (ed.), *German Literature of the High Middle Ages* (Rochester, NY: Camden House, 2005), pp. 123f.

3 RSM, ¹Frau 9 /511 (*Repertorium der Sangsprüche und Meisterlieder des 12. bis 18. Jahrhunderts*, ed. by Horst Brunner and Burghart Wachinger, 16 vols. (Tübingen: Max Niemeyer, 1986ff.). The stanzas are quoted following my own transcriptions. The rhyming patterns are complex, often requiring "Schlagreim", i.e. a series of internal rhymes; the "Goldene Ton" would ideally require for the first two syllables

Aber iij in dissem ton straft welt weltlichen gewalt	Again three verses following this form. They reproach the world and worldly power

1 Slug Judith Olofernen,	When Judith slew Holofernes,
klug waz ir sin der frauwen.	her womanly sense was clever.
sie wug daz volck behalten,	She dared it to save the people,
trug sie daheim daz haubet,	she carried home the head,
5 ja get der welt es so.	indeed, these are the ways of the world.
Da als sin volck des fürsten	Since all the prince's people
nicht im gehelfen künde	could not help him
icht wider gottes willen,	against God's will at all,
schier sollent ir bedencken,	you should consider now
10 waz gottes crafft vermag;	what God's power can bring about;
Dag unde nacht dez walten,	they should take care day and night,
sit ir begirde begünde,	ever since their sinful desire first began
daz er sie dez wolt erne.	that He will make them suffer for it.
ir herren, ob üch krencken	My Lords, if you are weakened by
15 des übermuotes türsten,	the boldness of your pride
daz solt ir selber stillen.	you should overcome it yourselves.
wie mag uch trost beschouwen,	How can you achieve divine help
lat ir in wahsen ho?	if you allow it to grow to great height?
wem ubermut beraubet,	He who is weakened by pride,
20 dem wirt der gottes slag.	will be struck down by God.

The example of Holofernes's fate is used to address the *herren* directly with a dire warning. The didactic purpose is to caution men by talking about the vicissitudes of the world and emphasizing that no worldly power can withstand God's might. Judith is not criticized at all; she is seen as acting in the name of the noble cause of saving her people and later on in the stanza it is made absolutely clear that it is God who ordains that pride comes before a fall. Nevertheless, Judith is tainted by association since she brings about the downfall through her own female cunning. The very first information we receive about her is not her piety but her cunning. She is not shown as the faithful instrument of a divine plan but rather as working alongside God in taking the active role of Fortune, turning her wheel.

In a second verse in the same "Ton," the focus is again on male rulers.[4]

of the first line to rhyme (Slug / Ju-dith, cf. the first line of the following stanza as example: Do / O-lofern).

4 RSM (fn. 3), ¹Frau/9/100 following the edition GA-S XII, 204 ([= Göttinger Ausgabe – Supplement] *Sangsprüche in Tönen Frauenlobs. Supplement zur Göttinger Frauenlob-Ausgabe*, ed. by Karl Stackmann and Jens Haustein, I: Einleitungen, Texte (Abhandlungen der Akademie der Wissenschaften in Göttingen, Phil.-hist. Klasse III 232) (Göttingen: Vandenhoeck & Ruprecht, 2000).

1 Do Olofern mit grimme	When Holofernes with great wrath
so krefftigleich erwelte	and so mightily, at such a well chosen
zit, hohes künigreiche	time, did indeed conquer
jo er bezwang mit streite,	a great kingdom in battle
5 das sie im zinses pflagen.	so that they paid tribute to him.
Was halff sein preite menge?	What did his mighty host avail him?
ein weip in doch erquelte,	A woman tortured him to death after all,
kein helt kam im zu troste.	no hero came to his relief.
das kam von gotes state,	God offered the opportunity to bring this about
10 do in Judit betrog.	when Judith deceived him.
Och was ir mut geleiche,	Further she acted with great equanimity,
den ir got selb erwelte.	Which God himself chose for her.
fro da mit linder stimme	Joyfully and with a gentle voice,
kam sie zu irem rate	she came to her council
15 und liept in rechter lenge,	and made a proper delay attractive to them,[5]
Betulia erloste	liberated Bethulia
pas: vletzet auf dem velde	all the better: wounded upon the field of battle
mit grosem schall da lagen,	amidst mighty noise, there they lay,
die sie von freuden leite,	all those whom she deprived of joy,
20 wie sich der arge zoch.	in spite of the evil man's endeavors.

Judith's actions are presented in terms of a divine strategy; an alternative translation of line 9f would be: *"this was actioned by God when Judith betrayed him"* – God approves not only of the act of murdering the tyrant but also of her cunning as a means to an end. But this license is only mentioned after the ignominy of a man being tortured to death by a woman has been exposed. The word *erqueln* (l. 7), a neologism derived from *queln* (inflicting pain; the prefix *er-* denotes an action taking place from the inside out),[6] serves to suggest that Judith's behavior before she delivers the fatal stroke of the sword is also part of the torture process: the torture of seduction leads to the killing. Female cunning action is thus established as the main characteristic of Judith.

This form of *Spruch* narrative inevitably foreshortens the perspective on Judith since the confined form of a single stanza with the additional challenge of a highly complex metrical structure calls for condensed characterization. "Judith" here stands as shorthand for "Pride goes before a fall"; and this fall is as often as not brought about by women. After Judith has made

5 Stackmann took the *rat* to be the counsel to kill Holofernes and the phrase "liebt in rechter lenge" to mean "love up to the right point" (taking "in" as preposition). Since the account is in historical order, I take the line to refer to Judith's counsel with the city elders after her return to town, i.e., "in" as dative plural of the personal noun ("to them") and "lieben" as a factitive verb "to make lovable."

6 Jacob Grimm, *er*, in *Deutsches Wörterbuch*, vol. III3 (1859), col. 693.

this transition from a narrative to a gnomic context, and from a figure as part of a wider divine strategy to one who herself performs momentous acts, the way is open for different accentuations of this "cipher Judith," and the most prominent of these for early modern times is the "cunning woman" topos.

Example 2: Judith among Cunning Women

A particularly good example of Judith's growing association with this complex of cunning as a precursor to cutting can be found in a stanza in the form of Frauenlob's "Langer Ton." Its popularity is evident from the wide range of versions and contexts in which it exists: as part of longer poems, in the form of a caption for a mural in the Haus zur Kunkel in Constance and as the basis for a text-image composition in a late-medieval compilation of mnemotechnical drawings.[7] In the Rosenwald manuscript (Fig. 13.1), the stanza is written in the top right-hand corner and is given visual expression in a series of boxed drawings on the left-hand side and in a summary illustration of Love's fools at the bottom of the page.

Adam, den ersten menschen,	Adam, the first man,
den betrog ein wip.	was deceived by a woman;
Sampsones lip	Samson himself
wart durch ein wip geblendet.	was blinded by a woman,
David der wart geschendet.	David was put to shame.
5 von einem wib kunig Salomon	By a woman, king Solomon
von gottes rich gepfendet.	was deprived of God's kingdom.
Absolons schone nit verfieng	Absalom's beauty did not succeed,
in het ein wip betöret.	a woman had him dazzled.
Gewaltig Alexander was,	Mighty as Alexander was
geschach alsus.	– no different.
Virgilius	Virgil
trog man mit falschen siten,	was deceived by false means.
10 Olfernus wart verschnitten.	Holofernes was chopped up,
so wart auch Aristotileß	same as Aristotle was ridden
von einem wib geritten.	by a woman.

7 Washington, Rosenwald Collection, ms. 4, fol. 8ʳ, Bavarian, start of the fifteenth century RSM (fn. 3), ¹Frau 2/514a (3) = 537a (1). My text follows Marcus Castelberg, *Leibeswohl und Seelenheil* (diss. masch. Fribourg University, 2005), who generously allowed me to use his chapter on Frauenlob. For the manuscript, see also Karl-August Wirth, "Lateinische und deutsche Texte in einer Bilderhandschrift aus der Frühzeit des 15. Jahrhunderts," in *Latein und Volkssprache im deutschen Mittelalter 1100–1500* (Regensburger Kolloquium, 1988), ed. Nikolaus Henkel and Nigel F. Palmer (Tübingen, 1992), pp. 256–95.

DARKER?,

13.1. *German Miscellany*, early 15th century. Washington, Library of Congress, Rosenwald Collection MS 4, fol. 8r. Photo credit: The Library of Congress.

(top left) Judith and Holofernes: "*Pecula die Stat. Judich Oliuernis*";
(top right) The singer and his Lady: "*der minnen stral hat mich gar ser verbunt So hat ir fewr mich enczunt*";
(middle left) Charlemagne and Gisela: "*Rex Carolus*";
(middle right) Secundus and his mother: "*Secundus philosophus, mater eius*";
(bottom) Absalom, Samson, Vergil, Aristotle, Alexander, Salomon queuing for Venus: "*Allexander vnd Salomon Sampson vnd absolon aristoles vnd vergilius sprechent all sampt alsus. Das chain maister nie so weis ward, dicz weiz an der toren vart. Ich hoffe mir geling von der liebsten.*" (Alexander, Salomon, Samson and Absalom, Aristotle and Virgil all together say thus: No master ever became so wise not to join the train of fools. I hope I will be successful with my beloved!)

Troya die stat und alles lant	Troy, city and country alike,
wart durch ein wip zerstoret.	were destroyed by a woman.
Achilles, dem beschach alsam.	Achilles suffered the same.
der schnelle Asahel wart zam.	The fast Asahel became tame.
15 Artuses scham	The shaming of Arthur
von wibe kam,	originated from women,
und Parcifal mang sorge nam.	and Perceval had many troubles.
sit diss bezwang der minne stam,	Since love conquered them all
was schat dann, ob ein reines wip	what does it matter if a pure woman
mich brennet unde fröret?	burns and chills me?

It is again Holofernes who is the central focus here: the name of Judith does not appear in the stanza at all. In the top left hand illustration she is the living stand on which his head is mounted; the misspelled captions (*"Pecula die Stat."* for the city of Bethulia, *"Judich"* for Judith, and *"Oliuernis"* for Holofernes), reduce the story to its most recognizable moment and make it probable that the illustrator took the full set from a preexisting cycle showing famous couples rather than working from a written source. The bottom scene, taking its cue from the rhymed caption that mentions figures from the Old Testament and antiquity as part of the train of fools, literally reveals who is causing all this mess: it is the obscenely uncovered Lady Love, for whose favors peers of Holofernes are queuing. In the imagery of this album leaf, Judith becomes a prop of Venus, one of many historical hooks cast out to entrap and bring about the fall not only of princes like Holofernes but also of wise men like Aristotle, medieval knights like Perceval, and whole countries like Troy.

The stanza, with its punch line that puts the singer on an equal footing with the greats of literary tradition and ranks his lady above the dangerous women of antiquity, presents the cunning of women as a threat common to all the members of this comic mix of great men and contemporary figures. This tradition stretches right into modern times and even cabaret. When Brecht writes in his "Solomon Song" about the agonies suffered by famous people from Solomon to Macheath, he taps into the tradition of cunning women running through late medieval literature.[8]

8 Bertolt Brecht, "Solomon Song." The form of the stanza and punch line are taken from Francois Villon's "Double Ballad" in the *Grande Testament*.

Example 3: Judith's Cunning in Broadsheet Format

Late-medieval stanzas from the *Meistersinger* tradition form the basis of several early modern popular forms of knowledge transfer and entertainment. The Lutheran Reformation in Germany brought with it a huge increase in the use of the printing press for broadsheets that could be used to disseminate sermons as well as sensational news. These broadsheets found a wide audience especially in the cities where the cheap prints would circulate widely and be read and sung aloud. The Judith song "to the tune of Pavia" (Fig. 13.2 and appendix) from around 1560 is a striking example of this popular genre, combining biblical instruction and salacious sensationalism. In this ballad-style song, religious instruction and theological argument, mostly reduced to idiomatic phrases, are blended with elements of oral narration and popular subject matter. In fact, the song brings new life to the medieval tradition of biblical paraphrase in a form that remained vibrant through the centuries; there is, for example, an eighteenth-century broadside ballad, "*The Overthrow of Proud Holofernes.*"[9] The fact that our broadsheet belongs to this tradition of popular storytelling is indicated from the start by the specification "*Wie das Lied von Pouey*" ([to be sung to the same tune] as the song of Pavia). The popular song about the battle of Pavia in 1525 was frequently used as a melody for other poems.[10]

The visual presentation of the material stands in sharp contrast to the way the subject matter is presented in the stanzas of the song itself. The text is treated as a product to be marketed; this is obvious even in the external aspect of the song. The sheet, folded into a single quire of eight pages, is printed so as to make best use of the space. As we might expect, there is a clear drop in quality between the personalized manuscripts that the *Meistersinger* produced and an anonymous broadsheet; the printer Christian Müller the Younger, who worked in Strasbourg in the 1560s, probably produced small jobs such as this between larger projects. The broken edges of the woodcut, which might be recycled from a Bible edition, and the

9 Oxford, Bodleian Harding B 39(203): *The overthrow of proud Holofernes, and the triumph of virtuous queen Judith* ("When king Nebuchadnezzar / was puffed up with pride ..."); a facsimile of the text is electronically available as part of the broadsheet project of the Bodleian Library, cf. http://www.bodley.ox.ac.uk.

10 Rochus von Liliencron, *Die historischen Volkslieder der Deutschen*, III (1867), nr. 369, pp. 422–4, *Ein hübsch new lied von der stat Pavia, wie sie vom künig auß Frankreich belegert vnd zum sturm geschoßen ward* (A delightful new song about the town Pavia, how it was besieged by the king of France and bombarded to be attacked). The song in turn is a *contrafactum* of a popular mercenary song, "Start battle and attack."

CAN THIS BE IMPROVED?
RESOLUTION

¶ Die Frewlin hand so klůgen list
Keyn mann so starck so weiß auch ist
So heylig auch auff erden
Winckt jm ein fraw mit einem blick
Bald hat sye jn an irem strick
Mag jm doch offt nit werden.

Getruckt zů Straßburg bey
Christian Müller.

¶ Judith heyß ich ein Jüdin frey
Mir liebt noch nye kern bůlerey
Noch thet ich des geleichen/
Biß ich dem Holophernes klůg
Sein haubt im schlaffen abgeschlůg
Kundt ich von dannen weichen
¶ Im thon / Wie das Lied von Pouey.

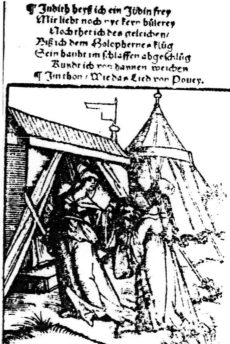

13.2. Judith-song "In the tune of the song about the battle at Pavia," ca. 1560.
Cover. Strasbourg: Christian Müller. Photo credit: Bibliotheca Palatina,
Micro-Fiche F5290.

smudged letters indicate a high print run and the popularity of the genre.[11]
The broadsheet's "marketing strategy" is certainly well conceived, with the
first page standing as an advertisement for the rest of the booklet. This first
page consists of a woodcut and an introductory stanza, and another single
stanza concludes the song on the back of the booklet. These two framing
stanzas effectively focus the narration toward the figure of Judith; the first
stanza can stand on its own and is obviously designed to complement the
woodcut and catch the reader's eye.

Judith presents herself to an imagined audience to which she describes
her deeds (Stanza I, line 1, full text in appendix):

Judith heyß ich ein Jüdin frey Judith is my name, a free Jewess;
 Mir liebt noch nye keyn bůlerey… I never did love any dalliance…

11 For information on printers in the German-speaking area in the sixteenth cen-
tury, cf. http://www.vd16.de/.

By the very act of denying any *"bůlerey,"* she slyly hints at it and its potentials for the story.

The short stanza on the cover, with its typographically stressed rhyme pattern *aab ccb,* serves as an effective tasting for the prospective buyer. In this short first-person summary, a maximum of effect is achieved. The stanza becomes a speech bubble for the woodcut on the title page. Judith is shown simultaneously singing, turning elegantly to display her courtly garments to best effect, presenting the sword, handing over the head, and addressing the audience. Her song identifies the head she is handing to the woman with her back to the viewer as that of Holofernes, the sack as the one she cleverly took with her for her food provisions, and the setting with the grand tent and the banner on her left as the place from which she makes the swift exit she describes in the last line (*"Kundt ich von dannen weichen"*: and I managed to escape). On a bookseller's table, the last page would have been visible next to the first page (Fig. 13.2). Thus, the initial and the final stanza are connected by their similar layout and their function as a framework for the narration. The final stanza works as a postlude that presents the moral of the story, underlined by the ornamental border.

The first-person digest that forms the first stanza transposes the song of Judith from the Vulgate, chapter 16, into a "trailer," providing in the heading the credentials, the mode of performance, a full spotlight on the heroine, and the subtitle for the illustration. There is even a hint of scholarly information when the etymology of the name Judith, echoing Luther's poignant reminder in his introduction to the translation of the Book of Judith, is evoked by the equation of Judith with a free Jewess.

The second stanza goes back to the beginning and starts the story again, even giving the traditional initial, the *A* for Arfaxat, with which all Latin versions of the story begin (and which in manuscripts is frequently used as the shape for the tent in which Holofernes is beheaded, thus anticipating the action highlight of the story in the same way as the title woodcut does for the Judith song). All stanzas are treated as separate narrative blocks through which the story is told in a quick succession of images, direct speech, and factual information. Each of stanzas II to V presents one hero in a characteristic situation, summing up whole chapters in six lines: Arfaxat builds his city (II); Nebuchadnezzar wants to be considered as God (III); Holofernes wins victory (IV); Eliakim, the priest, counsels trust in God (V). This last action is the first that is commented upon by the narrator who states: *"daran thet er gar weiße"* (in this he acted wisely).

This form of presenting the story is necessarily elliptic in content as well as style and does in fact require some previous knowledge on the part of the audience. For example, Achior's speech in front of Holofernes starts without any explanation of who he is and why he is "answering" Holofernes; the later events of Achior's surrender and conversion can only be understood if the audience knows that he had been one of Holofernes's captains. The principles of Israeli history explained by him are condensed to form stanza VIII and its relation to the rest of the story has to be surmised by those in the know. It might well have been intended that this information should be provided by a performer who could not only supply the missing links in the story but also mark different speakers by gestures and different registers of speech or song, especially since a typical feature of the bit-size narration in the stanzas is the sudden plunge into direct speech without naming the speaker.

The story line follows the biblical account but uses the biblical motifs more freely; for example, the phrase in stanza XXIV about the mice emerging from their holes is taken from Jdt 14:12 when the chiefs of the Assyrian army joke about the Jews who have swarmed like mice from the cavern to provoke a battle, but here it is used as a positive characterization. In places the text seems to reflect a written source, as if following an existing translation in its phrasing, but a precise identification of this is impossible. Those coined phrases that seem to be literal quotations (for example: *"wolt er mit seinem scharpfen schwert Sein bluot vergiessen auff die erdt"* [He wanted to shed his blood with his sharp sword], IX 4f, or *"Die red was jm gleich als ein traum"* [He regarded the speech as a mere dream], IX 1) cannot be found in any version of the Book of Judith, neither in the Vulgate nor in the translations of the Luther or Zurich Bible. The parallel between the priests' request to Judith as a "God-fearing woman" to intercede for them (XIII 1f: *"Gottsförchtig bist du, heyliges weib. Bitt Gott für vns"*) and the Luther Bible version (Jdt 8:24: *"Darumb bitte fur vns zum Herrn, Denn du bist ein heilig Gottfürchtig weib"*) seems to point not to a direct dependence but rather to the influence of the Vulgate on both of the versions (Vulg. Jdt 8:29: *"nunc ergo ora pro nobis quoniam mulier sancta es et timens Dominum"*) or perhaps a vernacular paraphrase of the Vulgate since the name forms are not congruent: in the Judith song, the High Priest is called Eliachim (Luther: Joachim), and the king is called Nabuchodonosor (Luther: NebukadNezar). The text takes as much inspiration from oral traditions of ballad-style narration as it does from the biblical text; in this it still follows in the tradition of Bible paraphrase, using the vernacular style of contemporary prose.

Judith's entrance into the story, which in the biblical book comes with-
out warning after the lament of the Israelites, is prepared in the Judith
song through her self-introduction in the first stanza and also through the
ongoing structure of the poem, since new characters are introduced at the
beginning of each new stanza. The action gradually narrows in on Judith:
in stanza 10 the Jews come into focus, in stanza 11 the city of Bethulia, and
finally in stanza 12 Judith herself, who immediately takes over the action,
chiding the priests for being "depraved" (*verrûchet*) because of their readi-
ness to hand over the town. When Judith unfolds her plan of courting the
enemy ("*hofieren*,"), the enhancement of her beauty by God (XIV 6: "*Gott
gab auch jrer schoene zů*") implies the divine approval explicitly noted in
the Vulgate. Up to the point when Judith enters the camp, the story line is
close to the source despite the intense condensing, but from then on Judith
dominates the stage and the love and seduction imagery of the Book of
Judith forms the basis for most of the amplification. The metaphor of catching
Holofernes in the "snare of his own eyes" (Jdt 9:13: "*capiatur laqueo oculo-
rum suorum in me*") is the cue for a hunting scene, fleshed out with prover-
bial phrases that come readily to mind when talking about the pursuit of
the beloved. The decapitation of Holofernes is staged as the felling of game:
Judith starts by setting the trap (stanza XIX 1), hunts for three days (XVII 6),
and when Holofernes approaches the banquet like an animal attracted to
the bait, she fells him and takes his head as a trophy, hiding it in the bag so
that nobody can "get her scent" (XX 6). This is commented upon with the
saying that "a good meal is worth hanging for," taking up the tradition of
a "Henkermahlzeit," a good last meal given to a person condemned to die
by being hanged. A further saying is used in connection with the hunting
imagery: "a bearskin should not be sold before the bear is captured" (XXII
4f). The rest of the story presents an anticlimax, tying up the loose ends of
the story line: Achior's life is saved, the Assyrians flee, the Israelites bring
home great wealth – a happy if somewhat abrupt ending.

In a legacy of the *Spruch* poetry, the last two stanzas function as self-
contained entities. The last but one stanza sums up the moral of the story in
terms of a mirror of princes by pointing to the fall of Arfaxat and Holofernes
which was brought about by their lack of "*Demütigkeit*" (humility). Interest-
ingly, Nebuchadnezzar as the link between Arfaxat and Holofernes is not
included here, either because of his complex persona or rather personae in
several other books of the Bible or because Arfaxat (who had to be included
to make clear that the story has now come full circle since his initial forms the

very beginning of the whole book) could then be presented as an example of God's success rather than Nebuchadnezzar's. The stanza with its *aab ccb* scheme is constructed so as to fall into two parts with a distinct caesura in the middle, which makes here for a clear distinction between the instruments of their respective downfalls: Arfaxat is punished for his pride (*hoffart*) by God, who commanded humility; Holofernes's boasting (*bochen*) is quenched by Judith, in accordance with God's plan for Israel. In this stanza Judith's role is characterized as that of Humility personified, following the tradition set out, for example, in the *Speculum Virginum*. Her actions are wholly divine, part of a preordained pattern. The final verse paints a quite different picture, however.

The very last stanza, printed separately on the last page, works as a counterpart to the independent first stanza and echoes the initial assertive presentation of Judith as the free Jewess, acting as an independent agent. Taken in isolation, the stanza could apply to nearly every song that involves a cunning woman. It presents the facts from a completely different perspective: it is not God's command that sets the events in motion and it is not pride that is instrumental in the downfall, but instead suddenly the whole responsibility for the outcome rests with the *"freulein"* (young women) and their *"kluoge list"* (clever cunning). No names are given, no particulars mentioned; rather disconcertingly, the power of women is presented as universal. It might, like the woodcut, be a product of recycling since the assertion that even holy men fall for women flies in the face of the traditional story line, which stresses that only through pride and sin are men exposed to God's wrath personified in a murderous woman.

The broadsheet literally presents a double-sided Judith. In the inner story, as told from page two of the booklet onwards, all her actions are judged as being beyond reproach – by the other figures (such as the priests and Achior), by the narrator, and by God himself. On the outer cover of the booklet, Judith is presented as a dangerous seductress – not openly, but the proximity of the first and the last leaf invites the identification of the cunning young women mentioned in the last stanza with the self-portrayal of the cunning heroine in the first one. The different levels of representation of Judith mean that she becomes an ambiguous figure for the reader, who realizes with a shudder of anticipation where the casual sex mentioned in the opening lines might lead: to decapitation.

The broadsheet thus presents us with a snapshot of how the popular conception of Judith had developed into a permanent state of ambiguity by the sixteenth century, shaped by the divergent focuses of the short texts of

the previous centuries. From now on, Judith is one of the cunning women, whether a specific text foregrounds this or not. Proof of this can be found in the irony with which Sixt Birck – who is a staunch defender of Judith's virtue – plays with the topos when he has the herald sing a serenade as entertainment during Holofernes's banquet; the third stanza begins: "*O Frawen list / wol gschwind du bist*" (O women's cunning: you are a quick one). The stage direction tells the actor to perform it to the tune of "According to God's Will" or alternatively "Mad world"; here, as with the broadsheet, the tune indicates the turn events are taking, but Holofernes is too deeply ensnared to listen to common sense let alone to analyze songs. Ambiguous examples like these prepare the ground for images of Judith of the sixteenth, seventeenth, and eighteenth centuries that are concerned with notions of temptation and threat and that construct a Judith-seductress figure.[12] Hans Baldung Grien's illustration gives his own take on the *Weiberlisten* topic when he, like the Rosenwald leaf, pairs Judith, who is holding Holofernes's head and is a monumental naked figure, together with Venus and opposite Adam and Eve. While this runs against the grain of the original text, for contemporaries it must have been a more than impressive demonstration of the fall of men in the face of cunning women. When Judith is portrayed as cunning, she may be a praiseworthy divine instrument or a condemnably dangerous seductress, depending on the context and the specific construction of femininity. Undeniably, the ambiguity of early modern German popular representations of Judith releases a dramatic potential that keeps Judith alive and fascinating through the ensuing centuries.

Appendix to Chapter 13

Judith-Song

The edition follows the anonymous print in the copy of the Bibliotheca Palatina F5290, Straßburg: Christian Müller, ca. 1560.

The accidentals (ů etc) and i/j- and u/v-forms have been normalized to their presumed phonetic value, abbreviations have been resolved, punctuation introduced.

12 Cf. the catalogue by Adelheid Straten, *Das Judith-Thema in Deutschland im 16. Jahrhundert. Studien zur Ikonographie. Materialien und Beiträge* (Munich: Minerva-Fachserie Kunst, 1983).

Im thon wie das Lied von Pouey.	To the tune of the song about Pavia.

I	Judith heyß ich, ein jüdin frey;	Judith is my name, a free Jewess;
	Mir liebt noch nye keyn buolerey,	I never did love any dalliance
	Noch thet ich des geleichen,	nor did I ever do it,
	Biß ich dem Holophernes kluog	until I cleverly hacked off
		Holofernes's head
5	Sein haubt im schlaffen abgeschluog	while he was asleep
	– Kundt ich von dannen weichen.	– off I went safely.

II	Arphaxat daucht sich mechtig reich,	Arfaxat thought himself mighty
		powerful,
	Als fünd man nirgend sein geleich.	like no other king of the castle.
	Ein stat hat er gebawen	He built a town with turrets high,
	Mit türnen hoch im Meder landt,	in the land of the Medes it did lie;
5	Egbathanis ist sie genant.	Ecbatana was its name.
	Darein het er vertrawen.	In it he put his trust.

III	Es gschach seins reich im	It happened in the 12th year of
	zwelfften ior:	his reign:
	Kriegt in Nabuchodonosor,	Nebucadnezar was attacking him,
	Behielt den syg im felde.	retained the victory in the battle.
	Mit seinen Fürsten hielt er rhot;	He held council with his princes;
5	Geachtet wolt er sein als Gott,	he wanted to be revered as God,
	Alleyn inn dißer welte.	as the only one in this world.

IV	Sein hauptman Holophernes hieß,	His captain was called Holofernes,
	Thet manchem man groß widertrieß,	many a men did he offend,
	Brach vil der starcken feste,	breached many a strong castle,
	Bracht etlich Land inn solche forcht,	set several countries in such fright
5	Das man im lebendt gern gehorcht;	that men served him gladly their
		lives to save;
	Das daucht sye das aller beste.	this seemd the best course.

V	Die jüdischeyt hofft in Gottes güt,	The Jewish people hoped for God's
		mercy;
	Jerusalem muost sein behüt,	Jerusalem had to be protected;
	Versahen sich mit speise.	they laid in a stock of food.
	Eliachim gab in den rhot,	Eliachim advised them
5	Umb hulff solten sye bitten Gott;	to ask God for help;
	Daran thet er gar weiße.	in this he was wise indeed.

VI	Umbgieng?? [print damaged] bürg??,	(The citizens say)...
	„Ob Holofernes uns erwürg,	even if Holofernes strangles us,
	Noch wöllen wir mit im streitten."	we will still fight him."
	Verhägten allenthalb ir weg,	Everywhere they fortified their roads.
5	Wann all sein Ritterschafft da leg,	Even were all his knights assembled on that spot,
	Küntens hynauff nit reiten.	up there they could not venture.
VII	Es wundert Holofernes seer,	Holofernes was sore amazed
	Was dißes volck hett für gewer,	at what guarantees this people had,
	Wie fest ir Stett auch were.	however mighty the city walls.
	Achior antwort im getürst:	Achior answered him boldly:
5	„Zuo schanden du noch werden würst	"Your pride will soon be laid low,
	Mit allem deinem here.	as well as all your army.
VIII	Gott gab von hymmel inen speiß,	God gave them food from heaven;
	Den ehren sye mit glaubens preiß,	Him they worship with faithful praise,
	Der kann sye wol beschirmen.	He can well protect them,
	Als lang sye seind inn seiner huld,	as long as they earn his favour,
5	Nit gfallen inn der sünden schuld,	and have not fallen into the mire of sin,
	Schreckst du sye nit mit stürmen."	your attacks will not daunt them."
IX	Die red was im gleich als ein traum,	These words as mere fantasy him did strike,
	Band Achior an einen baum.	he tied Achior to a tree.
	Wann er das Land gewinne,	When he captured the country,
	Wolt er mit seinem scharpfen schwert	he would take his sword so sharp
5	Sein bluot vergiessen auff die erdt,	and cause his blood to flow to the earth
	Wo er in fünd darinne.	if he chanced upon him in there.
X	Die juden waren auff der wacht,	The Jews were on the watch,
	Der ding namen sye eben acht,	Nothing escaped their sharp eyes.
	Achior gert der stangen.	Achior gave himself up to them.
	Entbunden ward er und gefragt;	He was delivered from his bonds and questioned;
5	All ding er in von anfang sagt,	he told them everything right from the start,
	Wie es im was ergangen.	how he had fared.

XI	Bethulia groß klag erhuob,	Betulia raised wailing voices to the sky
	Da man ir brunnen in abgruob,	when their fountains were blocked,
	Verwegten sich irs leben.	they gave their lives up as lost.
	Ozias gab in bald den rhot,	Ozias counselled the following course:
5	Hulff in nit inn fünff tagen Gott,	if God did not help within five days,
	Ir Statt woltens auffgeben.	they should surrender the city.
XII	Da Judith diße red entpfieng,	When Judith heard these words,
	Eylendts sye zuo den Priestern gieng:	to the priests she hurried:
	„Wie seind ir so verruochet!	"How can you be so corrupt!
	Schetz ir den schirm auß Gottes güt	If you place a price on God's mercy shield,
5	Nach eurem willen und gemüt,	measured by your mere mortal will
	Das heyßt Gott wol versuchet."	and mind, God will be sore empted."
XIII	„Gottsförchtig bist du, heyliges weib.	"God-fearing you are, holy woman;
	Bitt Gott für uns, dein rhat auch gib,	pray to God for us; council us
	Wie wir zuo Gotts huld kemen."	how we might come to God's mercy."
	„So geht diß nacht hyn an die pfort	"Then go tonight to the gate.
5	Hynauß will ich still an ein ort	I will slip out steathily to certain place,
	Ein Megdlin mit mir nemen."	taking a servant-girl with me."
XIV	Als sye volbracht het ir gebett	When her prayers she had ended,
	Die witwe kleyder sye auß thett	she put away her widow's garb;
	Irn leib begund sye zieren	her body she did adorn,
	Ir haubt, arm, oren, händ und füß,	her head, arms, ears, hands and feet
5	Keyn zierd sye underwegen ließ:	– no ornament did she omit:
	Dem feind solt sye hofieren.	to court the enemy was her intent.
XV	Gantz frü sy zuo der pforten kam,	Full early she came to the gate,
	Ir megdlin, das sye mit ir nam,	the servant-girl she was taking with her
	Truog auff ir tranck und speiße.	carried her meat and drink.
	Zuor pforten ward sye auß gelon,	She was let out of the gate,
5	Von feinden bald entpfangen schon;	by the enemies soon received courteously;
	Der schöne hat sye preiße.	she reaped the praise for her beauty.

XVI	Für silber und für rotes goldt	Above silver and red gold,
	Ward Holofernes ir so holdt,	Holofernes loved her so sweetly
	Das er ir bitt geweret	that he granted her request.
	Zuom bätt gieng sye nachts auß und yn,	For prayer, she went nightly in and out,
5	Nyemandts sye fragt: „wo gehst du hyn?"	nobody asked her: "Whither?"
	Biß sie ihr speiß verzeret.	until she had finished her food.
XVII	Gott gab auch irer schöne zuo	God her beauty did enhance:
	Des Fürsten hertz mocht han keyn rhuo,	the prince's heart could find no rest,
	Thet stetigs nach ir sinnen.	his thoughts on her did constant dwell:
	"Diß land hat freylich schöne kind,	"Indeed, this country's daughters dazzle,
5	Darin so hübsche freulin sind –	such pretty lasses, one and all
	Wir wöllen es gewinnen.	– we want to win it!"
XVII	Der abendt bracht die vierde nacht,	Evening brought the 4th night nearer,
	Groß wirtschafft Holofernes macht.	Holofernes a splendid banquet did stage.
	Judith was unverzaget.	Judith was undaunted.
	Geladen kam sye auch dahyn.	Invited, she came to the feast:
5	Das wildt wolt ye gefangen sein;	the wild game must be netted;
	Drey tag hat sy es gejaget.	three days the hunt had lasted.
XIX	Das freulin hat ir garn gestellt;	The lass had set her trap;
	Ob sye das wildt bald nider fellt	will she soon fell the game
	Mit seiner seitten waffen?	with its own side-weapon?
	Ein köstlich mal ist henckes wert!	A tasty meal is worth the hanging!
5	Sye hat acht auff sein eygen schwert,	She noted where his own sword was,
	Als sye beyd giengen schlaffen.	when they both went to bed.
XX	Die diener waren gleich so wol	Like their master Holofernes,
	Als Holofernes alle vol.	the servants were completely sloshed.
	Ir megdlin hielt die thüren.	Her servant-girl did guard the doors.
	Sein haupt schnit sye im schlaffend ab,	His head she cut off him, sound asleep,
5	Der magt sye es inn ir säcklin gab;	she gave it to her servant for her sack;
	Nyemandts kund es da spüren.	there, nobody could guess it.

XXI	Sye gieng vß wie sye vormals thet,	She went out as had been her wont,
	Als wolt sye gen an ir guot bätt,	as if for her prayer so good,
	Durch all gezelt ins tale.	through all the tents down into the valley.
5	Bethulia ward ir auff gethon,	Bethulia opened its gates for her,
	Von allem volck entpfangen schon,	she was well received by all the people,
	Gepreißet überalle.	praised universally.

XXII	Seins lebens was frey Achior,	Achior's life was spared when the head
	Da man das haupt steckt hoch empor,	was raised high on a stake of him
	Der alle landt wolt zwingen.	who wanted to bend all countries to his will.
	Keins Beren haut nyemands verkauff,	No bear skin should be sold
5	Ee das er in vorhin erlauff:	before the struggle is successful:
	Man muoß vor mit im ringen.	first comes the fight.

XXIII	Ein lermam macht der jüdisch bundt;	A racket the Jewish covenant did make;
	Dem Fürsten wolt man es thuon kundt;	they wanted to tell the captain;
	Nyemant dorfft in bald wecken.	nobody was allowed to wake him suddenly
5	Biß sye darzuo zwang grosse nodt.	until dire necessity pressed them to it.
	Im bluot lag er, on haubt, was todt;	In his blood he lay, headless, dead
	Bracht in fast grossen schrecken.	– plunged them into fear and trembling.

XXIV	Die meng der Aßyrier floch;	The Assyrian crowd fled;
	Zuo lauffen was in also goch,	so quick to run were they
	Das sye irs guots nit achten.	that they forgot their worldly goods.
	Die flucht kam den Hebrern wol;	The flight went down well with the Hebrews;
5	Lieffendt als mäuß auß irer hol;	they ran like mice out of their hole;
	Groß reichtumb sye heym brachten.	great wealth they brought back home.

XXV	Demütigkeyt uns Gott gebeüt:	Humility is God's command to us:
	Arphaxat kam umb Land und leüt,	Arfaxat lost his country and his men,
	Sein hoffart ward gerochen.	his pride was punished.
	Dem Holofernes ward auch wor,	For Holofernes,
5	Das im gesagt hatt Achior:	Achior's words came true:
	Judith stillt im sein bochen.	Judith quenched his boasting

XXVI Die Freulin hand so kluogen list: Young women have such clever cunning:

Keyn mann so starck, so weiß auch ist, no earthly man so strong, so wise,
So heylig auch auff erden: so holy he may be:
Winckt im ein fraw mit einem blick, if a woman beckons him with a glance,

5 Bald hat sye in an irem strick; soon will she have him in her coils;
 Mag im doch offt nit werden. but seldom he will get her

Getruckt zuo Straßburg bey Printed in Strasburg by
 Christian Müller Christian Müller

14. The Role of Judith in Margaret Fell's *Womens Speaking Justified*

Janet Bartholomew

Seventeenth-century England produced a rich body of literature that debated the inherent spiritual, moral, and intellectual worth of men and women. The early Quakers, as a new and controversial religious sect, were one of many groups who utilized this popular form of public discourse in order to justify their unique religious views. This prolific sect produced hundreds of publications by 1700 that defended their religious beliefs in a predominantly Protestant environment that was openly hostile toward Quakers and other protofeminist religious groups. As one of the few groups to claim spiritual equality between the sexes, some of the Quaker tracts were focused specifically on the advocacy of women's preaching. The spiritual egalitarian message of the Quakers, in which men and women were both equally called to speak on behalf of the Light of Christ, needed an extraordinary amount of defending during this era.[1] Therefore, biblical women were sometimes used in Quaker tracts as examples of God's condoning of women's preaching, teaching, and prophesying in public. Although Judith was not as popular a choice in Quaker proto-

1 Condoning women's preaching was unusual in early modern England, so protofeminist groups like the Quakers needed to defend the practice in print. For an early Quaker, the polemical discourse of the early modern era presented some doctrinal challenges because their view scripture differed from their Protestant counterparts. A core tenant of the Quaker religion is a non-gendered 'inner light' possessed by every individual that granted him or her access to God. Rebecca Larson explains in her book *Daughters of the Light* that "the basis of legitimate spiritual authority for Quakers was inward (the Light of Christ within each person)"; Rebecca Larson, *Daughters of Light: Quaker Women Preaching and Prophesying in the Colonies and Abroad, 1700–1775* (New York: Alfred A. Knopf, 1999), p. 29.

feminist and apologist tracts as other biblical women, possibly because of the Catholic embrace of deuterocanonical texts and the Quaker desire to separate themselves from their Papist counterparts, Judith still appears in an important tract written by the "Mother of Quakerism," Margaret Fell.[2] In her 1666 pamphlet *Womens Speaking Justified, Proved, and Allowed by the Scriptures*, Fell uses Judith in a way that was unique for her time. Fell's tract was the first to be written by a woman since the Reformation to plead for the recognition of the spiritual equality of men and women.[3] While other pamphlets used Judith as an example of the vices of women, the virtues of women, or the dichotomous nature of women, Fell's

2 Quakerism was not the only Christian religion in early modern England seeking to distinguish itself from the Catholic Church. In a time and country where Catholicism was unpopular, polemicists of the dominant Protestant faith also sought to differentiate themselves from their Papist counterparts, and one way of doing this was to reject some of the deuterocanonical works embraced by the Papists. Since the English schism with the Roman Catholic Church, several different versions of the Bible in English had appeared throughout the sixteenth and seventeenth centuries. With the several differing Bible translations and religious views in England at the time, inevitably there was a debate in print over whether or not apocryphal texts such as the Book of Judith should be accepted as scripture; examples of this theological debate can be found in George Abbot's *The Reasons which Doctour Hill hath Brought, for Upholding of Papistry* (1604), Richard Baxter's *The English Nonconformity as under King Charles II and King James* (1689), Henry Ainsworth's *A Defence of the Holy Scriptures* (1609), and John Vicars's *Unholsome Henbane Between Two Fragrant Roses* (1645) (Early English Books Online, http://www.jisc-collections.ac.uk/eebo, accessed March 2, 2008; March 2, 2008; March 5, 2008; and February 22, 2008).

Aside from rejecting the apocryphal texts, another technique used to differentiate Protestant biblical exegesis on Judith from that of the Papists was for the Protestant polemicists to embrace Judith as a symbol of their own religious cause. Although some Protestant authors did so with the acknowledgment of her dubious position as a possible non-canonical character, several seventeenth-century tracts nevertheless used Judith as a credible counterpoint in public biblical exegesis. Judith thus embodied both the English dread of the Catholic Church while also exhibiting favorable traits to the Protestant movement. Judith embodied the meekness associated with both being a woman and being an ideal Christian, in addition to systematically saving her people by decapitating the tyrant Holofernes, thus symbolizing cutting off the head of the Papal church (Margarita Stocker, *Judith: Sexual Warrior. Women and Power in Western Culture* (New Haven, CT: Yale University Press, 1998), pp. 62–64). Margaret Fell may have chosen to include Judith in her tract because she wanted to appeal to the Protestant audience that embraced Judith as a symbol of victory over the Catholic Church; at the very least, Fell considered Judith to be a figure credible enough to use in her polemics on women's preaching. For further reading on the early Quakers and apocrypha, see Henry Cadbury's essay, "Early Quakerism and Uncanonical Lore" (*The Harvard Theological Review*, 40.3 (1947), pp. 177–205).

3 Isabel Ross, *Margaret Fell: Mother of Quakerism* (London: Longmans, Green & Co., 1949); p. 201.

Judith is an authoritative figure who exemplifies the Quaker belief that all women are potentially called to speak on God's behalf.

Margaret Fell, a gentlewoman born to the prominent Askew family, converted to Quakerism soon after hearing the charismatic founder, George Fox, preach in 1652. Enthusiastically embracing the new religion, Fell soon became a key leader of the Quaker movement, using her powerful position as both a gentlewoman and the wife of a renowned judge, Thomas Fell, to assist the Quakers in legal and political affairs.[4] Fell, like many of the Quaker women, was literate and used this to spread the message of the Quakers and defend the spiritually egalitarian message in print.[5] Fell's tract, *Womens Speaking Justified*, not only defended her religious sect in print from anti-Quaker sentiments, but it also defended her sex in a time when misogyny was a part of the cultural norm.[6] Like other protofeminists, Fell uses a variety of biblical women in her tract as evidence of God's approval of her sex. Her biblical exegesis, however, had a specific aim: to justify the Quaker belief in a woman's ability to preach, teach, and prophesy in public. In a society that openly persecuted women who preached in public, Fell attempts to convince her predominantly Protestant audience that biblical women have a history of preaching and prophesying in public, and that these women were rightfully praised for their efforts.

4 Margaret was born in 1614 and married Thomas Fell when she was eighteen, remaining his wife until his death in 1658. Even as Thomas Fell's widow, Margaret maintained several political ties with figures such as Oliver Cromwell, and later King Charles II and the Queen Mother, Henrietta Maria. In 1669, Fell married Quaker founder George Fox. After his death in 1691, Margaret did not remarry; she continued working for the Quaker cause until her death in 1702. For further reading on the life of Margaret Fell, see Isabel Ross, *Margaret Fell: Mother of Quakerism* (London: Longmans, Green & Co., 1949); Bonnelyn Kunze, *Margaret Fell and the Rise of Quakerism* (Stanford, CA: Stanford University Press, 1994); Elsa Glines, *Undaunted Zeal: The Letters of Margaret Fell* (Richmond, VA: Friends United Press, 2003).

5 Quaker women wrote and published 171 documents between 1641 and 1700, and thirteen percent of these were written by Margaret Fell (Kunze, *Margaret Fell and the Rise of Quakerism*, p. 131).

6 For a further discussion of early modern views on gender, see Merry E. Wiesner, *Women and Gender in Early Modern Europe*, 2nd ed. (Cambridge: Cambridge University Press, 2000); Gerda Lerner, *The Creation of the Feminist Consciousness: From the Middle Ages to Eighteen-seventy* (New York: Oxford University Press, 1993); Cristina Malcolmson and Mihoko Sukuki (eds.), *Debating Gender in Early Modern England, 1500–1700* (New York: Palgrave Macmillan, 2002). For examples of anti-Quaker pamphlets that spoke directly against women's preaching, see the anonymous *The Devil Turned Quaker* (1656), *A Friendly Dialogue Between Two Countrymen* (1699), Richard Baxter's *One Sheet Against the Quakers* (1657), and John Bewick's *An Answer to a Quakers Seventeen Heads of Queries* (1660) (Early English Books Online http://www.jisc-collections.ac.uk/eebo, accessed December 2, 2006; March 2, 2008; and December 2, 2006).

In Fell's tract, *Womens Speaking Justified*, Judith appears alongside several other women of the bible, such as Esther, Martha, and the woman with the alabaster jar.[7] As a Quaker, Fell uses Judith as an example of God's condoning of women's speaking to justify the spiritual egalitarian message of founder George Fox. For Fell, Judith is a mouthpiece for the Lord because she is chosen not only to deliver the Jews from Holofernes, but to also spread the word of her act and praise of God. Therefore, Fell focuses on the end of Judith's tale, when Judith returns victorious and preaches to the people about God. Because of her forward portrayal of Judith, Margaret Fell thus becomes a unique figure in the seventeenth-century gender war in print. By portraying Judith as a virtuous woman who preached to the Jews, Fell redeems Judith from the popular misogynist interpretation of her story and the stories of other biblical women.

"The Gate of Death": Judith and Misogyny

The misogyny that Fell opposed was found throughout the literature of the period, and in some cases men used Judith as an example in their tracts of the qualities they despised in women. Even though Judith is found in many women apologist texts, she also appears in several texts that enforce the seventeenth-century belief that women not only are lustful and deceitful creatures, but they also use their beauty and wanton behavior to ensnare and destroy men. Joseph Swetnam, in his popular 1615 misogynist tract *The Arraignment of Lewd, Idle, Froward, and Unconstant Women*, tells his audience that in his pamphlet his readers will "see the power of women, how it hath beene so great, and more preuailed in bewitching mens wits, and in ouercomming their sences, then all other things whatsoeuer."[8] He then lists several women who caused the ruin or the death of important historical and biblical men, such as Herod, Hercules, Samson, and Adam.

7 *Womens Speaking Justified* was first printed in 1666 but was reprinted in 1667, this time with an addendum that included biblical women such as Hulda, Miriam, and Hanna (Margaret Fell, *Womens Speaking Justified, Proved, and Allowed by the Scriptures* [1666, 1667], Early English Books Online http://www.jisc-collections.ac.uk/eebo, accessed January 2, 2007). The pamphlet was then translated into Dutch and reprinted in 1688 to use in Quaker proselytizing abroad, which was highly unusual for a protofeminist tract of this era. For more information, see *Margaret Fell: Mother of Quakerism* by Isabel Ross, pp. 191–210. The tract is available at http://eebo.chadwyck.com/search.

8 Joseph Swetnam, *The Arraignment of Lewd, Idle, Froward and Unconstant Women* (1615), p. 21, Early English Books Online. http://www.jisc-collections.ac.uk/eebo (accessed November 22, 2006).

Amongst these victims he mentions "That great Captain Holofernes, whose sight made many thousands to quake, yet he lost his life, and was slaine by a woman."[9] He advises men that when it comes to women, it is better "to auoid the sight, [which] many times is the best rasor, to cut off the occasion of the euill which commeth by women; for had not Holofernes seen the beauty of Iudeth, and marked the fineness of her foote, he had not lost his head by her."[10] To Swetnam, Judith is an example of how dangerous women can be to men, and she is proof that a woman's wiles can be deadly.

Judith as an instrument of death is a reoccurring theme in early modern English tracts, and several times she is used to portray the ultimate fate for men who drink or lust excessively. Women, as the bane of mankind, could be tools used by God to smite sinful men. Thomas Beard, in his pamphlet *The Theatre of Gods Judgements* (1642), explains why a sinful man's death by God at the hands of a woman is a fitting punishment. When Holofernes boasts that "there is no God [but] Nabuchadnezzar," God is displeased and "for this blasphemy the Lord cut him short, and prevented his cruell purpose by sudden death, and that by the hand of a woman, to his further shame."[11] According to Beard, Judith was sent to smite Holofernes not just for his blasphemy, but also for his hedonism. In a later section dedicated to opposing drinking to excess, he recalls, "Whilest Holofernes besotted his sences with excesse of wind and good cheare, Iudith found meanes to cut off his head."[12] For a great military leader, having his career cut short by the hands of an inferior woman would have been a dishonorable and embarrassing death. Thus Judith becomes a warning to all men, that God may bring them to shame by sending a woman as punishment for their sins.

How Judith defeated Holofernes is embodied in the kind of sexist stereotype that Margaret Fell combated in her protofeminist works: the image of the deceitful harlot. Beauty was dangerous, and in many sermons and publications, men were warned against women who used this to their advantage. Women, as daughters of Eve, were thought to be naturally destructive, and men were advised in books and sermons to take care not to be beguiled by a woman's beauty. For men, lust was a catalyst for destruction and death, and historical and biblical texts contained several examples

9 Ibid., p. 23.
10 Ibid., pp. 23–24.
11 Thomas Beard, *The Theatre of Gods Judgments Wherein is Represented the Admirable Justice of God Against All Notorious Sinners* (1642), p. 132. Early English Books Online http://www.jisc-collections.ac.uk/eebo (accessed 5/3/08).
12 Ibid., p. 285.

of men who met their downfall by lusting after a woman. The women in these stories, however, were not always innocent in these destructive relationships; the dichotomy of woman as both a virgin and a whore gave men the opportunity to blame women for purposefully invoking lust in men. Robert Burton, in *The Anatomy of Melancholy* (1621), asks his audience, "For what's an whore [...] but a pillar of youth, ruine of men, and a death, a deuourer of patrimonies, a downefall of honour, fodder for the diuell, the gate of death, and supplement of hell."[13] He then provides examples of men who have fallen because of the wanton nature of women, for he tells his male audience, "Let him see the euent and successe of others, Sampson, Hercules, Holofernes, &c. those infinite mischiefes attend it."[14] Judith, like Delilah and Deianira, was blamed for the downfall of a mighty hero because of her wanton nature and renowned beauty.[15]

For Margaret Fell, this popular view of woman as femme fatale created a polemical obstacle that could only be overcome through protofeminist biblical exegesis. Margaret Fell, in *Womens Speaking Justified*, reinterprets scriptures used in the misogynist arguments and portrays them in a more gender-balanced manner. She also uses various passages to verify the authority women have to preach on the behalf of God. Although reinterpreting the writings of Paul that prohibited women's preaching was critical in her tract, in addition to using the scriptures to establish women's authority to preach, one of the greatest strengths of Fell's pamphlet is in her use of biblical women who preached and prophesied as evidence of a long-standing tradition of God using the "weaker sex" to speak on his behalf. In this section of her tract, Judith becomes more than just another example of a woman preaching: Judith becomes a weapon with which Fell polemically smites her misogynist enemies.

13 Robert Burton, *The Anatomy of Melancholy What It Is. With All the Kindes, Causes, Symptomes, Prognostickes, and Seuerall Cures of It* (1621), p. 369. Early English Books Online http://www.jisc-collections.ac.uk/eebo (accessed March 5, 2008).
14 Ibid.
15 This particular view of Judith is one of the key elements of the seventeenth-century debate in England over whether or not the apocrypha should be considered part of the Protestant canon. George Abbot, in his 1604 tract *The reasons which Doctour Hill hath brought, for the vpholding of papistry*, explains one of the reasons why the Book of Judith should be excluded from the canon:

> They are not matters to bee commended by the penne of the holy Ghost, that Iudith should dress and tricke her selfe more than became a matrone, that so she might allure Holofernes to wantonnesse; that shee should make shew as not to deny to lie with him: that shee should tell such evident vntruthes to his servants at her first taking, and to himselfe afterward. (318)

"Thou Art an Holy Woman": Judith and Women's Preaching

For many protofeminist women, the misogynist interpretation of the scriptures was particularly frustrating. In the letters of Margaret Fell, it is evident that she too felt anger and frustration toward men who used scriptures to inhibit women, particularly priests and ministers who preached their misogyny to their congregations. In a letter written to John Ravell in 1654, Margaret Fell openly berates him for misusing the scriptures:[16]

> [T]hou had written downe many scripteurs in thy paper, but thou art soe blind & Ignorant, that thou hast not wreten them as they weare spoken, but sume thou hast corrupted, to sum thou hast added, to sume diminished[,] in sume thou hast set other words then they stand in the Scripteurs, as thou can doe noe other whoe art of another Spirit & of another Nateur then spoke them forth... .[17]

For Fell, a man who misuses or misquotes the Bible "brings the scripteurs but as the devil did, when he temted Christ" for "the divell knows the scripturs" and can use them to his own advantage.[18] As a forward protofeminist, Fell was unafraid of telling her critics exactly what she thought of them. In the midst of Fell's polemicist tirade, she tells Ravell, "thou confesseth [the scriptures] were given forth by Inspiration of the holy gost, which thou never knew but art an enemy to [...] soe lett thy mouth be stopped," thus reciprocating the commandment to be silent from one sex to the other.[19]

In *Womens Speaking Justified*, Margaret Fell uses Judith as both an example of a woman preacher but also as a means of challenging her male opponents. First Fell provides a counterpoint to the argument that women are liars and use their speech to deceive men. By producing Judith as evidence of a woman speaking truth, she establishes that Jewish heroines were

16 Elsa Glines writes that currently "no biographical information is available about John Ravell [however] internal evidence indicates that he may have been a minister; that he wrote controversial papers, like Margaret Fell; and that he had criticized her writings, accusing her of not knowing the scriptures" (pp. 68–69). In Fell's impressive body of work, there is evidence that Fell was in fact well versed in the scriptures, for not only does she quote them amply in her publications, but in her letters alone she quotes, paraphrases, or alludes to over one thousand different lines of scripture, ranging from Genesis to Revelations (Glines, *Undaunted Zeal*, pp. 495–500).

17 Quoted in Glines, *Undaunted Zeal*, p. 69.

18 Ibid., p. 70.

19 Ibid., p. 69.

publicly honored for bringing truth to the people. For Fell's purpose, the focal point of Judith's story happens after she returns to the Jews with the head of Holofernes and tells her people of her deed while openly praising God in public. Fell, however, takes this scene a step further and focuses on what Judith tells the elders specifically. After discussing Esther, she tells her audience:

> Likewise you may read how Judith spoke, and what noble acts she did, and how she spoke to the Elders of Israel, and said, Dear Brethren, seeing ye are the honorable & Elders of the People of God, call to remembrance how our Fathers in time past were tempted, that they might be proved if they would worship God aright; they ought also to remember how our Father Abraham, being tried through manifold tribulations, was found a friend of God; so was Isaac, Jacob, and Moses, and all they pleased God, and were stedfast in Faith through manifold troubles.[20]

In this section, Fell is using Judith as a woman of authority, for she not only preaches to the Elders of Israel, but she also instructs them in the scriptures. Judith is exhibiting her authority as an instrument of the Lord, thus giving her the ability to preach to the male authority figures of the Jews. Not only does Judith preach to the Jews without being challenged by the church elders, but she also instructs from the scriptures.

Judith, in Fell's tract, is preaching not only to the Elders of Israel but also to her misogynist audience. Just as Judith becomes the mouthpiece of God, Judith also becomes the mouthpiece for Fell, thus lending her authority as a woman preacher to Fell's message. Judith reminds the men about how the "Fathers in time past were tempted, that they might be proved if they would worship God aright," just as the Quakers were currently being tested by society in their faith to their spiritually egalitarian message. Several laws had been passed that were targeted at limiting the rights of radical religious sects, including the Quaker Act of 1662, which ultimately resulted in the imprisonment of several Quakers for meeting in public. Margaret Fell herself was arrested and imprisoned in 1664 at Lancaster Castle; it was during this imprisonment that Fell wrote *Womens Speaking Justified* in 1666. Just like Fell, Abraham was "tried through manifold tribulations" and "was found a friend of God" in the end. If Abraham could prove his faith in God through his own trials, then perhaps Margaret Fell and the early Quakers could prove to their opponents that they too were "friend[s] of God."

For Margaret Fell, a spiritual justification of her own imprisonment and the harsh treatment of the Quakers may have helped her cope with her desperate situation. Fell uses Judith's words to indirectly offer hope to other

20 Fell, *Womens Speaking Justified*, p. 15.

Quakers who were also suffering for their faith. Biblical patriarchs such as Isaac, Jacob, and Moses all suffered and found their faith tested by God directly, so perhaps God is testing the early Quakers in the same way. By enduring their suffering, Fell tells us that these patriarchs "pleased God," so perhaps the suffering of the Quakers is also finding them favor in the Lord. By aligning the Quakers with these patriarchs, Fell is also lending further credibility to her protofeminist claims. If historically holy men were tested by God and endured public persecution to prove their loyalty to God, what does that say of women who are tried and arrested for preaching and yet still maintain their belief in God's approval of their preaching? Just as these biblical patriarchs were "stedfast in Faith through manifold troubles," so were the Quaker women preachers.

Acknowledging how the Elders of Israel responded to Judith's preaching is critical in Fell's tract because this would establish whether or not the holy forefathers condoned the act of women's preaching. In her tract, Fell challenges her audience to read "how the Elders commended [Judith], and said, All that thou speakest is true, and no man can reprove thy words, pray therefore us, for thou art an holy woman."[21] Here not only has Judith followed the will of God by assassinating Holofernes but is praised by the male authority figures of the Jews for preaching to the people. God openly condones her public speaking, and the men of the tribe recognize her authority as a "holy woman" and handmaid of the Lord. Judith is not only recognized by the elders as a conveyer of truth, an important counterpoint considering the misogynist belief that all women were liars, but also "no man can reprove [her] words," which is a challenge to the men who are reading Fell's tract. If a man were to condemn the words of Judith or any other woman who is speaking on God's behalf, he would be guilty of heresy, a powerful accusation that Fell uses to further discredit her male adversaries.

In *Womens Speaking Justified*, Judith becomes more than just an example of another biblical woman preacher; she becomes the means through which Fell openly chastises the men who inhibit women preaching in public. For Fell, Judith's story is proof that God condones the practice of women's preaching, for not only what Judith says is true and inspiring, but the Elders of the tribe condoned her preaching as well. If Fell's male audience would not accept her observation that God condoned women's preaching, then perhaps they would consider listening to the authority of the men in the story who directly praised Judith for preaching to the tribe. Fell concludes

21 Ibid., p. 12.

that "these elders of Israel did not forbid [Judith's] speaking, as you blind Priests do," thus accusing misogynist priests of going directly against the elders of the religion whenever they oppose women's preaching.[22] These men, to Fell, are blind to the authority of women preachers, just as they are blind to their own hypocrisy.

Fell continues to degrade the credibility of her opponents when she directly chastises them for their hypocrisy after her account of Judith's role as a preacher. When men fail to accept early modern Quaker women preachers, Fell implies that these men are also failing to accept women preachers of the Bible and pseudo-biblical texts. Essentially, she is accusing men who reject women's preaching of heresy, reciprocating the charge of heresy men had placed on women preachers. Despite the evidence that God condones women's preaching through the Elders of Israel in Judith's story, Fell's audience may still not be deterred from rejecting women preachers. Fell responds to these men who openly condemn women's speaking: "yet you will make a Trade of Womens words to get money by, and take Texts, and Preach Sermons upon Womens words; and still cry out, Women must not speak, Women must be silent."[23] Here Fell establishes the hypocrisy of men in the print business or ministers who benefit from women's words, and she comments on the print culture of the seventeenth century that produced several tracts written by women in the open debate on gender and sold them for profit. For instance, in response to the before-mentioned misogynist tract *The Arraignment of Women* (1615), protofeminist Rachel Speght wrote the response *A Mouzell for Melastomus* (1615), Esther Sowerman wrote *Esther Hath Hanged Haman* (1617), and Constantia Munda wrote *The Worming of a Mad Dog* (1617). Although Sowerman and Munda were clearly pseudonyms that kept the true name and gender of the author anonymous, these tracts were sold with Speght's as women's responses to a misogynist tract. The gender war in print was a lucrative business. As Fell indicated in her tract, there was money being made with the words of women. Women's writing, although not as prevalent as men's, was a commodity to be bought and sold in print shops all over England for profit.

According to Fell, if men saw women's words to be fit enough to publish and thus profit from, and yet they did not embrace the worth of women's preaching, then these men were guilty of hypocrisy. When Fell observes that men "take Texts [and] preach sermons upon Womens words," she is

22 Ibid., p. 16.
23 Ibid.

making an even greater accusation of men's hypocrisy. Men were openly preaching the words of women over the pulpit, lending them authority and credibility through the act of using them in a public religious setting, and yet, when a woman attempts to preach her own words under her own authority, men deny her credibility as a preacher. Men's bifurcated treatment of women's words frustrated Margaret Fell, so she uses Judith to condemn men for this practice.

When men both use women's words for profit and preach women's words publicly and yet reject women's ability to act as God's mouthpiece, Fell reproves them by stating that they "are so far from the minds of the Elders of Israel, who praised God for a Womans speaking."[24] Here Fell is challenging men's claim to authority. If men claim their authority over women from the men in the Bible, then by rejecting the authority of the Elders of Israel they are essentially destroying their own patriarchal authority. Fell snares her misogynist opponents in a polemical trap: by rejecting the ancient patriarchy from which the early modern patriarchy draws its authority, the current patriarchy loses its authority; thus, the only way to maintain the authority of the current patriarchy, early modern men had to accept the authority of the ancient theological patriarchs, which meant that they also had to accept the authenticity of women preachers like Judith because they were accepted by these elders. Fell uses Judith's story to effectively challenge the patriarchal authority exerted over women in early modern England.

Conclusion

In the seventeenth century, Judith played a key role in the debate over gender, theology, and politics found in the print culture of England. Margaret Fell, as a protofeminist woman advocating women's preaching, utilized Judith as an example of women's preaching and as a catalyst through which she could criticize the misogynist use of the scriptures and apocrypha. Judith's role in the greater pamphlet war was complex, serving as a dichotomous symbol through which men and women could convey their views on theology and the sexes. Even though Judith was used in other tracts that defended women by emphasizing her "womanly" virtues and dismissing her "unwomanly" attributes, Margaret Fell not only established Judith as a virtuous woman but also a woman who effectively preached in her own right. Judith, as a mouth-

24 Ibid.

piece of God, was further proof that God condoned women's preaching and that early modern women were continuing the tradition.

Although currently there are no known misogynist tracts that challenge Margaret Fell's *Womens Speaking Justified* specifically, several pamphlets debating women's preaching and other Quaker spiritually egalitarian beliefs were published after 1666. Fell's contribution to the debate on women's speaking was a key protofeminist publication that embodied the changing views on a woman's spiritual worth. The main points and counterpoints in Fell's biblical exegesis illustrate the tools that would become standard in the debate over women's preaching and teaching in public. Fell's use of biblical (and apocryphal) women as examples of virtuous women who preached on God's behalf embodied one of the main methods used by protofeminists to lend authority to their spiritually egalitarian message.

Even though women were still years away from a more holistic feminist movement, Margaret Fell and other protofeminist writers helped balance the canon with biblical exegesis that persisted in explaining the spiritual equality that existed between men and women. The Quakers, as one of the more vocal and prolific spiritually egalitarian groups, continued to spread their protofeminist message in their missionary work. Fell herself witnessed many women in her lifetime who embarked on missions abroad, and watched how several of these women were persecuted and imprisoned for their preaching. Nevertheless, Quaker women continued to spread the message of the Light of Christ long after the death of Margaret Fell. How Fell's tract specifically was used in these missions has yet to be researched, as well as the full extent of how Judith was used in the gender war in print, but the fact remains that Margaret Fell defended her sex in a time when women were hated simply because they were women, and to do so she borrows Judith's sword and voice.[25]

25 The texts used for this project were found at the Newberry Library, the Tennessee State University Library, and the Vanderbilt University Library, as well as at Early English Books Online.

Staging Judith

Visual Arts

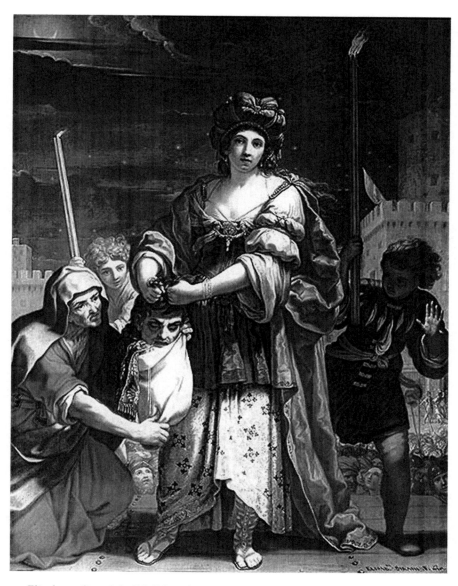

Elisabetta Sirani, *Judith Triumphant*, ca. 1658. Burghley House, Stamford, UK.
Photo credit: G.E.M.A. (Grande Enciclopedia Multimediale dell'Arte).

15. Judith, Jael, and Humilitas in the *Speculum Virginum*

Elizabeth Bailey

Introduction

The illuminated manuscript of the *Speculum Virginum*, or Mirror of Virgins, in the British Library, Arundel MS. 44, dated ca. 1140, contains at the right an image of Judith as victor over Holofernes (fol. 34v; Fig. 15.1). She and her counterpart Jael, standing triumphantly over Sisera, flank the allegorical figure of Humilitas, who kills Superbia. The Latin text, which has been attributed to Conrad of Hirsau, or Scribe A of Arundel 44, or yet another anonymous author, is composed in the form of a dialogue between a religious advisor, Peregrinus, and Theodora, a Virgin of Christ. It was intended as a guide for women wishing to live the religious life.[1]

The *Epistula* at the very beginning of the manuscript reads: "From C. [the author, who speaks through the voice of Peregrinus], the least of Christ's poor, to the holy virgins N. and N. [the recipients of the manuscript]: may you attain the joy of blessed eternity."[2] This dedication introduces the con-

* Acknowledgments: The author would like to thank Kevin Brine, his foundation, and the staff of the New York Public Library for making the conference and collection of essays on Judith possible. The author would also like to thank all of those who offered invaluable advice and encouragement, especially Mary D. Edwards and the editors, Elena Ciletti and Henrike Lähnemann.

1 Conradus Hirsaugiensis, *Speculum Virginum* (London: British Library, MS Arundel 44, ca. 1190) (hereafter cited as Arundel 44). See also Thomas Howard Arundel, *Catalogue of Manuscripts in the British Museum, New Series, The Arundel Manuscripts*, 1:1 (London: British Museum, 1834–40); Jutta Seyfarth (ed.), *Speculum Virginum*, in *Corpus Christianorum Continuatio Mediaevalis*, 5 (Turnhout: Brepols, 1990); Arthur Watson, "The *Speculum Virginum* with Special Reference to the Tree of Jesse," *Speculum* 3 (1928), pp. 445–69.

2 Barbara Newman, "*Speculum Virginum*: Selected Excerpts," in Constant J. Mews (ed.), *Listen Daughter: The Speculum Virginum and the Formation of Religious Women in*

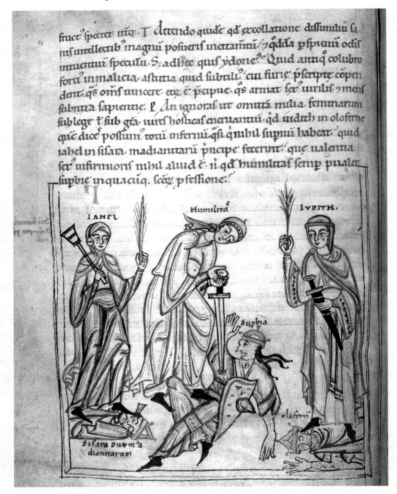

15.1. "Judith, Humilitas, and Jael," *Speculum Virginum*, ca. 1140. London, British Library, MS Arundel 44, fol. 34v. © British Library Board.

cept that humility, expressed by the phrase, "the least of Christ's poor," and virginity, represented by the recipients of the manuscript, form the foundation of the way to perfection and "blessed eternity." Throughout the *Speculum Virginum*, Peregrinus repeatedly emphasizes humility as the basis for the other virtues, especially the highest virtue of charity, which he calls "the flower and fruit of eternity."[3]

the Middle Ages (New York: Palgrave, 2001), p. 269.

3 Constant J. Mews, "Virginity, Theology, and Pedagogy in the *Speculum Virginum*," in Constant J. Mews, *Listen Daughter*, p. 25.

In this essay, I will discuss the iconography of Judith and Humility in the image on fol. 34v of Arundel 44, proposing that this is the first extant work of art in which the figure of Judith and the personification of Humilitas are paired in the same illumination. I will show that this new conception results from a combination of images in the *Psychomachia* of Prudentius and illuminated Bibles to help virgins attain humility and become Brides of Christ. In so doing I will relate the iconography of fol. 34v to other illuminations in Arundel 44, as well as to those in the *Speculum Humanae Salvationis* and the *De laudibus sanctae crucis*.

Arundel 44 (The *Speculum Virginum*)

Arundel 44 is the earliest extant copy of the *Speculum Virginum*. The manuscript came into the possession of the Cistercian abbey of Eberbach in Rheingau before the end of the twelfth century, and from Klöster Eberbach the *Speculum Virginum* was widely disseminated in copies.[4] Many accept Arundel 44 as the original manuscript, while others believe that it was copied from a lost prototype of Benedictine, Cistercian, or Augustinian origin; arguments can be made for and against all three. Important to this study is the fact that the *Speculum Virginum* was written during the period of reform and growth of monastic houses and of the tremendous increase in the numbers of women joining or becoming associated with religious communities. The pedagogical format of the *Speculum Virginum,* in which the male Peregrinus is the teacher and the female Theodora the pupil, suggests that the book was intended for monks and priests to use for the instruction of women associated with their communities; thus it provides an appropriate model for the interaction between women and men in the religious life.[5] In fact, the abbey of Eberbach, the twelfth-century home of Arundel 44, was responsible for administering female religious houses.[6]

Arundel 44 contains one hundred and twenty-nine folios. The text is divided into twelve parts or chapters, through which Peregrinus leads his

4 Jutta Seyfarth, "The *Speculum Virginum*: The Testimony of the Manuscripts," in Constant J. Mews, *Listen Daughter*, pp. 41–57. See also Nigel F. Palmer, *Zistersienser und ihre Bücher: Die mittelalterliche Bibliotheksgeschichte von Kloster Eberbach im Rheingau* (Regensburg: Schnell & Steiner, 1998); Jeffrey F. Hamburger and Susan Marti (eds.), Dietlinde Hamburger (trans.), *Crown and Veil: Female Monasticism from the Fifth to the Fifteenth Centuries* (New York: Columbia University Press, 2008).
5 Julie Hotchin, "Female Religious Life and the *Cura Monialium* in Hirsau Monasticism, 1080 to 1150," in Constant J. Mews, *Listen Daughter*, pp. 59–84.
6 Constant J. Mews, *Listen Daughter*, p. 5.

pupil Theodora on her journey to becoming a Virgin of Christ.[7] There are twelve illustrations corresponding with the text, and they often introduce the chapters.[8] Through the text and images Peregrinus exhorts Theodora to view herself in the Mirror of Virgins, so that she may see her own virtues and vices reflected there. Referring to the manuscript as a whole, he states: "You ask for a mirror, daughter. Here you can behold … fruit and … how much you have progressed and where you are still wanting. Here, indeed, if you seek you will find yourself."[9] Then, specifying the illuminations, he directs her to use her eyes "so that what is drawn in through the eyes' gaze may bear fruit to the consideration of the mind."[10]

Peregrinus also advises Theodora to use the *speculum* in the biblical sense, as a reflection of divine truth. In his opening *Epistula*, Peregrinus points to the example of Moses, who made a laver from the mirrors of the women who watched the door of the tabernacle (Ex 40:29). Peregrinus reminds his pupil that in this life one can know God only indirectly, as a reflection, but that in the next life the soul will know His essence. Peregrinus states: "When the 'enigma and mirror' by which we know God in part has passed away, what is now sought invisibly in the Scriptures will be seen 'face to face'" (1 Cor 13:12).[11]

7 The chapters are as follows: 1. The flowers of Paradise and the form of Paradise with its four rivers signifying the evangelists and doctors who irrigate the whole church by word and example the truth; 2. a warning to virgins against falling into sin; 3. the daughters of Zion exhorted to humility and the meaning of the Virgin's dress; 4. humility and pride; 5. the quadriga of Mary, Jesus, John the Baptist, and John the Evangelist and the good and bad teachers of virgins; 6. the wise and foolish virgins; 7. the three levels of women, which are virgins, widows, and wives; 8. the fruits of the flesh and spirit and the six ages of the world; 9. the ascent of the ladder of humility; 10. the act of thanksgiving; 11. the gifts of the spirit and the virtues and powers of the number seven; and 12. the exposition of the Lord's Prayer. See Arundel 44, fol. 2r, and Watson, "The *Speculum Virginum* with Special Reference to the Tree of Jesse," p. 447.
8 The illuminations are as follows: 1. the Tree of Jesse; 2. the Mystic Paradise; 3. the Tree of Vices; 4. the Tree of Virtues; 5. Humilitas with Judith and Jael; 6. the Quadriga; 7. the Wise and Foolish Virgins; 8. the Three Types of Women; 9. the Flesh and Spirit; 10. the Ascent of the Ladder; 11. Majestas Domini; 12. the Fruits of the Spirit.
9 Morgan Powell, "The Audio-Visual Poetics of Instruction," in Constant J. Mews, *Listen Daughter*, p. 123.
10 Powell, "The *Speculum Virginum* and the Audio-Visual Poetics of Women's Instruction," p. 121.
11 Newman, "*Speculum Virginum*: Selected Excerpts," p. 270.

The Virtue of Humility

As a beginner in devotion, Theodora "sees through a glass darkly" (1 Cor 13:11), and Peregrinus stresses that Theodora must first seek humility, the root of all virtue. Throughout the texts and images, Peregrinus interweaves allegorical, biblical, and even pagan figures with spiritual advice to inspire Theodora to imitate virtue. Those mentioned in the text include the Amazons, Semiramis of Babylon, Thamar, queen of the Scyths, and queens Marpesia and Lamphetus, all of whom overcame tyrants and ruled their realms with great discipline. Theodora states that she appreciates the female models for they give "strength of a virile spirit to women's hearts."[12]

Peregrinus emphasizes another female model, the third-century martyr Perpetua, by illustrating her vision of a ladder that reached to heaven on fol. 93v (Fig. 15.2). In her legend, Perpetua underwent many vicissitudes, including fighting an "Ethiopian," and in this illumination that bearded, sword-wielding enemy of virtue tries unsuccessfully to prevent the seven virgins from climbing the ladder.[13] In the text, Peregrinus states that the attainment of humility is like climbing a ladder, referring to the Ladder of Humility in the Rule of St. Benedict (480–after 546), and noting that "the sides of [Benedict's] ladder constitute a form of heavenly discipline, providing steps for our body and soul."[14]

In the *Speculum Virginum* Judith, already an age-old example of virtue, is especially associated with humility. While the image on fol. 34v of Arundel 44 is not a narrative one, it refers to the Book of Judith, which tells the story of the beautiful young widow who saved her town Bethulia from the tyranny of the Assyrian general Holofernes (see Fig. 15.1). When the Hebrew leaders thought they would have to surrender, Judith, who had faith in God, courageously risked her life and virtue to enter the enemy camp, charm the libidinous Holofernes, make him drunk, and then behead him with his own sword. In the image on fol. 34v, Judith, on the right, neither cuts off the head of Holofernes nor escapes with the gruesome prize, as she is most often depicted. Rather, she stands triumphant, grasping her sheathed sword and trampling Holofernes, whose head is still attached but whose eyes are closed in death. In her right hand she holds aloft a feathery object which has been interpreted as either a palm of victory or the branches

12 Mews, "Virginity, Theology, and Pedagogy," p. 25.
13 Watson, "The *Speculum Virginum* with Special Reference to the Tree of Jesse," p. 453.
14 Mews, "Virginity, Theology, and Pedagogy," p. 29.

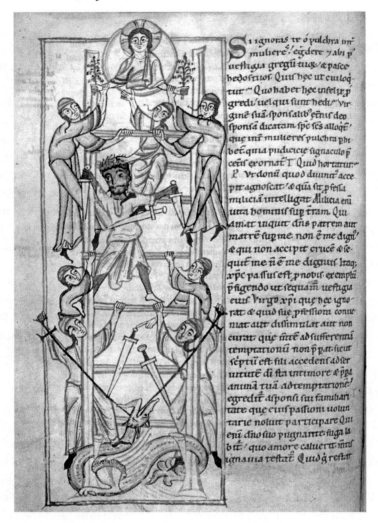

15.2. "Perpetua's Ladder," *Speculum Virginum*, ca. 1140. London, British Library, MS Arundel 44, fol. 93v. © British Library Board.

she distributed to the women of Bethulia in celebration of their liberation (Jdt 15:12). In either case, it symbolizes Judith's victory.[15]

Regarding the relationship among the six figures on the folio, our heroine turns to face Humility who, standing atop Pride, thrusts her sword into

15 Nira Stone, "Judith and Holofernes: Some Observations on the Development of the Scene in Art," in James C. VanderKam (ed.), *"No One Spoke Ill of Her": Essays on Judith* (Atlanta: Scholars Press, 1992), p. 80.

the breast of her nemesis. Falling backwards, a "mannish" Pride lifts her hand in capitulation to Humility's superiority, her shield falling to her side and her mouth opening in a scream of agony as Humility drives her sword into Pride's chest. To the left of this pair, Jael is posed atop Sisera, another enemy of Israel, already killed by a tent peg hammered through his temple. The image of Humility, Judith, and Jael is a *speculum*, or mirror, which the adviser Peregrinus holds up to Theodora that she might see herself reflected in the figures' virtuous humility and, like them, conquer the vice of pride.

Judith, Humilitas, and the *Psychomachia* in the Ninth and Tenth Centuries

How did the figure of Judith become united with the personification of Humilitas in the illumination on fol. 34v? To answer this question, it is enlightening to look back to the earliest representations of Judith and Humilitas in manuscript illuminations. In the Carolingian period, the ninth and tenth centuries, Judith appeared in Bibles in two formats: one, as a portrait bust within the decorated letter *A*, the first letter of both the preface and the Book of Judith;[16] and, two, as an actor in a sequence of scenes, usually arranged in registers, telling her story.[17] However, the most important source for the allegorical representation in Arundel 44 seems to have been the *Psychomachia*, the conflict within the soul between the spirit and the flesh, by Prudentius (348–ca. 410), the earliest extant illustrations of which also date to the ninth and tenth centuries.

In the Tours *Psychomachia* (Paris, Bibliothèque Nationale, Latin 8318) the story of Humilitas defeating Superbia covers several pages and includes both narrative and iconic representations.[18] An example of narrative depiction is on fol. 51v, where, in the topmost image, Pride falls from her horse, itself a biblical symbol for pride (Prv 21:31), and lands in a ditch dug by Fraud. Below this, she tries to use her steed as a shield, as Hope

16 Paris, Bibliothèque Nationale, Bible, Latin1, fol. 300v.

17 Rome, San Paolo fuori le Mura, Bible of St. Paul, fol. 234v. See Frances Gray Godwin, "The Judith Illustration of the *Hortus Deliciarum*," *Gazette des beaux-arts*, 36 (1949), fig. 4. The author wishes to thank Diane Apostolos-Cappadona for generously sharing her "list" of images of Judith in medieval manuscripts with the author.

18 Adolf Katzenellenbogen, *Allegories of the Virtues and Vices in Medieval Art* (New York: W. W. Norton, 1939), pp. 1–12. See also Colum Hourihane, *Virtue and Vice, The Personifications in the Index of Christian Art* (Princeton, NJ: Princeton University Press, 2000); Helen Woodruff, "The Illustrated Manuscripts of Prudentius," *Art Studies*, 7 (1929), pp. 33–79.

and Humility arrive at the right. In the last image Hope hands Humility a sword, while Pride, her clothes stripped from her body, lies supine atop her horse. An example of an iconic image is on fol. 53r, where Superbia sits astride her horse and Humilitas, with her sword and shield, stands as stony as a statue. The representation of the virtues and vices in these early images conforms to Prudentius's text, in that the figures wear classical female clothing. Moreover, the vices possess some positive qualities, such as Superbia's courage, albeit impetuous.[19] Humilitas and Judith in Arundel 44 are both descendants of the Carolingian prototypes represented in the Tours *Psychomachia*, especially in their long female garments and serene faces. The composition as a whole is similar to the Tours manuscript in that it combines narrative (Humilitas killing Superbia) and iconic (Judith standing in a static pose) images.

Two other motifs in the Tours *Psychomachia* foreshadow Humilitas and Judith in Arundel 44, those of Virtue treading on Vice and Good standing atop Evil. On fol. 50v of the Tours *Psychomachia* the virtue of Faith defeats the vice of Idolatry with one knee bent, similar to that of Humility treading upon Superbia in Arundel 44 (Fig. 15.1). And, on fol. 55v of the Tours *Psychomachia*, a crowned king treads upon a snake just as Judith and Jael stand upon Holofernes and Sisera.

While Humility and Judith in Arundel 44 resemble both the virtues and vices of the Tours *Psychomachia* in their classical costume and treading poses, Superbia descends from a different type of illumination represented by the Reims *Psychomachia* (Paris, Bibliothèque Nationale, Latin 8085). This manuscript exhibits a stunning contrast in the portrayals of the virtues and vices with those in the Tours *Psychomachia*, just discussed. For instance, on fol. 60v of the Reims manuscript illustrating the story of Humilitas defeating Superbia, the virtues and vices do not wear female robes, nor are they classically serene. Rather, the female figures have donned the helmet, armor, short kilt, and boots of male Roman soldiers; and Superbia, in the lower right corner, is dramatically caricatured, with her contorted posture, wide eyes, and unruly hair. These differences owe to the fact that the Tours and Reims manuscripts represent two distinct categories of illuminated manuscripts of the *Psychomachia*: the classical and the dramatic.[20]

19 Katzenellenbogen, *Allegories of the Virtues and Vices in Medieval Art*, p. 4.
20 Katzenellenbogen, *Allegories of the Virtues and Vices in Medieval Art*, pp. 8–9. See also Lester K. Little, "Pride Goes before Avarice: Social Change and the Vices in Latin Christendom," *The American Historical Review*, 76 (1971), fig. 2, which shows Pride as a twelfth-century male knight on the Last Judgment tympanum of Sainte

The figure of Superbia in Arundel 44 is not the spirited horsewoman or the classically clad figure with a serene face, as are the vices of the Tours manuscript. Rather, reflecting the dramatic tradition of the Reims manuscript, she has an intense, desperate expression, with a coarse profile and open mouth. Her snake-like hair flies wildly behind her. Her pose, with one leg upraised, makes her "mannish," as noted above, and her shoulders are very broad. As for her costume, her robe is Byzantine in style with a crosshatched belt and a band with three spots at her thigh. And finally, she wears a medieval crown or a helmet, associating her with prideful kings or military leaders. This headgear contrasts starkly with the cloth headdresses concealing the hair of Judith and Humilitas, perhaps associating them with the modest women of the religious life.

In the illuminations of the *Psychomachia*, Judith was not the Old Testament figure chosen to exemplify humility. That was Abraham, depicted on fol. 49v of the Tours *Psychomachia*, with his sword raised, preparing to sacrifice Isaac, but halted by the angel. Abraham was traditionally associated with humility because he put aside his own desires, submitted to God's will, and obeyed His commands, even to the point of sacrificing his own son. Just as Peregrinus replaced the male figures climbing Benedict's ladder with female virgins, so too he replaced Abraham with Judith and Jael to represent humility. As chapter 16 of the Book of Judith states, Judith possessed "fear of the Lord," one of the medieval Gifts of the Holy Spirit, a quality synonymous with humility; and, because she feared God, He gave her the courage to enter the enemy camp and defeat Holofernes. Like Abraham, Judith's attribute is the sword, that is, "the sword of the Spirit, which is the Word of God" (Eph 6:17).

Prudentius did, however, include Judith as a model of a virtuous woman in his text of the *Psychomachia*, especially associating her with chastity. He wrote that "the unbending Judith, spurning the lecherous captain's jeweled couch, checked his unclean passion with the sword, and woman as she was, won a famous victory over the foe with no trembling hand, [and] with boldness heaven-inspired."[21] Prudentius related Judith's chastity to the Virgin Mary's purity as both powerful and sacred and her beheading of Holofernes to Chastity's piercing of Lust's throat with a sword.[22] For Prudentius,

Foy at Conques. The author would like to thank Mary D. Edwards for pointing out the illustration.

21 Prudentius, *Psychomachia*, trans. H. J. Thomson, 2 vols. (Cambridge, MA: Harvard University Press, 1949), 1, p. 283.

22 Prudentius, *Psychomachia*, 1, p. 285.

as for other Church fathers, Judith also possessed other virtues, including humility.[23] Thus, because of her chastity, humility, courage, and determination in using a sword to defeat the enemy, Judith, along with Jael, was an ideal model to replace Abraham in a visual relationship with Humilitas.

Judith and Humilitas in the Eleventh Century

The full-length, statuesque, iconic Judith as portrayed in Arundel 44 (Fig. 15.1) became popular in the eleventh century when she was also depicted with the attributes of a saint or even a goddess. This type is exemplified by a Bible in the Munich Staatsbibliothek, and a similar image in Rome (Vatican 4), of a haloed Judith posed frontally with her sword raised and holding Holofernes' head in her hand.[24] Our Judith on fol. 34v of Arundel 44 is also frontally posed and statuesque, though not as flat and rigid as the eleventh-century examples. As for Humilitas, by the eleventh century she was widely portrayed not only in other manuscripts of the *Psychomachia*, but in a variety of art forms, such as reliquaries and sculptures. She could appear simply as an allegorical portrait along with other virtues as on fol. 173r of the Gospels of Abbess Hitda.[25] Thus, in the eleventh century Judith and Humilitas acquired some independence from their stories in the Book of Judith and the *Psychomachia*, and were portrayed as individual allegorical figures. The full-length standing figure of Judith, in particular, seems to foreshadow her statuesque image in the *Speculum Virginum*.

The "Three Types of Women" and Judith as a Widow

From the development discussed above, one may conclude that the artist of Arundel 44 provided a new, fresh visual model for religious women in the twelfth century by shaping age-old ideas in a different way. Judith is the only Old Testament figure to be depicted more than once in the *Speculum Virginum*. She appears first on fol. 34v as a model of humility, and then on fol. 70r as an earthly widow who receives the rewards of humility (Fig. 15.3). The sparse, somber, allegorical figurative style of Judith, Humilitas, and Jael on fol. 34v (Fig. 15.1) may be contrasted with the florid, patterned, diagram-

23 Margarita Stocker, *Judith: Sexual Warrior. Women and Power in Western Culture* (New Haven, CT: Yale University Press, 1998), p. 21.
24 Volker Herzner, "Die 'Judith' der Medici," *Zeitschrift für Kunstgeschichte*, 43 (1980), fig. 3; Godwin, "The Judith Illustration of the *Hortus Deliciarum*," fig. 7.
25 Katzenellenbogen, *Allegories of the Virtues and Vices in Medieval Art*, pp. 33–34.

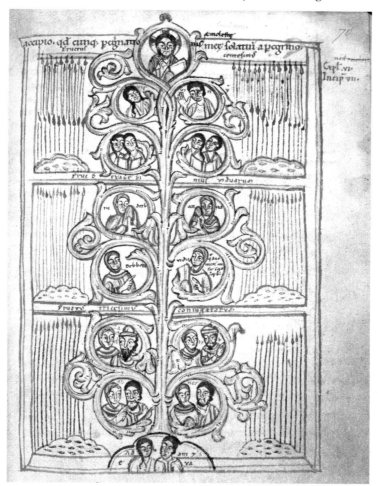

15.3. "The Three Types of Women," *Speculum Virginum*, ca. 1140. London, British Library, MS Arundel 44, fol. 70r. © British Library Board.

matic composition of fol. 70r in the *Speculum Virginum* that represents St. Jerome's "three types of women." The women, who receive rewards according to their level of virtue, are depicted as portrait busts placed within a three-register arrangement of the typical medieval tree diagram. The portrait bust was a popular form, and indeed, elsewhere in Arundel 44 on fol. 29r, the bust of Humilitas appears at the base of the Tree of Virtues.

In the "Three Types of Women" on fol. 70r, busts of Adam and Eve form the roots from which the tree grows upwards in a curvilinear, vine-like design. In the lowest register, the four loops contain married women

(paired with their husbands) who shall receive thirty-fold rewards; these are identified as Abraham and Sarah, Zacharias and Elizabeth, Noah and his wife, and Job and his wife. The second register shows widowed women who receive their rewards sixty-fold; they are Deborah and Judith, and Anna and the poor widow who placed her last few coins in the treasury of the synagogue (Mk 12:41–42). The highest register depicts virgins who receive their rewards one-hundred-fold; these last female figures are shown with their hair fully exposed, in contrast to the married women and widows, whose heads are covered. On the sides the fruits (or rewards) are represented by stalks of grain. Since Judith occupies the middle register for widows, whose fruits multiply sixty-fold, her stalks are rust colored, not brown as those in the lowest level, but not verdant blue and green as those in the upper level.[26] Judith in this instance is not in the guise of an allegorical figure of a virtue, but in the role of a chaste widow. The image suggests that all women may reach a level of perfection and participate in the blessings of God, regardless of their stations in life and according to their virtue.

The "Quadriga" Judith and the Virgin Mary

Closer in composition to the depiction of Judith, Humilitas, and Jael is fol. 46r, called the "Quadriga," with its tripartite division of space and full-length monumental figures (Fig. 15.4). It shows the Virgin Mary, the Child Jesus, John the Baptist, and John the Evangelist along with the four wheels of the cart that transports virgins to heaven. The imagery is based on the Quadriga of Aminadab from the Song of Songs, a chariot whose wheels were traditionally interpreted as the four evangelists or the four cardinal virtues.[27] As a devotional image, the Quadriga was often depicted as a four-wheeled wagon filled with holy virgins whose marriages with the Lamb have been consummated through their martyrdoms. On fol. 46r the Quadriga is symbolized by the four wheels, each beneath the feet of the four figures. The wheels are reminiscent of the wheels of cherubim in Ezekiel (Ez 1:5–11) and suggestive of other ascension images, such as the ascension of Elijah in a wheeled vehicle.

The Virgin Mary, as the perfect female virgin, occupies the center of the illustration. In the text Peregrinus admonishes Theodora that, because she

26 Watson, "The *Speculum Virginum* with Special Reference to the Tree of Jesse," p. 451.

27 Watson, "The *Speculum Virginum* with Special Reference to the Tree of Jesse," p. 450.

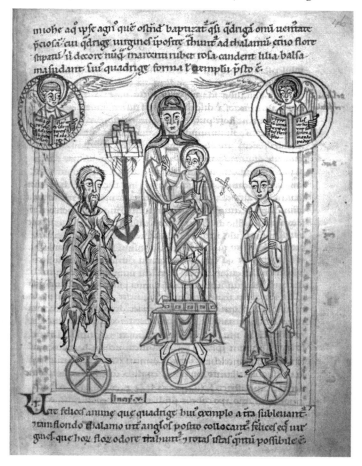

15.4. "The Quadriga," *Speculum Virginum*, ca. 1140. London, British Library, MS Arundel 44, fol. 46r. © British Library Board.

cannot yet achieve mystical understanding, she must mimic Mary's humility, which will be the key to wisdom.[28] The Virgin Mary, as a paragon of humility, is based on her response to the angel of the Annunciation, when she said: "Behold the maidservant of the Lord. Let it be to me according to your Word" (Lk 1:38). Mary, like Judith, was a servant in the way that Abraham had been God's servant; they acknowledged the sovereignty of God and submitted to his commands. Augustine of Hippo emphasized the Virgin's obedience to God's will in humility, which made her the opposite

28 Kim E. Power, "From Ecclesiology to Mariology: Patristic Traces and Innovation in the *Speculum Virginum*," in Constant J. Mews, *Listen Daughter*, p. 98.

of Eve, whose disobedience stemmed from pride. Judith was a precursor of the Virgin in conquering pride when she obeyed God's command to enter the enemy camp and defeat Holofernes. For Augustine, pride was the basis of sin and the first of the vices, for it was the desire to place oneself above God and others; the only salvation was humility, which led to the reverse, the placement God and others above oneself (Phil 2:3).[29] Thus, in her chastity, humility, faith, and obedience, Judith in the *Speculum Virginum* foreshadows the Virgin Mary; and if virgins follow both their examples, they will receive the "key to wisdom."

Judith, Mary, and Humility in Later Manuscripts

In later manuscripts, Judith and Mary are more closely related in the visual sense, especially in the illustrated copies of the fourteenth-century *Speculum Humanae Salvationis*. In it, each scene from the life of Christ and Mary is followed by three parallel examples from the Old Testament and classical antiquity, placed as a continuous image strip on the top of confronting double pages. For example, on fol. 32v of the fourteenth-century version in Munich (Clm. 146), Mary, surrounded by instruments of Christ's Passion, tramples the devil. Next to this image on the same folio Judith raises her sword as she prepares to behead Holofernes. Here the horizontal beam of the cross behind Mary corresponds with Judith's raised cross-shaped sword, held parallel to the earth. Facing Mary and Judith on fol. 33r are Jael and Thomyris, the Queen of the Massagetes who beheaded the Persian King Kyros after he had killed her son; thus Jael and Thomyris, like Judith, are also precursors of Mary in conquering evil.[30]

The degree of influence of the *Speculum Virginum* on later manuscripts is difficult to determine. Aside from copies of the *Speculum Virginum* itself,

29 Allan D. Fitzgerald (ed.), *Augustine through the Ages, an Encyclopedia* (Grand Rapids, MT: Eerdmans, 1999), p. 680; Elisabeth Bos, "The Literature of Spiritual Formation for Women in France and England, 1080 to 1180," in Constant J. Mews, *Listen Daughter*, p. 212.

30 Jean Miélot, Jules Lutz, and Paul Perdrizet (eds.), Jean Miélot (trans.), *Speculum humanae salvationis, Texte critique (1448), Les sources et l'influence iconographique principalement sur l'art alsacien du XIVe siècle, Avec la reproduction, en 140 planches, du Manuscrit de Sélestat, de la série complète des vitraux de Mulhouse, de vitraux de Colmar, de Wissembourg*, 2 vols. (Leipzig 1907–1909). See also Nigel F. Palmer, "'Turning many to righteousness,' Religious didacticism in the *Speculum humanae salvationis* and the similitude of the oak tree," in Henrike Lähnemann and Sandra Linden (eds.), *Dichtung und Didaxe, Lehrhaftes Sprechen in der deutschen Literatur des Mittelalters* (Berlin: de Gruyter 2009), pp. 345–66.

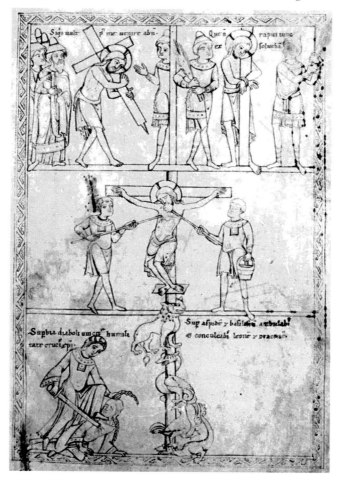

15.5. *De laudibus sanctae crucis*, ca. 1170. Munich, Staatsbibliothek, Clm. 14159, fol. 6r, Regensburg-Prüfening. Photo credit: urn:nbn:de:bvb:12-bsb00018415-2 © Bayerische Staatsbibliothek.

Judith and Humilitas are not paired again on the same folio. However, in the manuscript of the *De laudibus sanctae crucis* in Munich (Clm. 14159) dated ca. 1170–85, also written as a dialogue, the visual association between Judith, Mary, and Humilitas is quite close, but in a new way.[31] On the facing page, fol. 6r, at the bottom left of the Crucifixion in which the cross impales the beasts from Psalm 90, Humilitas thrusts her sword into the chest of Superbia in a similar manner as Humilitas in Arundel 44 (Fig. 15.5).

31 Wolfgang Hartl, *Text und Miniaturen der Handschrift Dialogus de Laudibus Sanctae Crucis* (Hamburg: Verlag Dr. Kovac, 2007).

In the *De laudibus sanctae crucis* she is placed at the lower left where Mary Ecclesia stands in other illuminations of the Crucifixion at this time. Directly above, Longinus pierces Christ's right side with the spear, while Stephaton thrusts the sponge saturated with vinegar into His face. The message is clear that through His supreme humility, God came to earth, assumed mortal flesh, allowed himself to be humiliated, and sacrificed himself on the Cross, thereby defeating evil. On the facing page, fol. 4v, at the upper left, Judith decapitates Holofernes, while her maid waits outside the tent. Thus, even though Judith and Humilitas are not represented on the same folio, they are together, side by side, on contiguous pages. Once again the two parallel each other meaningfully.

Conclusion

In this essay, I have demonstrated the importance of Judith as an example of the virtue of humility in the earliest extant version of the *Speculum Virginum*, Arundel 44, intended as a devotional guide for women in the religious life. I have shown how the composition with Judith and Humilitas on fol. 34v of Arundel 44 developed from illuminated manuscripts of the *Psychomachia* from the Carolingian period forward, and how Judith and Humilitas developed further in the eleventh century. I have argued that Judith was important for the *Speculum Virginum* not only as an allegory of humility but also as a chaste widow. Moreover, I have shown how she is a precursor of the Virgin Mary for her many virtues, especially chastity and humility.

The illumination of Judith, Jael, and Humilitas in Arundel 44 could be called unique in that it was the first representation, of which we know, where Humility is paired with Judith in order to teach virgins how to become brides of Christ. While the composition of fol. 34v may be seen as a combination of old traditions and familiar images, it may also be viewed as innovative. On the folio, Judith, a classical, serene figure in a long female gown, stands icon-like atop Holofernes, while the similarly clad classical Humilitas actively defeats Superbia, who seems like a character from a tragic play. The composition, with its subtle relationships, must have been especially created to send a deeply moving message to the virgins that they should imitate Judith and Jael as well as the Virgin Mary and seek true humility. This simple yet powerful composition must have been effective, for this, the first known version in Arundel 44, was repeated again and again for over three hundred years.

16. Judith between the Private and Public Realms in Renaissance Florence

Roger J. Crum

In 1497, at a time of famine, three thousand women amassed in the Floren-tine Piazza della Signoria demanding the distribution of bread. Shouting "Pane! Pane!" (Bread! Bread!), the women soon transformed their chant to "Palle! Palle!" (Medici! Medici!). This transformation was understood as a call for the return of the exiled Medici, whose heraldic symbols were balls or *palle*. As the Florentine Security Commission tried to avoid a riot, one woman pelted a servant of the commission with stones after he had struck her daughter. The government eventually yielded to the women's demands and ordered bread distributed throughout the city.[1]

Taking place in the central public and governmental space of Flor-ence, this protest also transpired in the shadow of Donatello's *Judith and Holofernes* (Fig. 17.1). Donatello's work had been seized from the Medici Palace in 1495 and placed on the *ringhiera* outside the public Palazzo della Signoria in declaration of the city's triumph over the Medici.[2] Two years later, once the announcement was made that bread would be dis-tributed, the protesting women of 1497, so a chronicler reports, "took themselves off home," appeased and silent.[3] Just as the biblical heroine represented in Donatello's statue had returned home to Bethulia after having killed Holofernes in his nearby camp, these latter-day "Judiths"

1 Natalie R. Tomas, "Did Women Have a Space?," in Roger J. Crum and John T. Paoletti (eds.), *Renaissance Florence: A Social History* (Cambridge and New York: Cambridge University Press, 2008), p. 312.

2 For the documents relating to the transfer, see Eugene Müntz, *Les collections des Medicis au XVe siècle* (Paris and London: Librairie de l'art, 1888), pp. 100–04.

3 Tomas, "Did Women Have a Space," p. 312.

redomesticated themselves in quiet triumph after performing their heroism in the public arena.

Whether representing the act of killing Holofernes, or literally show-ing a subsequent return to Bethulia, Florentine representations of Judith all variously imply or directly reference the eventual return to domestica-tion of the heroine. That these representations may have been more than merely narrative and may have been received among contemporary view-ers as additionally resonating with their own social ideal of the domestica-tion of women is likely, especially after moments in which women might have temporarily entered the public sphere. Fifteenth-century Florentines carefully guarded the chastity and public honor of their patrician women, with the walls, doors, and windows of the city's palaces carefully moni-tored against any form of social violation. "It would hardly win us respect," announces one of the male interlocutors in Alberti's fifteenth-century *Della famiglia,* "if our wife busied herself among the men in the marketplace out in the public eye."[4] Judith's return to a domestic context had therefore to conform to Florentine norms of social behavior and control.

Alberti's reference and other material from the social history of women in Renaissance Florence have lent themselves to illuminating feminist approaches to images of women in the city's art and visual culture. These approaches could easily be applied to an interpretation of the redomestica-tion that is equally overt or implied in contemporary Florentine images of Judith.[5] The focus of this essay, however, is less on feminist than political questions of how Florentines may have understood the shifting private and public roles of the Old Testament Judith narrative in relation to the particu-lar private and public dynamics in Florentine culture. There was through-out Florentine history a continual negotiation between the public and the private realms in a society that was still navigating the uncertain urban terrain of its late medieval and Renaissance evolution.[6] Commissioned,

4 Leon Battista Alberti, *The Family in Renaissance Florence,* trans. Renée Neu Wat-kins (Columbia, SC: University of South Carolina Press, 1969); see also Jane Tylus (ed.), *Sacred Narratives* (Chicago, IL: University of Chicago Press, 2001), p. 34.

5 For portraits of Florentine women, see Patricia Simons, "Women in Frames: The Gaze, the Eye, the Profile in Renaissance Portraiture," *History Workshop* 25 (1988), pp. 4–30. For the social history of women in Renaissance Florence in general, see Natalie R. Tomas, *The Medici Women: Gender and Power in Renaissance Florence* (Al-dershot, UK: Ashgate, 2003); Dale V. Kent, "Women in Renaissance Florence," in David Alan Brown (ed.), *Virtue and Beauty* (Princeton, NJ, and Woodstock, UK: Prin-ceton University Press, 2001).

6 For the most recent account of the political history of Florence, one that particu-larly speaks to this tension between the private and the public, see John M. Najemy,

owned, and displayed by members of the same patrician, office-holding class who carefully guarded the balance of the private and public in their lives, images of Judith could not have been insignificant to this negotiation.

Representations of Judith and Holofernes, like those of David and Goliath, are among the most familiar images from Renaissance Florence. Together with John the Baptist, patron saint of Florence, Judith and David had such a currency in Florentine art, particularly in the fifteenth and early sixteenth centuries, that scholars have long interpreted them as coequal Old Testament protector figures of the city.[7] David and Judith could easily have been engaged in this patriotic role for their biblical stories run along strikingly similar narrative and typological routes. Although unlikely figures for heroic and patriotic deeds, Judith and David emerge from sheltered private roles – Judith as a widow, David as a shepherd – to protect the weak against the strong, to avert disaster and subjugation for their people, and to be instruments of divine will in furthering the historical course of the Jews. Judith sets aside her mourning, dons her exquisite robes, and steps forward to save her native Bethulia against the Assyrian army of Holofernes; David similarly saves his people by setting aside his animal husbandry, employing his shepherd's sling to greater purpose, and slaying the tyrannous Philistine Goliath.

It is here, however, that the two biblical stories significantly part their ways: David continues in his public role, eventually becoming king, while Judith, almost Cincinnatus-like, returns to Bethulia and, after a period of leading her people in triumph, to a resumption of her old life as a widow on her husband's estate. There, a private citizen, she dies at one hundred and five years of age.

The different public and private conclusions of the David and Judith stories parallel a similar public–private divergence in representations of these Old Testament figures in Florentine art. Mirroring the public role of David in the later chapters of the biblical story, imagery of David in Florence had a strikingly public dimension. Notable among other works, Donatello's marble *David*, his later bronze *David*, Ghiberti's David panel for the Gates of Paradise, Verrocchio's *David*, and Michelangelo's *David* were all commissioned for or eventually brought into the public sphere. There is also Ghirlandaio's image of David in fresco on the exterior of the Sassetti Chapel in Santa Trinita, itself a relatively public location though

A History of Florence 1200–1575 (Malden, MA: Blackwell Publishing, 2006).

7 For general reference to David and Judith as patron figures of Florence, see Bonnie A. Bennett and David G. Wilkins, *Donatello* (Oxford: Phaidon, 1984).

clearly decorated through the patronage of private families.[8] By contrast, Florentine images of Judith were predominantly private and domestic objects. With the exception of Ghiberti's representation of Judith on the Gates of Paradise (Fig. 16.1), which was obviously for public display, Donatello's celebrated bronze group (Fig. 17.1), several examples from Botticelli and his circle (Fig. 16.2), a bronze statuette by Antonio del Pollaiuolo (Fig. 16.3), and two engravings attributed to Baccio Baldini (Fig. 16.4) all come from the private sphere or were clearly intended for reception in non-public, intimate environments.[9] Joining this group are several representations from *cassone* panels, including an example attributed to the Master of Marradi in the collection of The Dayton Art Institute (Fig. 16.5), and Andrea Mantegna's non-Florentine National Gallery of Art *Judith and Holofernes* (Fig. 16.6) that may have been owned by the Medici family and displayed in their palace.[10]

8 For the image of David in Florentine art, which was not strictly reserved to public imagery, see Gary M. Radke (ed.), *Verrocchio's David Restored: A Renaissance Bronze from the National Museum of the Bargello, Florence* (Atlanta, GA: High Museum of Art, 2003).

9 For the image of Judith in Florentine art, see Adrian W. B. Randolph, *Engaging Symbols: Gender, Politics, and Public Art in Fifteenth-Century Florence* (New Haven, CT, and London: Yale University Press, 2002), pp. 242–85. For Ghiberti's *Judith*, see Richard Krautheimer, *Lorenzo Ghiberti* (Princeton, NJ: Princeton University Press, 1982), p. 173; for Donatello's *Judith and Holofernes*, see H. Janson, *The Sculpture of Donatello* (Princeton, NJ: Princeton University Press, 1963), pp. 198–205; Roger J. Crum, *Retrospection and Response: The Medici Palace in the Service of the Medici, c. 1420–1469*, Ph.D. dissertation, University of Pittsburgh, 1992, pp. 110–38; for Botticelli and Botticelli circle images, see R. W. Lightbown, *Sandro Botticelli* (Berkeley, CA: University of California Press, 1978); for Pollaiuolo's *Judith*, see Alison Wright, *The Pollaiuolo Brothers: The Arts of Florence and Rome* (New Haven, CT, and London: Yale University Press, 2005), pp. 329–34; Patricia Lee Rubin and Alison Wright with Nicholas Penny (eds.), *Renaissance Florence: The Art of the 1470s* (London: National Gallery Publications, 1999), pp. 268–71; for Baldini, see Rubin, Wright, and Penny, *Renaissance Florence*, pp. 268–71; Randolph, *Engaging Symbols*, pp. 268–69; for Mantegna, see Fern Rusk Shapley, *Catalogue of the Italian Paintings* (Washington, DC: National Gallery of Art, 1979), pp. 296–97; Marco Spallanzani and Giovanna Gaeta Bertela (eds.), *Libro d'inventario dei beni di Lorenzo il Magnifico* (Florence: Amici del Bargello, 1992), p. 51: "Una tavoletta in una chassetta, dipintovi su una Giudetta chon la testa d'Oloferno e una serva, opera d'Andrea Squarcione." The name of Squarcione, another painter (like Mantegna) from Padua, was often confused with Mantegna.

10 Ellen Callmann, *Apollonio di Giovanni* (Oxford: Clarendon Press, 1974), p. 50, notes that Judith imagery became common on *cassone* chests in Renaissance Florence, especially after 1450, "when there is a marked upsurge in the expression of republican sentiment and opposition to tyranny." For The Dayton Art Institute *cassone* picture, see Roger J. Crum, "The Story of Judith and Holofernes," in *Selected*

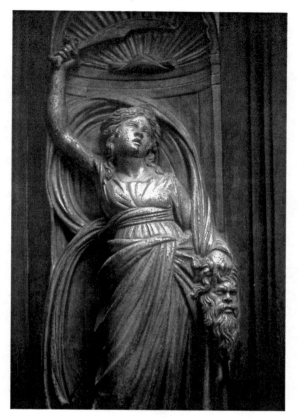

16.1. Lorenzo Ghiberti, Detail of Judith and
Holofernes from the *Gates of Paradise*, 1425–1452.
Baptistry, Florence, Italy. Photo credit: Timothy
McCarthy/Art Resource, NY.

Scholars have long advanced various political meanings for Florentine
images of David. As already noted they have predominantly focused on
seeing David as a protector figure for Florence against foreign aggres-
sion.[11] The same has been true with Judith imagery, but to a lesser extent,
and largely these interpretations have been formulated in relation to the

Works from The Dayton Art Institute Permanent Collection (Dayton, OH: The Dayton
Art Institute, 1999), p. 214.

11 For exceptions to interpreting David in relation to foreign aggression, see
Roger J. Crum, "Donatello's Bronze *David* and the Question of Foreign Versus
Domestic Tyranny," *Renaissance Studies*, 10 (1996), pp. 440–50; and Sarah Blake
McHam, "Donatello's *David* and *Judith* as Metaphors of Medici Rule in Florence,"
The Art Bulletin, 83 (2001), pp. 32–47.

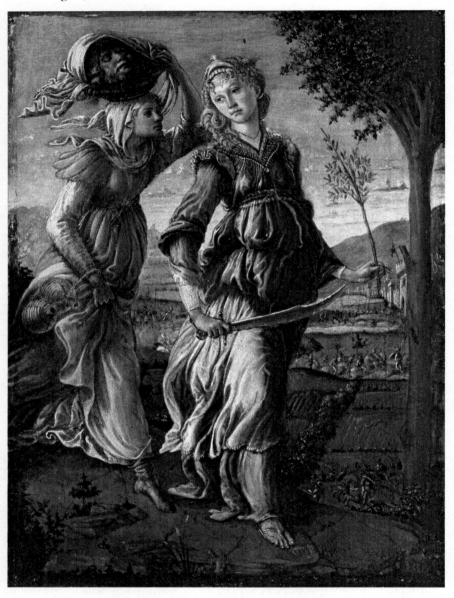

16.2. Sandro Botticelli, *Judith*, ca. 1472. Uffizi, Florence, Italy.
Photo credit: Scala/Art Resource, NY.

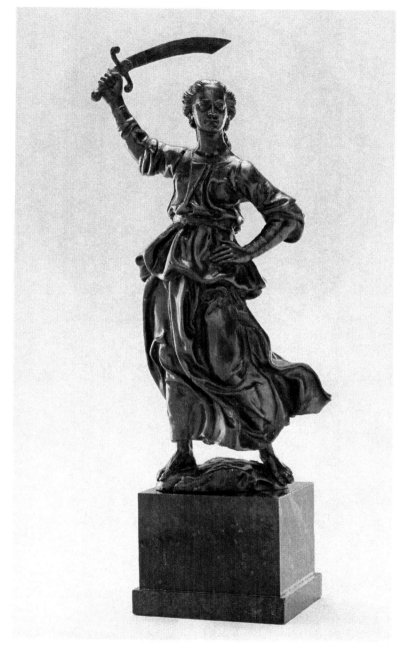

16.3. Antonio del Pollaiuolo, *Judith*, ca. 1470 (bronze with traces of gilding). The Detroit Institute of Arts/Gift of Eleanor Clay Ford, Detroit, MI. Photo credit: The Bridgeman Art Library.

16.4. Baccio Baldini, *Judith with the Head of Holofernes*.
The British Museum. Photo credit: © The Trustees of the British Museum.

16.5. The Master of Marradi, Florentine, *Judith and Holofernes*, 15th century.
The Dayton Art Institute, Dayton, OH. Photo credit: The Dayton Art Institute.

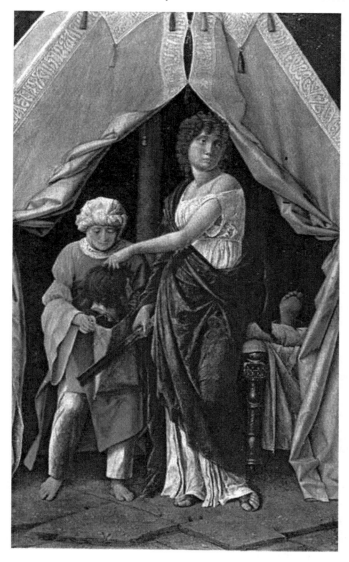

16.6. Andrea Mantegna, *Judith*, 1491. National Gallery of Art,
Widener Collection, Washington, DC. Photo credit: G.E.M.A.
(Grande Enciclopedia Multimediale dell'Arte).

quite obviously political and Medicean raison d'être of Donatello's *Judith and Holofernes*.[12] Beyond Medicean party politics, political meaning could be explored for these images through an acknowledgment that Florence (almost like the biblical Bethulia) was almost constantly at war between the late fourteenth century and 1454, the date of the Peace of Lodi, and intermittently thereafter. It was also a society that was quite familiar with the experience of siege warfare, or at least the threat of such.[13]

There is yet an additional area, beyond the specifics of Medicean politics, warfare, or siege situations, in which political meaning might be established for Judith imagery, especially in relation to the predominantly private and domestic nature of these works. That is in the area of the tensions experienced by the office-holding class of Florentines between their ambitions and obligations to serve the city publicly and their reluctance and anxieties about not extending themselves too boldly beyond the private sphere.

From the political commentary of Dante's *Divine Comedy* to the social castigations of Savonarola's sermons and Machiavelli's ruminations on the vicissitudes of political affairs in the city, it is clear that Florentines struggled to define the balance of the public and private in their lives. Mindful of any dangerously assertive projection of the self into an always volatile body politic, Florentines lived lives that were defined by cautious advances and hasty retreats across the permeable though fortress-like membranes of their domiciles.[14] Even a cursory examination of Florentine politics through the formative years of the republic is sufficient to reveal that the development of civic humanism, particularly in the late fourteenth and early fifteenth centuries with its prescriptions for public engagement and its support for the common good, was more an aspiration for an ideal state of affairs than a direct reflection of a much less attractive reality.[15] Less an "Athens on the Arno," Florence was a problematic, suspicious environment in which even – or perhaps especially because – Florentines were never quite certain or confident that there truly existed

12 See Crum, *Retrospection and Response*, pp. 110–138; McHam, *The Art Bulletin*, 83 (2001), pp. 32–47; and Sarah Blake McHam's essay in this volume (Chap. 17).

13 Najemy, *A History of Florence*, pp. 188, 190. For the relationship between Florentine culture and what might be called a "siege" mentality, see Hans Baron, *The Crisis of the Early Italian Renaissance* (Princeton, NJ: Princeton University Press, 1955).

14 See Roger J. Crum and John T. Paoletti, "... Full of People of Every Sort: The Domestic Interior," in Crum and Paoletti (eds.), *Renaissance Florence*, pp. 273–91.

15 For the classic explication of civic humanism, see Baron, *The Crisis*.

a definable or definably safe separation between the public and private dimensions of their lives.[16]

This problem came to a head in the fifteenth century as the private identity and motivations of the Medici family steadily and problematically blurred with their public ambitions for running of the city. On his deathbed Giovanni di Bicci de' Medici is reported to have urged his sons Cosimo and Lorenzo to maintain always a low public profile and to go to the Palazzo della Signoria only when summoned.[17] Nevertheless, the contemporary chronicler Giovanni Cavalcanti was quick to point out, surveying the whole of the problematic Florentine political landscape both before and after the rise of the Medici, that decisions of the republic were as often made at dining tables than in the proper halls of government.[18] Cosimo de' Medici would become famous for his ready protestations throughout his political career that he was little more than a private citizen, but such protestations were to no avail as contemporaries – most alarmingly those within the Medici party itself – increasingly voiced concern that the family was operating tyrannically beyond the private realm in the interest of subjugating to its factional will the common good of the city.[19] The dramatic rise of Savonarola and the events surrounding the eventual expulsion of the Medici from Florence in 1494 are the culmination of this sentiment in the late fifteenth century.[20] This was only followed by the great sculptural punctuation of this theme of tyrannical suppression in the early sixteenth century by the installation of Michelangelo's *David* before the Palazzo della Signoria.[21]

The rise of the Medici and their associates, and the mounting public anxiety surrounding their gradual and problematic merging of the public

16 For these tensions and anxieties within the city, see particularly Nicolai Rubinstein, *The Government of Florence under the Medici (1434–1494)*, 2nd edition (Oxford: Clarendon Press, 1997); Dale Kent, *The Rise of the Medici: Faction in Florence, 1426–1434* (Oxford and New York: Oxford University Press, 1978).

17 Crum, *Retrospection and Response*, p. 27.

18 Giovanni Cavalcanti, *Istorie fiorentine*, ed. F. Polidori, 2 vols. (Florence: Tip. All'insegna di Dante), 1838–39.

19 For Cosimo's political character and concerns, see Dale V. Kent, *Cosimo de' Medici and the Florentine Renaissance: The Patron's Oeuvre* (New Haven, CT, and London: Yale University Press, 2000). For the Medici and problems within their own party, see Arthur Field, *The Origins of the Platonic Academy of Florence* (Princeton, NJ: Princeton University Press, 1988).

20 For Savonarola and his influence on Florentine politics, see Donald Weinstein, *Savonarola and Florence: Prophecy and Patriotism in the Renaissance* (Princeton, NJ: Princeton University Press, 1970).

21 See Charles Seymour Jr., *Michelangelo's David: A Search for Identity* (Pittsburgh, PA: University of Pittsburgh Press, 1967).

and the private, coincide with the aforementioned concentration of Judith imagery in Florentine art. This is unlikely to have been purely coincidental. While it is always risky to align broad political developments with specific religious imagery in specific examples of art, at least two aspects of the Judith story do correspond with notable contemporary anxieties to the extent that we can reasonably venture a suggestion that Florentines could have been both aware of and motivated by these factors when commissioning, collecting, or viewing such works of art. The first is that the biblical Judith is clearly a tyrant killer, a suppressor of Holofernes's overweening pride. Since Florentines of the patrician class were deeply sensitive to the issue of pride and its negative repercussions for the political process, it is reasonable to assume that this awareness stood somewhat behind their commissions of Judith imagery.[22] The second, as noted above, is that Judith notably redomesticates herself after her heroic act, and in so doing preserves the balance of the private and the public in her life and, most importantly, in the life of Bethulia. The sword of Judith running through Florentine imagery would thus seem at once to have presented this society – and the Medici and their associates in particular – with an awareness of the problematical realities and seductions of extending oneself into the public sphere (the prideful and tragic example of Holofernes) and a possible resolution of the private–public dilemma (the dutiful Judith with her willingness to return home and not assume further powers).[23]

The history of Donatello's *Judith and Holofernes* points the way toward examining this broader dimension and anxiety in Florentine society between the private and the public. That Donatello's statue was originally a domestic work for the interior garden of the Medici Palace, and was only later transferred to the public Piazza della Signoria upon the family's expulsion in 1494, makes it the exception – or an anomaly within the history of one work – that proves the generally private role of Judith imagery in Florence. But it is the exception that pointedly brings forward the tensions within that society between the private and the public. It would even seem that the Medici, when first they owned and displayed the work, may have consciously played upon the public and private dimensions and ten-

22 For the relationship among pride, discord, and the Medici party in the mid-fifteenth century, see Field, *The Origins of the Platonic Academy*.

23 For a similar instance in which an iconography of a tyrant killer is directed to an internal as opposed to an external audience in Florence, see Crum, "Donatello's Bronze *David*."

sions of the Judith story by positioning the work in such a way that it could have been visible at times along the axis that ran from the street entrance of the building to the back garden where the statue was located.[24] As we have reviewed, the Medici ascent in Florentine politics and society witnessed that family and its principal members constantly, carefully, and craftily maneuvering back and forth between their public roles and private retreats. An image like Donatello's *Judith and Holofernes*, with its reference to a story in which the heroine herself moves from the private, to the public, to the private again, could only have resonated as a form of political self portraiture *and* wise self protection of the Medici against their detractors by means of the biblical model. By killing Holofernes Judith saved Bethulia from the prospect of tyranny at the hands of the Assyrians and then assiduously withdrew herself from the possibility of replacing that threat with any form of domination or rule of her own. The Medici, it seems, constantly had this lesson before them in the form of Donatello's *Judith and Holofernes* and did, at least for a period, hold at bay a disastrous conflation of the public and private in their political lives.

What is particularly striking about how the Medici dealt with this issue of the private and the public in Donatello's statue is that they plainly dealt with it head on, cleverly raising the issue of the tension *themselves* that animated and disturbed their contemporaries, only to distance themselves simultaneously from the taint of any culpability. In other words, they took the fight directly to the enemy (largely members of their own political party who were inclined toward disaffection with the leading family and who regularly visited the Medici Palace to conduct business with the family) and diffused the issue in no uncertain terms. Of course, the Medici did this with the theme of the statue itself, a tyrannicide, but this they underscored by accompanying the work with the following inscription that dealt with the suppression of pride, the very vice that might lead the family to succumb to private interests at the expense of the common good: "Regna cadunt luxu surgent virtutibus urbes caesa vides humili colla superba manu" (Kingdoms fall through luxury, cities rise through virtues; behold the neck of pride severed by the hand of humility).[25]

24 Francis Ames-Lewis, "Art History or *Stilkritik*? Donatello's Bronze *David* Reconsidered," *Art History*, 2 (1979), pp. 139–55; G. Cherubini and G. Fanelli (eds.), *Il Palazzo Medici Riccardi di Firenze* (Florence: Giunti, 1990); and Crum, *Retrospection and Response*, pp. 110–38.

25 For this inscription, see Roger J. Crum, "Severing the Neck of Pride: Donatello's *Judith and Holofernes* and the Recollection of Albizzi Shame in Medicean Florence," *Artibus et Historiae*, 22 (2001), pp. 23–29.

Elsewhere I have discussed how the theme of the suppression of pride with humility and, by extension, the matter of private interests subordinated to the common good was not limited to Donatello's statue but ran as a *leitmotif* through several works in the main reception spaces of the Medici Palace.[26] In this linking of imagery and theme through the semiprivate/semipublic spaces of the palace, there is ample evidence to support why the redomestication of Judith in Donatello's statue would not have been an insignificant aspect of the story to the Medici and their associates. As noted above, the Medici faced periodic challenges and charges, from both within and beyond their immediate associates in their party or faction, that the family was assuming too much power in the city. Judith, as a tyrant killer and, most importantly in this context, as an exemplar of an heroic figure who serves but both withdraws and reserves power for others, would definitely have served the Medici as a suitable antidote to charges that the family was overextending its role in the city and treading dangerously on the public prerogative. In this regard, it is perhaps not insignificant that Donatello's *Judith* was paired in the Medici Palace with the sculptor's equally celebrated bronze *David*. The iconography and presentation of that group are extraordinary, and scholars have long been at pains to interpret the singular uniqueness of David's modest, withdrawn, and even distant demeanor in this work when compared to more triumphant presentations of the Old Testament hero boy in works by the youthful Donatello, the mature Verrocchio, and the young Michelangelo. Perhaps the answer to this particular iconographic enigma in Donatello's bronze *David* is that the sculptor and his patrons – in both the bronze *David* and the *Judith and Holofernes*, in which Judith similarly has a distant expression – were intent upon emphasizing more of the reserve than the assertiveness of the family in the public eye and arena of Florentine politics.

26 Crum, *Retrospection and Response*, pp. 139–64; Roger J. Crum, "Roberto Martelli, the Council of Florence, and the Medici Palace Chapel," *Zeitschrift für Kunstgeschichte*, 59 (1996), pp. 403–17. A focus on pride and its suppression was not limited to Donatello's *Judith and Holofernes* and other examples of the visual arts in the Medici Palace. Notably, Lucrezia Tornabuoni, the wife of Piero de' Medici and the mother of Lorenzo the Magnificent, composed a *sacra rappresentazione* on the Old Testament heroine Judith and gave particular focus to the issue of pride in those writings. That Lucrezia was writing on Judith in the pivotal years between her husband Piero's control of the Medici party and her son Lorenzo's ascension to power after 1469 – years that very much tested the Medici's ability to balance the public–private dimensions in Florentine politics – is clearly significant. For Lucrezia's writings, see Tylus (ed.), *Lucrezia Tornabuoni: Sacred Narratives*, pp. 118–62; Fulvio Pezzarossa (ed.), *I poemetti sacri di Lucrezia Tornabuoni* (Florence: Olschki, 1978).

While it would be useful to have similar corroborating evidence for what may have motivated other patrons and collectors of other Judith imagery in fifteenth-century Florence, such does not exist. We simply have the objects, but we do know that they belonged to a class of people who were contemporaries of the Medici, often social equals to that dominant family, and perhaps even on occasion political associates of Cosimo, his son Piero, and Piero's son, Lorenzo the Magnificent. If even one of these categories includes those individuals who were responsible for the other representations of Judith in Florentine art, it is clear that we are dealing with people whose period mentality operated very much with a level of comfort in fronting and defusing the problem of the private–public tension in Florentine society and politics. Just as the Medici seem to have addressed this matter directly in Donatello's *Judith and Holofernes*, the bronze *David*, and other works in their palace, so too their contemporaries may well have regarded it as prudent public posturing to emphasize similar private reserve by commissioning and collecting, contemplating, and asking others to contemplate, images of Judith in the private interiors of their often public palaces.

As indicated, our best circumstantial evidence that these images of Judith may somehow have been drawn into contemporary concerns about tyranny and liberty and of the overextension of a family's private concerns into the public arena comes from the vicissitudes in the political fortunes of the Medici family. Yet increasingly Lorenzo the Magnificent and, after his death in 1492, his son Piero so notably set aside any anxiety about holding any untoward advances into the public arena in check. The result must certainly have been that whatever may have originally motivated the iconography of Donatello's *Judith and Holofernes* – and here I have suggested that it was pointedly to emphasize that Judith is heroic but is also a heroine who ultimately maintains the balance between the private and the public – that iconography had to have increasingly rung hollow and hypocritical as the house of the Medici and the house of the Florentine state became ever more one in the later years of the Medici regime in the fifteenth century. This very evident folding into one another of the private and the public, denounced by contemporaries in their charges of tyranny, came to a head in 1494 when Piero di Lorenzo de' Medici was expelled from Florence on a wave of republican fervor and Savonarolan prophecy. That the Medici eventually so perverted the balance between the private and the public may go far in explaining why Donatello's *Judith and Holofernes* was thereafter confiscated

and placed *outside* the Florentine Palazzo della Signoria. Notably, the sculptor's bronze *David*, also from the Medici Palace where it had been located in the courtyard, was installed in the more private reaches *within* the same public edifice. Only the Florentine patriciate, deeply familiar as it was with the history and meaning of Judith and David imagery in the city, could have appreciated the biting irony of this "inverted" installation. It seems that in order to drive home the point that the Medici had offered both hollow rhetoric and deceitful actions with regard to the balance of the private and the public, the Florentines needed Judith to remain, at least for a period, on guard and in the public eye. That period soon turned into permanency with Donatello's *Judith and Holofernes* never actually returning home to Bethulia as all images of Judith and Holofernes had variously implied when, in the earlier, halcyon days of the Florentine republic and the Medici regime, there was still a glimmer of optimism (or merely a looking the other way in self-deception) that one's privately driven actions and one's model in the biblical, public-spirited heroine were in honorable alignment.

17. Donatello's *Judith* as the Emblem of God's Chosen People

Sarah Blake McHam

This essay addresses the different symbolic resonances that Donatello's *Judith and Holofernes* (Fig. 17.1) acquired when, in 1495, the newly reinstated Florentine Republic appropriated it from the Palazzo Medici, changed the inscriptions on the base, and transferred the ensemble to the *ringhiera*, the elevated platform that fronts the wall of the Palazzo della Signoria, the city's center of government. These events, which occurred less than a year after the Medici family had been expelled from power, reveal that the regime recognized that the statue could be converted into a potent political symbol of its ideology.

On the most obvious level, the confiscation of a statue that had been prominently displayed in the garden of the Palazzo Medici was a sign of the new Republic's triumphant termination of Medici rule. Republican triumph also attended the simultaneous removal to the town hall of Donatello's bronze *David* (Fig. 17.2), a statue that had stood in the Palazzo Medici's courtyard near the *Judith* in the adjacent garden. Although the circumstances of their commissions are still somewhat unclear, the two statues had constituted a *de facto* pair: they were the only two modern free-standing sculptures displayed in the outdoor spaces of the Medici Palace for three decades, from ca. 1464/6–1495.[1]

The reinstated Republic had further reasons to move the sculptures to the commune's center. Although the inscriptions the statues had borne

1 For a summary of the problems about the commissions and their dates, see Sarah Blake McHam, "Donatello's *David* and *Judith* as Metaphors of Medici Rule in Florence," *Art Bulletin*, 83 (2001), p. 32.

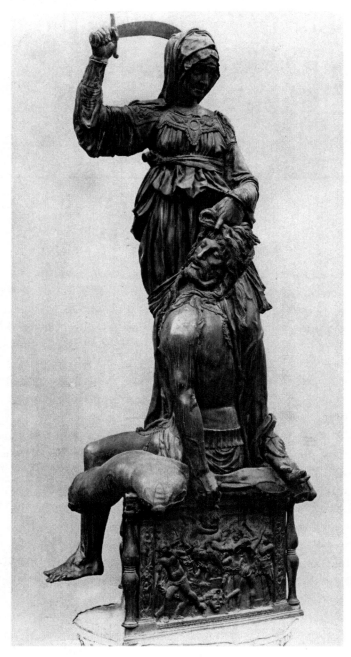

17.1. Donatello, *Judith and Holofernes*, 1457–64. Palazzo della Signoria, Florence, Italy. Photo credit: Scala/Art Resource.

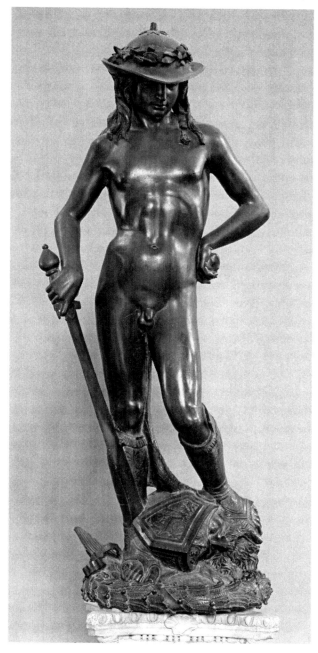

17.2. Donatello, bronze *David*, late 1430s?.
Museo Nazionale del Bargello, Florence, Italy.
Photo credit: Erich Lessing/Art Resource, NY.

in the Palazzo Medici were effaced, they both still recalled their former associations, which I argued in a previous article emphasized the two Old Testament heroes as tyrant-slayers.[2]

Originally, both bronzes evoked republican themes that the Medici aimed to embrace and co-opt. The associated meanings of the *Judith and Holofernes* and the *David* were signaled by their related inscriptions. The one once on the *David* read: "The victor is whoever defends the fatherland. God crushes the wrath of an enormous foe. Behold! A boy overcame a great tyrant. Conquer, O citizens!"[3]

David's identification as a tyrant-slayer was corroborated by the statue's obvious relation to Donatello's earlier commission of the same theme, his marble *David*, which an earlier republican regime had ordered installed in the Palazzo della Signoria in 1416. It was inscribed: "To those who bravely fight for the fatherland God will offer victory even against the most terrible foes."[4] Such a political interpretation of David was unusual. Although the Old Testament figure's identity as a victorious warrior has become familiar through such later sculptures as Michelangelo's colossal *David*, we overlook that before Donatello's marble sculpture almost every representation of David interpreted him in other ways, as a king, prophet, writer of the Psalms, or ancestor of Christ.

Unlike David, Judith had never been associated with Florence, even though the textual source, the apocryphal Old Testament Book of Judith, lent itself to a political interpretation: it recounted the tale of Judith's salvation of the Jews from the armies of Nebuchadnezzar to inspire Jewish patriotism. In the medieval period Jewish and Christian writers alike interpreted Judith as a moral, religious, and political heroine. In Christian symbolic thought her victory over Holofernes was elaborated as the triumph of virtue, specified variously as self-control, Chastity, or Humility, over the vices of Licentiousness and Pride. Associations with these virtues meant that Judith came to be regarded as a type of the Virgin and of the Church.

Donatello's depiction of *Judith and Holofernes* continues these traditions. Judith's virtue is indicated by the demure clothing and veil that cover her from head to toe while Holofernes, in contrast, is almost naked. His nudity, drunkenness, and the cushion on which he is propped identify Holofernes as a figure of Lust and Licentiousness whereas Judith represents Chastity. The medallion, which has swung around to Holofernes' slumping bare

2 Ibid., pp. 32–47.
3 Ibid., p. 32.
4 Ibid., p. 34.

back, depicts a galloping horse, symbolic of Pride or Superbia, the vice traditionally defeated by Humility, represented by Judith. Her valiant act of decapitating Holofernes is dramatically emphasized by Donatello, who created the first (and only) representation in monumental sculpture of this moment. Equally unprecedented is Donatello's narration of the actual killing. The moral meaning of the decapitation is underscored by the inscription recorded on the base while the statue was in the Palazzo Medici's garden: "Kingdoms fall through luxury [sin], cities rise through virtues. Behold the neck of pride severed by the hand of humility."

I contended that the *David* and the *Judith and Holofernes* drew on descriptions of the Athenian statue group called the *Tyrannicides* and on the writings of the twelfth-century English theologian John of Salisbury to create a visual rhetoric insinuating a controversial, self-serving message. They were to suggest that the Medici's role in Florence was akin to that of venerable Old Testament tyrant slayers and saviors of their people, symbolically inverting the growing chorus of accusations that they had become tyrants.[5]

The removal of Donatello's bronze *David* to the government center complemented the political associations of Donatello's own marble *David* situated on the palace's second floor and Verrocchio's bronze *David*, commissioned by the Medici family, but sold to the government it controlled. Verrocchio's *David* was placed on the landing just outside the priors' audience hall when that space was renovated in 1476.[6] These three sculptures were soon joined by the colossal marble that the Republic commissioned from Michelangelo (1501–4), installed on the *ringhiera*.

The decision to create a cohort of four sculptures of *David* inside and outside the palace makes clear the important role that Old Testament characters played in the identity the republican government was constructing for itself. In part the link with David evoked the regime's connection with the earlier period of republican rule in Florence. The statues connoted, however, more than continuity with the past and victory over the Medici. Most important, the depiction of the youthful David served to symbolize the Republic's desire to present the city under its rule as chosen by God, just like David and his people, and protected against every powerful enemy.

In *Judith*'s new situation in front of the Palazzo della Signoria, the statue fulfilled the same purpose. The statue's base was reinscribed, "Exemplum sal[utis] pub[licae]. Cives pos[uerunt] MCCCCXCV" (An exemplar of the

5 Ibid., pp. 36–41.
6 See Andrew Butterfield, *The Sculptures of Andrea del Verrocchio* (New Haven, CT: Yale University Press, 1997), pp. 204–05.

public good. The citizens installed it here in 1495). It identified Judith's deed as an exemplary model and emphasized that a government in which the citizenry fully participated had decided on its placement. It implied the Republic's unified endorsement of Judith's divine role as a savior of Florence. The new inscription evoked a stock Roman republican phrase, well known in the Renaissance through Cicero's maxim "the safety, security, or well-being of the public is the highest law" (*salus publica* suprema lex esto), linking the Florentine Republic to its most illustrious precedent.

Both statues' messages, that God's agent would be victorious over tyranny, were not only directed against the recently overthrown Medici regime (which still had many adherents), but they also symbolized the Republic's future direction. Specifically militant meanings associated with Judith were new in late-fifteenth-century Florence, but her imagery had a political history elsewhere that must be reviewed to understand the statue's transfer to the *ringhiera*.

Early patristic writers had remarked not only on Judith's feminine virtues of chastity, humility, and piety; some had emphasized that she embodied a bravery and wisdom surpassing her gender that made her a model of statesmanship. The key figure in this political interpretation is Hrabanus Maurus, the Abbot of Fulda, who, in the early 830s, presented the Carolingian empress Judith with commentaries he had written on the Book of Esther and the Book of Judith.[7] In an accompanying letter, he praised the empress for having already conquered most of her enemies by her prudent decisions and deeds and offered his commentaries as a helpful source of further sagacious and inspiring counsel. The empress, the second wife of Charlemagne's son Louis the Pious and the mother of Charles, the future king of the west Frankish kingdom, had been accused of adultery and twice sent into a monastery to do penance. The controversy had caused such dissension within Charlemagne's family that the dynasty was imperiled.

Hrabanus Maurus cited Jerome's preface to the Book of Judith as the source of his interpretation of Judith as a model of prudence. In the intervening four centuries since Jerome had composed the Vulgate, no Christian writer had written a commentary on the Book of Judith, perhaps because the book was not a universally acknowledged part of the Christian apocrypha. The abbot's commentary helped to establish it in the Christian canon. Although Hrabanus Maurus alluded to theological authorities, he

7 Mayke de Jong, "Exegesis for an Empress," in Esther Cohen and Mayke De Jong (eds.), *Medieval Transformations: Texts, Power, and Gifts in Context* (Leiden: Brill, 2001), pp. 69–100.

elaborated his own readings. He praised Judith and Esther above all for the mental vigor, maturity, and prudence that had allowed them to vanquish their spiritual and physical foes, and acclaimed them as apposite models for both male or female rulers.

His political interpretation of Judith had an important afterlife in Christian thought. In the twelfth century it encouraged John of Salisbury to cite her as an exemplar of justified tyrannicide in the *Policraticus*, his widely circulated treatise that inspired righteous citizens to a number of assassinations in later centuries.[8] Hrabanus Maurus's commentary also led to a less specific reading of Judith as a symbol of just punishment not only for tyrants, but for other criminals against the state.

The evolution of this alternative emphasis can be traced in text and imagery; given our focus, analysis is limited to Tuscany. The treatise *Li Livres dou Tresor*, written in the 1260s by Brunetto Latini, is crucial. Latini, forced to leave his native Florence when the Holy Roman Emperor Manfred defeated the city's Guelphs at Montaperti (1260), spent the next seven years in France, returning when news reached him of Manfred's death and the Ghibelline defeat in Florence. Throughout the rest of his life, he served the newly established Florentine Republic, modeled on that of ancient Rome, and was mentor to Dante.[9] Latini's book, a compendium of science, ethics, rhetoric, and practical politics, was often recopied and translated.[10]

Book one dealt with world history, which Latini began at the Creation and summarized in brief biographies of its heroes, including Judith ("the valiant woman ... stronger than any man"),[11] David, and Solomon.[12] Latini dedicated the second book to the "active" or cardinal virtues, as they dictated ethics. In his opening words, he alerted the reader that his authority was Aristotle,[13] but to support his theoretical analysis, he cited other experts, among whom Cicero, Seneca, and Solomon were favorites. Latini never made analogies to specific persons who exemplified the virtues. As a result, he did not engage the Christian tradition of Judith as a model of prudence, even though, like Aristotle, he stressed prudence's primacy,

8 McHam, "Donatello's *David*," pp. 39–41.
9 Brunetto Latini, *Li Livres dou Tresor*, ed. Spurgeon Baldwin and Paul Barrette (Tempe, AZ: Arizona Center for Medieval and Renaissance Studies, 2003), pp. ix–xi.
10 Ibid., pp. xii–xiv. Latini abridged the text as a poem in Italian; see Brunetto Latini, *Il Tesoretto*, ed. Julia Bolton Holloway (New York: Garland, 1981).
11 Latini, *Li Livres*, p. 37.
12 Ibid., pp. 32–33.
13 Ibid., p. 153: Latini prepared to explain his ethical system with the words "ci commence Etique Aristotes."

because its control of rational thought "illuminated" the path to fortitude, temperance, and justice, the other virtues.[14] Latini went beyond Aristotle, however, to address the punishment of vices and crimes.[15] The Greek had not considered man's primordial nature, leaving Latini to depend on Seneca, and other pagan and Christian Latin authors.[16] He concluded that "superbia," or overweening pride, was the prime cause of the sins considered crimes in society.[17] Latini adhered to his principle of abstract argumentation and did not adduce historical examples. Latini applied his theoretical analysis to practical ends. He contended that the commune was the ideal government. Administered by an elected leader and representatives, chosen for their virtues, above all prudence, they would serve to uphold the common good through the rule of law and just punishment accorded wrong-doers.[18]

Between 1338 and 1340 this system of "good government" was immortalized in fresco by Ambrogio Lorenzetti on the walls of Siena's Palazzo Pubblico, and contrasted to the rule of a diabolic tyrant on the adjacent wall through allegorical personifications and cityscape vistas. The painter portrayed a massive leader who epitomizes the "common good" paramount in his administration of the commune, flanked by personifications of the active virtues. Prudence sits beside him in the place of honor on his right; Temperance, Fortitude, and Justice, are nearby. The seated figure of Justice holds a sword and the decapitated head of a bearded man rests on her lap, suggesting Judith and Holofernes. On the same bench sits Magnanimity, a secondary virtue in Latini's system,[19] and Peace, the necessary condition for states to flourish. Another personification of Justice (Fig. 17.3), the second-largest figure in the hieratically arranged allegory, balances him on the fresco's other side. She holds her traditional sword and scales, which are connected by ties to the city's elected officials. On Justice's scale, an angel

14 Ibid., pp. 152–53. Following his conceit that his book was a treasure chest of jewel-like virtues, Latini identified prudence as the primary virtue, the carbuncle that illuminated the night and all other jewels, such as temperance, a sapphire; fortitude, a diamond; and justice, an emerald, in that order; see ibid., pp. 226–38 and 249–61, for further explanation.

15 Ibid., pp. 382–83, for Latini's statement that government officials must punish or absolve criminals in order to maintain the common good ("la chouse dou comun").

16 Quentin Skinner, "Ambrogio Lorenzetti: The Artist as Political Philosopher," *Proceedings of the British Academy*, 72 (1986), pp. 16–20.

17 Latini, *Li Livres*, pp. 288–89.

18 Ibid., pp. 363–91.

19 Ibid., pp. 239–41.

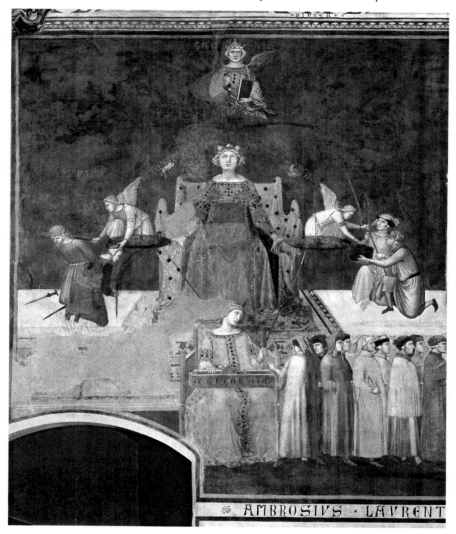

17.3. Ambrogio Lorenzetti, Justice, from *Allegory of the Good Government*, 1338–40. Palazzo Pubblico, Siena, Italy. Photo credit: Scala/Art Resource, NY.

epitomizing divine retribution punishes bound criminals by decapitation while another rewards good citizens. Although her action evokes Judith's slaying of Holofernes, and the pictorial allegory's emphasis on justice proceeding from prudence recalls Judith as a model of that virtue, the figure's wings identify her as an angel.[20] This first monumental visualization of "distributive justice," the execution of fair punishment, is directly inspired by Latini's treatise, whereas most other aspects of the program have their roots in Aristotelian thought.[21]

The third Tuscan landmark in the evolution of Judith's political identity occurred in 1464, about when the Medici commissioned Donatello's *Judith* for their palace garden. It is a fresco by an anonymous artist on the walls of the government center in Lucignano, a small subject city in the Sienese territory (Fig. 17.4).[22] There she joined an extensive cycle of mainly male pagan, biblical, and historical figures, all identified by accompanying inscriptions.[23] The ensemble confronts the *Madonna, Child, and Saints* on the opposite wall. The combination repeats the arrangement and iconography of Siena's town hall where Simone Martini's *Maestà* is on the walls of a room next to that decorated by Ambrogio Lorenzetti's frescoes contrasting the virtues and benefits of good government's just rule with the vices and mayhem of tyranny.

20 In the fifteenth century, Judith's attribute, the decapitated head of Holofernes, continued to be subsumed into the personification of Justice who holds it and a sword, as on the tomb of Raffaele Fulgosio (1367–1427), an important law professor and jurist in the Santo, Padua, carved between 1429 and 1431. The figure, which appears alongside Prudence and Charity, is illustrated in Wolfgang Wolters, *La Scultura veneziana gotica 1300/1460*, 2 vols. (Venice: Alfieri, 1976), 2, figs. 578–80. Significantly, it reappears in a civic context (the large sequence of virtues on the balcony of the Palazzo Ducale), Venice; see ibid., figs. 491–93. I thank Elena Ciletti for reminding me of the relevance of these monuments. Historians have argued whether a number of important later commissions such as Giorgione's painting (Hermitage, St. Petersburg), usually called *Judith*, and Titian's figure once on the Fondaco dei Tedeschi, Venice, should be identified as Judith or Justice, generally arguing against a conflation of their identities. See most recently, Paul Joannides, *Titian to 1518; The Assumption of Genius* (New Haven, CT: Yale University Press, 2001), pp. 59–68. These naysayers are unaware, however, of the history traced here that justifies the conflation in the context of civic law and justice.
21 See Skinner, "Ambrogio Lorenzetti," pp. 1–56.
22 See Christiane L. Joost-Gaugier, "Dante and the History of Art: The Case of a Tuscan Commune Part I: The First Triumvirate at Lucignano," *Artibus et Historiae*, 11 (1990), pp. 15–30, and "Dante and the History of Art: The Case of a Tuscan Commune. Part II: The Sala del Consiglio at Lucignano," ibid., pp. 23–46. I thank Elena Ciletti for bringing these articles to my attention.
23 The thirty-one heroes range from Noah to Constantine the Great. The only other woman included is the Roman Lucretia.

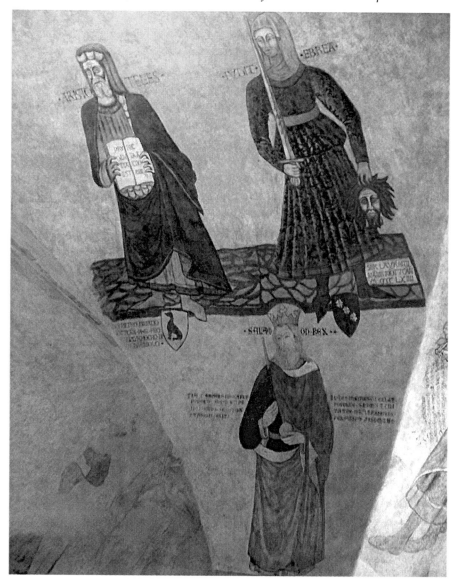

17.4. Anonymous, Fresco of Judit Ebrea, Aristotle, and Solomon, ca. 1463–65. Palazzo del Comune, Lucignano, Italy. Photo credit: Elena Ciletti.

Clearly identified by the inscription "Iudit Hebrea," Judith wears a widow's veil that demurely covers her hair and carries a bloody sword and Holofernes's bearded head. Judith is isolated on a cove of the room's barrel vault alongside Aristotle, who opens his book toward viewers so that they can easily discern its inscription, which translates: "Prudence is the right action." It is the guiding principle of his *Nicomachean Ethics* and appropriate to Judith, its Christian exemplar. Solomon, who stands below the pair, is accompanied by the inscription "Salamon Rex" and partially obliterated verses that underscore his wisdom and prudence in ruling his people.[24] This visual articulation of civic justice derives from Dante, who alluded to all the figures in Lucignano's elaborate cycle.[25] I contend that it also evokes the concept of legitimate punishment conceptualized by Dante's mentor Latini and Lorenzetti's imagery of it. In the late Cinquecento, Lomazzo described the appropriate tradition of representing Judith at public sites of justice,[26] so there are likely other components to the textual and visual development of Judith's identity as the exemplar of prudence executing all aspects of civic justice. Nevertheless, the cycle in Lucignano crystallizes the connections and demonstrates their vitality in fifteenth-century Tuscany.

This tradition of Judith's Christian political interpretation proves that the Republic intended Donatello's statue to mean more than victory over the Medici, and hence over a regime it deemed tyrannical. It intended the *Judith* to recall her identity as a model of prudent statesmanship and just punishment, and the role of the first Republic of Florence's statesman Brunetto Latini in shaping that interpretation.

The transfer of *Judith* accorded as well with themes popularized by the regime's most influential spokesman, the reactionary Dominican Savonarola, in his stream of sermons and writings.[27] Savonarola excoriated Medici rule as an ungodly tyrannical regime. After their ouster from power in 1494, he prescribed the ideal government for the city, a representative government that would guard against tyranny.[28] He exhorted Florentines to take up a

24 See the description and transcribed inscriptions in Joost-Gaugier, "Sala del Consiglio," p. 37.

25 See ibid., pp. 37–38, for this conclusion.

26 Gianpaolo Lomazzo, "Trattato dell'arte de la pittura," in Roberto Ciardi (ed.), *Scritti sulle arti*, 2 vols. (Florence: Marchi & Bertolli, 1974), 2, p. 298.

27 Matthias Krüger, "Wie man Fürsten empfing. Donatellos *Judith* und Michelangelos *David* im Staatszeremoniell der Florentiner Republik," *Zeitschrift für Kunstgeschichte*, 71 (2008), pp. 481–96, which also addresses Savonarola's sermons in regard to these sculptures, appeared too late for me to take it into account.

28 Savonarola condensed these constant themes of his sermons in the "Treatise on the Rule and Government of the City of Florence" (1498?), translated in Anne Borelli

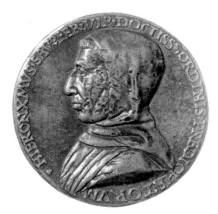

17.5. Niccolò Fiorentino, style of (Ambrogio & Mattia della Robbia?): Girolamo Savonarola, Dominican Preacher [obverse]; Italy Threatened by the Hand of God [reverse], ca. 1497. National Gallery of Art, Samuel H. Kress Collection, Washington, DC. Photo credit: © 2008 Board of Trustees, National Gallery of Art, Washington, DC.

larger role, which he characterized as their divinely appointed mission to purify Italy from personal sin and clerical corruption. Preaching to over-flow audiences, Savonarola railed against tyranny and immorality, assuring his listeners that Florentines could supplant the Jews as God's chosen peo-ple, to whom God would ensure victory over evil, no matter what the odds. Savonarola encouraged them to go beyond cleansing God's city of Florence to purging God's temple of enemies like the dissolute Pope Alexander VI Borgia, then reigning in Rome, assuring his audience of God's support.

The preacher typically built series of sermons around books from the Old Testament. He went through them line by line in order to develop moral teachings and prophetic ideas pertinent to his current context. Savonarola favored the books written by the Jewish prophets, implicitly linking his predictions about Florence to their visions of a faithful Israel's messianic redemption punctuated by dire warnings about disobedience to God and his messengers.

The cycle of sermons he launched in November 1494, days before the Medici were expelled, was based on the Book of Haggai and Psalms. He threatened Florentines into action through references to his vision of God's sword hanging over them.[29] It became his subject in a sermon on the Book

and Maria Pastore Passaro (eds.), *Selected Writings of Girolamo Savonarola. Religion and Politics, 1490–1498* (New Haven, CT: Yale University Press, 2006), pp. 176–206.
29 The sermon, titled "Behold, the Sword of the Lord over the Earth Soon and Swiftly," is translated in ibid., pp. 59–76.

of Psalms, delivered the following January. A portrait medal cast ca. 1497 (Fig. 17.5) reveals that the prophecy had become his symbol. Reminding Florentines that three years earlier he had predicted a wind that would shake mountains, Savonarola explained that wind as the French invasion that had already blown over Italian states (like Milan). He cautioned that God's sword would deliver a punishing blow if Florentines did not heed his vision of the city's role in the divine plan. Haggai's prophecies about the reconstruction of the Temple of Jerusalem became the pretext for further pleas that Florentines repent their sins and rebuild Florence as the city of God.

Although Savonarola never based a sequence of sermons on the Book of Judith, he alluded to her. I shall focus on the sermons he delivered on the Book of Ezekiel in the Duomo during Advent 1496, about a year after Donatello's *Judith* had been transferred to the Palazzo della Signoria.[30] Savonarola understood Judith's connection to Ezekiel: her story and his prophecies were supposed to have occurred during Nebuchadnezzar's reign, and Judith's salvation of the Jews averted another destruction of the Temple in Jerusalem and enslavement such as Ezekiel described. The ways in which Savonarola referred to Judith typify the nature of his comments about her and his pattern of analysis.

In his twenty-ninth sermon on Ezekiel's prophecies, Savonarola addressed the verse in Ezekiel 16, "Confident of your beauty, you have fornicated. ..." Ezekiel was castigating the Jews, or the people of Juda, then exiled in Babylon, for their faith in false prophecies. Threatening God's wrath, he likened them to dead wood about to be thrown into the fire. He framed his most vitriolic denunciation as a personification of the people, Juda, and lambasted her as a shameless harlot.[31]

Savonarola approached the verse as a metaphor of the wayward self-reliant human who denied God's supreme power. Beseeching his audience to return to God, he reminded them of his merciful forgiveness and steadfast support, itemizing Old Testament patriarchs like Moses, Joshua, Samuel, and David, whom God aided despite their faults and lapses of faith. At the end of his all-male list, Savonarola cited Judith and Esther.[32] Although he did not elaborate on his reasons for including the two virtuous Jewish women, their identities as unwavering believers and divinely

30 The date heads the cycle's first sermon transcribed in person by Lorenzo Vivuoli; see Girolamo Savonarola, *Prediche sopra Ezekiele*, ed. Roberto Ridolfi, 2 vols. (Rome: Angelo Belardetti, 1955), 1, p. 3.

31 Ibid., 2, pp. 1–16.

32 Ibid., 2, p. 8.

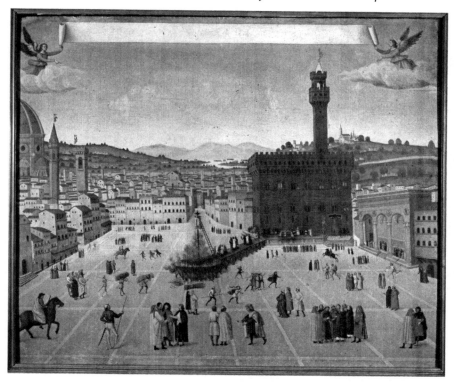

17.6. Anonymous, *The Martyrdom of Savonarola*, 15th century.
Museo di S. Marco, Florence, Italy. Photo credit: Scala/Art Resource, NY.

empowered saviors of their people make them antitypes of Ezekiel's harlot Juda.

In the next sermon, Savonarola eased into an attack on the Church by reminding his listeners that in the scriptures fornication was often synonymous with idolatry, or false religion.[33] Then he took off his gloves, attacking the Church's luxurious trappings of piety that concealed a godless core. He lambasted her for perverting even the Eucharist. In sermon thirty-two he continued his diatribe about her simony and sins, charging her with becoming the devil. He addressed the Church repeatedly by name, calling her a whore, "meretrice Chiesa."[34] For Savonarola the Christian Church had become the new harlot Juda, the polar opposite to beautiful and chaste women, namely Judith and Esther, the only two he had mentioned.

33 Ibid., 2, pp. 23–31.
34 Ibid., 2, pp. 60–61.

17.7. *Play of Iudith Hebrea* staged in 1518. Title-page.
Florence, 1589. National Art Gallery, Victoria and
Albert Museum. Photo credit: Sarah Blake McHam.

Even after many Florentines rejected Savonarola's call for a crusade and collaborated in his execution in 1498, on a pyre in front of the Palazzo della Signoria under *Judith*'s impassive eye (Fig. 17.6), the charismatic preacher's ideas continued to resonate. His followers went underground, maintaining their allegiance to the Dominican's ideals as an important, if covert, minority. Following Savonarola's death, the Medici family seized power from the Republic in 1512, only to be defeated by a new republican regime in 1527, which reasserted Savonarola's ideology. Once the family crushed that regime in 1530, it controlled the city until 1737.

Several episodes demonstrate Judith's enduring power as a republican symbol of Florence as the chosen people. Many families who can be identified as closet followers of Savonarola enrolled their sons in the

Confraternity of the Purification, a well-established youth organization and one of the most important Florentine societies for the moral edification of young boys. As part of their activities, the boys of the Purification staged a play during Carnival in 1518, *Iudith Hebrea*, which enacted the Christian interpretation of her story that Savonarola's sermons had made current in Florence. It was published the following year.[35]

The Annunciate Angel opens the play by introducing Judith's slaying of Holofernes as the exemplary victory over proud, cruel, luxury-loving rulers and a model of the virtuous path to celestial glory, visualized in the woodcut on a later edition's title page (Fig. 17.7).[36] The play dramatized the Book of Judith's plot in pithy, vivid speeches, beginning with the council of Nebuchadnezzar and his lords extolling his virtues and cleverness in ruling a vast empire. Only the Jews dared repel his advances, citing their allegiance to their God in words akin to Savonarola's exhortations to Florence.[37] When Holofernes was about to force Bethulia's elders to sue for peace, Judith intervened. Ozias recognized her as a "saintly widow" and praised her unswerving faith.[38] Judith and Holofernes's subsequent encounter culminated in his praising her to his soldiers, first of all for her great prudence.[39] When Judith was about to decapitate him, she called aloud to God, asking him to steady her hand and resolve so that she could kill God's enemy. When she escaped to Bethulia with Holofernes' head, Ozias saluted her as a "woman whom God should bless" because she had saved the Jews by her actions and prudence (*governo*).[40] A description of God's angel aiding the

35 Lorenzo Polizzotto, *Children of the Promise. The Confraternity of the Purification and the Socialization of Youths in Florence, 1427–1785* (Oxford: Oxford University Press, 2004), pp. 141–42, claimed Judith was a symbol of Divine Justice in popular Florentine political discourse, citing the largely unpublished legal documents called "protests for justice." Emilio Santini, "La *protestatio de iustitia* nella Firence Medicea del sec. XV," *Rinascimento*, 10 (1959), pp. 33–106, collected a group of them. Polizzotto referred to Santini's example (ibid., p. 88) invoking Judith as "a daring and courageous woman ... who for love of liberty took on a man's courage (or soul)" to kill the tyrant Holofernes.

36 See *La Rappresentazione di Iudith Hebrea* (Florence: Giovanni Baleni, 1589), unpaginated, a later edition of that published by Francesco di Giovanni Benvenuto in 1519. My thanks to Meghan Callahan for procuring me a copy.

37 Ibid.: Achior, Nebuchadnezzar's ambassador, explains to Holofernes, "They have great faith in a God who always defends and protects them, and they give him all their devotion."

38 Ibid.: Ozias, speaking to Judith, called her "vedovetta santa," commended her devout faith that could change God's severe will, and asked her to pray for the Jews.

39 Ibid.: "You should perceive [in Judith] the most prudent woman ever. ..."

40 Ibid.: "May you be blessed by God Eternal ... for your hard work alone, for your prudence alone. ..."

Jews to destroy Holofernes's armies followed, and the play concluded with the lesson that the path to such victories lay in penitence.[41]

Shortly before the play was staged, the Medici family had tried to reclaim the sculpture. In 1513, on the anniversary of its return of power, the Signoria, by then a puppet institution under Medici control, decreed that the statues of *Judith* and of *David* should be returned to the family. Averardo di Bernardo de' Medici, the leader of this initiative, argued that the statue of *Judith* should be handed back to its rightful owners and reinstalled in the Palazzo Medici. The decree was never carried out. The Signoria's leader convinced them that the appropriation might foment rebellion against their nascent regime.[42] By this time Donatello's bronze group had become such a potent symbol of Florence that it was too dangerous to move.

The only strategy left open to the Medici was to co-opt its meaning. The most notable maneuver occurred in 1545, when Duke Cosimo, the founder of the revived dynasty, commissioned Cellini to create a sculpture of *Perseus and Medusa* that was a mirror image of Donatello's *Judith* in its material and in the arrangement of slayer and victim, although it reversed their genders.[43] Positioned nearby in the Loggia dei Lanzi adjacent to the Palazzo della Signoria, where Donatello's group had been transferred, the mythological tale and Medicean undertones embodied by Cellini's bronze were intended to leech away from the *Judith* any associations with Florence's defeated Republic and Savonarola's championing of it as the context for the new city of God.

41 Ibid.: "The Angel gives license. ... There is no need for other teachings. Do penitence and you will see" (the fulfillment of the Angel Gabriel's opening promise that following Judith's model will lead to virtue and glory in heaven).

42 See Luca Gatti, "Displacing Images and Renaissance Devotion in Florence: The Return of the Medici and an Order of 1513 for the *Davit* and the *Judit*," *Annali della Scuola Normale Superiore di Pisa*, ser. 3, 23 (1993), pp. 349–373.

43 The group's political implications are analyzed by Thomas Hirthe, "Die Perseus- und Medusa-Gruppe des Benvenuto Cellini in Florenz," *Jahrbuch der Berliner Museen*, 29 (1987–88), pp. 197–216.

18. Costuming Judith in Italian Art of the Sixteenth Century

Diane Apostolos-Cappadona

In the almost thousand years of Judith imagery between the sculptures and stained glass of medieval cathedrals and the choreography of Martha Graham, the costuming evidenced most specifically by the "ornaments," or jewelry, of the Jewish heroine underwent significant development, beyond the typical attitudes of the "modes of fashion." Central to this remodeling in Christian art is the changing interpretations of the scriptural assertion that Judith "omnibus ornamentis suis ornavit se" (Jdt 10:3), that is, she "adorned herself with all her ornaments." Italian Renaissance artists from the mid-fifteenth century contributed a new dimension to her transformation from a simply dressed medieval widow into a bejeweled Renaissance lady. Donatello's innovations in his influential bronze sculpture *Judith and Holofernes* (Fig. 17.1) provided the essential impetus, in his ornamentation of the heroine's garment with mythological figures that symbolically reference armor and thereby her warrior nature (Fig. 18.1). From this sculpted Early Renaissance revision into the art of the Italian Baroque world, Judith's dress, hairstyle, and, especially, jewelry were made to correspond with her identity as a female hero.

The development of Donatello's innovations in the "tradition of costuming" can be traced in the work of the next several generations of Italian artists: from Sandro Botticelli, Andrea Mantegna, Michelangelo, and Giorgio Vasari to Caravaggio and Artemisia Gentileschi. The symbolic meanings and cultural origins of these alterations to Judith's costuming in the works

* I acknowledge all those libraries, museums, and archives that graciously opened doors, files, archival photographs, and other research materials as indicated in specific endnotes. I thank Maja B. Häderli, Kunsthistorisches Institute in Florence, for her assistance in May 2008.

A BIT LIGHTER?

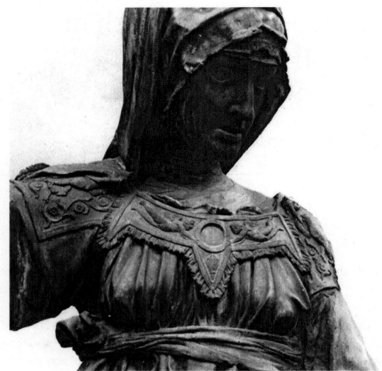

18.1. Judith's upper body and right hand with sword from Donatello, *Judith and Holofernes*, 1457–64. Palazzo della Signoria, Florence, Italy. Photo credit: Scala/Art Resource.

of these artists reflect values from the classical tradition of the female agency of Athena, Artemis, and the Amazons, those independent women who either wore armor or carried weapons in anticipation of battle or the hunt.

Although the historical question of the origin of the Book of Judith lies outside my field of expertise, the Christian visual persona of Judith as an exemplary (read pious and chaste) widow whose faith led her to perform extraordinary deeds made her one of the traditional prototypes for the Virgin Mary. The Christian patristic practice of deciphering classical traditions and the Hebrew scriptures as prophecies, in terms of persons and episodes, to be fulfilled in the Christian scriptures, was transferred from texts to images and became one of the keystones of Christian iconography. Thereby, Judith like her female Jewish scriptural ancestors and descendants, whether their stories were apocryphal or canonical, entered into the visual canon of Christianity defined through a clearly Christian lens.

Following this pattern of interpretation from the early Christian fathers such as Clement of Rome to Augustine and Jerome, Christian artists initially depicted Judith as an appropriately dressed chaste (read virginal) widow in simple flowing garments with her hair covered as a sign of modesty and respect. Her deed, however, separated her from the typical Jewish widow, if not from Jewish women generally, when read through the commentary of, say, Clement of Rome, who identified her among those singular women who, "… being strengthened by the grace of God, have performed numerous *manly exploits*."[1] However, in doing so, these early Christian theologians began the transformation of Judith from a Jewish woman into a Christian prototype for the Virgin who fused both the aspects of the so-called Hebraic heritage of Christianity with the classical world in which this new religion was nurtured. Hence from her earliest Christian visual beginnings, Judith was a fusion of the pious devotion of a Jewish widow and the agency of the classical female warrior framed within the contemporary religious and cultural category of virginity.[2]

1 Alexander Roberts (ed.), *The Ante-Nicene Fathers* (Grand Rapids, MI: W. B. Eerdmans, 1950), I, p. 20, as cited in Elena Ciletti, "Patriarchal Ideology in the Renaissance Iconography of Judith," in Marilyn Migiel and Juliana Schiesari (eds.), *Refiguring Woman: Perspectives on Gender and the Italian Renaissance* (Ithaca, NY and London: Cornell University Press, 1991), p. 63. Italics are mine.
2 Diane Apostolos-Cappadona, "Virgin/Virginity," in Helene Roberts (ed.), *Encyclopedia of Comparative Iconography* (Chicago, IL: Fitzroy Dearborn, 1998), 2, pp. 899–906.

From Rome to Florence: Judith's Journey from Pious Widow to Female Warrior

The earliest identifiable Christian image of Judith is found among the eighth-century frescoes of Santa Maria Antiqua in Rome. Although the current damaged state of the Judith fresco would make any discussion of her figure virtually impossible, the late nineteenth- and early twentieth-century tinted photographs and color drawings of the magisterial Christian archeologist, Josef Wilpert, provide a window into what this frescoed figure looked like.[3] Dressed in a green-striped garment embellished with an embroidered maroon trim, shod with gold and green sandals, and carrying the severed head of Holofernes, this image of Judith and the presentation of this episode in her story became the model for her presentations until the sculpture by Donatello. Evidenced by my own research of over 150 medieval manuscript illuminations, dating from the mid ninth to the early fifteenth centuries, these presentations of a Judith – whether in the act of decapitating Holofernes or returning to Bethulia with the trophy of his severed head – emphasize the calm nature of her person in contrast to the gruesome nature of her actions. As such, her earliest iconography suggests that she is the simple instrument and handmaiden of the Lord, thereby visually correlating her with the Virgin Mary.

From these manuscript illuminations, Judith is characterized as a simply dressed widow throughout those narrative episodes depicted in medieval sculptures such as those on the capitol relief in the Cathedral of the Madeleine in Vézèlay or on the north porch dedicated to the Virgin Mary and female saints, heroines, and martyrs of the Cathedral of Notre Dame in Chartres. This medieval visual model of Judith embodied the contemporary Christian virtues of Chastity and Humility, both of which identified her further with the Virgin Mary and built upon the textual foundations not only of patristic texts but also of Jerome's Vulgate. In fact, he clarified further the parallel between both the "before, during, and after" of Mary's virginity with Judith's celibate (read chaste and virginal) life before her marriage, during her widowhood, and after her return to Bethulia.[4]

3 I am grateful to Dr. Olof Brandt, Secretary, Pontifical Institute of Christian Archaeology, Rome, for my research in the Wilpert Archives with Dr. Giorgio Nestori, Librarian and Prefect of the Wilpert Archives, 27 May 2008.
4 See Ciletti, "Patriarchal Ideology," p. 42, referencing Jerome's translation of Jdt 16:26.

The early Church was uncomfortable with both the idea of Judith's alleged seduction (with its sexual nature that was never clearly stated in the formal text) and the passage denoting her elaborate costuming. However, Jerome's description of Judith's "dressing up" for Holofernes was a pious action as it was "the Lord [who] increased her beauty … because all this dressing up did not proceed from sensuality, but from virtue."[5] Curiously, Jerome was one of the strongest advocates for modesty and humility in female attire even unto his pronouncements against makeup, coiffure, and jewelry for Christian women who were to take Mary as their model. Nonetheless, from the fourth-century alignment of Christianity with the Roman Empire into the time of the Reformation, even the Virgin Mary was garbed in the more elegant attire, adornments, and coiffures of the ladies of the court.

As Judith became more formed and reformed into a prototype of the Virgin, especially once the prophecy of Genesis 3:15 – "inimicitias ponam inter te et mulierem et semen tuum et semen illius ipsa conteret caput tuum et tu insidiaberis calcaneo eius"[6] – became critical to the theological readings of Mary. This "manly exploit" was paralleled to Judith's severing of Holofernes's head from his body, so that she became a female paragon of feminine and masculine virtues.[7] Even as Judith moved into the world of Renaissance art and Christian theology, she maintained her image of a virtuous *femme forte* even as artists like Donatello, Michelangelo, and Vasari visually identified her with the heroic women of the classical world.

The transition in the iconography of Judith from the early Christian and medieval worlds into the Renaissance and Baroque was influenced as much by the newer cultural attitudes highlighted with an interest in the psychology of both viewer and subject as by the humanizing of religious art. Judith's metamorphosis from the simply dressed widow to an elegant lady, signified outwardly by the change in her costuming, was evidenced first in Donatello's bronze sculpture of *Judith and Holofernes*. The classic description of this Judith as the personification of Sanctimonia Humilitas in contrast to that of Lussuria Superbia by the defeated Holofernes at her feet

5 Jdt 10:4 as cited in Ciletti, "Patriarchal Ideology in the Renaissance Iconography of Judith," p. 45. This discussion in Jerome's translation is intriguing given his sermons, texts, and letters to women, such as "Letter to Eustochium" detailing the proper modes of dress for "Christian women."
6 Douay reads: "I will put enmities between thee and the woman, and thy seed and her seed: she shall crush thy head, and thou shalt lie in wait for her heel."
7 Giorgione's *Judith* (1500–1504: Hermitage, Saint Petersburg) parallels Mary as the Second Eve with Judith who stands with her left foot atop Holofernes's decapitated head.

was established by the eminent art historian Edgar Wind.[8] Continuing the tradition of relating Judith to the Virgin Mary, other commentators have noted the history of this work and its technical innovations; however, much ink has been spilled over discussions of the iconography. There has been very little, if no, discussion of the meaning of Judith's "ornaments" and how those "ornaments" helped to identify her persona and transformations in the Renaissance and Baroque.

Clearly, this sculpture has had a significant history, if for no other reason than the following lines excerpted from the minutes of the Florentine Senate when it decided to move Donatello's bronze sculpture in favor of Michelangelo's *David*:

> Judith is an omen of evil, and no fit object where it stands, as we have the cross and lily for our emblems; besides, it is not proper that the woman should kill the male; and above all, this statue was erected under an evil star, as things have gone from bad to worse since then.[9]

While other contributors in this present volume have addressed the history of this particular sculpture and its place in Florentine history, I want to reflect on how Donatello sets a pace for future generations of Italian artists in their presentation of Judith. His heroine was not "an omen of evil" but an independent female warrior whose "dressing up" was so significant to Jerome that he incorporated it into his Latin translation of the Bible and commented upon this act.

First, consider the visual evidence in looking at the sculpture in its cleaned and restored condition. The elegantly pivoting pose of the figure of Judith rises above the twisted base, which sets a tone for the movement of the viewer's eyes, to stand triumphant over both the carefully illustrated triangular base original to the sculpture and the collapsed body of a seated and weak Holofernes. She takes the classical posture of victory as she stands over her defeated enemy. Her calm and beautiful face looks downward not so much at her victim but past him to her elegantly shod left foot. Her right arm is raised high above her head, risking injury to herself as well as signifying the power required to swing the sword forward to decapitate Holofernes. By this action Judith's right hand and wrist are exposed. This "revealing" begins the diagonal movement within the sculpture that runs from the hovering sword past Judith's elevated right shoulder to her

8 Edgar Wind, "Donatello's *Judith*: A Symbol of *Sanctimonia*," *The Journal of the Warburg and Courtauld Institute*, 1 (1937), pp. 62–63.
9 Ciletti, "Patriarchal Ideology," p. 68, citing the translation in Robert Klein and Henri Zerner (eds.), *Italian Art* (Englewood Cliffs, NJ: Prentice-Hall, 1966), p. 41.

girdle and the first tier of her garment toward her left hand as she grasps the head of Holofernes by his hair, following the scripture "adprehendit comam capitis eius" (Jdt 13:9), or "she took him by the hair of his head" and then further downward past her knee and lower leg supporting the drunken general, to the sandal on her *en pointe* foot. Thus, Donatello draws our attention not only to the actions Judith performs in the swing of the sword, her grasp of Holofernes, and the placement of her feet, but to her costuming, from her exposed wrist with its "bracelet" to the elegance of her sandaled and pedicured foot.

Held too close to the multi-layered headpiece covering her hair in the style of a modest matron, the curve of her scimitar draws attention to the embroidered trim on her headband and "bonnet,"[10] which were made of sackcloth. This curve is counterbalanced by the curve on her neckline as it draws our eye to what appears to be either richly embossed trim or an elaborate necklace. Above these two curves of headpiece and neckline, Judith's upraised right hand and wrist hover, so that I note the continuation of the trim from her neckline, in the form of a cuff bracelet, onto her wrist (Fig. 18.1). Careful inspection of the detailed images on Judith's headpiece, right wrist, and neckline confirm that these are neither simple "trim" nor jewelry. Rather, comparing these costuming highlights with other sculptures of Donatello, the visual quotations are recognizable as being both classical in nature and following the traditional patterns of the armor worn by members and soldiers of the Medici family. Judith's heavy "neckpiece" can be read as quotation of the cuirass from the *Athena Armed as Athena Parthenos* (Fig. 18.2), and her bracelet as the piece of armor known as a vambrace. Both incorporate images of chariots and putti with weapons, flowers, or fruit, thereby referencing the classical mythology of the warrior hero. Further, the arrangement of the winged putti holding the empty disk in the center of Judith's cuirass can be read as a visual quotation from the classical and early Christian sarcophagi on which winged genii held a medallion with a portrait of the deceased.[11]

However, the empty disk is more likely than not a visual reference to the relationship between the scriptural Judith and the classical Perseus. The monstrous chthonic female known as the Medusa was characterized by her

10 Douay translation of *mitram* (Jdt 10:3) is "bonnet."

11 For example, the lid from the late third-century child's sarcophagus #31503 in the Museo Pio Cristiano, Musei Vaticani. Archival photographs from the 1988 cleaning confirmed that the disk is empty; consultation with Dr. Angela Busemi, Photographic Archives of the Comune di Firenze Servizio Musei, on 20 May 2008.

serpent tresses and a face that was simultaneously beautiful and terrifying to behold. Whoever looked at this tortured creature was immediately turned into stone. Aided by Athena and Hermes, Perseus conquered the dreaded Medusa by not looking at her face during combat but having her look at her own face in his mirrored shield. Thereby, he was able to sever her head and deliver it to Athena who emblazoned her shield, the Aegis, with this facial insignia, and became invincible in battle. Such a reference would further connect Judith with the virginal goddess of wisdom, war, and weaving. Athena emphasized this tripartite interconnection by consistently aiding her devotees (like Odysseus) with a plan for the Trojan horse just as Judith created a plan for the siege of Bethulia at the cost of only one life. Further, as the patron of Athens, Athena became a significant referent for Judith, who (like David) became symbolic of Florence as "the new Athens."[12]

The multi-tiered garment Donatello creates for his Judith, which is employed also by Botticelli and modified by Michelangelo and Vasari, appears from the side perspectives to flutter in the wind like the cape of a rider. Judith stands astride Holofernes's shoulders and grasps locks of his hair with her fingers just as the rider holds the reins of a horse. This visual metaphor of Judith as the rider and Holofernes as the horse connotes the reality that the rider, normally of a smaller weight and stature than the horse, controls the horse by dominance of will and thought, thereby again referencing the classical traditions related to Athena. The positioning of Judith's left leg, especially her knee, become significant as it and the connecting pleats in her garment draw attention to the midpoint of Holofernes's back. There the chain he wears around his neck has been turned around so that the medallion hangs down his back. Impressed upon the medallion, just by Judith's knee, is the image of a horse and rider.

Donatello began a series of visual trends in the depiction of Judith that connected the classical culture being rediscovered in the Renaissance with the Christianization of this Jewish heroine. Further, his innovations influenced other artists of the Italian Renaissance and Baroque periods. Judith was imaged from this point forward no longer as the simply dressed widow of the early Christian and medieval periods but more in the line of the seventeenth-century playwright Federico Della Valle's description: "gran macchina bellezza."[13]

12 Apostolos-Cappadona, Diane, "The Lord has struck him down by the hand of a woman!...Images of Judith," in Doug Adams and Diane Apostolos-Cappadona (eds.), *Art as Religious Studies* (New York: Crossroad Publishing, 1987), p. 85.

13 Federico Della Valle, *Judit* (1627), (1978 trans., 3.4.431 as cited by Elena Ciletti,

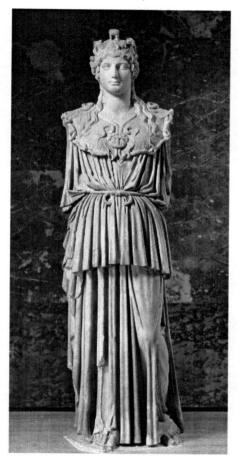

18.2. *Athena Armed as Athena Parthenos*, Third century B.C.E. Musée du Louvre MR285, Paris. Photo credit: Réunion des Musées Nationaux/Art Resource, NY.

Judith as Renaissance Warrior

One of Andrea Mantegna's versions of the theme of *Judith and Holofernes* clarifies further the interconnections between Early Renaissance depictions and classical traditions. His *Judith and Holofernes* (1491) (Fig. 16.6 and compare Fig. 18.2) presents Judith dressed in classical Greek garments of a flowing white chiton and blue mantle dramatically wrapped around her

"'Gran Macchina è Bellezza.' Looking at the Gentileschi *Judiths*," in Mieke Bal (ed.), *The Artemisia Files* (Chicago, IL: University of Chicago Press, 2005), p. 69. Her translation reads, "Beauty as a great war machine (machination)" and thereby identifies Judith as Christianity's female warrior.

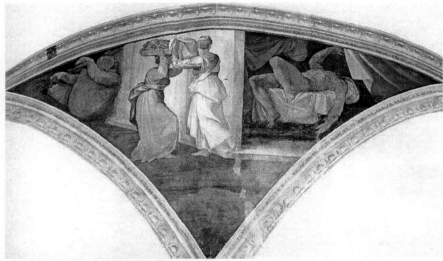

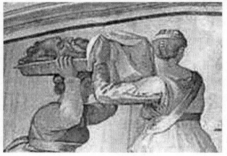

18.3. Michelangelo, *Judith with the Head of Holofernes*, 1509–11. Sistine Chapel, Vatican City, pendentive fresco; (left) detail of the same. Photo credit: G.E.M.A. (Grande Enciclopedia Multimediale dell'Arte).

right arm and her pelvic area.[14] However, unlike Donatello and his later descendants, there is no visual appeal specifically to armor or to jewelry. There was direct referencing both to Athena and to classical depictions of the hero. The passive, almost eerily calm (to twenty-first-century eyes) demeanor of this Judith, who lowers her sword with her right hand as she places the severed head of Holofernes into the bag with her left hand, belies the gruesome nature of the act this woman has committed. Yet the face of the hero in classical Greek and Roman art was one of calm and serenity, a convention followed in both secular and Christian art through the sixteenth century.[15] Further, the classical head – even unto the coiffure that Mantegna paints on his Judith – is a visual quotation from classical depictions of Athena.

14 Apostolos-Cappadona, "The Lord has struck him down," pp. 89–91.
15 Moshe Barasch, "The Crying Face," *Artibus et Historiae*, 15 (1987), pp. 21–36.

While Michelangelo's Judith (Fig. 18.3) wears no jewelry, perhaps because we see her both from the back and after the action, her costume does allude to Donatello's employment of the multi-tiered dress and armor.[16] Her "bonnet" covers her hair while also forming a first line of defense between her head and the helmet she might wear during battle. Further, the detailing on this "bonnet" is distinctive and connotes a military referent. More important is the referencing to a warrior's cuirass in her blue and green over-bodices. Her yellow epaulettes – a visual pun on ailettes, or armorial shoulder wings – again signify her warrior image, while the color suggests that Judith, at least as conceived by Michelangelo, was of Jewish heritage.

Giorgio Vasari, perhaps best known as the author of the *Lives of the Artists*, painted an extraordinary image of *Judith and Holofernes* in ca. 1554 (Fig. 18.4).[17] A student of Michelangelo and an admirer of Donatello, Vasari combined visual quotations from both masters' works with his own special "twist" in the presentation and meaning of Judith's "ornaments." Dressed in a garment composed of a pale pink cuirass with gold trim at the neck, shoulders, and sleeves, Vasari's Judith sports a multi-tiered, high-waisted, pale green skirt clasped with an extraordinary girdle. My initial attention is given over to the elegant girdle studded with cameos and the partially unhooked high-waisted skirt. The former is, of course, new in Judith iconography. I believe that Vasari is the first artist to incorporate the cameo so prominently in this theme, while Artemisia Gentileschi transports this ornament to its highest artistic presentation.

The cameo, jewelry historians relate, is a symbol of transformation signified by its own transformation from shell to cameo.[18] Worn as an amulet or a talisman, the cameo was understood to reveal characteristics of the wearer; for example, the cameo of Apollo and Marsyas on Botticelli's *Portrait of a Young Girl* (1480–85) identifies the wearer's love of music. In the case of Vasari's Judith, there are two distinctive presentations of cameos: first as noted on the elegant girdle and second on the left (and ostensibly the right) shoulder medallions. While the horizontal ovals on the girdle

16 I am grateful for the research privileges and conversation with Dr. Anna Maria De Strobel, Curator for Medieval, Modern, and Byzantine Art, Pinacoteca, Musei Vaticani, 28 May 2008.

17 I examined this painting accompanied by Judith W. Mann, Curator of European Paintings, Saint Louis Art Museum, 9 April 2008. I thank her for insightful comments, permission to research in archival files, and the references dispatched later.

18 Silvia Malaguzzi, *Oro, gemme e gioielli* (Milan: Mondadori Electa, 2007), p. 313; also James David Draper, "Cameo Appearances," *The Metropolitan Museum of Art Bulletin*, LXV.4 (Spring 2008).

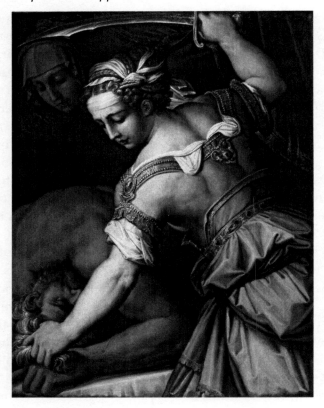

18.4. Giorgio Vasari, *Judith and Holofernes*, ca. 1554. Saint Louis Art Museum, St. Louis. Photo credit: Saint Louis Art Museum, Friends Fund and funds given in honor of Betty Greenfield Grossman.

appear to depict nude male figures resting on their sides like the personifications of rivers, the shoulder medallion provides an immediate visual reference to the classical connectives of Donatello's bronze. The figure is that of a woman holding her shield with her right hand and allowing it to rest against her right leg as her left hand is raised as if to strike at either her enemy or her hunted prey. While there is no visible weapon, there are direct visual analogies between Vasari's Judith and Donatello's references to Athena and Artemis.

However, the more direct visual quotations retain a connection with the classical world through the influence of Michelangelo's fresco of the Libyan Sibyl (Fig. 18.5) from the Sistine Chapel ceiling. This classical prophetess sits across the ceiling from her Hebraic counterpart, Jeremiah, as they frame the center episode of the Separation of the Light from the Dark. This

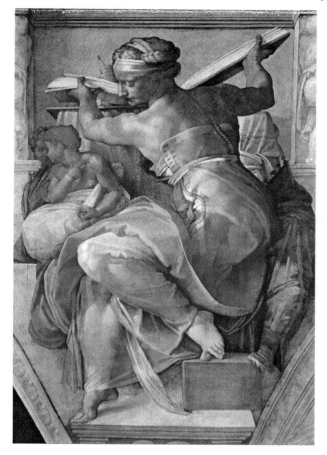

18.5. Michelangelo, *Libyan Sibyl*, 1515. Sistine Chapel, Vatican City. Photo credit: Erich Lessing/Art Resource, NY.

is an appropriate partnership as the Libyan Sibyl prophesied the "Coming of the day when that which is hidden shall be revealed." Initially interpreted as a reference to Alexander the Great as the conqueror and ruler of Egypt, the Church Fathers understood it as foretelling Christ as the "Light of the World."

Michelangelo's sibyl – clearly inspired by the powerful movement and dimensionality of Hellenistic sculptures, such as the Belvedere torso – is seated, like Vasari's Judith, with her back turned toward the audience. Further, both women have naked shoulders and upper backs to emphasize their muscularity and their freedom of movement. Similarly, both wear that

high-waisted skirt which is unhooked above the girdle, thereby drawing attention to this section of the painting. The elegant coiffures of braided and bound blonde hair provide another visual connector between the Christian Judith and the classical world.[19]

From Father to Daughter: Judith in the Paintings of Orazio and Artemisia Gentileschi

The jewelry historian Diana Scarisbrick noted that the inclusion of jewelry in a painting is fundamentally for the purpose of calling the viewer's eyes to that object and then from there to the activity of the wearer.[20] Orazio Gentileschi, the father of the more famous Artemisia, painted several versions of the Judith story, including variations on the theme of *Judith and Her Maidservant with the Head of Holofernes*.[21] Present in the Wadsworth and the Vatican versions of this theme is a gold and possibly cameo bracelet visible and partially wrapped in the upturned and blood-stained cuff of Judith's right sleeve. Orazio's Judith sports a gold hoop earring with a pearl drop in her left ear, an obvious visual reference to the painting of Judith by Caravaggio, whose work is also quoted by Artemisia.

Two of Artemisia Gentileschi's five versions of the theme of Judith include significant visual referencing to her "ornaments" and highlight the diminishment of Judith's presentation as God's faithful female warrior. Although these two paintings were completed after the Council of Trent and its eventual formal inclusion of the Book of Judith in the Vulgate in 1546, Judith continued to garner the attention and interest of artists and patrons. As with other biblical women, Judith became an identifying *topos* for the portraits of noble women, as well as an *exemplum* of moral virtue or of the cunning woman.

Artemisia painted two powerfully dramatic renderings of *Judith Slaying Holofernes*, the first version in 1612–13, now in the collection of the Capodimonte in Naples, and the second in 1620, now in the collection of the Galleria degli Uffizi in Florence (Fig. 18.6). One of the clear distinctions between these two versions is that Judith wears no jewelry in the Capodimonte painting, while she has an intriguing bracelet in the Uffizi canvas.

19 As noted by Jerome, "… et discriminavit crinem capitis sui …" (Jdt 10:3). Douay reads, "… and plaited the hair of her head. …" (Jdt 10:3).
20 Consultation with Scarisbrick, 30 April 2008.
21 There are four versions by Orazio – the earliest in the Nasjonalgalleriet, Oslo; the best-known version in the Wadsworth Atheneum; a copy in the Pinacoteca, Musei Vaticani; and an undated version in a private collection.

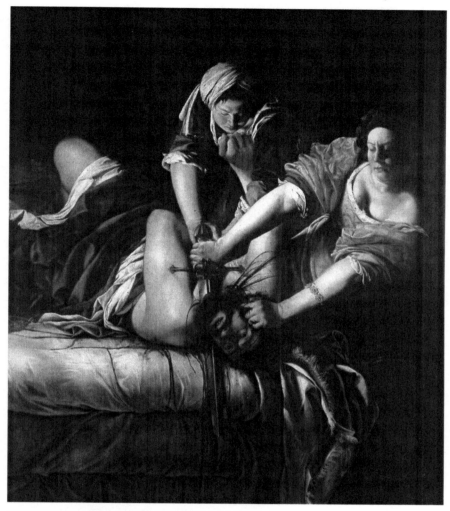

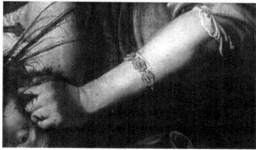

18.6. Artemisia Gentileschi, *Judith Slaying Holofernes,* ca. 1620. Galleria degli Uffizi, Florence; (left) detail of the same showing Judith's left lower arm with cameo bracelet. Photo credit: G.E.M.A. (Grande Enciclopedia Multimediale dell'Arte).

Taking her cue from the great master of the Italian Baroque, Caravaggio, Artemisia paints two images of terrifying realism and psychological terror as we see Judith driving her sword through Holofernes's neck. This activity is vividly highlighted in the Uffizi painting as the blood explodes from his neck onto Judith's bodice and the bracelet on her left forearm.[22]

Both jewelry historians and makers of cameos[23] commented, upon seeing a reproduction of Artemisia's painting, on the unique nature of what the art historian Mary Garrard identifies as Judith's "delicate bracelet" (Fig. 18.6).[24] Of the three cameos facing the viewer, two display partially clear figures who I believe are female, given both the shapes and postures of their bodies. The middle cameo portrays a female figure positioned at mid-stride holding a bow while the lower cameo incorporates another female figure striding forward with raised left arm and an animal at her feet. Clearly, both depictions are of figures in the midst of an action paralleling Judith, who was in the midst of slaying Holofernes. Unfortunately, the visual evidence is not clear enough to affirm these as depictions of Athena and Artemis, Judith's classical ancestors, along with Judith, as prototypes of the Virgin Mary.

Further, the unseen segments of the cameo bracelet have been suggested as containing the images of Judith's masculine counterparts – Perseus holding the head of Medusa and David holding the head of Goliath. However, I want to suggest that the entire series of cameos on the bracelet are depictions of Artemis, the virgin goddess of the hunt and the moon, who is a prototype of the Virgin Mary, and an obvious reference to both Judith and to the painter.[25] The significance of this bracelet – both in its imagery and its placement on Judith's forearm – was signaled by the spray of Holofernes's blood forward across Judith's arm, creating an arc paralleling the curvature of the cameo bracelet. This placement and the cameo motifs are unique to Artemisia's iconography of Judith.

While Artemisia painted variations on the theme of *Judith and Her*

22 Mary D. Garrard, *Artemisia Gentileschi* (Princeton, NJ: Princeton University Press, 1989), p. 324.
23 From my interviews with Scarisbrick, 30 April 2008, and specialists in the making of cameos in Venice and Florence, May 2008.
24 Garrard, *Artemisia*, p. 324.
25 Garrard notes a visual and verbal pun on the names Artemis and Artemisia (p. 327); however, I think of the ideal widow Artemisia as the referent for the artist's name and as an identifying parallel with Judith. See the entry "Artemisia" in Diane Apostolos-Cappadona, *Encyclopedia of Women in Religious Art* (New York: Continuum, 1996), p. 26.

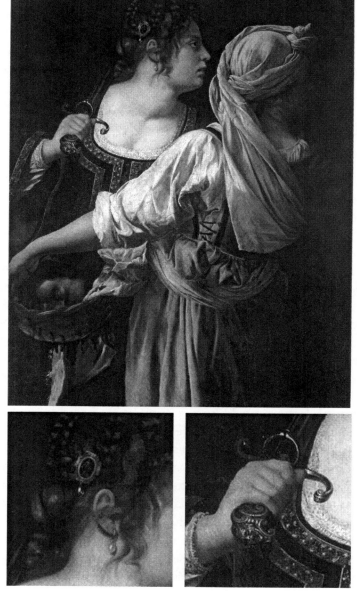

18.7. Artemisia Gentileschi, *Judith with Her Maidservant*, ca. 1613–14.
Galleria Palatina, Palazzo Pitti, Florence; (bottom left) detail of the same showing
cameo ornament (brooch?) in Judith's hair; (bottom right) detail of the same
showing sword hilt with head of Medusa. Photo credit: G.E.M.A.
(Grande Enciclopedia Multimediale dell'Arte).

Maidservant, the most interesting version is in the Galleria Palatina of the Palazzo Pitti dating from 1613–14 (Fig. 18.7). The two conspirators, Judith and Abra, stand facing each other and almost as polar opposites within what Garrard characterizes as an image of "classic restraint." The maidservant in the foreground, back turned to the viewer, basket with the exposed severed head slung on her left hip, the bodice of her garment partially unlaced under her left arm, and her head covered by an elaborately twisted covering, turns to her left as her mistress's left hand steadies her shoulder. Elegantly garbed in gold-trimmed dark velvets, Judith stands resolutely in the dark background.

The lace trim of her white linen under-blouse is visible through her low neckline as the sleeves and cuff protrude from under the enormous sleeve of her garment. The red lining of her sleeve is contrasted with the white linen and lace-trimmed blouse, and calls attention to that which fills the space between Judith's right hand, clasped tightly around the hilt of the sword that rests dangerously on her shoulder. The pommel of Judith's sword displays an open-mouthed, screaming head of the Medusa in apparent contrast to the calm, severed head in Abra's basket (Fig. 18.7). The two "heads" rest like reversed mirror images on top of each other; however, should Judith lower her sword in a backward swing, the female monster and the male general would then be positioned face to face.

The strong diagonal line created by the upturned white sleeve of Abra's blouse leads the viewer's eye past Judith's sword to her head, where once again a pearl drop on a gold hoop earring hangs from her right ear. Just above this single earring, and paralleling it, is another teardrop pearl dangling from the cameo on Judith's braided hair (Fig. 18.7). As with the other items of jewelry discussed in this essay, the cameo is placed, as Scarisbrick stated, to draw our attention. Given her classical foremothers, Judith's head is the seat of wisdom, so like Athena she stands guard here and protects her faithful servant. She has successfully completed the first phases of her plan, but to execute their escape she needs to keep her wits about her. As Garrard has noted, there are visual parallels between this Judith's profile and demeanor to that of Michelangelo's *David*.[26]

At least one reference work on jewelry has indicated that the figure depicted on Judith's cameo is that of David,[27] while Scarisbrick believed the figure to be that of Mars Ultor.[28] As with the cameos on her bracelet,

26 Garrard, *Artemisia*, p. 324.
27 *Oro, gemme e gioielli*, p. 86.
28 Interview, 30 April 2008. I note that her response was immediate as I handed

this figure is partially clear. Without doubt, it is a male figure, standing at attention as he holds his lance in his outwardly extended right hand and his shield in his lowered left hand so that it leans against his leg. There is an undecipherable object or markings by his left foot. While some see this image as that of David slaying Goliath, I read the body depicted as too mature to be the young David but rather as one of Judith's classical forefathers. Her wearing of this cameo extends the amulet or talismanic properties of this jewelry, for Judith garners both association and strength from the man in the cameo as they both stand in readiness. While the "deed is done," Judith and Abra are not yet in the clear, and this positioning in the painting suggests the dramatic possibility that they will be discovered before they have made good their escape from Holofernes's tent.

Concluding Thoughts

The figure of Judith and her costuming undergo significant symbolic and cultural metamorphoses in her journey through Christian art. Like her scriptural sisters, particularly Eve, Salomé, and Mary Magdalene, she garners multiple personae and iconographies in her afterlife in the arts and popular culture. She becomes a metaphor and thereby also a lightning rod for the cultural perceptions of the independent Jewish woman, especially in the works of late nineteenth- and early twentieth-century artists. Donatello's *Judith* and her derivatives wear symbolic armor as the frivolous luxury of jewelry is transformed into the armor of chastity, righteousness, and fear of the Lord.[29]

her a detail photograph.
29 I am grateful to Erika Langmuir, Emerita Head of Education, the National Gallery, London, for our consultation on the female hero and jewelry in Christian art, 29 May 2008.

19. Judith Imagery as Catholic Orthodoxy in Counter-Reformation Italy

Elena Ciletti

The Book of Judith and its controversial protagonist were much in evidence in sixteenth- and seventeenth-century Italian culture. For art historians, the foremost examples are the now iconic easel paintings of Caravaggio and Artemisia Gentileschi, images whose implacable vehemence commands attention. But if we look beyond the borders of secular patronage, we find a less familiar yet fully contingent world of contemporary Judithic imagery. It proclaims her rhetorical appropriation by the Catholic or Counter-Reformation Church against the "heresies" of Protestantism. Judith saved her people by vanquishing an adversary she described as not just one heathen but "all unbelievers" (Jdt 13:27); she thus stood as an ideal agent of anti-heretical propaganda. Nonetheless, the extent of her role in the Church's militant discourse has not been fully recognized. In the visual arts her service is most acutely apparent in ecclesiastical commissions, which have been little studied overall.[1] Such works present the institutional or "official" face of Judith and can be shown to converge with polemics on a variety of contested Catholic traditions. This is the subject of this essay. I examine both the terms by which the apocryphal Jewish heroine was deployed as an instrument of Post-Tridentine orthodoxy and the engagement of selected Italian images in that mission.

The most salient example is an extraordinary fresco cycle painted in 1588–89 for Sixtus V (r. 1585–90), the archetypal pope of the Church Militant.

1 An exception to this general rule is Bettina Uppenkamp, *Judith und Holofernes in der italienischen Malerei des Barock* (Berlin: Reimer, 2004), especially chapter 9; although the number of ecclesiastical images discussed is not large, hers is the most sustained treatment of Italian iconography in its Counter-Reform context.

Its locale could not be more prestigious: the Palazzo Lateranense in Rome – the rebuilt patriarchum of Constantine and the historical seat of papal rule.[2] The frescoes occupy the vault of the south loggia on the *piano nobile*; as in all Sixtine enterprises, they were designed by Giovanni Guerra and Cesare Nebbia and executed by their workshop (Figs. 19.1–19.3).[3] Consisting of twenty-eight scenes that illustrate much of the Vulgate narrative, the cycle is unequalled in scale and ambition among representations of Judith.[4] Yet despite their scope, the importance of the site, and the lavish recent attention paid to Sixtus V's patronage and taste, these Lateran frescoes have been given very little attention, none of it within the scholarship on Judith.[5]

As with the better known work for this pope, the Judith vaults manifest the triumphalist rhetoric of the resurgent Church. Throughout the Lateran, the dense iconographic program proclaims the lineage of pontifical rule and the achievements of the Sixtine golden age; among its targets are Protestant denials of papal authority. This Judith participates in a vast typology of the pope's predecessors and prefigurations: a multitude of biblical, historical, and classical personages of unimpeachable authority. No other female or Old Testament figure is given as much attention at this site. Guerra and Nebbia's cycle thus speaks volumes about the magnitude of Judith's worth to Sixtus V and the Church he ruled.[6] This essay will situate some

2 I thank Monsignor Pietro Amato, director of the Museo Storico Vaticano at the Lateran, for generous facilitation of my examinations of the frescoes. My brief treatment of them here derives from a monographic study in progress.

3 For these artists, their Lateran workshop and their other Sixtine projects, see Maria Luisa Madonna (ed.), *Roma di Sisto V. Le arti e la cultura* (Rome: DeLuca, 1993). The team included Paul Bril, Andrea Lilio, Paris Nogari, and Antonio Viviani. This volume is an indispensable compendium and guide to Sixtus and the scholarship devoted to his patronage.

4 In the sixteenth and seventeenth centuries, the best known and widest-ranging Judith series are graphic, inevitably smaller in size than the frescoes, such as the engravings and etchings after Maerten van Heemskerck. There are also more episodically limited tapestry sets from Flanders, and paintings on canvas made in Italy (Veronese) and France (School of Fontainebleau). On a more monumental scale, I am aware only of stained glass, for Catholic churches, the grandest of which is the window designed by Dirck Pietersz Crabeth in 1571 for Sint Janskerk, Gouda.

5 Only Corinne Mandel has noted them, briefly, and identified their components in her *Sixtus V and the Lateran Palace* (Rome: Istituto Poligrafico e Zecca dello Stato, 1994), pp. 52, 206–8, fig. 6a. See also her "Il Palazzo Lateranense," in *Roma di Sisto V*, pp. 94–103, fig. 31, 108–11, 117–18. My generalizations about Sixtus's program are owed primarily to Mandel's essential work and to Jack Freiberg, *The Lateran in 1600: Christian Concord in Counter-Reformation Rome* (Cambridge: Cambridge University Press, 1995).

6 At the Vatican palace, earlier evidence of papal interest in Judith was not lacking. In addition to Michelangelo's famous pendentive on the Sistine ceiling for Julius II, a more recent and explicitly Counter-Reform precedent for Sixtus V was the Judith

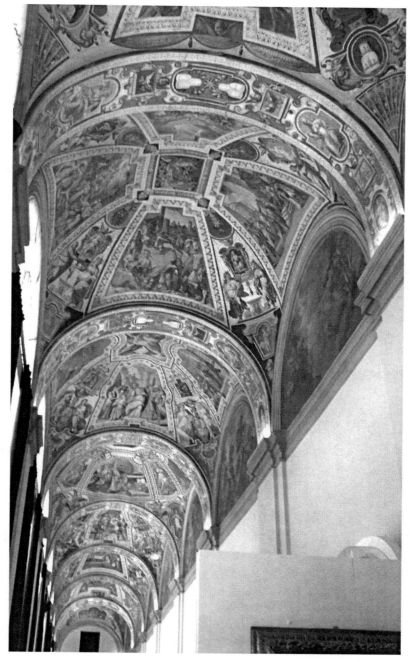

19.1. Giovanni Guerra and Cesare Nebbia, *Judith Cycle*, 1588–89.
Palazzo Lateranense, Rome. Photo credit: Elena Ciletti.

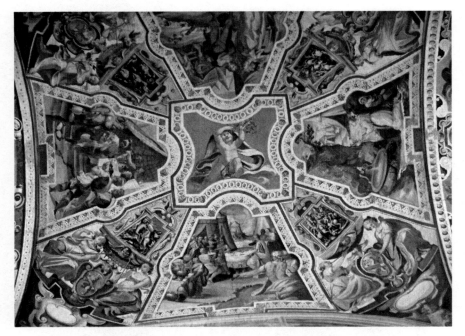

19.2. Guerra and Nebbia, 5th bay, *Judith Cycle*, 1588–89. Palazzo Lateranense, Rome. Photo credit: Elena Ciletti.

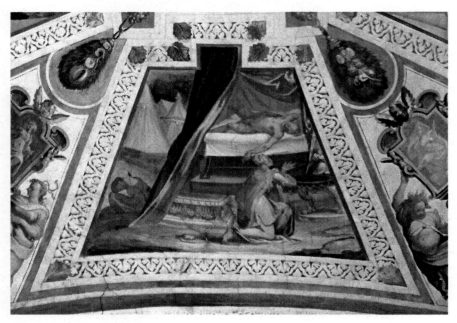

19.3. Guerra and Nebbia, 6th bay, *Judith Cycle*, detail, 1588–89. Palazzo Lateranense, Rome. Photo credit: Elena Ciletti.

aspects of these frescoes, together with other relevant works, within the framework of contemporary religious concerns.

Judith in the Anti-Heretical Discourse: Lineage

It must be noted that Judith's timeliness was enhanced by the Assyrian nationality of Holofernes. This assured his conflation with Islam (in the form of the encroaching Ottoman Turks), an updating of his traditional satanic characterization. In this idea, as in so many others, the Church reanimated patristic and medieval concepts, examined elsewhere in this volume, which allegorized Judith's beheading of Holofernes as Ecclesia Triumphant over its enemies, and as Chastity and Humility victorious over Lust and Pride. There was an anti-heretical intent to this revival, as Calvin had dismissed allegorical readings of Scripture in favor of literal ones.[7] By the midsixteenth century, Roman Catholic fidelity to its own age-old customs was energetically promoted, in response to accusations by the Reformers that the Church had squandered its authority by diverging from its original doctrines and practices. It was during the papacy of Sixtus V, and with his sponsorship, that the most authoritative arguments for the legitimacy of the unbroken Catholic tradition were launched, most notably by Robert Bellarmine and Cesare Baronio. Of paramount importance are the former's doctrinal *Disputationes … De Controversiis Christianae fidei* and the latter's historical survey of the early Church, the *Annales Ecclesiastici*; the first volumes of each were dedicated to Sixtus V.[8] As we shall see, Judith provided supporting evidence for both authors. The privileging of the lineage that Bellarmine and Baronio charted was intrinsic to every aspect of Counter-

fresco by Matthijs Bril, for his predecessor. See Nicola Courtright, *The Papacy and the Art of Reform in Sixteenth-Century Rome: Gregory XIII's Tower of the Winds in the Vatican* (Cambridge and New York: Cambridge University Press, 2003).

7 See Steven Ostrow, *Art and Spirituality in Counter-Reformation Rome: The Sistine and Pauline Chapels in S. Maria Maggiore* (Cambridge: Cambridge University Press, 1996), pp. 97, 102. Ostrow provides an excellent case study of Sixtus V's patronage and his culture; my essay is indebted to it throughout.

8 Bellarmine, *Disputationes … De Controversiis christianae fidei adversus huius temporis haereticos*, 3 vols. (Ingolstadt: Sartori, 1586–93). Cesare Baronio, *Annales Ecclesiastici*, 10 vols. (Rome: Vatican, 1588–1602; Antwerp: Plantinus, 1602–1658). Bellarmine's first volume and Baronio's first two were dedicated to Sixtus V. Both authors' purpose was to dispute the arguments of the Reformers, as compiled in the socalled *Magdeburg Centuries*, published in Basel from 1559 to 1574. The bibliography on both works is immense. For an integrated approach, see Stefano Zen, "Bellarmino e Baronio," in Romeo de Maio et al. (eds.), *Bellarmino e la Contrariforma* (Sora: Centro di Studi Sorani "Vincenzo Patriarca," 1990), pp. 277–322.

Reform culture; it is an essential component of the Church's approach to the subject of Judith.

At the most fundamental level there was the vexed matter of the canonicity of the Book of Judith itself. When the entire Old Testament apocrypha was rejected by most Protestant confessions, the Vulgate canon became a battleground. The Council of Trent confirmed the official status of the full Vulgate in 1546 and declared an anathema on transgressors of its canon, thus defining any challenge to Judith's legitimacy as heresy.[9] No one was better prepared to exploit the contested nature of the heroine and her text than Sixtus V, the former inquisitor who famously identified with St. Jerome, the original "hammer of heretics." It was in honor of his patristic alter ego that Sixtus undertook his own notorious edition of the Vulgate.[10]

Elite Catholic patrons who commissioned representations of Judith would have been well aware that the defense of her authenticity was basic to the project of Catholic renewal, as Bellarmine's *De Controversiis* demonstrated. Its first volume, published in 1586, opens with a detailed confirmation of the inclusive Vulgate canon and a refutation of Protestant objections to the apocrypha.[11] Addressing Luther's arguments against the Book of Judith's veracity, Bellarmine maps out the counter-brief for its historicity and its traditional acceptance by the Church as "infallibilis veritas." He verifies its nomenclature and chronology, for instance, even weighing what can be deduced about the latter from Judith's genealogy, beauty, and long life span (43–47). Bellarmine's definitive formulations provided the foundation for subsequent apologists. We find his reasoning, for instance, in the explicative apparatus in the English Douay Vulgate Old Testament of 1609, with its overt rejection of Luther: Judith's saga is defined as "a Sacred Historie ... of a most Valiant Matrons fact."[12]

9 See the decrees in J. Pelikan and V. Hotchkiss (eds.), *Creeds and Confessions of Faith in the Christian Tradition*, vol. 2: *Creeds and Confessions of the Reformation Era* (New Haven, CT: Yale University Press, 2003), pp. 822–24.

10 He was a despised Inquisitor in Venice, 1557–60. See Paul Grendler, *The Roman Inquisition and the Venetian Press, 1540–1605* (Princeton, NJ: Princeton University Press, 1977), pp. 115–26. His self-identification as *Hieronymus redivivus* is a leitmotiv in Sixtine studies. For the Vulgate debacle, see, e.g., Henri de Sainte-Marie, "Sisto V e la Volgata," in Tarcisio Stamare (ed.), *La Bibbia "Vulgata" dalle origini ai nostri giorni* (Rome: Libreria Vaticana, 1987), pp. 61–67.

11 *Disputationes*, Book I, De libris sacris et apocryphis: chapters 4, 10 and especially 12 (De libro Iudith).

12 *The Holie Bible Faithfully Translated into English out of the Avthentical Latin* (Douai: Laurence Kellam, 1635). The quotation is from vol. 1, the opening *Argument of the Book of Judith* (1010–1011), which discusses Jerome and lists the corpus of theolo-

Guerra and Nebbia's Lateran frescoes of 1588–89 can be seen as contributing to this program. The twenty-eight narrative scenes, four per vault, are replete with descriptive detail, providing contextual specificity that reifies Bellarmine's contemporary claims for the Book of Judith's historical truth. Bethulia, for instance, which is not described in the Vulgate, is envisioned by Sixtus V's artists as an impressive city of temples, towers, aqueducts, and obelisks. These particulars not only ground the story but also make reference to the patron's own well-known contributions to the urban fabric of Rome, thereby underscoring Sixtus's identification with Judith and her magnanimity toward her people.[13] The palatial scale of her dwelling affirms her status, which is grand from the start: in her first entrance, she addresses the awed elders with regal bearing fully in keeping with her setting. Every visual effort is made to show Judith's situation as congruent with the imperial tone of the papacy as manifest in Sixtus V. Moreover, as is the norm in Sixtine works, the pope is ubiquitous in the ornamentation that frames the narratives and fills the vaults; its visual vocabulary is drawn from his heraldic devices – triple mountains, pears, lions, and stars.

A key rationale for Judith's inclusion in the Sixtine pontifical genealogy, whose promulgation is the chief point of the entire Lateran program, can be located in the first volume of Baronio's *Annales Ecclesiastici*, which was issued by Sixtus V's new Vatican press in 1588, the year the frescoes were under way.[14] In book one, Baronio provides a link between Judith and the concept of papal authority by invoking her in the discussion of a passage in Acts 10 that illustrates the early deference paid to Peter. This implication of her typological relationship to the first pope must have been welcomed by Sixtus, to whom the volume was dedicated and which he enthusiastically received. Baronio's reference reveals that Judith was more than a generic personification of the triumphant Church: she was fashioned as a pillar of the contentious doctrine of papal sovereignty itself. We find here yet another reason for the Catholic insistence on her canonicity.

A purposeful Counter-Reform agenda can also be seen in the very shaping of the Lateran's Judith cycle, which reveals a militant intent. The rarely

gians who defended its canonicity. Cf. also the marginal notations to individual passages in the Book of Judith itself (1010–1035). Judith is inscribed in the time line of the *Historical Table of the Old Testament* at the end of vol. 2, hypothetically in the year 3500 after the Creation.

13 Without analyzing the frescoes, Mandel does observe that victorious Judith, *typus Ecclesiae*, is also *typus Sixti V.* See her *Sixtus V and the Lateran Palace*, p. 52.

14 *Annales Ecclesiastici*, v. 1, col. 369–71; cf. col. 248–49, where the context is observation of Jewish feasts.

represented early episodes of the Assyrian military campaign dominate the first two vaults, and the painted narrative not only begins but ends on a martial note. In a marked deviation from the biblical source, the concluding victory celebrations and the heroine's last years are omitted from the frescoes. As a result, one enters and leaves the loggia beneath episodes of warfare: the Assyrians' preparations for the invasion in the first bay and their rout by the Bethulians in the seventh. The narrative symmetry is underscored visually by the identical design scheme in both bays. Even in vaults whose narratives do not involve combat – the fifth, for instance, wherein Judith prays at the spring and dines with Holofernes – the scenes are flanked by framed battle scenes in grisaille (Fig. 19.2). These are supported by allegorical figures holding the coat-of-arms of Sixtus V. The point is clear: Judith is a historical personage and a prototype of both *Ecclesia Militans* and its pope, who will ensure the defeat of their heretical enemies.

Within a decade of the Lateran commission, Catholic scholars enlarged the vindication of Judith's saga into full-blown exegetical exercises, initiating what I take to be an important new stage of its reception in the early modern period.[15] The first large-scale commentary of the Book of Judith since the Middle Ages was printed in Germany in 1599: *In Libros Ivdith* by Nicholas Serarius.[16] His arguments were developed throughout the next century, as for instance in the monumental volume by his fellow Jesuit, Diego de Celada, in Spain, *Ivdith illustris perpetuo commentario*, first published in 1637[17] (Fig. 19.5). The purpose of such works is to define and substantiate Judith for, as Serarius says in his introduction, "our age of heretics"; the first task is the defense of her canonicity.[18] These scholars thus rejuvenated the partisan advocacy of the first Judith exegete, Rhabanus

15 See the useful but incomplete list of exegeses in D. Giuseppe Priero, *Giuditta. La Sacra Bibbia: Volgata Latina e Traduzione Italiana*, 4 (Turin: Marietti, 1959), pp. 31–32.

16 It is part of his *In Sacros Divinorum Bibliorum Libros, Tobiam, Ivdith, Esther, Machabaeos, Commentarius* (Mainz: Lippius), reissued in 1610 and 1612 in Paris, and included as *In Librum Judith*, with modern annotations, by Migne, in *Patrologia Latina, Scripturae Sacrae Cursus Completus*, vol. 14 (Paris: Apud, 1840), pp. 786–1283. See the entry *ad vocem* in Carlos Sommervogel, *Bibliothèque de la Compagnie de Jésus*, new ed., 12 vols. (Brussels-Paris: Schepen-Picard, 1890–1932), 7, pp. 1134–1145. I thank Michael Tinkler for his generous help with Latin.

17 Over 700 pages long, published by Prost in Lyon and subsequently reissued there, Madrid, and Venice until 1650, Celada's work has to my knowledge escaped scholarly analysis. For publishing history, see Sommervogel, *Bibliothèque de la Compagnie de Jésus*, 2, pp. 936–37.

18 Serarius's Prolegomenon IV refutes Protestant objections to her canonicity. *PL, Scripturae Sacrae*, 14, pp. 790–801.

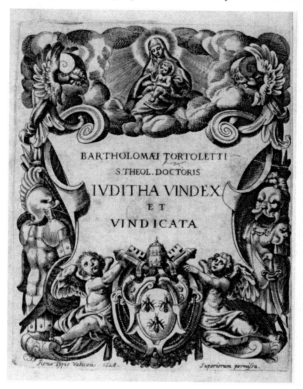

19.4. Bartolomeo Tortoletti, *Ivditha Vindex et Vindicata*, 1628.
Title page. London, British Library, 11409.gg.17.
Photo credit: © British Library Board.

Maurus, whose famous commentary addressed political struggles of the ninth century.[19] Their hortatory message was heard beyond their own now obscure biblical scholarship.

We see this, for instance, in the circle of another major Counter-Reform pope, Urban VIII Barberini, in a literary work dedicated to him by the poet Bartolommeo Tortoletti: *Ivditha Vindex et Vindicata* (Fig. 19.6). An epic poem with commentary, it was first issued in Latin in 1628 by the Vatican press and again in 1648 in an expanded Italian edition, *Giuditta Vittoriosa*; both were illustrated.[20] The titles and the enframing armor on the frontispiece

19 It was reissued with annotations in 1566 by Pamelius (Joigny de Pamele) in Antwerp; I consulted his 1626 edition of Rhabanus's *Opera Omnia*, 3 vols. (Cologne: Hierati), 3: 243–77.

20 Bartolomeo Tortoletti, *Ivditha Vindex et Vindicata* (Rome: Stamperia Vaticana, 1628), was actually composed ca. 1608; *Giuditta Vittoriosa* (Rome: Ludovico Grignani, 1648). The engravings are after designs by Antonio Tempesta and Nicolas de la

19.5. Diego de Celada, *Ivdith Illustris perpetuo commentario*, 1635. Title page.
London, British Library, L.17.e.8.(2.). © British Library Board.

make the same martial point, while the Barberini *stemma* bespeaks Judith's official ratification by the Vatican.

Tortoletti's orientation is that of the Church Triumphant under Urban VIII, supported by impeccable theological sources who include Bellarmine and the exegetes Serarius and Celada. In the final stanza of *Giuditta Vittoriosa*, for instance, the divinely ordained victory of the Bethulians over the Assyrians is characterized as the salvation of the Church from the "talons" of the "barbarians" from the east and the north, the latter subsumed under the name of Luther. Judith is thus made an agent of mercy in "the calamities of our time," which is to say the Thirty Years' War, as the dates of the two editions reveal.[21] Tortoletti's texts, like those of the authors he invokes, are later literary corollaries of the Lateran frescoes.

Judith in the Anti-Heretical Discourse: The Marian Typology

The evidence indicates that the Judithic arena in which the Catholic battle against heresy was most fiercely waged was Marian theology. Here too the familiar patristic tradition, which had made Judith a *mulier sancta* and a prefiguration of Mary, was not only continued but intensified. The reason is clear: the Reformation critique of the Church's investing of Mary with supernatural authority that had no direct scriptural foundation. One relevant example is the doctrine of the Assumption, every aspect of which was disputed and whose feast was excised from Lutheran constitutions.[22] As the Assunta, the humble carpenter's wife of the gospels is metamorphosed into the Queen of Heaven, bodily carried there by angels to intercede for all of humankind. What was needed for its Catholic defense was an Old Testament genealogy for Mary. Hence the strategic importance of the canonicity of the apocryphal Book of Judith: it demonstrated the Virgin's scriptural ancestry. Judith's own lineage, the longest of any woman

Fage. The only modern analysis is Lorenzo Carpanè, *Da Giuditta a Giuditta. L'epopea dell'eroina sacra nel Barocco* (Alessandria: Edizioni dell'Orso, 2006), chapter 1, which I was able to consult late in the composition of this essay, thanks to the generosity of Paolo Bernardini. It confirms my contentions.

21 In Canto X, 323. At the opening and the close: "Così volesse il Ciel, che da gli artigli / Barbari d'Oriente, e d'Aquilone / Ricourasse la Chiesa i prisci figli, / E Lutero cacciasse, ... / GIVDITTA impetra tu, questa pietade / A le calamità di nostra etade." For the full stanza, see Carpanè, p. 54.

22 See Beth Kreitzer, *Reforming Mary: Changing Images of the Virgin Mary in Lutheran Sermons of the Sixteenth Century* (Oxford: Oxford University Press, 2004), p. 122.

in the Old Testament, reinforced Mary's descent from the royal house of David, thereby confirming her celestial rank. Thus does Tortoletti announce at the start of the Italian translation of his poem that Judith is a prefiguration of Mary as the "Regina degli Angeli."[23]

This predilection appears already on his title page, where it is Mary who appears in the clouds at the apex of the composition, cradling the Christ Child in her lap (Fig. 19.4). It is noteworthy indeed that Judith herself is not represented visually; rather, she is subsumed into the figure of her Christian "rationale." Tortoletti was well versed on this point, as his citations of the Marian exegeses of Serarius and Celada indicate. It is the latter who expanded the typology to the greatest extent. What had been an integrated leitmotiv for Serarius in 1599 became for Celada in 1637 a lengthy independent appendix that rings every possible change on the Judith-as-Mary premise: "de Ivdith figvrata; id est de Virginis Deiparae laudibus." It is announced on the frontispiece and visually confirmed by the twinned illustrations of the two heroines at the top and bottom (Fig. 19.5). Such authors remind us that Judith was a "regular" in the emergent Mariological theology of Canisius, Suarez, Del Rio, and many others in their wake.[24]

This typology depends fundamentally on the Vulgate Book of Judith's emphasis on the protagonist's chastity and humility, discussed by others in this volume. Despite the text's abundant erotic energy, Judith saves her people by thwarting the lust of the proud Holofernes. It cannot be overstressed that although she dissembles and allows him to believe that she will accede to his carnal desires, she does not seduce him before beheading him. All Counter-Reform defenses of the heroism of Judith are founded on this point. Tortoletti, for instance, refutes charges that her deed was scandalous because "full of deception and the allurement to sin" (pieno d'inganno, e d'allettamenti a peccare).[25] His is the Church's standard defense: her appearance may be decorative and compliant, but in her actions she is the chaste "warrior of God" (Guerriera di Dio) and warfare justifies her strategies.

As important to Judith's Marian identity as chastity is her piety, a key indication of which is her propensity to prayer. Moreover, since it is through prayer that Judith enlists God's aid for her people, she was long seen by the

23 Tortoletti, *Giuditta Vittoriosa*, Apparato, c. 5. For the full statement, see Carpanè, p. 47. It's not irrelevant that the dedicatee is Anne of Austria, Queen of France.
24 The pioneering treatise is by Canisio, Petro (St. Peter Canisius), *De Maria Virgine incomparabili et dei Genitrice Sancrosancta* (Ingolstadt: Sartorius, 1577). See Hilda Graef, *Mary: A History of Doctrine and Devotion*, vol. II: *From the Reformation to the Present Day* (New York: Sheed and Ward, 1965), pp. 18ff.
25 Tortoletti, *Giuditta Vittoriosa*, Apparato, c. 3.

Church as an antetype of Mary's role as intercessor in heaven for human-kind, and thus of the Assumption. Serarius makes just this point, at length, and concludes with a taunt to his Protestant adversaries: "Are you gnash-ing your teeth, heretics?" (Quod frendes, haeretice?)[26]

The Lateran Judith cycle is permeated with this very Marian purpose. This is typical of Sixtus V's artistic patronage and indeed his papacy overall, one of whose signal aspects was his devotion to Mary. We have already noted that at the Lateran, Judith and her dwelling are portrayed by Guer-ra and Nebbia as regal; as for her piety and intercessional efficacy, they assign three scenes to her prayers. This is most striking in the sixth vault, where she kneels in supplication to God before the bed on which the naked Holofernes is splayed in unconscious inebriation (Fig. 19.3). Her chastity is signaled here also: nothing so well denotes the absence of seductive in-tent (or action). The sixteenth-century transformation of the figure of Judith, especially in northern Europe, from paragon of modesty to icon of crafti-ness and dangerous erotic allure, is well known. No grist for this mill is provided by Nebbia and Guerra.

Moreover, their insistence on the carnal physicality of the drunken Assyrian general is unusual in ecclesiastical art of this period and has spe-cific resonance in anti-heretical discourse. It is inseparable from his identity as an infidel. In Tortoletti's poem, for instance, the "Tartar" Holofernes is undone by his own heathen libido.[27] This commonplace of sectarian rheto-ric was much aired in this period; as the ultra-Catholic Jean Boucher put it in 1614, heresy is "born in lust."[28] There is additional congruence here with the ancient associations between blood and lust, so central to the *Psychomachia* of Prudentius. Thus the usual patristic interpretation of Judith as Chastity, Piety, and Humility, vanquisher of Holofernes as Lust, Blas-phemy, and Pride, had contemporary cogency in the Counter-Reformation, where the Marian typology had the most militant of applications.

This can be seen in the insistence on Mary's identity as a warrior. Her image was carried by Catholic soldiers into battle because, as was noted in 1616 by Andrea Vittorelli, she was the "glorious fighter ... the invincible warrior ... the queen and captain of the soldiers of Heaven" (gloriosa com-battrice ... Guerriera invincibile ... Capitana della soldatesca del Cielo).[29] It's

26 See *PL, Scripturae Sacrae*, 14, pp. 1047–1054, with quotation on p. 1052.
27 See, e.g., Canto VIII of *Giuditta Vittoriosa*.
28 Quoted in John Marshall, *John Locke, Toleration and Early Enlightenment Culture* (Cambridge: Cambridge University Press, 2006), p. 278.
29 *Gloriose Memorie della B.ma Vergine Madre di Dio* (Rome: Facciotto, 1616), p. 128.

clear that such bellicosity was a revival of her ancient identification as the Church itself and thus as the "Exterminator of Heretics."[30] The convergence with Judith was irresistible. As Vittorelli put it, she and the Virgin "cut off the heads of the hydra of heresy" (tagliate le teste all'hidra dell'heresie) in what he subsequently described as the "perpetual war with the Devil and his spawn, the heretics" (perpetua guerra con il Diavolo, e con gli Heretici, seme di lui).[31] We see here an updating of the definitive patristic claim by Sixtus V's alter ego, St. Jerome himself: Judith was a type both of Mary and "of the Church which cuts off the head of the devil."[32] The Lateran frescoes belong within this discursive tradition.

The Marian Judith: Typological Theology and Its Figurations

For Catholics, the Marian Judith was and remains official dogma, with verses from her text recited in the liturgies of Mary's feasts.[33] We will now consider some of the theological underpinnings of the Mary/Judith typology and their visual ramifications in fresco and ink, along with the Lateran cycle. The core authority for the paradigm was Jerome's Book of Judith itself, which, I would argue, may be seen as a Marian text, shaped by him with the typological imperative in mind. Such an argument would revolve around his well-known molding of the protagonist to raise the profile of her chaste and humble widowhood, compared to the treatment of the Greek Septuagint. Such idiosyncrasies of Jerome's scripture, plus his other utterances on Judith, were assiduously mined by patrons and artists in the sixteenth and seventeenth centuries.

The greatest concentration of Marian tropes is found in the episodes of Judith's exultant homecoming and the subsequent celebrations. Indeed, the quotations from the Book of Judith most frequently put to liturgical use as descriptions for Mary are drawn from the encomia of the high priests at the

See Ostrow, *Art and Spirituality in Counter-Reformation Rome*, pp. 184–85.
30 Martin del Rio used the honorific "Haeresum Expugnatrici" in his *Opus Marianum* (Lyon: Horatium Cardon, 1607), p. 3; Polemic 6, 884–909, is "De Divina Militia."
31 Vittorelli, *Gloriose Memorie*, pp. 128, 245.
32 In his letter (79) to Salvina and his Vulgate commentary on the prophetical Book of Sophoniam. For the former, see http://www.newadvent.org/fathers/3001079, with the quoted phrase in the final paragraph; for the latter, *Corpus Christianorum, Series Latina, LXXVI A: S. Hieronymi Presbyteri Opera Part I Opera Exegetica 6* (Turnholt: Brepols, 1970), p. 655.
33 See Priero, *Giuditta*, pp. 28–29.

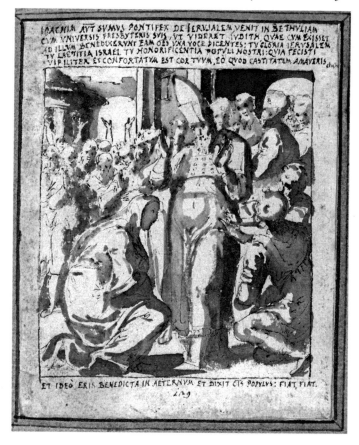

19.6. Giovanni Guerra, *Judith Praised by the High Priest*, ca. 1606. Avery
Architectural and Fine Arts Library, Columbia University, New York.
Photo credit: Avery Library, Drawings and Archives Department.

victory festivities in Jdt 15:10–11: "tu gloria Hierusalem, tu letitia Israel, tu
honorificentia populi ... eo quod castitatem amaveris" (Thou art the glory
of Jerusalem, thou art the joy of Israel, thou art the honor of our people
... because thou hast loved chastity). An interesting representation of this
very scene is provided by Guerra, not in the Lateran frescoes but in a rather
obscure series of ink drawings, made perhaps around 1606[34] (Fig. 19.6).

34 A bound collection of 134 drawings illustrating the entire Book of Judith, with
the date and Guerra's name in a handwritten inscription. I thank Dr. Claudia Funke,
the curator of the Rare Books Room and the Prints and Drawings Collections at the
Avery Library, at Columbia University, and her staff for their exemplary assistance.
Although mentioned in the Guerra literature, these drawings do not seem to have
been the object of sustained analysis, a lacuna I plan to rectify. The Guerra attri-

In this modest image, the patristic purpose is realized: the veiled heroine kneels in humility at the feet of High Priest Joachim, even as she is proclaimed the "Glory of Jerusalem."

With this in mind, it should not be surprising that representations of Judith's reception in Bethulia (Jdt 13:19–26) would be much disseminated in the period under consideration. There is additional conformity to Jerome here, namely to the directive in his preface to the Book of Judith to not only imitate her chastity but to also "with triumphant laud make her known in perpetual praises." Unveiling the trophy head to the joyous Bethulians, the heroine proclaims her chastity to have been undefiled by the lust of Holofernes, as she was protected by God from the "pollution of sin" (Jdt 13:20; sine pollutione peccati). To that end, Jerome goes so far as to provide her with a guardian angel. It is the only supernatural touch in the story, and it is unique to the Vulgate.

Jerome's Angel

The angelic motif is highlighted in one of the most unusual of Catholic Reformation representations of Judith, the little-studied fresco by Leonello Spada of ca. 1615, in the Servite basilica of the Madonna della Ghiara in Reggio Emilia (Fig. 19.7).[35] The decorative program of this shrine is an *enciclopedia mariana*, its purpose the exaltation of the Virgin as the Queen of Heaven and as *Ecclesia*. Judith is one of the twelve Old Testament prefigurations of Mary; she is prominently placed adjacent to the central cupola, also by Spada, which depicts the Assumption. The inscriptions above and below his Judith fresco are the "tu gloria Hierusalem" and "tu honorificentia populi" of Jdt 15:10–11, intoned in the liturgy of this very feast.

Spada dramatizes his *Judith Beheading Holofernes* to maximum effect, by the nocturnal lighting, the commanding figure of the heroine holding the head of Holofernes aloft in one hand and a blood-streaked sword in the other, and the steep worm's-eye perspective. The whole is enhanced by the

bution was first published by Phillip Pouncey in a review of A. Bertini's *I disegni italiani della Biblioteca Reale di Torino* (in *Burlington Magazine* 99, 1959, p. 297); thence discussed by Elena Parma Armani in *Libri di Immagini, Disegni e Incisioni di Giovanni Guerra*, exhibition catalogue (Modena: Palazzo dei Musei, 1978) and also her "La Storia di Ester in un libro di schizzi di Giovanni Guerra," in *Bollettino Ligustico*, 1973 (1975), pp. 82–100, with the Judith series on pp. 85–87.

35 See Fiorenzo Gobbo in Vincenzo Benassi et al. (eds.), *La Madonna della Ghiara in Reggio Emilia: Guida storico-artistica* (Reggio Emilia: Communità dei Servi di Maria, 1988), pp. 25, 34–42.

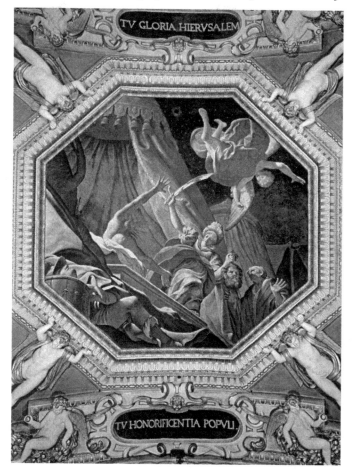

19.7. Lionello Spada, *Judith Beheading Holofernes*, ca. 1615. Basilica
della Madonna della Ghiara, Reggio Emilia. Photo credit: G.E.M.A.
(Grande Enciclopedia Multimediale dell'Arte).

vivid presence of Jerome's guardian angel, performing dazzling acrobatics
in the dark sky. The angel is essential to the composition: its pose com-
pletes the gruesome central diagonal formed by the sword and the gesticu-
lating upper arm of the headless trunk which spurts blood out into space,
itself a rare element in Judith imagery in churches. Given its scale, lighting,
and hyperbolic contortions, Spada's angel declares its Vulgate purpose as
defender of Judith's chastity in the tent.

But the angel is not mentioned at this point in the scriptural narrative. It
enters the story only subsequently, in Judith's assertion back in Bethulia of

its protective presence throughout her journey. Spada's composition therefore depicts the letter not of the scene it illustrates but of Judith's recollection of it, the point of which is the triumph of Chastity over Lust. In the double context – the Marian basilica site and the contemporary discourse of Protestant heresy-as-lust – the angel is a purposeful and multi-faceted polemical invention.

This is further seen in another, less-expected dimension of Catholic apologists' appropriations of Judith: her role in the cause of the newly popular and controversial veneration of guardian angels. It can be documented that she was invoked as proof of their existence, against Luther, Calvin, and other "impii & imperti haeretici." This language comes from a prominent work on this theme, another treatise by Vittorelli, *De Angelorum Custodia*, dedicated in 1605 to the new Pope Paul V, who would soon approve the *Officium Angeli Custodis*.[36] There were Marian dimensions to this cult, via Gabriel, which brings us to the Annunciation.

"Blessed Art Thou"

No aspect of Judith's triumphant return from the Assyrian camp is more relevant to the Marian typology than the praise bestowed upon her by the Bethulian elder Ozias (Jdt 13:23). His words were read by Catholics as explicitly pointing to Mary: "Blessed art thou, O daughter, by the Lord the most high God, above all women on earth" (Benedicta et tu filia a Domino Deo excelso prae omnibus mulieribus super terram). We recognize here the adumbration of Gabriel's salutations to Mary at the Annunciation and the Visitation, respectively: "blessed art thou among women" (Lk 1:28: benedicta tu in mulieribus). This is of course the language enshrined in the *Ave Maria*. The most fundamental of Marian doctrines and prayers were thus construed as Judithic in their essence, affirmed by the Church as scriptural confirmation of Mary's unique supernatural destiny.

The verbal similarity between Ozias's address to Judith and Luke's for the Annunciation illuminates the keystone of the typology: the parallel between the beheading of Holofernes and the conception of Christ. Central to the idea is the symbolic association of Holofernes with Satan and thus with the serpent in Eden who tempted Eve, precipitating the Fall and the redemptive mission of Christ. The ultimate crushing by an unnamed woman

36 *De Angelorum Custodia* (Padua: Petri Pauli Tozzi, 1605), p. 98; Judith is discussed on pp. 44–45. This is one of Vittorelli's several books on the theme. Tortoletti too gives prominence to Judith's angel throughout *Giuditta Vittoriosa*.

of the head of the serpent was prophesied in the "ipsa conteret caput tuum" of Genesis 3:15. That controversial feminine pronoun, "ipsa," a grammatical error in the Vulgate text and much derided by reformers, was maintained by the Church as a reference to Mary, who crushes Satan's head by humbly accepting the incarnation of Christ in her virgin womb. The step to Judith's dispatching of the head of Holofernes was inevitable. She thus enters into the symmetrical theology of *Eva/Ave*, Mary as the Second Eve: the original sin is caused by a woman, the concupiscent mother of us all, and redeemed by a woman, the virgin who conceives the Messiah at the Annunciation.[37] As a patristic source put it, "the serpent deceived the former [Eva], so Gabriel might bring glad tidings to the latter [Mary]."[38]

The foreshadowing of Gabriel's "glad tidings" for Mary by Ozias's "Blessed art thou" for Judith was grafted onto this dynamic. It was Jerome himself who gave the most vivid expression of the application to Judith in his best-known letter, written to (Saint) Eustochium: "the chain of the curse is broken. Death came through Eve, but life came through Mary. ... Then chaste Judith once more cut off the head of Holofernes. ..."[39] It would be hard to overstate the influence of this formulation on Marian theology and its visual expression across the centuries. In Rome, it is found by at least the early eighth century, in the church of Santa Maria Antiqua in the Forum, where frescoes of *Judith Returning to Bethulia* and the *Annunciation* are in close proximity.[40] By the early sixteenth century, it was widely diffused. Dürer, for instance, incorporated a simulated relief of Judith with the head of Holofernes in his woodcut *Annunciation* of 1503, as did Giovanni Battista Caroto in a painting soon thereafter for San Giorgio in Braida, Verona[41] (Fig.

37 Forged in second-century polemics against "calumnious insinuations of pagans and Jews" (Justin Martyr, Irenaeus, etc.), it became an essential Mariological theme. See Luigi Gambero, *Mary and the Fathers of the Church: The Blessed Virgin Mary in Patristic Thought*, trans. T. Buffer (San Francisco, CA: Ignatius Press, 1999), pp. 46, 48, 52–8, 124–25.

38 From the "Catecheses" traditionally attributed to St. Cyril of Jerusalem; see Gambero, ibid., pp. 131–140, with quote on p. 135.

39 Letter 22. See http://www.newadvent.org/fathers/3001022.htm. The quotation is in paragraph 21. Likewise the *Psychomachia* of Prudentius, which allegorizes the beheading of Holofernes/Lust in identical Marian terms. See the quotation and discussion in this volume by Mark Mastrangelo.

40 See Ann van Dijk, "Type and Antetype in Santa Maria Antiqua: The Old Testament Scenes on the Transennae," in J. Osborne et al. (eds.), *Santa Maria Antiqua al Foro Romano cento anni dopo* (Rome: Campisano, 2004), pp. 113–27.

41 Dürer's print is from the well-known *Life of the Virgin* series. Caroto's *Annunciation* is a diptych, with Mary and Gabriel on two separate canvases; it is generally dated to ca. 1508 or slightly later.

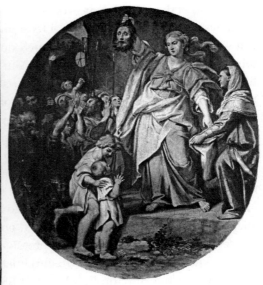

19.9. Domenichino, *Judith Triumphant*, ca. 1628.
Bandini Chapel, San Silvestro al Quirinale,
Rome. Photo credit: G.E.M.A. (Grande
Enciclopedia Multimediale dell'Arte).

19.8. Giovanni Caroto, *Virgin
Annunciate*, ca. 1508. Museo del
Castelvecchio, Verona.
Photo credit: ARTstor,
103-41822000556140.

19.8). Conversely, Gabriel opens the popular Florentine drama, *La rappre-
sentatione di Iudith Hebrea*, and appears as the illustration of the title page by
the late sixteenth century[42] (Fig. 17.7, in McHam, Chap. 17).

The most expansive visual analogue of Judith's link to the Virgin
Annunciate is the fresco cycle at the Lateran. The encyclopedic gamut of
subjects painted at this site plots an immense panorama of time from the
beginning of Creation to the era of Sixtus V. In the loggias of the *piano
nobile*, biblical themes prevail: the Genesis sequence to the west begins
with the creation of Adam and Eve, while the Christological wing to the
east opens with the prelude to the birth of Jesus. In a stunning piece of

42 See the discussion in this volume by Sarah Blake McHam (Chap. 17); also Frank
Capozzi, "The Evolution and Transformation of the Judith and Holofernes Theme
in Italian Drama and Art before 1627," Ph.D. dissertation (Madison, WI: University
of Wisconsin, 1975), pp. 32–58.

plotting, the loggia of Judith to the south is the bridge between the two. The entrance into her narrative – into the commencement of the Assyrian invasion of Judea – is through the first bay of the Genesis loggia, whose climactic scene depicts the Fall. The exit from the Judith loggia – from under the scene of the defeat of the Assyrians – is into the first bay of the adjoining wing, whose climax is the Annunciation and Visitation. Jerome's view of Judith's place in the cycle of humanity's fall and redemption is thus succinctly summarized. Her saga begins with *Eva* and ends with *Ave*, the vault of her victory leads to the realm of "Blessed art thou among women." Sixtus's artists are here illustrating his hero Jerome's explanation to Eustochium: Eve made Mary necessary, and one route between the two is through the tent of Holofernes.

The logic of Judith as a bridge between the "ipsa conteret" of Genesis 3:15 and Gabriel's honorific greeting at the Annunciation was part of the Church's defense of the most inflammatory of all Marian doctrines, the Immaculate Conception.[43] These phrases, with their Judithic resonance, were said to provide scriptural confirmation for that doctrine. In a sermon by Bellarmine of ca. 1570, for the vigil of the Immaculate Conception, the discussion of Gabriel's salutation to Mary leads to Ozias's greeting of "that most strong and most chaste Judith, who did not cut off the head of Holofernes, rather she crushed and smashed the head of the infernal serpent" (quella fortissima e castissima Giuditta, che non troncò il capo di Oloferne, ma schiacciò e stritolò il capo del dragone infernale).[44] Another locus is the Marian appendix and the title page illustration of the exegesis by Celada (Fig. 19.5). There, Judith is paired with Mary as the Immacolata, standing on the serpent and inscribed "ipsa conteret caput tuum."[45] It is as a type of the Immacolata that Holofernes's beheader enters this Mariological battlefield, as seen in the "cut(ting) off the heads of the hydra of heresy" rhetoric of Vittorelli. The full Judithic extension of the Immaculate Conception, which also involves the Turks, is beyond the scope of this essay. To conclude this

43 Sixtus V was an ardent Immaculist. His famous sermon on the subject invoked Judith: *Predica della Purissima Concettione della Gloriosa Madre di Dio, Maria Vergine*, preached in 1554, while he was still a friar, at San Lorenzo, Naples. It was published there in that year by Cilio Allifano and in 1588 by Cacchij.

44 See Roberto Bellarmino, *Ave, Maria* (Siena: Cantagalli, 1950), pp. 29–51; the quote is on p. 42.

45 It seems to me that the source of the Judith illustration is a print by Claude Mellan after a painting by Virginia da Vezzo, 1620s. For the print, see Luigi Ficacci (ed.), *Claude Mellan, gli anni romani: un incisore tra Vouet e Bernini*, exhibition catalogue (Rome: Multigrafica, 1989), pp. 218–19.

one, we'll connect the foregoing Annunciation material to the related but more contained case of the Assumption.

Judith Triumphant

The immediate next step from the Annunciation is the Visitation, where Mary's cousin Elizabeth instantly recognizes the Incarnation of the savior within Mary's womb. Elizabeth's greeting to Mary, "blessed art thou among women," repeats that of Gabriel, and therefore provides another echo of Ozias's praise of Judith. The Visitation had thus become a commonplace in the Judith/Mary typology of the Middle Ages. It was reanimated in the Post-Tridentine era, where we find it, for instance, in the exegesis of Serarius.[46] The most energetic of its applications was as a scriptural vindication of the doctrine of the Assumption. Elizabeth's and Gabriel's rhetoric was held to announce the future spiritual triumph of Mary over death in her bodily assumption into heaven, because it establishes her physically unique role in Christ's ultimate spiritual victory over Satan/Sin.

A timely example of the intersection of Judith, the Visitation, and the Assumption is the discussion by the Jesuit Vincenzo Bruno in his meditations on Mary's feasts, first published in 1585 and reissued many times thereafter.[47] Judith appears as the first of the Old Testament "figures" of the Visitation, immediately after the Gospel of Luke. Bruno's book was the source of the iconography of an important pictorial site dedicated to the Assumption in Rome, the Bandini chapel in the Theatine church of San Silvestro al Quirinale, frescoed by Domenichino in ca. 1628.[48] In the pendentives there, Judith joins David, Esther, and Solomon in the foreshadowing of Mary's ascent to heaven (Fig. 19.9).

In this setting, the rationale for Domenichino's theme, *The Triumphant Return of Judith to Bethulia*, is Bruno's correlation of the joyful reception of

46 In Prologue IV: *PL, Scripturae Sacrae*, 14, p. 800.

47 Vincenzo Bruno, *Delle Meditationi sopra le sette Festivita principali della B. Vergine le quale celebra la Chiesa*. It was incorporated into Bruno's *Meditationi sopra i principali Misteri della Vita, Passione, e Risurrezione di Cristo* (Venice: Gioliti, 1585 and henceforth). See Sommervogel, *Bibliothèque de la Compagnie de Jésus*, 2, pp. 266–71. I used the Venetian edition (Misserini, 1606), where the Visitation reference is on p. 167.

48 See Maria Grazia Bernardini, "La Cappella Bandini," in Richard Spear et al. (eds.), *Domenichino 1581–1641*, exhibition catalogue, Rome, Palazzo Venezia (Milan: Electa, 1996), pp. 318–29. The first person to adduce Bruno as Domenichino's source was Emile Mâle in 1932 in *L'Art religieux après le Concile de Trente*; see the rev. ed., *L'art religieux du XVIIe siècle et de XVIIIe siècle* (Paris: Colin, 1951), pp. 341–42.

the victorious Judith back in Bethulia with that of Mary by Elizabeth: in both cases, the vanquished enemy is Satan.[49] The celebratory tone is essential to the typological parallel, and so the painter is careful to register the awe and applause of the crowd. His characterization of Judith – restrained, modestly garbed and posed, morally worthy of the cynosure she inspires – fits the Marian program perfectly.

Domenichino's adoption of the link between the rapturous welcome of the Bethulians and that of the heavenly hosts at the Assumption is a useful reminder that Judith was in fact a familiar figure in representations of this theme. As in Correggio's celebrated cupola in the cathedral at Parma in the 1520s, she appears in such important later depictions of the Assumption as the dome fresco by Volterrano, done 1680–83, at Santissima Annunziata in Florence.[50] There she stands out in a group of Hebrew heroines that includes Jael and Esther. It is at the Assumption that Judith most overtly belongs to the court of, to repeat Tortoletti, the "Regina degli Angeli." The point would have registered with particular satisfaction in Florence, as Judith's place among Mary's celestial courtiers had the imprimatur of Dante, in the *Paradiso*.[51]

Conclusion

In the Catholic Reformation, the "official" Judith was the Marian Judith. She was preached from pulpits, theorized in treatises and poetry, and painted on church walls and papal palaces. In Rome alone, the sites with her depictions from this period include those of the highest significance, among them the churches of the Gesù, Santa Maria in Vallicella, Santa Maria del Popolo, and St. Peter's itself. The paintings discussed in this essay are therefore not exceptions to the rule: they belong to the most authoritative discourse of their time, one that is rooted in popular belief as well. They show us how the apocryphal Book of Judith, whose scriptural authority was contested by most Protestants, was visualized to reinforce dogmas of

49 See also Uppenkamp, *Judith und Holofernes in der italienischen Malerei des Barock*, pp. 111–17.
50 David Ekserdjian, *Correggio* (New Haven, CT: Yale University Press, 1997), p. 253; the only other recognizable Old Testament woman is Eve. For Volterrano, see Maria Cecilia Fabbri, "'La più grande e perfetta opera' del Volterrano: l'affresco nella tribuna della Santissima Annunziata," in *Antichità Viva*, 35, no. 2/3 (1996), pp. 43–58, especially p. 49 and fig. 23. On site one sees that Judith is placed directly above the word VIRGINI in the inscription below.
51 Canto XXXII, 10.

even greater controversy. In this doubling of the polemical stakes, the rhetorical potency of Judith was assured.

Music and Drama

Thomas Theodor Heine, comic drawings for Johann Nestroy's *Judith*, 1908.

20. Judith, Music, and Female Patrons in Early Modern Italy

Kelley Harness

Of the numerous musical treatments of the Judith narrative composed in Italy before the nineteenth century, probably the best known today is Antonio Vivaldi's *Juditha triumphans* (1716) – the composer's only surviving oratorio – originally performed by the well-trained female musicians of the Pio Ospedale della Pietà of Venice as part of that institution's roughly twenty-year tradition of performing Latin oratorios.[1] As suitable models of piety for young (and not-so-young) women, biblical women and female saints appeared frequently in dramatic works performed by communities of women. But Giacomo Cassetti, the oratorio's librettist, also intended his oratorio to be read as an allegorical response to Venice's ongoing war with the Ottoman Empire: he appended an allegorical poem (*Carmen allegoricum*) predicting that Judith's victory would foreshadow Venice's own success against its enemy, and in the final accompanied recitative of the oratorio, the high priest Ozias prophesies that Venice "erit nova Juditha" and will defeat its Asian enemies. As he calls on the daughters of Zion to "applaudite Judithae Triumphanti," both audience and performers would have appreciated that the daughters of Venice had just done precisely that.

Oratorios such as *Juditha triumphans* make up the majority of pre-1900 dramatic settings of the Judith story, especially after ca. 1650. But during the sixteenth and early seventeenth centuries, theatrical (i.e., staged) works predominate. Like oratorios these plays were meant to edify their audi-

1 Antonio Vivaldi, *Juditha triumphans: Sacrum militare oratorium*, ed. Alberto Zedda (Milan: Ricordi, 1971); see Michael Talbot, *The Sacred Music of Antonio Vivaldi* (Florence: Olschki, 1995), pp. 409–47.

ences by means of the biblical narrative, and, as Cassetti would do in the early eighteenth century, their authors drew on the multiple possibilities for interpretation inherent in that narrative.[2] Since authors began with a predetermined central plot, they often relied on extra-biblical scenes to highlight and amplify specific didactic messages. These were often located in musical *intermedi*, interludes performed between the acts of comedies as a means of providing both diversion and a dramatic frame for the spoken play. Sets of these interludes survive for at least five dramatic works on the subject of Judith from the period 1500–1650:

> Anonymous, "Commedia di Judit" (Florence: Biblioteca Riccardiana [=I-Fr], Ricc. 2976, vol. 4)[3]
>
> Giovanni Andrea Ploti, *Giuditta* (Piacenza: Giovanni Bazachi, 1589)
>
> Andrea Salvadori, *La Giuditta* (Rome: Vatican Library [=I-Rvat], Barb. lat. 3839, fols. 66r–94v; published in Salvadori, *Poesie*, 2 vols. [Rome: Michele Ercole, 1668], 1, pp. 91–128)[4]
>
> Antonio Maria Anguissola, *La Giuditta: attione scenica* (Piacenza: Giacomo Ardizzoni, 1627; reprint, Venice: Marco Ginammi, 1629)
>
> Padre Fra Bastiano, frate della Santissima Nonziata, "Il trionfo di Iudit: comedia dilettevole" (I-Fr, Ricc. 2850, vol. 3)

Although the music has been lost for all five works, stage directions, as well as the texts themselves, reveal that Judith plays featured a wide range of musical genres, from plainchant and *laude* to operatic recitative and commedia dell'arte songs. The latter appear in the two *intermedi* appended to Fra Bastiano's "Il trionfo di Iudit." In the first (fols. 48r–49r), designated "Aria d'Intruonni" – possibly a reference to the character Pasquariello Truonno – stanzas illustrating the brevity of earthly existence conclude with a warning addressed specifically to Holofernes: the ferocious boar's poison can quickly bring about the death of the bold hunter. Fra Bastiano entitles the second *intermedio* (fols. 49v–50r) "Aria di Scarpino [*sic*]," and its rhyme scheme and

2 See Elena Ciletti, "Patriarchal Ideology in the Renaissance Iconography of Judith," in Marilyn Migiel and Juliana Schiesari (eds.), *Refiguring Woman: Perspectives on Gender and the Italian Renaissance* (Ithaca, NY and London: Cornell University Press, 1991), pp. 35–70.

3 First noted by Elissa Weaver (*Convent Theatre in Early Modern Italy: Spiritual Fun and Learning for Women* [Cambridge: Cambridge University Press, 2002], pp. 141–48, 244–52), who transcribes the prologue and two of the *intermedi*. I would like to thank The Jessica E. Smith and Kevin R. Brine Charitable Trust for making possible two research trips to Italy in 2008, which allowed me to consult numerous Judith plays, including those listed below.

4 In subsequent references to this work I will use the page numbers from the printed edition.

line lengths correspond exactly to the "Aria di Scapino" published in 1638 by the Bolognese comedian Francesco Gabrielli, who specialized in that role.[5] As with the first *intermedio*, the strophic song offers generic advice – in this case a warning of the pain and torment in store for those who follow earthly, rather than divine, love – before shifting focus in the final two stanzas to the divergent paths chosen by Holofernes and Judith.

The four cardinal virtues deliver similarly moralistic messages in the choruses that follow each of the five acts of Giovanni Andrea Ploti's *Giuditta* (Piacenza, 1589). Their order of appearance – Prudenza, Giustitia, Fortezza, and Temperanza – mirrors the trajectory of the plot, with each virtue commenting on the events of the previous act. These observations are of a general sort (Judith is never named directly); rather, each chorus interprets the narrative by isolating moments in the drama to exemplify larger moral truths, a strategy summarized in the closing lines of the final chorus, which the virtues deliver as a group: "Imparate / voi quì tutti, Mortali, / il ben seguir, e dechinar da i mali." (Learn, all you mortals here, to follow good and to decline evil. [120]).

Among the mortals to whom the virtues addressed their moralistic messages was the play's dedicatee, Laura Cecilia Scota[o], countess of Agazzano and Vicomarino. Judith plays often seem to have been dedicated to or otherwise associated with women, including four of the five works listed above (the Fra Bastiano play is the exception). Ploti calls particular attention to the issue in his dedication, acknowledging the early modern ideal of decorum: "il soggetto di quella par, che più à Donna, che ad Huomo si convenga" (the subject appears better suited to a woman than to a man). Conformity to decorum dictated the consideration of other qualities as well, such as age, marital status, and social class. Politically astute playwrights knew to distinguish plays intended for nuns, for example, from those destined for a court performance. In the case of the Judith narrative, the diversity of interpretations attached to the heroine and her deed simplified their task.

Possibly one of the clearest examples of the multiple interpretations inherent in dramatizations of the biblical narrative can be found in Andrea Salvadori's *La Giuditta*, written at the request of the widowed Archduchess Maria Magdalena of Austria (1587–1631), grand duchess of Tuscany from 1609 and, between February 1621 and July 1628, co-regent of the duchy,

5 On Gabrielli and his aria, see Anne MacNeil, *Music and Women of the Commedia dell' Arte in the Late Sixteenth Century* (Oxford: Oxford University Press, 2003), pp. 24–30.

along with her mother-in-law, Christine of Lorraine.[6] Sung throughout to music by court composer Marco da Gagliano, *La Giuditta* deserves special mention as the first opera on the subject of Judith, although its music unfortunately does not survive. It was apparently performed just once, on 22 September 1626 as part of the festivities celebrating Cardinal Francesco Barberini's brief stopover in Florence on his return to Rome after (ostensibly) negotiating the Treaty of Monzon between France and Spain. On one level, Salvadori's entire libretto supports reading the opera as an endorsement of the papacy's preemptive role in negotiating peace in Europe so that the combined forces of Christianity could then join against the enemies of the Church. Salvadori frames the biblical narrative by two small scenes, somewhat inaccurately termed *intermedi*. While filled with encomiastic references to Rome and the Barberini family, figures in both *intermedi* propose that the cardinal and, more importantly, his uncle, Pope Urban VIII, should now direct their attention toward the east. In the first *intermedio*, a personification of the Appenines promises support through a donation of his (i.e., Italy's) resources if, in imitation of the pope's zealous predecessors, he will renew the holy war with the Turks (98). The final *intermedio* praises the papacy's reunification of Catholic countries in even more explicit terms. Here Iris, emissary of peace and Juno's messenger, informs her mistress and Jupiter that credit for securing peace in Europe belongs to the bees, the most distinctive feature of the Barberini coat of arms. Juno expresses the hope that Iris's intervention will turn Mars's bellicosity toward a location more deserving of it, namely Thrace, while at the conclusion of that same *intermedio* Europe praises the Barberini and optimistically predicts that, under the sun's influence, Europe may now eclipse the moon of Asia, in reference to an Islamic symbol.

These *intermedi* invite the audience to view what takes place between them, that is, Judith's defeat of Holofernes, as an allegory of a modern-day state's victory over the Turks, an expansion of Judith's role as a symbol of the Church Triumphant. But Judith also typified the sort of female worthy that characterized other works commissioned by, or dedicated to, the archduchess during the period of the regency – the principal court-sponsored opera performed in 1624 and 1625 was *La regina Sant'Orsola*, another Salvadori/Gagliano collaboration. Virgin martyrs and other chaste heroines

6 Due to space limitations, I am able to provide only a brief overview of this work. For a fuller discussion see Kelley Harness, *Echoes of Women's Voices: Music, Art, and Female Patronage in Early Modern Florence* (Chicago, IL: University of Chicago Press, 2006), pp. 111–41.

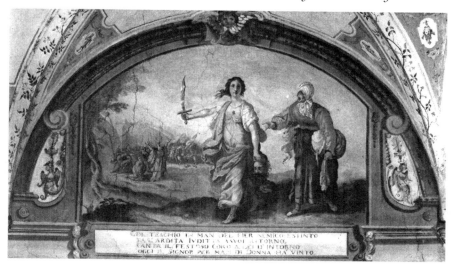

20.1. Giovanni Battista Vanni or Cecco Bravo, *Judith*. Villa Poggio Imperiale, Florence. Photo credit: G.E.M.A. (Grande Enciclopedia Multimediale dell'Arte).

dominated the court festivities honoring state visitors to Florence during the period of the regency.

Maria Magdalena was also the dedicatee of Cristofano Bronzini's treatise *Della dignità, et nobiltà delle donne* (Florence, 1622–32), a dialogue in which supporters of women's roles in public life refute their misogynist counterparts by citing examples of worthy women from history, including Judith. The heroine of Bethulia joined other biblical heroines in the lunette frescoes that Maria Magdalena commissioned ca. 1622 for her antechamber in her Villa Poggio Imperiale, complementing the female saints and female rulers that decorated her bedroom and audience room there. Positioned directly in the center of the fresco (Fig. 20.1), one of Judith's bared, muscular arms points the raised sword upward to the source of her victory, while the other grasps the hair of Holofernes's severed head, eschewing the sack and her maid's help.

Judith likewise stands alone in *La Giuditta*. With her defining action – the decapitation of Holofernes – moved off-stage, Salvadori and Gagliano needed to convey the heroine's purposefulness and strength of character solely through her words and her music. Salvadori ensured that Judith's verses affirm her strength of purpose by contrasting her style of speech with that of the opera's other principal characters, especially Holofernes. Although Holofernes, his enemies, and his followers describe the general

as a fierce warrior, his actual words instead recall the dramatic tradition of the love-struck youth. At the beginning of act 2 he pleads to the stars, asking them to tarry in order that he might extend his time with the beautiful Judith, verses that are the most expressive of the libretto (106–7):

Sfavillate ridenti,	O bright, nocturnal stars,
chiare notturne stelle,	let your shining rays
vostri raggi lucenti,	sparkle, smiling,
che quante in ciel voi sete,	for as many as you are in heaven,
tanti saranno in terra i miei contenti:	so many will be my pleasures on earth:
sfavillate ridenti,	O bright, nocturnal stars,
chiare notturne stelle,	let your shining rays
vostri raggi lucenti;	sparkle, smiling;
e tù, quanto tù puoi,	and you, shadowy night,
ne le Cimmerie grotte	remain as long as you can
trattienti ombrosa notte,	in the Cimmerian caves,
che mentr'aver poss'io	for while I can have
la mia bella Giuditta,	my beautiful Judith,
altro giorno, altro sol più non desio.	I no longer desire another day,
	another sun.

By contrast, throughout much of the opera Judith displays calmness and strength. She answers her maid's lengthy lamentation on her mistress's flirtation with dangers to her chastity (act 1.3) by commanding the woman to put her trust in God (104–5):

Abra, non ben conosci	Maid, you do not know well
lo Dio cui servo, e però vano affetto	the God whom I serve, and thus useless worry
per me ti turba il petto.	over me disturbs your breast.
Lascia di quel ch'io tento à lui la cura:	Leave to him concern over that which I attempt:
Ei, che move il mio core, ei l'assicura.	he, who moves my heart, he who assures it.

Gagliano likely mirrored Judith's terseness and rationality with similarly uninflected recitative. At the opera's conclusion Judith sings a moralistic speech drawn directly from the Book of Judith (16:7–8), warning against an over-reliance on earthly power and admonishing the audience to pay heed to the meaning of her story, a moral that clearly served the purposes of the female regents: when guided by God, women acquire the spiritual and physical strength necessary to overcome their enemies (118).

This final speech highlights yet another facet of the opera, for Judith was

of course also a symbol of Florentine agency in response to a more powerful, outside aggressor.[7] And unlike the political implications of Judith imagery in fifteenth- and sixteenth-century Florence, in 1626 actual female rulers presided over the city, with the effect that Judith could act as the allegorical representation not only of Florence, but of its regents. Salvadori's *La Giuditta* thus evokes multiple allegorical interpretations, no one of which invalidates the others. At the level closest to the surface, the opera demonstrates that a woman's initiative can defeat the agents of heresy and destruction, in conformity with representations of the heroine as the personification of the Church. But given the antagonistic nature of relations between Florence and Rome ever since Urban VIII declared his intention to reclaim the duchy of Urbino – which Florence had hoped to acquire as a result of the marriage arranged between Prince Ferdinando II de' Medici and Vittoria della Rovere – a more topical allegorical interpretation of *La Giuditta* also emerges: Florence, in particular its female leadership, did not intend to relinquish passively what it viewed as its rightful territory, even in the face of the papacy. And just as throughout its history Judith's story was perceived as the most problematic when it intersected with the deeds – real or imagined – of actual women, just a few days after the performance the archduchess recognized the danger in this particular diplomatic strategy. She asked her secretary of state to convince the pope that the opera did not refer to the Barberini family – an extraordinary example of what a modern-day political commentator might term "damage control."[8]

As an operatic heroine, Salvadori's Judith conveys at least some of *La Giuditta*'s musical messages herself. But she also communicates through others. In the final two plays to be discussed here, prophets deliver these messages: in the anonymous sixteenth-century convent play, "Commedia di Judit," four sibyls – Cumana, Sambetta, Delfica, and Erithrea, described by the author as "prophetesses and virgins" – frame the prologue by means of individual speeches in *ottava rima* and a sung *lauda*, then pair off to predict the events of each act in six sung *intermedi*. Antonio Maria Anguissola separated the acts of his *attione scenica* entitled *La Giuditta* (Piacenza, 1627) with four musical *intermedi*, featuring (in order) the biblical prophets Elijah, Jonah, Balaam, and Habakkuk.[9]

7 See Ciletti, "Patriarchal Ideology," p. 58; Harness, *Echoes of Women's Voices*, pp. 113–23.

8 Florence, Archivio di Stato, Mediceo del Principato 1409, transcribed and translated in Harness, *Echoes of Women's Voices*, p. 141.

9 Giovanni Ciampoli's oratorio *Coro di profeti* also links Judith to the prophets, as

This linking of Judith and prophecy in two dramatic works may be sim-
ply coincidence. But both authors may have drawn on a tradition of describ-
ing Judith as a prophet, a view whose principal source, Isidore of Seville's
Etymologies, remained influential well into the seventeenth century. Isidore
cites Judith near the end of his extended list of Old Testament prophets (VII.
viii.29): "Iudith laudans, vel confitens" ("Judith, 'she who praises' or 'she
who proclaims'").[10] Verse 32 confirms unambiguously the nature of the pre-
ceding list: "Hi sunt prophetae Veteris Novique Testamenti, quorum finis
Christus" ("These are the prophets of the Old and New Testament, of whom
the last is Christ").[11] Sibyls are also prophets; according to Isidore's under-
standing of the term, Judith herself might be described as a sibyl (VIII.viii.2):
"Sicut enim omnis vir prophetans vel vates dicitur vel propheta, ita omnis
femina prophetans Sibylla vocatur. Quod nomen ex officio, non ex propri-
etate vocabuli est." ("And just as every man who prophesies is called either a
seer [*vates*] or a prophet [*propheta*], so every woman who prophesies is called
a Sibyl, because it is the name of a function, not a proper noun.")[12]

Although Isidore and other authors often associated individual sibyls
with specific prophecies, aside from a handful of particularizing references
in the convent play (e.g., Delfica cites the statue erected in her honor by
the Roman senate, while Erithrea summarizes the apocalyptic prophecy
for which she was best known), the author takes a more generic approach:
in the octaves that precede the prologue, the Persian (i.e., Sambetta), Del-
phic, and Erithrean sibyls all remind the audience of their prophecies of the
birth, life, and passion of Christ, and all but Erithrea stress their virginity,
an attribute they share with the nuns who portrayed them and the mem-
bers of the audience, as well as, according to some, Judith herself.[13] This
focus on virginity aligns the sibyls' octaves with contemporary conduct lit-
erature, which was in turn strongly influenced by Jerome, who limited his

well as to the Virgin Mary: performed ca. 1635 on the feast of the Annunciation,
the third soprano recounts Judith's triumph in the recitative "Venga Betulia afflit-
ta," which was published with a slightly altered title ("Ecco Bettulia afflitta") in
Domenico Mazzocchi, *Musiche sacre, e morali a una, due, e tre voci* (Rome, 1640; re-
print, Florence: Studio per edizioni scelte, 1988), pp. 42–45. I would like to thank
Virginia Lamothe for calling my attention to this work.
10 Isidore of Seville, *Isidori Hispalensis Episcopi Etymologiarum sive originum*, ed.
W. M. Lindsay (Oxford: Oxford University Press, 1911); English translation from
Isidore of Seville, *The Etymologies of Isidore of Seville*, trans. Stephen A. Barney et al.
(Cambridge: Cambridge University Press, 2006), p. 168.
11 Isidore of Seville, *Etymologies*, trans. Barney et al., p. 168.
12 Isidore of Seville, *Etymologies*, trans. Barney et al., p. 181.
13 On Judith's virginity, see Ciletti, "Patriarchal Ideology," p. 43.

discussion of the sibyls to that single attribute as he defended the Church's position on virginity (*Against Jovinianus* 1.41): "What need to tell of the Sibyls of Erythrae and Cumae, and the eight others? For Varro asserts there were ten whose ornament was virginity, and divination the reward of their virginity."[14] Juan Luis Vives shared Jerome's focus: he cites Jerome then quotes him directly, like Jerome mentioning the sibyls only in reference to their virginity.[15]

The final scene of the comedy makes it clear that the nuns were being encouraged to contemplate Judith's relationship to their daily lives. Not only was the role of Judith acted by a nun, but Judith in a sense becomes a nun when, according to the stage directions, she sings the first verse of the canticle *Hymnum cantemus Domino* (Jdt 16:15–21) in the sixth psalm tone, after which the others join her (fol. 82v). Judith sings her biblical words using a recitation formula that the nuns likely used while singing her canticle each week. But although she begins with verses 15–16, rather than continuing with the verses found in the Roman Breviary (i.e., vv. 17–21), which first celebrate God's might then warn those who would threaten God's people, in this play Judith sings verses 7–14, which recount her deed with a particular emphasis on her gender.[16]

Although it is impossible to determine whether or not a nun actually wrote the "Commedia di Iudit," the author's inclusion of liturgical music and scenes from everyday convent life illustrates the close connections between the play, its music, and the nuns who constituted its performers and its audience. The convent context also helps explain the single-minded focus on virginity in the sibyls' opening stanzas: their message is both pre-

14 Jerome, *Letters and Select Works*, trans. W. H. Fremantle, vol. 6 of *Nicene and Post-Nicene Fathers*, ed. Philip Schaff and Henry Wace, 2nd ser. (New York: Christian Literature Publishing Company, 1893; reprint, Peabody, MA: Hendrickson Publishers, 1999), p. 379.

15 Juan Luis Vives, *The Education of a Christian Woman: A Sixteenth-Century Manual*, trans. Charles Fantazzi (Chicago, IL: University of Chicago Press, 2000), pp. 66, 82.

16 The comedy features music in three other locations: the author attempts to create a realistic banquet scene in act 4.15 by including stanzas to be sung in Holofernes's tent by a musician who accompanies himself on lute or kithara (fols. 53r–v), concluding the scene with directions that the performer should play "*moresche* and similar things" (fol. 54r); in act 5.10 Ozias commands the Bethulians to sing the verset *Benedixit te dominus in virtute sua, quia per te ad nihilum redegit inimicos nostros* (Jdt 13:22) in the sixth tone, before and after Psalm 116, *Laudate Dominum, omnes gentes*; and in act 5.11 the entire cast honors the triumphant heroine with a seven-stanza *canzona* that begins "Al' inclita, vittoria, / tutti rendiamo honore" (To the glorious, victorious woman, we all return honor), sung, according to the stage directions, to the tune known as "Tu ti lamentiti a torto Signiora, del mie more" (fols. 67r–v).

scriptive and celebratory, isolating the source of their abilities while simultaneously commending the nuns on theirs.

A very different type of performance context dictated a very different sort of Judith play in 1627, the year that Antonio Maria Anguissola dedicated his *attione scenica* to Margherita Aldobrandini Farnese (1588–1646), the widowed duchess of Parma and Piacenza and, from February 1626 to April 1628, sole regent for her son, Odoardo. Like Archduchess Maria Magdalena, Margherita seems to have sought out works featuring strong female protagonists: in the play's (undated) dedication letter Anguissola refers to an earlier version of *La Giuditta* that she had ordered to be performed at court some months earlier. Margherita had been the recipient of several such works since her marriage to Duke Ranuccio I Farnese in 1600, including Antonio Maria Prati, *La Maria racquistata* (Parma, 1614) and Ranuccio Pico, *La principessa santa, ovvero la Vita di Santa Margherita Reina di Scotia* (Venice, 1626). The year after Anguissola first published his Judith play, the duchess was the dedicatee of yet another literary work on the subject, Ludovico Bianchi's heroic poem *La Giuditta* (Parma, 1628). In his dedication Bianchi praises both Judith and his patron, the widow who so resembles her ("à Vedova serenissima, che tanto la somiglia" [5]). He singles out the manner in which Margherita has shouldered the responsibilities of government, and he predicts: "And even if she does not have occasion, as had the courageous Judith, to kill Holofernes and to prostrate armies, she would not lack the willpower to do it, in defense of the country and of her dominions" (E s'ella non ha occasione, come hebbe l'animosa Giuditta, d'uccidere Oloferni, & di atterrarne esserciti, non le mancarebbe però l'animo di farlo nell'occorenze in difesa della patria, e de' suoi Stati [4]).

Anguissola may have hoped that the combination of a powerful female heroine and spectacular stage effects would convince the duchess to remount a more elaborate performance of the work in the as yet unused Teatro Farnese.[17] For the play's four *intermedi* he seems to have selected prophets whose presence virtually required the stage machinery that was such a necessary part of court spectacle: a chariot of fire drawn by four simulated horses carries Elijah to heaven (26–28); Jonah emerges from the belly of the whale (57–58); Balaam and his donkey sing in dialogue

17 Correspondence from 1627 and 1628 confirms the duchess's direct involvement in the theatrical preparations that would finally inaugurate the theater in 1628 (Parma, Archivio di Stato [=I-PAas], Carteggio Farnesiano interno, busta 372; I-PAas, Teatri e spettacoli Farnesiani, busta 1, mazzo 1 [fasc. 9, sottofasc. 5; fasc. 13, sottofasc. 2, 4–8; and fasc. 20–23]).

(78–79); and an angel carries Habakkuk through the air in order to bring food to Daniel in the lion's den (94–95). None of the prophets' *canzonette* mention Judith or the plot directly, and, in the published list of costumes and props, Anguissola discloses that the *intermedi* are actually unrelated to the main action and can be eliminated or changed if desired ("Come gl'Intermedij sono totalmente separati dall' Attione principale, così possono tralasciarsi affatto, ò mutarsi, à beneplacito altrui"). His disclaimer may simply have been directed to potential buyers who lacked access to the sorts of machinery required, for despite his claims, the *intermedi* are connected closely to the main action, highlighting words, images, and the overall mood of the play's five acts.

One of these images, and a central theme of *La Giuditta* and its *intermedi*, is blindness, in both the literal and metaphorical senses. Blindness provides for some comic banter in act 2.3, as the women of Holofernes's camp prepare a theatrical entertainment disparaging love – the actress who plays Cupid complains that her blindfold has been tied too tightly (43). In this scene the women also sing two strophic *canzonette* on the subject of Cupid's blindness, "Quell' acuto, e fiero strale" and "Ecco l'ombra di quel nume" (42–45). An inability to perceive the truth – blindness in another sense – motivates the actions of at least three of the play's characters: Holofernes deceives himself as to the nature of the feelings Judith harbors for him (act 2.2), Judith's nurse laments what she fears is her mistress's lascivious behavior (act 4.5), and the newly invented character of Elciade, the Bethulian ambassador, misconstrues Judith's presence in Holofernes's camp and persuades the Bethulians that she has betrayed them (act 5.1–3). Only Judith seems able to discern the truth behind what she sees, for example in act 3.5, when she recognizes that a celestial apparition is actually her guardian angel.

The *intermedi* explore the theme of blindness along a trajectory that follows the plot of the play. In the first *intermedio* Elijah's condemnation of a world given over to corruption alludes only indirectly to blindness, but the second *intermedio*, sung by Jonah, contains concrete references to the theme. Addressing his opening stanza to humanity, Jonah warns, "Ahi con qual mente cieca / ci aggiriamo, ò mortali" (Alas, with what blind intellect, O mortals, we deceive ourselves [57]). His *canzonetta* recalls not only his own shortcomings but also those of Holofernes, who in the previous act deceives himself into believing that Judith returns his desire. Jonah reveals that only within the whale, his blind prison ("cieca prigione"), was he finally able to perceive the truth. In *intermedio* 3 the prophet Balaam suffers from

a similarly delayed comprehension: unable to see the angel of God that is visible to his donkey, who tries to avoid it, he beats the animal until God gives the beast the power of speech, so that she might question her master's actions (Nm 22:21–35). The donkey does not reveal the cause of her fear in the biblical account, but rather, God opens Balaam's eyes (*Protinus aperuit Dominus oculos Balaam* [Nm 22:31]). In Anguissola's text, the donkey calls attention to Balaam's blindness: "Mira Balaamo, mira, ... non scorgi tu di morte hora 'l periglio?" (Look, Balaam, look … do you not perceive now the danger of death? [78]).

Anguissola restores sight to these biblical prophets in the final *intermedio*, which precedes act 5 and foreshadows Judith's return to Bethulia and its citizens' own belated understanding of the truth. Drawn from the deuterocanonical appendix to the Book of Daniel known as "Bel and the Dragon" (Dn 14:32–38), in the final two stanzas of Habakkuk's joyful *canzonetta* the prophet predicts the wondrous sights he will see on his journey, and he uses the verb *vedrò* (I will see) three times in seven lines. These wonders include the face of Cynthia (i.e., the moon) and the stars, her handmaidens, likely a reference to the six stars on the Aldobrandini coat of arms, featured prominently on the title page of the 1627 edition. Perhaps, Habakkuk muses, he will hear that the stars call God with his proper name ("Forse, forse udrò come / tutte le chiama Dio col proprio nome" [95]). The phrase "his proper name" appears to point to a lengthy speech that one of the high priests delivers in act 5.6. Initially commending Judith, the speech takes an unexpected turn at lines 17–19, as it metamorphoses into a prophecy of the Virgin Mary: "Behold the crushed head, behold the dead serpent, behold the woman who prefigures another such woman" (Ecco il capo schiacciato / ecco morto il serpente, ecco la Donna, / che ne figura un' altra Donna quella [118]).[18] The Jewish high priest goes on to predict – among other events – the coming of the Messiah and the appearance of a powerful pope, undoubtedly a reference to Margherita's most illustrious forebear, her great uncle, Ippolito Aldobrandini, Pope Clement VIII from 1592 to 1605. Like her uncle, the Catholic duchess would have believed that as Jews the Bethulians would blindly refuse to acknowledge the fulfillment of this prophecy when it occurred. Distorting the Book of Judith, Anguissola may have used his dramatization of Judith's story, along with its *intermedi*, in order to allude to *Caeca et obdurata* (Blind and Obstinate), her

18 On Judith as a prefiguration of Mary, see Ciletti, "Patriarchal Ideology," p. 42.

uncle's papal bull of 1593 expelling Jews from all the papal states except Rome, Ancona, and Avignon.[19]

Such a misappropriation of a Jewish heroine in support of anti-Semitic rhetoric strikes the modern reader as deeply troubling. But as a work celebrating one powerful widow and dedicated to another, this could never have been perceived as the play's sole meaning. As with the Salvadori opera of 1626, as well as the other plays discussed here, Anguissola's *La Giuditta* demonstrates the interpretative flexibility inherent in dramatic works on the subject; they were at once reenactments of a "worthy woman" narrative in line with contemporaneous ideals of decorum, glorifications of civic female heroism on behalf of women who wielded real political power, and sites of the sort of dynastic praise so necessary to court spectacle in the sixteenth and seventeenth centuries.

19 *Bullarum, diplomatum et privilegiorum sanctorum Romanorum pontificum taurinensis*, ed. Luigi Tomassetti et al., 25 vols. (Augustae Taurinorum: Seb. Franco, H. Fory et Henrico Dalmazzo, 1857–1872), 10, pp. 22–28.

21. Judith in Baroque Oratorio
David Marsh

From the Quattrocento onward, the story of Judith often inspired Italian writers and artists to produce masterpieces celebrating female heroism. Around 1470, Lucrezia Tornabuoni, the mother of Lorenzo de' Medici, wrote a *Storia di Giuditta* in *ottava rima*.[1] A century later, Federico Della Valle established his primacy in Italian Baroque theater with the play *Iudit* (ca. 1590), whose protagonist he describes as a foreshadowing (*ombra*) of the Virgin Mary. The biblical heroine was popular with painters from Giorgione onwards, and the beheading of Holofernes became a *Grand Guignol* staple of Baroque paintings. With the emergence of oratorio around 1600, the dramatic potential of the biblical book was realized in a succession of libretti set by distinguished composers.[2] The present essay examines some sixty years of libretti written on the theme between 1675 and 1734, and set to music as late as 1771, thus roughly spanning a century. Let us begin with a review of the book of Judith and with its dramatization by Federico Della Valle.

The Biblical Account

The Book of Judith contains a fascinating mixture of public and private elements. Even the name Judith appears symbolic: it is the feminine form of Judah, and the widow thus represents both individual heroism and collective survival. The two narrative foci of the story are the hill town of Bethulia

1 See Lucrezia Tornabuoni de' Medici, *Sacred Narratives*, trans. Jane Tylus (Chicago, IL: University of Chicago Press, 2001), pp. 118–62.
2 See Giorgio Mangini, "'Betulia liberata' e 'La morte d'Oloferne': Momenti di drammaturgia musicale nella tradizione dei 'Trionfi di Giuditta,'" in Paolo Pinamonti (ed.), *Mozart, Padova e la Betulia Liberata: Committenza, interpretazione e fortuna delle azioni sacre metastasiane nel '700*, Atti del convegno internazionale di studi, 28–30 settembre 1989 (Florence: Leo S. Olschki Editore, 1991), pp. 145–69. At p. 145 n. 1, he says that he has identified 220 libretti on the subject written between 1621 and 1934.

and the armed camp of its Assyrian besiegers. Within these public spaces, Judith seeks out private places that fulfill her mission as faithful widow and faithful worshiper. In Bethulia, she prepares for her undertaking by withdrawing to her place of prayer. (As the musicologist Lino Bianchi has pointed out, the wording of a detail in the Vulgate story of Judith antici-pates the musical oratorio of the Baroque. Jerome's account describes how the widow often repaired to a special place reserved for prayer – appar-ently a sort of tent or tabernacle – but when Jerome translated the Hebrew text, he introduced the Latin noun *oratorium* to describe her little chamber or *cubiculum*.[3]) Later, in the camp of Holofernes, she is admitted into the enemy's tent, a sort of pagan inner sanctum, in which she not only defends her own chastity, but safeguards the welfare of her entire people.[4]

The complementarity of Judith's public and private spaces is reflected in the performance of Baroque oratorio. In order to serve her people, Judith must withdraw to her oratorium; and in order to save them, she must enter the tent of Holofernes. Both worlds are made public in Baroque oratorio, which is likewise characterized by performances that are public concerts or private chamber recitals. In either case, the private world of the heroine is made immediate to a public audience. And when the people of Bethulia rejoice at their deliverance in the final chorus, the faithful spectators of a Judith oratorio presumably rejoice with them.

3 Lino Bianchi, *Carissimi, Stradella, Scarlatti e l'oratorio musicale* (Rome: Edizioni De Santis, 1969), pp. 9–10; see pp. 268–71 for a summary of *La Giuditta* "di Napoli."
4 Judith's concern for her chaste reputation is evident from her words in show-ing Holofernes's head to the Bethulians (Jdt 13:16): "As the Lord lives, who has protected me in the way I went, I swear that it was my face that seduced him to his destruction, and that he committed no sin with me, to defile and shame me." The passage is somewhat different in Jerome's Vulgate (Jdt 13:20): "Vivit autem ipse Do-minus, quoniam custodivit me angelus eius et hinc euntem, et ibi commorantem, et inde huc revertentem, et non permisit Dominus ancillam coinquinari, sed sine pol-lutione peccati revocavit" (But the Lord himself lives, because his angel guarded me while leaving here, dwelling there, and returning here again; and the Lord did not let his handmaiden be polluted, but brought her back without the stain of sin). On this point, cf. Elena Ciletti, "'Gran Macchina è Bellezza': Looking at the Gentileschi *Judiths*," in Mieke Bal (ed.), *The Artemisia Files: Artemisia Gentileschi for Feminists and Other Thinking People* (Chicago, IL: University of Chicago Press, 2005), p. 77: "The language and the plot [of the biblical accounts] are replete with sexuality, but all versions of the text are emphatic regarding the heroine's avoidance of 'defilement.' Even her town's name, Bethulia, refers to (her) sexual abstinence: it is etymologi-cally close to the Hebrew word for virginity, *bethula*."

Federico Della Valle

The drama *Iudit* of Federico Della Valle elaborates the biblical tale according to Baroque poetic sensibilities.[5] Cast in the canonical five acts, the drama features a dozen speaking characters and a chorus of Assyrians whose function recalls that of ancient Greek tragedy. The principal stylistic model is Tasso, whose meter in the pastoral play *Aminta* (combined *settenari* and *endecasillabi*: verses of seven and eleven syllables) was to dominate libretti well into the Settecento. And Tasso's predilection for female warriors and nocturnal settings have clearly influenced Della Valle.[6] The play opens with the night-time appearance of Judith and her servant Abra making their way to the Assyrian camp, and ends with the nighttime laments in that camp of the eunuch Vagao and general Arismaspe. Delighting in symmetrical antithesis, Della Valle exploits the contrast between day and night – a counterpart to the *chiaroscuro* depictions of Baroque artists.[7] And the center of his drama hinges on a similar polarity that contrasts male desire and female beauty.[8] (Della Valle also wrote the play *Ester*, in which the heroine incarnates public politics, rather than private fortitude.)

5 Federico Della Valle, *Iudit* (1627), ed. Andrea Gareffi (Rome: Bulzoni, 1978) idem, *Opere*, ed. Maria Gabriella Stassi (Turin: UTET, 1995). For some comparisons between Della Valle's verbal description and Artemisia Gentileschi's visual portrayal, see Mary D. Garrard, *Artemisia Gentileschi: The Image of the Female Hero in Italian Baroque Art* (Princeton, NJ: Princeton University Press, 1989), p. 316; and Elena Ciletti, "'Gran Macchina è Bellezza,'" pp. 63–105, at 69–75.

6 See Jean-Michel Gardair, "Giuditta e i suoi doppi," in M. Chiabò and F. Doglio (eds.), *I Gesuiti e i primordi del teatro barocco in Europa* (Rome: Centro studi sul teatro medioevale e rinascimentale, 1995), pp. 457–63, on Della Valle's *Iudit*, evoking Tasso's nocturnal Clorinda and seductive Armida. See also Franca Angelini, "Variazioni su Giuditta," in Lucia Strappini (ed.), *I luoghi dell'immaginario barocco* (Naples: Liguori 2001), pp. 135–45, at 138 on "l'opposizione giorno-notte."

7 For nocturnal imagery, see *Iudit* I. prol. 37–38: "però notturna con la serva sola / move a pregar"; I.1: "Solitarie, notturne ..."; I.160: "mira in ciel quelle stelle!"; III.1.37: "notturno ciel"; III.2.206 "notturna venne"; III.5.601: "toglie il notturno velo"; IV.1.133: "solitaria notturna"; IV.2.220–23 (Oloferne): "O carro et ore, che portate il die / a la tacita notte, / ahi, perché ad andar siete / sì neghittose e lente?"

8 For Olofernes' desire (*voglia*), see the insistent repetitions in II.1.97,107,112,121,136, and 190. Cf. also III.1.20, 64: "a le mie voglie cede"; III.4.313–14: "placide voglie e dolci / mi stanno intorno al core"; III.4.371: "la mia placida voglia"; III.4.380–81: "solo il vinca / d'Oloferne la voglia!"; V.3.226–29 (Coro: the moral of the story): "d'orgoglioso re superba voglia ... spesso costa la vita." For Judith's beauty (*bellezza*), see II.1.72: "Bella bellezza anco nemica piace!"; II.1.130: "Bellezza sovra ogni altra aventurosa"; II.4.500: "Bellezza è sempre bella"; III.4.534: "Bellezza è de' dèi"; IV.4.31: "Gran machina è bellezza"; IV.8.975–986: "Iudit bella ... tanto in molle bellezza / ebbe ardir e fortezza!"

Marc-Antoine Charpentier

In his Latin *Judith sive Bethulia Liberata* of 1675, Marc-Antoine Charpentier, who had studied in Rome with Carissimi, began a series of oratorios about *femmes fortes*, apparently written for Madame de Guise; his work dramatized a condensed version of the Vulgate account, alternating between *historicus* recitative and solo or choral song.[9] This bare-bones oratorio retains the biblical structure of the narrative in Judith 7–13, abridging the story to roughly a third its length in the Vulgate. The opening lines set the scene in summary fashion. The Chorus paraphrases Judith 7:1 – "Stabat Holofernes per montes urbis Bethulia ut eam oppugnaret, et accesserunt ad eum duces exercitus eius et illi dixerunt" (Holofernes camped in the mountains around Bethulia in order to take the city, and the generals of his army came to him and spoke); and a Trio sings the words of Judith 7:7 – "Filii Israel non in lanceis nec in sagittis confidunt, sed montes defendunt illos et muniunt illos colles" (The sons of Israel do not rely on spears or arrows; rather, the mountains defend them and the hills protect them).

There follow a series of recitatives, arias, and choruses that dramatize the story. After the opening scene of Holofernes and his Assyrian troops, Ozias and the people of Bethulia lament their sins. Judith now takes center stage, announcing her plan, praying in sackcloth, and then changing into seductive finery. The drama of the oratorio lies in the exchanges between Judith and both sides of the conflict – the people of Bethulia, the Assyrian scouts who first meet her, and the daunting Holofernes – and changes of scene are underscored by instrumental interludes or *sinfonie*. Charpentier's librettist follows the Vulgate in making Judith a "handmaid of the Lord," but minimizes the appeal of her physical beauty.[10]

9 For the composer's autograph score (Paris, Bibliothèque Nationale, Rés. Vm¹ 259), see Marc-Antoine Charpentier, *Oeuvres complètes*, 28 vols. (Paris: Minkoff France Éditeur, 1991), 2, pp. 7–39. On Charpentier's Latin oratorios, see Howard E. Smither, *A History of the Oratorio*, 4 vols. (Chapel Hill, NC: University of North Carolina Press, 1977–2000), 1:419–432. During this period, Racine (1639–1699) also celebrated *femmes fortes* in *Andromaque* (1667), *Bérénice* (1670), *Iphigénie* (1674), *Phèdre* (1677), *Esther* (1689), and *Athalie* (1691). The last two plays were adapted for English librettos set by Handel in 1718 and 1733, respectively.

10 The final chorus celebrates Judith in words that evoke the Virgin Mary: "Et tu benedicta es mulier" (And you are blessed, woman). Charpentier's text omits two references to the heroine's striking beauty: Jdt 7:14 ("Erat in oculis eorum stupor, quoniam pulchritudinem ejus mirabantur nimis"): There was amazement in their eyes, because they wondered greatly at her beauty, and Jdt 7:19 ("Non est talis mulier super terram in aspectu, in pulchritudine, et in sensu verborum"): There is no other such woman on the earth in appearance, in beauty, and in the wisdom of her words.

The encounter between Judith and Holofernes marks the high point of the drama. Received by the Assyrian general, Judith predicts the fall of Bethulia, thus establishing a pretext for staying in the enemy camp. On the fourth day, when Holofernes is overpowered by wine, she prays to God for assistance in slaying him. Then she returns to Bethulia, where she sings, "Aperite portas, quoniam nobiscum est Deus, fecit enim virtutem in Israel" (Open the gates, for God is with us and has shown his power in Israel) – a moment followed by a *sinfonia*. Showing the head of Holofernes, she leads the people of Bethulia in a hymn of praise to the Lord, who has delivered them.

Alessandro Scarlatti

In the next generation, the libretti of Italian musical oratorios focused on the most striking dramatic elements of the biblical narrative. At the end of the seventeenth century, Alessandro Scarlatti set texts written by members of the Ottoboni family, who were relatives of Pope Alexander VIII (1689–1691). The libretto of the five-part "Naples" *Giuditta* (SSATB; 1694) was written by Cardinal Pietro Ottoboni (1667–1740); that of the three-part "Cambridge" *Giuditta* (SAT; 1697) by his father, Antonio Ottoboni.[11]

The Naples *Giuditta* situates Judith as the dramatic link between Bethulia (Ozias and an anonymous Sacerdote) and the Assyrian camp (Oloferne and a Capitano who recalls Della Valle's character), offering vivid contrasts between scenes of martial spirit and intimate seduction. In the interest of variety, Pietro Ottoboni alternates scenes between Bethulia and Holofernes's camp.

Prima Parte
Betulia: Giuditta, Ozia, Sacerdote
Campo: sinfonia bellica, Oloferne, Capitano (Achiorre)

Seconda Parte
Campo: Giuditta, Oloferne, ancella (muta)

11　See Norbert Dubowy, "Le due 'Giuditte' di Alessandro Scarlattti: due diverse concezioni dell'oratorio," in Paola Besutti (ed.), *L'oratorio musicale italiano e i suoi contesti (secc. XVII–XVIII)*, Atti del convegno internazionale, Perugia, Sagra Musicale Umbra, 18–20 settembre 1997 (Florence: Leo S. Olschki Editore, 2002), pp. 259–88. Antonio Ottoboni also supplied the libretto *Caino o il primo omicidio* set by Scarlatti in 1707. Pietro Ottoboni furnished Scarlatti with six other libretti: *La SS. Annunziata, L'assunzione della BVM, S. Filippo Neri, Il regno di Maria assunta in Cielo, Il martirio di S. Cecilia, Oratorio per la Passione*. (Pietro Ottoboni was later the Roman patron of the young Handel, whose English oratorios about heroic women – *Esther, Deborah, Susanna*, and *Theodora* – do not include Judith.)

Betulia: Sacerdote, Ozia, Capitano (=Achiorre)
Campo: Oloferne, Giuditta, ancella (muta)
Betulia: Sacerdote, Ozia, Capitano (=Achiorre), Giuditta, ancella (muta)

This setting exploits many of the devices of Baroque musical theater. The scene in Holofernes's camp is introduced by a *sinfonia bellica*, which frames Holofernes's "rage aria" – "Lampi e tuoni ho nel sembiante" (I have lightning and thunder in my face) – which is soon followed by the Captain's similarly furious "Vincerai se 'l ciel vorrà" (You shall conquer if heaven wills it).[12] By contrast, Judith's first aria in the enemy camp insists (like Della Valle's play) on her beauty: "Se di gigli e se di rose porto / il volto e il seno adorno, / bramo ancora più *vezzose* / *le bellezze* in sì gran giorno" (Though my face and breast are graced by lilies and roses, I desire more charming beauties on such a great day).

By contrast, the Cambridge *Giuditta* reduces the drama to the essential trio of Judith, her maid (Nutrice), and Holofernes, as in the Baroque depictions of Caravaggio and Gentileschi; and it offers a chiastic structure that is closer to the biblical account:

Parte prima
Betulia: Giuditta, Nutrice
Campo: Giuditta, Nutrice, Oloferne

Parte seconda
Campo: Giuditta, Nutrice, Oloferne
Betulia: Giuditta, Nutrice

Antonio Ottoboni thus gives the drama a feminist slant, emphasizing the collaboration between Judith and her maid – a sort of anticipation of the comic partnership of Don Giovanni and Leporello.[13] In the tradition of Della Valle, Holofernes's arias emphasize the overpowering beauty of Judith.[14] Before the "moment of truth," Holofernes and Judith sing a duet – "Tu m'uccidi e non m'accogli" (You slay me and do not embrace me) – which is sanctioned more by operatic convention than by biblical precedent. The actual slaying is portrayed as vividly as the sung medium allows. The Nurse

12 A notable parallel in biblical oratorio may be seen in Herod's "Tuonerà tra mille turbini" in Alessandro Stradella, *San Giovanni Battista* (1675). On the latter, see Smither, *History of the Oratorio*, 1, 321–37, with an excerpt from what he calls Herod's "forceful first aria in fanfare style" at pp. 323–24, example VII-6c.

13 Cf. Franca Angelini, "Variazioni su Giuditta," in Lucia Strappini (ed.), *I luoghi dell'immaginario barocco* (Naples: Liguori, 2001), pp. 135–45, at 135–36, for a partial comparison with Don Giovanni.

14 Oloferne, "Togliti da quest'occhi / Per non ferirmi il cor, bellezza infida" (Remove yourself from my sight lest you wound my heart, treacherous beauty).

(the "Abra" of scripture) sings an ominous lullaby about Samson as Holofernes falls into a drunken slumber.[15] Although he briefly rouses himself, Judith strikes a first blow, and then a second – both described in her recitative with that of the Nurse. In this scene, the emphasis on sleep reinforces the nocturnal setting; but as Judith and her attendant return to Bethulia, they sing a duet hailing daybreak, "Spunta l'alba più bella" (The fairest dawn is breaking). After a recitative account of her exploits, Judith exhorts her people either to obey God or (like Holofernes) to suffer the consequences.

Antonio Vivaldi

A decidedly political interpretation of the Judith story is furnished by Antonio Vivaldi's *Juditha triumphans devicta Holofernis barbarie* (Judith triumphant in the defeat of Holofernes's barbarity; 1716, SAAAA), set to a rhymed Latin text by Giacomo Cassetti and prefaced by Latin elegiacs that explain the poem's allegory.[16] As the subtitle *devicta Holofernis barbarie* (the defeat of Holofernes's barbarity) indicates, the "Eastern" threat of the Assyrian army offers a thin allegorical veil for the menace of the contemporary Ottoman Empire.[17] The work was performed at the Ospedale della Pietà, the girls' orphanage where Vivaldi was employed; and the exclusive use of female voices – including Holofernes, who is sung by a mezzo-soprano – might to a modern ear seem to undermine the martial themes of the work. But we must remember that operatic conventions of the day often assigned heroic roles such as Julius Caesar to the powerful treble voices of castrati.

The entire oratorio moves from the opening chorus of Assyrian soldiers – "Arma, caedes, vindictae, furores" (Arms, slaughter, vengeance, fury) – to the closing chorus of Bethulians hailing Judith as their savior and (incongruously) celebrating the future peace of the Adriatic, "Adria vivat et regnet in pace" (Let the Adriatic live and reign in peace):

15 Norbert Dubowy, "Le due 'Giuditte,'" p. 268.
16 "Praesens est bellum, saeve minantur et hostes; / Adria Juditha est, et socia Abra Fides. / Bethulia Ecclesia, Ozias summusque sacerdos, / Christiadum coetus, virgineumque decus, / Rex Turcarum Holofernes, dux Eunuchus, et omnis / Hinc victrix Venetum quam bene classis erit" (War is near, and enemies fiercely menace; Judith is the Adriatic, and her companion Abra our Faith; Bethulia is the Church – Ozias the supreme pontiff – the union of Christians and the honor of virgins; Holofernes is the King of the Turks, his general a Eunuch; and hence how fitting that the whole fleet of the Venetians will conquer).
17 Smithers, *History of the Oratorio*, 1, 348–55.

Pars prior
Sinfonia
1. In castris: Chorus, Holofernes, Vagaus
2. Ad castra: Juditha, Abra; Chorus, Vagaus
3. In castris: Holofernes, Juditha, Abra
4. Bethulia: Chorus

Pars altera
1. Bethulia: Ozias
2. In castris: Holofernes et Juditha; Chorus; Vagaus, Abra
3. Juditha, Abra; Vagaus
4. Bethulia: Ozias; Chorus

Despite the martial subtext, lyrical moments are not lacking in the first half: thus, the initial encounter of Judith and Holofernes is represented as a sort of a pastoral idyll. In accordance with the biblical account, the libretto stresses Judith's radiant beauty (*splendor*) and the admiration (*stupor*) it causes.[18] Abra sings the aria "Vultus tui vago splendori" (The charming splendor of your face) and in a recitative Holofernes describes her effect upon him, declaiming, "Quid cerno! Oculi mei / Stupidi, quid videtis? / Solis an caeli splendor?" (What do I behold! My dazzled eyes, what do you see? The splendor of the sun or heaven?). In a Metastasian vein, Judith twice describes herself as a bird: first as a storm-tossed swallow – "Agitata infido flatu ... Maesta hirundo" (The sad swallow buffeted by fickle winds) – and then as a turtledove – "Veni, veni, me sequere fida ... Turtur gemo ac spiro in te" (Come, come, follow me faithfully ... Like a turtledove I groan and sigh for you) – in an aria symbolically accompanied by a chalumeau.[19]

18 Cf. Jdt 10:4: "Cui etiam Dominus contulit splendorem: quoniam omnis ista compositio non ex libidine, sed ex virtute pendebat: et ideo Dominus hanc in illam pulchritudinem ampliavit, ut incomparabili decore omnium oculis appareret" (And the Lord bestowed radiance on her, for all her grace derived not from lust, but from virtue; and therefore the Lord increased her beauty, so that she would appear of incomparable charm in everyone's eyes); and 10:14: "Et cum audissent viri illi verba ejus, considerabant faciem ejus, et erat in oculis eorum stupor, quoniam pulchritudinem ejus mirabantur nimis" (When the men had heard her words, they observed her face, and there was amazement in their eyes, because they greatly wondered at her beauty).
19 Vivaldi had already written a swallow aria, "Se garrisce la rondinella" (If the swallow chirps), in Braccioli's 1716 *Orlando finto pazzo*, and would write another turtledove aria, "Sta piangendo la tortorella" (The turtledove is weeping), in Metastasio's 1734 *L'Olimpiade*. Vivaldi was also famed for the instrumental birdcalls in *The Four Seasons* and the flute concerto called *Il cardellino* (*The goldfinch*). (Handel too wrote celebrated "bird" arias and choruses in *Rinaldo* and in the oratorios *L'Allegro ed il Penseroso* and *Solomon*.) Metastasio's lyrics involving birds are collected in Pietro Metastasio, *Opere*, vol. 16 (Florence: Gabinetto di Pallade, 1819),

The second half of the oratorio is dominated by the contrast between night and day. The fall of darkness prepares the scene for the prospect of lovemaking – Holofernes's aria "Nox obscura tenebrosa / Per te ridet luminosa" (The dark and shady night laughs radiant for you) and the fulfillment of Judith's daring deed — Juditha's "Summe astrorum Creator" (Supreme Creator of the stars) and "In somno profundo" (In deep slumber). Indeed, Holofernes falls asleep to Juditha's lullaby "Vivat in pace" (Live in peace), an aria accompanied only by the higher strings and decidedly more soothing than the Samson lullaby in Scarlatti's Cambridge *Giuditta*. As dawn returns on the morrow, the eunuch Vagaus sets the scene in a tranquil recitative, "Iam non procul ab axe / Est ascendens Aurora" (Now nearing the sky Aurora rises); but when he discovers Holofernes's decapitated corpse, he launches into a vibrant "rage aria":

Armatae face, et anguibus	Armed with torches and serpents,
A caeco regno squallido	from your dark and squalid kingdom,
Furoris sociae barbari,	as partners in savage fury,
Furiae, venite ad nos.	O Furies come to us.
Morte, flagello, stragibus,	By death, scourges, and slaughter,
Vindictam tanti funeris	as leaders teach
Irata nostra pectora	our angry hearts
Duces docete vos.[20]	to avenge this great death.

By contrast, the dawn of the new day heartens the triumphant Bethulians, as Ozias sings, "Quam insolita luce / Eois surgit ab oris ... Aurora ... Venit, Juditha venit" (With what unusual light Aurora rises in the East ... She comes, Judith comes). Like the first part, the second ends with a chorus in triple time.

Francisco António de Almeida

Support for Italian poetic and musical culture soon arrived from abroad. In the first quarter of the century, King John V of Portugal sent a number of musicians to Rome to study composition – among them Antonio Teixeira

pp. 321–22 (swallow) and pp. 331–32 (turtledove).

20 The reference to *vindictae* (vengeance) echoes the opening chorus, and also anticipates the Italian libretto set by Almeida (see below). The expression *caeco regno* (dark kingdom) recalls the *cieco mondo* (dark world) of Dante, *Inferno* 4.13, and its echo in the aria "Nel profondo cieco mondo" (In the deep dark world) in Act I of Vivaldi's *Orlando Furioso*. Cf. also Metastasio's lyric, "Gemo in un punto e fremo ... ho mille Furie in sen" (I groan and rage together ... I have a thousand Furies in my breast) in *L'Olimpiade*, set by Vivaldi in 1734.

and João Rodrigues Esteves – and in turn summoned Domenico Scarlatti to Lisbon in 1719. In 1725, he donated a property on the lower Janiculum to the Academy of Arcadia, which was renamed the Bosco Parrasio, or Arcadian Grove. Around 1720, he helped send the young musician Francisco António de Almeida (ca. 1702–1755) to Rome, where he wrote two oratorios: *Il pentimento di Davidde* (1722, now lost) and *La Giuditta* (1726, SSAT). Dedicated to the Portuguese ambassador in Rome, and performed in the Oratorio of St. Philip Neri adjacent to the Chiesa Nuova, Almeida's work uses an anonymous Italian libretto that contrasts the heroine's role to the three male characters, Holofernes, Ozias, and Achior – omitting the servant Abra. The anonymous librettist has chosen an alternating pattern of scenes:

Prima parte
Introduzione
1. Betulia: Giuditta
2. Campo: Oloferne, Achiorre
3. Betulia: Ozia, Giuditta, Achiorre
4. Campo: Oloferne
5. Betulia: Ozia, Achiorre e Giuditta

Seconda parte
1. Betulia: Giuditta, Ozia e Achiorre
2. Campo: Oloferne, Giuditta
3. Betulia: Ozia, Achiorre

Perhaps as a Baroque appeal to the passions, the libretto repeatedly emphasizes the unbiblical theme of revenge (*vendetta*): witness Holofernes's three arias: "Invitti miei guerrier, / voglio vendetta" (My invincible warriors, I want revenge); "Dal mio brando fulminante ... con rigor vendicherò" (With my thundering blade I shall sternly avenge); "Date, o trombe, il suon guerriero! Su, miei fidi, a voi s'aspetta / far vendetta" (O trumpets, sound the warlike call! Up, my faithful friends, vengeance is expected of you); as well as Judith's "Dalla destra onnipotente / scenda un fulmine fremente / tanti oltraggi a vendicar" (From his omnipotent right hand may a roaring bolt descend to avenge such great insults).[21] There are also a number of

21 Cf. Judith's recitative "Tal è del mio Signor l'alto volere ... egli m'ha scelto a far vendetta" (Such is the high will of my Lord ... He has chosen me to take revenge). Vivaldi's *Juditha triumphans* opens with a chorus alluding to *vindictae* (vengeance). The only parallel in the Vulgate is Jdt 7:20, where the Bethulians call upon God to take pity or to *punish* their iniquities: "Tu, quia pius es, miserere nostri, aut in tuo flagello *vindica* iniquitates nostras" (Because You are devout, have mercy on us, or with your scourge avenge our iniquities).

set pieces, using traditional operatic imagery, especially Judith's two quasi-Metastasian arias invoking the helmsman who overcomes a tempest: "Saggio nocchiero in ria procella" (The wise helmsman in the dire tempest) and "Godete, sì, godete … Tal, dopo ria procella … il timido nocchiero / ritorna a far gioir" (Rejoice, yes, rejoice … Just so, after the dire tempest the fearful helmsman again may rejoice).[22] Like Vivaldi, Almeida concludes his work with pieces in triple time – two arias and a duet.

Metastasio

Inevitably, the master of Baroque libretti Pietro Metastasio dealt with the story, as one of seven oratorios he wrote for Holy Week in Vienna between 1730 and 1740.[23] Composed in 1734, his *La Betulia liberata* (Bethulia delivered) foregrounds five Jewish protagonists (Ozias, Amital, Achior, Charmis, and Cabris), and places the emphasis on the doctrinal and devotional nature of their community.[24] Thus, unlike Della Valle and Vivaldi, he makes the people of Bethulia his Chorus, rather than the enemy Assyrians; and he assigns the convert Achior a more important role than Holofernes.[25] Indeed, Metastasio omits altogether the erotic confrontation of Holofernes and Judith, relegating the heroine's deed to a sort of messenger's account (what the Greeks called *angelou rhesis*) or narration after the fact.[26] Initially set by Reutter and Jommelli, the libretto was brilliantly reused in 1771 by the fifteen-year-old Mozart (SSSATB). In his setting, the ruler of Bethulia, Ozia, is a tenor, an anticipation of the emperor Titus in *La clemenza di Tito*, the Metastasian libretto adapted by Mazzolà for Mozart twenty years later.[27]

22 For Metastasian lyrics involving the helmsman, see the 1819 *Opere*, vol. 16 (n. 17 above), pp. 309–13, citing 16 examples.

23 On Metastasio, see Smithers, *History of the Oratorio*, 1, 390–95; 2, 51–67.

24 Maria Grazia Accorsi, "Le azioni sacre di Metastasio: Il razionalismo cristiano," in Pinamonti (ed.), *Mozart, Padova e la Betulia Liberata*, pp. 3–26, esp. 13–24.

25 Mangini, "'Betulia liberata,'" p. 151: "Il finale della prima parte rivela quindi come sia assegnato a Achior, e non ad Oloferne come nel passato, il ruolo dell' antogonista."

26 Cf. Smithers, *History of the Oratorio*, 2:54: "In *Betulia*, because the place is the city of Bethulia, the audience learns of Judith's experiences in the Assyrian camp (including her beheading of the enemy commander Holofernes) only after she has completed the deed and returned to the city. Holofernes is not even a personage in that work, and thus Metastasio, with customary restraint, rejects the dramatic potential of dialogue between him and Judith."

27 Other Mozart operas based at least in part on Metastasio include *Il sogno di Scipione* (1772), *Lucio Silla* (1772), and *Il re pastore* (1775).

Parte prima
Betulia: Ozia, Amital, Cabri, Coro; Achior; Cabri; Giuditta

Parte seconda
Ozia e Achior; Amital; Giuditta; Achior converted; Carmi reports the flight of the Assyrians; Coro

In the first part, Achior sings "Terribile d'aspetto" (Terrible to behold), a "rage aria" describing Holofernes, who in fact does not appear in the drama![28] The second part opens with a theological debate between Ozia and Achior.[29] Then Amital sings a "Quel nocchier che in gran procella" (The helmsman who in a great tempest), a "helmsman aria" typical of Metastasian lyric.[30] In the second part, the climax of the oratorio seems rather static, and even Mozart's youthful genius cannot evoke anything like dramatic heroics. After ten minutes of recitative, in which Judith relates how she slew Holofernes, the spotlight falls on Achior, who still remains doubtful after viewing the severed head of the enemy. Yet when Judith sings a metaphor aria reminiscent of Gluck, "Prigionier che fa ritorno" (The prisoner who returns), Achior is converted and sings the aria "Te solo adoro, mente infinita" (Thee alone I worship, infinite mind). Amital too is moved to penitence, and the oratorio concludes with the rejoicing of the Bethulian people at this double victory – the public rout of the Assyrians and the private conversion of Achior.[31]

28 Mangini, "'Betulia liberata,'" p. 151, compares it to Holofernes's "Lampi e tuoni ho nel sembiante," in Scarlatti's Naples *Giuditta* (mentioned above). On Mozart's treatment of the words, see David Humphreys in H. C. Robbins Landon (ed.), *The Mozart Compendium: A Guide to Mozart's Life and Music* (London: Thames and Hudson, 1990), p. 321.
29 See Paolo Pinamonti, "'Il ver si cerchi, / non la vittoria': Implicazioni filosofiche della *Betulia* metastasiana," in idem, *Mozart, Padova e la Betulia liberata*, pp. 73–86.
30 In the 1819 *Opere* (see n. 19 above), this lyric is on p. 312.
31 While heroic oratorio and opera protagonists often mention victory and conquest, the Vulgate contains only one reference to God's victory: "revocavit me vobis gaudentem in *victoria sua*, in evasione mea, et in liberatione vestra" (Judith 13:20: He has restored me to you rejoicing in his victory, in my escape, and in your delivery).

22. Judith in the Italian Unification Process, 1800–1900

Paolo Bernardini

Judith Lore from the Eighteenth to the Nineteenth Century: From Individual to "National" Hero

According to one of the major historians of the Risorgimento (the Italian unification process), the figure of Judith played only an ambiguous and marginal role among the vast number of heroines who shaped the cultural landscape of nineteenth-century Italy. This is true not only for Italian opera – the most important and popular form of cultural-political public art during the key decades (1830–1860) of Risorgimento – but also for melodrama, poetry, and the visual arts.[1]

My essay aims to answer some of the questions about Judith raised by Alberto M. Banti. Why was Judith only a marginal and ambiguous figure during this era, after having kept her identity more or less unshaken for centuries, maybe millennia? Why, while plenty of female heroes emerged from the past and from the literary imagination of contemporary authors, did Judith, the "proto-heroine," the embodiment of female courage and feminine agency, undergo such a marked decline?[2]

* I wish to thank Elisa Bianco (Boston University) as well as Marian McHugh (Trinity College, Dublin) for their invaluable help in drafting and revising this essay. During the initial drafting of this essay, Professor Alberto M. Banti (Università di Pisa) and Dr. Marco Mondini (Università di Padova) gave me valuable hints and friendly assistance. This essay is dedicated to Judith Lane, with fond memories, and to the memory of Professor Frederick C. Lane.

1 Alberto Mario Banti, *L'onore della nazione. Identità sessuali e violenza nel nazionalismo europeo dal XVIII secolo alla Grande Guerra* (Torino: Einaudi, 2005), p. 324.

2 For a slightly different view of Judith in the Italian Risorgimento, see the essay

In order to answer these questions, we have to take into account both ideological motifs and the evolution of the artistic genres, especially music. We will also dwell upon the eighteenth century as much as on the following one, so as to better bring into focus the original individualistic spirit of Judith, before her "nationalization" (we will see what this was). Evolution in ideology and development in music are two elements that run in parallel and occasionally intertwine.

If we begin with music history, we can perceive first of all a dramatic decline of oratorio, chamber music, and in general of small ensembles by the first decades of the nineteenth century. This decline is due, *inter alia*, to the powerful rise of opera, a musical genre that requires large orchestras, a wide variety of singers (i.e., of characters), and a choir. Opera is the perfect genre for collective, "national" actions, and was perceived as such by the public since its very beginnings in Italy where it was first created.[3]

Artistic portrayals of Judith's triumph from the Renaissance to the late Baroque and the end of the eighteenth century are often in the form of an oratorio or other cognate musical forms, which are characterized by a small orchestra, a limited number of singers and characters, a simple plot, and a strongly religious (Catholic) content, or at least a religious inspiration, as well as a religious pedagogical aim. If we look more closely at some examples among the leading "Judiths" before the end of the eighteenth century, we find all these elements, often together with political metaphors, which relate the heroine to the lore of one or another major European power. However, while the eighteenth century was still a time of dynasties and dynastic kingdoms, so that heroes and heroines were basically at their service, the nineteenth century was the century of nations and nation-states (often fighting against established dynasties, as was the case with Italy, battling for independence against the Habsburgs and the Bourbons). In the nineteenth century, therefore, heroes had to have a strong connection to the nation, act according to its "general will," and be the forerunners, the very élite, of national revolts and revolutions. Judith acted on her own, in contradiction to the policy originally set by the leaders of her people. She thus could not fulfill the typical nineteenth-century ideal of a hero. This essay will illuminate this change in Judith's status, beginning with a close look at the eighteenth-century model – a model that was later completely transformed.

by Alexandre Lhâa in this volume (Chap. 23).

3 One of the choruses of Verdi's *Nabucco* became a sort of unofficial Italian national anthem, still sung as such as an alternative to the dull and occasionally meaningless official national anthem by Goffredo Mameli.

The Last Phase of the Individual Heroine in the Age of the Enlightenment: Vivaldi and Cassetti, Mozart and Metastasio

Vivaldi's *Juditha triumphans* (1716) (RV 644) is the basis of eighteenth-century treatments of Judith, which were first and foremost musical ones, including the portrayals by Vivaldi and Mozart. Judith's prominence in the visual arts began to decline in the eighteenth century, a process that continued into the nineteenth. Metastasio, whose text formed Mozart's libretto, did not substantially change the treatment of the biblical heroine, which remained more or less the same until the end of the eighteenth century. A fine example of "musica sacra vocale" (sacred vocal music), *Juditha* is one of the three oratorios composed by Vivaldi – quite a small portion of his immense production, which includes no fewer than 48 "melodrammi." As an "oratorio latino bipartito," at first glance it might appear to be a purely sacred composition. In the first two decades of the eighteenth century strong waves of heterodoxy, skepticism, and the first signs of deism and Enlightenment became visible in Venice, so that a fierce musical/poetical defense of Catholicism and of post-Tridentine orthodoxy, would have been neither unexpected nor unwelcome.[4]

The *Juditha triumphans* belongs at least in part in this context, but its main aim is different. In the frontispiece of the libretto written for the *Juditha* by Giacomo Cassetti (1682–1757), a minor local poet (and sculptor), it is clearly indicated that this is a "sacrum militare oratorium." The two dimensions, the sacred and the military, are in no sense in contradiction to each other. This oratorio was quite probably composed to celebrate the last major victory of the Venetians against the Ottoman Turks, and the conquest of the island of Corfù in 1716. This was the last major military enterprise of Saint Mark's Lion. Therefore, composers, painters, and poets did their best to celebrate it, probably aware, along with the local authorities and the Church, that this victory was bound to be the last for Venice. The Greek island remained a Venetian possession until the very end of the glorious republic in 1797. Here, Judith is Venice and Holofernes is the evil Sultan. Among the other characters, Abra (Judith's elderly servant) represents the Christian Faith; Bethulia the Catholic Church; Ozias symbolizes the whole of the Christian flock. The oratorio was performed in one of the many Venetian

4 See Federico Barbierato, *Politici e ateisti. Percorsi della miscredenza a Venezia tra Sei e Settecento* (Milano: Edizioni Unicopli, 2006).

confraternities, that of the Ospedale della Pietà, in November. The Venetian army had defeated the Turks in August, thanks to its alliance with a state that was much more powerful at that time, the Holy Roman Empire, and which sent one of its best generals, Count Johann Matthias von der Schulenburg, to lead the armies, whose ranks were swelled by many local patriots. It is worth noting that in the following century the Habsburgs became the strongest enemies of the Italian patriots. Events had unfolded thus: the Turks had laid a long siege to Corfù, in retaliation against Venice. Back in 1687, the Serenissima Repubblica, under Doge Francesco Morosini, had conquered the Peloponnese, which was renamed Morea by the Venetians. In 1715 the Turks had reconquered the territory; so that the Serenissima felt the urge to regain at least some of her provinces lost to the Turks, who were at the time as decadent as the old "Italian" republic. From the historical perspective, the struggle of the peoples in the Greek islands against the Ottoman Turks is merely an anticipation of the wars of the first decades of the nineteenth century, when Greece became for the first time in its history an independent state. These revolts fueled a new nationalism that was Greek rather than Venetian, and which became mature only at the beginning of the nineteenth century. As for Judith, this was a clear use of the myth for political purposes – the Greek island became Venice, and Venice is embodied by Judith. It is also a clear indication of the holy nature of the figure of Judith, who by saving Venice is saving the whole of Christianity from the threat of the Ottomans. In fact, the Turks ceased to be a substantial threat in the Mediterranean after Lepanto (1571), and after the unfortunate siege of Vienna in 1683 they were also no longer a threat on land.

The purpose of Vivaldi's (or rather Cassetti's) *Juditha* is not only to reinforce the notion that the western side is the true "holy" part of the world; even more importantly, it is also to reinforce the link (which was quite shaken at that time) between Venice and the Church. In the spirit of the time, however, this work contains ambiguous, dark elements. Holofernes appears as a skilled seducer, almost a womanizer, able to strike all the right chords with Judith in a most sentimental fashion in order to try and seduce her. Yet his actions toward Judith are not those of a shrewd rapist. On the contrary, there are moments of almost feminine sensuality in his words, and in the scene where he tries to seduce Judith, the oboe and the organ create a sophisticated, erotic atmosphere. Judith resists, but she seems very close to succumbing. In Vivaldi's work there is a surprisingly vast range of materials. Even today this material is continuing to prove fruitful: it has

provided the anthem of a state yet to be born for a new party founded in 2008, the Partito Nazionale Veneto. At the same time, Vivaldi's *Juditha* also suggests some of the reasons why the story of Judith would seem quite unfit to become a substantial part of the nineteenth-century founding myths of the Italian nation. Judith embodies a powerful mix of feminine virtue and of masculine violence, of deceit and honesty, of forbearance and sexual appeal – in short, a mix that would throw the mythmakers of nineteenth-century Italy into confusion.

No major variations in the musical and literary treatment of Judith take place in Italy until Metastasio wrote *La Betulia liberata*, and more significantly Mozart wrote the music for it. Mozart's music for Metastasio's *La Betulia liberata* (K. 118) was written in 1771, when Mozart was 15 and living in Padova. Before approaching this text, however, we also need to consider the pre-history of the construction of unified Italy. All representations of Judith in the eighteenth century embodied a primarily religious idea connected both to the figure of Judith *per se*, and to her relationship with the Virgin Mary. At the same time, new elements that were anti-religious or simply not religious at all were foregrounded, such as the sensuality of the heroine, the themes of warfare and siege, and the literary attractiveness of the story. The plots of several versions differ substantially from the biblical narratives in Greek and Latin: new elements are introduced as always happens with contemporary treatments of biblical themes. The absence of a definitive *urtext* makes judgments about fidelity to a foundational rendering hypothetical, but it may well be that no single version of the story of Judith follows the original account literally. One might say that it is always violated.

What is relevant for this essay, however, is the political meaning of Judith. She is primarily a solitary heroine who demonstrates that a woman, and a single woman, can be a) stronger than her people and b) able to defeat an entire army (who incidentally belongs to an entirely different people) acting with only a single accomplice. In any case, peoples or nations (to use an eighteenth-century concept, or more precisely, a concept entirely reshaped and reformulated in political terms in the eighteenth century) do not play any role in the Judith story. In fact, if we were to foreground the role of "nations" in the story, this role would be a negative one. So, if we wish to interpret the myth politically, we can see that in the case of Cassetti and Vivaldi, Judith becomes the incarnation of Venice, while in the case of Metastasio and Mozart, she is probably the embodiment of Vienna.

But can she be seen as the incarnation of a "nation," fighting for its free-

dom? This problem is at the core of my essay. Certainly, the individuality of Judith is strongly present in all the Baroque and Enlightenment representations of her. Judith as an individual, the liberation of Bethulia, the defeat of the threat, and the triumph of Israel are depicted in Metastasio once again as a private covenant, or an emergency clause of the covenant, which is signed by God on the one hand and by a single woman on the other. What God as well as Judith is aiming at is not the freedom and/or survival of a single woman, but that of an entire "chosen" people, or at least of an entire city, Bethulia. The solitary nature of Judith's deed is highlighted here even before it receives such treatment in literature or in the (rare) pictorial representations of Judith in the eighteenth century, and in the even rarer ones of the nineteenth. For instance, Metastasio depicts the Assyrians in a very lurid light, and the Jews are not much better. The story begins here with a long attack on the "vergognosa viltà" (shameful cowardice) of the Jews, the chosen people. In fact, since the Assyrians are *goyim* – Gentiles, heathens – they are spared the invective; one of them, Achior, a prince who is close to Holofernes, converts to Judaism, and is saved (both in this world and in Heaven). At the end, the most important scene in the drama is Achior's conversion, which is presented as a universal declaration of faith, with a teleological implication: the conversion of this heathen is an anticipation of the conversion of all mankind to Christianity. In much the same way, the martyrdom of John the Baptist, which can be considered a reversal of Judith's tale, is the preparation for that of Christ, just as the baptism of John the Baptist was in preparation for that of Christ, and thus for the whole of mankind.

In Metastasio's version, the chosen people are full of uncertainty and, most of all, fear. The Assyrian army, in contrast, is quite strong and compact, but the description of its disarray when Holofernes's corpse is discovered reveals enormous confusion and an army that has fallen prey to terror; the air is full of curses ("bestemmie") and a real apocalypse is taking place. There is absolutely no space for any collective action in Metastasio's work, and Mozart's music is extremely focused upon Judith. The work is a triumph for the traditional Christian trinity of the virtues, "Fede Speranza Carità" – faith, hope and divine love in the form of charity – that are the first protection against the seven (or eight) canonical vices. Metastasio's text was used by several other composers until 1822, when his text, with the music of an unknown composer, was staged in Venice for the last time as far as we know, in the palace of the Morean family. It is likely that the music was composed by Salieri, whose version of the "azione sacra" had been performed in Vienna

the year before. But we are already in a different time, when the figure of Judith was undergoing a dramatic transformation into a decadent heroine.

Metamorphosis and Decline of Judith: The Italian Nineteenth Century

The eighteenth century saw the triumph of the myth of Judith. This was mostly due to the heritage of the Baroque, the last sparks of a tale that is profoundly in tune with the culture of horror and sophistication typical of the seventeenth century – a culture that resurfaced in several forms both in the eighteenth century (the "sublime" of Burke and Kant) and in the nineteenth (the horror stories of rape, murder, and mass killings, which have been studied by Alberto M. Banti).[5]

Could Judith, however, as a very individualistic heroine, survive in the age of nations and nationalism(s)?

On the one hand it seems that she could, for we do find quite a few poets writing works devoted to Judith in a variety of genres, from poems to texts meant for music, albeit (at least for Italy) in a quantity (and quality) which is much inferior to that of the seventeenth or the eighteenth centuries.[6]

On the other hand, however, these "Judiths" found a far smaller audience in the nineteenth century, when the plot itself needed to be changed and adapted both to the new musical taste, "il nuovo gusto musicale," and, more particularly, to the new political climate, especially in Italy. The main problem was "how to let the people, the nation, the collectivity, interact more positively on the scene, and to have a more positive role." Also, the new vogue of the "opera" had little in common with the "azione sacra," operetta and "melodrama," and *a fortiori* oratorio. It required more characters, as well as powerful collective characters, possibly acting patriotically and bravely. A typical example of the nineteenth-century patriotic nationalist opera is Verdi's *Aida*, where in contrast to the situation depicted in the tale of Judith, the Jews act bravely and are longing and fighting for freedom. Thus, the enslaved, exiled Jews of *Aida* became an ideal for the Italian patriots who, although scattered among many groups with different political ideas and agendas, shared the collective goal of the liberation, and later

5 See Alberto M. Banti, *La nazione del Risorgimento. Parentela, santità e onore alle origini dell'Italia unita* (Torino: Einaudi, 2000).
6 See the provisional Paolo Bernardini, Elisa Bianco, "Judith in the Italian Literature: A Comprehensive Bibliography," in the pre-print of the papers of the Sword of Judith Conference.

on, unification of Italy. Metastasio, with all his religiosity and individual-
ism, went slowly but inexorably out of fashion. Instead several minor au-
thors created quite different treatments of Judith.[7]

Pietro Guglielmi (1727–1804) of Massa, for example, wrote the music
for a strange new text, drawn from Metastasio, but so altered as to seem
another work. This work was staged several times from 1791 until 1816,
with the title *Il trionfo di Giuditta, o sia la morte di Oloferne*. While the music
remained the same, the text underwent several modifications between
1791 and 1816. This period saw the first phase of the Italian Risorgimento,
the unification process which ultimately led to the creation of the unified
Kingdom of Italy in 1861. Thus, a new character was introduced, Giora-
mo, a strong masculine figure who is the general of a brave but ultimately
unlucky Jewish army. This character had not been present before, even in
the original pseudo-biblical text. A love story between Judith and Gioramo
is hinted at in one of the editions of this libretto, a true work in progress.
The presence of an army, albeit defeated, and of a masculine hero, albe-
it humiliated and caged, make for a sense of a "marginalization" of the
main character of the drama. Judith slowly moves out of center-stage. The
nationalization of the drama is achieved by the presence of an army, led
by a true though unsuccessful hero. Its "romance," so as to comply with
the new times, is provided by a more and more complicated plot, where
love stories, sordid affairs, and other (totally new) elements enter the stage.
Ultimately, the really brand-new character of the Judiths in the nineteenth
century is the "people." As Giorgio Mangini wrote: "the people is the new
character of the librettos that narrate Judith's tale in the nineteenth century."[8]

Choral scenes are a requirement of opera, of course, whereas "azio-
ni sacre" normally required just single characters. While a choral scene
was present in one of the oldest works, *Iudit* by Federico Della Valle
(1560–1628), written in the late sixteenth century, it is simply com-
posed of the Assyrians, in despair after their commander's death. In the

7 Other noteworthy works, such as that of Paolo Giacometti, are discussed in
Alexandre Lhâa's essay in this volume (Chap. 23). Occasionally, the focus of the
nineteenth-century treatment of Judith became a reevaluated Holofernes. See Mi-
chelangelo Prunetti and Giovanni Rossi, *La morte di Oloferne, dramma sacro per musica*
(Rome, 1823). Other interesting "nationalized" Judiths are those of Emilio Cianchi
(Firenze, 1854) with a text once again by Peruzzini and Emiliano Ravazzini (Sas-
suolo, 1885).
8 See Giorgio Mangini, *"Betulia liberata* e *La morte di Oloferne*. Momenti di dram-
maturgia musicale nella tradizione dei Trionfi di Giuditta," in Paolo Pinamonti (ed.),
*Mozart, Padova e la "Betulia liberata": Committenza, interpretazione e fortuna delle azioni
sacre metastasiane nel Settecento* (Florence: Olschki, 1991), pp. 145–69, 166.

nineteenth century the role of the masses, both enemies and Jews, became more and more pronounced. Furthermore, by the nineteenth century it was regarded as inappropriate for a single woman to perform military and/or violent action, which was now seen as requiring masculine vigor, and even in the most important staging of Judith in the Italian Risorgimento, the *Giuditta* written by Marco Marcello, with Achille Peri's music, at Judith's side there is a powerful army and a single brave man who is in love with her.[9]

The most important nineteenth-century example is the famous *Giuditta* by Giovanni Peruzzini (1815–1869), with the music of the Venetian-Jewish composer Samuele Levi. It was staged first at La Fenice in 1843, on the eve of the major revolutionary events that led to the creation of the Republic of Venice, led by Daniele Manin in 1848, a short-lived democratic Jacobin independent state that was to be reconquered by the Habsburgs in 1849.[10]

From 1854 until 1912 this work went through several new editions and performances, in the Florentine church of San Giovanni Evangelista. Emilio Gianchi replaced Levi as composer, although Peruzzini's text remained the same. Peruzzini was a prolific author, well in tune with the new Risorgimento ideology. In his *Giuditta*, the choral action is paramount. Judith herself is sidelined, overwhelmed by choirs of women, warriors, and priests from both sides. The culmination of this process is Marco Marcelliano Marcello's drama, mentioned above, with the music of Achille Peri, and dated 1860. Technically the Kingdom of Italy was already formed in 1859, though the unification process was still under way. By 1861 it was completed with the conquest of Sicily, thanks to Giuseppe Garibaldi. So Marcello's *Giuditta* appeared at a crucial moment of Italian history. Marcello was a musical journalist and writer of some renown. He rewrote works by Goldoni and commented positively on Verdi. He was a man of the new ideology as well, and flourished in these decades. In his work, which met with success, Giuditta is completely reduced and marginalized. Here, major choirs set the tone of the opera and of all the events: there are old men, warriors, slaves, eunuchs, and a diverse array of people from both sides, in a manner reminiscent of a Victor Hugo novel. The original plot is altered in a very dramatic and unprecedented way. Judith's action is only marginal, and is made possible by the victory against Holofernes's troops won by the Jewish army, which is composed of men. Judith's act of slaughter becomes almost

9 See the essay of Alexandre Lhâa in this volume (Chap. 23).
10 See the recent book by Jonathan Keates, *The Siege of Venice* (London: Cape, 2007).

unnecessary. And, even more astonishingly, she has no longer a maidserv-
ant (Abra) close to her, but a strong Jewish captain.[11]

The definitive decline of Judith is due to several factors. Hebbel's tragedy
(1840), which was translated into Italian and was well known in Italy, depicts
Judith as having slept with Holofernes, and bearing his child. This gives a
further negative and terrible nuance to Judith, which is also unprecedented.
The gothic atmosphere of this tragedy was such that Johann Nestroy wrote
a salty parody of it. Comic remakings of the drama were also staged in Italy,
marking the end of the Judith myth and of its power (at least until the early
twentieth century). From this point on, Judith becomes either the subject of
parodies and comedies, or her story is even staged as ballets or fashionable
musical pieces, in the style of operetta, or else she becomes the subject of
"Oriental" musical and literary tales, where the sensual elements in her char-
acter play an overwhelming, and occasionally exclusive, role. This does not
mean that oratorio and other more traditional treatments of Judith disap-
pear completely from the nineteenth-century Italian scene. On the contrary,
there is a Judith underworld, there are close religious circles where Judith is
still performed in the canonical way, i.e., in the way which culminated with
Mozart. Yet the mainstream portrayal of Judith is now farcical or sensual, or
else Judith is overwhelmed by collective and/or masculine characters, who
are either absent or play a totally different role in the original story – for
example, the cowardly Jews are now portrayed as brave. Along with comic
poems in dialects (in Italian-Hebrew, Roman, and Leghornese), quite a few
of the parodies of this period are very interesting.

The funniest and most notable parody is a musical *Giuditta*, written by
Attilio Catelli, with music by Telesforo Righi, which was performed in 1871,
the first year after the completion of the unification process (Rome was
taken by arms by the Savoy troops on September 20, 1870). Here, Giuditta
(Judith) and Holofernes meet in Bethulia when they are both students
there; the troubled Jewish city becomes a happy contemporary university
city. Divided by fortune, they go through several comic adventures, until in
the end Giuditta marries a journalist, and kills Holofernes, who has become
a kind of stalker and tries to rape her while completely drunk. The final
scene sees Bethulia singing and dancing, with her entire population prais-
ing Giuditta and her beauty. For a long time after that, the tragic and heroic

11 On the feminine characters in the Risorgimento plays and operas, and their
relation to male counterparts, see Francesca Savoia, "From Lucia to Violetta: roman-
tic heroines of the 19th-century Italian opera," *Revue de littérature comparée*, 66:3
(1992), pp. 311–26.

original meaning of the tale was lost, at least in Italy. Judith also stayed alive as a chapter in Italian "Orientalism," a movement of artists, musicians, librettists, and poets that is still in need of a comprehensive scholarly treatment (*à la* Said) and that includes such fascinating and ambiguous figures as the writer Emilio Salgari and the painters Francesco Hayez, Francesco Paolo Michetti, and Giulio Rosati.

Conclusion. Judith between Farce and Sensual Decadence: Paving the Way for Klimt

The nineteenth century could have been an auspicious time for Judith. Preliminary research into some lists of names given to babies in Padova in the early decades of the nineteenth century, for instance, reveals that the name *Giuditta* was very frequent – much more frequent than today, since this name began to go definitively out of fashion at the end of World War II. Furthermore, some very important women of the age of the Risorgimento bear this name, including Mazzini's lover, Giuditta Sidoli, and the great soprano, Giuditta Negri Pasta. But the most famous Giuditta of the Italian unification saga is undoubtedly Giuditta Tavani Arquati. There are streets, squares, and political associations bearing her name. Along with her husband and her first son, who was 13 years old, she was killed at a relatively young age, on October 25, 1867, while she was pregnant. The assassins were "zuavi pontifici," a regiment created in 1860 on the French model, and mercenaries of Pope Pius IX. One of them, John Surratt, had been involved in the assassination of Abraham Lincoln. Tavani Arquati's marble bust was placed in Via della Lungaretta in the Trastevere district of Rome, where the carnage took place and where she was born and had lived all her life. She and her husband were secretly corresponding with Garibaldi's agents. Another important Giuditta of the Italian nineteenth century was Giuditta Turina, who had a very unfortunate love affair with the great composer Vincenzo Bellini.

Apart from the high frequency of the name *Giuditta* among all social classes of nineteenth-century Italy, another occurrence could have been pivotal in launching the figure of Judith in the bright heaven of Italian nationalism and nation-state–making process. The Italian historian Alberto Mario Banti has shown how many "women with a sword" were rediscovered or created anew, like the French "Marianne," to embody and forge the (feminine) identity of the "nation." They are almost all warriors, or warriors and saints at the same time, like the ancient French patriot, Joan of Arc. They

kill and fight, they defend themselves and their heirs, the members of the nation. They are idealized in poems and novels, and immortalized through bronze, marble, and stone monuments, all over "nationalized" Europe: in Italy, in Britain (where "Britons" had been forged as an ideological entity if not a real one as early as the beginning of the eighteenth century, as Linda Colley has brilliantly demonstrated), in Germany, and in France. These "Judith-like" figures, however, are not identified, and cannot be identified as Judith herself, although in some monuments they look remarkably like Judith after the beheading. Their lore, meaning, and origins are, however, very diverse and there is no firm evidence that Judith was their prototype. Judith does not play any significant role in the Risorgimento's rhetoric. The new century of nations and nationalism needed new heroes who do not come into conflict with their own nation, who do not call their people "cowardly," who do not sign a private pact with a God who entrusted them with the role of savior of a weak, passive flock.

There is only one exception, dealt with extensively by Banti: the character of Odabella in one of the lesser known works of the Risorgimento, Giuseppe Verdi's opera *Attila*, with a libretto by Temistocle Solera. The first performance took place once again in Austrian Venice, at La Fenice, on March 17, 1846, at the time of the preparations for the 1848 Venetian uprising. Here Odabella is, as young people would say, a "wannabe" Judith. Her aim is to kill Attila, the barbarian king who conquered Aquileia, a mirror image of Bethulia. However, everything goes wrong, the plot becomes extremely complicated, and the happy ending is only possible because of the intervention of the Christian army, and because Odabella kills Attila with one neat stroke of the sword, as if in a duel. In fact, Attila loves her and is astonished and frozen with stupor when the beautiful lady (who is not a widow) strikes him with the strength of a male warrior. This opera is very revealing. At the end the destiny of an entire people is determined not by deceit and cunning, but by open confrontation, loyalty, and chivalry. Judith acts as a man, challenging her enemy to a regular duel, which does not occur only because of Attila's deep astonishment.

In addition, in the original story Judith is a widow with no children. She is rich and belongs to an aristocratic family. Her genealogy is the longest, for a woman, in all biblical narratives. She acts against the passivity of her people, and truly despises most of them. She is extremely beautiful, and beauty is something the Italian patriots normally dislike as an aristocratic quality. She survives while most men are killed. In the Risorgimento sagas

the fate of women such as Anita Garibaldi, who are courageous but certainly not beautiful, is to die.

There is, in conclusion, enough to make Judith an outmoded figure in popular, pseudo-democratic nationalism. She is certainly not a hero of the "Volk." Still, visual representations of Judith offer a rich reservoir for statues and paintings. These feminine warriors in many cases look like her, but only externally; this resemblance may be coincidental or may be due to a lack of any alternative model.

Furthermore, and lastly, she is a Jew. She belongs to the ancient Jewish nation, in a century in which only Jews who were assimilated, or well on the way to being so, were accepted in society and in the arts. In some cases, the Italian "Volk," longing and fighting for liberation, is equated with the Jews; for example, in Marcello's *Giuditta*, both appear as a holy and chosen people. This is, however, something that the "liberali," anti-Catholic founding fathers of Italy, could not easily stomach. The Risorgimento was essentially a secular, occasionally fiercely anti-religious (not only anti-Catholic) movement. Therefore, the very fact that her book was excluded from the Jewish biblical canon, and her tale always treated in parallel with that of the Virgin Mary, did not help her cause throughout the nineteenth century. Mary was not a well-regarded figure among Italian "liberal" patriots and insurgents, apart from some southerners (the "Viva Maria!" were a strong anti-liberal, anti-French, and anti-Italian movement in southern Italy).

Therefore, only with decadence, with "the pleasures of beheading" first rediscovered by Aubrey Beardsley in his poignant *Salomé*, and by Oscar Wilde, is a new space opened for Judith, as Klimt's masterpiece of sensuality clearly testifies. Here, any political meaning is lost. The triumph of blood and sensuality hint at long-lost images of Judith, from the splendor of Caravaggio, to the sensuality of Allori. This artistic use of Judith is a signal of the strong detachment of the artist from the political world, which is now in the hands of those who have inherited the "nations" formed during the previous century. The immense carnage of the First World War, where the heads of so many patriots, but not of ministers and leaders, were lost to the terrible "democratic" bullets of machine guns, would have been enough to appall any brave Judith, fighting only with her God-given skills, beauty and cunning.

23. Marcello and Peri's *Giuditta* (1860)

Alexandre Lhâa

Introduction: A Successful Opera

"One of the best melodramas to come out for many years." It is with these laudatory terms that the *Gazzetta dei teatri* reviewed *Giuditta*, the day after its creation on the stage of the most important theatre of Milan: La Scala.[1] Composed by Achille Peri on a libretto by Marco Marcello, this biblical melodrama premiered on 26 March 1860. The subject matter, popular and widely diffused on the Italian peninsula,[2] was reputed inadaptable to the lyrical stage.[3] Nevertheless, it proved to be a triumphant success.[4]

The melodramatic adaptation of the biblical episode, realized by Marco Marcello, introduces the reader/spectator to Bethulia besieged by the Assyrians. Several voices proclaim the surrender of the city. However, spurred on by the exhortations of the High Priest, Eliachimo, they all swear to fight until death. Giuditta announces that she has just discovered water for the thirsty inhabitants. Eliachimo declares that Heaven has destined her

1 Throughout this study, translations – of books, newspaper articles, or *libretti* – are my own unless otherwise stated. I would like to express my most sincere thanks to Tul'si Bhambry for her help in these translations and patient support as a friend. *Gazzetta dei teatri*, 27 March 1860.
2 *La Perseveranza* stresses that children, "while having read it in the sacred volume as well as admired it in the illustrations or in the famous painting of Horace Vernet, will also remember, as grown-ups, having seen it in puppet theaters, with Arlequin, who held the bag, and the tremendous wooden head of Holofernes, who in his greatly disturbed eye sockets moves his mechanical pupils." (*La Perseveranza*, 28 March 1860.)
3 "Judith […] is thought to be unfit to assume melodramatic forms and musical format" (ibid.).
4 Ibid. The newspapers counted between ten and twenty curtain calls for the composer.

to accomplish a high mission, whereupon she promises to deliver her home-
land from the enemy. Later, Gionata, a young warrior, offers his protection
to Giuditta, whereas the populace demands her death, upon learning that
the water she discovered was poisoned. When he declares his love for her,
she turns him down, explaining that her only desire is to dedicate herself
to God and her homeland. Giuditta convinces the people of her innocence
and assures them that she will find the means to liberate Bethulia. Then
she enters the Assyrian encampment and approaches General Holofernes
with the request that he cease to oppress her people. He asks her to become
queen at his side. She promises to give herself to him that very night. Elia-
chimo and Gionata, captured near the Assyrian encampment, are brought
before Holofernes, in chains. Appalled at Giuditta's presence at the gen-
eral's side, they both disown her. She asks Holofernes to free Eliachimo, but
to surrender to her Gionata, so that she could punish him for insulting her.
The general agrees. Then, when the celebrations take place in Holofernes's
pavilion, Giuditta comes to free Gionata, who has been chained up in a
remote part of the camp, and promises to do everything to liberate Bethulia.
After the sleeping Holofernes has been conducted into his alcove, Giuditta
prays to God for the force to accomplish her deed. As a tempest brews out-
side, she enters the alcove with a sword in her hand. At this precise instant,
the Assyrian camp is put to rout and engulfed in flames. After the tempest
subsides, on a hill in the rising sun, Giuditta appears next to Holofernes's
impaled head. The curtain falls at the moment of her apotheosis.

The additions made to the initial framework of the Judith narrative
derive either from Marcello's main source or from his own imagination. In
the prefatory notice of the libretto, he indicates that he has consulted Mad-
ame de Girardin's *Judith* from 1843, Friedrich Hebbel's *Judith*, dated 1840,
and finally Paolo Giacometti's eponymous tragedy, *Giuditta*, published in
1857, which the librettist names as a particularly vital inspiration. Marcello
claims to have made "some cuts indispensable to brevity, to concision,"
allowing himself only such rare – but highly significant – initiatives, as
the final "Hymn to Liberty," which bears little similarity to Judith and the
Hebrew people's hymn of thanksgiving in the Bible, and does not even
appear in the acknowledged source. Marcello's adaptation – even though
greeted almost unanimously – was notably criticized by the Milanese press
for being too long and confused.[5] Some journalists picked out imperfec-
tions both in the libretto and in the score. Moreover, the performance was

5 *Gazzetta di Milano*, 27 March 1860.

handicapped by the tenor's immediate loss of voice. These failures seem incompatible with the huge enthusiasm related by the press.

A remark from the *Gazzetta di Milano* offers an explanation of the success of *Giuditta*. The journalist underlines that the Judith narrative belongs to the category of "grandiose and national" subjects. Among the plurality of possible readings of the Book of Judith, the librettist's preference seems unsurprising. His choice and *Giuditta*'s success with the audience are accounted for by the immediate historical context of the opera's creation and performance. On 20 April 1859, Austria presented an ultimatum to the Piedmont, provoking hostilities. A few months later the Franco-Piemontese alliance secured the victories of Magenta (4 June) and Solferino (24 June), gaining control of Milan and Lombardy. The enthusiasm that *Giuditta* provoked in the audience, far from being due to the opera's formal quality only, can be explained by Marcello's ability to make the biblical narrative echo back contemporary realities of the Italian war of independence.

The aim of this paper is to show how the librettist infused the Book of Judith with the nationalist-patriotic ideology of the Risorgimento and tried, by undertaking an indispensable – though apparently insufficient – adjustment, to turn the biblical character into an emblem of the national movement of independence.

The Political Usage of the Judith Narrative

"Libertà" (Liberty), the last word of the opera, is repeated four times in the eponymous hymn. To the noun is added the verbal form: "liberar" (to liberate).[6] This insistence contributes to confirm the idea of a patriotic reading of *Giuditta*, in tune with the ultimate events of the Risorgimento.[7] The context in which it was composed substantiates a political reading of the opera. Milan was then "invaded by 'politico-mania,'"[8] and the lyrical stages were not spared by this movement. On 15 August 1859 and on 26 February 1860, two hymns were performed at La Scala in the presence of the King of Piedmont-Sardinia, Victor-Emmanuel II. The librettist of *Giuditta* himself wrote the lyrics of the first one. Marco Marcello extolled the liberation of

6 See the text in the appendix.
7 I reproduce here the concise and relevant definition that Alberto Mario Banti has given of the Risorgimento (1796–1870): "the Risorgimento must be considered as a politico-cultural process that is based on the idea of the Nation and that has the construction of an Italian state as a goal." Alberto Mario Banti, *Il Risorgimento italiano* (Roma and Bari: Laterza, 2004), pp. x–xi.
8 *Gazzetta dei teatri*, 2 December 1859.

Lombardy from a "blind tyranny," and affirmed that the moment of the liberation of Italy in its entirety would occur soon. The journalist who related the events of that evening wrote of the exaltation provoked by such lyrics, in which he saw "the will of a people ready to sacrifice everything, for independence and for liberty."[9]

The first indication of Marcello's intention to give a political dimension to Judith's action lies in the comparison with Charlotte Corday, who was at the center of numerous political debates, especially in France.[10] He saw in Judith "la Carlotta Corday dell'istoria ebraica" (the Charlotte Corday of the Hebraic history). This comparison is established at the beginning of the prefatory note, in an assertion evoking the words of Paolo Giacometti. If Marcello claims to have drawn his inspiration from Giacometti's play, he nonetheless disagreed with him on this point. Indeed, Giacometti clearly refutes the parallel between the two women, adding: "Politics has nothing to do with this purely religious and theocratic war."[11] But Giacometti's play was performed shortly before the second independence war, and was therefore grasped by the audience as containing a strong political significance, one contrary to its author's intentions. This is certainly one of the reasons why Marcello made of Giacometti's *Giuditta* the main source of inspiration for his own work.

On the day after the performance of Marcello and Peri's opera, the critics highlighted the allusion to the immediate context of the Risorgimento by making clear the implicit association of the Assyrians with the Austrians. *La Perseveranza*, describing the final chorus of the third act, mentions "a resounding call to arms, challenging this kind of Austrian to the battle." Later, commenting on the stage setting at the end of the opera, the journalists employ nominal substitution: "[...] we see the people of Bethulia, who, artistically arranged around Radetsky's skull start singing [...] a hymn [...]."[12] Joseph Radetzky, who takes Holofernes's place in this critic's article,

9 *La Perseveranza*, 15 August 1859.
10 Charlotte Corday was the murderess of the French revolutionary leader Jean-Paul Marat. For her defenders she embodies the struggle against oppression. Thus, in 1797, the anti-revolutionary play *Charlotte Corday ou la Judith moderne* constitutes the first work to introduce a comparison between the murderesses of Marat and of Holofernes, making a Holofernes of Marat and a Judith of Corday, and identifying the Hebrew with the royalists persecuted by the republicans. Several years later, the parallel between Corday and Judith reappears, in a more balanced manner, in Lamartine's *Histoire de Charlotte Corday*.
11 Paolo Giacometti, *Teatro*, ed. Eugenio Buonaccorsi (Genoa: Costa & Nolan, 1983), p. 330.
12 *La Perseveranza*, 28 March 1860.

had died two years before. As general of the Austrian army, he had crushed the Milanese insurrection of 1848, defeating Charles-Albert of Sardinia, Victor-Emmanuel II's father, during the battles of Custoza (1848) and Novara (1849).

Carlotta Sorba has underlined the striking permeability between the political and theatrical spheres during the war of 1848.[13] The very foundation of the melodrama as a genre resides in the Manichean opposition between good and evil, a stylistic figure omnipresent in nationalistic discourse. In *Giuditta*, as the Assyrians are described in dark terms, the anti-Austrian rhetoric coincides with the essentialism which governs – in the operatic genre in particular – the depiction of the Oriental: cruel, ungodly, indulging in luxuriousness. Faced with them, Giuditta is described as a "santa donna" (holy woman), the "angiol salvator" (savior angel) of a thirsty and threatened people. Furthermore, the slaughter of the Assyrians in the Bible after Judith ordered it is not mentioned in the opera.

Moreover, some easily identifiable rhetorical features of the Risorgimento can be found throughout *Giuditta*. The association Assyrians/Austrians revolves around the figure of the "barbarian" — a word that is uncannily familiar to nationalistic writers and speakers in reference to the Austrians.[14] In the opera, Arzaele and Giuditta go further: the servant tells how she fell "preda" (prey) to the Assyrians while Giuditta draws a picture of Holofernes as a "tigre feroce" (fierce tiger).[15] Both the chronicles and the melodramas of the period depict enemies capable of violence, in particular against women. Sexual abuse against women constitutes the highest insult to the nation's honor. Alberto Mario Banti emphasizes how many narratives contemporary with national movements used to highlight feminine chastity and fragility — two distinctive traits that favored the development of plots constructed around the enemy's attempt to violate the most precious quality of national heroines: virginal purity.[16]

Giuditta provides two more striking examples of the intermingling of

13 Carlotta Sorba, "Il 1848 e la melodrammatizzazione della politica," in A. M. Banti and P. Ginsborg (eds.), *Storia d'Italia. 22: Il Risorgimento* (Torino: Einaudi, 2007), pp. 481–508.
14 See Domenico Buffa on Austrian people and the description used in the proclamation to the Bolognese priests and Italians of 2 August 1848, both quoted in Carlotta Sorba, "Il 1848," p. 499.
15 These words bring to mind Costanza d'Azeglio's assertion: "they are no longer men, they are wild beasts."
16 Alberto Mario Banti, *L'onore della nazione: identita sessuali e violenza nel nazionalismo europeo dal XVIII secolo alla grande guerra* (Torino: Einaudi, 2005).

opera and the discourse of the Risorgimento: the oath and the readiness to sacrifice. Facing the inhabitants of Bethulia, Gionata takes an oath. The scene, which appears neither in the Holy Scriptures nor in Giacometti's tragedy, is an addition by Marcello:

Gion. (con impeto supremo)	Gion. [with the highest fervor]
Giuriamo, in pria di cedere	Let's swear, before surrendering
Al barbaro Oloferne,	to the barbarous Holofernes,
Di seppellirci tutti nelle natie caverne ...	All to bury ourselves in the native caves ...
Meglio perir distrutti, che scerre una viltà.	It is better to die destroyed, than to choose vileness.
Spesso il furor d'un popolo Gli acquista libertà.	Often the fury of a people awards it freedom.
[...] (Tutti ripetono il giuramento di Gionata invasi dal suo fuoco.)	[...] [They all repeat Gionata's oath, conquered by his ardor.]

According to Sorba, the collective oath represents "the most evident dramatization of the birth of a political community, which becomes self-identified in this ritual."[17] One of the major characteristics that emerges from these oaths is the notion of sacrifice. The sacrifice of one's child or of one's self — nothing can be refused to the Homeland. Marcello's Giuditta, who is ready to give her life, is the perfect embodiment of this spirit. If the sacrifice is never accomplished (because the Lord keeps a watchful eye on her, as she underlines it), Giuditta at the least assumes the will to accomplish it. While she finds herself threatened by the inhabitants of Bethulia, she answers:

Giud. [...] Perché depor quell'armi,	Giud. [...] Why lay down these arms
Levate a trucidarmi ?	raised for slaying me?
Io sono inerme, debole:	I am defenseless, weak:
Compite il sagrifizio ...	execute the sacrifice ...
Ah, possa questa vittima	Ah, could this victim make
Rendervi il ciel propizio !	Heaven more favorable to you!
Morendo ancor, Giuditta	Dying, Giuditta
A voi benedirà.	will still bless you.[18]

17 Sorba, "Il 1848," p. 502. Sorba stresses that the collective oath was borrowed from the stage by the nationalists. Two very famous examples are the oath in Verdi's *La Battaglia di Legnano* (*The Battle of Legnano*) and the one related by Giuseppe Montanelli in his *Memorie sull'Italia e specialmente sulla Toscana dal 1814 al 1853*. Both can be found in Sorba, "Il 1848."

18 In this aria sung by Giuditta, the discourse of the Risorgimento on sacrifice merges with the operatic discourse that makes the sacrificial dimension a major characteristic of the Romantic heroine.

In the prefatory notice of his tragedy, Giacometti defends the sacrifice accomplished by her – i.e., her will to give her honor, "the holiest of human feeling" – to the Homeland, and considers it higher than that accomplished by Brutus, who had, as a consul of Rome, given the blood of his sons, conspirators against the Republic.[19] We must keep in mind that the defense of women's honor does not bind exclusively women but the whole community: as Banti asserts,

> the idea that the national community has sexual frontiers and an internal structure founded on monogamous marriage, on lineage, and therefore on the certain individuation of paternity, makes of sexual aggression a concrete threat for the passage of national lineage, as well as a proof of the poor ability of the nation's men to defend their own women.[20]

The reactions of Gionata and Eliachimo, finding Giuditta in Holofernes's pavilion, translate this dimension attached to the honor of women:

Gion. E l'onor, la patria, Iddio,	Gion. [...] And the honor, the homeland, God:
Empia tu tradivi intanto! ...	Impious, you betrayed in the meantime!
Eran tue virtù mendaci, Era falso il tuo pudor! ...	Your virtues were false, Your modesty was insincere! ...
Sul tuo fronte io veggo baci	Upon your face I see the kisses
Che ti diede l'oppressor	That the oppressor gave you.
[...]	[...]
Eliac. Eri il giglio d'Israele	Eliac. You were the lily of Israel
Per virtudi, per pudor:	By your virtues, by your modesty:
Or macchiata ed infedele	Now sullied and unfaithful,
De' fratelli sei l'orror!	You are the horror of your brothers!

But the case of Giuditta is specific. In patriotic representations, women who must protect their honor are represented as passive: either their honor is defended by men, or they commit suicide not to be dishonored. Here, Giuditta openly takes the risk to expose her honor for the sake of the Homeland:

E se illibata mai	Should I not emerge
Non esca dal conflitto,	Uncorrupted from the conflict,
Me rinfacciar vorrai	Will you want to reproach me
Del santo mio delitto?	

19 Banti stresses that "self-sacrifice, in the Christian tradition and in the re-elaborations realized by the political religions of the nineteenth century" allows one to justify "defeat, pain, and bereavement and possesses a function of testimony toward the community." Banti, *L' onore della nazione*, p. 152.

20 Ibid.

È periglioso il còmpito	For my pious crime?
Che a me la patria indice:	The task which the homeland indicates to me is perilous:
O vinta o vincitrice,	Either winner or loser
Pensa che Iddio lo vuol!	Think that this is God's will!

As she reminds Gionata, her name must be preserved from infamy and her sacrifice must not be in vain: it will have to serve to edify the coming generations that they might remember that she "died for the liberation of her Homeland." Marcello's libretto even makes divine participation in the national movement unavoidable and exalts liberty more than divine will.

In this sense, Marcello's work distinguishes itself from two precedent works dedicated to Judith. Giacometti's tragedy and the opera of Giovanni Peruzzini (librettist) and Emilio Cianchi (composer), created in Venice in 1844, and performed again in Florence in 1860, both end with an exaltation of divine will.[21] What, then, is the treatment of the religious dimension in Marcello's opera?

The Religious Dimension

The choice to present a biblical episode, and that of Judith in particular, can be understood as the librettist's desire to legitimate the independence movement's struggle through identification with the Hebrew people, which obviously enjoys God's support. In Marcello's *Giuditta*, God supports the liberation of the Homeland from barbarians. The words "Iddio"/"Dio" (God) and "Signor" (Lord) are uttered more than twenty times by the Hebrew characters, making him appear several times as a warrior God, justifying in this way the war against Austria-Assyria. Besides, Eliachimo describes the conflict as a "santa guerra" (holy war) and the character who actually brings about the liberation of Bethulia, Giuditta, is endowed, throughout the opera, with religious qualities or compared to other biblical figures: the piety of the character is strongly emphasized and she is alternately described as a "santa donna" (holy woman – twice), "l'ispirata figlia di Mèrari" (the inspired daughter of Merari) or as an angel. She is said to be "la suora di Iäel" (the sister of Jael), "la nuova Debora" (the new Deborah), and after she has vanquished Holofernes, a "new Deborah, more undefeated than Jael." Right from the first war of independence at the end of the 1840s, the conflict was described by the members of the nationalistic

21 See these two texts in the Appendix.

movement as a "holy crusade." Their discourse was imbued with mention of religious words, symbols, and rites.

In *Giuditta*, the Assyrians present themselves as the archenemies of the religion:

Sulle vette del sacro Sïonne	On the peak of holy Zion
Fia distrutto di Ièhova l'impero;	May the empire of Jehovah be destroyed;
Del suo tempio fra l'auree colonne	Holofernes's horse will neigh,
Nitrirà d'Oloferne il destriero.	Among the golden columns of his temple.
Sulla terra Nabucco, nel cielo	On earth Nabucco, in Heaven
Belo sol oggimai regnerà […]	Only Baal will reign from now on […]

Later, Holofernes affirms: "Ora vo' guerreggiar contro gli Dei" (Now I want to fight against the gods).[22] This scene echoes the anti-Austrian images diffused when Austrian imperial soldiers had, on several occasions, burst into churches. They were described as barbarians "who have violated the temples sacred to your cult, shed the members of the dying priests on the altars covered with blood, desecrated the Holy Virgins […] had said in the fury of slaughters: we are God."[23]

The identification of the Italian people with the Hebrew people is not only the result of a specific correspondence between the Judith narrative and the historical context. Beyond this parallel, a deep link has been established by Vincenzo Gioberti, one of the main thinkers of the Risorgimento. He explained that he envisaged "the biblical narrative as the explicative paradigm of History" and added that "Italy is the chosen people, the typical people, the creator people, the Israel of the modern age." According to him, "in Italy, like in Israel, […] God enters into an alliance with a special people in order to train it to be mediator and bonding element of universal fellowship."[24]

Furthermore, in 1860, following opposition and harsh attacks on the national liberation movement by Pope Pius IX, there was a need to assert more strongly its religious legitimacy. In 1848, the pope had renounced the idea of heading an Italian confederation, and had tried to discredit the movement as impious, definitively condemning the national movement. Thus, the choice of the Judith narrative and the incessant references to God proved useful to legitimate the movement of liberation against the Austrians but also against the Catholic hierarchy.

22 The plural used here is due to poetic considerations.
23 "Preghiera alla Vergine," Pistoia, 1848, quoted in Enrico Francia, "Clero e religione nel lungo Quarantotto italiano," in *Storia d'Italia: 22*, pp. 436–37.
24 Quoted in Francia, "Clero e religione," p. 446.

But beyond the nationalist reading offered by the Judith narrative and its readiness to act as a vehicle to assert the religious dimension of the Risorgimento, the way Marco Marcello treats the heroine herself and the reception of the character in the press betray a striking awkwardness vis-à-vis the representation of a triumphant woman.

An Awkward Femininity

At first glance, the choice to stage a "triumphant Judith" can appear surprising with regard to the rules that govern the representation of women in patriotic discourse, but also regarding the role of heroines in Romantic opera. Soprano roles are characterized by a vocation to martyrdom. Romantic operas end, generally if not inevitably, with the "sacrificial immolation" of the heroine.[25] This representation of femininity greatly exceeded the sphere of the mere melodrama. Authors like Alessandro Manzoni or Niccolò Tommaseo shared this vision of a suffering femininity. Tommaseo wrote in *La Donna*: "in everything [the woman] is condemned to suffer."[26] Furthermore, as Banti demonstrates, the gender division of roles was evident in the representation of the nation in conflict: "to men the weapons, to women tears and prayer."[27] But Giuditta, although she is conscious that prayer is the attitude proper to a woman – "debole donna ... Pregar mi lice ..." (weak

25 Simonetta Chiappini, "La voce della martire. Dagli 'evirati cantori' all'eroina romantica," in *Storia d'Italia*: 22, p. 315. See also Martine Lapied, "La mort de l'héroïne, apothéose de l'opéra romantique," in Régis Bertrand, Anne Carol, and Jean-Noël Pelen (eds.), *Les narrations de la mort* (Aix-en-Provence: Publications de l'Université de Provence, 2005). Another Romantic heroine is an exception to the rule: Odabella in Verdi's *Attila* (1846). This quarrelsome virgin makes a reference to the biblical heroine:
ODABELLA
Foresto, do you remember
Judith who saved Israel?
[...] Odabella swore to the Lord
To renew the story of Judith
[...] Look, it is the sword of the monster.
This is the Lord's will!
[...] Valor mounts in my breast!
("*Attila* libretto e guida all'opera," ed. by Attila Marco Marica, Programma di sala [2004] http://www.teatrolafenice.it/public/libretti/58_2246attila_gv.pdf, 28 [11 April 2008].)
26 Niccolò Tommaseo, *La donna. Scriti vari* (Milan, 1872, first edition 1833), quoted in Simonetta Chiappini, "La voce del martire. Dagli 'evirati cantori' all'eroina romantica," p. 315.
27 Banti, *L'onore della nazione*, p. 229.

woman ... to pray I am allowed ...) – is absolutely not a weeping woman. She acts, without the help of any man, for the successful liberation of Bethulia, whereas even the bravest women in traditional representations could only encourage their lovers to fight against the enemy of the Homeland, even if they had been disconsolate at their departure. In these representations, there are no women at all who would take up arms to fight, either alone or alongside men: even the allegories of the nation are frequently disarmed, if not physically, then at least symbolically.[28] Can Giuditta then be considered an opera that advocates the participation of women in the Risorgimento? The sharp contrast between Giuditta and the men of Bethulia seems to confirm it. Whereas they appear cowardly[29] in the first scenes of the opera, Giuditta, facing them, shows the courage which they lack:

Ebben, poiché negli uomini	Well, as virtue
È spenta la virtù,	is dead in men,
L'avrà una debol femina;	a weak woman shall have it;
E quella io sono.	and I am the one.

These verses evoke both Giacometti's and Niccolò Tommaseo's words. The latter expressed notably the canon of "idealtypology"[30] of the national Italian woman in his book, *La Donna*, published for the first time in 1833: "the Italian woman, capable of inspirations, knowing how to obey, knowing how to command wherever necessary, is for us the guarantee of a destiny less severe. Whereas men show themselves to be more corrupted and weaker, women have more courage and virtue."[31] But in the nationalist-patriotic ideology, women must show these moral values in the domestic sphere, and not on the battlefield, or within political institutions. Thus, during this period, the domestic role of women inside the family was strongly emphasized,[32] whereas a role to play in the public sphere was clearly

28 Ibid.
29 This evokes the leaders of the Italian independence denouncing the cowardice of the inhabitants of the Italian peninsula. As Christopher Duggan emphasizes, the task of the Risorgimento was not only to secure a territorial independence but, more fundamentally, to banish from the population such vices as subservience and lack of martial ardor. Christopher Duggan, *The Force of Destiny. A History of Italy since 1796* (London: Penguin Books, 2008), p. xvii.
30 The expression is used by the Italian historian Michela di Giorgio.
31 Niccolò Tommaseo, *La Donna, scritti vari*, quoted in Michela de Giorgio, "La bonne catholique," in G. Fraisse and M. Perrot (eds.), *Histoire des femmes en Occident, IV. Le XIXème siècle* (Paris: Perrin, 2002), p. 209.
32 Silvana Patriarca has stressed an "intimate convergence between nationalism and the new sexual morality." Silvana Patriarca, "Indolence and Regeneration: Tropes and Tensions of Risorgimento Patriotism," *The American Historical*

refused to them.[33] Giacometti, for his part, moves away from this idea. If he also writes in his prefatory notice that "we must be grateful to the woman who knows how to rise above the men of her people, if those men are weakened by fear, and quite like cadavers," he then evokes the women who shed their blood defending the Homeland and condemns "the will to exclude women of generous and strong works."[34] Although Marcello acknowledges Giacometti's tragedy as his main source of inspiration, his position on the subject seems radically different. Indeed, several scenes previously she proclaims that she will get the virtue that men have lost; Giuditta promises to save the Homeland. Upon hearing this, the chorus exclaims:

O prodigio! In lei di donna	O miracle! at this point,
Or più nulla ormai restò.	there remains nothing of a woman in her.
Di una vedova ha la gonna,	She gets a widow's skirt,
D'eroina il cor mostrò.	she shows the heart of a heroine.

Here, Marcello's words de-sexualize Giuditta.[35] They are reminiscent of a French journalist's comments on the murder committed by Charlotte Corday, that by this deed she has thrown herself "absolutely out of her sex."[36] In both cases, the unconventional, extraordinary action – whose realization defines the hero – cannot be accomplished by a woman. This negation of

Review, April 2005; http://www.historycooperative.org/journals/ahr/110.2/patriarca.html (accessed 10/4/08).

33 A striking example of the rejection of women from the public sphere is given by a journalist of the *Corriere delle Dame*, who evokes, before making his review of *Giuditta*, the debate about women's right to vote:

Isn't it true, my Ladies, that these days you have envied us men for our right to vote? [...] But where would moderation and concord go, if among the skinny trousered legs and the wretched *frac*, the *bouillonnées* dress and the voluminous *crinolines* would approach the ballot-box? [...] We, poor pilots of the human genre, would completely lose our bearings [...] We promise you that all codes, all laws will be made in your benefit [...] we will give a greater value and at the same time greater recognition and greater credit to your amiability, to the kindness, to the good taste and to the strongest and more precious endowments of which the three just mentioned are the brilliant gloss. (*Corriere delle Dame*, 30 March 1860)

34 Giacometti, *Teatro*, p. 263.

35 Judith's final triumph at the price of the supreme transgression, i.e., of the murder of a man, has frequently implied her "virilization." See Jacques Poirier, *Judith: échos d'un mythe biblique dans la littérature française* (Rennes: Presses Universitaires de Rennes, 2004), pp. 98–102 ("La guerre des sexes").

36 Quoted in Geneviève Dermenjian and Jacques Guilhaumou, "Le 'crime héroïque' de Charlotte Corday," in G. Dermenjian, J. Guilhaumou, and M. Lapied (eds.), *Le Panthéon des femmes: figures et représentation des héroïnes* (Paris: Publisud, 2004), p. 149.

Giuditta's femininity lies within the more general framework of the redefinition of the hero. If the literary genre of biographies of illustrious women relates several stories of women putting on men's clothes in order to go fight, the prevailing model is the representation of the homeland savior as male – a trend initiated during the French Revolution and perpetuated during the national conflicts of the nineteenth century.

The correspondence of Giuditta to the canons of idealtypology, and the denial of her femininity at the moment when she accomplishes her act, clearly show either Marcello's adhesion to patriarchal discourse on women, or at least his desire to correspond to the audience's expectations. But this denial seems insufficient according to some journalists' reactions. For the most part, the press remains silent about Giuditta's heroism. What's more, the following surprising observation in *La Perseveranza* stands out: according to the author, a great part of the success of the adaptation of the Judith narrative to the opera lies in the presence in this narrative of "the ardor of the violent and generous passions, which are love of the woman and of the Homeland." The author doesn't even mention Giuditta's action and lingers instead on Gionata, a character who does not participate in the liberation of Bethulia. He describes him as "Gionata [...] l'Achille del poema" (the Achilles of the poem), and qualifies him as a "giovane eroe" (young hero). He even attempts to ridicule Giuditta by a sarcastic remark about the scene preceding the murder of Holofernes: "Giuditta, who was lying in wait [...], seizes the scimitar, and, after some gymnastic exercise, she manages to wield it around in the air like a branch, and then to drop it on the head of the abhorred tyrant."[37] Probably, the journalist was uneasy in the same way as Bismarck was in front of a reproduction of Karl Weissbach's Germania: "A woman with a sword in such an aggressive posture is unnatural."[38]

Conclusion: The Dangerous Seductress

In Marcello's opera, Giuditta's character assumes a clearly paradoxical dimension, sandwiched between the nationalist usage to which she lends herself and the gender structures of contemporary Italian society. She is exalted as a liberator of the Homeland, while at the same time her femininity is denied. Giuditta, among many others, is "plagued by interpretative needs of a male-dominated society."[39]

37 *La Perseveranza*, 28 March 1860.
38 Quoted in Banti, *L'onore della nazione*, p. 5.
39 Anne Eriksen, "Etre ou agir ou le dilemme de l'héroïne," in P. Centlivres, D.

Marcello's work, transformed, was performed again in 1862, never to be staged again at La Scala. The Hymn to Liberty has been replaced by a tribute to God, doing away with Giuditta's apotheosis.[40] Moreover, the Judith narrative echoed the political context once again, as shown by an article of the *Gazzetta di Milano* dated 25 September 1862. The journalist ironically[s] criticizes the fact that when Judith cuts off Holofernes's head, she is considered a "heroine," a "saint," whereas "nowadays proceedings are instituted against Garibaldi."[41] Beyond the irony, the journalist uses a striking vocabulary to describe Judith's act – "to seduce," "charms," "treacherously" – these words echo verses from the opera, e.g., where Giuditta refers to herself and Holofernes ("Fra I lubrici nodi di astuto serpente / Il tigre feroce costretto morrà" (between the lubricious knots of an astute snake / the fierce tiger will die packed). The librettist's metaphor as well as the journalist's comment – whose terms echo Victorin Joncières's words about Saint-Saëns's heroine, Dalila[42] – both announce the anxious fascination with the figure of the dangerous seductress, which will culminate in the culture of the fin-de-siècle.

Fabre, and F. Zonabend (eds.), *La fabrique des héros* (Paris: Editions de la Maison des Sciences de l'Homme, 1998).

40 Between the performance of March 1860 and that of 1862, a peace treaty had been signed between France and Austria (11 July 1860). At the close of the plebiscites and of the conquest of the south by Garibaldi's army in 1860, Victor Emmanuel II had been officially proclaimed King of Italy on 14 March 1861. The Venetian and Roman questions, linked to the diplomatic relationships with France, would not be resolved for several years. This probably explains the disappearance of the nationalistic dimension in the 1862 version of *Giuditta*.

41 In 1862, the famous figure of the Risorgimento led an expedition against Rome – at that time under the papal rule – to complete the process of unification. But Garibaldi's troops were defeated by the Italian army – the new Italian state was opposed to this expedition – and Garibaldi was arrested, prosecuted, and put in jail.

42 Joncières denounces a treacherous Dalila whose voice "hypocritically affectionate, add[s] charm to the troubling song of the seductive courtesan." Victorin Joncières, "Revue musicale," *La Liberté* (21 June 1897). Quoted in Jann Pasler's analysis of the adaptations of the Judith narrative in French dramatic music in this volume.

Appendix to Chapter 23

Giuditta. Melodramma biblico in tre atti. Poesia di M. Marcello; musica del maestro Achille Peri. Da rappresentarsi al Regio Teatro della Scala in Milano nella stagione di quaresima 1860 (Milano, Paolo Ripamonti Carpano, 1860, p. 45)

Scena ultima

Sopra un'altura GIUDITTA, recante in mano la gran scimitarra di Oloferne insanguinata, accanto a lei ABRAMIA: alla sua destra ELIACHIMO, in atto di benedirla, e GIONATA prostrato alla sua sinistra. La testa di Oloferne conficcata ad un'asta nel mezzo. POPOLO EEBREO [sic] intorno prostrato; mentre un drappello di DONZELLE recano ghirlande e spargono fiori innanzi all'Eroina.

Esaltati dal più sublime degli entusiasmi, accompagnato dalle arpe intuonano il seguente:

I.
Sull'arpe d'oro un cantico
si levi in Israele.
Alfine I guai cessarono
Di servitù crudele:
Alfin la patria liberata
Di nuovo sorgerà.
Eccheggi fino a Solima
L'Inno di Libertà.

Giuditta. A Biblical Melodrama in Three Acts. Lyrics by M. Marcello; music by maestro Achille Peri. To be staged at the Royal Theater La Scala in Milan during the Lent season of 1860 (Milan, Paolo Ripamonti Carpano, 1860, p. 45 / my translation)

Last scene

On an elevation GIUDITTA, carrying in her hand Holofernes's great scimitar stained with blood; next to her, ABRAMIA; to her right, ELIACHIMO, in the act of blessing her; and GIONANTA, prostrated, to her left. In the center, Holofernes's impaled head. HEBREW PEOPLE prostrated nearby, while a group of maidens is bringing garlands and scattering flowers before the heroine.

Exalted in sublime enthusiasm, accompanied by harps, they strike up the following:

I.
On the golden harps a canticle
Rises in Israel.
Finally the misfortunes
Of a cruel servitude will cease:
Finally the free Motherland
Will rise again.
All the way to Solima must echo
The Hymn to Liberty.

II.

Te, rediviva Debora,
Più di Iäele invitta,
Te festeggiante il popolo
Esalti, o pia Giuditta.
Viva il tuo nome splendido
Nelle future età :
Eterno simbolo
Ei sia di Libertà.

III.

A liberar dei barbari
Il suo terren natio
Quando combatte un popolo,
Con lui combatte Iddio.
Eroe diventa il pargolo
Che in campo scenderà,
Contro i stranieri eserciti,
Gridando: Libertà!

IV.

O Libertà magnanimo
Sospiro d'ogni gente:
Dove tu regni è limpido
Il cielo, e il suol fiorente:
Per tuà virtu germogliano
L'amore e la pietà ...
Per te morire o vivere
E bello, o Libertà!

(*Apoteosi di Giuditta*)

Fine

II.

You, new Deborah,
More undefeated than Jael,
You thrill the people
That celebrates you, O pious Giuditta.
Long live your splendid name
So that to future generations
She be an Eternal Symbol of
Liberty.

III.

When a people fights
To liberate its Homeland
From barbarians
God fights with it.
A hero is what a child becomes
When he runs down into the battlefield
Against the foreign armies,
Shouting: Liberty!

IV.

O Liberty, generous sigh
Of every people:
Where you reign, the sky
Is limpid, and the soil is in bloom:
Because of your virtue
Love and pity germinate ...
To live or to die for you
Is beautiful, O Liberty!

(*Apotheosis of Giuditta*)

The End

Giuditta: melodramma biblico in tre atti. Poesia di M. Marcello; musica del maestro Achille Peri. Da rappresentarsi nel Regio Teatro alla Scala nella stagione d'autunno of 1862 (Milano, F. Lucca, 1862, p. 43)

Giuditta: A Biblical Melodrama in Three Acts. Lyrics by M. Marcello; music by maestro Achille Peri. To be staged at the Royal Theater La Scala in Milan during the autumn season of 1862 (Milan, F. Lucca, 1862, p. 43 / my translation)

Scena ultima

Last scene

S'incomincia a vedere Betulia rischiarata dal sole. Bandiere spiegate sulla rocca e sulle mura. S'avanzano Guerrieri ebrei guidati da Gionata, ed infine il popolo guidato da Pontefice.

Bethulia, illuminated by the sun, is gradually becoming visible. Banners unfurled on the rock and on the wall.
Guided by Giuditta, Hebrew soldiers advance, and towards the rear, people guided by the Pontiff.

Coro. Spento è Oloferne !...
Fuggono i barbari oppressor !

Chorus. Holophernes is dead!...
Barbarian Oppressors are fleeing!

Giuditta col crine disciolto
E la veste macchiata di sangue

Giuditta with her hair undone
And her dress stained with blood

Giu. Gia splende il quinto sol.

Giu. Already, the sun of the fifth day is rising.

Tutti. ...Giuditta ! Salva !....

All. . . .Giuditta! Safe!...

Giu. E questa mano ancor di sangue intrisa
Il patto che giurò fida ha serbato.

Giu. And this hand, still drenched in blood,
Stayed faithful to the pact I had sworn.

Tutti. Un popolo che langue :
Di vil servaggio l'onta
Degl'oppressor col sangue
Solo lavar potrà.

All. A people that languishes
Will only be able to wipe out
The insult of the oppressor
Only with blood.

Giu. Della grand'opra al Ciel si deve il vanto,
A Dio prostrati al suol sciogliate il canto.

Giu. We owe to Heaven the merit of the great deed,
Prostrate yourselves on the ground, raise a song to God.

(Tutti s'inginocchiano, meno Giuditta ed il Pontefice)

(They all kneel down, except Giuditta and the Pontiff)

Coro. Sia gloria al dio possente
Ch'ebbe di noi pietà.
Risorga più splendente
Il sol di libertà.

Chorus. Glory be to God almighty
Who took pity on us.
Rise again more shining
The sun of liberty.

Fine

The End.

Giacometti, Paolo, Giuditta in idem, Teatro [a cura di E. Buonaccorsi, p. 330)

Giuditta [...] Dio e patria son uno, son tutto
Per noi figli d'un Nume verace,
Non vi è patria se l'ara è mendace,

Vile è il popol che muta la fé.

Oh fratelli ! una gente infedele
Non calpesti le sante contrade,
Dio vi guarda, vi affila le spade,

Io Giuditta a guidarvi verrò.
Or vi lascio – nessuno mi segua;

Sola riedo all'ostello natio,
Ho compiuta la legge di Dio,
Dritto alcuno agli omaggi non ho.

(Coperta del suo mantello nero s'incammina lentamente, e seguita da Abramia, sale la montagna, mentre tutti silenziosi la guardano, compresi di meraviglia e di ammirazione. Quando è scomparsa dietro alle rupi, tutti s'inginocchiano ai piedi della montagna, e cala la tenda.)

Giacometti, Paolo, Giuditta in idem, Teatro [ed. Buonaccorsi, p. 330 / my translation)

Giuditta [...] God and the Homeland are one, they are everything
For us, sons of a true Deity,
There is no Homeland if the altar is untrue,
The people that veers from its faith is vile.

Oh brothers! An unfaithful people
Must not trample on the sacred lands,
God takes care of you, he sharpens your swords,
I, Giuditta, will come to lead you.
Now I leave you – let nobody follow me;
Lonely I return to the native abode,
I have completed God's will,
I have no right to homage.

(Covered by her black coat she slowly sets off, and, followed by Abramia, climbs the mountain, while all the others silently look at her, filled with amazement and admiration. When she has disappeared behind the rocks, they all kneel down at the foot of the mountain, and the curtain falls.)

Giuditta: tragedia lirica in quattro atti. Posta in musica dal sig. Maestro Emilio Cianchi e fatta eseguire per la seconda volta le ultime tre sere di carnevale 1860 nella chiesa delle Scuole Pie dalla Congregazione di Maria SS. Addolorata E.S. Giuseppe Calasanzio (Firenze, dalla tip. Calasanziana, 1860, p. 32)

Giuditta: A Lyrical Tragedy in Four Acts. Set to music by Maestro Emilio Cianchi and performed for the second time during the last three nights of the Carnival of 1860 in the Church of the Pious Schools of Maria SS. Addolorata E.S. Giuseppe Calasanzio's Congregation (Florence, Printing house Calasanziana, 1860, p. 32 / my translation)

Scena V

Scene V

GIUDITTA seguita da ZELFA, e detti.

GIUDITTA followed by ZELFA, and those mentioned above.

Giud. Ho vinto !
L'Assiro duce per mia mano è spento :
All'orrendo spettacolo di sangue
Compreso di sgomento
Tutto il campo sarà. – Fia lieve a noi,
Dal divino favor resi più forti,
Fra le rie tende seminar le morti.

Giuditta. Victory is mine!
The Assyrian leader is dead by my hand:
The whole camp will be drenched in dismay
At the horrible sight of blood. –
Rendered stronger by divine favor,
May our task be light: to spread out the dead
Amid the evil camp

Coro ed Ozia. La salvatrice tua,
Betulia, onora...
Laudi a Giuditta!

Chorus and Ozia. Let honor your savior, Bethulia . . .
Praise be to Giuditta!

Giud. Non a me, soltanto
Dell'ardua impresa a Dio si deve il vanto!
Ei solo il braccio mio
Ei possente rendea !...Sien laudi a Dio !
Nel riso suo più splendido
(Spuntano i primi raggi del sole)
Il sole... ecco si mostra !...

Giud. Not to me, to God only
Is due the merit of the arduous feat!
He only strengthened my arm!
God be glorified!
In his mirth more magnificent
(the first rays of the sun are rising)
The sun... Look it is appearing!...

Zel. E Coro. Astro, risplendi e illumina
Or la vittoria nostra.

Zel. and Chorus. Oh star, shine bright now and shine upon our victory.

Tutti. Come il tuo raggio, ardenti
Noi piomberem sull'empio :
A consumar lo scempio,
Muovi men ratto, o Sol.
Se per si lungo strazio
Lassi, Signor, siam noi,
Scendan le schiere, ah scendano
De'Cherubini tuoi,
Ed al portento attonite
Apprendano le genti,
O Nume di Betulia,
Ad adorar Te sol !

Fine

All. As your ray does, ardently we will fall
Upon the impious:
To commit the massacre,
Move slower, O Sun.
Oh Lord, if we are tired
Of such enduring torture,
Come down the ranks
Of your Cherubs, ah come down
And stupefied by the miracle,
The people learn, O God of Bethulia
To worship only you!

The End.

24. Politics, Biblical Debates, and French Dramatic Music on Judith after 1870

Jann Pasler

In late-nineteenth-century France, composers were drawn to exploring musical images of female strength. In the visual arts, painters depicted Judith as predatory femme fatale, associating her with feminine evil. In French dramatic music of the 1870s, however, it was not her hateful betrayals that appealed. Indeed, in the wake of French defeat by Prussia, Judith emerged as a model to emulate both for her faith in God and her willingness to risk her life for her country, an allegory for a new political identity based on agency and courage. The frightening qualities of Judith were less important than her individual strength, charm, and, for some, her potential to reignite French fervor for a return to war. When Judith returned to French stages in the 1890s, however, an emerging hostility toward the "new woman" and renewed strength from the Franco-Russian alliance contributed to a radically different reception, one that was fearful and almost misogynist.

Music and public reception of works about Judith, particularly as understood in response to ongoing conflicts in politics and biblical studies, suggest the different ways in which Judith was understood. They argue that Judith's voice is as crucial to her identity and the accomplishment of her mission as her faith and beauty, and offer important clues to the shifting meaning invested in her symbolism over the years.

* I am very grateful to The Jessica E. Smith and Kevin R. Brine Charitable Trust for supporting research in the preparation of this article.

Political Struggles and New Biblical Translations

Saddled with five billion francs in war reparations and the loss of Alsace and Lorraine, then horrified by the destruction of Paris and the brutal repression of the Commune, France craved order in the 1870s and needed to reinvent itself. Its people were fiercely divided. Most French were Catholics, and those who believed in a close relationship between church and state looked to the pope for guidance and for the most part supported a return to monarchy. Sharing an interest in maintaining the strength of the Church as a force for social order, legitimist and Orleanist monarchists as well as Bonapartists nostalgic for empire saw a revival of Christianity as "the first condition of the recovery of France."[1] In contrast, republicans, led by rationalist and pragmatic freemasons and open to Protestants and Jews, wished to get the Church out of their classrooms and teach a secularized notion of critical judgment instead of religious doctrine as a way to prepare people to become citizens. Although the monarchist coalition controlled the government until the end of the century, installing what they called the "moral order," republican strength grew steadily. In 1875, they pushed through a new constitution, and in 1876 became the majority party in parliament. In 1878 they took control of the Senate and, in January 1879, the presidency.

Amid these political struggles, biblical scholars published new French translations of the Bible with critical commentaries, some supporting a Catholic monarchist agenda, others a Protestant or republican one. Edouard Reuss, professor of theology at the University of Strasbourg – the center for Protestant studies in France – based his sixteen volumes (1874–79) on the Septuagint version, which he believed to be the oldest. One volume, entitled "Political and Polemical Literature," included the books of Judith, Ruth, Esther, and Maccabeus. Reuss here argues that the story of Judith was "absolutely fictional"; she was a "moral allegory." The Hebrew name "Ieehoudit" means "La Juive," not an individual person but a collective designation, as she simply represents the nation. Similarly, the Greek word "Bet-Eloah" means "house of God," a reference to Jerusalem. Reuss saw the book's purpose as "teaching," inspiring patriotism. Since Christian morality did not approve of Judith's actions, he points to a Jewish perspective which renders Judith "less inexcusable" because her people were "reduced to weakness without any other forms of resistance than those that could

1 Gabriel Hanotaux, *Contemporary France* (New York: Putnam, 1905–12), II, pp. 35, 46–47.

arise from trickery and be employed in the shadow of the night." As such, she is "the expression of concentrated national hatred." While portraying her as an emblem for the nation and pointing to her "aspirations for vengeance," Reuss alludes to the role such an allegory might play in contemporary France, its people seething for revenge against the Germans.[2] Moreover, Holofernes, a proud and arrogant tyrant, could offer a warning to those who might want to return to monarchy.

In the late 1870s, as anti-clerical republicans threatened to marginalize the role of the Church in French society, Catholic biblical scholars made new translations of the Vulgate version of the Bible that had long dominated French Catholicism. The Archbishop of Paris commissioned *La Sainte Bible* (1873–85), forty volumes edited by Fulcran Vigoureux, professor of the Bible at Saint-Sulpice (1868–90), and many collaborators. Building on new archaeological evidence, they sought to support the authenticity of its stories and characters and argued forcefully against Reuss's conclusions and hermeneutical methods that reduced exegesis to "literary history."[3] In 1879, Abbé Gillet, a priest from the diocese of Versailles, translated and wrote a critical commentary on Tobit, Judith, and Esther. While he mentions in the text "vengeance against the proud foreigners aiming to destroy Israel," he contextualizes this with Judith's request for God's strength. Carefully rebutting the arguments and opinions of predecessors and Protestants, he insists on the book's "historical reality." Recently discovered Assyrian documents, he argues, document the "spirit of revolt" in Asia Minor, mentioned in the first chapter of Judith, and a people who "refused obedience and absolute submission" to a general who resembled Holofernes. In his closing, he refers to the "infallible decision" of the Council of Trent in accepting the canonicity of the book, reminding readers of Catholics' belief in the infallibility of the Church and the pope, dogmatically defined by the First Vatican Council of 1870.[4]

For all their differences, some of which related to the long-debated question of whether the Bible was divinely inspired or not, Judith brought

2 Edouard Reuss, Introduction (to the Book of Judith), *La Bible. Traduction nouvelle avec Introductions et Commentaires. Ancien Testament*, vol. 7: *Littérature politique et polémique* (Paris: Sandoz et Fischbacher, 1879), pp. 326–30.

3 Charles Tronchon, *La Sainte Bible, Introduction générale*, vol. 1, p. 577, as discussed in François Laplanche, *La Bible en France entre mythe et critique, XVIe–XIXe siècles* (Paris: Albin Michel, 1994), pp. 169–70.

4 Abbé Gillet, Preface, *La Sainte Bible, Texte de la Vulgate; Tobi, Judith, et Esther, Introduction critique, Traduction française et Commentaires* (Paris: Lethielleux, 1879), pp. 69, 71–82, 88.

to the forefront concerns shared by clericals and anti-clericals, Catholics and Protestants, monarchists and republicans. Whether she was real or imaginary, by her example she preached self-sacrifice and duty to forces larger than herself. If she shared this with Judas Maccabeus and certain other women in the Bible, she also resembled the heroines in Corneille and the music of Gluck and Lully. While compared to Holofernes her life-style of pious asceticism, chastity, and humility seemed weak, she showed what strength can be achieved through faith, and without the assistance of angels. Republicans and Catholics alike saw Judith as capable of inspiring a renewal of moral strength in the French people as well as patriotism and pride in their nation.

Setting Judith to Music

Dramatic music was an ideal domain in which to explore the binary oppositions characterizing the Judith story: not only two peoples (Hebrews versus the Assyrians) and two religions (Judaism versus paganism), but also two principles (the weak versus the strong, the humble versus the proud, the chaste versus the lustful) mapped onto the female and male characters. Before the Franco-Prussian War, dramatic works reflected on problematic issues raised by Judith – her lies, her trickery, her threat to betray her people, and especially her killing of another human being. In his 1868 "biblical drama in verse," a five-act play called *Judith*, Gustave Gilles portrays her as extremely troubled. "Is it a crime?" she asks repeatedly of her wise elder and God. Only when she has a vision of her deceased husband does she embrace the task ahead. The husband's approval diffuses anxiety about her actions. In marginal notes to his translation of the Vulgate, Gillet directly addresses hesitations of Catholics regarding Judith's actions. "The Bible does not present Judith as impeccable," he explains, "but as a model of energy and courage, the only arm she had being trickery, also a weapon of war." If Moses and Aaron could use it against the Pharaoh, he suggests, we should not criticize Judith for doing the same.[5]

Given the need for what Judith could inspire after the war and particularly as republicans became more powerful, the official musical world and French composers embraced Judith as a woman willing to put duty to country over personal interests. In 1876, the Académie des Beaux-Arts chose *Judith* as the libretto that young composers would set to music in the

5 Gillet, *Judith*, p. 129.

annual Prix de Rome cantata competition. The same year, the Paris Opéra put on Charles Lefebvre's three-act opera, *Judith*, begun in 1873. To the extent that Judith was a "moral allegory," the exploits of similar heroines were also set to music. Camille Saint-Saëns composed *Samson et Dalila* (1868–77), inspired by the Book of Judges, and Ernest Reyer, *Salammbô* (1870s), based on Flaubert's novel. There were also works about Judith for schoolchildren, such as a "drame scolaire" with music (1876), and light-hearted secular parodies, such as Edouard Deransart's *Judick et Halonferme* (1878). All of these focus on chapters 8–16 of the Book of Judith. The historical parts of the story are thus of little interest, the strength of Holofernes and his conquests recounted but not shown, while the strength of Judith and her conquest are enacted and experienced by Holofernes, particularly in their duet.

Not surprisingly, such works emphasized religious faith – an important component of national regeneration, as Alexandre Lhâa has suggested on the topic of Risorgimento Italy.[6] Most begin and end in religious sentiment. Audiences familiar with the Vulgate Bible would have known that God always listened to the "prayer of the humble"; in the Septuagint Bible, Judith also calls Him "the God of the humble, the patron of the small, the support of the weak, the protector of the scorned, the savior of the hopeless."[7] In Paul Delair's libretto for the 1875 cantata competition, Judith's nurse tells her to pray that the "strength of God descend into her breast!" Like Joan of Arc, also popular at the time, through prayer Judith calls on God's strength to overcome her natural weakness.

The manner in which Prix competitors set this text, however, suggests different attitudes toward religion. In Paul Hillemacher's winning score, after an ominous introduction with passionate waves of chromatic sixteenth notes comes a "prayer," andante religioso, based loosely on chapter 9. Its first verse climaxes on "let him fall in my trap," with Judith's vocal line rising to E, fortissimo, before descending abruptly a major seventh to F-sharp (Example 24.1). Veronge de la Nux's rendition begins similarly but is followed by an "invocation." In it, he gives no musical emphasis to Holofernes falling into Judith's trap, but instead, and throughout, reiterates the word "Seigneur" (Lord), which appears only once in the libretto. Moreover, he chooses "Seigneur," also frequently used in the Vulgate Judith, rather than "Jehovah" from the cantata's second stanza.[8] With this repetition and

6 See his essay in this volume (Chap. 23).
7 Reuss, "Judith," p. 349.
8 The libretto's first stanza is inspired by Jdt 9:12–13, as translated by Gillet, *Judith*, p. 122, except that "le piège de son regard sur moi" is replaced in the cantata with

24.1. Paul Hillemacher, *Judith* (1876). Paris: H. Lemoine. Photo credit: Jann Pasler.

a recurring one-measure pattern in the accompaniment, the music coheres around the subject of God. To reinforce the invocation's importance in the cantata as a whole, Nux repeats a whole section. How a composer treats a libretto thus could be as important as the text itself in communicating Judith's relationship to God, whether she is praying to Him for the success of her cause (in Hillemacher), or invoking God's help for who He is (in Nux).

As in the cantata, both Lefebvre's *Judith* and Saint-Saëns's *Samson et Dalila* begin and end with entreaties to God. In Lefebvre's opera, the suffering Hebrews ask God to "heed our prayer." Judith later prays to God that His "strength" enter her soul. But just before her duet with Holofernes, she addresses God passionately, with sweeping melodies and leaping intervals, and the music becomes passionate. When she refers to how God helped David against Goliath, the music suddenly modulates from A-flat major to E major. After the drive up in Judith's melody to a high F-sharp on "strength," followed by the lower B on "in my soul," a huge leap down a twelfth, intensity builds as rising thirty-second-note chromatic octaves, one series after another, accompany Judith as she cries, "this is the hour, that the vengeful arm rises up" (Example 24.2). The prayer culminates on her leap up of a major seventh to a high A-flat as she pleads for strengthening her "arm," a note to which she later returns in the duet with Holofernes when singing of "striking" him. In writing *Samson et Dalila*, Louis Gallet amended the biblical story to make Dalila resemble Judith, that is, motivated by religion and disinterested hatred (rather than money).[9] However in this opera, it is Samson who prays to the Hebrew God (Dalila implores "love" to reinforce her "weakness"). At the end, while God grants Samson strength to destroy the temple of Dagon, in Lefebvre's opera Judith's people praise His glory. Of interest here is that Lefebvre wrote two conclusions (based on Judith's "cantique" from 16:2, 5, 7), with the second one reducing the song of praise from eleven to four pages, shifting the emphasis to honoring Judith whom God blessed, cutting completely the exuberant final "Glory to God," and ending instead with "Let us sing our triumphal hymns." This suggests that Lefebvre was sensitive to multiple meanings the story could conjure for various audiences, and wanted alternative endings, one reinforcing God's actions through Judith and another Judith's actions, aided by God.

"le piège de mon amour." The second stanza is based on the last lines of Judith's final song, referring to the "curse" (16:20–21).

9 Henri Collet, *Samson et Dalila de C. Saint-Saëns, Etude historique et critique, Analyse musicale* (Paris: Mellottée, 1922), pp. 45–51.

24.2. Charles Lefebvre, *Judith* (1877). Paris: F. Makar. Photo credit: Jann Pasler.

If religious sentiment frames such works, it nevertheless often has political undertones. Judith embodied the warrior spirit while bringing an end to war.[10] The 1876 cantata begins and ends with Judith's warning, "Curses on anyone who threatens your holy temple or your race!" Audiences may have heard this as an explicit effort to inflame French feelings about the Prussians, especially since the Vulgate explicitly refers to God's vengeance and his "curse" of any "nation that might turn against them."[11] Act I of Lefebvre's opera culminates in Judith's exhortation to her people, "Have you forgotten Moses' hymn of deliverance?" "Seized by a sudden inspiration," which the tremoli accompaniment suggests is the voice of God speaking through her, she tells them, echoing Samson from Voltaire's famous opera, "People of God, awake, don't remain oppressed, beloved Nation, pray for me. ... " In Saint-Saëns's opera, Samson similarly sings, "Let Israel be free, Let us rise once again." After 1870, Judith's virtue and faith in God may have pleased Catholics, but it was her agency that appealed to republicans and Protestants, an agency that called upon religious faith for the sake of the nation. The biblical translations would have supported this difference, as the Vulgate refers to God's promise to raise up Jerusalem, while the Septuagint emphasizes what Judith's "hands are going to do for the glory of Jerusalem."[12] Moreover, Judith, a woman who took part in the public sphere, represented the active citizenship promoted by republicans.

Voice, Desire, and Charm

Besides giving expression to religious and political narratives, these music dramas also explore a perspective downplayed in the Bible: the importance of the voice. In chapter 9, Judith prays that Holofernes is "taken in by [her] beauty" and "the sweetness of [her] lips."[13] But in her final "cantique," which she asks to be accompanied by drums and cymbals, she asserts that it was her "beauty" (S) / or the "beauty of [her] face" (V) as well as her clothes and perfumes that "captured" Holofernes. In the Vulgate

10 "Le Seigneur est un dieu qui met fin aux guerres" (Reuss, "Judith," p. 360); "Le Seigneur termine les guerres," 16:3 (Gillet, *Judith*, p. 145).
11 "Malheur à la nation ... car le Seigneur, le Tout-Puissant, se vengera d'elle," 16:20 (Gillet, *Judith*, p. 147).
12 "Mes mains vont faire pour la gloire de Jérusalem" (Reuss, "Judith," p. 355); "tu relèves comme tu l'as promis Jérusalem ta ville" (Gillet, *Judith*, p. 134).
13 "Quand je les aurai trompés par mes discours ..." (Reuss, "Judith," p. 349); "Qu'il soit pris par le piège de son regard sur moi: et frappe-le par la suavité de mes lèvres," 9:13.

it is his "soul" (âme) that she desires, his "senses" (sens).[14] Such a claim shifts attention away from Judith's flattery, lies, false promises, and deception, so problematic to Christians. At the same time it denies what Holofernes himself experienced: "her discourse" (S) / "all these words (V) which "brought him pleasure," her "beauty as well as good sense" (S) / "beauty as well as the meaning of her words" (V).[15] In musical renditions of the story in 1870s France, the voice is front and center of the story, and for important reasons.

Choruses bring to life the voice of the people, their suffering and their triumphs, and enact the conflict between enemies. In the opening of Lefebvre's opera, a women's chorus laments the Hebrews' despair. Their hesitating, "almost spoken" lines, the notes off the beat, suggest that they can barely speak. "Dying ... of thirst ... ," one group utters, "my lips burn," responds another. The groups come together, fortissimo, again on off-beats and on a dissonant E-flat over a low F in the orchestra, "There is no more hope." The insistent "We must give in," repeated over and over by individual voices and larger and larger groups with the orchestra moving chromatically up, climaxes in their unified sentiment, "We are dying of hunger." The final chorus of Act 1, "Go, Judith ... save us," elicited particular praise in its first performances. In the operas on Judith figures, composers use choruses to give praise and to comment on the characters and their actions, as might a chorus in a Greek tragedy. A double chorus of Assyrians and Hebrews in Lefebvre's *Judith* engage in a battle of wills over their differences, with the Assyrians accusing the Hebrews of being an "enslaved race" while the Hebrews admit, "our dear country bends under your laws." Even if it is replete with dissonances between the two choruses (the Hebrews hold a long B and then C as they sing of bending to Assyrian laws, as the Assyrians hold a C and then D as they assert themselves as "masters"), the music, however, suggests irony (Example 24.3). The Hebrews, singing in a unified voice, homophonically, with long phrases and long notes in a march-like 4/4, seem proud. Their music maintains its intensity over the Assyrians' lively but oppressive rhythms in 3/8, numerous short phrases such as "hit them, hit them, without remorse," and divided voices.

14 "Sa beauté captiva ses sens" (Reuss, "Judith," pp. 360–61); "sa beauté a rendu son âme captive," 16:8–11 (Gillet, *Judith*, pp. 145–46).
15 "Ces discours firent plaisir à Olophernes ... pour la beauté et le bon sens" (Reuss, "Judith," p. 353); "Toutes ces paroles plurent à Holoferne; par sa beauté et par le sens de ses paroles," 11:18–19 (Gillet, *Judith*, p. 129).

24.3. Charles Lefebvre, *Judith* (1877). Paris: F. Makar. Photo credit: Jann Pasler.

Such choruses also underline national/racial differences. In *Samson et Dalila*, Saint-Saëns suggests the strength and unity of the Hebrews with tonal harmonies and four-square rhythms, inspired by Bach's cantatas and Handel's oratorios. The Philistines sing in sinuous arabesques and dance to music with exotic scales and timbres. In the 1870s, if choruses in Lefebvre's and Saint-Saëns's operas were criticized for resembling oratorio more than music drama, then with its references to German musical traditions, audiences may have likened the Hebrew choruses and their brute sonic force to a united Germany after 1871, especially when coordinated and under the control of a conductor the likes of Bismarck.

When it came to Judith and Holofernes, the voice allowed for both depiction of these figures as mediums for powerful forces – Dalila and Samson each claim that their god "speaks through me" and that strength comes from "listening to His voice." Their voices also enabled exploration of their character and feelings. To suggest a mature woman who was capable of heroism, composers set Judith for a mezzo-soprano. Moreover, Saint-Saëns conceived Dalila for Pauline Viardot, whose voice he considered "of enormous power and prodigious range ... made for tragedy," lending "incomparable grandeur" to whatever she performed. Lefebvre, whose chorus praises Judith for her "intrepid voice," dedicated his *Judith* to Viardot. And Reyer claimed that he would not have *Salammbô* performed in Paris without the diva for whom he conceived it, Rose Caron: "Tall, superb, at once haughty and likable, she communicates from her first appearance that an inexorable destiny weighed on her." Although Samson had physical strength of mythic proportions, Saint-Saëns wrote the character for a tenor and wanted his voice to suggest something other than the stereotypical male hero. In the "exquisite" voice of Henri Regnault, a painter friend who sang the role of Samson in the private premiere, Saint-Saëns appreciated an "enchanting timbre" with "an irresistible seduction," a certain feminine-like charm he found in "his whole personality." With performers who would draw attention to the complexities of gender in the story, Saint-Saëns could de-essentialize conventional notions of who is strong and who is weak, who speaks through them and what they represent. As such, music drama fleshed out the biblical story by humanizing its characters, encouraging empathy from audiences.

France had a tradition of humanizing biblical characters, most notably evident in Ernest Renan's *Vie de Jésus* (1863). In his three oratorios based on the Bible, *Marie-Magdeleine* (1871–72), *Eve* (1874), and *La Vierge* (1877–78),

Massenet brought together the sacred and the secular in these females whom he portrayed as erotically charged. But with the Judith story, three forces contributed to the extensive attention these operas give to the characters' desires and passions: the story (especially in the Septuagint Bible), musical convention, and republican ideology.

Crucial to the musical representation of the Judith story in nineteenth-century France is the seduction. This is treated very differently in the Vulgate and Septuagint Bibles. The Vulgate mentions explicitly that Judith "put on new clothes to seduce him" (16:10). However, while Holofernes tells his eunuch of his intention to "live with" Judith, there is no actual seduction – his heart is "moved," he "burns with lust," and he "was transported with joy." As Gillet points out, he does not say anything openly and he passes out, drunk. In contrast, the Septuagint Bible states not only that Holofernes sought to "have her company" but that "she would mock us if we did not caress her."[16] In the Septuagint, moreover, Judith asks God to "permit her words to seduce the Assyrians," a line absent in the Vulgate.[17] The Septuagint also notes that Holofernes was looking for an occasion to "seduce her" since they met.[18] And, perhaps most importantly, in this version he flatters Judith: "You are beautiful in shape and you know how to speak well," also not in the Vulgate.[19] Because Judith is represented as a "moral allegory" in the Septuagint Bible, rather than as an authentic person who actually lived, the seduction too can be read allegorically as a conquest as challenging as that of armies over nations, rather than as a tale about a woman's moral weakness.

Arguably the greatest role music could play in such dramas was to give expression to the unspoken as well as spoken exchanges characterizing seduction. To unsettle conventional relationships between the weak and the strong – how can the weak become strong? how can weakness triumph over strength? – the answer was charm. These works delve into the voice as both the initiation of charm and its most profound expression. In Lefebvre's opera, with flattery of all sorts, Judith tempts the king with her voice, which he says he cannot resist. In *Samson et Dalila*, charm is associated with

16 In *The Anchor Bible Judith* (Garden City, NY: Doubleday, 1985), Carey Moore translates "avoir sa compagnie" (Reuss) and "habiter avec moi" (Gillet) as "having" her, or "making" her, which she takes to mean sexual intercourse. She notes that Holofernes was "a man of direct and blunt speech" (pp. 221, 223).

17 "Permits que ma parole les séduise [the Assyrians] pour leur perte et ruine" (Reuss, "Judith," pp. xi, 349).

18 Ibid., pp. 354–55.

19 "Tu es belle de figure et tu sais bien parler" (ibid., p. 353).

24.4. Paul Hillemacher, *Judith* (1876). Paris: H. Lemoine. Photo credit: Jann Pasler.

Dalila, her people, and their music, which excited listeners. The Bacchanale and the Dance of the Priestesses were transcribed for many instruments and grew popular in orchestral concerts long before the opera was performed in France.[20] Such excerpts were juxtaposed with German music in concerts to foreground charm as crucial to French musical distinction.

In dramatic music, seduction takes place conventionally in duets, but in these duets the nature of charm comes across as ambiguous and sometimes ironic, as in the Book of Judith.[21] In the 1876 cantata libretto, as Judith and Holofernes begin to sing together – the conventional moment when feelings become aligned – they speak in asides, Judith to her God and Holofernes to himself. One voice drowns out the other. When they use almost the same words – "She is mine / He is mine [Elle est à moi / Il est à moi]. ... Who resists kings? / who resists God?" – Hillemacher sets these in imitative arpeggios in both parts in the same key. Judith here echoes Holofernes. The irony of their different intentions remains hidden until the arpeggios move in contrary motion (Example 24.4). Then, as Judith and the king seduce one another, their pitches slowly move toward one another until they touch and intertwine. Judith's chromatically descends E-flat to G in counterpoint with the king's rising thirds and fourths, rather than in unison or parallel thirds as in the climactic moments of most duets in French opera. Musically, the superimposition of E-flat over F-sharp on the two *moi*'s suggests the inherent dissonance of the situation, although by the end they do come together on E-flat. Veronge de la Nux also sets "She is mine / he is mine" in contrary motion, which points to their conflicting purposes. However, they soon begin to sing these words together in parallel thirds and alternate imitative rhythmic patterns – musically emblematic of sexual play. The largo, forte, that they reach together slowly repeating the same E's and moving up to G-sharp, is the musical equivalent of sexual ecstasy, which they here experience as "given by God," despite whatever else they might say (Example 24.5).

In the analogous duet in Lefebvre's opera, the music also suggests attraction. They touch on the same pitches and eventually sing in parallel thirds passages such as "It is love that beckons / In my veins a fire burns."

20 See Jann Pasler, "Contingencies of Meaning in Transcriptions and Excerpts: Popularizing *Samson et Dalila*," in Byron Almén and Edward Pearsall (eds.), *Approaches to Meaning in Music* (Bloomington, IN: Indiana University Press, 2006), pp. 170–213.
21 As Carey Moore notes in *The Anchor Bible Judith*, few books of the Bible are as "quintessentially ironic as Judith." He gives many examples of the characters meaning the opposite of what they say (pp. 78–85). I am grateful to Deborah Gera for pointing me to this book and its discussion of irony.

24.5. Veronge de la Nux, *Judith* (1876). Paris: H. Lemoine.
Photo credit: Jann Pasler.

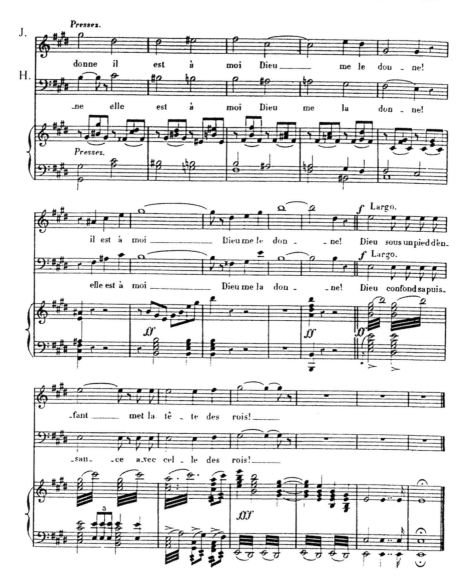

24.5. *(cont.)* Veronge de la Nux, *Judith* (1876). Paris: H. Lemoine.
Photo credit: Jann Pasler.

As Judith sings of "death coming," they touch on octaves, as if attaining the ecstasy of sexual union. However, before they reach a musical climax in unison, Holofernes feels weak and collapses, the momentum grinding to a halt. This suggests that to the extent that the seduction is merely aural, the woman can remain chaste.[22] Judith then stabs him, accompanied by three shrill eleventh chords on A, fortissimo, off the beat.

Music thus adds playfulness to the deceit, and encourages listeners to consider a close relationship between deceit and seduction. The duets imply that, for these to work, the attraction must be mutual. Judith needed to desire Holofernes as he desired her. The cantata libretto makes this explicit from the beginning. Judith finds Holofernes a "sublime warrior" who "resplendit comme une *tour*." She hesitates before killing him, singing slowly, "How handsome he is," and, painfully, "He said he loved me," to which her nurse responds in fortissimo outbursts. Only after he momentarily awakes and boasts of his "thirty campaigns" does Judith's anger return and she takes up the sword.

Love duets not only create dramatic tension, but also lend an air of tragedy to the works, especially in *Samson et Dalila* and *Salammbô*. With curves and chromaticisms carefully manipulated in their every nuance, Dalila gives voice to desire in one of the most powerful moments of musical charm. Soaring up to E-flat over and over, she musically links the memory of his "caresses" with her idea of "love." Then, "to enslave him," to "enchain" him to herself, she starts on the pitch (A-flat) on which he left off singing "I love you" and goes on to entreat him, "respond to my tenderness, give me ecstasy [*ivresse*]," symbolized musically by three interlocking chains of chromatically descending lines that end on the tritone G-flat–C. In exchange for her song and "in hopes of learning the secret of his strength," she asks to possess not his body, but his voice, it being the key to his power: "My heart opens to your voice … let your voice speak again." Her charms do not have to be entirely sincere to take effect. In the duet that follows, he echoes her descending chromaticisms and sings with her a third lower. Finally, at the end of the stanza, he moves into unison with her as she pleads for ecstasy (Example 24.6). Musically, this is the surrender that love calls for; Samson's music follows Dalila's; the man loses his will to the woman's. Love has rendered the Other in a sense powerless, but in this case the Other is male. Having given her his "voice," even if only briefly, we understand why the Philistines come and why he returns in

22 Mastrangelo (Chap. 8) and Llewellyn (Chap. 11) have found this preoccupation in other Judith narratives.

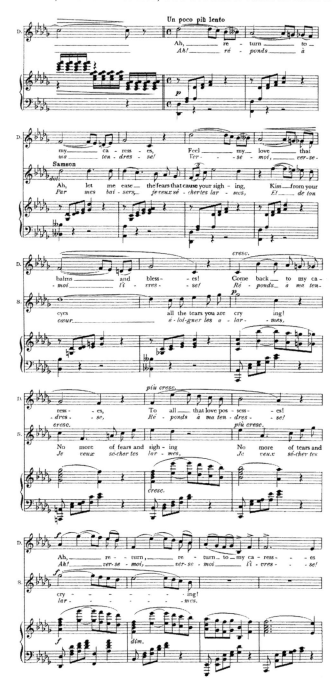

24.6. Camille Saint-Saëns, *Samson et Dalila* (1868–77, 1890, 1892).
Paris : Durand, Schœnewerk & cie. Photo credit: Jann Pasler.

Act III with his hair shorn. The *deus ex machina* at the end of the story – saving Samson's integrity and the patriarchal power he signifies – does not deny what has already transpired. In some ways it validates Dalila's strength for having warded off such a move earlier. But it does revive the vicious circle of fear and desire and suggests there is no end to it.

Love duets were crucial to these works' allegorical meaning, particularly for republicans. Love was essential in republican, freemason-based ideology, the family a model for the nation. In conflicts, the strength of love makes the choice of duty to country feel all the more significant. To the extent that Judith and Holofernes represented different countries, they also expressed the complex relationship of France to Germany at the time. Many French felt great attraction to German culture, envy of their army's strength, their schools, and their music. They were also aware that the French had been lax, like women during the Second Empire, fleeing combat and allowing the Germans an easy victory in their own land. Women like Judith suggested that the weak (the French after their defeat) could triumph over the strong (the Prussians) to the extent that their feminine attributes, their charm, could be turned to their advantage. That is, metaphors that drew attention to their weakness as a people, their "hearts of women," and the "enslavement" they endured under the Germans, may have embarrassed the French, at the same time as they, ironically, elevated as their saviors strong, powerful women who, unlike them (it is presumed), are not afraid to act. To the extent that their charm works and audiences are seduced into the illusion, listeners are given the opportunity to explore what these existentially weak women call on to survive, learn about the nature of their charm, its uses, and the limits of its power. Judith thus helped audiences to consider what it means to be the weaker in a dyad, what kind of relationship is possible with stronger Others, and how they might appropriate these tactics (like the composers do) as a way to empower themselves.

In 1878, with the success of the Paris Universal Exhibition and as republicans became more secure in their power, a light-hearted comedy performed in a café-concert took on these lofty associations with Judith. In Edouard de Deransart's *Judick et Halonferme*, a "Roman general full of adventure," just back from war in Palestine, sings of his exploits, accompanied by drums and fanfare, "Sim-ba-la-boum! Ba-la-boum. V'la guerre!" After he falls asleep to a lullaby,[23] Judick arrives – his wife. In her "nocturnal

23 Possibly a reference to the lullaby that put Holofernes to sleep in Vivaldi's *Judith triumphans*.

march," she contemplates her husband's betrayal with other women, learned from a friend, and takes his sword while he snores. As she moves to "take revenge," she waxes lyrical about how handsome he is, how she wants to hug him once more, how she loves him still. Nevertheless, "vengeance above all," and, one, two, three, off goes his head.

But the story does not end there. A "grand duo" follows the decapitation. That is, Judick unwittingly cut off the top of the box Halonferme painted to sleep under (presumably as a decoy for potential aggressors). After he awakens, he hides under the table, lending his voice to the "speaking decapitated head." He explains he'd been an innocent victim and, in a waltz tempo, declares his love for Judick. She cries as he laughs, touching on the same notes, and later, both laughing, they come together in long unison passages as in operatic duos. Eventually, Halonferme reveals himself and they celebrate their reconciliation by "decapitating" a bottle of champagne. Their singing in thirds culminates on an octave. Trickery, the threat of betrayal, the mutual attraction of a proud warrior and an angry woman, vengeful but still attracted to him, their duet, and a decapitation – the conventions of the story as set to music are all present. But here allegorical meaning is deconstructed, discarded, and replaced with a banal happy ending.

New Context, New Meaning

Judith did not return to French stages in any significant way until the 1890s. With the advent of the new independent woman and a military alliance with Russia, signed in 1891, French interest in Judith soared even as her reception changed significantly. Between December 1891 and November 1892, the Opéra finally produced *Samson et Dalila* and, in 1892, *Salammbô*, preceding these with a new opera on a Judith-like heroine, Bourgault-Ducoudray's *Thamara*. The latter revisits the thematic treatment of Judith given in these other works. The struggle between paganism and Christianity is represented by choruses in contrasting musical meters and Orientalist dances. Thamara, this time a pious virgin, is intent on killing the enemy to deliver her besieged homeland. She listens to the voice of God, but also falls for the sultan, his "voice like a caress," and in the end, devastated, also kills herself. In reviews, unlike in the 1870s, critics focused on these operas as representations of strength and masculine virility. Thamara, Salammbô, and Dalila are strong because they listen to the voice of authority whose voices they "obey" without question. Pougin considers Dalila "a ferocious fanatic" who stands for religion,

not women.[24] Salammbô is more complicated because when she kills herself, one wonders whether this is the price of not only love, but also racial mixture, she being white and her lover a "young barbarian." In spite of their courage, the dependence of these women on others underlines the role of patriarchy. Reyer explains that *Samson et Dalila* is not just about an exotic seductress. He focuses entirely on the "Jewish Hercules" and how he resists Dalila's charms, "always master of his secret."[25] Misogynist sentiment could grow when France no longer needed strong women to inspire their renewal.[26]

If Judith's actions helped audiences to feel more than carnal desire, perhaps catharsis, albeit an ambiguous one if she dies, such figures also teach self-sacrifice for the greater order, one of the principal values of the Republic. But if, with the new focus on Samson and the male choruses, the Hebrews could be viewed and thus identified with as proto-Christians, then Samson's God-ordained destruction of the temple after Dalila's betrayal "would have been understood as an act of liberation."[27] By the work's one-hundredth performance at the Opéra in 1897, one critic could only write of Dalila as "treacherous," her voice "hypocritically affectionate, adding charm to the troubling song of the seductive courtesan."[28] Judith's meaning in music thus was hardly static. The very different reception given to works based on the Judith story in the 1890s suggests not only how powerful such stories can be, but also how malleable and contingent on context.

24 Arthur Pougin, "Semaine théâtrale: *Samson*," *Ménestrel* (9 November 1890), pp. 354–56.

25 Ernest Reyer, "*Samson et Dalila*," *Journal des débats* (9 November 1890).

26 A review of *Samson et Dalila* at the Teatro alla Scala in Milan, published in *Gazetta di Lombardia* (18 January 1895), acknowledged the connection between Dalila and Judith, "a prophetess of patriotism," but objected to the librettist's changes in the biblical character, preferring "the feminine perversity of the biblical Dalila" which, he felt, "rendered her personality stronger and more interesting." I am grateful to Alexandre Lhâa for sharing this. For a major study of this topic, see Bram Dijkstra, *Idols of Perversity: Fantasies of Feminine Evil in Fin-de-Siècle Culture* (New York: Oxford University Press, 1986), especially pp. 375–80.

27 Ralph Locke, "Constructing the Oriental 'Other': Saint-Saëns's *Samson et Dalila*," *Cambridge Opera Journal*, 3 (1991), pp. 263, 282. Locke also addresses the problem of whether to read the Philistines and Dalila as "Other" or "us" (pp. 285–93) and suggests that the music sometimes subverts these binary paradigms.

28 Victorin Joncières, "Revue musicale," *La Liberté* (21 June 1897). On the importance of charm and the reception of this opera in the 1890s, see my *Composing the Citizen: Music as Public Utility in Third Republic France* (Berkeley, CA: University of California Press, 2009).

25. Judith and the "Jew-Eaters" in German *Volkstheater*

Gabrijela Mecky Zaragoza

Fated to represent the Jewish people, as Martin Luther asserted in his 1534 Bible,[1] the figure of Judith has been the subject of religious festivities, fine art, music, and literature over the centuries. An examination of the rich history of the story's reception reveals why many church fathers consider the Book of Judith holy and useful. Edifying for Christians because of its allegorical potential,[2] the Jewish narrative is an ideal mode for expressing a wide diversity of Christian virtues.[3] Throughout the Middle Ages and the early modern era, it was used as both a spiritual and a worldly tool of resistance, for example against the Ottoman invasion, papal supremacy, and Luther's growing influence.[4] Voices criticizing the story, such as the comparison of the Bethulians to mice in Luther's Bible[5] or the herald's warnings about cunning Jewish girls in Sixt Birck's 1536 drama,[6] are still restrained by the Bible's undisputed authority. This changes in the age of secularization.

1 Martin Luther, "Vorrhede auffs buch Judith" and "Das Buch Judith," in *Biblia/ das ist/die gantze Heilige Schrifft Deudsch. Wittemberg 1534* (Cologne: Taschen, 2002), p. IIr. The 1999 edition of the Luther Bible will be used for all other biblical references: *Die Bibel. Nach der Übersetzung Martin Luthers mit Einführungen und Bildern. Mit Apokryphen* (Stuttgart: Deutsche Bibelgesellschaft, 1999).
2 Luther, "Vorrhede," p. IIr.
3 Mieke Bal terms it an "ideo-story," "a narrative whose structure lends itself to be the receptacle of different ideologies," in *Death and Dissymmetry: The Politics of Coherence in the Book of Judges* (Chicago, IL: University of Chicago Press, 1988), p. 11.
4 The following two studies provide an overview over most literary treatments of the story: Edna Purdie, *The Story of Judith in German and English Literature* (Paris: Librairie Ancienne Honoré Champion, 1927) and Otto Baltzer, *Judith in der deutschen Literatur* (Berlin: de Gruyter, 1930).
5 Luther, "Judith," p. IXv.
6 Sixt Birck, "Ivdith," in Manfred Brauneck (ed.), *Sämtliche Dramen*, 3 vols. (Berlin: de Gruyter, 1976), 2, p. 137.

When Johann Nestroy's Joab, donning Judith's clothes, coquettishly calls Holofernes a "Judenfresser"[7] (Jew-eater), he refers to a dark and little-known phenomenon of German popular theater: Judith and anti-Semitism. The anonymous 1818 drama, *Judith und Holofernes*,[8] and Nestroy's 1849 parody of Friedrich Hebbel's 1840 tragedy, *Judith*, introduce a decisive change in the perception of the story. For the first time in German and Austrian literature, the Jewish narrative is connected to the Jewish Question and is used to create different images of the Jewish *Other*. This is no coincidence. Although Jews were a small minority in the German-speaking world,[9] the issue of their civil rights was a major political one. The anonymous drama was written during the time of the Restoration. With Napoleon's defeat and the Congress of Vienna in 1815, the German Jews lost the citizenship rights that had been granted to them under French rule. In practice, each state of the German Confederation enacted different, often highly discriminatory, laws for dealing with its Jewish population.[10] Moreover, this was the time of the "Hep-Hep" riots against the German Jews. Nestroy's travesty was written at a time when the struggle for the acquisition of political rights for Jews had already made progress. Still, Vienna's Jews did face numerous and vocal opponents during and after the 1848 Revolution.[11] Nestroy was not an anti-Semite[12] and his text does not bear on the Jewish Question, but his controversial representation of Jewish figures is related to the concurrent rise of anti-Semitism in the Austrian Empire. The present study will

7 Johann Nestroy, *Judith und Holofernes*, in John R. P. McKenzie (ed.), *Johann Nestroy. Sämtliche Werke. Stücke 26/II. Historisch-kritische Ausgabe*, 42 vols. (Vienna: Deuticke, 1998), 26.2, p. 109, hereafter cited in the text; all translations are my own. The term "Judenfresser" was used in a pejorative sense for those hostile to Jews, for example in Jakob Korew's 1862 Purim play *Haman, der grosse Judenfresser*, kept in the Bibliotheek Universiteit van Amsterdam. The term "Antisemit" was coined by Wilhelm Marr's *Antisemitic League* to replace the term "Judenfresser" with a more "scientific" term that would make Jew-haters look better and emphasize racial connotations.
8 [Anon.], *Judith und Holofernes. Ein Drama in fünf Akten (1818)*, ed. by Gabrijela Mecky Zaragoza (Munich: Iudicium, 2005), hereafter cited in the text; all translations are my own. For an in-depth analysis, see my introduction to the drama (pp. 7–37) and the chapter on *Judith und Holofernes* in my book: *"Da befiel sie Furcht und Angst ..." Judith im Drama des 19. Jahrhunderts* (Munich: Iudicium, 2005), pp. 100–32.
9 Michael Brenner, Stefi Jersch-Wenzel, and Michael A. Meyer, *Deutsch-jüdische Geschichte in der Neuzeit: Emanzipation und Akkulturation 1780–1871*, 4 vols. (Munich: Beck, 1996), 2, pp. 57–66.
10 Ibid., 35–49.
11 Colin Walker, "Nestroy's *Judith und Holofernes* and Antisemitism in Vienna," *Oxford German Studies*, 12 (1981), p. 87.
12 Friedrich Walla, "Johann Nestroy und der Antisemitismus. Eine Bestandaufnahme," in *Österreich in Geschichte und Literatur*, 29.1 (1985), pp. 41–43.

show how Judith's story was rewritten in nineteenth century *Volkstheater* to negotiate images of Jewishness as well as the Jewish Question.

Judith und Holofernes (1818)

The anonymous drama, *Judith und Holofernes*, which was first published in the Anhaltian city of Zerbst in 1818, gives rise to many questions. The number of copies printed remains undetermined. Equally uncertain is whether it was read or performed in anti-Semitic circles. Since November 1855 it has belonged to the Königliche Bibliothek Berlin. The preface permits a few assumptions about the author. First, the author was probably a man. Considering the repressive gender models for women at the time, the use of vulgarisms in the drama makes it unlikely that the text was written by a woman. Second, the author was probably a "kleine[s] liebenswürdige[s] Christenkind" (dear little Christian child) (42). He distinguishes between "wir Christen" (we Christians) and "d[en] Juden" (the Jews) (43), takes sides against the "böse gesinnten Juden" (evil-minded Jews) (41), and abuses Yiddish words and syntax to create a negative Jewish ambience. Third, the author was probably Protestant. Intertextual evidence indicates that the Luther Bible was one of his sources. His deprecating attitude toward apocryphal books is a signal that he uses Luther's carefully phrased concerns about the Book of Judith and its subsequent exclusion from many Protestant Bibles as an opportunity to back up his dramatic campaign with a famous name. By calling Judith's deed "gotteslästerlich" (blasphemic) (43), he legitimizes an anti-Semitic rewriting of the Jewish story, purportedly for the good of the German nation.

Fighting the "Evil Talmudic Principles"

In his opening remarks about the noble, great, patriotic Jewish people in the preface (41), the author seems to oppose the real and metaphorical exclusion of Jews in the states of the German Confederation. But one soon notes that he opens the doors of the Jewish ghetto for one reason only: he wants to Christianize the Jews. Haunted in equal measures by his cravings for recognition and by conspiracy theories, he maintains one primary objective: a "Jew-free" Germany. An emerging focal point of the preface is the struggle for the so-called "Nation" (41), a collection of diffused fantasies of unity with political, social, religious, and linguistic connotations.

The author wants to "refine" the German nation by replacing the "bösen talmudischen oder schlechtprophetischmoralischen Grundsätze mit unsern weit bessern christlichen" (evil Talmudic or evil-prophetic-moral principles with our much better Christian ones) (41). In other words, Jews must become Christians. The author sees his program of "replacement" as the only way to transform "diese armen, bisher schwächlichen Leute auch zu arbeitsamen, kraftvollen Menschen, wie die christlichen Knechte und Mägde" (the poor, weak people into industrious, strong humans like the Christian servants and maids) (41). His overriding goal remains to establish Christian baptism as the port of entry to German nationality. As such, his core program still resembles common Christocentric approaches to the Jewish Question in the late Enlightenment.[13] By referring to the "evil Talmudic principles," however, he attacks more than just the Talmud, traditionally considered the heart of Jewish life and identity. He confirms widespread "Jew-eater" stereotypes, and in so doing, he sows seeds of doubt about whether evil can turn into good or, more precisely, whether "evil" and "weak" Jewish "people" are capable of becoming "better" and "stronger" non-Jewish "humans" by merely replacing their principles. His strategy of "Verabscheuung" (abomination) (43) fulfills a dual function. On the one hand, it aggressively promotes Jewish assimilation; on the other hand, it nourishes fears about pseudo-assimilated Jews and collapsing German nations.

The strategy of "abomination" plays an important role in the author's concept of the refined nation. Negative behavior must be presented to the public, preferably in a theater house, so that it can be loathed and ridiculed. Although he relates this function of theater to both Christians and Jews (43), he makes no secret of the fact that he views his theater, above all else, as a political institution that is able to subdue the "evil Talmudic principles."

[E]inige alte höchst schädliche Vorurtheile und Grausamkeiten, die von den Bethuliern begangen worden sind, und von einigen Juden jetzt noch als löbliche Thaten gerühmt werden, sollen in diesem Drama zur Verabscheuung derselben figuriren. (43)	Some of the most harmful old prejudices and inhumanities that were committed by Bethulians are still vaunted by Jews as laudable deeds. They shall be exposed as abominable deeds in this drama of abomination.

The author articulates a veritable formula of detestation: negative

13 A representative example is Christian Konrad Wilhelm Dohm, *Ueber die bürgerliche Verbesserung der Juden* (Hildesheim: Olms, 1973).

exposition gives rise to abomination which in turn leads to baptism, the very core of a refined nation. In order to enhance this formula, he uses a plethora of Jewish images. According to him, the end justifies all means. But do his means actually lead to the holy water stoup and, therefore, to a refined nation? The drama itself gives reason to doubt this simple formula. Apparently, abomination does not necessarily lead to refinement. In fact, the drama's excess of "evil Jews" develops its own dynamics and thereby undermines the author's dramatic goal.

In the preface, the author evokes two main images of horror: the image of the cursing Jew and the image of the fatal Jewess. The scenarios of the Haman feast are particularly interesting here.

Auch giebt es gewiß noch etliche Juden, welche an ihrem Hamansfeste den 109ten und 118ten Psalm bloß wider uns Christen zu Jehovah beten, um uns mit jenen entsetzlichen Flüchen, die diese Psalmen enthalten, zu behexen, da sie doch den eigentlichen Haman jetzt wohl nicht mehr damit todtschlagen können? Schreiber dieses Vorworts hat ja selbst mehr als einmal gehört, wie solche böslich gesinnte Juden kleine liebenswürdige Christenkinder in deutscher Sprache außerordentlich geliebkoset, und zugleich in ihrer jüdischen mit solchen entsetzlichen Flüchen, wie die gedachten Psalmen enthalten, gar grausamer Weise verflucht, und ihnen alle nur mögliche Krankheiten, nebst Tod und Verderben, auf den Hals gewünscht haben. (41-42)

There are Jews who, when they pray to Jehovah during their Haman festivities, only recite the 109th and 118th Psalms in order to bewitch us Christians with the dreadful spells contained in these psalms. They do this because they cannot slay the real Haman anymore. The writer of this preface has heard on more than one occasion how these evil-minded Jews speak sweetly to the dear little Christian children in the German language, but when they speak their Jewish language, they curse them terribly with the dreadful spells contained in the aforementioned psalms, wishing them not only all kinds of diseases, but also death and ruin.

The reference to Psalm 118 is important because the closing psalm of the small Egyptian Hallel articulates a messianic hope. After the suffering in Exile, Jews are able to finally enter the gates to God (118:19–21). The reference to Psalm 109 is important because this vindictive psalm is deadly for all those who want to undermine the messianic kingdom. Its curses do not only clothe the enemy, like a robe or a dress, but they enter his belly

like water, seeping into his bones like oil (109:18). The figure of Haman confirms the destructive forces of (hidden) Jewish curses; Haman has been slain. Closely connected to the image of Haman is the image of the fatal Jewess. The Haman feast refers to the Purim feast, which is based on the Book of Esther. The Book of Esther describes an unexpected boomerang effect. Haman plans to rid the city of its Jews (3:6). But the "Jew-eater" does not expect Esther's reaction. The figure of Esther leads a life with two identities. Married to the Persian king, Mordecai's daughter lives under her Persian name, Hadassah, in the Persian kingdom (2:20). Learning of Haman's plot and its dire consequences for her people, she reveals her Jewish identity (7:3–4). Secretly, she pulls the strings (5:1–8) and obtains the king's edict to kill Haman (7:6–10). Esther's hidden actions imply that Jews always remain Jews and support the Fichtian theory of Jews as a hostile state within a state.[14] The idea of the hidden Jew and the idea of a hidden language of the Jews are intertwined – (sweet) language serves as a powerful tool for concealing and therefore achieving the hidden goals of the cursing Jews.[15] Apparently, the anonymous author fears that pseudo-assimilated Jews could undermine his dreams of a refined German-Christian nation. He fears that those who have to give up their "evil Talmudic principles" will turn out to be "indigestible chunks" in the nation, waiting for another boomerang effect in their favor on the way to the messianic kingdom that remains closed for all the "dear little Christian children." By turning a Jewish heroine into a treacherous assassin, he shows what happens if a pseudo-civilized Jewess is integrated into a civilized non-Jewish nation: the nation collapses.

Perverting Non-Jewish/Jewish Encounters: *Der Verkehrte Verkehr*

The anonymous author reverses the biblical plot. In his drama, the "civilized" Assyrians fight against the "wild" Jews from Bethulia. This contrast is already reflected in the play's topographical descriptions; the Assyrian camp is situated in the foreground, next to the wilderness, Bethulia is situated

14 Johann Gottlieb Fichte, "Beitrag zur Berichtigung der Urtheile des Publicums über die französische Revolution. Erster Theil: Zur Beurtheilung ihrer Rechtmässigkeit," in Immanuel Hermann Fichte (ed.), *Fichtes Werke*, 11 vols. (Berlin: de Gruyter, 1971), 6, pp. 149–50.

15 Ritchie Robertson investigates this idea of a "hidden language of the Jew" in *The "Jewish Question" in German Literature 1749–1939. Emancipation and Its Discontents* (Oxford: Oxford University Press, 1999), pp. 156–63.

in the background, in the wilderness, hidden behind the "unersteiglichen Felsen" (invincible cliffs) (47). While the standard-German-speaking Assyrians are committed to "Mannszucht" (51), consisting of hospitality, courage, and holy love, the Yiddish-mumbling Bethulians are depicted as cowardly mice and money-grubbing servants of the devil (46–47). Although Bethulia is seen as the world's hotbed of "beterkeln" (betrayal) (46), "Brünst" (rut) (68), and "Abra! Kadabra!" (abracadabra) (66), only one of its wild inhabitants can pose a real threat to the civilized Assyrian army: Judith.

According to the anonymous author, Judith arouses "den tiefsten Abscheu in jedem rechtschaffenen Herzen" (the deepest repugnance in every upright heart) (43). What makes his Judith the very showpiece of horror? It is the fact that Judith crosses borders. The author associates female activity in the political sphere with chaos and death. With the two women of the preface and drama – implicitly Esther and explicitly Judith – he illustrates what happens if women are allowed to leave the boundaries of behavior ascribed to their sex: "Dein Wille söll sind unterworfen dein Mann, ünd er s[ö]ll sind dein Baalbohs!" (Your will shall be submitted to your husband's, and he shall be your master!) (71) While Esther remains faithful to her husband and king and fights Haman with words, Judith abuses Holofernes's "heilige Liebe" (holy love) (43) and stabs him in the back. Furthermore, due to her Trojan self, Judith is able to cross the invincible border between civilization and wilderness. On the one hand, she has a number of wild features at her disposal. She betrays each and everyone (71–72), craves fame and recognition (74–75), sees sexual intercourse as an indispensable component of her mission (87), and signs away her soul to evil forces – twice (74, 99)! On the other hand, Judith displays some civilized features too. She leaves Bethulia as a virgin (81), wears a white linen dress (76), smells of rose perfume (78), is beautifully polished (76), and speaks *Hochdeutsch*. Judith's pseudo-civilized image is a perfect façade of innocence for hiding her wild ambitions and for preventing any negative reactions from the Assyrians.

The "Meuchelmord" (treacherous assassination) (43) is the core ingredient of the strategy of "abomination" for several reasons. First, it is the devil himself who originally initiates the killing of the "edelmüthigen Feldherrn" (noble captain) (43). Infuriated by Holofernes's refusal to give in to his evil temptations – he ties the devil to a tree – he seeks to punish him (60). Eventually, however, it is the rabbi Charmi who develops the concrete action plan and forms an alliance with the cloven-hoofed Adramelech (66–69). Second, it is Judith who becomes the instrument of this axis of evil.

When the devil's minister, disguised as Ariel, appears in Judith's dream and advises her in God's name to murder Nebuchadnezzar's famous general, she overlooks his hoofs and horns and blindly follows his call (74). After stealing Holofernes's heart and having sex with him on his carpet, she kills him from behind (87). But this is not all. The scene of Judith and Holofernes together has a deeper meaning. Third, it is a pseudo-civilized Jewess who causes the death of a civilized micro-state. Judith's permission to move freely in the camp paves the way for the perverted encounter between the civilized and the wild forces (82). Judith kills Holofernes in the darkness of night, and it is precisely this dark omission of the entire scene that gives her deed a treacherous touch and stresses the destructive nature of the Jewish/ non-Jewish encounter (84–85). The drama implies that any non-Jew who gets involved with a Jewess will lose his head – and die! From this point on, the drama deploys strong mechanisms to tame the representative of the "evil Talmudic principles." While the Bible luminously celebrates Judith in the brightness of the following day, this author ensures that his dark Judith is banished from the surface of the text (101). The verdict of the brave Assyrian soldiers initiates the act of containment of the abominable border crosser. Judith's banishment to hell leaves little doubt. The least one can say is that the author's approach to the Jewish Question remains ambiguous.

Updating the Judith/Jewish Question

Although the anonymous author promotes Jewish assimilation, he is haunted by his fear of pseudo-assimilation. At the end, however, his Judeophobic beliefs gain the upper hand. With his numerous stab-in-the-back legends, he raises doubts about the possible success of Jewish integration in Germany. In fact, since his dramatic strategy of "abomination" is soaked with religiously and racially motivated anti-Semitic stereotypes, he comes dangerously close to the "Hep-Hep" strategies of other contemporary German "Jew-eaters." It is perhaps excessive to detect a link between his program of replacement, Holofernes's headless body, and radical programs of replacement, such as the Fichtian idea, "[den Juden] die Köpfe abzuschneiden und andere aufzusetzen, in denen auch nicht eine jüdische Idee sey"[16] (to cut off the heads of the Jews, and to set new ones on their shoulders, which contain not a single Jewish idea). Nevertheless, by holding a pseudo-civilized Jewish "border-crosser" responsible for the end of a civilized

16 Fichte, "Beitrag," p. 150.

micro-state, the drama supports the concrete and metaphorical significance of the "invincible cliffs." In doing so, it induces the notion of (naturally grown and essentially important) boundaries between wild (Jewish) and civilized (non-Jewish) territories. In other words, the anonymous author leaves us with a disturbingly dark final message. Since the assimilation of the German Jews bears the risk of failure and pseudo-assimilated Jews can cause Germany's bloody end, there seems to be only one way out for the nation's self-appointed fighters – to keep the doors of the Jewish ghettos closed, even locked, more tightly than ever and, as the devil's minister puts it, for eternity – "auf ewig!" (100).

Johann Nestroy's *Judith und Holofernes* (1849)

Nestroy's one-act play, *Judith und Holofernes*, was first performed anonymously in the Viennese Carltheater on March 13, 1849, the first anniversary of the revolution in Vienna. The figure of Judith/Joab was played by Nestroy himself. The closeness of the parody in many scenes to Hebbel's text, which was available to Nestroy in printed form since 1841, shows that Nestroy's text developed in an essentially literary way.[17] However, there are also several scenes in his text for which there are no analogues in the Bible or in Hebbel's play. The abundance of deviations of this text from the original sources produces a host of comic effects. As it turned out, Nestroy's *Judith und Holofernes* was enough to make not only the Assyrians, but also the members of the audience lose their heads. Nestroy's March première achieved what Hebbel's February première could not, namely, storms of both enthusiastic applause and deep indignation. What had happened? On the one hand, his play was a big success. In its first month, it was performed seven times and its average profit was 373 *gulden* higher than that of Nestroy's other March pieces.[18] On the other hand, because of its representation of Judith and the Jewish people, some contemporaries called it "die kolossalste Gemeinheit, die noch je eine Bühne entehrt hat"[19] (the greatest insult that has ever dishonored the stage). Still, in contrast to the anonymous author, Nestroy subverts his stereotyping machinery in several ways.

17 W. E. Yates, *Nestroy. Satire and Parody in Viennese Popular Comedy* (Cambridge: Cambridge University Press, 1972), p. 113.
18 See Johann Hüttner, "Machte sich Nestroy bezahlt?," in *Nestroyana*, 1 (1979), pp. 3–25.
19 The "Dramatische Wochenbericht" was published in Ignaz Kuranda's *Ost-Deutsche Post* on March 18, 1849. It has been reprinted in McKenzie's critical edition of Nestroy, *Judith und Holofernes*, pp. 396–97.

He frees Judith of the devil's grip and grants her a parodic yet glorious victory over a world-famous "Jew-eater."

Stigmatizing the Jews

Before any of Nestroy's Jews appears on stage, the Mesopotamian emissary characterizes the Bethulians:

Der Gesandte: Die Hebräer sind ein merkwürdiges Volck. [...] Handwerk und Ackerbau ist ihnen verhaßt.

Emissary: The Hebrews are a strange people. They hate manual labor and agriculture.

Holofernes: Kein Ackerbau? ja von was leben s' denn hernach?

Holofernes: No agriculture? What do they live on, then?

Der Gesandte: Von Rebach, ihre Nahrung besteht aus Vierteln, aus Achteln und aus Vierzehnteln, auch saugen sie aus allem Möglichen Percente. [...] Im Kämpfen sind sie schwach. (91–92)

Emissary: On capital gain. Their nourishment consists of fourths, eighths, and fourteenths. Also they suck out percentages of all possible things. In battle they are weak.

According to the emissary, the Bethulians do not earn their living by the sweat of their brow; instead they live on capital gain, suck out all possible things, and make a poor showing on the battlefield. *Re(i)bach* is a German term for profit gained by deception, derived from the Yiddish word *rewach* (interest).[20] Nourishment evokes physiological processes of internalization, here the journey of *Reibach* and its fourths, eighths, and fourteenths through the digestive system. Since the goal of nourishment is the absorption of particles, in this case of *Reibach* particles, the emissary suggests that capital gain is not only an external activity, but an internalized part of the Jewish self. This negative image is further emphasized through the verb "[aus]saugen," which evokes the picture of the Jew as *Sauger*, someone who likes to suck out all possible things. The *Blutsauger* (blood-sucker) takes this correlation one step further. Moreover, the words *Sauger* and *saugen* contain the word *Sau* and can thus evoke sculptures of the *Judensau*, images of Jews sucking from the teats of a female pig or making other obscene use of the animal. The emissary also implies that the Jews are unable to join the armed forces. His words echo the satire in contemporary lampoons and caricatures where Jews were deemed too cowardly, ill-disciplined, or weak to fulfill their civil obliga-

20 Hans Peter Althaus, *Kleines Lexikon deutscher Wörter jiddischer Herkunft* (Munich: Beck, 2003), p. 169.

tions.[21] Through the combination of a specific set of anti-Semitic stereotypes with a specific language – Viennese dialect, misspelled foreign words, and Yiddish expressions – the ancient Hebrews are made to embody the alleged defects of modern Viennese Jews. It does not end here.

A volunteer in the Hebrew army challenges the idea that the Jews are God's chosen people: "Wie Gott freye Wahl unt'r all'n Völkern hat g'habt, / Hat er ohne viel B'sinnen auf d'Häbräer glei tappt." (When among the peoples of the earth the choice was up to God, / Without a great amount of thought he gave the Jews the nod.) (95) With the verb *tappen* (to grope), Joab evokes the proverbs *in die Falle* or *im Dunkeln tappen*. The latter refers to a path one wanders along without knowing where one is going. Combined with "ohne viel B'sinnen," this expression describes a lack of orientation due to failing senses. The proverb *to be in the dark* comes from Moses's warning in his fifth book: if you do not observe all his commandments, you shall grope at noonday, as the blind gropes in darkness (28:29). By saying that God was groping in the dark when he chose the Jews, Joab asserts that the Almighty chose them thoughtlessly, senselessly – poorly! The implicit reference to Moses in Joab's first song is followed by an explicit reference to "Der Moses der Moses" (95) in his monologue. By making fun of Moses, the liberator, leader, lawgiver, and prophet of the Jewish people, the man who is credited with having written the Torah, Joab drives a stake through the heart of Judaism. Furthermore, in his second song, Joab extends his criticism and negates the importance of Old Testament stories and miracles altogether: "So was nennt man kein Wunder jetzt mehr heutzutag', / Man findt's ganz natürli und kein Hahn kraht darnach." (We moderns find such stories in no way wondrous / But really rather commonplace, no cause for cocks to crow.) (98) According to Joab, biblical stories are commonplace, but, after all, it is he who uses the story of Judith in order to free his people.

Challenging Stereotypes

Nestroy's text subverts its own stigmatizations in several ways. First, the text breaks theatrical illusions. Nestroy's "German, I mean, Hebrew"-speaking figures (108) know that they live in the Vienna of the 1848 wine (110), but that they have to act as if they were "graue[] Vorzeitler" (prehistoric graybeards) (90). Their distinct style of juggling with images

21 See Walker's excellent analysis of anti-Semitic texts and images in contemporary Vienna (pp. 85–110).

reveals that everything and everyone on this stage is a product of Nestroy's complex machinery of illusions. Second, the text contrasts the Assyrians with the Bethulians. The Assyrian priests are hypocrites (89), the Assyrian soldiers have an *Untertanen* mentality (88), and Holofernes is both a "Menschenfresser" (man-eater) (97) and a "Judenfresser." Compared to the Assyrian gluttons, Bethulia's inhabitants appear in a more favorable light. Nestroy presents them not only as haggling and mumbling types, but also as city-dwellers who love art and science (91), as moderns who do not believe in miracles and fortune-telling (94), and as pacifists who oppose militarism and authorities (93). Third, the text's main protagonist fights against anti-Semitic and gender stereotypes.

With the figure of Joab, Nestroy questions his depiction of Jews for two reasons: first, Joab is different from the other Jews, and second, he successfully fights against a "Jew-eater." Joab is the opposite of the cowardly shirker and greedy "sucker." In the second Book of Samuel, Joab is so hotheaded and pugnacious that he gets cursed (3:29). In Nestroy's play, however, he presents himself as a courageous, considerate, and critical contemporary who clearly describes his own "Erleuchtung" (enlightenment) in the 15th scene: "Mein Plan is ein Wunder des Himmels wenn er gelingt –" (My plan is a miracle from Heaven if it works –) (98). Joab demonstrates that stereotypes about Jews and the gluttonous creatures that nourish them can be defeated with the help of a new – Viennese – version of Judith. Although he wants his sister Judith to follow in the footsteps of her famous namesake, he is confronted with the simple fact that this could-be-heroine is not available for heroic deeds and decides to take over her role (97). By staging a peculiar encounter – the muscleman Holofernes, hiding his "schönes Geschlecht" (beautiful sex) (97), meets the lithe and lissome "Hebräer-Maid," Judith, hiding her male sex – Nestroy shows that in matters of gender, nothing is as it seems. Since the mission of his Judith travesty is possible without causing tragic side effects, such as slayed generals, paralyzed heroines, and banishments to hell, Nestroy crosses the supposedly natural borders of common bourgeois gender models elaborately described in Hebbel's flower bulb scenario: "Das Weib ist in den engsten Kreis gebannt: wenn die Blumenzwiebel ihr Glas zersprengt, geht sie aus."[22] (Woman is confined to the narrowest circle; if a flower bulb breaks its glass, it goes out.) The only

22 Friedrich Hebbel, *Tagebücher. Sämmtliche Werke. Historisch-kritische Ausgabe. Neue Subskriptions-Ausgabe*, ed. by Richard Maria Werner, 4 vols. (Berlin: Behr's, 1905), 1, p. 366.

one in Nestroy's play who resembles a paralyzed "something" in the last scene is a chained "Jew-eater."

Fighting the "Jew-Eaters"

Although "Holofernesse" (89) have by definition the duty to conquer the world, Nestroy depicts his Holofernes as a "Jew-eater" who ruthlessly expresses his goals: "Morg'n um die Zeit giebt's gar kein Juden mehr. [...] [D]ein Volck verbrennt – rein Alles verbrennt." (By this time tomorrow there won't be any Jews left. Your people will be burned, burned to a crisp.) (110–11) By equipping Nebuchadnezzar's general with the voice of a modern Jew-hater who wants to fry his "Kartoffel-Schmarre" (105) with the flames of a burning city, Nestroy gives Judith's ancient struggle a topical dimension and suggests that new types of enemies require new strategies of resistance. In Nestroy's text, Holofernes's unexpected ruse prevents his expected death. After having a nightmare about the biblical Judith, he asks his chamberlain to put a fake head on his bed. Nestroy's Joab, donning Judith's clothes, strikes his murderous blow but does not thereby become a murderer. Although the juggling with an "Überfluß an Köpfen" (abundance of heads) (113) has a long tradition in Viennese popular theater, the beheading of a fake head is particularly significant in a story of Judith. A "kaschirte[r] Kopf" is made of papier-mâché or plaster. If one interprets Nestroy's "dem Holofernes ähnlichen, aber größeren, kaschirten Kopf" (112) as a *Pappmaschee* head, the dual meaning of the German word *Papp-Kopf* becomes interesting: it is both a head made of paper and other materials mixed with glue as well as a colloquial term for "idiot." In any case, a fake head is always a head without a brain. In addition, this big and brainless head resembles Holofernes. Though a head-centered reading might seem excessive, it is worth noting that Holofernes's *Papp-Kopf* develops its own dynamics in the text. Because Joab is not a *Papp-Kopf,* he makes sure that the wrong head produces the right result: Holofernes's real head is declared invalid by both the panic-stricken Assyrian army – too busy running to look – and the approaching Hebrew army (113). Since the "Jew-eaters" completely rely on a *Papp-Kopf* to deceive and defeat a potentially dangerous visitor, they behave like real *Papp-Köpfe*, provoking their absurd end. Nestroy's text implies that because of their cerebral emptiness, "Jew-eaters" can easily be beaten. However, independently of how one reads Holofernes's "kaschirten

Kopf," there seems little doubt that the victory over a German-speaking Assyrian "Jew-eater" has a redeeming function on Nestroy's stage:

Schlachtmusik [...] Man hebt Joab auf einen Schild und trägt ihn in Triumph herum; vor ihm wird Holofernes in Ketten geführt. Während der Zug die Bühne vorn umkreist, sieht man im Hinter-grunde das Lager in Flammen aufgehen. Unter dem Triumph-geschrei der Hebräer fällt der Vorhang. (114)	Martial music. Joab is lifted upon a shield and carried about trium-phantly. Before him, Holofernes is led in chains. While the pro-cession circles about within the tent, one can see the camp burn-ing in the background. Triumphal shouts of the Hebrews.

This triumphal end makes an update on Nestroy and the Judith/Jewish Question necessary.

Updating the Judith/Jewish Question

Colin Walker criticizes Nestroy's "insensitivity" since he subjected to ridi-cule members of an anxious minority at a critical time in their fortunes.[23] Indeed, several scenes in his play nourish notions of the anti-social essence of Judaism, and thus reinforce certain stereotypes with which contempo-rary "Jew-eaters" tried to justify the re-ghettoization of Viennese Jews. It is not clear, however, whether Nestroy, the Carltheater, or future admirers of the Jewish story would have been better served if *Judith und Holofernes* had always been banished from the stage, as Walker rhetorically suggests.[24] Nestroy's rewriting does not seem to be the greatest insult that has ever dis-honored the Viennese stage. In contrast to the anonymous author, he leaves us with three messages of hope. First, his text shows that Judith's story con-tinues to be relevant in post-revolutionary Vienna: it provides instructions to free a city and to fight "Jew-eaters;" it saves Judith, the savior; and it lays the foundation for a collective metamorphosis. His parody can be read as a call for a new approach to the story of Judith in particular and perhaps, considering the martial shouts of Joab's compatriots in the last scene, to the Jewish people in general. Second, the text undermines its own stereotyping machinery in several ways and grants a Jewish heroine a travestic but glori-ous comeback. Nestroy's Judith is neither a devil's servant nor a paralyzed belladonna; *she* is a disguised *he* who is allowed to celebrate her victory

23 Walker, "Nestroy," p. 109.
24 Ibid., p. 110.

over Holofernes without going to hell for it. Third, the disgraceful end of a "Jew-eater" contains a political message. The final scene speaks for itself: anti-Jewish voices are drawn out by the Jewish howl of triumph, and the stage is neither "Jew-free," as Holofernes had planned, nor "Judith-free," as in the 1818 drama. On the contrary, this text makes sure that a "Jew-eater" and *Papp-Kopf* finally gets what he deserves. In doing so, Nestroy's stage of Viennese *G'spaß* gives a surprisingly serious answer to Vienna's Jewish Question. New encounters with Jews and Jewish stories can become reality if (and only if) the Viennese put all the empty-headed "Jew-eaters" in chains, verbally and physically. While the anonymous text creates new boundaries between Jews and non-Jews, Nestroy's text marks the start of a new beginning in Jewish/non-Jewish relations, in Bethulia and beyond.

Bibliography

Primary

Abbot, George. *The Reasons which Doctour Hill hath Brought, for Upholding of Papistry* (1604). Early English Books Online, http://www.jisc-collections.ac.uk/eebo.

Adamietz, Joachim. *Juvenal, Satiren (Sammlung Tusculum)*. Munich: Artemis & Winkler, 1993.

Ælfric, "Letter to Sigeweard." In *The Old English Version of the Heptateuch*, ed. S. J. Crawford. Early English Texts Society, old series 160 (1922).

Alberti, Leon Battista. *The Family in Renaissance Florence*. Trans. Renée Neu Watkins. Columbia, SC: University of South Carolina Press, 1969.

André, L. E. Tony. *Les Apocryphes de l'ancien testament*. Florence: O. Paggi, 1903.

The Anglo-Saxon Chronicle. Trans. Rev. James Ingram (London, 1823), with additional readings from the translation of Dr. J.A. Giles (London, 1847). London: Everyman Press, 1912, http://omacl.org/Anglo.

Anti-Coton, or A Refutation of Cottons Letter Declaratorie ... apologizing of the Iesuites Doctrine, touching the Killing of Kings. Trans. George Hakewill. London: T[homas] S[nodham] for Richard Boyle, 1611.

Assman, Bruno. "Abt. Ælfric's angelsächsische Homilie über das Buch Judith." *Anglia* 10 (1888).

Ball, Charles James. "Judith." In *The Apocrypha*, ed. Henry Wace. London: John Murray, 1888.

Baronio, Cesare. *Annales Ecclesiastici*, 10 vols. Rome: Vatican, 1588–1602; Antwerp: Plantinus, 1602–1658.

Baxter, Richard. *One Sheet Against the Quakers* (1657). Early English Books Online, http://www.jisc-collections.ac.uk/eebo.

— *The English Nonconformity as under King Charles II and King James* (1689). Early English Books Online, http://www.jisc-collections.ac.uk/eebo.

Beard, Thomas. *The Theatre of Gods Judgments Wherein is Represented the Admirable Justice of God Against All Notorious Sinners* (1642). Early English Books Online, http://www.jisc-collections.ac.uk/eebo.

Bellarmino, Roberto. *Ave, Maria* (I Classici Christiani 5–6). Siena: Cantagalli, 1950.

— *Disputationes ... De Controversiis christianae fidei adversus huius temporis haereticos*, 3 vols. Ingolstadt: Sartori, 1586–93.

Bewick, John. *An Answer to a Quakers Seventeen Heads of Queries* (1660). Early Eng-

lish Books Online, http://www.jisc-collections.ac.uk/eebo.

Biblia beyder Allt und Newen Testaments Teutsch. Worms: Peter Schöffer, 1529.

Biblia, beider Allt vnnd Newen Testamenten, fleissig, treülich vnd Christlich, nach alter, inn Christlicher kirchen gehabter Translation ... Durch D. Johan Dietenberger, new verdeutscht. Mainz: Peter Jordan, 1534.

Biblia sacra juxta vulgatam versionem. Stuttgart: Deutsche Bibelgesellschaft, 1994.

Birck, Sixt. "Ivdith." In *Sämtliche Dramen*, 3 vols., ed. Manfred Brauneck. Berlin: de Gruyter, 1976.

Börner-Klein, Dagmar. *Gefährdete Braut und schöne Witwe: Hebräische Judit-Geschichten.* Wiesbaden: Marix Verlag, 2007.

Bradley, S. A. J. *Anglo-Saxon Poetry.* London: J. M. Dent & Sons, 1995.

Brunner, Horst, and Burghart Wachinger (eds.). *Repertorium der Sangsprüche und Meisterlieder des 12. bis 18. Jahrhunderts*, 16 vols. Tübingen: Max Niemeyer, 1986–.

Bruno, Vincenzo. *Delle Meditationi sopra le sette Festivita principali della B. Vergine le quale celebra la Chiesa* (incorporated into Bruno's *Meditationi sopra i principali Misteri della Vita, Passione, e Risurrezione di Cristo*). Venice: Gioliti, 1585.

Buchanan, George. *De iure regni apud Scotos.* Edinburgh: John Ross, 1579.

Burton, Robert. *The Anatomy of Melancholy What It Is. With All the Kindes, Causes, Symptomes, Prognostickes, and Seuerall Cures of It.* Oxford: Lichfield and Short, for Henry Cripps, 1621. Early English Books Online, http://www.jisc-collections.ac.uk/eebo.

Calvin, John. *Institutes of the Christian Religion.* Ed. John T. McNeill, trans. Ford Lewis Battles. Philadelphia, PA: Westminster Press, 1960.

Camden, William. *Annales, the True and Royall History of the Famous Empresse Elizabeth*, trans. Abraham Darcie from the French of Paul Bellegent, not from the Latin of 1615. London: George Purslowe et al., 1625.

Camps, W. A. (ed.). *Propertius Elegies.* Cambridge: Cambridge University Press, 1966.

Canisio, Petro (St. Peter Canisius). *De Maria Virgine incomparabili et dei Genitrice Sancrosancta.* Ingolstadt: Sartorius, 1577.

Carpanè, Lorenzo. *Da Giuditta a Giuditta. L'epopea dell'eroina sacra nel Barocco.* Alessandria: Edizioni dell'Orso, 2006.

Cavalcanti, Giovanni. *Istorie fiorentine*, ed. F. Polidori, 2 vols. Florence: Tip. All'insegna di Dante.

Celada, Diego de. *Ivdith illustris perpetuo commentario.* Lyon: Prost, 1637.

Certain Sermons or Homilies (1547) and a Homily against Disobedience and Wilful Rebellion (1570). Ed. Ronald B. Bond. Toronto: Toronto University Press, 1987.

Charpentier, Marc-Antoine. *Oeuvres complètes*, 28 vols. Paris: Minkoff France Éditeur, 1991.

Coignard, Gabrielle de. *Oeuvres chrétiennes*. Ed. Colette H. Winn. Geneva: Droz, 1995.

Conradus Hirsaugiensis. *Speculum Virginum*. London: British Library, MS Arundel 44.

Cook, Albert S. (ed.). *Judith, An Old English Epic Fragment*. Boston: J. M. Dent & Sons, 1904. http://www.elfinspell.com/JudithStyle.html.

Corpus Christianorum, Series Latina, LXXVI A: S. Hieronymi Presbyteri Opera Part I Opera Exegetica 6. Turnhout: Brepols Publishers, 1970.

Cunningham, M. (ed.). *Aurelii Prudentii Clementis Carmina* (Corpus Christianorum, series latina 126). Turnhout-Brepols: Leuven University Press, 1966.

Curnow, M. C. *The Livre de la cité des dames: a Critical Edition*. Ph.D. dissertation, Vanderbilt University, 1975.

Della Valle, Federico. *Iudit* (1627). Ed. Andrea Gareffi. Rome: Bulzoni, 1978.

— *Opere*. Ed. Maria Gabriella Stassi. Turin: UTET, 1995.

Devil Turned Quaker, The (1656). Early English Books Online, http://www.jisc-collections.ac.uk/eebo.

Deschamps, Eustache. *Œuvres complètes d'Eustache Deschamps*. Ed. G. Raynaud. Paris: Firmin Didot, 1901.

Dolce, Lodovico. *Dialogo della institution delle donne*. Venice: Ferrari, 1545.

Donovan, Claire. *The Winchester Bible*. Toronto and Buffalo, NY: University of Toronto Press, 1993.

Du Bartas, Guillaume de Salluste. *La Judit*. Ed. André Baïche. Toulouse: Faculté des lettres et sciences humaines de Toulouse, 1971.

Dubarle, André Marie. *Judith: Formes et sens des diverses traditions: i: Études; ii: Textes*. Rome: Institut Biblique Pontifical, 1966.

Dufour, Antoine. *Les Vies des femmes célèbres* [1504]. Ed. G. Jeanneau. Genève: Droz, 1970.

Erasmus, Desiderius. "Vidua Christiana." In *Opera omnia Desiderii Erasmi Roterodami*, ed. J. N. Bakhuizen van den Brink. Amsterdam and Oxford: North-Holland Publishing Co., 1969.

— *Modus orandi Deum*. In *Opera Omnia Desiderii Erasmi Roterodami*, vol. V, ed. J. N. Bakhuizen van den Brink. Amsterdam and Oxford: North-Holland Publishing Co., 1977.

Erasmus, Collected Works of. Ed. J. W. O'Malley, trans. Jennifer Tolbert Roberts. Toronto: University of Toronto Press, 1988.

Fell, Margaret. *Womens Speaking Justified, Proved, and Allowed by the Scriptures* (1666, 1667). Early English Books Online, http://www.jisc-collections.ac.uk/eebo.

Fichte, Johann Gottlieb. "Beitrag zur Berichtigung der Urtheile des Publicums über die französische Revolution. Erster Theil: Zur Beurtheilung ihrer Rechtmässigkeit." In *Fichtes Werke*, 11 vols. Ed. Immanuel Hermann Fichte. Berlin: de Gruyter, 1971.

Flach, Dieter (ed. and trans.). *Marcus Terentius Varro, Gespräche über die Landwirtschaft* (Texte zur Forschung 66). Darmstadt: Wissenschaftliche Buchgesellschaft, 1997.

Fried, N. "A New Hebrew Version of *Megillat Antiochus*." *Sinai* 64 (1969).

Friedländer, Ludwig. *D. Junii Juvenalis. Saturae XIV.* Leipzig: S. Hirzel, 1895.

Friendly Dialogue Between Two Countrymen, A (1699). Early English Books Online, http://www.jisc-collections.ac.uk/eebo.

Garrison, Daniel H. *Horace. Epodes and Odes. A New Annotated Latin Edition.* Oklahoma Series in Classical Culture, vol. 10 (1991).

Gaster, Moses. "An Unknown Hebrew Version of the History of Judith." *Studies and Texts.* New York: KTAV, 1971.

Gillet, Abbé. Preface, *La Sainte Bible, Texte de la Vulgate; Tobi, Judith, et Esther, Introduction critique, Traduction française et Commentaires.* Paris: Lethielleux, 1879.

Goodman, Christopher. *How Superior Powers Oght to be Obeyd.* Geneva: Crispin, 1558.

Goulart, Simon. *Commentaires et annotations sur la Sepmaine* [sic.] *de la Création du Monde (La Judith. L'Uranie. Le triomphe de la foy, etc.) de G. de Saluste Seigneur du Bartas.* Paris: A. Langelier, 1583, first pub. 1582.

Griffith, Mark (ed.). *Judith* (Exeter Medieval Texts and Studies). Exeter: University of Exeter Press, 1997.

Grintz, Yehoshua M. *Sefer Yehudith: The Book of Judith.* Jerusalem: Bialik Institute, 1957.

Habermann, Abraham Meir. *Hadashim Gam Jeshanim: Texts Old and New.* Jerusalem: Reuven Mass, 1975.

Hanhart, Robert (ed.). *Septuaginta*, vol. 8.4: *Iudith.* Göttingen: Vandenhoeck & Ruprecht, 1979.

Hebbel, Friedrich. *Judith. Eine Tragödie in fünf Akten.* Stuttgart: 1980 [1839/40].

Herrad of Hohenbourg, *Hortus Deliciarum.* Ed. Rosalie Green, Michael Evans, Christine Bischoff and Michael Curschmann, with contributions by T. Julian Brown and Kenneth Levy under the direction of Rosalie Green (Studies of the Warburg Institute 36), 2 vols. London/Leiden: Warburg Institute, 1979.

Holie Bible Faithfully Translated into English out of the Avthentical Latin, The. Douai: Laurence Kellam, 1609.

Hudson, Thomas. *Thomas Hudson's Historie of Judith.* Ed. James Craigie. Edinburgh: William Blackwood & Sons, 1941.

James VI. *The Trew Law of Free Monarchies.* London: Waldegrave [i.e., Thomas Creede], 1598.

Jellinek, Adolph. *Bet ha-Midrasch* (2nd ed.). Jerusalem: Bamberger and Wahrmann, 1938.

Jerome. Letter to Furia, no. 54. http://www.newadvent.org/fathers/3001054.htm.

— Letter to Salvina, no. 79. http://www.newadvent.org/fathers/3001079.htm.

— *Preface to Judith*. In *Biblia Sacra Iuxta Vulgatam Versionem*, ed. Robert Weber. Stuttgart: Deutsche Bibelgesellschaft, 1969.

— *Letters and Select Works*. Trans. W. H. Fremantle, vol. 6 of *Nicene and Post-Nicene Fathers*, ed. Philip Schaff and Henry Wace, 2nd ser. New York: Christian Literature Publishing Company, 1893; reprint, Peabody, MA: Hendrickson Publishers, 1999.

Joncières, Victorin. "Revue musicale." *La Liberté*, 21 June 1897.

Judith-song 'In the tune of the song about the battle at Pavia'. Strasbourg: Christian Müller, ca. 1560. Ed. Leonard Boyle. Bibliotheca Palatina, Druckschriften, Microfiche Ausgabe. Munich: Saur, 1989–95.

Judith und Holofernes. Ein Drama in fünf Akten (1818). Ed. Gabrijela Mecky Zaragoza. Munich: Iudicium, 2005.

King James I, *His Maiesties Poeticall Exercises*. Trans. Guillaume de Salluste Du Bartas. Edinburgh: Waldegrave, 1591.

Knight, A. *Mystères de la procession de Lille*. Geneva: Droz, 2001–2004.

Latini, Brunetto. *Il Tesoretto*. Ed. Julia Bolton Holloway. New York: Garland, 1981.

— *Li Livres dou Tresor*. Ed. Spurgeon Baldwin and Paul Barrette. Tempe, AZ: Arizona Center for Medieval and Renaissance Studies, 2003.

Lee, S. D. (ed.). Ælfric's homilies on Judith, Esther, and Maccabees. http://users.ox.ac.uk/~stuart/kings/main.htm.

Leiter, Moshe Chaim. *A Kingdom of Priests: On Chanukah*. Modi'in, [s. n.], 2006.

Lomazzo, Gianpaolo. "Trattato dell'arte de la pittura." In *Scritti sulle arti*, 2 vols., ed. Roberto Ciardi. Florence: Marchi & Bertolli, 1974.

Löwinger, D. Samuel. *Judith-Susanna: New Versions Edited According to Budapest Manuscripts*. Budapest: F. Gewuercz, 1940.

Lutherbibel. Die Bibel nach der Übersetzung Martin Luthers mit Einführungen und Bildern. Mit Apokryphen. Stuttgart: Deutsche Bibelgesellschaft, 1999.

Luther, Martin. "Vorrhede auffs buch Judith" and "Das Buch Judith." In *Biblia/das ist/die gantze Heilige Schrifft Deudsch. Wittemberg 1534*. Cologne: Taschen, 2002.

Lyfe of ... Colignie Shatilion, The. Trans. Arthur Golding from the *Vita* of Jean de Serres. London: Vautrollier, 1576.

Mankin, David (ed.). *Horace. Epodes* (Cambridge Greek and Latin Classics). Cambridge: Cambridge University Press, 1995.

Martin, Gregory. *A Treatise of Schisme*. London: W. Carter, 1578.

Marulić, Marko. *Judita* (1501). Ed. Henry R. Cooper, Jr. Boulder, CO and New York: East European Monographs and Columbia University Press, 1991.

Mazzocchi, Domenico. *Musiche sacre, e morali a una, due, e tre voci*. Rome, 1640; reprint, Florence: Studio per edizioni scelte, 1988.

Mehlman, Bernard H. and Daniel F. Polish. "Ma'aseh Yehudit: A Chanukkah Midrash." *Journal of Reform Judaism*, 26 (1979).

Metastasio, Pietro. *Opere*, vol. 16. Florence: Gabinetto di Pallade, 1819.

Milton, John. *The Tenure of Kings and Magistrates*. London: Mathew Simmons, 1649.

Mistère du Viel Testament. Judith and Holofernes. A Late-Fifteenth-Century French Mystery Play. Ed. G. Runnalls. Geneva: Droz, 1995; Fairview, NC: Pegasus Press, 2002.

Mojsisch, Burkhard, Hans-Horst Schwarz, and Isabel J. Tautz. *Sextus Propertius. Sämtliche Gedichte*. Stuttgart: Reclam, 1993.

Molinet, Jean. *Les faicts et dictz de Jean Molinet*. Ed. N. Dupire. Paris: Société des Anciens Textes Français, 1936.

— *Judith and Holofernes: A Late-Fifteenth-Century French Mystery Play*, ed. and trans. Graham A. Runnalls. Fairview, NC: Pegasus Press, 2002.

Montaigne, Michel de. *The Complete Essays*. Trans. M. A. Screech. London: Penguin, 2003.

Moore, Carey A. *The Anchor Bible Judith: A New Translation with Introduction and Commentary*. Garden City, NY: Doubleday, 1985.

Nestroy, Johann. *Judith und Holofernes*. In *Johann Nestroy. Sämtliche Werke. Stücke 26/II. Historisch-kritische Ausgabe*, 42 vols., ed. John R. P. McKenzie. Vienna: Deuticke, 1998.

Nowell Codex. Cotton Vitellius A. xv. London: British Library.

Origen. *Letter to Africanus 19*. In *Origène, La lettre à Africanus sur l'histoire*. Sources Chrétiennes 302, ed. Nicholas de Lange. Paris: Éditions du Cerf, 1983.

overthrow of proud Holofernes, and the triumph of virtuous queen Judith, The. Oxford, Bodleian Harding B 39(203). http://www.bodley.ox.ac.uk.

Parallel Apocrypha, The. Greek text, King James Version, Douay Old Testatment, the Holy Bible by Ronald Knox, Today's English Version, New Revised Standard Version, New American Bible, New Jerusalem Bible. Ed. by John R. Kohlenberger. New York: Oxford University Press, 1997.

Pezzarossa, Fulvio (ed.). *I poemetti sacri di Lucrezia Tornabuoni*. Florence: Olschki, 1978.

Pietersma, Albert and Benjamin G. Wright (eds.). *A New English Translation of the Septuagint: Ioudith*. Trans. Cameron Boyd-Taylor. New York and Oxford: Oxford University Press, 2007.

Pizan, Christine de. *Le Livre de la cité des dames: a critical edition*. Ed. M. C. Curnow. Ph.D. dissertation, Vanderbilt University, 1975.

— *A Medieval Woman's Mirror of Honor: The Treasury of the City of Ladies*. Ed. Madeleine Pelner Cosman, trans. Charity Cannon Willard. Tenafly, NJ: Bard Hall Press, 1989; New York: Persea Books, 1989.

— *Le Livre des trois vertus*. Ed. Charity Cannon Willard. Paris: Librairie Honoré Champion, 1989.

Politicorum sive Civilis Doctrinae Libri Sex. Leiden: Plantijn, 1589.

Ponet, John. *A Short Treatise of Politique Povver*. Strasbourg: heirs of W. Köpfel, 1556.

Pougin, Arthur. "Semaine théâtrale: *Samson*." *Ménestrel*, 9 November 1890.

Prudentius. *Psychomachia*. http://suburbanbanshee.wordpress.com/2006/12/25/psychomachia-modesty-vs-lust/.

— *Psychomachia*. Trans. H. J. Thomson, 2 vols. Cambridge, MA: Harvard University Press, 1949.

Prunetti, Michelangelo and Giovanni Rossi. *La morte di Oloferne, dramma sacro per musica*. Rome, 1823.

[H]Rabanus Maurus (Rhabanus Maurus). *Expositio in librum Iudith*. *Patrologia Latina*.

Rappresentazione di Iudith Hebrea, La. Florence: Giovanni Baleni, 1589 (a later edition of that published by Francesco di Giovanni Benvenuto in 1519).

Reuss, Edouard. Introduction (to the Book of Judith). *La Bible. Traduction nouvelle avec Introductions et Commentaires*. *Ancien Testament*, vol. 7: *Littérature politique et polémique*. Paris: Sandoz et Fischbacher, 1879.

del Rio, Martin. *Opus Marianum*. Lyon: Horatium Cardon, 1607.

Ronsard, Pierre de. *Œuvres completes*. Ed. Gustave Cohen. Paris: Bibliothèque de la Pléiade, 1938.

Savonarola, Girolamo. *Prediche sopra Ezekiele*. Ed. Roberto Ridolfi, 2 vols. Rome: Angelo Belardetti, 1955.

Schonaeus, Cornelius. *Terentius Christianus, sive Comoediae duae. Terentiano stylo conscriptae. Tobaeus. Iuditha*. London: Robinson, 1595.

Serarius, Nicholas. *In Sacros Divinorum Bibliorum Libros, Tobiam, Ivdith, Esther, Machabaeos, Commentarius*. Mainz: Lippius, reissued in 1610 and 1612 in Paris, and included as *In Librum Judith*, with modern annotations, by Migne, in *Patrologia Latina, Scripturae Sacrae Cursus Completus*, vol. 14. Paris: Apud, 1840.

Sixe Bookes of Politickes or Ciuil Doctrine. Trans. William Jones. London: Field for Ponsonby, 1594.

Sixtus V, Pope. *Predica della Purissima Concettione della Gloriosa Madre di Dio, Maria Vergine*. Naples: Allifano, 1554.

Skeat, W. W. *Ælfric's Lives of Saints: A Supplementary Collection*, EETS, OS 76, 82, 94, 114, 4 vols. London: N. Trübner & Co., 1881–1900; reprint in 2 vols. Oxford: Oxford University Press, 1966.

Soubigou, Louis. "Judith: traduit et commenté." In *La Sainte Bible*, iv, ed. Louis Pirot and Albert Clamer. Paris: Letouzey & Ané, 1952.

Speculum Virginum. In *Corpus Christianorum Continuatio Mediaevalis*, vol. 5, ed. Jutta Seyfarth. Turnhout: Brepols Publishers, 1990.

St. Paulinus of Nola. *The Poems of St. Paulinus of Nola*, trans. P. G. Walsh. New York: Newman Press, 1975.

Stackmann, Karl and Jens Haustein (eds.). *Sangsprüche in Tönen Frauenlobs. Supplement zur Göttinger Frauenlob-Ausgabe*. Göttingen: Vandenhoeck & Ruprecht, 2000.

Swetnam, Joseph. *The Arraignment of Lewd, Idle, Froward and Unconstant Women* (1615). Early English Books Online, http://www.jisc-collections.ac.uk/eebo.

Sylvester, Joshua. "Bethulians Rescue." In *The Parliament of Vertues Royal*. London: Humphrey Lownes, 1614.

TANAKH: A New Translation of the Holy Scriptures. Philadelphia, PA: Jewish Publication Society, 1985.

Thomson, H. J. *Prudentius* (Loeb Classical Library). Cambridge, MA: Harvard University Press, 1949.

Tommaseo, Niccolò. *La Donna, scritti vari* (1833), quoted in Michela de Giorgio, "La bonne catholique," in *Histoire des femmes en Occident, IV. Le XIXème siècle*, ed. G. Fraisse and M. Perrot. Paris: Perrin, 2002.

Tortoletti, Bartolomeo. *Giuditta Vittoriosa*. Rome: Ludovico Grignani, 1648.

Tortoletti, Bartolomeo. *Ivditha Vindex et Vindicata*. Rome: Stamperia Vaticana, 1628.

Tylus, Jane (ed.). *Lucrezia Tornabuoni: Sacred Narratives*. Chicago, IL: University of Chicago Press, 2001.

Vermigli, Pietro Martire. *Common places of ... Doctor Peter Martyr*. Trans. Anthony Marten. London: Henry Denham and Henry Middleton, 1583.

Vier Historien des Alten Testaments. Bamberg: Albrecht Pfister, May 1462.

Vittorelli, Andrea. *De Angelorum Custodia*. Padua: Petri Pauli Tozzi, 1605.

— *Gloriose Memorie della B.ma Vergine Madre di Dio*. Rome: Facciotto, 1616.

Vivaldi, Antonio. *Juditha triumphans: Sacrum militare oratorium*. Ed. Alberto Zedda. Milan: Ricordi, 1971.

Vives, Juan Luis. *The Education of a Christian Woman: A Sixteenth-Century Manual*. Trans. Charles Fantazzi. Chicago, IL: University of Chicago Press, 2000.

Writings by Pre-Revolutionary French Women. Ed. Anne R. Larsen and Colette H. Winn. New York and London: Garland Publishing, 2000.

Yassif, E. (ed.). *The Book of Memory: The Chronicles of Jerahme'el*. Tel Aviv: Tel Aviv University, 2001.

Zurich Bible [Gantze Bibel], vol. 5: *Diss sind die bücher die by den alten vnder Biblische gschrifft nit gezelt sind, ouch by den Ebreern nit gefunden. Nüwlich widerumb durch Leo Jud Vertütschet*. Zurich: Christoph Froschauer, 1529.

Secondary

Accorsi, Maria Grazia. "Le azioni sacre di Metastasio: Il razionalismo cristiano." In *Mozart, Padova e la Betulia Liberata*, ed. Pinamonti.

Adams, Doug and Diane Apostolos-Cappadona (eds.), *Art as Religious Studies*. New York: Crossroad Publishing, 1987.

Adler, Israel. "A Chanukah Midrash in a Hebrew Illuminated Manuscript of the Bibliothèque Nationale." In *Studies in Jewish Bibliography, History, and Literature in Honor of I. Edward Kiev*, ed. Charles Berlin. New York: KTAV, 1971.

Ainsworth, Henry. *A Defence of the Holy Scriptures* (1609). Early English Books Online, http://www.jisc-collections.ac.uk/eebo.

Alonso-Schökel, Luis (ed.). *Narrative Structures in the Book of Judith*. Berkeley, CA: University of California at Berkeley, 1975.

Althaus, Hans Peter. *Kleines Lexikon deutscher Wörter jiddischer Herkunft*. Munich: Beck, 2003.

Ames-Lewis, Francis. "Art History or *Stilkritik*? Donatello's Bronze *David* Reconsidered." *Art History*, 2 (1979).

Anderson, Jaynie. *Judith*. Paris: Éditions du Regard, 1997.

Angelini, Franca. "Variazioni su Giuditta." In *I luoghi dell'immaginario barocco*, ed. Lucia Strappini. Naples: Liguori, 2001.

Apostolos-Cappadona, Diane. "Virgin/Virginity." In *Encyclopedia of Comparative Iconography*, ed. Helene Roberts. Chicago, IL: Fitzroy Dearborn, 1998.

— *Encyclopedia of Women in Religious Art*. New York: Continuum, 1996.

Armani, Elena Parma. "La *Storia di Ester* in un libro di schizzi di Giovanni Guerra." *Bollettino Ligustico*, 1973 (1975).

— *Libri di Immagini, Disegni e Incisioni di Giovanni Guerra*. Modena: Palazzo dei Musei, 1978.

Arundel Manuscripts, The (Arundel, Thomas Howard). *Catalogue of Manuscripts in the British Museum, New Series*. London: British Museum, 1834–40.

Astell, Ann. "Holofernes' Head: *Tacen* and Teaching in the Old English *Judith*." *Anglo-Saxon England* 18 (1989).

Bakhtin, Mikhail. *Rabelais and His World*. Trans. Helene Iswolsky. Bloomington, IN: Indiana University Press, 1984.

Bal, Mieke. *Death and Dissymmetry: The Politics of Coherence in the Book of Judges*. Chicago, IL: University of Chicago Press, 1988.

— *Quoting Caravaggio: Contemporary Art, Preposterous History*. Chicago, IL and London: University of Chicago Press, 1999.

— (ed.). *The Artemisia Files: Artemisia Gentileschi for Feminists and Other Thinking People*. Chicago, IL and London: University of Chicago Press, 2005.

Baltzer, Otto. *Judith in der deutschen Literatur* (Stoff- und Motivgeschichte der deutschen Literatur 7). Berlin: de Gruyter, 1930.

Banti, Alberto Mario. *La nazione del Risorgimento. Parentela, santità e onore alle origini dell'Italia unita.* Torino: Einaudi, 2000.

— *Il Risorgimento italiano.* Roma and Bari: Laterza, 2004.

— *L'onore della nazione: identita sessuali e violenza nel nazionalismo europeo dal XVIII secolo alla grande guerra.* Torino: Einaudi, 2005.

— and P. Ginsborg (eds.). *Storia d'Italia: 22, Il Risorgimento.* Torino: Einaudi, 2007.

Bar Ilan Online Jewish Responsa Project. http://www.biu.ac.il/jh/Responsa/.

Barasch, Moshe. "The Crying Face." *Artibus et Historiae,* 15 (1987).

Barbierato, Federico. *Politici e ateisti. Percorsi della miscredenza a Venezia tra Sei e Settecento.* Milan: Edizioni Unicopli, 2006.

Baron, Hans. *The Crisis of the Early Italian Renaissance.* Princeton, NJ: Princeton University Press, 1955.

Barthes, Roland, et al. *Word for Word – Artemisia No. 02.* Trilingual edition (English/French/Italian). Paris: Yvon Lambert, 1979.

Baumgärtel, Bettina and Silvia Neysters. *Die Galerie der starken Frauen: Die Heldin in der französischen und italienischen Kunst des 17. Jahrhunderts.* Munich: Keinkhardt and Biermann, 1995.

Beaudet, Pascale. *L'Effet Judith: Stéréotypes de la Féminité et Regard de la Spectatrice sur les Tableaux d'Artemisia Gentileschi.* Lille: Atelier National de Reproduction des Thèses, 2001.

Beckwith, Roger T. *The Old Testament Canon of the New Testament Church and Its Background in Early Judaism.* Grand Rapids, MI: W. B. Eerdmans, 1986.

Bélime-Droguet, Magali. "Nicolas de Hoey. De Fontainebleau à Ancy-le-Franc," *Revue de l'art,* 163:1 (2009).

Bell, Dean Phillip, and Stephen G. Burnett (eds.). *Jews, Judaism and the Reformation in Sixteenth-century Germany.* Leiden and Boston: Brill, 2006.

Belsey, Catherine. *The Subject of Tragedy: Identity & Difference in Renaissance Drama.* London and New York: Methuen, 1985.

Benassi, Vincenzo, et al. (eds.). *La Madonna della Ghiara in Reggio Emilia: Guida storico-artistica.* Reggio Emilia: Communità dei Servi di Maria, 1988.

Benjamin, Walter. "Der Erzähler. Betrachtungen zum Werk Nikolai Lesskows." In *Gesammelte Schriften,* vol. II, no. 2. Frankfurt/Main, 1977. Translation in *Illuminations: Essays and Reflections.* New York: Harcourt, Brace & World, 1968; reprint, Schocken, 1969.

Bennett, Bonnie A. and David G. Wilkins. *Donatello.* Oxford: Phaidon, 1984.

Bernardini, Maria Grazia. "La Cappella Bandini." In *Domenichino 1581–1641,* ed. Richard Spear et al. Milan: Electa, 1996.

Bianchi, Lino. *Carissimi, Stradella, Scarlatti e l'oratorio musicale.* Rome: Edizioni De Santis, 1969.

Bogaert, Pierre-Maurice. "Un emprunt au judaïsme dans la tradition médiévale de l'histoire de Judith en langue d'oïl." *Revue théologique de Louvain,* 31(3) (2000).

Borelli, Anne and Maria Pastore Passaro (eds.). *Selected Writings of Girolamo Savonarola. Religion and Politics, 1490–1498.* New Haven, CT: Yale University Press, 2006.

Bos, Elisabeth. "The Literature of Spiritual Formation for Women in France and England, 1080 to 1180." In Mews, *Listen Daughter.*

Brenner, Michael, Stefi Jersch-Wenzel, and Michael A. Meyer. *Deutsch-jüdische Geschichte in der Neuzeit: Emanzipation und Akkulturation 1780–1871,* 4 vols. Munich: Beck, 1996.

Brophy, Robert H. "Emancipatus Feminae: A Legal Metaphor in Horace and Plautus." *Transactions and Proceedings of the American Philological Association* (1975).

Brown, Peter. *The Body and Society: Men, Women, and Sexual Renunciation in Early Christianity.* New York: Columbia University Press, 1988.

Butler, Harold E. and Eric A. Barber. *The Elegies of Propertius.* Oxford: Clarendon Press, 1933.

Butler, Kim. "The Immaculate Body in the Sistine Ceiling." *Art History,* 3.2:2 (April 2009).

Butterfield, Andrew. *The Sculptures of Andrea del Verrocchio.* New Haven, CT: Yale University Press, 1997.

Cadbury, Henry. "Early Quakerism and Uncanonical Lore." *The Harvard Theological Review,* 40.3 (1947).

Callaghan, Leslie Abend. "Ambiguity and Appropriation: The Story of Judith in Medieval Narrative and Iconographic Traditions." In *Telling Tales: Medieval Narratives and the Folk Tradition,* ed. Francesca Canadé Sautman, Diana Conchado, and Giuseppe Carlo Di Scipio. New York: St. Martin's Press, 1998.

Callmann, Ellen. *Apollonio di Giovanni.* Oxford: Clarendon Press, 1974.

Campbell, Jackson J. "Schematic Technique in Judith." *ELH: A Journal of English Literary History,* 38 (1971).

Cancik, Hubert and Helmuth Schneider (eds.). *Der neue Pauly. Enzyklopädie der Antike. Das klassische Altertum und seine Rezeptionsgeschichte.* Stuttgart: J. B. Metzler, 1996–2000.

Caponigro, Mark. "Judith, Holding the Tale of Herodotus." In *"No One Spoke Ill of Her": Essays on Judith,* ed. James C. VanderKam. Atlanta: Scholars Press, 1992.

Capozzi, Frank. "The Evolution and Transformation of the Judith and Holofernes Theme in Italian Drama and Art before 1627." Ph.D. dissertation. Madison, WI: University of Wisconsin, 1975.

Caroli, Flavio. *Fede Galizia.* Turin: Allemandi, 1989.

Carpanè, Lorenzo. *Da Giuditta a Giuditta*. Alessandria: Edizioni dell'Orso, 2006.

Castelberg, Marcus. *Leibeswohl und Seelenheil*. Diss. masch. Fribourg University, 2005.

Catholic Encyclopedia on-line. http://www.newadvent.org/fathers/3001053.htm.

Chamberlain, David. *"Judith*: A Fragmentary and Political Poem." In *Anglo-Saxon Poetry: Essays in Appreciation for John C. McGalliard*, ed. Lewis E. Nicholson and Delores W. Frese. Notre Dame, IN: University of Notre Dame Press, 1975.

Chartier, Roger. *Forms and Meanings: Texts, Performances, and Audiences from Codex to Computer*. Philadelphia, PA: University of Pennsylvania Press, 1995.

Cherubini, G. and G. Fanelli (eds.). *Il Palazzo Medici Riccardi di Firenze*. Florence: Giunti, 1990.

Chiappini, Simonetta. "La voce della martire. Dagli 'evirati cantori' all'eroina romantica." In *Storia d'Italia: 22*, ed. A. M. Banti and P. Ginsborg.

Ciletti, Elena. "Patriarchal Ideology in the Renaissance Iconography of Judith." In *Refiguring Woman: Perspectives on Gender and the Italian Renaissance*, ed. Marilyn Migiel and Juliana Schiesari. Ithaca, NY and London: Cornell University Press, 1991.

— "'Gran Macchina è Bellezza': Looking at the Gentileschi *Judiths*." In *The Artemisia Files: Artemisia Gentileschi for Feminists and Other Thinking People*, ed. Mieke Bal. Chicago, IL: University of Chicago Press, 2005.

Clarke, E. "Engendering the Study of Religion." In *The Future of the Study of Religion*, ed. S. Jakelic and L. Pearson. Leiden: Brill Press, 2004.

Clemoes Peter (ed.). "The Chronology of Ælfric's Works." In *The Anglo-Saxons: Studies in Some Aspects of Their History and Culture Presented to Bruce Dickins*, ed. Peter Clemoes. London: Bowes, 1959.

Cohen, Shaye J. D. *The Beginnings of Jewishness: Boundaries, Varieties, Uncertainties*. Berkeley, CA: University of California Press, 1999.

Collet, Henri. *Samson et Dalila de C. Saint-Saëns, Etude historique et critique, Analyse musicale*. Paris: Mellottée, 1922.

Conybeare, Catherine. *Paulinus Noster: Self and Symbols in the Letters of Paulinus of Nola*. Oxford: Oxford University Press, 2001.

Courtney, Edward. *A Commentary on the Satires of Juvenal*. London: The Athlone Press, 1980.

Courtright, Nicola. *The Papacy and the Art of Reform in Sixteenth-Century Rome: Gregory XIII's Tower of the Winds in the Vatican*. Cambridge and New York: Cambridge University Press, 2003.

Craven, Toni. *Artistry and Faith in the Book of Judith*. Chico, CA: Scholars Press, 1983.

— "The Book of Judith in the Context of Twentieth-Century Studies of the Apocryphal/Deuterocanonical Books." *Currents in Biblical Research*, 1(2) (2003).

Crawford, Sidnie White. "Esther and Judith: Contrasts in Character." In *The Book of Esther in Modern Research*, ed. Sidnie White Crawford and Leonard J. Green-

spoon. London: T&T Clark, 2003.

Crum, Roger J. *Retrospection and Response: The Medici Palace in the Service of the Medici, c. 1420–1469*. Ph.D. dissertation, University of Pittsburgh, 1992.

— "Donatello's Bronze *David* and the Question of Foreign Versus Domestic Tyranny." *Renaissance Studies*, 10 (1996).

— "Roberto Martelli, the Council of Florence, and the Medici Palace Chapel." *Zeitschrift für Kunstgeschichte*, 59 (1996).

— "Severing the Neck of Pride: Donatello's *Judith and Holofernes* and the Recollection of Albizzi Shame in Medicean Florence." *Artibus et Historiae*, 22 (2001).

— "The Story of Judith and Holofernes." In *Selected Works from the Dayton Art Institute Permanent Collection*. Dayton, OH: The Dayton Art Institute, 1999.

— and John T. Paoletti. "'... Full of People of Every Sort': The Domestic Interior." In *Renaissance Florence: A Social History*, ed. Roger J. Crum and John T. Paoletti. Cambridge: Cambridge University Press, 2008.

Darlow, T. H. and H. F. Moule. *Historical Catalogue of the Printed Editions of Holy Scripture*. London: Bible Society, 1911.

Dermenjian, Geneviève and Jacques Guilhaumou. "Le 'crime héroïque' de Charlotte Corday." In *Le Panthéon des femmes: figures et représentation des heroines*, ed. G. Dermenjian, J. Guilhaumou, and M. Lapied. Paris: Publisud, 2004.

Der Nersessian, Sirarpie. *Miniature Painting in the Armenian Kingdom of Cilicia from the Twelfth to the Fourteenth Century*. Washington, D.C.: Dumbarton Oaks, 1993.

Dijkstra, Bram. *Idols of Perversity: Fantasies of Feminine Evil in Fin-de-Siècle Culture*. New York: Oxford University Press, 1986.

Dohm, Christian Konrad Wilhelm. *Ueber die bürgerliche Verbesserung der Juden*. Hildesheim: Olms, 1973.

Donovan, Claire. *The Winchester Bible*. Toronto and Buffalo, NY: University of Toronto Press, 1993.

Dotson, Esther Gordon. "An Augustinian Interpretation of Michelangelo's Sistine Ceiling," *Art Bulletin*, 61 (1979).

Draper, James David. "Cameo Appearances." *The Metropolitan Museum of Art Bulletin*, LXV.4 (Spring 2008).

Dubarle, André Marie. *Judith: Formes et sens des diverses traditions, i: Études; ii: Textes*. Rome: Institut Biblique Pontifical, 1966.

Dubowy, Norbert. "Le due 'Giuditte' di Alessandro Scarlattti: due diverse concezioni dell'oratorio." In *L'oratorio musicale italiano e i suoi contesti (secc. XVII–XVIII)*, ed. Paola Besutti. Florence: Leo S. Olschki Editore, 2002.

Duggan, Christopher. *The Force of Destiny. A History of Italy since 1796*. London: Penguin Books, 2008.

Ekserdjian, David. *Correggio*. New Haven, CT: Yale University Press, 1997.

Erasmus, Desiderius. "On the Christian Widow." In *Collected Works of Erasmus*, vol.

66, ed. John W. O'Malley, trans. Jennifer Tolbert Roberts. Toronto: University of Toronto Press, 1988.

Eriksen, Anne. "Etre ou agir ou le dilemme de l'héroïne." In *La fabrique des héros*, ed. P. Centlivres, D. Fabre, and F. Zonabend. Paris: Editions de la Maison des Sciences de l'Homme, 1998.

Fabbri, Maria Cecilia. "'La più grande e perfetta opera' del Volterrano: l'affresco nella tribuna della Santissima Annunziata." *Antichità Viva*, 35(2/3) (1996).

Feldman, Louis H. "Hellenizations in Josephus' Version of Esther." *Transactions of the American Philological Association*, 101 (1970).

Ficacci, Luigi (ed.). *Claude Mellan, gli anni romani: un incisore tra Vouet e Bernini*. Rome: Multigrafica, 1989.

Field, Arthur. *The Origins of the Platonic Academy of Florence*. Princeton, NJ: Princeton University Press, 1988.

Fitzgerald, Allan D. (ed.). *Augustine through the Ages, an Encyclopedia*. Grand Rapids, MI: Erdmans, 1999.

Francia, Enrico. "Clero e religione nel lungo Quarantotto italiano." In *Storia d'Italia*: 22, ed. A. M. Banti and P. Ginsborg.

Freiberg, Jack. *The Lateran in 1600: Christian Concord in Counter-Reformation Rome*. Cambridge: Cambridge University Press, 1995.

Freud, Sigmund. "Das Tabu der Virginität" and "Über die weibliche Sexualität." In *Ders. Studienausgabe V. Sexualleben*. Frankfurt a.M.: Fischer, 1972.

Friedman, Mira. "The Metamorphoses of Judith." *Jewish Art*, 12–13 (1986–87).

Gaca, Kathy. "Early Christian Antipathy to the Greek 'Women Gods.'" In *Finding Persephone*, ed. Marilyne Parca and Angeliki Tzanetou. Bloomington, IN: Indiana University Press, 2007.

Gambero, Luigi. *Mary and the Fathers of the Church: The Blessed Virgin Mary in Patristic Thought*. Trans. T. Buffer. San Francisco, CA: Ignatius Press, 1999.

Gardair, Jean-Michel. "Giuditta e i suoi doppi." In *I Gesuiti e i primordi del teatro barocco in Europa*, ed. M. Chiabò and F. Doglio. Rome: Centro studi sul teatro medioevale e rinascimentale, 1995.

Garrard, Mary D. *Artemisia Gentileschi: The Image of the Female Hero in Italian Baroque Art*. Princeton, NJ: Princeton University Press, 1989.

— *Artemisia Gentileschi around 1622: The Shaping and Reshaping of an Artistic Identity*. Berkeley and Los Angeles, CA: University of California Press, 2001.

Gatti, Luca. "Displacing Images and Renaissance Devotion in Florence: The Return of the Medici and an Order of 1513 for the *Davit* and the *Judit*." *Annali della Scuola Normale Superiore di Pisa*, ser. 3, 23 (1993).

Georges, Karl Ernst. *Lateinisch-Deutsches Handwörterbuch*. Darmstadt: Nachdruck, 1918.

Giacometti, Paolo. *Teatro*. Ed. Eugenio Buonaccorsi. Genoa: Costa & Nolan, 1983.

Gill, Christopher. *Character and Personality in Greek Epic and Tragedy.* Oxford: Oxford University Press, 1996.

— *The Structured Self in Hellenistic and Roman Thought.* Oxford: Oxford University Press, 2006.

Giorgio, Michela de. "La bonne catholique." In G. Fraisse and M. Perrot (eds.), *Histoire des femmes en Occident, IV. Le XIXème siècle.* Paris: Perrin, 2002.

Glines, Elsa. *Undaunted Zeal: The Letters of Margaret Fell.* Richmond, VA: Friends United Press, 2003.

Godwin, Frances Gray. "The Judith Illustration of the *Hortus Deliciarum.*" *Gazette des Beaux-Arts,* 36 (1949).

Goff, Barbara. *Citizen Bacchae: Women's Ritual Practice in Ancient Greece.* Cambridge: Cambridge University Press, 2004.

Graef, Hilda. *Mary: A History of Doctrine and Devotion,* vol. II: *From the Reformation to the Present Day.* New York: Sheed and Ward, 1965.

Grendler, Paul. *The Roman Inquisition and the Venetian Press, 1540–1605.* Princeton, NJ: Princeton University Press, 1977.

Grimm, Jacob and Wilhelm Grimm. *Deutsches Wörterbuch.* Leipzig: S. Hirzel, 1854–1960.

Gruen, Eric. "Novella." In *Oxford Handbook of Biblical Studies,* ed. J. W. Rogerson and Judith M. Lieu. Oxford: Oxford University Press, 2006.

Hamburger, Jeffrey F. and Susan Marti, eds. *Crown and Veil: Female Monasticism from the Fifth to the Fifteenth Centuries.* Trans. Dietlinde Hamburger. New York: Columbia University Press, 2008.

Hanhart, Robert. *Iudith.* Göttingen: Vandenhoeck & Ruprecht, 1979.

Hanotaux, Gabriel. *Contemporary France.* New York: Putnam, 1905–12.

Harness, Kelley. *Echoes of Women's Voices: Music, Art, and Female Patronage in Early Modern Florence.* Chicago, IL: University of Chicago Press, 2006.

Harris, Nigel. "Didactic Poetry." In *German Literature of the High Middle Ages,* ed. Will Hasty. Rochester, NY: Camden House, 2005.

Hartl, Wolfgang. *Text und Miniaturen der Handschrift Dialogus de Laudibus Sanctae Crucis.* Hamburg: Verlag Dr. Kovac, 2007.

Hebbel, Friedrich. *Tagebücher. Sämmtliche Werke. Historisch-kritische Ausgabe. Neue Subskriptions-Ausgabe.* Ed. Richard Maria Werner, 4 vols. Berlin: Behr's, 1905.

Helck, Wolfgang. "Moskitonetze." *Lexikon der Ägyptologie,* vol. 4 (1982).

Herzner, Volker. "Die 'Judith' der Medici." *Zeitschrift für Kunstgeschichte,* 43 (1980).

Hirthe, Thomas. "Die Perseus- und Medusa-Gruppe des Benvenuto Cellini in Florenz." *Jahrbuch der Berliner Museen,* 29 (1987–88).

Hollywood, A. "Agency and Evidence in Feminist Studies of Religion: A Response to Elizabeth Clark." In *The Future of the Study of Religion,* ed. S. Jakelic and L.

Pearson. Leiden: Brill Press, 2004.

— "Gender, Agency, and the Divine in Religious Historiography." *Journal of Religion*, 84.4 (2004).

Hotchin, Julie. "Female Religious Life and the *Cura Monialium* in Hirsau Monasticism, 1080 to 1150." In Mews, *Listen Daughter*.

Hourihane, Colum. *Virtue and Vice, The Personifications in the Index of Christian Art.* Princeton, NJ: Princeton University Press, 2000.

Hüttner, Johann. "Machte sich Nestroy bezahlt?" *Nestroyana* 1 (1979).

Ilan, Tal. *Integrating Women into Second Temple History.* Tübingen: C. B. Mohr (Paul Siebeck), 1999; repr. Peabody, MA: Hendrick Publishers Inc., 2001.

Isidore of Seville. *Isidori Hispalensis Episcopi Etymologiarum sive originum.* Ed. W. M. Lindsay. Oxford: Oxford University Press, 1911.

— *The Etymologies of Isidore of Seville.* Trans. Stephen A. Barney et al. Cambridge: Cambridge University Press, 2006.

Jacobus, Mary. *Reading Women.* New York: Columbia University Press, 1986.

Janson, H. *The Sculpture of Donatello.* Princeton, NJ: Princeton University Press, 1963.

Jastrow, Marcus. *Dictionary of Targumim, the Talmud Babli and Yerushalmi, and the Midrashic Literature.* London and Leipzig, 1903; reprint, Peabody, MA: Hendrickson, 2005.

Joannides, Paul. *Titian to 1518; The Assumption of Genius.* New Haven, CT: Yale University Press, 2001.

Johnson, Sara Raup. *Historical Fictions and Hellenistic Jewish Identity: Third Maccabees in Its Cultural Context.* Berkeley and Los Angeles, CA: University of California Press, 2004.

Jones, Ann Rosalind. "Surprising Fame: Renaissance Gender Ideologies and Women's Lyric." In *Feminism and Renaissance Studies*, ed. Lorna Hutson. Oxford: Oxford University Press, 1999.

Jong, Mayke de. "Exegesis for an Empress." In *Medieval Transformations: Texts, Power, and Gifts in Context*, ed. Esther Cohen and Mayke De Jong. Leiden: Brill, 2001.

Joost-Gaugier, Christiane L. "Dante and the History of Art: The Case of a Tuscan Commune Part I: The First Triumvirate at Lucignano," and "Dante and the History of Art: The Case of a Tuscan Commune. Part II: The Sala del Consiglio at Lucignano." *Artibus et Historiae*, 11 (1990).

Joosten, Jan. "The Original Language and Historical Milieu of the Book of Judith." In *Meghillot v–vi: A Festschrift for Devorah Dimant*, ed. Moshe Bar-Asher and Emanuel Tov. Jerusalem and Haifa: Bialik Institute and University of Haifa, 2007.

Karnafogel, Ephraim. *Jewish Education and Society in the High Middle Ages.* Detroit, MI: Wayne State University Press, 1992.

Katzenellenbogen, Adolf. *Allegories of the Virtues and Vices in Mediaeval Art.* New York: W. W. Norton, 1939.

Keates, Jonathan. *The Siege of Venice*. London: Cape, 2007.

Kent, Dale V. *The Rise of the Medici: Faction in Florence, 1426–1434*. Oxford and New York: Oxford University Press, 1978.

— *Cosimo de' Medici and the Florentine Renaissance: The Patron's Oeuvre*. New Haven, CT and London: Yale University Press, 2000.

— "Women in Renaissance Florence." In *Virtue and Beauty*, ed. David Alan Brown. Princeton, NJ and Woodstock, Oxfordshire: Princeton University Press, 2001.

Ker, Neil Ripley. *Catalogue of Manuscripts Containing Anglo-Saxon*. Oxford: Clarendon Press, 1957.

Kiely, Maria. "The Interior Courtyard: The Heart of Cimitile/Nola." *Journal of Early Christian Studies*, 12:4 (2004).

King, K. "Prophetic Power and Women's Authority: The Case of the Gospel of Mary (Magdalene)." In *Women Preachers and Prophets through Two Millennia of Christianity*, ed. Beverly Mayne Kienzle and Pamela J. Walker. Berkeley, CA: University of California Press, 1998.

Kirschbaum, E. (ed.). *Lexikon der christlichen Ikonographie*. Freiburg: Herder Verlag, 1968–1976.

Klein, Robert and Henri Zerner (eds.). *Italian Art*. Englewood Cliffs, NJ: Prentice-Hall, 1966.

Knight, A. E. *Aspects of Genre in Medieval French Drama*. Manchester: Manchester University Press, 1983.

Kraggerud, Egil. *Horaz und Actium. Studien zu den politischen Epoden*. Oslo: Universitetsforlaget; Irvington-on-Hudson, NY: Distribution, Columbia University Press, 1984.

Krautheimer, Richard. *Lorenzo Ghiberti*. Princeton, NJ: Princeton University Press, 1982.

Kreitzer, Beth. *Reforming Mary: Changing Images of the Virgin Mary in Lutheran Sermons of the Sixteenth Century*. Oxford: Oxford University Press, 2004.

Krüger, Matthias. "Wie man Fürsten empfing. Donatellos *Judith* und Michelangelos *David* im Staatszeremoniell der Florentiner Republik." *Zeitschrift für Kunstgeschichte*, 71 (2008), pp. 481–96.

Kunze, Bonnelyn. *Margaret Fell and the Rise of Quakerism*. Stanford, CA: Stanford University Press, 1994.

Lacocque, André. *Subversives, ou, Un Pentateuque de femmes* (Lectio divina 148). Paris: Editions du Cerf, 1992.

Lähnemann, Henrike. "From Print to Manuscript. The Case of a Manuscript Workshop in Stuttgart around 1475." In *The Book in Germany*, eds. William A. Kelly *et al*. Edinburgh: Merchiston Publishing, 2010.

— *Hystoria Judith*. Berlin: de Gruyter, 2006.

Lapied, Martine. "La mort de l'héroïne, apothéose de l'opéra romantique." In *Les*

narrations de la mort, ed. Régis Bertrand, Anne Carol, and Jean-Noël Pelen. Aix-en-Provence: Publications de l'Université de Provence, 2005.

Laplanche, François. *La Bible en France entre mythe et critique, XVIe–XIXe siècles.* Paris: Albin Michel, 1994.

Larson, Rebecca. *Daughters of Light: Quaker Women Preaching and Prophesying in the Colonies and Abroad, 1700–1775.* New York: Alfred A. Knopf, 1999.

Lavater, Hans Rudolf. "Die Stimme ist Jakobs Stimme, aber die Hände sind Esaus Hände." In *Die Zürcher Bibel von 1531.* Zurich: Theol. Verl., 1983.

Lerner, Gerda. *The Creation of the Feminist Consciousness: From the Middle Ages to Eighteen-seventy.* New York: Oxford University Press, 1993.

Lerner, Meron Bialik. "Collections of Tales." *Kiryat Sefer,* 61 (1986).

Levine, Amy-Jill. "Character Construction and Community Formation in the Book of Judith." In *A Feminist Companion to Esther, Judith and Susanna,* ed. Athalya Brenner. Sheffield: Sheffield Academic Press, 1995.

Liddell, Henry George and Robert Scott. *A Greek-English Lexicon.* Oxford: Clarendon Press, 1889; reprint New York and Oxford: Oxford University Press, 2000.

Lightbown, R. W. *Sandro Botticelli.* Berkeley, CA: University of California Press, 1978.

Little, Lester K. "Pride Goes before Avarice: Social Change and the Vices in Latin Christendom." *The American Historical Review,* 76 (1971).

Liuzza, Roy Michael. *Beowulf: A New Verse Translation.* Peterborough, Canada: Broadview Press, 2000.

Locke, Ralph. "Constructing the Oriental 'Other': Saint-Saëns's *Samson et Dalila.*" *Cambridge Opera Journal,* 3 (1991).

Lohfink, Norbert. *Neues Bibel Lexikon.* Zürich, 1991.

Lutz, J. and P. Perdrizet (eds.). *Speculum Humanae Salvationis, Die Quellen des "Speculum" und sine Bedeutung in der Ikonographie besonders in der clässichen Kunst des XIV Jahrhunderts,* 2 vols. Trans. Jean Mielot. Leipzig: Buchdruckerei Ernst Meininger, 1909.

MacNeil, Anne. *Music and Women of the Commedia dell' Arte in the Late Sixteenth Century.* Oxford: Oxford University Press, 2003.

Madonna, Maria Luisa (ed.). *Roma di Sisto V. Le arti e la cultura.* Rome: DeLuca, 1993.

Malaguzzi, Silvia. *Oro, gemme e gioielli.* Milan: Mondadori Electa, 2007.

Malcolmson, Cristina and Mihoko Sukuki, eds. *Debating Gender in Early Modern England, 1500–1700.* New York: Palgrave Macmillan, 2002.

Mâle, Emile. *L'Art religieux après le Concile de Trente.* Paris: Colin, 1932, revised ed. 1951.

Mandel, Corinne. "Il Palazzo Lateranense." In *Roma di Sisto V. Le arti e la cultura,* ed. Maria Luisa Madonna. Rome: DeLuca, 1993.

— *Sixtus V and the Lateran Palace.* Rome: Istituto Poligrafico e Zecca dello Stato, 1994.

Mangini, Giorgio. "*Betulia liberata* e *La morte di Oloferne*. Momenti di drammaturgia musicale nella tradizione dei Trionfi di Giuditta." In *Mozart, Padova e la Betulia Liberata: Committenza, interpretazione e fortuna delle azioni sacre metastasiane nel Settecento*, ed. Paolo Pinamonti. Florence: Olschki, 1991.

Mantel, Hugo. "Ancient Hasidim." *Studies of Judaism* (1976).

Marcus, Ivan. *Rituals of Childhood: Jewish Acculturation in the Middle Ages*. New Haven, CT and London: Yale University Press, 1996.

Marica, Attila Marco (ed.). "*Attila* libretto e guida all'opera," Programma di sala [2004]. http://www.teatrolafenice.it/public/libretti/58_2246attila_gv.pdf.

Marshall, John. *John Locke, Toleration and Early Enlightenment Culture*. Cambridge: Cambridge University Press, 2006.

Mastrangelo, Marc. *The Roman Self in Late Antiquity: Prudentius and the Poetics of the Soul*. Baltimore, MD: Johns Hopkins University Press, 2008.

Maurach, Georg. *Horaz. Werk und Leben*. Heidelberg: Universitätsverlag C. Winter, 2001.

Mazzonis, Querciolo. *Spirituality, Gender and the Self in Renaissance Italy: Angela Merici and the Company of St. Ursula (1474–1540)*. Washington, D.C.: Catholic University Press, 2007.

McFarlane, I. D. *Buchanan*. London: Duckworth, 1981.

McHam, Sarah Blake. "Donatello's *David* and *Judith* as Metaphors of Medici Rule in Florence." *The Art Bulletin*, 83 (2001), 32–47.

McLaren, Anne. "Rethinking Republicanism: *Vindiciae contra tyrannos* in Context." *The Historical Journal*, 49 (2006).

Medvedev, P. N. *The Formal Method in Literary Scholarship: A Critical Introduction to Sociological Poetics*. Trans. Albert J. Wehrle. Cambridge, MA: Harvard University Press, 1985. Quoted in Gary Saul Morson and Caryl Emerson, *Mikhail Bakhtin: Creation of a Prosaics*. Stanford, CA: Stanford University Press, 1990.

Méniel, Bruno. *Renaissance de l'épopée: la poésie épique en France de 1572 à 1623*. Geneva: Droz, 2004.

Mergenthaler, Volker. *Medusa Meets Holofernes. Poetologische, semiologische und intertextuelle Diskursivierung von Enthauptung*. Bern: Peter Lang, 1997.

Merideth, Betsy. "Desire and Danger: The Drama of Betrayal in Judges and Judith." In *Anti-Covenant: Counter-Reading Women's Lives in the Hebrew Bible*, ed. Mieke Bal. Sheffield: Almond Press, 1989.

Mews, Constant J. (ed.). *Listen Daughter: The Speculum Virginum and the Formation of Religious Women in the Middle Ages*. New York: Palgrave, 2001.

— "Virginity, Theology, and Pedagogy in the *Speculum Virginum*." In Mews, *Listen Daughter*.

Miélot, Jean, Jules Lutz, and Paul Perdrizet (eds.), Jean Miélot (trans.). *Speculum humanae salvationis, Texte critique (1448), Les sources et l'influence iconographique principalement sur l'art alsacien du XIVe siècle, Avec la reproduction, en 140 planches,*

du Manuscrit de Sélestat, de la série complète des vitraux de Mulhouse, de vitraux de Colmar, de Wissembourg, 2 vols. Leipzig, 1907–1909.

Mirsky, Samuel Kalman. *Sheeltot de Rab Ahai Gaon: Genesis, Part ii*. Jerusalem: Sura Institute, Yeshiva University and Mossad Harav Kook, 1961.

Moore, Carey A. "Why Wasn't the Book of Judith Included in the Hebrew Bible?" In *"No One Spoke Ill of Her": Essays on Judith*, ed. J. C. VanderKam. Atlanta: Scholars Press, 1992.

— *The Anchor Bible Judith*. Garden City, NY: Doubleday, 1985.

Morey, James H. "Peter Comestor, Biblical Paraphrase, and the Medieval Popular Bible." *Speculum*, 68 (1993), 6–35.

Müntz, Eugene. *Les collections des Medicis au XVe siècle*. Paris and London: Librairie de l'art, 1888.

Murphy, Caroline. *Lavinia Fontana: A Painter and Her Patrons in Sixteenth-Century Bologna*. New Haven, CT and London: Yale University Press, 2003.

Najemy, John M. *A History of Florence 1200–1575*. Malden, MA: Blackwell Publishing, 2006.

Newman, Barbara. "*Speculum Virginum*: Selected Excerpts." In Mews, *Listen Daughter*.

Nordhagen, Per. *The Frescoes of John VII (A.D. 705–707) in S. Maria Antiqua in Rome*. Rome: Bretschneider, 1968.

Oakshott, Walter. *The Artists of the Winchester Bible*. London: Faber & Faber, 1945.

Orazio and Artemisia Gentileschi, ed. Keith Christiansen and Judith Mann. New York and New Haven, CT: Metropolitan Museum of Art and Yale University Press, 2001.

Orchard, Andy. *Pride and Prodigies: Studies in the Monsters of the* Beowulf *Manuscript*. Toronto: University of Toronto Press, 2003.

Ostrow, Steven. *Art and Spirituality in Counter-Reformation Rome: The Sistine and Pauline Chapels in S. Maria Maggiore*. Cambridge: Cambridge University Press, 1996.

Otzen, Benedikt. *Tobit and Judith*. London: Sheffield Academic Press, 2002.

Palmer, Nigel F. "'Turning many to righteousness,' Religious didacticism in the *Speculum humanae salvationis* and the similitude of the oak tree." In Henrike Lähnemann and Sandra Linden (eds.), *Dichtung und Didaxe, Lehrhaftes Sprechen in der deutschen Literatur des Mittelalters*. Berlin: de Gruyter, 2009.

— *Zistersienser und ihre Bücher: Die mittelalterliche Bibliotheksgeschichte von Kloster Eberbach im Rheingau*. Regensburg: Schnell & Steiner, 1998.

Panofsky, Erwin. *Studies in Iconology: Humanistic Themes in the Art of the Renaissance*. Boulder, CO: Westview Press, 1972.

Parca, Marilyne and Angeliki Tzanetou (eds.). *Finding Persephone: Women's Rituals in the Ancient Mediterranean*. Bloomington, IN: Indiana University Press, 2007.

Pasler, Jann. "Contingencies of Meaning in Transcriptions and Excerpts: Popular-

izing *Samson et Dalila*." In *Approaches to Meaning in Music*, ed. Byron Almén and Edward Pearsall. Bloomington, IN: Indiana University Press, 2006.

— *Composing the Citizen: Music as Public Utility in Third Republic France*. Berkeley, CA: University of California Press, 2009.

Patriarca, Silvana. "Indolence and Regeneration: Tropes and Tensions of Risorgimento Patriotism." *The American Historical Review*, April 2005. http://www.historycooperative.org/journals/ahr/110.2/patriarca.html.

Pauly, August, et al. (eds.). *Paulys Realencyclopädie der classischen Altertumswissenschaft*. Stuttgart: J.B. Metzler, 1894–1980.

Pelikan, Jaroslav. *Mary through the Centuries: Her Place in the History of Culture*. New Haven, CT and London: Yale University Press, 1996.

— and V. Hotchkiss (eds.). *Creeds and Confessions of Faith in the Christian Tradition*, vol. 2: *Creeds and Confessions of the Reformation Era*. New Haven, CT: Yale University Press, 2003.

Pershall, S. "Reading *Megillat Antiochus* on Hanukkah." *HaDoar*, 53 (1974).

Pfeiffer, Robert. *History of New Testament Times: With an Introduction to the Apocrypha*. New York: Harper, 1949.

Pinamonti, Paolo (ed.). *Mozart, Padova e la Betulia Liberata: Committenza, interpretazione e fortuna delle azioni sacre metastasiane nel '700*. Florence: Leo S. Olschki Editore, 1991.

— "'Il ver si cerchi, / non la vittoria': Implicazioni filosofiche della *Betulia* metastasiana." In *Mozart, Padova e la Betulia Liberata*, ed. Pinamonti.

Poirier, Jacques. *Judith: Échos d'un mythe biblique dans la littérature française*. Rennes: Presses Universitaires de Rennes, 2004.

Polizzotto, Lorenzo. *Children of the Promise. The Confraternity of the Purification and the Socialization of Youths in Florence, 1427–1785*. Oxford: Oxford University Press, 2004.

Pouncey, Phillip. Review of A. Bertini's *I disegni italiani della Biblioteca Reale di Torino. Burlington Magazine*, 99 (1959).

Powell, Morgan. "The Audio-Visual Poetics of Instruction." In Mews, *Listen Daughter*.

Power, Kim E. "From Ecclesiology to Mariology: Patristic Traces and Innovation in the *Speculum Virginum*." In Mews, *Listen Daughter*.

Prescott, Anne Lake. "The Reception of Du Bartas in England." *Studies in the Renaissance*, 15 (1968).

Priero, D. Giuseppe. *Giuditta. La Sacra Bibbia: Volgata Latina e Traduzione Italiana*, 4. Turin: Marietti, 1959.

Pringle, Ian. "'Judith': The Homily and Poem." *Traditio*, 31 (1975).

Puglisi, Catherine. *Caravaggio*. London and New York: Phaidon, 2000.

Purdie, Edna. *The Story of Judith in German and English Literature*. Paris: Librairie Ancienne Honoré Champion, 1927.

Radavich, David. *A Catalogue of Works Based on the Apocryphal Book of Judith. From the Mediaeval Period to the Present* (Bulletin of Bibliography 44). Boston Book Co., 1987.

Radke, Gary M. (ed.) *Verrocchio's David Restored: A Renaissance Bronze from the National Museum of the Bargello, Florence.* Atlanta, GA: High Museum of Art, 2003.

Rakel, Claudia. *Judit – Über Schönheit, Macht, und Widerstand im Krieg.* Berlin: de Gruyter, 2003.

Randolph, Adrian W. B. *Engaging Symbols: Gender, Politics, and Public Art in Fifteenth-Century Florence.* New Haven, CT and London: Yale University Press, 2002.

Rank, Otto. *Art and Artist: Creative Urge and Personality Development.* New York and London: W. W. Norton & Co., 1968.

Reau, Louis. *Iconographie de l'art chrétien.* Paris: Presses universitaires de France, 1956.

Rebenich, S. *Jerome.* London: Routledge, 2002.

Reyer, Ernest. "*Samson et Dalila.*" *Journal des débats,* 9 November (1890).

Riviale, Laurence. *Le vitrail en Normandie entre Renaissance et Réforme (1517–1596)* (Corpus Vitrearum, France, Études, VII). Rennes: Presses Universitaires de Rennes, 2007.

Robbins Landon, H. C. (ed.). *The Mozart Compendium: A Guide to Mozart's Life and Music.* London: Thames and Hudson, 1990.

Roberts, Alexander and James Donaldson (eds.). *The Ante-Nicene Fathers,* vol. 1. Buffalo, NY: Christian Literature Publishing, 1886. 2nd edition, Grand Rapids, MI: W. B. Eerdmans, 1950.

Robertson, Ritchie. *The "Jewish Question" in German Literature 1749–1939. Emancipation and Its Discontents.* Oxford: Oxford University Press, 1999.

Ross, Isabel. *Margaret Fell: Mother of Quakerism.* London: Longmans, Green & Co., 1949.

Rothstein, Max. *Die Elegien des Sextus Propertius.* Berlin: Weidmann, 1924.

Rubin, Patricia Lee and Alison Wright, with Nicholas Penny (eds.). *Renaissance Florence: The Art of the 1470s.* London: National Gallery Publications, 1999.

Rubinstein, Nicolai. *The Government of Florence under the Medici (1434–1494),* 2nd ed. Oxford: Clarendon Press, 1997.

Sainte-Marie, Henri de. "Sisto V e la Volgata." In *La Bibbia "Vulgata" dalle origini ai nostri giorni,* ed. Tarcisio Stamare. Rome: Libreria Vaticana, 1987.

Santini, Emilio. "La *protestatio de iustitia* nella Firence Medicea del sec. XV." *Rinascimento,* 10 (1959).

Savoia, Francesca. "From Lucia to Violetta: romantic heroines of the 19th-century Italian opera." *Revue de littérature comparée,* 66:3 (1992).

Schaff, P. and H. Wace (eds.). *St. Ambrose, Nicene and Post-Nicene Fathers of the Christian Church,* second series, vol. 10. New York: The Christian Literature Company, 1896.

Schernberg, Dietrich. *Ein schön Spiel von Frau Jutten*, ed. Manfred Lemmer. Berlin: E. Schmidt, 1971.

Schmitz, Barbara. "Zwischen Achikar und Demaratos – die Bedeutung Achiors in der Juditerzählung." *Biblische Zeitschrift*, 48 (2004).

— *Gedeutete Geschichte. Die Funktion der Reden und Gebete im Buch Judit* (Herders Biblische Studien 40). Freiburg: Herder, 2004.

— "Casting Judith: The Construction of Role Patterns in the Book of Judith." In *Biblical Figures in Deuterocanonical and Cognate Literature. International Conference of the ISDCL at Tübingen,* ed. Hermann Lichtenberger and Ulrike Mittmann-Richert. Berlin: Walter de Gruyter, 2009.

Schneider, Laurie. "Donatello and Caravaggio: The Iconography of Decapitation." *American Imago* 33:1 (1976).

Scott, Joan W. "The Evidence of Experience." *Critical Inquiry*, 17 (1991).

Seyfarth, Jutta. "The *Speculum Virginum*: The Testimony of the Manuscripts." In Mews, *Listen Daughter.*

Seymour, Charles Jr. *Michelangelo's David: A Search for Identity.* Pittsburgh, PA: University of Pittsburgh Press, 1967.

Shapley, Fern Rusk. *Catalogue of the Italian Paintings.* Washington, D.C.: National Gallery of Art, 1979.

Sherwood-Smith, Maria. "Studies in the Reception of the 'Historia scholastica' of Peter Comestor." The "Schwarzwälder Predigten," the "Weltchronik" of Rudolf von Ems, the "Scolastica" of Jacob van Maerlant, and the "Historiebijbel van 1360" (Medium Ævum Monographs. new series XX). Oxford: Blackwell for the Society for the Study of Mediaeval Languages and Literature, 2000.

Shmeruk, Chone. "Reshitah shel ha-prozah ha-sipurit be-Yidish u-merkazah be-Italyah." In *Sefer zikaron le-Aryeh Leoneh Karpi: kovets mehkarim le-toldot ha-Yehudim be-Italyah,* ed. Itiel Milano, Daniel Carpi, and Alexander Rofe. Jerusalem: Mosad Shelomoh Meir, 1967.

— "Defuse Polin be-Yidish." In *Kiryat Sefer,* reprinted in his *Sifrut Yidish be-Polin.* Jerusalem: Magnes, 1982.

— "Defuse Yidish be-Italyah." *Italyah* 3:1–2 (1982).

Simons, H. "Eating Cheese and *Levivot* on Hanukkah." *Sinai,* 115 (1995).

Simons, Patricia. "Women in Frames: The Gaze, the Eye, the Profile in Renaissance Portraiture." *History Workshop Journal,* 25 (1988).

Skinner, Quentin. "Ambrogio Lorenzetti: The Artist as Political Philosopher." *Proceedings of the British Academy,* 72 (1986).

Smither, Howard E. *A History of the Oratorio,* 4 vols. Chapel Hill, NC: University of North Carolina Press, 1977–2000.

Sommers, Paula. "Louise Labé: The Mysterious Case of the Body in the Text." In *Renaissance Women Writers: French Texts/American Contexts,* ed. Anne Larsen and Colette H. Winn. Detroit, MI: Wayne State University Press, 1994.

Sommervogel, Carlos. *Bibliothèque de la Compagnie de Jésus*, new ed., 12 vols. Brussels-Paris: Schepen-Picard, 1890–1932.

Sorba, Carlotta. "Il 1848 e la melodrammatizzazione della politica." In *Storia d'Italia: 22*, ed. A. M. Banti and P. Ginsborg. Torino: Einaudi, 2007.

Spallanzani, Marco and Giovanna Gaeta Bertela, eds. *Libro d'inventario dei beni di Lorenzo il Magnifico*. Florence: Amici del Bargello, 1992.

Spear, Richard. "Artemisia Gentileschi, Ten Years of Fact and Fiction." *The Art Bulletin*, 82 (September 2000), 568–79.

Spier, Jeffrey, et al. *Picturing the Bible: The Earliest Christian Art*. New Haven, CT and London: Yale University Press, 2007.

Stemberger, Günter. "La festa di Hanukkah, Il libro di Giuditta e midrasim connessi." In *We-Zo't Le-Angelo: Raccolta di studi giudaici in memoria di Angelo Vivian*, ed. Giulio Busi. Bologna: Associazione italiana per lo studio del giudaismo, 1993.

Stocker, Margarita. *Judith: Sexual Warrior. Women and Power in Western Culture*. New Haven, CT and London: Yale University Press, 1998.

Stone, Nira. "Judith and Holofernes: Some Observations on the Development of the Scene in Art." In *"No One Spoke Ill of Her": Essays on Judith*, ed. James C. VanderKam. Atlanta: Scholars Press, 1992.

Straten, Adelheid. *Das Judith-Thema in Deutschland im 16. Jahrhundert. Studien zur Ikonographie. Materialien und Beiträge*. Munich: Minerva-Fachserie Kunst, 1983.

Talbot, Michael. *The Sacred Music of Antonio Vivaldi*. Florence: Olschki, 1995.

Taylor, Graeme. "Judith and the Infant Hercules." *American Imago* 41:2 (1984).

Tea, Eva. *La Basilica di Santa Maria Antiqua*. Milan: Società Editrice "Vita e Pensiero," 1937.

Timm, Erika. *Historische jiddische Semantik: die Bibelübersetzungssprache als Faktor der Auseinanderentwicklung des jiddischen und des deutschen Wortschatzes*. Tübingen: Niemeyer, 2005.

Tomas, Natalie R. *The Medici Women: Gender and Power in Renaissance Florence*. Aldershot, UK: Ashgate, 2003.

— "Did Women Have a Space?" In *Renaissance Florence: A Social History*, ed. Roger J. Crum and John T. Paoletti.

Tomassetti, Luigi, et al. (eds.). *Bullarum, diplomatum et privilegiorum sanctorum Romanorum pontificum taurinensis*, 25 vols. Augustae Taurinorum: Seb. Franco, H. Fory et Henrico Dalmazzo, 1857–1872.

Trible, Phyllis. *Texts of Terror: Literary-Feminist Readings of Biblical Narratives*. Philadelphia, PA: Fortress Press, 1984.

Trisolini, Giovanna. "Adrien D'Amboise: l'Holoferne." In *Lo Scrittore e la Città*, ed. G. Barbieri. Geneva: Slatkine, 1982.

Tronchon, Charles. *La Sainte Bible, Introduction générale*, vol. 1.

Trout, Dennis E. *Paulinus of Nola: Life, Letters and Poems*. Berkeley, CA: University of California Press, 1999.

Turniansky, Chava. "Yiddish and the Transmission of Knowledge in Early Modern Europe." *Jewish Studies Quarterly* 15:1 (2008).

Uppenkamp, Bettina. *Judith und Holofernes in der italienischen Malerei des Barock*. Berlin: Reimer, 2004.

VanderKam, James C. (ed.). *"No One Spoke Ill of Her": Essays on Judith*. Atlanta: Scholars Press, 1992.

— *An Introduction to Early Judaism*. Grand Rapids, MI: W. B. Eerdmans, 2001.

Van Der Koon, Karel. *Scribal Culture and the Making of the Hebrew Bible*. Cambridge, MA: Harvard University Press, 2007.

van Dijk, Ann. "Type and Antetype in Santa Maria Antiqua: The Old Testament Scenes on the Transennae." In *Santa Maria Antiqua al Foro Romano cento anni dopo*, ed. J. Osborne et al. Rome: Campisano, 2004.

van Henten, Jan Willem. "Judith as Alternative Leader: A Rereading of Judith 7–13." In *A Feminist Companion to Esther, Judith and Susanna*, ed. Athalya Brenner. Sheffield: Sheffield Academic Press, 1995.

Wacholder, Ben Zion. "Review of Mirsky, *Sheeltot de Rab Ahai Gaon*." *Jewish Quarterly Review*, 53 (1963).

Walker, Colin. "Nestroy's *Judith und Holofernes* and Antisemitism in Vienna." *Oxford German Studies*, 12 (1981).

Walla, Friedrich. "Johann Nestroy und der Antisemitismus. Eine Bestandaufnahme." *Österreich in Geschichte und Literatur*, 29.1 (1985).

Wanegffelen, Thierry. *Ni Rome, ni Genève. Des fidèles entre deux chaires en France au XVIe siècle*. Paris: Champion, 1997.

Warner, Marina. *Alone of All Her Sex: The Myth and the Cult of the Virgin Mary*. New York: Random House, 1983.

Wasserstein, Abraham and David J. Wasserstein. *The Legend of the Septuagint: From Classical Antiquity to Today*. Cambridge: Cambridge University Press, 2006.

Watson, Arthur. "The *Speculum Virginum* with Special Reference to the Tree of Jesse." *Speculum* 3 (1928).

Weaver, Elissa. *Convent Theatre in Early Modern Italy: Spiritual Fun and Learning for Women*. Cambridge: Cambridge University Press, 2002.

Weinberg, Joanna. *The Light of the Eyes: Azariah de' Rossi*. New Haven, CT: Yale University Press, 2001.

Weinstein, Donald. *Savonarola and Florence: Prophecy and Patriotism in the Renaissance*. Princeton, NJ: Princeton University Press, 1970.

Weitzman, Steven. *Surviving Sacrilege: Cultural Persistence in Jewish Antiquity*. Cambridge, MA: Harvard University Press, 2005.

Wiesemann, Falk. *"Kommt heraus und schaut": Jüdische und christliche Illustrationen*

zur Bibel in alter Zeit, eds. Marion Aptroot and William L. Gross. Essen: Klartext Verlag, 2002.

Wiesner, Merry E. *Women and Gender in Early Modern Europe*. Cambridge: Cambridge University Press, 1993, 2nd edition 2000.

Wills, Lawrence M. *The Jewish Novel in the Ancient World*. Ithaca, NY: Cornell University Press, 1990.

— "Ascetic Theology before Asceticism? Jewish Narratives and the Decentering of the Self." *Journal of the American Academy of Religion*, 74(4) (December 2006).

Wind, Edgar. "Donatello's *Judith*: A Symbol of *Sanctimonia*." *The Journal of the Warburg and Courtauld Institute*, 1 (1937).

Wolters, Wolfgang. *La Scultura veneziana gotica 1300/1460*, 2 vols. Venice: Alfieri, 1976.

Woodruff, Helen. "The Illustrated Manuscripts of Prudentius." *Art Studies*, 7 (1929).

Woolf, Rosemary. "The Lost Opening of Judith." *Modern Language Review*, 50 (1995).

Word for Word – Artemisia No. 02. Texts by Roland Barthes, Eva Menzio, and Léa Lublin. Paris: Yvon Lambert, 1979.

Wright, Alison. *The Pollaiuolo Brothers: The Arts of Florence and Rome*. New Haven, CT and London: Yale University Press, 2005.

Yates, W. E. *Nestroy. Satire and Parody in Viennese Popular Comedy*. Cambridge: Cambridge University Press, 1972.

Zaragoza, Gabrijela Mecky. "*Da befiel sie Furcht und Angst ...*" *Judith im Drama des 19. Jahrhunderts*. Munich: Iudicium, 2005.

Zen, Stefano. "Bellarmino e Baronio." In *Bellarmino e la Contrariforma*, ed. Romeo de Maio et al. Sora: Centro di Studi Sorani "Vincenzo Patriarca," 1990.

Zenger, Erich. "Das Buch Judit." *Jüdische Schriften aus hellenistisch-römischer Zeit* 1. Gütersloh: G. Mohn, 1981.

Ziolkowski, Theodore. "Re-Visions, Fictionalizations, and Postfigurations. The Myth of Judith in the Twentieth Century." *Modern Language Review*, 104 (2009).

Abbreviations

List of abbreviations of books of the Bible and versions of the Bible as used in this volume (according to *The Chicago Manual of Style*, 15th ed., 2003, sections 15.50–54).

The Jewish Bible/Old Testament

Am	Amos	Jgs	Judges
1 Chr	1 Chronicles	1 Kgs	1 Kings
2 Chr	2 Chronicles	2 Kgs	2 Kings
Dn	Daniel	Lam	Lamentations
Dt	Deuteronomy	Lv	Leviticus
Eccl	Ecclesiastes	Mal	Malachi
Est	Esther	Mi	Micah
Ex	Exodus	Neh	Nehemiah
Ez	Ezekiel	Nm	Numbers
Gn	Genesis	Prv	Proverbs
Hg	Haggai	Ps	Psalms
Hos	Hosea	(pl. Pss)	
Is	Isaiah	Ru	Ruth
Jer	Jeremiah	1 Sm	1 Samuel
Jb	Job	2 Sm	2 Samuel
Jl	Joel	Sg	Song of Solomon
Jon	Jonah		(=Song of Songs)
Jo	Joshua	Zec	Zechariah

The Apocrypha

Jdt	Judith
1 Mc	1 Maccabees
2 Mc	2 Maccabees
Sus.	Susanna
Tb	Tobit

The New Testament

Acts	Acts of the Apostles
1 Cor	1 Corinthians
2 Cor	2 Corinthians
Eph	Ephesians
Jas	James
Jn	John (Gospel)
Lk	Luke
Mk	Mark
Mt	Matthew
Phil	Philippians
1 Thes	1 Thessalonians

Versions and sections of the Bible

Apoc.	Apocrypha
AV	Authorized (King James) Version
DV	Douay Version
HB	Hebrew Bible
LXX	Septuagint
Vulg.	Vulgate

Indexes

Index of Biblical Citations

Note: Citations within each entry are in numerical order by chapter and version, indicated in boldface type.

Index of Citations for the Book of Judith